PROTESTANTS & PICTURES

PROTESTANTS & PICTURES

Religion, Visual Culture, and the Age of American Mass Production

David Morgan

New York Oxford

Oxford University Press

1999

Oxford New York

Athens Auckland Bangkok Bogotá Buenos Aires Calcutta
Cape Town Chennai Dar es Salaam Delhi Florence Hong Kong Istanbul
Karachi Kuala Lumpur Madrid Melbourne Mexico City Mumbai
Nairobi Paris São Paulo Singapore Taipei Tokyo Toronto Warsaw

and associated companies in
Berlin Ibadan

Published by Oxford University Press, Inc.
198 Madison Avenue, New York, New York 10016

Oxford is a registered trademark of Oxford University Press

Library of Congress Cataloging-in-Publication Data
Morgan, David, 1957–
 Protestants and pictures : religion, visual culture, and the age
of American mass production / David Morgan.
 p. cm.
 Includes bibliographical references and index.
 ISBN 0-19-513029-4
 1. Protestantism in art. 2. Spirituality in art.
3. Popular culture—United States—History—19th century.
4. Popular culture—United States—History—20th century. I. Title.
 N7903.7 M67 1999
 246′.5—dc21 98-45312

Part I: Edward Bookhout, engraver, "A Sabbath in the Woods," *Christian Almanac* (1858), p. 21.

Part II: "Illustrations of Miller's Views of the End of the World in 1843," date and publisher unknown. Courtesy of the American Antiquarian Society.

Part III: Alexander Anderson, engraver, title page, *On Early Religious Education,* tract no. 143, *Publications of the American Tract Society* (New York: American Tract Society, 1842).

Part IV: Heinrich Hofmann, *The Savior,* oil on canvas, date and size unknown. Courtesy of Riverside Church, New York.

9 8 7 6 5 4 3 2 1

Printed in the United States of America
on acid-free paper

Preface

A project that stretches over several years accumulates many debts on the thin promise that it will one day repay them. I am therefore very happy to acknowledge here the assistance of a number of institutions and individuals without which I would not have been able to write this book. Support for my research began with a faculty fellowship in the Pew Program in Religion and American History at Yale University. The Henry Luce Foundation provided much-needed assistance with a grant to support travel to and research at key collections and libraries. Valparaiso University provided summer research support in a subsequent year. A postdoctoral fellowship in the Getty Grant Program in Art History and the Humanities enabled another year of uninterrupted work on the project. An American Historical Print Collectors Society fellowship at the American Antiquarian Society allowed me to bring the project to completion. The Henry Luce Foundation supported the publication of the manuscript with a subvention grant. And the Ziegler Foundation provided assistance with additional costs of publication. I sincerely thank each institution and the many people at each foundation, library, and university who offered me so much help.

Research for this book meant long periods of archival burrowing, during which I was able to rely on the good graces and magnificent collections of a host of libraries and archives around the country. My warm thanks go to the following institutions and their indispensable staffs: New York Public Library, Billy Graham Museum, Riverside Church, Rockefeller Archives, American Antiquarian Society, Jesuit-Kraus-McCormick Library, Newberry Library, Library of Congress, Regenstein Library (University

of Chicago), James White Library and Adventist Heritage Center at Andrews University, Moody Bible Institute, Moellering Library, Valparaiso University, Aurora University Library, and Anderson University Archives.

A host of friends and colleagues must line up to receive overdue thanks. My colleagues in the Department of Art at Valparaiso University became accustomed to my frequent absences, but carried on with distinction—my sincere thanks for their support and friendship. Several administrators at Valparaiso swallowed hard as I slipped away one year after another to work on this book, and I am much obliged to their forbearance. Many library, archive, and museum staffpersons led me through collections whose holdings changed the nature of my project in ways I could not have anticipated. I would like to thank Wendy Miller at the Billy Graham Museum, Ken Sawyer at the Jesuit Krauss McCormick Library, Georgia Barnhill and Laura Wasowicz at the American Antiquarian Society, Victor Jordan at the archives of the Riverside Church in Manhattan, and Jim Ford, curator at the Advenist Heritage Center.

I am indebted to several colleagues who have written on behalf of this project at one point or another, reviewed drafts, recommended bibliography, commented on different versions of chapters at conferences, helped shape fellowship proposals, or discussed aspects of the project as it developed: Sally Promey, Erika Doss, Paul Gutjahr, Betty DeBerg, Colleen McDannell, Peter Hawkins, Harry Stout, Jon Butler, Ronald Numbers, David Nord, Georgia Barnhill, Jane Pomeroy, Noel Cormack, Shirley Wajda, Bret Carroll, Nandini Bhattacharya, Leigh Schmidt, and Stewart Hoover. To each of them a hearty thanks. Special thanks to Sally Promey for her ever reliable good sense as colleague and friend. My thanks also to Phillip Morgan, Keiko Oyama, Kerri Klein, and Naomi Strom for their photographic work.

Finally, I dedicate this book to my children, Ashley, Ben, and Peter, who made coming home the best part of research trips.

Contents

List of Illustrations

Part Heading Illustrations

PROTESTANTS *&* PICTURES

Introduction

In the autumn of 1799, very near the occasion of his twenty-fourth birthday, Ebenezer Francis Newell (1775–1867) left his family home in Worcester County, Massachusetts, to seek his fortune abroad. Arriving at the coast, he booked passage to London. But Newell was persuaded to forego the voyage by a kindly ship captain who regarded the "old Country" as a "corrupt place" that offered nothing of profit to "a young man without much money."[1] Newell determined to enroll in the study of navigation ashore before embarking on a career at sea. He boarded with a Methodist deacon named Watson, who possessed a library stocked with the writings of John Wesley and a parlor with two pictures that attracted Newell's attention (figs. 1 and 2).

Befriended by other Methodists and clergy, Newell spent the next year of his life undergoing religious conviction. As an old man of seventy-one, he recalled in his memoirs the importance of the deacon's pictures in his conversion process. Devoting nearly three pages to the "hieroglyphic trees," one allegorically depicting the fruits of the sinner's life, the other those of the Christian's, Newell dwelled on the significance of the images' symbolism for himself. Contrasting the "pride," "lust," "despair," "unbelief," and "wrath!" delineated in the first image with the "heavenly-mindedness" and "grace" inscribed on the fruit of the second, the young Newell came to a gripping conclusion: "My heart passed sentence on myself as one standing on the brink of ruin with nothing but the brittle thread of life holding me out of the lake of fire."[2]

These allegorical images of condemnation and redemption—the life of perdition and the life of divine benevolence—were charged with a special

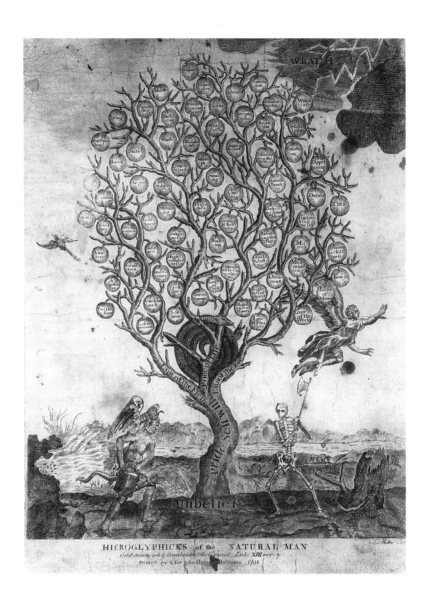

HIEROGLYPHICKS of the NATURAL MAN

power as Newell beheld them. Emblematic engravings commonly used in late-eighteenth-century printed books and broadsides, the sinner and Christian trees moved the young Newell, poised as he was at the moment of seeking a vocation in a wide, new world that must have seemed very bewildering to him. It is no mistake that conversions often happen to the young, and it is not hard to understand why images helped foment the emotional crisis in Newell's life that led to conversion and eventually to his ordination as a Methodist clergyman.

Or at least the role of images in this does not seem so unnatural to us looking back from a world steeped in films, photographs, and pixilated visions. Yet Newell's words are striking. That the sensation of "the brittle thread of life" holding him "out of the lake of fire" should be occasioned by the contemplation of two images is surely remarkable. Not much more

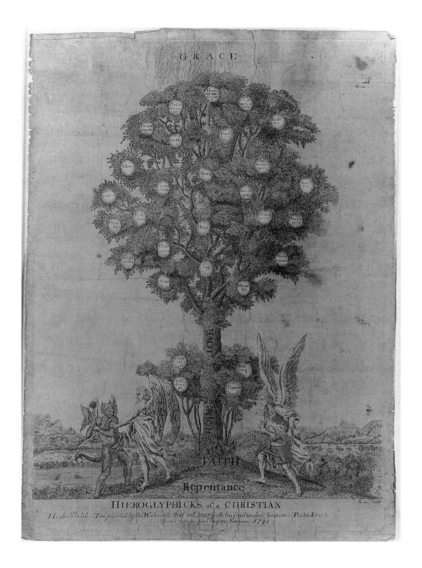

than half a century before his day, the sinner dangling over the pit of doom would have found himself placed there by the homiletics of Jonathan Edwards, who required no use of pictorial images to evoke the heat and billowing steam of an angry God. In the rich and brutal rhetoric of his most famous sermon, Edwards memorably portrayed the situation of the unconverted among his congregation as poised over "that lake of burning brimstone . . . hell's wide gaping mouth," with only the hand of a good and gracious God holding them up.[3] Of course, the Second Great Awakening of Newell's day made no less use of the oral culture of revival, but a new moral technology supplemented the Protestant apparatus of conversion—the image, mass-produced as well as hand-painted.

Perhaps Methodists were less resistant to the emotional suasion of images. In any case, something had happened by 1800. Printed images of a highly abstract and allegorical character had long appealed to even the staunchest Puritans.[4] Printed pictures—engravings that illustrated reli-

Fig. 2
[?] Morton, *Hieroglyphicks of a Christian*, engraving, 6 1/4 × 5 1/16, printed by John Hagerty, Baltimore, 1791. Courtesy of the Maryland Historical Society, Baltimore.

gious texts and served to encapsulate religious doctrine—posed no threat to Protestant iconophobes. By the beginning of the nineteenth century, however, American Protestants such as Newell could find an important place for images in their religious lives. Such personal accounts as Newell's are not many, but the role of images among the American offspring of Calvinism would only grow as the century passed. I propose to study this development among nineteenth- and early-twentieth-century Protestants who increasingly found that looking at mass-produced images was an act imbued with the power of belief or to make one believe. Seeing was believing in a culture that was undergoing what sociologists have since referred to as massification.

The history of mass-produced religious images in the United States during the nineteenth century is a story composed of many elements: the commerce of religion, technological innovations, ideologies of progress and millennialism, the politics of nationalism, and anxieties over the fragility of democracy. The visual culture of belief that was shaped in this field of social forces was rich and diverse. Religious images served to instruct children and immigrants. Others operated as banners of religious identity and markers of social difference. Protestant Americans even developed icons for contemplation and devotion. Whatever the purpose, the visual culture of nineteenth-century Protestantism participated in a cultural economy in which belief was converted into graphic information and disseminated cheaply over great distances by virtue of a mass-produced medium and an ever-expanding infrastructure of distribution. This book is a history of Protestant visual culture and the power of images in the last phase of what Walter Benjamin called the age of mechanical reproduction.[5]

But invoking Benjamin raises several problems. In his classic essay "The Work of Art in the Age of Mechanical Reproduction," 1936, which argued for the epochal significance of the mechanical means of modern visual reproduction (from lithography to film), Benjamin highlighted the material role of mass mediation as a modern invention and drew attention to the ideological performance of images in the politics of modern culture. Benjamin's premise was that the development of the mechanical reproduction of images undermined the "aura" of the cult image, that is, its uniqueness and authenticity. Fascinated as a Marxist by the decay of proprietarial status that the democratizing power of mechanical reproduction entailed, Benjamin theorized that the uniqueness or essence of the original cult image was eliminated as the object was replicated and appropriated to contexts for which it was not originally intended. Deprived of its sensuous presence and its authorization in the religious rite, the authenticity of the work of art was compromised. Benjamin believed that mechanical reproduction would liquidate heros, myths, gods, and cult figures, since reproducing them in film eliminated the "traditional value of the cultural heritage" by adapting the image of the original to the time and place of subsequent viewers.[6]

Benjamin offered crucial insights in his essay. First, certain kinds of images possess an aura, a presence or power that impresses upon viewers the authencity, veracity, or authority of whomever or whatever the image depicts. This aura seems to emanate from the image and should not be con-

fused with the didactic value of the image as a form of information nor with the image's ability to express its maker's feeling. Aura pertains to the image as an object present before the viewer. Benjamin helpfully delineated a category of the image that anthropologists had formerly placed in the large and unwieldy category of the "fetish."[7]

Benjamin was also surely correct in recognizing the power of mechanical reproduction to democratize visual response by concealing the original behind its replications. Certainly the unchecked flood of reproductions issuing from printing presses and cameras encouraged the right of viewers to make what they would of an image's significance. Yet the appropriation of images did not begin with mechanical reproduction. In fact, the human past is an unrelenting succession of appropriations. One civilization borrows from another, making the architecture, art, stories, and names of one people into those of another. Mechanical reproduction only facilitates the operation of making the meaning of an image one's own. This is what nineteenth-century reproductive technologies did by helping to re-construct culture, religion, and beauty in the increasingly ephemeral worlds of consumers and believers. But humans have always lifted artifacts or ideas from one setting and redeployed them in another. Every act of appropriation tailors what is borrowed or imitated to the new context, refashioning both the borrowed world and the world of the borrower. Moreover, there is nothing to stop believers from reinvesting a copy with the status of an original—and they readily do this. As William Wroth has observed, for example, southwestern Latino and Mestizo Catholics did this in the nineteenth century when they replaced older Mexican woodcuts of saints with American or European chromolithographs. The mass-produced lithographs easily displaced the older forms without forfeiting the value attached to the cult image.[8]

So while I acknowledge Benjamin's delineation of the epoch of mechanical reproduction, I do not accept his notion of the inevitable loss of aura through such media as photography and modern printmaking methods. Indeed, the history of Protestant visual piety in nineteenth- and twentieth-century America contradicts Benjamin's thesis. Believers have enshrined inexpensive copies of commercial religious art and treated them reverentially in domestic piety and public worship. Aura has never vanished because it is a function not merely of an image's fabrication but largely of its reception. In fact, mechanical reproduction has magnified rather than eliminated aura in Protestant visual piety over the last two centuries.[9]

The final chapters of this study will describe the emergence of the devotional image in the history of mass-mediated images in American Protestantism. The devotional image consisted of what Benjamin meant by the "cult value" of an image: its performance in the ritual action of prayer, worship, or devotions to make present a deity, a hero, or a desired state of affairs.[10] This may occur whether or not an image is mass produced, although mass-produced images contributed significantly to the formation of a devotional visual piety among American Protestants in the second half of the nineteenth century. Contrary to Benjamin's assertion that "mechanical reproduction emancipates the work of art from its parasitical dependence on ritual," I will demonstrate that the visual reproduction was considered by many believers to be transparent, capable of of-

fering the viewer the aesthetic qualities and moral effects available in viewing the original. Aura, in other words, was graphically transmissible.

Mechanical reproduction did not distance the image from its original but brought to the devout viewer the very subject of the image—in most instances Jesus but also historical subjects and places of the Bible. Part of the reason for this was an American version of the very democratization that Benjamin praised: as I will show in chapters 7 and 8, illustrated books and reproductions of original works of art were believed to disseminate knowledge and artistic value for the good of everyone, for common enlightenment and the progress of the nation toward realizing the ideals of democracy. This democritization was hailed by graphics theorist William Ivins, who resented the "snobbishness" of the wealthy who were the only ones able to afford expensive, hand-produced art books. Ivins also argued that the introduction of photography submerged the graphic means of representation beneath the perceptual threshold of human beings such that the units or pictorial codes of depicting objects *appeared* continuous with what the human eye sees.[11] The hatching that moves in varying weights across the surface of a wood engraving determines an object's volume and distance from the visual plane that separates the world depicted in the image from the viewer. The column behind Christ in Mary Byfield's *Suffer the Little Children* (fig. 3), for instance, is modeled from light to dark by coding tonal variation in the density of black and white engraved lines. At a certain distance from the viewer's eye the gravure is transfigured from a pattern of wavy vertical lines into the appearance of a solid mass across which light falls. When we hold the image closer to our eyes, however, we see that the graver's marks interpose themselves as translations or interpretations of how light might appear on an actual column. By contrast, the constituent element of the halftone, a screen that imposes a tiny grid on incoming light, retains a much greater amount of tonal information from the image falling on the photographic plate. The magic of the photographic process, according to Ivins, was that nothing interfered with the transposition of reality to the image. Photographs, he wrote, are "exactly repeatable visual images made without any of the syntactical elements implicit in all hand made pictures."[12]

Of course, as Eustelle Jussim demonstrated in her superb study of reproductive techniques, this presumed continuity was constructed within the context of nineteenth-century image making.[13] Images condition human vision, and "truth" is historically shaped. In the nineteenth century the move from handmade print techniques to the halftone engraving *seemed* to eliminate human intervention and make the image all the more immediate. The original was believed to stand fully accessible behind the transparent window of the photographic image. The photograph helped bring the Protestant devotional image into existence by enabling Protestants to use works of art as part of the pedagogy of nurture and character formation, which imbued the image with a presence in domestic and devotional life. Contrary to what Benjamin argued, mechanical reproduction helped infuse the original with aura by deploying the image through mass mediation in the rituals of Protestant visual piety. The copy was as good as the original because the means of reproduction were thought transparent or unintrusive.

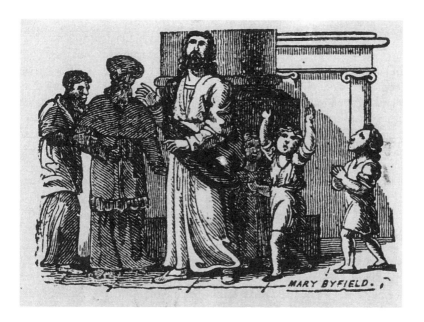

The visual culture I examine in this study developed from images that taught (didactic imagery) to images that were contemplated in the quiet of chapels, sanctuaries, bedrooms, and living rooms (devotional imagery). This historical development began with the pedagogical practice of instructing the unconverted and the child, filling their memories with information about salvation. The study ends by chronicling the emergence of a devotional visual piety in which images were used to nurture in addition to instruct, to monitor and shape behavior, to praise God, and eventually even to direct the prayers and pious meditations of Protestants. If antebellum Protestants distanced themselves from their new Catholic neighbors on the issue of image veneration, many twentieth-century Protestants, liberals and conservatives, were much less inclined to do so.[14]

Devotional images emerged from the concern to nurture youth rather than a concern to program them with information supporting evangelical conversion. Nurture was thought to shape character in a gradual unfolding of image into reality through the course of childhood and later life. If didactic imagery filled the memories of children with knowledge of the Bible, devotional imagery crafted memories of relations with a nurturing parent, savior, and home life. Nurture drew its iconography from the antebellum cult of the mother, whose lap and home were the womb envisioned as embracing the Victorian child in warmth and gentleness. Nurture was also applied to the task of elevating national taste through the use of religious fine art. This imagery found its way into the Protestant home in the form of gift books and illustrated lives of Christ, which included portrait imagery of Jesus, whose physical appearance and historicity became a matter of increasing concern to Americans as the century passed.

The final chapter explores the application of the devotional image to Protestant pedagogy, informed as it came to be around the turn of the cen-

Fig. 3
Mary Byfield, *Suffer the Little Children,* wood engraving, from *Address to a Child.* (New York: American Tract Society, n.d. [c. 1828–1832]), facing p. 8. Courtesy of the Billy Graham Center Museum.

tury by developmental psychology. In fact, Protestant educators, in their efforts to form the character of children and youth, brought together the instructive and nurturing virtues of religious imagery with all the vigor and optimism of a scientifically minded, reform-oriented belief in social progress and enlightened religion. Of special interest are publications that keyed certain kinds of images to specific age and gender groups. These and others allow us to trace the emergence of the iconography and thematic concerns that dominated devotional and instructional sources from the late nineteenth to the early twentieth centuries. Even here, in the enthusiastic embrace of liberal Protestantism and scientific modernity, the more things changed, the more they remained the same. Although the theocracy of the Puritans, the paternalism of the Federalists, and the republicanism of the Whigs was long gone, the religious liberals espoused a social philosophy of democratic progress in which America retained its missiological significance. Postmillennialism survived, if in transmuted form.

With the rise of reproductive media in the nineteenth century—wood engraving, lithography, and photography—came the popularization of the portrait. Linked to these technologies and their use in book and print production were traditions of interpretation such as physiognomy and phrenology, which taught that a person's character was displayed best in the features of the face or head. In the course of the second half of the nineteenth century, Americans became accustomed to the image of the face as the mass-mediated index of a person's character. At the same time character acquired a new meaning as identity or personality shaped over time but developed most substantially during youth. In the expansive egalitarianism of the new republic where individuals were empowered to shape their own destinies and to do so without the benefit of privileged birth, character was no longer something inherited but was molded by one's environment and polished by one's beliefs and practices. By the end of the century one's environment, including the images one saw at home and in church, was understood to exert a powerful influence on the evolution of the personality. Therefore images came to enjoy a special place in the instruction and entertainment of the young.

In an age when the daguerreotype, the photograph, and the halftone engraving pictured contemporaries and the world with an immediacy and intricate accuracy at the same time that modern critics were disassembling the scriptures and allowing the solidity of the biblical accounts to dissolve, the idea of recovering the likeness of the historical Jesus seemed especially attractive to American believers. When we add the late Victorian anxiety over the masculinity of Jesus and definitions of virility generally, we realize that the longing for Christ's likeness, pursued in the spate of illustrated lives of Christ published between the Civil War and the turn of the century, was no idle curiosity but a quest for certainty in a time of underlying doubt. William Barton expressed the manly resentment of an effeminate Christ in art in his 1903 illustrated life of Christ when he placed the following assertion in the mouths of painters who perniciously refused the masculine ideal in their work: "We will make our Christ with a woman's face and add a beard."[15]

In religious life the new idea of character as individual and self-formed rather than inherited and generic was applied to the task of the Christian

parent and teacher who shaped children into pious individuals. From the discovery of the propensities of young people for conversion in Sunday school or revival meeting to Horace Bushnell's philosophy of nurture, Christian pedagogues explored how best to instruct and influence children. When in the second half of the nineteenth century this aim was furthered by the contribution that images could make, Protestant devotional art began to take a place beside instructional imagery. Understood as an image capable of influencing the personal constitutions of those who meditated on it, devotional art must be distinguished from the strictly didactic image whose principal concern was the memorization of information or the facilitation of learning. In the gilded age, the image was one of the external agencies empowered by the tendency to explain behavior in terms of environmental rather than individual influences.

It was in the context of the iconography of the face and the formation of character that the portrait of Jesus became an important part of Protestant visual piety during the last quarter of the nineteenth century and the first decades of the twentieth. Whereas image production among the benevolence and Sunday school societies was geared toward the distribution of information aimed at the goal of conversion to evangelicalism, the desire to form rather than merely inform character made special use of images and thrived among liberal Protestants from Horace Bushnell to G. Stanley Hall. Fundamental to the new devotional conception of images among Protestants was the notion that images shaped behavior by shaping feeling and that fine art refined individual and national character. The final two chapters focus on the mass culture of the halftone reproduction in illustrated lives of Christ, in religious education, and in the growing cult of religious fine art around the turn of the century. Out of these new uses of mass-produced visual culture developed the Protestant devotional image and its application in domestic and public rituals of worship. By devotionalizing the image, creating a Protestant iconography of the face, Protestant teachers, pedagogues, and clergy reclaimed mass-produced religious images for use in communal life, fashioning face-to-face encounters from mass-mediated imagery and imbuing the printed picture with the aura of such an encounter in order to provide the semblance of local culture in a mass culture that competed increasingly for the young person's attention. The resulting formats and iconographies of imagery formed the basis of instructional and devotional materials that have dominated Sunday school, church camp, and domestic piety among American Protestants for the remainder of the twentieth century. The phenomenal success and familiar repertoire of such religious artists as Warner Sallman and Harry Anderson were built on this history and cannot be understood apart from it.[16]

Media, Millennium, Nationhood

There were many aspects to the complex social phenomenon of the Second Great Awakening, a period of revivals that enlisted rural and urban Americans in the cause and practices of evangelical Protestantism during the opening decades of the nineteenth century. The cause was to convert a young nation of postrevolutionary Americans and immigrants in search of a new life. The practices ranged from camp meetings, domestic devotion, mission work, Sabbath worship, and the religious instruction of children to various social and moral reform agendas embraced by the country's broad range of conservative and liberal Protestants. The significance of two interrelated strands concerns us here, whether the discussion refers to Methodists, Baptists, Congregationalists, or Adventists. On the one hand, the revival of evangelical Protestantism meant for its participants the return to the primitive truth of Christianity as experienced in the press and duress of camp-meeting conversion or congregational renewal. On the other hand, the success of the revival, its staying power, depended on subsequent application of the new vision of purpose through the convert's involvement in such voluntary efforts as tract distribution and the formation of sabbath societies or through the consumption of tracts, the practice of temperance or abstinence, and the attendance of church or associational meetings. The benevolent work of the voluntary organizations such as the American Bible Society (ABS), the American Sunday School Union (ASSU), and the American Tract Society (ATS) provided the activity to which converted or rededicated Christians applied their commitment.[1]

Throughout the antebellum period, evangelical Christians were widely united in voluntary benevolence dedicated to the national and global aims of evangelization. These Protestants—largely Congregationalists, Presbyterians, Baptists, evangelical Episcopalians, and Reformed Protestants—defined themselves positively in terms of their collaborative efforts to proclaim conversion to Christ and negatively in their opposition to Roman Catholicism ("popery"), all non-Christian religions ("heathenism" and "paganism"), and Unitarians, Universalists, and deists, who were often collectively referred to as infidels by many evangelicals. Evangelical Protestants were dedicated to proselytism, education, volunteerism, and revivalism. Basic to revival and the activist expression of it during the antebellum period were two portentous convictions. First, once converted, one must convert others; and second, the converted, by converting others, were able to inaugurate the thousand years of peaceful reign prophesied, many believed, in the Book of Revelation. But to understand that, we must consider the Protestant perception of contemporary American society, its prospects for the future, and its mission.

In this age of canal transportation, steam-powered engines and printing presses, telegraphs, and the improvement of the national postal system, evangelical Protestants framed their cause in terms of technology and communication. They believed that the new American republic exhibited unique and progressive features that were more than accidental. In 1851 Robert Baird (1798–1863), an evangelical Presbyterian minister and historian who was active in the ASSU and the ATS, published "a summary of the scientific, moral, and religious progress of the first half of the nineteenth century," in which he praised the very technological developments that fueled mission and benevolence work and hinted at their origin and purpose:

> What elements of power are here entrusted to us! These arts of printing that multiply the Word of God literally with every minute; these accumulations of capital still active, still accumulating; these means of communication over sea and land, through the broad earth—who does not hear the voice of God in all these?[2]

Baird's reading echoed the ASSU's assessment of the present conditions of American society and development as summarized by a pamphlet published in 1829 that offered an overview of the association's publications. On behalf of the ASSU, the author considered the present moment to be one of intense preparation for the dawning of the millennial age. Of particular interest in the following passage, which enumerates the signs of the times, is the central role of communications:

> Some things there are . . . which the faintest human reason might lay down as precursors of the blessed restitution of mankind to God. Among these would be such as the following: an increase of exchange between country and country; rapid and safe communication; the mastery over the multiple dialects which have arisen from the confusion of Babel; the predominance and diffusion of such tongues as contain stores of truth, or are spoken by good men; the advancement of knowledge,

and the means for propagating it, especially the press in its improved condition; wonderful reaching towards perfection in the arts; and, above all, greatly accelerated movement in the sacramental host, towards the illumination of the world.[3]

By "sacramental host" the pamphlet referred to the recently combined efforts of evangelical Protestants in the United States and in Great Britain, that is, the host of believers at work in the sacred cause of converting the world to evangelical Christianity as the benevolent associations collectively defined it. This united effort undertook the universal communication of the Gospel as the necessary propaedeutic to the arrival of the millennial age.

Nineteenth-century evangelicals believed that they were the special beneficiaries of a providentially designed confluence of changes in modern civilization. The present age was filled with prospects for the spiritual transformation of the nation and progress toward the millennium. An article in the 1834 *Christian Almanac,* published by the ATS, included among the "characteristics of the age" the "liberty of the people," the proliferation of voluntary associations, the practical benefits of technological innovations, enhanced commerce and transportation, the universal dissemination of knowledge, and the power of the printing press. "The churches . . . are beginning to survey the field and map it out. Commerce is opening the roads and bridging the seas. The [printing] press is felling the dark forests of ignorance. The way is clear."[4] Commerce, technology, government, and nationhood combined to promise an unprecedented revival in the United States that would usher in the glorious reign of Christ. What remains of significance for historians today in all of this triumphalist rhetoric is not only the early formation of American nationalism, the modern reformulation of American exceptionalism, or a noteworthy manifestation of America's perennial crusade for national homogenity and purpose, but also a clear view of the religious grounding of modern mass culture.

Defining Mass Culture

The *Christian Almanac,* like the majority of books, tracts, and periodicals published by the ATS and the ASSU, was illustrated with wood engravings and lithographs like the cover image of the *Almanac* during the 1830s (fig. 4), which depicts the Tract Society's national and international mission of outreach. An American missionary preaches in the midst of the world's inhabitants gathered emblematically on an exotic island home of the non-Caucasian heathen. An image of the wilderness as American evangelicals conceived it in their missionary zeal, it was well calculated to fire the Protestant imagination in an age of national expansion. At the same time, it is important to realize, this image was printed on paper for mass distribution—an early example of the mass-mediation of voluntary religion in the wake of the constitutional disestablishment of religion.

Discussion of mass mediation presupposes a more fundamental concept of mass culture, which deserves attention at the outset of this study since

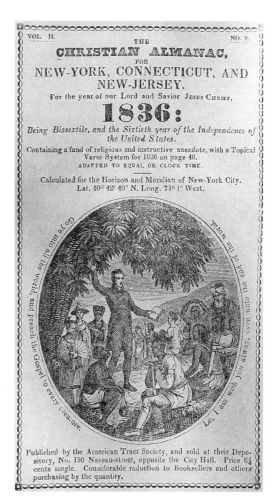

Fig. 4
Alexander Anderson,
engraver, Missionary
preaching, cover, *Christian
Almanac*. New York:
American Tract Society,
1836.

it is of basic importance. By mass culture I mean a sociocultural system of producing and consuming uniformly manufactured commodities in markets that do not require the producer to know or encounter the consumer in a face-to-face manner. Mass culture allows consumers to acquire more different kinds of goods at lower prices and to convert their labor more readily into acquisitions through the fluid intermediary of money. What we might call folk or local or parochial culture, by contrast, relies on local relations to affix or negotiate value, often to translate it from one good to another in bartered exchanges. Local culture is traditional (rooted in a shared history that is resistant to changes from outside the tradition), interpersonal and heavily dependent on oral communication (conducted on a face-to-face basis), and communal (rooted in a fixed set of likenesses). An abiding array of obligations binds producer and consumer in local culture that is not as encompassing or as interpersonal in mass culture because the relationship in that context is characterized by anonymity and reliance on the medium of a uniform system of capital.

The mediation of money reinscribes the social contract of honor, loyalty, deference, and social standing (all features of a cultural economy

that depends heavily on face-to-face encounter and oral communication) with the new protocols of consumption and commodification. Money also concentrates the relationship into a transaction, which can be conducted at great distance (through such intermediaries as the mail-order catalogue) by relying on an extensively developed infrastructure that transports goods from the site of production to countless and scattered marketplaces. The vendor in all likelihood is not the producer of the item but its retailer. Thus, production and sales in mass culture are typically an intricate system of relationships that separate the consumer from the raw goods and the skill of the craftsperson in local culture.[5]

Mass culture is not merely the product of a large supply of goods but is constituted by the *circulation* of the supply, that is, the coupling of supply with demand. As a system of exchange, mass culture is therefore a pattern of linking the economic and technological conditions of production with the social and cultural conditions that help create and maintain the need for such production. Therefore, it is not an instance of mass culture simply if a producer generates a large quantity of uniform items or distributes them across the countryside. The conditions for a genuinely mass culture arise only when economies of scale become a sustainable opportunity because a predictable supply of raw materials and a predictable access to markets justify large-scale, mechanized production. Circulation means the production, distribution, and sale of goods within a marketplace that offers continuous feedback. This suggests that a basic feature of mass culture is consumption, defined not merely as the use of a commodity but as a cycle running from production to disposal. Consumption locates production outside of the home and relies on monetary exchange as the primary medium of aquisition. Consumers are those social agents who earn money and exchange it for manufactured goods.

Consumption is therefore a necessary precondition for the appearance of mass culture. And industrialization is the necessary technological and economic precondition for consumption, since industrialization allows for the material fabrication of commodities. Both consumption and industrialization developed in eighteenth-century England and transformed the colonial market of North America. In his stimulating analysis of the impact of British Protestantism on the formation of modern consumption, sociologist Colin Campbell has argued that in the cultural economy of the middle class, money and leisure allowed consumers to seek pleasure repeatedly, to fulfill wants ad infinitum.[6] Longing was (and remains) particularly characteristic of middle-class consumption, hence the popularity of romance in literature, art, and drama, according to Campbell, as well as the importance of fashion, which provided a regularly renewed selection of desirable and disposable commodities. Romanticism itself, as Campbell understands it, was a cultural construction of consumer desire. Life in modern consumerism remains a rhythm of want, acquisition, depletion, and renewed want. The cycle constitutes consumption. One has neither enough nor too little. The romantic imagination makes the commodity by turning things into objects of desire that can be consumed.

Images, it follows, fuel consumption by both perpetuating desire and making satisfaction appear possible. Yet what the consumer buys is not the fulfillment of desire but the appearance of fulfilling desire—a promise

that is never kept. Mass culture, we may conclude, is a heightened state of desire and frustration, moved by a deep sense of urgency, but haunted by the suspicion that desire will never rest, that fulfillment will remain forever elusive. At the heart of modern life resides a deep insecurity, a restlessness that defies the stability and permanence that bourgeois values so commonly endorse. The millennialisms that animated Protestant belief during the nineteenth century express this dialectic of desire and frustration in the very bosom of institutional Christianity.[7]

Mass culture began to emerge in the antebellum period in step with the territorial gains of the United States, the migration of pioneers, and what historians have called the "market revolution."[8] Mail order, a reliable postal system, uniform currency, widespread literacy, and dependable transportation via an ever-expanding infrastructure of roads, railroads, canals, and steam-powered river vessels provided the material base on which mass-produced publishing enterprises could flourish. Furthermore, antebellum religious benevolence defined itself in terms of its goal of universal evangelization—a goal it proposed to achieve not merely by the traditional means of oral culture (sermons, revivals, and face-to-face evangelism) but also through the new mass culture of printed material. In a widely cited essay, David Paul Nord has even attributed to the evangelical Christians of the American Tract and Bible Societies the achievement of inventing the mass media in America.[9] This would date its origin to the second and third decades of the nineteenth century. The 1820s are for technological and commercial reasons a compelling point at which to locate the emergence of mass mediation in the United States. It was during this decade that the decline in the cost of paper caused by the completion of the Erie and Champlain canals and the adoption of more efficient mill technology in the northeast boosted book and periodical publication. Paper production shifted from local to regional markets, centered in New York City, which became the primary consumer of paper. Regional prices fell steadily through the 1820s while local prices rose nominally.[10] Beginning in the 1820s, the scale of printing leapt over any previous level. The most widely published texts in eighteenth-century America—almanacs, primers, and Bibles—usually did not exceed a few hundred or a few thousand copies in print runs. Difficulties in transportation severely limited what vendors could reasonably expect to sell. By the early nineteenth century, however, regional transportation via river, canal, and coastline had so markedly improved that the size of print runs increased precipitously. In 1825, to cite one instance, the ATS issued fifty thousand copies of its illustrated *Christian Almanac* alone. By 1829, the number had increased to 127,500 copies.

But there is no reason to focus too narrowly on the 1820s, since innovations in paper milling and printing technology only increased in pace over the next several decades. Mass culture took shape over the course of the nineteenth century in the United States as a cultural system, an integrated pattern of production and consumption. Richard Ohmann has provided a thoughtful analysis of the origin of mass culture, which he argues came into mature form during the 1890s with the appearance of publications that circulated among millions, therefore shaping a national audience of consumers. Yet, as Ohmann is aware, all the basic wherewithal for

mass culture was in place by midcentury or so: a monetary economy, an increasingly national system of transportation, a very high literacy rate, a plethora of competitive producers and ready capital, massive supplies of available raw materials, and the requisite technology. Circulation among millions of subscribers to newspapers and magazines did not occur, however, until the end of the century when advertising replaced subscription as the basis of a publisher's profits. But the fundamental components of the cultural apparatus for mass mediation were in place before the Civil War, and mass culture existed at a regional level in several parts of the nation.[11] It is important, therefore, to qualify the facile claim that the invention of halftone engraving in the 1880s and its incorporation into the commercial reproduction of images in periodicals and books in the 1890s was the origin of mass culture.[12] The halftone continued to boost numbers at the end of the century, but the move from the use of images in local to mass culture had been initiated at least three-quarters of a century earlier.

In any case, the conditions of production and consumption were changing rapidly and in tandem from the 1820s to the 1890s. Mass-produced visual culture appeared early in the century as part of these new conditions. Images stimulated the quest for and application of new technologies from lithography to stereotyping to the camera. Pictures quickly became an indispensable part of religious and public education, and illustrated children's books became a staple of many publishing houses. Images also offered attractive forms of visual pleasure in the form of illustrations that were inserted in publications or broadsides that were used as premiums to enhance sales. From women's magazines to illustrated newspapers, the age of the mass-mediated image had dawned. Although advertising only slowly proved itself in the nineteenth century, in the last third of the Victorian age the image was able to replace the text in ads as the primary bearer of meaning. All of these aspects of mass-mediated visual culture signaled the debut of the image as a primary avenue of cultural information and social meanings. With the pervasive impact of pictures on commerce, education, religious practice, journalism, and leisure, Americans were bound to wonder about as well as exploit the influence of the new media. It is a question they have not ceased to ponder since then.

Influence: Concept and Practice

Protestants in nineteenth-century America poured time, effort, and money into mass publication because they fervently believed it was a powerful way of effecting change. Tracts and Bibles were held to influence thought and to help control behavior. This has led many scholars to discern in the media instruments for social domination. It is worth recalling Walter Benjamin's keen awareness of the power of images. Although he hoped that mechanically reproduced images would become political tools for Marxist liberation, he lamented the powerful uses to which film could be put by fascism. Mass-produced images—photography, film, television—have often been used as means for persuasion because of their ability to broadcast a beguiling form of evidence: the image as trace or deposit of the way things "really" are. Add to this the motives of commerce, the

Enlightenment suspicion of religion as "priestcraft," the Marxist view of religion as opiate of the masses, or the Freudian notion that religion is an institutionalized delusion, and it is not surprising that many scholars have regarded religious media as instruments for domination. One influential school of interpretation developed the "social control" thesis, which has commanded a good deal of authority in American historiography of the early republic, having been applied assiduously to antebellum religious benevolence.[13] This should not, however, persuade us to suppose that religious mass culture in the nineteenth century was a unilateral medium of social control. However much the stewards of benevolent organizations may have wanted to control the unstable aspects of the American populace, they did not get the job done. Furthermore, reception no less than production contributes to the social construction of reality, though often its traces are silent or invisible, if they are ever recorded. People made what they wanted of the books, pamphlets, and pictures given to them, often irrespective of the aims of the producers. "Control" is an unfortunate word since it implies coercive, authoritarian power, which was rarely the case in the history of nineteenth-century religious benevolence. People could and did reject the tracts, Bibles, religious books, and invitations to attend church, Sunday schools, or temperance meetings. Indeed, such rejections were often the subject of evangelical homilies and pious literature.

"Influence" is the better term, and the one that Christian reformers and philanthropists more typically used. Were they successful? Only in a very mixed sense. On the one hand, religious benevolent groups succeeded at founding thousands of Sunday schools and congregations, reforming some alcoholics, spawning widespread revivals, supporting blue laws and sabbatarian legislation, and distributing millions of copies of their publications. On the other hand, Catholic and immigrant converts were few, immigration continued to soar virtually unchecked from the 1820s to the First World War, political movements that reflected the interests of conservative Protestants (among many others) such as the Federalist party or Nativists were short-lived and never broadbased, and American society as a whole or even in large part never embraced the conservative evangelicalism of antebellum Calvinism or postbellum Fundamentalism. This is not to suggest that the United States is or ever has been a secular society.[14] But the dreams of Lyman Beecher or Dwight L. Moody were never, could never be realized in a country as religiously and ethnically diverse as this one, committed as it largely was and is to the separation of church and state.

But if we employ the term "influence" instead of "control" in assessing the social impact of evangelical Christianity, we may set the secularization thesis aside and proceed to understand the importance of Christianity in the nineteenth century not as a failure or as an evolution into something postreligious but as a historical adaptation of evangelicalism, originally Puritanism, to modern society. Accordingly, the first phase of mass visual culture in the United States was developed by conservative Christians on a mission to convert the early republic to evangelicalism and by sometimes more liberal believers as a tool in the cause of reforms such as abolition.

Antebellum evangelicals enthusiastically applied the concept of influence to the practices of mass mediation. At a meeting in Boston in 1831,

convened to support the ASSU's mission to establish Sunday schools from the Alleghenies to the Rockies, Lyman Beecher (1775–1863), Congregationalist minister and anti-Catholic activist, spoke on the subject that consumed him in that decade and the next: the problems posed by immigrants. "The children of the rising generation," he proclaimed, "are they by whom, not improbably, the political destiny of the nation may be decided."[15] Beecher and the ASSU stressed "how powerful and benign" were "the influence of preparing the reading material of the children and youth of a nation." *Powerful* because, as another ASSU speaker defined "character," the child is the father of the man; "wherever a stream first begins to flow, there it cuts a channel for itself, and there it is likely to flow forever."[16] *Benign,* Beecher insisted, because such "influence" posed no threat whatsoever to the separation of church and state. Influence was not coercion or force but a form of motivation that was the moral necessity of a republic:

> [I]t is one thing to obtain liberty by conquest, and another to preserve it. To conquer is easy, because it is force opposed to force. But to preserve it is difficult, because force cannot govern mind, and moral influence can alone avail. But moral influence is unspeakably cheaper than force, and infallible in its results, if faithfully applied.[17]

For Beecher and others, this moral influence was Christian, and the proper means of instilling it was the home and Sunday school. Heman Humphrey (1779–1861), president of Amherst College, addressed ASSU officers, managers, and members on this point and underscored what he and his audience believed was the necessary religious foundation of American liberty. "Our government is not a government of force, but of influence. Its only sure basis is the virtue and piety of the people. In the absence of these, should Heaven in its wrath ever visit us with so dark a day, it must inevitably fall."[18] It is not difficult to understand how Humphrey could conclude that by disseminating the means for moral influence, the ASSU hoped to provide a form of political union "which makes every patriot a Christian, and every Christian a patriot."[19] Religious and political leaders in the early republic worried about the power of the people in democracy since the population was growing so quickly, a large portion was under sixteen years of age, and immigrants from non-Protestant, nondemocratic societies were arriving in expanding numbers each year.

To preserve the republic, moral influence was deemed the best hope and became the self-appointed work of such important benevolent associations as the ATS, ASSU, and ABS. Each of these three—the largest, longest lived (all three still exist in some form), and best organized—specialized in the production and distribution of printed materials. Although they wasted no time providing tracts, books, and Bibles in a variety of languages, their collective mission in the United States was the spread of English and evangelical literacy, two forms of cultural knowledge that they did not care to separate. An overview of ASSU publications stated:

> It is no small gift to our country to present a library of juvenile books in pure English. It will be an evil day when our mother English shall have

been broken into dialects; a *patois* for every district; and the longer we can postpone this event, the happier will it be for the union of our States, and for the free course of commerce, learning, and religious benevolence.[20]

While the acquisition of literacy surely was and remains of basic importance to the preservation of democracy, Christian benevolence had a deeper interest in the matter of moral influence and the success of its evangelical aims. The pamphlet went on to applaud the emergence of English as the lingua franca in India as "one of the most remarkable signs of the times, in reference to the progress of religion among men." The evangelical intention regarded literacy as the prerequisite to universal evangelization, which was the precondition for the glorious return of Christ. The writer concluded: "Thus it is, that from writing of the infant primer, and the picture book, we have strayed into a subject the most sublime which can be presented to human minds; the return of all mankind to God. The two things are connected."[21]

The concept of influence operated at the level of political and national aims but was also an important component in contemporary psychology, ethics, theology, and pedagogy, where moralists and clergy sought ways to constrain the centrifugal forces that ruptured traditional orbits in American culture. Consider two instances. First, according to Horace Bushnell's romantic concept of human expression, "you cannot live without exerting influence. The doors of your soul are open to others, and theirs to you. You inhabit a house which is well nigh transparent: what you are within, you are ever showing yourself to be without, by signs that have no ambiguous expression."[22] Since everything a person did radiated some emanation, Bushnell taught that parents and teachers must attend to the unconscious formation of children. And second, according to Ann Douglas, who has treated influence in terms of nineteenth-century feminization, influence was a form of suasion exerted by middle- and upper-class women as the only form of power allocated to them in patriarchial American society. Whereas their traditional sphere of influence had been limited to the home in the early republic, by midcentury, Douglas shows, women had expanded that sphere to include publishing magazines, writing fiction and poetry, and organizing local benevolent activities.[23]

Yet influence was a concept of power forged by men who controlled national benevolent associations, which had developed in response to the disestablishment of religion no less than did the feminization that Douglas has described. Her account of influence is committed to a strong view of secularization, in which influence was only a nominally Christian social practice and much more what she considers an impulse of emergent consumerism.[24] I argue that "influence" remained a Christian enterprise and one that embraced consumption, even leading the way toward developing the apparatus of advertising and its visual culture of persuasion. In order to enforce her assumption about secularization, Douglas focused only on liberal clergy in New England, ignoring the vitality of conservatives within and without New England. Evangelical Congregationalists and Presbyterians, like their Methodist and Baptist counterparts, were keen on developing the benevolent empire as a vast system of Christian influence,

and they produced a large body of imagery to extend and convey this influence.

More than a way of restricting women to the domestic sphere, the idea of influence addressed the fractious, entropic energies of democracy that frightened mainline Protestants. Afraid that individualism would atomize American society, evangelicals looked for a power of social cohesion that would bind Americans together. The romantic concept of influence developed by Bushnell was espoused as such a cohesive power in a sermon in 1850 by Gardiner Spring (1785–1873), a Presbyterian pastor in New York City and longstanding leader in the ATS. As Spring understood it, the idea of influence assumed that persons were subject to physical, emotional or "sympathetic," and moral influence. Spring viewed the universe as a vast series of emanations from "the great Master-Mind . . . from which all other minds proceed and [who] is himself the source of all those hallowed agencies which control the celestial world, and overlay the earth on which we dwell." Like the natural order, human society is a "delicate framework" in which "every fibre and filament acts upon the collected and concrete assemblage."[25] Like Bushnell, Spring, who presented his discourse on influence in celebration of the twenty-fifth year of the Tract Society, understood the concept to work in opposition to the view of human beings as independent entities who operated without regard to one another. People did not stand alone but were moved by influences of good or evil. In fact, the idea of influence cut both ways: it secured the power of every person to influence another and therefore stressed moral agency, but those exerting influence needed to dominate the opportunities for influence by augmenting the role of associations or social groups that would exert collective influence in American life in order to counter the fractious tendencies of freedom.

In the egalitarianism of the early republic, fueled by the disestablishment of religion and the desire to own land and acquire wealth that led so many people westward, the bonds that tied people together into the patterns of social life were less and less based on deference or hierarchy. The ideal of the self-made man, the individualist, required a new means of shaping behavior—among parents, teachers, clergy, politicians, and retailers. The mass media formed one important answer among each of these classes of social formation. But it is important to add immediately that "the masses" who were shaped by the mass media were not always conceived as passive receivers of the impressions generated by cultural producers. The voluntary principle ideally assumed that each person could resist influences of various kinds and had to be approached with due respect in order to be persuaded. The sham, deception, humbug, charlatan, and snake-oil salesman, familiar in literature and entertainment, were evidence of popular fears and resentment of the abuse of good will.[26] Those responsible for the moral formation of the young assessed free will differently. Early theorists of advertising distinguished between advertising that took an argumentative approach, in which an ad attempted to demonstrate to potential customers a product's superior quality, usually by extended texts that rehearsed the product's virtues, and advertising that *suggested* the quality of a product, often by the use of imagery incorporated into the ad.[27] In the early twentieth century the older notion of influence,

indebted to moral discourse, was "scientized" and replaced by the idea of suggestion, which proceeded from the new science of psychology. Although the concept of free will became problematic for many psychological theorists and researchers, the language of voluntarism and conviction persisted throughout early advertising and the discourse on its methods and strategies.

The Power of the Press

Whether the effect was achieved by influence or suggestion, advertisers, like parents, teachers, clergy, and other leaders and shapers of opinion and behavior, constantly sought out channels of communication that would safely deliver their messages and maintain avenues of intercourse. In antebellum mass culture the printing press offered a convenient, inexpensive, and visual as well as textual medium for such communication. In the *Address of the Executive Committee of the American Tract Society to the Christian Public,* which announced the formation of the ATS in 1825, we read an assertion that was axiomatic to Society members and supporters: "[T]he press is the grand medium of communication in all parts of the missionary world."[28] The Tract Society hoped that the evangelical press could make up for the lack of pastors and missionaries in a world where Christians were a minority:

> Tracts, too, are as necessary for Heathen as for Christian countries; perhaps they are more so. They may be sent where the Missionary cannot go. While he is confined to a small district, they may traverse a large kingdom. While he preaches to a few hundred, they may preach to thousands.[29]

The press was so efficacious that one account from India, "that land of idols," reported the power of two tracts alone to convert an entire village of "the heathen." The story related that a missionary entered a remote village and inquired about the absence of signs of Hindu or Muslim worship. "We believe in Jesus," was the answer. The villagers told the missionary that one of their number had returned from a "distant fair" one day with two religious tracts, which the village members read. After doing so, they determined "to give up the worship of idols, and serve the living and true God."[30]

The power of the evangelical press was the autonomous capacity of the written word to convince the reader of the religious truths of evangelical Christianity. Faith in the Word made flesh was convertible into the word made of ink and paper; or, as one ATS document put it, print holds "the same relation to the word of God, in addressing the mind through *the eye,* that the living ministry does in addressing it through *the ear.*"[31] The advantage, of course, was that the tract was not limited to the oral medium of local culture but by virtue of mechanical reproduction helped create mass culture, a fundamentally visual culture. In order to assure the influence of their publications, the Tract Society identified the medium with the body—the channel or medium with the origin of the message.

Oral culture was magnified yet preserved in the new semiotic regime: "The religious press," announced the publishing department of the ATS in one report on tract distribution, "is the 'gift of tongues' to our foriegn missions. Through it, it may now almost be again said by the heathen: 'How hear we every man in our own tongue wherein we were born?'" As the quotation of scripture suggests (Acts 2:8), the ATS understood its work as a new Pentecost, in which the Holy Spirit operated unhindered in the medium of mass print.[32]

The ATS conflated oral communication with manual and mechanical forms in order to package mass culture as local. The intention was to enhance the printed text's persuasive effect by discerning in it the persistent presence of oral culture's face-to-face construction of authority.

> What is written is *permanent*, and spreads itself further by far, for time, place, and persons, than the voice can reach. The pen is an artificial tongue; it speaks as well to *absent* as to present friends; it speaks to them that are *afar off*, as well as those that are near; it speaks to *many thousands at once*; it speaks not only to the present age, but also to *succeeding ages*. The pen is a kind of image of eternity—it will make a man *live when he is dead*. . . . A man's writings may preach when he cannot, when he may not, and when by reason of bodily infirmities, he dares not; yea, and that which is more, when he *is* not.[33]

The written text replaced the body and therefore was in no way inferior to oral culture. Indeed, the text emulated the spoken word to the degree that it even achieved something "permanent."

The strategy of transposing aspects of local culture onto mass culture was applied to the millions of tracts produced by the Tract Society and scattered across the land. The tracts often incorporated first-person forms of address in order to fit face-to-face encounter to mass-culture practices of communication and included illustrations that picture personal exchanges (see figs. 3, 4, and 13). This imbrication of mass and local cultures preserved the oral encounter but made it available through the inexpensive medium of mass-produced ephemera. Thus, one tract opened: "Friend, before you throw these pages aside, permit one word with you." Another urged evangelical commitment in the manner of a revival sermon: "Before you rise from the perusal of this Tract, make the determination to devote your whole self to the cause of Jesus Christ."[34] Historian Paul Boyer has considered these pleas rather awkward acknowledgements of the tract genre's inferiority to personal presence, yet there is no reason to assume that the Tract Society's members would have agreed with him. In fact, the Society expressed great optimism about the power of the well-placed tract, scattered strategically like the Sower's seed of the biblical parable, to convert the infidel, bolster the backslider, or reconcile the errant son. The Tract Society's annual reports and periodicals such as the *Tract Magazine* and the *American Messenger* regularly carried excerpts and written testimonies to the power of the tract to attain just these ends.[35]

As novel as inexpensive mass printing and illustration had become, benevolent associations such as the ATS insisted that the press only extended the Protestant principle of evangelism, which amounted to an im-

pulse and a duty to communicate the divine will to all of humanity. Speaking at an annual meeting of the Tract Society in 1855, Asa Smith attempted to show that the Society's enterprise at colportage—the work of part and full-time salaried workers who sold the Society's evangelical goods door-to-door in addition to teaching and founding study groups and sabbath schools—was not an innovation per se but "as old as the church of God." God made Adam with "a heart, and a tongue the index to that heart," a heart that was impelled to proclaim God's glory, to announce "love to God and love to man" in accord with "the law of communicativeness—a law deeply imbedded in human nature." Therefore, Adam, according to Smith, was "the first colporteur." Modern tract distribution had "given some new shapings to this instrumentality, but there is no essential change as to its aim and its spirit."[36] In like manner, the ATS maintained that the "earliest Religious Tracts were the books of the Old and New Testaments; in which we have at once the divine sanction of the method of diffusing truth by the written or printed page."[37] Evangelical Protestants were fond of tracing a historical trajectory of the "true" church as leap-frogging from the apostolic age of those who "took the pen and expounded the Scriptures" to "the time of Luther, who took the pen and the press."[38] The Reformation represented the first use of the press to turn the tide against "Romanism" and to return the church to its primitive purity of declaring the Gospel.

As the engine of the Reformation's polemical publications, Luther was frequently lauded in benevolent literature and addresses. Gaining the posthumous approval of Luther for the enterprise was no small advantage—particularly among German immigrants. An agent for the ATS reported that a Lutheran minister in Ohio had assured his congregation that if "Luther were now on earth, his great heart would beat in sympathy with the Tract Society, and his voice would ring like a trumpet to arouse the Lutheran churches to its aid."[39] By anchoring tract distribution to the Reformation, indeed, to the "natural" order of Adam's creation, the Tract Society and its advocates naturalized their medium of communication, that is, identified the network of relations they were spreading across the nation and around the world as part of the nature of things. In so doing, they preserved the oral culture of preaching and individual conversion as they adapted evangelism to the new means of mass production. Direct address to the single auditor in the pew or seated on the revivalist's "anxiety bench" listening to the preacher was the communicative relation that evangelicals attempted to retain as the model for their use of mass media.

Education and literacy became a central concern among benevolent organizations since the channel of influence which they sought to employ—printed matter—depended for its efficacy on literacy. This meshed well with the Protestant imperative of direct access to scripture as the basis for religious liberty and freedom of conscience. As an emblem of the Tract Society's mission, the printing press appeared on a certificate of contributions to the Society in the 1840s (fig. 5), which enthrones the press on an earthy mound around which the diverse inhabitants of the world gather in a kind of Gutenbergian Sermon on the Mount. Indeed, the image bears a striking resemblance to illustrations of Christ's Sermon on the Mount

Fig. 5
Printing Press, wood
engraving on paper, 10
1/2 × 7 3/4 inches,
American Tract Society
Certificate of
Contribution, New
York, signed March 16,
1849. Courtesy of the
Billy Graham Center
Museum.

published in the mid–nineteenth century, such as Julius Schnorr von
Carolsfeld's *Bibel der Bildern* (Picture Bible) or Henry Warren's engraving
after a painting by John Rogers (fig. 6) published in Fleetwood's *Life of
Christ* in the 1860s.[40] The allusion to this biblical subject was not acciden-
tal since, as I have noted already, the printing and distribution of the Bible
and tracts was regarded as the appropriately modern instrument for evan-
gelizing the world. The preacher and orator were replaced by the tract and
colporteur just as Jesus has been transmogrified into a mechanical print-
ing press. Instead of listening to a sermonic discourse, the people gather
to read tracts distributed by the press's allegorical attendants. Rich and
poor, young and old, foreign and domestic, ancient and modern respond
alike over the ages to the inexpensive, ephemeral transcription of the
Word of God. The image conflates inspiration, production, and dissemi-
nation into a single moment that defies time and tradition in order to place
in the hands of everyone the changeless truths of divinity. It would be
difficult to point to a more Protestant image. Recalling personifications of
liberty, fame or truth, the female figure standing beside the press holds the
Bible in one arm and extends a tract to the multitude with the other, all
while looking heavenward in the image's only gesture acknowledging the
source of what the Tract Society fondly called its production of "printed
truth." By refusing to visualize more explicit connections to the divine, the
image centered the Society's efforts on the physical means of production
and dissemination, suggesting that the enterprise was indeed the result of
human initiative, a voluntary act, one that depended on human choice and
determination. It is impossible to overstate the optimism of benevolent or-
ganizations in antebellum America and the important role they played in
promoting belief in the social efficacy of philanthropy and religious be-
nevolence.

Figure 5 also depicts the belief that the tract was an untrammeled av-
enue of divine truth that could be sent everywhere without suffering any-
thing in translation from one culture and life-world to the next. The 1846

annual report of the ATS stated confidently that "geographical and denominational landmarks present no barrier to the diffusion of simple evangelical truth, common to the great body of believers."[41] The tracts and inexpensive books of the Society were the ideal tools of a united evangelical effort to distribute its message as widely as possible through the combined agencies of the printing press, colportage, and modern transportation and communication: "Is not the PRESS a grand instrumentality in the hands of the Friends of Christ, and in union with their personal efforts, for counteracting the progress of infidelity and irreligion, and saving the nation and the continent from moral desolation?"[42]

Reading scripture and tracts was the key to the spiritual enlightenment of the American populace. The Tract Society fostered an iconography of reading (see figs. 45 and 46) that expressed its chief ideological preoccupation: to assimilate non-English-speaking immigrants and illiterate, unchurched native speakers to a Protestant American republic. Perhaps the single most important role of images among antebellum Protestants was the use of illustrated primers and tracts among those learning to read. The ATS and the ASSU printed and distributed millions of picture books and primers geared to various levels of literacy for use in the home and school. Many colporteur reports from the ATS document the use of such illustrated materials among children and adults, native-born and immigrant. This use of imagery integrated benevolent activity with recurrent revivals and urges us not to think of revival and benevolence as discrete social phenomena.

Fig. 6
Henry Warren after John Rogers, *Christ's Sermon on the Mount,* steel engraving, in John Fleetwood, *The Life of Christ,* frontispiece of part 5 (New York: Virtue and Yorston, n.d. [1861?]). Courtesy of the American Antiquarian Society.

The Shadow of the Millennium

Antebellum America was a time, as Nathan Hatch has so aptly said, "when most ordinary Americans expected almost nothing from government institutions and almost everything from religious ones."[43] Religious "institutions," as Hatch is well aware, could mean everything from national, mainstream church bodies to benevolent organizations to itinerant upstart preachers to radical utopian communities. Therefore, this study examines both the highly structured, nationally organized groups such as the ATS and the ASSU as well as the ephemeral and marginal organizations gathered around a charismatic leader and a press. If the ATS and the ASSU attempted to create an edifice of influence with publications and networks of distribution, marginal groups such the Adventists created alternative visual and print cultures that resisted such influence and understood themselves in opposition to the religious and political establishment. Chapters 4 and 5 focus on just such instances of mass-mediated resistance.

Hatch's premise that the early republic was a period of growing individualism, egalitarianism, and the unseating of traditional authority in favor of individual entrepreneurship in religious enterprises comports well, as he himself has shown, with the study of antebellum Christianity's initiatives in communication, its rhetoric of mass persuasion, and the dynamics shaping new and ever-shifting popular audiences. Publisher-preachers such as James and Ellen White fit very well the profile of the antebellum entrepreneurs who thrust themselves without financial means, indeed, from the depths of Millerite bankruptcy, into the religious marketplace in the optimistic hope of a profitable return. What Hatch's study, as well as the more recent work of Laurence Moore, demonstrates is the genuine sympathy between populist preaching and mission efforts, a resourceful use of mass media, and commerce. As Moore seeks to show, "religion, with the various ways it has entered the cultural marketplace, has been more inventive than its detractors imagined."[44]

A theme of profound importance in the nineteenth century that receives attention throughout this book is millennialism. There were two prevalent versions in the nineteenth century: postmillennialism and premillennialism. The first expected a thousand years of the peaceful reign of Christ on earth before the end of time, whereas the latter looked for the imminent return of Christ and the end of the present world order. Such benevolent organizations as the ASSU and the ATS embraced a postmillennialist perspective as the cause for urgency in their task. The anonymous author of an essay on the publications of the ASSU noted the progress and movement of the present age and saw in it a millennial harbinger: "As the advent of Christ was preceded by remarkable changes in nations, so it is not unlikely that the final triumph of the gospel will be preceded by analogous preparation."[45] A Baptist pastor who supported the ASSU's mission into the Mississippi Valley expressed no reservations about the ultimate purpose of the enterprise, stating that "the Sabbath school, with quiet, simple, and yet mighty force, is training up a generation, such as this earth has not yet seen—such as will be worthy to stand and rejoice

in the morning light of the millennium."[46] Heman Humphrey lauded the millennial purpose of the ASSU in no less glorious terms, stating that the association's "grand design" was nothing less than "to empty the prisons and fill the churches; to expel misery and crime in every form from the land; to spread pure and undefiled religion over all the east, and west, and north, and south; and to train up our whole population for the kingdom of God."[47]

Postmillennialism was also at the heart of the evangelical mission of the ATS. Who, the *Christian Almanac* asked in 1829, "that calls himself a Christian, will not join with his whole heart in the glorious enterprise of delivering the world from the thraldom of sin and Satan?"

> [A]nd who that has faith but as a grain of mustard-seed, does not see in the movements to which we have adverted, the approach of that day, predicted in Holy Writ, when "the mountain of the Lord's house shall be established in the top of the mountains, and all nations shall flow into it," when "the kingdoms of this world shall become the kindgoms of our Lord and his Christ, and he shall reign forever and ever?"[48]

In the midst of the Second Great Awakening, the writers of the *Almanac* exalted the revival of religion and saw as its companion the temperance movement, which one editor of the *Almanac* characterized in 1832 as "the John Baptist of the last days," that is, the final harbinger before the arrival of the millennium and the return of Christ. Social reform and the efforts of evangelicals were to be instrumental in the construction of the final age of peace on American soil.[49]

As a central component in the exceptionalism of Americans' historical self-concept, expectations of the dawn of the millennium were linked to America's special role in realizing the last age of humanity. It was a mythic motif that stoked patriotic fervor by identifying Christianity with the national mission at a time when political leadership, consumerism, sports, and the mass spectacle of entertainment had not yet become the means of exercising freedom (or the illusion of freedom) in American life. The idea was often conceived in terms of Christian Union, as in a lithograph produced by a Philadelphia lithographer named Thomas Sinclair in 1845 (fig. 7). Several American clergymen—Presbyterians, Congregationalists, an Episcopalian, and a Quaker—embrace one another in unity around a simple altar on which rests an open Bible. An American Indian drops his tomahawk and other weaponry in response to the new spiritual age symbolized by the descent of the dove from heaven. An African slave responds with a gesture of gratitude. In the foreground the millennial lion and lamb nuzzle one another beside broken spear and sword.

Sinclair's *Christian Union* served as a model for another, much more accomplished Philadelphia engraver, John Sartain (1808–1897), who produced a mezzotint engraving in 1849 entitled *The Harmony of Christian Love: Representing the Dawn of the Millennium* (fig. 8), which visualizes very well the optimistic aims of American Protestants for their nation and faith. A group of Protestant clergymen—once again, Congregationalist, Episcopalian, Presbyterian, Quaker—gather around an altar.[50] In the spirit of ecumenical cooperation necessary to usher in the Christian Golden Age,

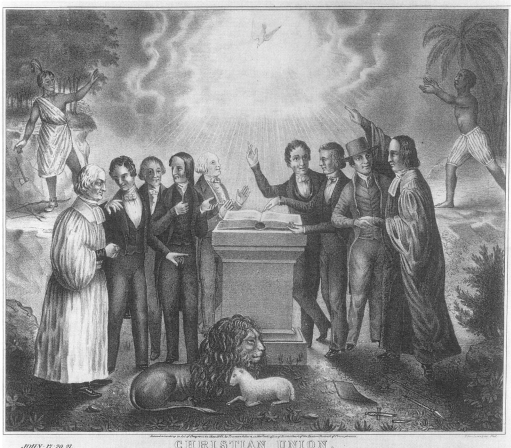

JOHN: 17: 20, 21.

CHRISTIAN UNION.

Neither pray I for these alone, but for them also which shall believe on me, through their word. That they all may be one, as thou Father, art in me, and I in thee, that they also may be one in us: that the world may believe that thou hast sent me.

JESUS CHRIST.

the print included a quotation from an eighteenth-century Englishman, John Gambold, who was a friend of John Wesley, an Anglican prelate, and a member of the Moravian Brotherhood, thus harmonizing in one person three orders of Protestantism.[51] Set in the same emblematic landscape as Sinclair's lithograph, consisting of a juxtaposition of American wilderness and tropical palms that recalls the scene of the missionary preaching on the cover of the 1836 *Christian Almanac* (fig. 4), the image brings East and West together with the world's multitudes visible in the distance, watching the Protestant divines officiate at the altar of the New World. An American Indian and an African slave join the clergymen, beckoned by the clerics' mediating gestures to hearken to the Christian revelation. In the foreground lay once again the emblematic motifs of the lion, lamb, and millennial child of the new age, and a broken sword, symbol of the end of earthly strife.

Sartain was a Unitarian and passionately committed to abolition and Fourierism, but the image, as small print in the caption indicates ("Devoted to the Home Missionary Cause"), may have been commissioned by

Fig. 7
Thomas S. Sinclair, *Christian Union*, lithograph, 10 1/2 × 12 3/8 inches, 1845. T. Sinclair Lithography, Philadelphia. Courtesy of the Library of Congress.

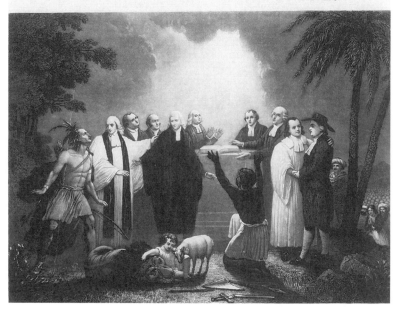

THE HARMONY OF CHRISTIAN LOVE: REPRESENTING THE
DAWN OF THE MILLENNIUM.

Fig. 8
John Sartain, *The Harmony of Christian Love: Representing the Dawn of the Millennium,* mezzotint engraving, 8 1/8 × 11 inches, 1849. Courtesy of the Library of Congress.

the American Home Missionary Society (AHMS), a Congregationalist and Presbyterian benevolent organization founded in 1826 to evangelize the country as it expanded westward. For the AHMS, the global scope, national mission, Calvinist Protestant hegemony, and patriarchal authority of the millennium were uniformly American. The same ideology appears to inform this image. One scholar of the AHMS has noted that an important part of the motive of mission work in the West was to curb the inroads made by non-Calvinist sects such as Methodists, Mormons, Baptists, and Millerites.[52] The absence of these groups as well as Roman Catholics in Sartain's image is no accident. Furthermore, the print appeared following a decade of growing criticism of the AHMS over the issue of slavery. Abolitionist members lobbied hard for the restriction of support and membership to nonslaveholders. Eventually the AHMS complied, but only reluctantly, since most members were not zealously opposed to slavery and since the South represented a vast and expansive domain of mission efforts. Sartain's depiction of the slave liberated before the millennial altar visualized what a vocal minority demanded of evangelical benevolent societies and attained only after prolonged controversy. But of course the message remains ambiguous. Is the slave freed at the arrival of the days of peace and harmony—or as a necessary condition for the dawn of the millennium?[53]

For anti-slavery members of the AHMS such as the Philadelphia Presbyterian pastor Albert Barnes (whose portrait Sartain had engraved in 1837), the aims of benevolence, the freedom of slaves, and the need for mission work in the expanding nation merged into a single evangelical cause. In 1846 Barnes published a long treatise on the Bible's position on slavery,

finding no scriptural basis for the practice in the modern world. Preaching in 1849 on behalf of the AHMS, Barnes saw the challenge of the West as continuous with the Puritan enterprise of occupying New England as the Promised Land. The primary enemies were unbelief, ignorance, and Catholicism. He likened the fate of the West to the apocalyptic battleground described in the Book of Revelation, though he believed that intervention could forestall the apocalypse. Barnes praised the AHMS as a social force in the battle to "make this a Christian land throughout . . . to make it, as it is destined to be, a leading power among the nations of the earth, a power whose influence shall be always peaceful and pure; to show to other people the spectacle of one Christian nation stretching from ocean to ocean." American exceptionalism, having acquired the political charter of democracy, remained rooted in Puritan millennialism nonetheless.[54]

For evangelicals in search of a renewed sense of national purpose, benevolent associations such as the AHMS and widespread revivals helped fill the gap between the new nation and the ideal of godly life. While by no means new, anxiety over this gap had been exacerbated by the disestablishment of compulsory religion during the early republic. Some New England evangelicals were anxious about democracy precisely because it lacked the system of social controls familiar to more traditional forms of government such as monarchy. And God himself remained a monarchist while America set loose the new energies of democracy. Systematic benevolence and intermittent revival were the enthusiastic means developed among evangelicals to affirm republican liberty without relinquishing the monarchically governed City of God. According to the ASSU, there was no disjuncture between the two. American republic and divine monarchy were entirely symbiotic. One could be subject and citizen without contradiction. The purpose of the ASSU, as Heman Humphrey put it, was "to enlighten the understanding and educate the heart—to make virtuous and happy families and neighborhoods—to make good men and good citizens—good rulers—good and loyal subjects of the king of heaven; and, as a matter of course, good and peaceable subjects of a republican government."[55] Humphrey blended the two forms of government with imperialistic language: America was a "mighty empire." Furthermore, neither he nor most Whig supporters of the benevolent associations spoke of "democracy"; instead they spoke of the American "republic." The fit between terrestrial republic and celestial monarchy was portrayed as seamless. Yet Whig apologists for the ASSU found it necessary to deny that their ulterior motive was a reestablishment of religion. Charles Wickliffe, United States congressman from Kentucky, stated baldly before the ASSU membership that he did not believe there was anyone in the country "who is silly or wicked enough to desire a union between church and state."[56] Lyman Beecher also made a point of rejecting this accusation and associated the merger of church and state with "priest-craft and popery" rather than with the New England ancien regime, of which he was a vocal and prominent member.[57]

For many antebellum evangelicals, the imperial aims of American postmillennialism mediated republicanism and divine monarchism. This mediation was important because American democracy, particularly as rep-

resented by the Jacksonians, was perceived by many Whig evangelicals as fragile and unstable, if not downright threatening. Beginning with the 1798 edition of his *Spelling Book,* Noah Webster included a "Federalist Catechism," in which he stated that "a pure democracy is generally a very bad government" whereas a "representative republic . . . is much the best form of government hitherto invented."[58] This view was intensified by immigration, which meant swelling numbers of voters who were often not Protestant and were being attracted to the Democratic party. The anxiety over democracy's instability was expressed in one conspiracy fantasy after another—from Lyman Beecher's anti-Catholic fear of incursions by European despots to the politically subversive aims of priests and religious orders to the nativism and secrecy of the Know-Nothings and the Adventist claim that Louis Napoleon and even the United States government were the Antichrist. The idea of the millennium allowed many evangelicals to anchor an unstable republic to an imperialistic scenario of the unfolding of the kingdom of God on American soil. Republican government thereby became yet another millennial means, a national sign of the times, an instrument to be shaped and influenced toward the higher end of divine kingship.

The Visual Culture of Premillennialism

While benevolent organizations undertook systematic attempts to reform American society for the sake of creating a new city on a hill, other groups, who also exploited the opportunities provided by modern technology, pursued a radically different course. Rather than improve society, Mormons and Adventists sought to secede from it by concentrating their energies on the imminent judgment of God and the return of Christ. Brigham Young and the Mormons set out to establish a separate nation of God's chosen in the far West. The followers of William Miller expected an immediate end to the present order of human existence in or about the year 1843. Among some of the few Adventists who did not desert the Millerite cause in the wake of the "great disappointment" there developed an apocalyptic conspiracy theory that villified republicanism, the United States government, and mainstream Protestantism as eschatological forces of evil. In its most extreme forms, premillennialism found no other use for government and democracy and looked for their imminent dissolution with the second coming of Jesus.

After beginning with the postmillennial efforts of the ATS, our story continues with a uniquely modern Protestant mass-produced religious image rooted in premillennialism: the prophetic charts of the Millerites and subsequent sabbatarian Adventists. These schematic diagrams (see figs. 56 and 69), used to teach Adventist interpretation of the biblical books of Daniel and Revelation as forecasting the imminent return of Jesus, have been almost entirely ignored by all but the Adventists themselves.[59] Not only were they mass produced, the charts were sold and distributed as inexpensive commodities—first as aids for traveling ministers, later as decorations suitable for the Adventist home. Priced between 15¢ and $2.00— ranging from the cost of a paperbound to a clothbound book—the charts

were advertised in Adventist newspapers and shipped via express mail or daily post all over North America and across both oceans as Adventist mission efforts got underway. Although charts had appeared in Protestant commentaries on the prophetic books since the seventeenth century (see fig. 57), images for the first time were presented to wide popular audiences in the nineteenth century. Adventists took advantage of the new medium of lithography in order to broadcast their use of highly didactic imagery encoded with elaborate schemes of biblical interpretation.

The Adventists were especially interested in images as a new "channel of information," to use a phrase from Uriah Smith, editor of the Seventh-Day Adventist *Second Advent Review and Sabbath Herald* and himself an illustrator.[60] Like many premillennialsts before them, Smith and his fellow Adventists believed that the symbols used in the books of Daniel and Revelation were a special avenue of prophetic revelation employed by God to provide a timetable for the movement of history toward the end of time. Prophetess and cofounder of Seventh-Day Adventism Ellen G. White, whose early visions explicitly sanctioned the use of the chart, spoke of the last period as the "gathering time" when God would bless attempts to "recover the remnant of his people" and when "efforts to spread the truth will have their designed effect."[61] The charts and the many publishing activities of Ellen and James White were among the wherewithal of this final dispensation.

The special and unabashedly visual form of revelation set down in the charts was shaped by the imperative of announcing the message of an imminent end and by the sudden explosion of new communications technologies in North America and Europe.[62] The result was another instance of the productive alliance among commerce, images, belief, and mass mediation whose history is the subject of my study. Among the Millerites, in contrast to many liberal and evangelical Christians, the point was not to redeem the culture, society, or civilization, not to identify one's interests with any traditional social or cultural institution, but to share with as many people as possible the news of the world's fast-approaching demise. The vehicles of communication were ephemeral: newspapers, tracts, pamphlets, stationery, broadsides, conferences, and revival camp meetings. As media for transmitting the word, these were considered unobtrusive channels of information, unadulterated representations of the pure gospel of the second advent. To be handed an Adventist tract, to hear William Miller or Josiah Litch preach, to read their articles in *Signs of the Times* or *Midnight Cry*, to inspect their carefully organized and annotated charts and diagrams was in every case to encounter the Word of God itself. According to the entrepreneurs of the new religious media, the means of evangelization safely and completely delivered the contents of the divine message. While it was impossible for the Millerites to travel the globe in person and announce the second advent to each individual, following the example of the ATS, they could undertake a massive, international distribution of their tracts and periodicals. Since God's word was the objective revelation of the Bible, and therefore separate from the act of faith that received it, the Bible could be readily transformed into mass-communicated information to be distributed along the emerging national and global circuits of communication. Mass communication and biblicistic evangelism

were mutually sympathetic because they enabled millennialists to realize the biblical mandate of universal evangelization before the second coming of Christ.

A unique and effective fit took shape between millennialism and mass communication. Encouraged by the publication efforts of tract and Bible societies, the Millerites exploited the daily newspaper, the private mail, and the widely circulated, inexpensively produced pamphlets and periodicals that transformed communications media in the 1820s and 1830s in the United States. The *Midnight Cry* reported that six hundred thousand pieces of Adventist literature had been circulated in New York City in a single year.[63] The *Voice of Truth* reported that by May 1844, five million Millerite periodicals had been put into circulation. One preacher boasted that by 1842 Adventist pamphlets, tracts, and books had been sent to "every missionary station in Europe, Asia, Africa, America, and both sides of the Rocky Mountains."[64] As Ernest Sandeen has pointed out, "[t]he millenarian missionary challenge was conceived in terms of 'dispersing' information rather than Christianizing the whole world, and it was in that sense that they understood the word 'evangelization.'"[65] To reject what the tract or article stated was to reject God himself. Like all forms of biblicism, Millerite hermeneutics identified the will of God in scripture with the text itself, the inerrant recording of divine revelation as God intended it. The Bible was understood to be God's speech infallibly preserved.[66] The sympathy between mass mediation and the Millerite mission justified commodification and embraced commerce and modern technology as the wherewithal of salvation.

The mutually constructive relation between antebellum millennialist theology and mass mediation (which, as Paul Boyer has shown, has continued down to the present moment among apocalypticists)[67] was bolstered by the experience of several Millerites in social reform before Millerism. Adventists such as Joshua V. Himes and Joseph Bates brought to the promotion of the second advent the attitudes and techniques of the publicist, which they had previously exercised in their work for such causes as abolition and temperance.[68] Social reform and evangelical eschatology were analogous in the minds of many; indeed, as one scholar has put it, "Miller appealed to values that many reformers held dear."[69] The crisis in the abolitionist movement, which degenerated into a strident factionalism at the time Millerism emerged, occasioned a transfer of reforming hopes to the second advent. Jonathan Butler has argued that Millerites "looked to the Second Coming not to reward reform but to erase its dismal failures."[70] A common cause brought to Millerism several leaders practiced in mass communication and the strategies of persuasion. Bates, Himes, and Elon Galusha were veteran public speakers on a variety of reform issues and were experienced in organizing public meetings. George Storrs had been a public figure in the abolitionist cause and Charles Fitch had authored a pamphlet against slavery. Bates regarded Millerism as the ultimate reform movement.[71]

In light of the Millerites' persuasive use of media for promoting their cause and their view of the mass media as a conduit for dispersing information to persuade a widespread, truly mass audience, it is not surprising that we should find a virtually immediate cooperation between advertis-

ing and Millerite periodicals. This relationship was no doubt enhanced by Joshua Himes's constant need for income to keep his ambitious publishing efforts afloat. Although most ads were brief notices of materials available from Himes's office, an advertisement for Webb's Camphene Burners, which appeared in *Signs of the Times* in the summer of 1842, described "those wonderful inventions connected with steam, by which men 'run to and fro' on railroads and steamboats, as on the wings of the wind" as "among the signs of the times, though less striking than earthquakes and conflagrations."[72] The copy for the ad sounds more post- than premillennialist: the "signs" could prefigure a coming time of plenty, a technological utopia, when darkness would be forever overcome—by Camphene Burners as well as by Jesus, the light of the world. Messrs. Curtis & Davis, the Boston vendors of Webb's Camphene Burners, called on the testimony of science to confirm the wonder of their product. The ad reported that Professor John Locke of the Medical College in Cincinnati had examined the lamp and provided his detailed appraisal of its superiority. The same use of expertise appears in the charts and Millerite publications that cited such luminaries as Gibbon, Newton, Luther, Ussher, and a number of other theologians, historians, and scholarly authorities in support of the Adventist reading of scriptural prophecy.[73]

Given the affinity between mass mediation and the Adventist cause, it is perhaps surprising at first blush that Adventist newspapers included little advertising for commercial products. The mid–nineteenth century in the United States saw magazine and newspaper publishers begin to pursue commercial advertisement for the revenue it generated.[74] There was of course no reluctance to advertise the items produced and sold by Adventist publishing houses. The publication lists of books, pamphlets, and tracts among Millerites and Seventh-Day Adventists, for instance, were always expanding. But ads for "secular" items, however useful in everyday life their manufacturers might claim them to be, were rare.

Reasons for this are not difficult to come by. Adventist papers did not circulate among those who were inclined to place much stock in creature comforts since they expected the imminent return of Jesus. The issue of advertising was taken up in an editorial statement in the *Review and Herald,* edited by James White, founder of the Seventh-Day Adventist church. The editorial, presumably written by White, stated that while rival (nonsabbatarian) Adventist papers inserted "common advertisements into their columns as a means of procuring subsistence," the members of the publishing committee of the *Review and Herald* "intend that our sheet shall be emphatically an *advertising* medium."[75] The editorial repeatedly italicized the word "advertise," turning it into a synonym of more traditional evangelical terms as "witness" and "testify." White pointed to ads like one for Ayer's Cherry Pectoral (fig. 9) that appeared in Adventist publications, such as the final seventeen issues of former Millerite Joseph Marsh's weekly newspaper *Advent Harbinger and Bible Advocate.*[76] In a day when thousands suffered from such fatal lung diseases as tuberculosis and whooping cough, for which the product promised a "rapid cure," one might expect Seventh-Day Adventists, like other Adventists, to promote medical products. But when the SDA church did commit itself to health reform under the direction of the visionary Ellen White in the early 1860s,

AYER'S

CHERRY PECTORAL

For the rapid Cure of

COUGHS, COLDS, HOARSENESS,
BRONCHITIS, WHOOPING-COUGH,
CROUP, ASTHMA, AND
CONSUMPTION.

Fig. 9
Ayer's Cherry Pectoral,
in *Harbinger and Advo-
cate* 5, no. 538 (April 22,
1854), 351.

the use of drugs was severely criticized and such alternative measures as hydropathy were promoted.[77] Neither Ayer's Cherry Pectoral nor the principle of commercial advertisement appealed to James White and his colleagues. "There are other things of more importance to a dying world of which the people should be well *advertised* and well warned." The mass media became the new means of proclaiming the advent message, and to this the editorial staff of the *Review and Herald* dedicated itself:

As far as in our power, therefore, we shall endeavor,

1. To advertise you of every new development in the fulfillment of prophecy . . .
2. To advertise you of every new point on which the light of truth may shine, by which our present position, and present duty, may be made more clear.
3. To advertise you of all the signs of the times which indicate our nearness to the final consummation.

The Good News became the Latest News, and modern journalism's urgency for novelty and the late-breaking story found an apt and willing partner in nineteenth-century premillennialism. Political events, earthquakes, astronomical phenomena all became "signs of the times" duly registered each week for immediate consumption in Adventist newspapers whose circulations mushroomed during the Millerite period and then, after a few years of disillusionment, steadily grew as Adventists and Dispensationalists undertook a mission of global outreach.

In their fascinating narrative of the career of the Prophet Matthias, a contemporary of William Miller and Joseph Smith, historians Paul John-

son and Sean Wilentz align Miller with Smith, Matthias, and Alexander Campbell as an extremist wing of opponents of the market revolution.[78] Represented by Charles Grandison Finney, bourgeois revivalist and favorite of the new managerial class of factory owners, investors, and bankers, the market revolution optimistically championed the progress of American culture and nationhood. Miller, Smith, and Matthias certainly had other ideas. But although Miller and Smith resisted the prospect of moral reform and evangelical regeneration as the key to national success, Miller and Brigham Young, if not Smith, embraced the machinery of the new mass culture in order to promote their respective causes. This is an important distinction to note because it signals a significant contribution of nineteenth-century Protestantism and many religious developments from it such as Millerism: the media of the new mass culture became part of the practice of belief. Many Protestants experienced religion in the broadcast or communication of belief. Seeing was believing, and mass culture only meant more ways of believing, or doing so on a grander scale. The historical relations of religion and culture are too subtle to allow such a simple parsing as mass culture deformed religion or instrumentalized it or that religion capitulated its mission by accommodating itself to the marketplace. This study will be content to shed light on the role that mass-produced religious images played in the new culture of mass society.

The Millennial Mission of the American Republic

THE FAMILY CHRISTIAN ALMANAC.

A SABBATH IN THE WOODS.

T~W~ ~O~

Evangelical Images and the American Tract Society

With the disestablishment of religion in the early nineteenth century, New England clergy and laity who had enjoyed in state-sanctioned Christianity a vision of a nation with a divine purpose were faced with the challenge of preserving their sense of national mission in a state that no longer officially authorized the practice of the Christian faith. Facing the steady growth of non-English-speaking, non-Protestant immigrants and the expansion of a frontier populated by unchurched whites and non-Christian Indians, a number of evangelical clergy, Christian professionals, businessmen, and well-stationed women formed benevolent societies such as the ABS (1816) and the ASSU (1824). These benevolent associations worked to reform the expanding American populace by producing enormous amounts of literature such as the Bible or Sunday school instructional materials and distributing them as widely as possible. The ATS was established in 1825 when the American Tract Society of Boston, formerly called the New England Tract Society, and many other smaller tract societies in the northeast merged with New York's Religious Tract Society to form a national organization based in New York City on Nassau Street. Composed primarily of Presbyterians, Congregationalists, and Baptists, the ATS set itself the task of distributing tracts throughout the United States and around the world. Yet its greatest efforts were domestic.[1]

Members of the ATS agreed to join together in the production and dissemination of printed materials that promoted what historian Charles Foster called a "united evangelical front," an alliance that avoided sectarian controversy for the sake of solidarity. The ATS was constituted by

members of a variety of religious denominations. The first group of elected officers, nearly all of whom were clergy, included members of the Congregationalist, Baptist, Methodist Episcopal, Presbyterian, Episcopalian, and Dutch Reformed churches. Ten years later the officers and board members came from thirteen different denominations.[2] The first article of the Society's constitution stated that the aim of the Society was "to diffuse a knowledge of our Lord Jesus Christ as the Redeemer of sinners, and to promote the interests of vital godliness and sound morality, by the circulation of Religious Tracts, calculated to receive the approbation of all Evangelical Christians."[3] As the final clause indicates, there was a careful attempt to avoid sectarianism. The constitution of the Society went on to state that in order to pursue the aims of the association, the officers and directors were to be drawn from different denominations; the publishing committee was not to contain more than one member from a single denomination; and "no Tract shall be published to which any member of that Committee shall object."[4]

Important to the Tract Society's efforts were wood-engraved illustrations used in tracts and a variety of other publications. The national organization of the ATS and its apparatus of distribution contributed significantly to the creation of a vast evangelical visual culture in the antebellum United States. Historical understanding of the imagery produced by the ATS depends not only on the technical conditions of its production but also on an examination of the visual rhetoric deployed in publications of the Tract Society. A cluster of questions follows closely on this approach. How were the images encoded with meaning? What relation did they bear to the texts that accompanied them? Why was the Tract Society attracted to illustrations, and what did it hope the images would accomplish? And how did images in ATS publications, particularly the *Christian Almanac,* on which I focus most closely, change over time in tandem with new initiatives, changes in publication format, and changes in audience interests and expectations?

The *Christian Almanac* and the Calculus of Doing Good

The *Christian Almanac* was introduced in 1821 by the New England Tract Society, founded in 1814 in Boston. In 1825, when the national organization of the ATS was formed, production of the *Almanac* moved to New York City and continued there. In the editor's preface to the *Christian Almanac* of 1822, its second year, we read that fourteen thousand copies of the previous year's *Almanac* were "scattered over the country" and "probably read by at least 50,000 persons." The numbers mattered in the new evangelical rhetoric of quantifying the work of the kingdom, for "if the information which the work contained, was calculated to do good, as undoubtedly it was, then, doubtless, the whole amount of good effected, was not small."[5] In the calculus of doing good there was no room for doubt. Every cent of outlay was accounted for in an economy of financial investment and spiritual return. Buying tracts was the same as sending more out, and the

means of circulation was identical to the substance of what was circulated. In the rhetoric of quantifying souls and matching to this sum the quantity of publications, medium and message intermingled:

> The proceeds of this work going into the Treasury of the Tract Society, increase the waters of the fountain, and thus send out new streams to flow through the land. Every copy that is sold, increases the number of Tracts circulated in the community. The profit of every one is a little imperishable fund, which may continue to send out one Tract, or more, every year, down to the end of time.[6]

After lamenting the lack of commitment and self-denial among contemporary Christians, the editor extended the metaphor of expenditure, investment, purchase, and financial return to the mechanics (or economics) of Christian soteriology:

> We were not educated to spend and be spent for Christ; and we find it hard, averse as we are to exertion, to learn the lesson in our advanced age. And as to giving, if we bestow almost as much as it costs us for a garment, or for the harness of a horse, or for papering our rooms, or, it may be, for the carpet upon our floor; we are apt to believe that we are good stewards of our Master's property, and shall safely get to heaven. Thus we go on; while the church of our Lord, for which he paid such a price, is struggling to gain a footing on lands purchased by his blood, and hardly succeeds, because we do so little.[7]

The Tract Society determined to publish an almanac in order to raise revenues and to promote the mission of the Society. The choice was a shrewd one because the almanac was a literary commodity with an established record of sales. No other publication save the Bible and children's primers had rivaled the almanac's popularity in colonial America. As a genre of literature that marked the cycle of the year, the almanac, as the ATS conceived it, remarked on the transience of all life. The editor opened the 1822 *Christian Almanac* with the following memento mori: "Some who read our little Manual for the last year are now, no doubt, slumbering in the grave."[8]

Adapting the almanac genre to the purposes of the ATS was not difficult. Editors eliminated many of the residues of the zodiac and astrological forms of knowledge that nonreligious American almanacs continued to offer well into the nineteenth century.[9] Furthermore, the lists of practical facts and admonitions that appeared each month in the *Almanac* were interlarded with notices of Christian publications and the efforts of the ATS. In the month of March, for instance, the farmer was reminded to prepare sugar utensils, pay school teachers punctually, get account books in order, and set aside resources for "Missionary, Education, Bible, and Tract Societies."[10] The long nights of February could be spent reading "the Missionary publications of the day, [which] will afford much interesting instruction."[11] Two pages of questions preceded five pages of facts about the need for foreign missions and the many benevolence societies in the United States and Europe. Finally, aphorisms, poetry, illustra-

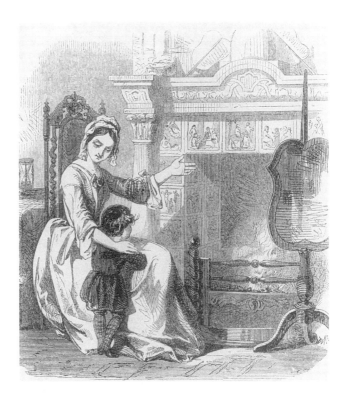

tions, and excerpts from the biographies of eighteenth-century evangelical heroes like Jonathan Edwards and Philip Doddridge (fig. 10) peppered the *Almanac*. One aim was clearly to encourage the reader to support Christian benevolence. Each edition of the *Almanac* also included a variety of carefully tabulated statistics that described the activity of the ATS. The assiduous computation and detailed display of the calculus of doing good was to dismiss any doubt about the propriety of the aims and methods of the Society and to foster investment among readers of the *Almanac*. By 1828 the editor could write that the *Almanac* was "believed to be one of the most useful Tracts which the Society has issued."[12]

The Millennial Impulse

The ecumenical measure responded to a basic presupposition about the mission of the new American republic as a millennial agent. A view held by many notable evangelicals in the first several decades of the nineteenth century was that the date of the millennium was not fixed but could be accelerated and must be prepared for by direct human efforts at universal evangelization and conversion. Millennial expectations had preceeded the American Revolution and helped give birth to the nation, offering new life to the older Puritan notion of a city on a hill.[13] Images of the millennial age in Bibles and books on the subject were widespread in the antebellum period when the myth was reshaped to fit new circumstances. Perhaps the

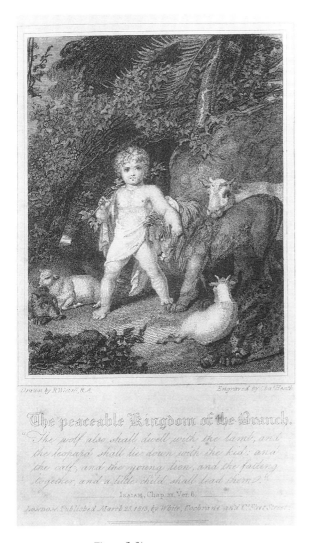

Fig. 11 *(left)*
Richard Westall, "The Peaceable Kingdom of the Branch," engraved by Charles Heath, in *The Holy Bible,* 3 vols. (London: White, Cochrane and Co., 1815).

Fig. 12 *(right)*
Josiah Priest, "A Chart of the River of Life," fold-out, wood engraving, in *A View of the Expected Christian Millennium* (Albany: Lomis' Press, 1828). Courtesy of the American Antiquarian Society.

most familiar image was "The Peaceable Kingdom of the Branch" (fig. 11), produced by the British artist and member of the Royal Academy Richard Westall for a three-volume edition of the Bible published in London in 1815.[14] The image was reproduced widely among American publications and was used by Edward Hicks as the basis for his many paintings of the subject.[15] The image was an icon for American and British postmillennialism, the pervasive idea that an age of peace was imminent when the world's ills would be cured and the wolf would dwell with the lamb. For instance, historian and millennialist author Josiah Priest (1788–1851) integrated the image into a linear scheme of images engraved in wood for his *View of the Expected Christian Millennium* (fig. 12).[16] Priest organized the dispensational ages of the world's history into a river stretching from Abraham to Armageddon according to his interpretation of a vision in Ezekiel 47. Viewing the ages of the earth as seven thousand-year epochs, Priest, like many, held the millennium to correspond roughly to the twenty-first century. Yet, given the proper efforts on behalf of Christendom, he predicted that the arrival of "the great sabbatical year and jubilee of Heaven," the "renewal of the paradistical state, the glory of the Messiah's Kingdom of earth," would occur perhaps within as little as fifty years. Priest speculated that Armageddon

> will probably consist of an universal civil war, occasioned by the diffusion of republican politics. The charms of popular government have smiled from the face of America as from the face of an angel, and filled many countries with an unextinguishable desire to shake off all monarchical authority. Two vast parties already exist, and their interests consist in the one upholding the fancied rights of kings, while the other more righteously aims at revolution—which will not be brought about but by the pouring out of blood.[17]

Priest did not believe that the great battle would eventuate as a "collision of religious sectarian interests" because of the "present charitable conduct of the different churches toward each other," by which he had in mind the cooperation of Protestants in the Bible and tract societies. In fact, he asserted that the productive efforts of the Sunday school movement and the Bible and tract societies were "the signs of our own times, which streak the horizon of our world with spiritual light." The millennium would follow as the new Christian benevolence took the gospel to all nations.[18]

Although Priest did not speak on behalf of members of the ATS, Lyman Beecher certainly did, since he had been a supporter of the Tract Society and a wide array of benevolent enterprises since the 1820s. In 1844 he was elected honorary vice-president of the ATS. The Society had long printed Beecher's *Sermons on Intemperance*.[19] For Priest, Beecher, and many others, the thousand years of Christ's reign on earth would arrive after conflict with evil and end with evil's final destruction. The millennium was not, however, merely the product of divine intervention into history but was a concrete result of the progressive development of human society led by the republic of the United States. At the opening of his *Plea for the West* (1835), Beecher signaled his agreement with the eighteenth-century divine

Jonathan Edwards that the millennium would commence in America and that it would do so precisely because of the political, moral, religious, and civil conditions that had been achieved in American society.[20] Beecher maintained that the millennium would come with "the triumphs of universal Christianity," which he felt would be introduced by the "rapid and universal extention of civil and religious liberty" since "all great eras of prosperity to the church have been aided by the civil condition of the world, and accomplished by the regular operation of moral causes." The church and state, though separate, worked together to usher in the reign of Christ.[21]

That America should be the agent of the millennium made sense to Beecher as the obvious answer to the question that he made the singular criterion for national qualification for the honor: "What nation is blessed with such experimental knowledge of free institutions, with such facilities and resources of communication, obstructed by so few obstacles, as our own?"[22] Beecher and many evangelicals believed that only republican institutions in a free society could foster the technology, mass literacy, the proliferation of true (Protestant) Christianity, and its ecumenical mobilization of an army of volunteers necessary to do the work of universal evangelization. The success of such benevolent organizations as the ASSU, the ABS, and the ATS at generating and disseminating enormous amounts of printed matter was undeniable and had deeply impressed Beecher with what the combined power of organized effort and the printing press could attain. As noted in chapter 1, the vast quantities of tracts, books, and Bibles placed in circulation by means of colportage, the railroad, steamships, canal systems, and the postal service encouraged many evangelicals to celebrate American technological development and to look forward to the approaching day when everyone on earth might have heard the word of God.

Hopes for the consequences of this crusade were not restrained. Whether in tract distribution or Sunday school attendance, benevolent associations matched their numerical imaginations to the eschatological task of evangelization. A writer in the *Sabbath School Visitant* recorded the following fantasy in 1829: "I began to make some calculations about the amount of reading which is produced in our country by means of Sabbath school libraries." He then calculated the circulation of Sunday school books and their annual readership. Falling asleep, the writer dreamed that each township contained a Sunday school with a library, producing a readership of eight million. "When I thought of this, my country seemed to rise in peace, waving in perennial greenness, and presenting to the world a scene of prophetic millennial glory."[23]

The same millennial hopes fired the engines of benevolence in the ATS. In outlining a "Great System of Benevolence for Evangelizing the World," the 1822 *Christian Almanac* stipulated that the gospel must be proclaimed universally, everyone must be supplied with Bibles, and war and slavery must be eliminated. When this occurred, the Society was bold to predict, the "Sabbath of rest, and peace, and righteousness [will] shed its heavenly light over the nations of the earth."[24] To this end, the *Almanac* stated, "a great system of means has been devised and put into operation." This sys-

tem was composed of world Bible societies, missionary efforts, and education and tract societies, all of whose names, membership statistics, income, and year of institution the *Almanac* carefully listed. The point was to argue for the rising wave of global activities, "the ornament and glory of the present age," and the imminence of achieving the final goal.[25] The editors of the *Almanac* waxed enthusiastically over the new age of benevolent societies organized into a "great system" whose historical precedent was considered to be the missionary system of the apostolic church. The global organization and the production and distribution of printed materials, meticulously tabulated in the *Almanac* and ATS annual reports, was a special source of pride among evangelical Christians. "Surely we may say to the Church," the editor announced, "'Arise, shine, for thy light is come.'" The global dissemination of printed materials and the monthly, quarterly, and annual quantification of production and distribution statistics was a sign of a new-found potency in the church. The millennium was within reach and attainable by virtue of organized labor and dutiful effort. The editor of the 1822 *Almanac* dated this "new era" from 1792, the origin of modern benevolent societies dedicated to missions, tracts, education, and Bible distribution. Thus, it was a postrevolutionary development in which the new American republic was charged with a vital role. Indeed, the author proudly listed the many American benevolent societies.[26] Like so much tract and Bible society literature, the editor sounded a clarion call to all Christians and did so with a cultural optimism. As David Paul Nord has put it, those who founded the ATS "were appalled by modern life but not terrified by it." In fact, they saw in the contemporary world's political and technological circumstances a keen opportunity to evangelize more effectively than had been done since the apostolic age. The editor of the 1823 *Almanac* wrote: "Perhaps nothing is better calculated to call forth the prayers and energies of the Christian community, than a collection of those animating facts, which mark the rapid advance of the Saviour's kingdom."[27]

In terms of the ATS's confident initiatives, the new energies of the democratic world were to be applied through the apparatus of the "great system" to the vast populations of "the heathen." By the *Almanac*'s calculations, six hundred million of the world's eight hundred million people had not been supplied with the Bible. "Allowing but one preacher for every 20,000 souls, not less than 30,000 missionaries are needed for the Heathen."[28] These were numbers that would have daunted a less optimistic leadership. But the world was shrinking by virtue of new forms of transportation and communication. Furthermore, the calculus of doing good set out to match every infidel soul with a Bible and tract. The enormous numbers of unconverted and the exotic, distant lands and languages were met with an exhaustive effort of tabulating the numbers of unbelievers, the millions of tracts and Bibles sent to them annually, the numbers of missionaries in the field and in training, the many and ever-increasing local tract and Bible societies, and the amount of dollars needed to reach entire populations. All these resources combined to "systematize" the awesome task of world evangelization and made it seem within the power of the new American republic and its millennial mission.

The Visual Culture of Antebellum Evangelism: The American Tract Society's *Christian Almanac*

The purpose of illustrations in the *Almanac,* like all other Tract Society publications, was to persuade anyone reading the text and looking at the imagery to support the cause of evangelism by taking to heart its message of repentance. Certainly illustrated almanacs were nothing new in North America; illustrated Bibles had been produced domestically since the 1780s and illustrated primers of a religious character nearly a century before that.[29] As pedagogical devices or informative illustrations, images were familiar to American audiences. What was novel about ATS production beginning in 1825 was the massive use of fairly well engraved images as a means of advertisement and public persuasion. The ATS sought to impress its readers with ephemeral tracts that did not sacrifice fine printing and illustration to affordability.[30] The Society did much from the 1820s until the 1870s to promote the use of the wood engraving in commerical illustration. In fact, one historian of nineteenth-century prints has pointed out that the wood engravings used so extensively by the ATS "demonstrate the part played by religious societies as the most powerful influence on the development of American book illustration from 1820 at least until mid-century."[31] The purpose of the images, according to the Tract Society, was to sell the product, to attract readers, and to preach the cause in a visual manner. The *Tenth Annual Report* (1824) of the ATS in Boston indicates that the publishing committee had

> also begun to ornament the publications of the Society with *Cuts*; both for the sake of rendering them more attractive and acceptable in their external appearance, and of exciting an interest in their contents. Within the last four months, [the committee has] prepared cuts for about sixty Tracts, and [has] every encouragement to proceed, till [it has] furnished them for all to which they are appropriate.[32]

The practice had been adapted from the model of the ATS, the London Religious Tract Society, founded in 1799, which produced illustrated tracts and children's books, as a report attached to ATS *Proceedings* of 1824 indicated.[33] The images performed two discrete functions: they attracted the eye to the tract and then awakened an interest in reading it. Images were exploited for their rhetorical capacity to persuade potential readers to give the tract their attention. The ATS understood the distribution of tracts in a way that welcomed this view of the image, for the tract was handed out on the move and in an instant, as is suggested by the cover illustration (fig. 13) of its first tract, by Alexander Anderson (1775–1870), in which a wealthy family distributes tracts to a working-class family. "A Tract can be given away and God's blessing asked upon it in a moment" and handed out on a large scale to achieve massive results, this tract, entitled *Address of the Executive Committee,* announced.[34] The ATS acknowledged the lesson they took from the Protestant Reformation and from Enlightenment pam-

THE **NO. 1.**

ADDRESS

OF THE

EXECUTIVE COMMITTEE

OF THE

AMERICAN TRACT SOCIETY,

TO THE

CHRISTIAN PUBLIC.

PUBLISHED BY THE

AMERICAN TRACT SOCIETY,

AND SOLD AT THEIR DEPOSITORY, NO. 144 NASSAU-STREET, NEAR

THE CITY-HALL, NEW-YORK; AND BY AGENTS OF THE

SOCIETY, ITS BRANCHES, AND AUXILIARIES, IN

THE PRINCIPAL CITIES AND TOWNS

IN THE UNITED STATES

Fig. 13
Alexander Anderson,
engraver, Distribution of
tracts, cover, *The Address
of the Executive
Committee of the
American Tract Society, to
the Christian Public,* tract
no. 1 (New York:
American Tract Society,
1825).

phleteers in this regard. Wood engravings conformed in medium and appearance to the format of the tract and its use: visual propaganda that was inexpensive, mass produced, and able to entice the eye with the tract and then its contents. The modern age of advertising with its transient claims on consciousness in the form of brief messages wrapped in bold imagery took shape in evangelical mission efforts to convert the gospel into graphic information for mass dissemination.

The wood engraving process provided essential material conditions for the role images early came to play in publications by the ATS. The medium of wood engraving in the vignette illustration had itself only recently been applied to book and tract publication.[35] Pioneered by Thomas Bewick (1753–1828), the British engraver who was internationally emulated, the wood-engraved vignette offered a number of significant advan-

tages to the mushrooming book trade in Britain, Europe, and America in the later eighteenth century. Book illustration before the widespread use of wood engraving relied on the intaglio process of metal plate engraving. While this technique could provide the conditions for superb artistic quality, it required a process for printing separate from the letterpress and therefore required more time in production. A heavier paper was generally used in order to withstand the intaglio printing process, in which the moistened page was pressed with great pressure into the indentions of the printing plate in order for the ink to be transferred to the page. The separate folios were then interleaved into gatherings of text and stitched in place. All of this took time and meant that an image was isolated from the page of text that it illustrated.

The wood engraving, by comparison, meshed much better with the production process. As a relief system of printing, the wood engraving shared the same procedure as letterpress; ink was applied to the raised rather than the lowered surface of the plate, as in intaglio. Because the wooden block in which the image was engraved could be milled to the same thickness as the letterpress (about one inch) and printed with the same pressure, the wood engraving could be run through the press at the same time as typography and printed as a piece.[36] The image could also appear on the same page as the text that referred to it. With this development, the vignette form came into its own as a visual device that immersed the image into the page, where it sat poised between units of text rather than isolated on a separate page (see fig. 14). Artists such as Bewick and those who studied his work explored different ways in which to fade the image into the page, to dovetail engraving and text, and to place word and image in a graphic dialogue that enhanced the meaning of both.

Certainly woodcuts had shared the page with text since the Reformation, but typically the images were printed separately. Nor did woodcuts offer the same degree of print quality over long runs as wood engravings, which were cut on the end grain of boxwood, a very hard and fine-grained surface that could support the minute gravure produced by the sharp tool that cut narrow troughs of wood from the surface. Conventional woodcuts removed large sections of wood from the surface by gouging and carving away the wood whose grain was softer and ran parallel rather than perpendicular to the surface of the block. Woodcuts produced a largely planar visual vocabulary, were typically very large, and allowed only rather small editions of several hundred prints before the edges of the block began to deteriorate. Because the wood engraving was carved from the surface of a hard end grain, it was able to preserve a highly articulated linear language of forms, exploit a range of textures on a much smaller scale than the woodcut, and last much longer in the printing process, thereby allowing vastly larger editions and resulting in greater profit.[37] The augmented reproducibility and small, refined images that resulted favored book and pamphlet production. While the woodcut worked very well for larger imagery such as broadsides and folio volumes, the softer wood and large expanses of inked surface were not conducive to consistently high print quality in large runs. The countless pictorial primers, chapbooks, and illustrated almanacs of the eighteenth century make this quite clear.[38] The new technique (if early accounts are correct,

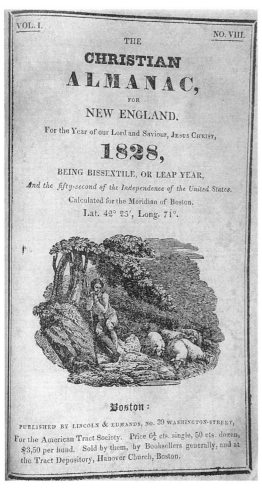

Fig. 14
Alexander Anderson, engraver, Shepherd and sheep, title
page, *Christian Almanac* (1828).

Fig. 15
Abel Bowen, engraver, cover, *Christian Almanac.* New
York: American Tract Society, 1821.

there was no one practicing wood engraving in the United States before the 1790s)[39] became the basis of popular illustrated periodicals and, as one study of Bewick has observed, "transformed visual information and thus helped to open what might be called the age of mass media."[40]

An early chapter of the history of wood engraving in the United States was written by the ATS. The *Christian Almanac* was illustrated even before the ATS's all-important tracts. The earliest volumes of the *Almanac* carried on their covers a wood engraving, signed "AB" for the Boston-based engraver Abel Bowen (1790–1850), the first Boston wood engraver.[41] Bowen's cover, used until as late as 1833, conveyed the purpose of the "great system" and the ATS in particular (fig. 15). A Caucasian missionary speaks with Bible in hand to a circle of listeners from a variety of cultures gathered on what may be a South Seas island. As the editor's address in the *Almanac* says of the missionaries, whose archetype adorns the cover: "Scattered over a world shrouded in the gloom of moral death, they resemble a small number of light-houses along a dark and stormy coast of ten thousand leagues."[42] Situated beneath what Bowen or his British source might have thought resembled a palm tree, the preaching figure enacts the biblical charter of the Anglo-American tract societies, which is inscribed about the oval image: "Go ye into all the world and preach the gospel to every creature," a paraphrase of Matthew 28:19–20. The print quality is so poor that individual figures are difficult to identify, but Native Americans, Asians, Africans are clear enough to recognize by virtue of costume and accoutrement. As early as 1828, Alexander Anderson provided a new cut similar to Bowen's image (though based on another early cover of the *Almanac* by an unknown, presumably British source). In his version (fig. 4), which continued to be in use as late as 1840, Anderson exchanged a less exotic leafage for the shredded palm fronds, though the scene still appears in an oceanic setting. The gesture of the preaching figure is less pedagogical than previously and more hortatory. Those gathered about him exhibit clearer ethnic codes: a Chinese hat, a Japanese fan, a Persian turban and coat, a Native American's quiver of arrows, headdress, and tomahawk, an African's loincloth, the gesture of a Hindu yogi, an eastern European or Russian hat.

Alexander Anderson was a physician from New York who left medical practice to take up wood engraving after the disastrous yellow fever epidemic in New York City killed nearly everyone in his family in 1798. His work appeared in tracts, newspapers, and books issued by the Society and in many Bibles and primers published by various firms in the first several decades of the nineteenth century.[43] On the basis of his well-received American edition of Bewick's *History of Quadrupeds,* one early authority on wood engraving called Anderson "the Bewick of America and the father of his art in this country."[44] The cover of the 1836 *Almanac* (fig. 4), re-cut to be clarified for printing on new green cover paper, displays the signature "A," a method of signing his work that Anderson had used since 1796.[45] The hatching and figure drawing are much better than the earlier version, exhibiting more cleanly defined volumes and surfaces of objects. Anderson's signed images appeared in work done for the New York Religious Tract Society's children's tracts as early as 1824.[46] These were turned over to the ATS when it formed in the next year and appeared in the first editions of ATS tracts (fig. 13). The *Almanac* of 1828 carried further

Fig. 16
Alexander Anderson, engraver, after Bewick, Worker returning home, title page, *Christian Almanac.* New York: American Tract Society, 1834.

Fig. 17
Thomas Bewick, Soldier returning home, from *1800 Woodcuts by Thomas Bewick and His School* (New York: Dover, 1962), plate 134. Courtesy Dover Publications

images by Anderson such as an illustration of a worker returning home in the evening, met by a small child on the pathway to his hovel (fig. 16). An image of a shepherd boy on the title page of the same year (fig. 14) carries another version of Anderson's signature, "A." Such pastoral imagery fit the agrarian theme of the *Almanac* as well as conveying a rustic piety calculated to appeal not only to the large rural readership of the publication but to everyone who understood the Christian faith in terms of the benevolence the *Almanac* promoted. The shepherd boy serves as an emblem of humble faith. Reflective and without airs, the young shepherd oversees his charges with a devotion symbolized by his clasped hands and the crook conspicuously displayed within his arms. In light of the paternalistic aims of the Tract Society, one wonders if this was intended as a self-portrait of the benevolent Christian taking care of the flock of the less fortunate.

A similar sympathy and pastoral condescenion appears in the illustration within, in which a lowly worker, probably a farmer or perhaps a mill

laborer as suggested by the mill in the distance, returns home, shovel in hand. (fig. 16). Beneath the image appears the following caption from Ecclesiastes 5:12: "The sleep of a labouring man is sweet, whether he eat little or much." Taken directly from an image by Thomas Bewick (fig. 17), the image documents the translation of the British practice of wood engraving to the United States. Although the composition is identical, Anderson introduced several changes in props: he substituted an American-style hat for the beret worn by Bewick's figure, who appears to be a soldier in the labor corps home from military service, toting his belongings in a duffle bag.[47] Anderson transformed him into a laborer on the banks of a river, downstream from a mill, which is not found in Bewick's engraving. A frequently itinerant section of the American workforce in the early nineteenth century spent twelve-hour days milling grain or lumber, pressing cider, operating power looms or lathes, or working in paper mills. Anderson's image portrays the soothing joy of returning home to the benefits of domesticity and family, set in the serenity of the country, at the end of the day (note the long shadows). Alternatively, if the figure is a laborer returning home from a day in the fields (as the spade suggests), the mill represents a picturesque detail in a pastoral landscape.

The scene in Anderson's image shows a pastoral relation between humanity and the technology of the early industrial revolution. The image both reflects and obscures labor conditions in America. In contrast to the situation in England, where wages were two or three times less and violent protest against textile manufacture in the first decades of the nineteenth century was caused by surplus labor, in the United States machine technology helped make up for the scarcity of workers.[48] Anderson's decision to depict not a factory but a lone country mill allowed him to situate labor in the peaceful countryside instead of in the noisy urban industrial center or the industrial village that some factory owners experimented with early on. Technology therefore was rendered unthreatening and of a piece with the life of the pious plebeian. Anderson's image depicts a scene as evangelicals wished it to appear: a father returning at day's end to a dutiful family. The image neither provoked Democrats made nervous by industrialization nor Whigs who would have deplored criticism of technological progress. The image seems to proclaim that poverty and humble conditions matter little or not at all when piety and gender relations are properly maintained, urging workers to identify themselves in the private terms of their families rather than in the public role of organized labor, protest, and calls for social justice. Machine technology was not a threat to the Christian Republic but a means of realizing and reinforcing it.[49]

The rural setting was at the heart of an evangelical message. In images of the countryside such as this one, the industrial revolution could be blended into the rhythms of rural life. The tensions between the machine and the garden that Leo Marx essayed could be either resolved or repressed and technology seen as an organic part of the whole.[50] But whatever one's views on technology in the evangelical experience of antebellum America, the rural ideal was widespread indeed. Urban scenes are rare in the *Almanac,* and sympathetic urban scenes virtually nonexistent. This is perhaps not surprising for a publication meant explicitly for farmers. But the message was made quite clear in a line quoted in the *Almanac* from the

eighteenth-century British poet William Cowper: "God made the *country,* and man made the town."[51] Historian Paul Boyer has remarked on the literary depiction of poverty in ATS tracts that "it is invariably in a country context and suffused with a sentimental glow" in the attempt to quicken "memories of that world" and to reassert "the claims of the moral order associated with it." The city was a dangerous place of distractions and temptations that caused one to stray from the moral order of the village or country life that was rapidly being displaced in antebellum America.[52]

The message of its imagery underscored the mission of the Tract Society, which was clearly concerned with stabilizing what Society members considered was a threatened social order. The Society looked to the established upper middle class for primary assistance. This was certainly what the cover illustration (fig. 13) of the Society's inaugural address to the public, the first tract in its series, announced. The *Address of the Executive Committee,* the Society's elite leadership, addressed itself to "those whose stations or whose character give them influence over the destiny of their fellow men." Tract distribution, it proclaimed, was a "method of instruction . . . peculiarly calculated for the poor."[53] Not only could the poor receive these "short, plain, striking, entertaining, and instructive" items from the generous hands of the well-to-do, they could, in turn, be converted to this method of benevolence and go about distributing tracts to their fellow poor. Thus, as the cover illustration showed, benevolence was a special way that the middle classes could "influence" the lower classes.[54]

Many scholars of the early republic have stressed in recent years that eighteenth-century political thought in America was rooted in a classical republicanism or civic humanism that envisioned a social hierarchy consisting of a landed gentry, who were fit to govern society and safeguard its values, and those who required the example of civic virtue to instruct them and preserve their participation in the new republican order.[55] This version of republicanism was increasingly challenged and finally unseated, but it required the two generations following the revolution to accomplish what Gordon Wood has characterized as the revolution's "radical" vision of the new republic. Wood has described how basic the idea of benevolence was to the new republican scheme of social relations in late-eighteenth-century America. Replacing the complex hierarchies of deference, benevolence in the discourse of civic humanism was experienced as sympathy with others in spite of social differences of rank. Moreover, the benevolent person rose above local society and all forms of sectarianism in gestures of cosmopolitanism, subordinating self-interest to the greater good of such republican virtues as science and its practical benefits, universal enlightenment, liberty, and the "great republic of humanity at large," as Washington put it. Yet the inertia of social hierarchy did not diminish overnight. Benevolence was a virtue more often associated with gentle society just as selfishness was associated with those from "the more humble walks of life."[56]

Republican benevolence taught that people ought to be moved by love of virtue and the good of the civic order rather than their own interest or gain. Binding everyone together was a common moral sense or sympathy. This ideology, which helped mitigate the hierarchialism of colonial society, subordinated personal interest to the good of others. Yet it did not sur-

vive the end of the eighteenth century intact because liberalism, premised on the economics of self-interest, gained ascendancy in the young nation and promoted modern commerce, individualism, and egalitarianism, all of which helped redefine citizenship and social relations. Still, the rhetoric of a paternalistic republicanism could be invoked when Federalists and Whigs bemoaned changes pressed by the likes of Jefferson and Jackson.[57] It is in this light that we should see the emergence of evangelical benevolence in the second and third decades of the nineteenth century. The founders and supporters of the ATS and other benevolent organizations often expressed the concern to secure the American republic in the face of a rapidly changing population. But these evangelicals understood the urgency of the task in terms of the salvation of each soul from eternal damnation. They proceeded on the basis of a voluntary principle that replaced the coercion of state-sponsored religion with the persuasive power of benevolence. Only by voluntarily giving of themselves would Christians save the American republic and make it to prosper in its providentially intended millennial role.

Once again, a key term in the evangelical discourse of benevolence was "sympathy," now defined as the capacity to be moved on behalf of the *spiritual* welfare of others. Whereas the cosmopolitan sympathy of civic humanism distinguished selfishness from the enlightened selflessness of benefit to others, evangelical sympathy focused on the differential of those living for themselves and those who died and were resurrected in Christ. It was the latter who enacted their evangelical faith by proselytizing, particularly to the immigrant and the lower classes, in order that these others might become regenerate and produce the moral conduct essential to the well-being of the republic. Thus, sympathy was often not self-effacing in a strict sense but could entail a subtle form of experiencing and reinforcing social difference—between those who enjoyed salvation and were moved to share it and those who were the object of evangelical sympathy and therefore (presumably) not in possession of salvation.[58]

Republicanism, evangelicalism, and efforts at social benevolence came together in the second and third decades of the nineteenth century in a set of far-reaching reconfigurations of republican rhetoric. Evangelicals stressed the importance of religion in promoting virtue and forming character as the indispensable means of preserving liberty in the new republic. In this age of suspicion about large and centralized political control, no one imagined that democratic government alone was able to ensure moral order and civil liberties without the assistance of a virtuous citizenry.[59] Hence the need for organized religious benevolence, which deployed in turn the rhetoric of republicanism—benevolence, self-denial, patriotism—but recast these terms into the discourse of evangelicalism. The revolutionary disdain for corruption became a fear of immigrants in the nationalistic ethos of the early republic; the disgust at luxury and vice became the distrust of literature, theatre, and dance; and moderation in matters of luxury in general was reconfigured as temperance and then teetotalism in the consumption of alcohol and the use of tobacco. In each rhetorical transformation, immigrants and the working classes came in for special treatment as objects of spiritual concern and the focus of efforts at moral reform.

In addition to the clearly class-conscious imagery (fig. 13), the Tract Society's paternalism was blatantly stated in visual terms in three early versions of the *Almanac's* cover illustration (figs. 15 and 4), which visualized the Society's international mission: to preach the gospel to the infidel around the world. By gathering the world's non-Christian population around the organ of Christian communication, the image conveyed the obvious message of the burden of the Christian West to preach to the world's other inhabitants, who were portrayed as passively and attentively receiving the evangelical preacher's proclamations. No less important, however, the message sent assurance to supporters and potential patrons of the Tract Society that money spent on benevolent organizations was money transfigured into the millennial work of the church in the race against infidelity to evangelize the world.

The use of images by Alexander Anderson from 1828 to as late as the early 1840s in the *Almanac* suggests a new editorial strategy. Production statistics show that in 1828 the production of the *Almanac* had increased by a factor of nearly two and one half times over the year 1826. By 1831 the amount had increased to virtually three times that of 1826.[60] It would appear, therefore, that the proliferation of images—and particularly images by Anderson—may have been tied to the increase in production with the hope of stimulating greater consumption. The 1828 *Almanac* proudly reported the increase in receipts at the ATS; income tripled from 1825–1826 ($10,158) to 1826–1827 ($30,413).[61] The number of tracts issued went from 697,000 to 3,117,100 over the same period. Always wary of the six hundred million souls who remained without Bibles and tracts, the Society included in its statistics the total number of pages of distributed material, which in 1828 came to 44,168,000. By 1832–1833, receipts at ATS had climbed to $61,905 and the total number of pages to 87,622,000. For very little money the ratio of number of pages to unevangelized souls was quickly diminishing. The increase in receipts allowed the *Almanac* to be produced in larger editions and sold for less. Prices dropped from 12¢ per copy and $9.00 per hundred in 1822 to 6 1/4¢ per copy and $3.50 per hundred by 1828, a price that remained steady well into the next decade. Much of this was due to technological provisions. As Lawrance Thompson noted, stereotyped plates of letterpress were first used by the ATS in 1823 (when engravings also began to appear on tracts).[62] Stereotypes allowed for an economy of scale in the cost of mass production since the greatest amount of labor went into typesetting the original letterpress. The stereotyping process took a mold in plaster or papier-mâché from the typeset text, then recast it in molten metal for further use. Once a book or tract was stereotyped, the original letterpress could be disassembled and reused, while the stereotype plates could be stored and used when needed.[63] The drop in prices also reflects the boom in paper production in the 1820s as a single regional market developed in New York and New England. Paper mills proliferated as canal transportation facilitated access to raw materials and marketplace. Thus, the price of paper per ream in New York City dropped by 20 percent from 1826 to 1830 while production for one Massachussets firm whose primary market was New York City increased by 25 percent from 1821 to 1830.[64]

One early history of the ATS noted that in 1828 the Society's executive committee "turned their attention particularly to the needs of the rapidly

developing frontier areas of the Mississippi Valley."[65] As the westward continental move got underway, the makers of the *Almanac* responded by increasing the number of editions keyed to local latitudes and meridians. In 1823 the *Almanac* was published in only four editions: Boston, Washington, D.C., Pittsburgh, and Rochester.[66] By 1826 only three additional locales had been added to this list: New York City, Philadelphia, and Huntsville Alabama.[67] But according to the *Third Annual Report* of the ATS in 1828, the *Almanac* was published in twenty distinct editions, nineteen of which were were adapted to local positions. The new list is telling as the ATS applied itself to the South and West and achieved greater consolidation among local tract societies around the country: Boston, Hartford, Albany, Rochester, Utica, Philadelphia, Pittsburgh, Baltimore, Richmond, Raleigh, Charleston, Augusta, Huntsville, Washington (Alabama), New Orleans, Nashville, Cincinnati, and St. Louis.[68] The ATS also changed the format of the *Almanac* in the search for a broader audience. In 1833 it was announced that the *Almanac* would be enlarged to forty-eight pages in order to render it "more extensively useful" and that it would be "adapted to interest and benefit common readers, and especially the young."[69]

The increased use of images was reflected in Tract Society publications in general. Of the fifteen volumes of the Evangelical Family Library published by the ATS and advertised in 1838, ten included "steel plate frontispieces" and / or engraved illustrations within the text. Bound in calf, each volume sold for 42¢ on average. Of the forty-three "Standard Volumes" offered by the Society, only four included neither illustration nor frontispiece in 1838, though all but six of the thirty-nine volumes including imagery contained only frontispieces.[70] Among books marketed to adult readers, Bunyan's *Pilgrim's Progress,* volume 4 in the Evangelical Family Library, was probably the most lavishly illustrated, with seven engravings plus a frontispiece. In 1839–1840, twelve thousand copies of *Pilgrim's Progress* were printed.[71]

Ornate book illustration became the emphasis of ATS visual culture in the mid-1840s when the visual format of the *Almanac* changed its original formula to a new cover concept. After 1846 a larger number of artists were engaged to provide illustrations. The new cover concept, first executed by William Howland, was an ornamental fantasy of picture frames, medallions, vignettes, ornate volutes, and floral interlace displaying images of domestic scenes, agrarian labor, and leisure and representing the seasons of the year (fig. 18).[72] Significantly, the style recalls the manner of illustration engraved by Joseph Adams (1803–1880) after designs by John G. Chapman (1808–1889) in Harper's *Illuminated Bible,* 1843–46 (fig. 19).[73] In fact, for his mammoth project, Adams had engaged a host of New York wood engravers who shortly later would work for the ATS: Benjamin Childs, William Howland, Augustus Kinnersley, Edward Bookhout, Robert Roberts, and Nathaniel Orr.[74] But the connection between Adams and the ATS preceded the Bible project since Adams, who had studied with Anderson, had contributed engravings for three books published by the Tract Society in 1838 and 1839.[75]

A monumental event in nineteenth-century publication history, Harper's Bible signaled a new era of technological application, commercial illustration, and graphic design in the United States. To print what were

eventually the seventy-five thousand copies of the Bible, Joseph Adams
employed the newly developed electrotyping process, which replaced the
method of duplicating plates via plaster mold with an electrochemical de-
posit of metal on wax impressions for a more accurate and much more
durable printing surface. As Eugene Exman recounted, the product was
promoted like no other by the Harper brothers, who placed ads through-
out the media.[76] Sales were so successful (the book was offered in fifty-four
installments that sold for 25¢ each, the cumulative cost was $13.50) that
Adams, who had contracted for 50 percent of the profit, retired after pro-
duction was complete. The book transformed the market for illustrated
volumes. Increased production of illustrated publications, particularly re-
ligious materials, quickly followed. The *Illuminated Bible,* published in in-
stallments from 1844 to 1846 (copyrighted in 1843), and then as a single vol-

ume in 1846 (of which twenty-five thousand copies were sold), contained sixteen hundred engravings that densely illustrated the text from beginning to end. Most of the images were small embellishments of chapter headings and the beginning of each book (fig. 20) or insets illustrating a particular figure, event, or place in the text (fig. 21). Images of a place were often depicted as vignettes in the conventional manner of the picturesque illustration. Particular moments such as the act of creation or Moses receiving the Law were framed in elaborate ornamental fantasies that claimed one-third or one-half of the page. Full-page illustrations were limited to frontispieces for each testament.

The ATS wasted little time in determining to apply the new style to its purposes. The annual report for 1847 celebrated the housing of the Society's novel initiatives in printing and illustration in a newly erected building. The new structure included a room for a wood engraver on the top floor, where six new roller presses were installed.[77] The Society purchased

Fig. 19
John G. Chapman designer, Joseph Adams, engraver, title page, Harper's *Illuminated and New Pictorial Bible* (New York: Harper Bros., 1846). Courtesy of the American Antiquarian Society.

THE

OLD TESTAMENT.

THE FIRST BOOK OF MOSES, CALLED

GENESIS.

CHAPTER I.

1 The creation of heaven and earth. 3 of the light, 6 of the firmament, 9 of the earth separated from the waters, 11 and made fruitful, 14 of the sun, moon, and stars, 26 of fish and fowl, 24 of beasts and cattle, 26 of man in the image of God. 29 Also the appointment of food.

IN the ᵃbeginning ᵇGod created the heaven and the earth.

2 And the earth was without form, and void; and darkness *was* upon the face of the deep: ᶜand the Spirit of God moved upon the face of the waters.

3 ᵈAnd God said, ᵉLet there be light: and there was light.

4 And God saw the light, that *it was* good: and God divided †the light from the darkness.

5 And God called the light ᶠDay, and the darkness he called Night: †and the evening and the morning were the first day.

6 ¶ And God said, ᵍLet there be a †firmament in the midst of the waters: and let it divide the waters from the waters.

Before CHRIST 4004.

a John 1, 1, 2. Heb. 1, 10.

b Ps. 8, 3, & 33, 6 & 89, 11, 12. & 102, 25, & 136, 5 & 146, 6. Isai 44, 24. Jer. 10 12, & 51, 15. Zech. 12, 1. Act 14, 15, & 17, 24 Col. 1, 16, 17. Heb. 11, 3. Rev 4, 11, & 10, 6.

c Ps. 33, 6. Isai 40, 13, 14.

d Ps. 33, 9.

e 2 Cor. 4, 6. † Heb. *between th light and betwee the darkness.*

f Ps. 74, 16, & 104 20.

† Heb. *And the evening was, an the morning was.*

g Job 37, 18. Ps 136, 5. Jer. 10 12, & 51, 15.

† Heb. *expansion.*

the same presses (recently developed by the Boston printer Isaac Adams) used by the Harper brothers to print their pictorial Bible. Since Joseph Adams had developed an electrotyping process to facilitate printing from wood engravings on the new press at Harper's, the ATS sought out engravers trained in electrotyping. Thus, in 1845–1846, the Society made arrangements "to secure the improvements recently introduced, especially by the artists Chapman and Adams, in the preparation and printing of wood engravings; and with this view a firm, trained in this kind of printing, were employed on the revised editions of the Children's series."[78] Since it was William Howland who engraved the cover of the 1845 cover of the *Almanac,* the firm mentioned was no doubt the Howland Brothers, which consisted of William and his two brothers Alfred and James and was listed in the New York Business Directory of 1846.[79] The new style of il-

Fig. 21
Inset portrait of Christ,
John 15:1, Harper's
*Illuminated and New
Pictorial Bible* (New York:
Harper Bros., 1846),
p. III. Courtesy of the
American Antiquarian
Society.

lustration appeared not only on the cover of the *Almanac* but on the other principal illustrated publications of the Society, children's tracts and books.

Although William Howland had produced similiar work as early as 1841 for another publisher, the ornately adorned title page from the Harper's Bible (fig. 20) was probably the model for the cover design of the *Almanac* used from 1845 to 1848 (fig. 18).[80] A series of illuminated medallions and picture frames orbit the title of each plate. Chapman's design intertwines a broad range of heroes and episodes into a classicizing format. Howland's design (his name appears in the lower left, traditionally reserved for the designer; the lower right for the engraver) was less graceful than Chapman's but more compact. Howland followed Chapman in organizing several framed pictures about the central text, each image representing the seasonal advance of the annual cycle. The times of the year come to rest in the lower center, winter, when the family gathers about the father figure who reads the Bible before the hearth, illuminated by a single symbolic candle flame that radiates from the very center of the circular motif. When the image first appeared on the cover, no other images were included in the *Almanac*.

The stunning financial success of Harper's Bible no doubt impressed the ATS. Illustration of good quality, size, and frequency had demonstrated the capacity to sell books. In 1857 the *Cosmopolitan Art Journal* (which was illustrated by the work of many New York engravers who had contributed both to the Harper's Bible and to ATS publications) looked back to the appearance of Harper's Bible as the origin of the "illustration mania" in books and periodicals. "Nothing but 'illustrated works' are profitable to publishers, while the illustrated magazines and newspapers

in everybody's hands—are vastly popular. HARPERS initiated the era, by their illustrated Bible."[81] The *Cosmopolitan Art Journal* promoted wood engraving as a popular and artistically respectable means of beautifying American life and elevating public taste. The journal's editors discerned an important shift in the artistic quality of wood-engraved illustrations that corresponded closely to the Tract Society's investment in the medium. "Those horrid cuts which were wont to disgrace children's books, comic newspapers, etc., will give place to designs exquisite in conception and finish, which will silently, by their beautiful presence, teach the power and grace of Art."[82] By 1850, the Society could boast of the *Almanac*: "Its elegant cuts would be an ornament to any work whatever."[83] But this achievement only came with the expediture of money. The 1850 annual report indicated that the Society possessed a stock of wood and steel engravings estimated at $16,747.35 in value. When the additional sum of $6,420 spent on engravings and designs is added to this amount, the total exceeded the $20,000 of expenses reported for Harper's *Illuminated Bible*.[84] The expense may have caused some to wince, for in 1848, after spending a year in the expensive new facility, the Society's publishing department sought to justify the financial "attention which has been given to the issuing of engravings in the first style of the art" with the firm belief that the expense would be "fully rewarded in the increased attractiveness and acceptance of a large portion of the Society's issues, especially those designed for the young."[85]

Joseph Adams's former student, Robert Roberts, a Welshman who first appeared in New York as an engraver in 1841, had worked on the Harper's Bible and then served as the Tract Society's first "superintendent of engraving" from 1847 until his death in 1850.[86] Roberts's experience as an engraver of the Harper Bible brought to the Society full-time service in everything it wanted in a new, embellished style of illustration. The decorative chapter headings designed by Chapman had merged scenery and portraiture with typography and festooned ornamentation. Text and illustration intermingled as a single visual product as on the opening page of the Book of Genesis (fig. 20). By 1848 illustrations within the *Christian Almanac,* procured and engraved by Roberts, followed the example. Not only did they grow in size and frequency, they became more atmospheric in the depiction of space and, again like the Harper's Bible, integrated image and text. An image of 1849, unsigned but presumably engraved by Roberts, shows the pastoral fantasy of a young man taking refuge from the heat of the day to read his Bible (fig. 22). As in Chapman's illustration of Genesis 1:1 in the Harper's Bible (fig. 20), falling water was used to erode the traditional blocks of text and carve out a niche for the image. The text that the *Almanac*'s image illustrates is framed by the image on two sides and conforms to the shape of the brook, the slope of type on the right margin echoing the cascade of water in the lower right.

Roberts had directed the production of "eleven historical and instructive engravings" in the 1850 *Almanac* before he died. Seven engravings (six unsigned, one by Anderson) had appeared in the 1848 *Almanac*; twelve (unsigned) in 1849. Roberts engraved a new cover for 1849 to accompany the new title, *The Illustrated Family Christian Almanac.* The same cover appeared on the 1850 *Almanac*. The manner of illustration employed by

The scorching heat reaches me ~
ot beneath this thick foliage. The dust from the
·avelled highway penetrates not these recesses.
Io voice of man disturbs my meditations. But the joy-
us melody of this babbling brook shall tune my spirit to
ong and praise. Here, in this solitude, this, sweet retreat,
hall my thoughts go forth to that bright and better land

Fig. 22
Young man reading book,
Christian Almanac. New York:
American Tract Society
1849, p. 31.

Fig. 23
Benjamin F. Childs, engraver,
Apache and bison, *Christian
Almanac.* New York: American
Tract Society, 1851, p. 35.

THE AMERICAN BISON, commonly called the buffalo,
once ranged in vast herds over the greater part of the
territory now constituting the United States; but now
is rarely seen except in the remote and unsettled re-
gions of the north and west. They are pursued by the

Roberts was confirmed by his successor, Benjamin F. Childs (1814–1863), who had learned wood engraving from his brother, Shubael, who had worked in Boston with Abel Bowen. A signed image in 1851 documents Childs's style (fig. 23); the image of an Indian hunting bison is composed of a very fine mesh of short lines that quickly change direction to produce a hazy or atmospheric quality. The effect is a subtle distinguishing of objects from one another that grows increasingly faint in order to convey depth. Childs augmented this visual richness by alternating patterns of dark against light. He clustered the tonal contrasts near the center of the image which tended to dissipate toward the edges. The result was an ever-expanding vignette that embraced the text and gestured toward the entire page.

The Tract Society continued to build on the excitement of increased production since the late 1840s. Childs's work was cited in the annual report of 1851, which announced that the *Almanac* for that year, "illustrated by Mr. B. F. Childs the Society's engraver, reached a circulation of 310,000," a number that was second only to the previous year's production of 320,000.[87] The report quoted a clergyman who sought to supply every member of his congregation with the publication:

> [I]ts tasteful illustrations, the variety and accuracy of its selected readings, all unite to make it a profitable and instructive companion for every family. . . . Its beautiful engravings attract the young, its anecdotes interest the curious, and its illustrations of divine truth, so direct, so graphic, and so practical, instruct and edify those who love the Saviour.[88]

In the previous year's report the "beautiful illustrations" of the *Almanac* were said to "improve the taste of the young, [while giving] them a body of information worth far more than its cost."[89] Since the early 1830s the *Almanac* had endeavored to attract a youthful audience in order to bolster sales and to plant the seeds of evangelical benevolence. The appointment of Roberts and then Childs to produce and direct the production of engravings in the Society's publications, particularly the *Almanac,* coincided with a redoubled effort to appeal to a young audience and to give publications an entertaining appearance. Images such as that of the Indian hunting bison (fig. 23) seem predisposed to engage the young viewer's imagination by picturing an exotic bison and Apache hunter. The bison, the caption reported, "once ranged in vast herds . . . but now is rarely seen except in the remote and unsettled regions of the north and west."

As a result of the influence of the Harper's Bible, the number and shape of illustrations changed. Howland enriched the signifying capacity of images on the 1845 cover by creating narrative, cyclical imagery in which seasonal subject matter was married to evangelical themes and given appropriate connotations. Thus, the seasonal planting and harvesting easily became references to New Testament parables of sowing and reaping. To be sure, the hortatory tone of earlier years persisted. The best instance of this was a cut by Alexander Anderson in 1848 of a drunkard stumbling into a tavern despite the pathetic pleas of his tattered wife and children (fig. 24). And images in the late 1840s remained keyed to the seasons, offering agrar-

Fig. 24
Alexander Anderson,
engraver, "The Rum-
Seller's Victim,"
Christian Almanac. New
York: American Tract
Society, 1848, p. 39.

ian and rural subjects. But the number of images increased dramatically
(the eight images in 1848 doubled the number of illustrations in 1841)
and the new visual style and less preachy tone were marked differences.
The *Almanac* of 1850 included eleven illustrations, that of 1851 seven (the
smaller number may have been due to Roberts's death and replacement
by Childs), and 1852 eleven once again. Ten illustrations per issue remained
the average throughout the decade, increasing to twelve in the 1860s.[90]

Under Childs's leadership the subject matter of images underwent an
important shift. After 1850 the *Almanac* ceased the practice of closely tying
images to seasonal themes and began to explore less direct means of ad-
dressing issues dear to the Tract Society's mission. Thus, instead of the pre-
ponderance of pastoral imagery of harvest or winter chores or such
moralistic propaganda as Anderson's print (fig. 24), illustrations became
free-floating items of general interest: strange facts, historical monu-
ments, natural history, popular legends, and technological feats. Each of
these images, which an 1868 ATS publication referred to as "elegant en-
gravings," might have been found in contemporary illustrated newspapers
and magazines.[91] Indeed, the same kinds of images were produced by the
very same engravers for the extremely successful *Harper's New Monthly
Magazine,* which began in 1850 and was being printed in fifty thousand
copies each month by the end of its first year.[92] In volume 10 of *Harper's*
(1854–1855), cuts appeared by a list of engravers whose work also adorned
the pages of the *Christian Almanac*: John Andrew, Alfred Bobbett, Nathan-
iel Orr, James Richardson, and Edward Hooper.[93] A variety of other en-
gravers who contributed to the *Almanac* in the 1850s—Elias Whitney (b.
1827), Nathaniel Jocelyn (1796–1881), John William Orr, Phineas Annin,

and J. Augustus Bogert—engraved the illustrations for Abbott's *Life of Napoleon Bonaparte,* also published by Harper Brothers in 1855. The same engraving style was applied to the publications of the ATS as to secular commercial publications. In 1863 Elias Whitney replaced Childs as superintendent of engraving at the Tract Society.[94]

Yet it would be wrong to conclude that the religious value and mission of imagery in Tract Society publications suffered compromise or dilution as a result of the connections to nonreligious commercial production. Neither the religious interests nor the visual means of the ATS were subject to creeping secularization. To the contrary. The ATS embraced new technologies as providential opportunities to advance its mission. Although images often no longer depicted explicitly religious or moralizing subjects, they still contributed to the mission of the ATS. What happened in the early 1850s under the artistic leadership of Roberts and Childs was the implementation of a new visual rhetoric. The style that Adams deemed appropriate for the Harper's Bible and for the *Christian Almanac* combined the compact, white-line technique of wood engraving mastered by Anderson (in which the negative shape carved from the block becomes a positive delineation in the printed image) with the airy, open, and wiry black line of copperplate engraving. The combination was especially effective for exploiting playful interactions between image and text. Intended to preserve the sketch quality of pen and ink, the black line broke out of the contained format of the Bewick tradition represented best by Anderson and could evoke the contemporary etchings and wood engravings of the British illustrator George Cruikshank, the baroque traditions of European etching, or the elegance of rococo engraving of the eighteenth century. The Tract Society hoped the new style of illustration would attract customers and increase sales, and that hope is clearly what was behind the boost of the 1850 *Almanac* to an unprecedented 320,000 copies, each with an unprecedented number of eleven illustrations gracing its pages.

In order to discern the character of the new visual rhetoric of the 1850s, it is helpful to borrow language from a contemporary manual of rhetoric. In 1827 Samuel Newman (1797–1842), professor of rhetoric at Bowdoin College, published his *Practical System of Rhetoric,* which became such a standard text that it went through sixty more editions by the Civil War. Following the ancient distinction of three basic styles of public speaking (simple, middle, and grand styles), Newman identified four styles that ranged from the "plain" to various degrees of "ornamented" style: simple, elegant, specious, and florid.[95] The plain style, according to Newman, was fitted to the purpose of instruction while ornamented styles employed various tropes in order to please and instruct. Accordingly, I propose to distinguish the plain or *programmatic* style of imagery from the ornamented or *embellished* style in Tract Society illustrations during the antebellum period. By "programmatic" I mean the image whose immediate and unambiguous concern was instruction in and promotion of the stated agenda of the ATS as stipulated in the Society's constitution, the first article of which endorsed "the interests of vital godliness and sound morality." What this meant in practical terms was clearly announced in the *Almanac's* literary and visual items: temperance or even abstinence; opposition to

gambling and tobacco, theatre, dance, and novel-reading; affirmation of sabbath school and church attendance; the regular reading of scripture, conversion, and the practice of prayer; and fostering the "family altar."[96] Recurrent themes were the imminence and inevitability of death; contradiction of atheists, Universalists, and Roman Catholic priests; conversions and testimonies of Hindus and Indians; and the Christian testimony of "great men." I have considered programmatic only those items that explicitly designated religious content or moral conduct sacred to the interests of the ATS.

Specifically, programmatic images are those that speak in what the Society characterized as the "short, plain, striking, entertaining, and instructive" language of its tracts to viewers about their spiritual welfare and do so visually in the explicit terms of an evangelical tract.[97] Therefore, by "style" I refer as much to the manner in which an image treats a theme peculiar to the Tract Society's agenda as to a distinctive set of visual features. Whether or not an image in an ATS publication after 1846 shared the new style of the Harper's Bible, its rhetorical manner or mode was programmatic whenever the image directly addressed the themes by which the ATS defined itself and did so without creating the surplus of meaning that rhetorical ornaments do by stretching the signification of a word or image.

In contrast to the plain style, by "embellished" I mean those images that operated with a degree of ambiguity, with an indeterminate, open-ended manner, owing to decorative features that worked in excess or even independently of a text's literal description of a scene. In addition to instructing the viewer, the images were to please—to please instructively, of course; but by the 1840s and the arrival of the new mass media of illustrated periodicals, ornamented visual pleasure was no longer considered excessive or inappropriate by the ATS. While all the images in ATS publications that exhibited the embellished style appeared with a caption, I will show how they were free to expand or interpret the text in ways that images in the plain style did not allow.

From 1841 to 1848, the total number of pages in the *Almanac* leapt from thirty-six to sixty and the number of illustrations from four to eight. This coincided with the appearance of Harper's Bible between 1843 and 1846. Illustrations also grew in size and quantity. In the 1820s, 1830s, and early 1840s illustrations were never larger than one-third of the page. They were printed as vignettes that took their place within a clearly defined register of the page as regularly milled pieces of wooden block nestled neatly between rectangular units of text. In the second half of the 1840s, as we have seen, the size and quantity of the imagery grew and its placement on the page broke out of the block format to surround or mingle with text.

Programmatic images were exclusive in the *Almanac* before 1845, the year in which the cover design changed. The new cover design was less hortatory and more decorative. But the new embellished style, now more fashionable than the older, plain style of Alexander Anderson, was no less rhetorical or given to persuading readers to support the mission of the ATS. Only the visual strategy had changed. The new decorative element was more subtle than the homiletic mode of imagery of town drunks disregarding wife and family. Such items as the seasonal cycle, images of rail-

roads and bridges, Audubonlike pictures of birds, or comets aglow in the black of outer space might appear ideologically neutral at first glance, indeed, as items of general interest that might show up in any almanac. But within the context of the *Christian Almanac* these subjects took on an aspect that undeniably served the evangelical purposes of the publication. The seasonal cycle easily gestured to biblical referents; the railway and transportation wonders such as bridges were fundamental to evangelizing the continent. Likewise, a nearly full-page image of an arctic bird, the auk, illustrated an article on Eskimos in which the auk's "vast numbers [were thought to] prove how careful is the Lord of the universe to supply the wants of his creatures; for where else could the poor Esquimaux market if not in the caverns and crannies of the sea-birds?"[98] And an 1860 illustration of a comet that passed Earth in 1858, a year of widespread religious revival, was accompanied by long paragraphs of fine print describing the comet's orbit, schedule, and speed and the history of its appearance. The text ended with a simple proclamation that pulled the heavenly body into the orbit of the Tract Society: "Truly, 'the heavens declare the glory of God.'"[99]

Before 1845 the indirect meaning of embellishment was absent. Virtually every image was an immediate visual statement of the evangelical effort to promote temperance, to read the scriptures, or to practice the rustic piety of simple laborers at work in the fields of the Lord. With the arrival of commercial illustrators like Childs and the new impetus to appeal to a public whose tastes gravitated toward the illustrated periodicals of the day, the makers of the *Almanac* and other ATS publications explored greater subtlety in illustration. The *Almanac* had to be able to appeal as visual entertainment beside such rivals for Americans' leisure time as illustrated daily newspapers and magazines.

The plain rhetorical style of Alexander Anderson's prints admonishing the viewer to avoid drink (see fig. 24) is difficult to confuse with the manner of Childs's depiction of an Apache Indian hunting bison (see fig. 23). Where Anderson strove for clarity and tonal contrast, Childs bathed forms in an evanescent treatment of light that accommodates the indices of motion and a playful movement of the eye. We see objects through skeins and gauzes. If Anderson was compelled to make each mark responsible for rendering one aspect of his somber subject's obdurate presence, Childs dissolved his subject in scintillating effects in order to approximate the subtle features of light in painting and photography.

This shift from moral tone to didactic entertainment is evident at many levels. Anderson would use labels such as "Tavern" in his images in order to insert the image into a textual narrative. His images also strongly respect the rectangular shape of the block and its format on the page while Childs enjoyed violating the previously block-bound frame of the vignette by allowing the image to wind its way about text, encroaching on and attenuating the amount of text that accompanied the image. Indeed, Childs' pictures were often displayed with much less text than Anderson's. This growing autonomy of the image (indebted in part to the fact that wood engravings after midcentury were increasingly taken from paintings and photographs and less from other wood engravings) contrasts sharply to Anderson's presentation of image, which derived from moralizing broad-

sides—what might be an episode from a Hogarthian suite of images narrating the downfall of a bourgeois family. Childs's picture, on the other hand, drew stylistically on fashionable commercial book and periodical illustration and thematically on the mythos of the American West then taking shape in the white American mind. An icon of adventure that appealed to the youthful readers of the *Almanac* and the *Child's Paper* (also published by the ATS), this image lamented the loss of an earlier form of life but regarded it finally as a fact of the cultural and religious superiority of white Americans—the manifest destiny and cultural imperative of evangelical Christianity.

In the 1850s and 1860s illustrations in the *Almanac* and the *Child's Paper* exhibited a fascinating degree of ambiguity. These images required of viewers a certain shared but unstated knowledge that allowed the image's meaning to take shape as a connotation rather than an explicit designation or tagging.[100] This more subtle cultural operation served the same end of promoting the evangelical ideal of the Tract Society but offered the advantage of appealing to viewers in a less direct, heavy-handed way. Images that operated with less explicitness and greater ambiguity engaged viewers in an imaginative construction of meaning. They were required to interpret the illustration, consciously or not, by reading it in tandem with an accompanying text and an implicit cultural context. The illustrations were most often picturesque visions of exotic places, popular heroes, technological achievements, sentimental domestic scenes, solemn moments in American history, and natural wonders in the American landscape. In every case the subject matter and its visual treatment fell into a pervasive mythic structure: the past from which the nation emerged and the future that it had been called to realize.

Among other things, the shift from the plain to the embellished style in the 1840s marked the emergence of the market revolution. The rural, local, patriarchal vision of agrarian America, rooted in subsistence farming and the piety of a paternalistic Protestantism, was vanishing beneath the rising tide of capitalism. Industrialization, urbanization, and consumption were creating a mass culture in which the embellished style fostered a sense of contemporaneity and inherited the sunny hopes for the advance of Christian civilization. By contrast, the figure of the humble yeoman who lived by the labor of his shovel on a scrap of land he longed to own, portrayed in the restrained, classical form of Anderson's plain style, preached a pastoralism and a moral severity that seemed nostalgic by mid-century. Where the plain style counseled self-denial and restraint, the embellished style welcomed visual delight, adornment, and the pleasures of refinement in a world in which wealth and industry were the promising signs of a redeemer-nation. That the ATS could still use both styles during the 1840s and 1850s delineates a transitional moment.

Viewed as formal devices that worked in tandem with mass-produced print, the plain and the embellished styles constructed an evangelical reality or worldview in very different ways. The plain style positioned the image and text in such a way that corresponded fully to one another, leaving nothing to explain. The image and the text faithfully interpreted one another, implying that the image seamlessly joined the world of things it depicted to the words it illustrated.

The embellished style, on the other hand, proceeded in excess of the text, which was appended to it in the dangling shape of a caption. Where the discourse of the caption trailed off, the image generated additional possibilities of meaning by evoking or suggesting connections between what was stated and what was not. This refusal to be explicit opened up a space in the referentiality of the image and invited the viewer to fill it up. Cued by the context of the ATS publication with the organization's understood mission, the viewer was prompted to project certain meanings. Viewing the image through the filter of this context and in the terms of the text provided as a caption allowed viewers to enjoy constructing the image's meaning as implied or connoted. Moreover, this participation in meaning making tended to naturalize the ideology implicit in the viewer's encounter with it.

In order to understand the new rhetorical operation of the embellished visual style in the *Christian Almanac* and the *Child's Paper,* the next chapter will focus on two bodies of imagery: depictions of racial and ethnic outsiders—African-American slaves, American Indians, and Roman Catholic immigrants—and images of the inside of evangelical culture—domestic and family scenes. This will allow us to scrutinize how particular images were connected to text and context and to understand how images visualized the evangelical worldview of the ATS.

The Visual Rhetoric of
Northern Evangelicalism

Viewed as a single iconographical system, the images illustrating the tracts, almanacs, books, and periodicals of the ATS form a pattern of messages that circulated a distinct ideology about Protestantism and the new American republic. The argument of this chapter is that images distributed by the Tract Society articulated a more or less uniform rhetoric and propagated a national mythology that consisted of expanding boundaries emanating from an inner heartland. In the introduction to their important study of sacred space, David Chidester and Edward Linenthal have argued quite cogently that a boundary or frontier is not a line but "a zone of intercultural contact and interchange."[1] Living as a native on the border of an expansive society means living in a situation that places the heartland to one's back and the land of others before one's face. The mass-mediated images produced by the ATS envisioned a national ideology that configured a border advancing against aliens in order to expand the heartland. The two—border and heartland—were constructed as parts of a single cultural system, positing one another in the politics of representation. The border was coded male and consisted of the conquest of such others as Mexicans, Indians, and Catholic immigrants; whereas the heartland was female, the domestic domain of the interior that generated the nation from within. While male colporteurs and missionaries engaged ethnic and racial others on the advancing borders of the American republic, the heartland was visualized in Tract Society publications as the sphere of the nurturing mother, ensconced in her domestic space caring for children. The two iconographies were part of a single ideology and intermingled on occasion, as I will show.

The millennial foundations of the ATS and much evangelical Christianity in the United States had by midcentury become articulated as the complementary terms of white America's archaic past and its promising future. More particularly, these terms were joined in the task of subduing the interior of the continent. The embellished style developed in Tract Society publications by the 1840s was especially suitable to this purpose. What could be more serviceable in this regard than repeatedly disseminating the themes of technological and natural wonders, American history, and domestic scenes, and presenting them in a way that avoided homiletics in favor of visual entertainment? In fact, the themes were often merged; exotic places such as the American wilderness became the setting for a popular hero such as Daniel Boone to forge American history by defeating a band of savage Indians (fig. 25). From this heroic past, formed from chaos, the (white) American people built a nation favored by God, whose glory was evident in such natural wonders as Niagara Falls and Yellow Stone Lake. The achievements of modern technology were celebrated in the *Almanac*'s illustrations of ocean steamers, the suspension bridge over the Niagara River, the telegraph, or the construction of the Capitol in Washington.[2] This genre of imagery testified to the American inheritance of the future and the national destiny of creating a benevolent society. The legend beneath an illustration by Whitney, Jocelyn, and Annin

Fig. 25
Benjamin Childs (?), engraver, Daniel Boone fighting Indians, *Christian Almanac*. New York: American Tract Society, 1851, p. 29.

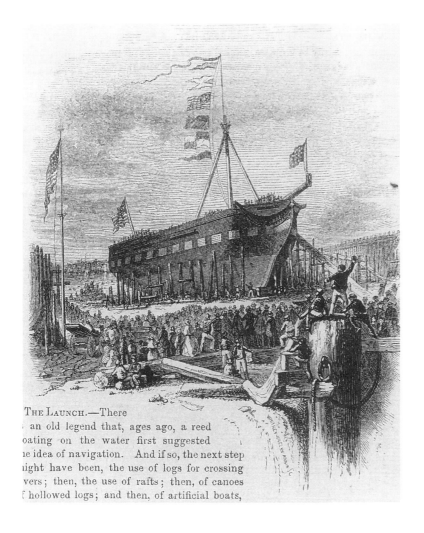

THE LAUNCH.—There
an old legend that, ages ago, a reed
oating on the water first suggested
ie idea of navigation. And if so, the next step
iight have been, the use of logs for crossing
vers; then, the use of rafts; then, of canoes
f hollowed logs; and then, of artificial boats,

of the launch of a vessel decked with American flags and banners (fig. 26) contrasts the "uncouth structures" of Greek and Roman ships with modern-day accomplishments. "How great the progress, and how vast the improvement manifest in the ships of the present day."[3]

The embellished style was used most frequently to display national attainment and the millennial future that awaited. As Childs's Indian hunting bison (see fig. 24) and the struggle of Daniel Boone with Indians (fig. 25) indicate, the embellished style could also be applied to the mission of the *Almanac* by portraying Indians as a dying, anachronistic race. Yet the adoption of the new visual language of the Harper's Bible did not exclude the rhetoric of the plain style in the *Almanac,* and other portrayals of American Indians were executed in the plain manner by showing the Indian as the subject of the missionary's efforts (fig. 27). While the ATS exploited the new style of illustration and the novel, embellished form of rhetoric to attract patronage, it often deployed both the older plain manner and Anderson's dated visual style to depict Indians as the foil against which the United States needed to exercise its evangelical and national imperative.

Fig. 26
Elias J. Whitney,
Nathaniel Jocelyn, and
Phineas Annin,
engravers, "The
Launch" *Christian
Almanac.* New York:
American Tract Society,
1854, p. 17.

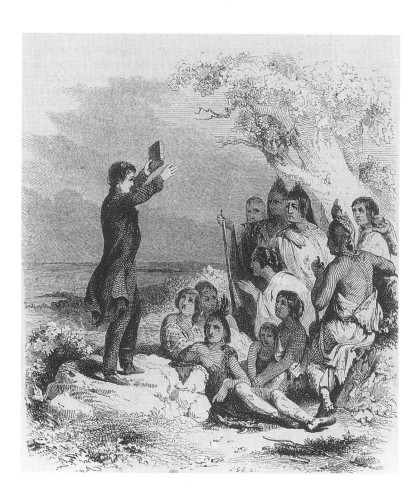

Fig. 27
"The Missionary,"
Christian Almanac. New
York: American Tract
Society, 1855, p. 23.

The role of Indians in the national story as told by Protestants and the iconography developed in the pages of the Tract Society publications clarified the raison d'être of the Society as it came under fire for soft-peddling slavery. Debates over the official attitude of such organizations as the ASSU and the ATS toward slavery were closely tied to the status of the western and southwestern territories and American manifest destiny. Through the 1840s and 1850s, congressional and presidential politics were increasingly structured by this bitterly divisive issue: would the new territories become slave states or "free soil" upon entering the Union?[4] Likewise, benevolent associations were wracked by dissent over whether or not they should denounce slavery as unchristian. In the context of this enduring controversy, I argue, Indians and Roman Catholics served much better than African Americans as the "other" in juxtaposition with white, Christian manifest destiny and millennial progress. The Native American's social status was not as politically volatile, and all Protestants could agree on the threat posed by Catholic immigration. For many Northerners, black slavery represented an anachronism, the residue of a predemocratic age that would gradually fall away in the march of progress. It is necessary, therefore, to examine the relationship of slavery, territorial expansion, and the mission efforts of the Tract Society in order to situate images of Indians

and blacks in Society publications within the national setting that shaped the viewers of these images. While images of Catholics in ATS publications were very rare, for reasons I will explore, the Society urged vigorous and systematic proselytism in the Western states and territories and pleaded with abolitionists to recognize "Romanists" as a greater threat than slavery.

This chapter focuses on the important role that several different iconographical themes played in Tract Society publications. African-American slaves, American Indians, and Roman Catholic immigrants all fit into the Society's ideology of manifest destiny and the millennial mission of the United States. Each was treated quite differently from the other, forming three discrete visual strategies in the cultural politics of representation. After examining these, I will turn to the depiction of women and families as potent signifiers of class and gender that served to organize the heartland of American society according to the ideals of the evangelical membership of the Tract Society. In the end, I will show that the Society developed a visual rhetoric that sought to persuade the American public of a certain notion of American civilization, one that struggled to realize the millennial mission of the nation in the shape of a circle with a fixed center and a marching periphery. In this form, articulated and distributed by the illustrated print media of the ATS, the ideology of white evangelicals constructed a nation.

The American Tract Society and the Slavery Controversy

Having founded themselves on a principle of unity that took great pains to avoid sectarian strife for the good of the global distribution of the Word, during the two decades before the Civil War, the ATS and the ASSU were faced with the grim specter of division and the catastrophic reversal of their advancement. The presence of the ATS in southern states had long been established. The New England forerunner of the ATS had opened tract depositories in Virginia, North Carolina, and the border state of Missouri as early as 1820 and published the *Almanac* in southern localities since 1824, expanding the presence of the Society in the South in each successive year.[5] By 1858 the national leadership of the ATS, now afraid of imminent division over slavery, announced that its colporteurs had been welcomed during the previous year "into more than two hundred thousand families in the slaveholding states."[6] Faced with the loss of this access to the South, it is not surprising that an organization so committed to attaining its goal was loathe to antagonize white evangelicals south of the Mason-Dixon line. But the opposition took shape as the ATS refused to change its policy of not addressing the slavery issue in its publications. Public criticism reached very harsh levels after the middle of the 1850s.[7]

Underway since 1831, the anti-slavery crusade in the United States had helped to galvanize political differences along an intensely debated front. The Whig party took up various positions against slavery while Jacksonian Democrats, though hardly champions of slavery, resisted abolitionism out of fear of the dissolution of the Union as well as the perceived threat of

lower-class labor being overwhelmed by the entrance of millions of emancipated blacks into the work force.[8] The Whigs, it is important to note, included former federalist clergy and conservative Protestant business leaders from the Northeast who took up the antislavery cause with special zeal, adding it to a host of reform causes such as temperance, Sabbath observance, Sunday school attendance, and opposition to gambling and such forms of entertainment as dance and theatre.

The evangelical anti-slavery contingent could bring considerable pressure to bear on benevolent and reform initiatives in the form of sustained scrutiny in the press. This became evident in 1848 when, under the lead of New England Congregationalists, and the anti-slavery paper, the *Independent*, founded by Lewis Tappan in that year, the ASSU came under intense fire for dropping a tract from its list that included what southern members of the ASSU regarded as uncomplimentary implications about American slavery.[9] In a tract published by Tappan's American and Foreign Anti-Slavery Society in 1848, the Congregationalist cause against the ASSU was set out; the organization was harshly criticized for caving in to southern pressure and bending to the agitations of the "slave power." A tract entitled *Jacob and his Sons,* first published by the ASSU in 1832, was by 1848 deemed inappropriate by a South Carolina vice-president of the ASSU and by the *Carolina Baptist,* which called on "all Southern Christians to withhold their funds" from the ASSU.[10] At least two other southern papers joined in the call. In response to the decision to remove the tract from circulation, a Congregationalist church in Connecticut informed the ASSU by open letter that it had voted overwhelmingly to remove the organization from its list of beneficiaries. And Lewis Tappan complained in a published letter to Frederick Packard, general editor of ASSU publications, that Packard and his colleagues had committed "a virtual subserviency to the wicked spirit of slavery in striking the book."[11]

The ATS shortly was to experience the same public scrutiny and censure from the Congregationalist church. In 1853 this church's General Association of Massachussets passed a resolution urging larger publishing societies not to avoid making slavery a subject of their efforts. At the same time the General Associations of Michigan, Iowa, and Illinois expressed the desire to see the ATS and the ASSU speak out against slavery. In 1855 the Fourth Congregational Church of Hartford stepped up pressure by protesting the ATS's neutrality on slavery.[12] In the second half of the 1850s the *Independent* became intransigent on the issue of abolition and took a hard stand against the ATS for refusing to condemn slavery and for editing tracts in such a way that potentially offensive references to slavery were neatly eliminated.

The ATS annual report of 1855 exhibits the impact of these mounting criticisms in the abstracts of addresses before its yearly gathering. In his speech, Theodore L. Cuyler, of the Dutch Reformed Church in New York City, insisted that the purpose of the Tract Society was not to publish tracts on social or civil reforms:

> [T]hat province belongs to the Temperance, Peace, and Anti-Slavery Societies. As for slavery, I yield to no man in abhorence for it. But it is not the province of this Society to publish tracts in discussion of it as a

civil institution. They [the members of the ATS] are to stick to their part of the Master's work, which is to preach the cross to black and white. It is the great evangelical alliance of the day.[13]

According to Cuyler, American evangelicals faced a different common enemy: "We have a great battle to fight for the valley of the Mississippi with the Vatican, and that battle is to be the battle of the world. The leading foe is one over whom a banner waves bearing this inscription, 'The mother of harlots.'"[14] The annual report on colportage for that year echoed the concern about immigrants, particularly German Catholic immigrants and the threat of "popery."[15] Cuyler's remark sought to deflect the impending doom of rupture within the Tract Society by casting the arrival of immigrants and their conversion in nothing less than apocalyptic terms. The fight was to be not over slavery but over the Roman enemy filling the Western territories.

Pressure from New England and New York Congregationalists to produce tracts that challenged slavery or at least raised it as a subject of discussion and Christian concern moved the Tract Society's Executive Committee (composed of members of the Publishing Committee, the Distributing Committee, and the Finance Committee—from eighteen to twenty people in all) to issue a circular in February 1856 that stated the Society's official position on publications regarding slavery.[16] The leadership contended that the Society's constitution opposed the publication of any tract that did not receive the complete approval of "all evangelical Christians" and that the committee was "especially precluded from presenting those aspects of any subject that involve the community in sectional or political strife."[17] A response from the anti-slavery side quickly followed: the repudiation of the ATS in the pages of the New York *Daily Tribune,* which was in turn published in a pamphlet. The anti-slavery response objected that the ATS had issued tracts against the use of tobacco and alcohol and against such amusements as dance and novel-reading without concern about offending the many evangelicals who moderately indulged in these activities.[18] The pamphlet also listed passages from four tracts that in their original British versions had mentioned slavery in negative terms and that in the versions published by the ATS had been expunged.

As late as 1856, the Executive Committee had naively hoped that the "earnest animadversion" on the topic of slavery had only been the result of "misapprehension."[19] But over the next two years the anti-slavery opposition became more organized in Boston while southern leadership and congregations grew outspoken. The Publishing Committee indicated in 1856 that it would publish nothing that might foster "political, national and sectional strife" but conceded that "there are other aspects of the subject and of duties and evils connected to it, in which it might be hoped that evangelical Christians, north and south, would agree. . . . Tracts of this character . . . the Committee know no reason why they should not be approved and published."[20] But when the committee considered publishing a selection of materials entitled *The Duties of Masters,* both southern members and northeastern abolitionists were outraged.

At the 1858 annual meeting, speakers from the South denounced *The Duties of Masters* as "an incendiary tract" and "a firebrand thrown into the

South and the South-West."[21] Other members seemed to regret any attempt to address the issue. In a long address on the issue of slavery, Episcopalian bishop Charles McIlvaine, a founding member of the ATS and one of its veteran tract writers, questioned whether it were even possible to author a tract that would satisfy the difficult provisions set out by the Publishing Committee. McIlvaine, like so many speakers at the meeting, expressed alarm at the threat of secession and the impact on colportage.[22] He voiced the concern of many when he contemplated the broadest consequence of the Society's dismemberment. Failure to support the Publishing Committee's rejection of *The Duties of Masters* would violate the principle of unity on which the organization dependend. For McIlvaine, the result of this violation would be catastrophic:

> And then what next? Why, the fence of our catholic field of united action is laid waste. The provided security is trampled under foot. Wild beasts of the forest may now enter in and devour. . . . [A]re we to say to the world, to the infidel, and to the vain boaster of papal unity, that after all our efforts and hopes, we have found out that we cannot stand together, that our Protestant unity is but a name? . . . This would be the destruction of a great power for promoting the Protestant faith by *Protestant hands.*[23]

Militant metaphors were to be expected from McIlvaine, who began his career as a chaplain and professor at West Point, but such rhetoric was of course characteristic of the Protestant mentality of manifest destiny and the eschatological battle with the powers of darkness over the fate of Christendom and the American nation. It was the domination of the continent by universal evangelization achieved through the technology of the printing press and the united front of evangelical Christians that mattered to conservative Protestants. "In our western land," an Indiana Presbyterian clergyman announced at the 1856 annual meeting, "what errors to be corrected, what infidelity to be routed, what vice to be conquered! Aye, and what heterogeneous elements of nationality, of language, of modes of thought, of laws, of manners, to be fused and refined and crystallized, ere the church shall stand forth beautiful as the morning and comely as Jerusalem."[24] It was progress toward this national goal of a new Jerusalem that depended on and was in part fulfilled in the united efforts of American evangelicals.

When the break came, the ATS suffered a secession that was smaller than it had feared. In 1858 the anti-slavery party was able to take control of the Boston branch of the Society and, in the following year, separated itself from the national organization in New York. The loss was considerably smaller than if the South had withdrawn. In fact, in 1860 the national organization opened an auxiliary in Boston. But with the outbreak of the war the issue soon became moot.[25]

Although its defenders insisted on the Tract Society's neutrality, in fact the ATS was much more careful to avoid provoking evangelical slaveholders and brethren in the South than the anti-slavery party of the North. Before the end of the war images of blacks never appeared in the pages of the *Almanac* or the *Child's Paper* in any capacity other than as servants.[26]

By 1849, only four of the 529 tracts that the Society had issued since its inception dealt substantially with Africans or African Americans. In all cases, the black person was portrayed as a model of piety, characterized by submission to God's will and a steadfast repression of any impulse to rebel, blame God, seek revenge, or question the order of things. For instance, a tract called *The Praying Negro,* first published in Boston in 1819, was praised in the annual report of the Boston ATS because the tract's protagonist, when injured, "found relief in prayer to God" and thereby converted a "respectable Physician" from infidelity.[27] The narrator of the tract relates that he happened upon a praying slave woman who asked God to bless her master and to forgive his blasphemies. She pleaded with the Almighty to forgive her own evil thoughts toward her master: "Keep me from wishing him bad—though he whips me and beats me sore, tell me of my sins, and make me pray more to thee—make me more glad for what thou hast done for me, a poor negro."[28] The narrator "exhorted her to continue in the exercise of a submissive and forgiving spirit towards her master . . . encouraging her with the prospect of a speedy release from all her sufferings— and that in due season, if she persevered in well doing, she would reap a rich reward in the kingdom of glory."[29]

The illustration accompanying *The Happy Negro,* a tract produced by London's Religious Tract Society and republished and illustrated by the ATS, conveys the typical social relations of white and black mapped out in the tracts (fig. 28). The black slave never stands as high as the condescending white narrator, who ambles into the domain of the slave's labor, interviews him or her, admonishes piety and perseverance, then leaves, touched and admonished by the primitive faith of the humble slave. In the case of *The Happy Negro,* an English gentleman visiting a plantation in the United States encounters a slave at work and asks him if "he would not gladly exchange" his present state "for his liberty." The slave replies that his master is good, takes care of his wife and children, taught him to read, and gave him a copy of the Bible.[30] That this racial distinction bothered white evangelicals, the slave's fawning deference notwithstanding, is evident in the closing section of the tract. Upon leaving the slave, the English gentleman is moved by the "one common language of the heart" that all Christians speak with one another. The concept of sympathy, derived from republican benevolence, sought to mediate the contradiction that slavery introduced among white and black evangelicals. In spite of such temporal inequities, the tract's addendum would have it, the hearts of believers were joined in a single, universal language or sympathy of feeling. Yet it was not a language that overcame the bonds of the present world, and the race relations visualized in the tract's illustration served to resist the dithyrambic language of the tract's conclusion by remaining firmly planted in the material world of slave and free.

In every instance the slave gladly submits to a servile state because he or she has found evangelical Christian faith that locates emancipation in the afterlife. This was the view that remained firm for many in the ATS from 1814, when the Boston branch was founded, through the slavery controversy. George W. Bethune, Dutch Reformed pastor of Brooklyn and a newly elected vice-president of the Society, spoke for many at the 1858 annual meeting when when he said of slaves, "I wish to make them freemen

THE HAPPY NEGRO.

By the late Ambrose Serle, Esq. England.

of the Lord. I care not, comparatively, whether they be bond or free. . . . [I]f they are saved by faith in the blood of Jesus, this world matters little. . . . Take riches, honor, friends, liberty, life, but give me Christ."[31] For anti-slavery activists in the Society, on the other hand, such sentiments did nothing but promote slavery. And when the ATS Publishing Committee cosmetically edited tracts, for example, emending the title *The Praying Negro* to *The Forgiving African* and changing a reference in Legh Richmond's *African Servant* to "thieves" who abducted an African boy to the "men" who did so, anti-slavery members of the Society were outraged.[32]

In the pages of the *Almanac* before the war African Americans were rarely mentioned, and the editors never announced opposition to slavery. During the war, because it was designed for use at all latitudes, the *Almanac* avoided provocation by sheepishly regarding the conflict simply as one rooted in the South's disruption of the Union. Mention of slavery was taboo. Thus, one passage in the 1863 *Almanac* was satisfied with quoting Tocqueville's lamentation of the "dismemberment of America" as a "great wound on the whole of the human race." Another text offered encomiums to union in abstracto.[33] The *Almanac* did not denounce slavery but regretted the secession as the loss of national unity. In the following year an article urged readers to write letters to soldiers in the field but did not identify which army. An engraving by Childs accompanying the text showed two French soldiers inspecting a civilian's luggage and reading a letter (fig. 29). The *Almanac* appropriates the image, attaching to it its own

story: "'I can always fight best after a rousing letter from home,'" ex-
claimed a young officer to his comrades, his lip quivering and his eye moist-
ening with the love and patriotic glow caught from the pages of an open
letter."[34] The text used the image to avoid committing the *Almanac* to ei-
ther Union or Confederate readers, for the soldiers in the engraving wore
the *bonnet rouge,* traditional headgear among French revolutionary forces.
Childs did nothing to change the French subject of the image to American
circumstances lest the image take sides. While those in the North might
have seen the use of republican imagery as a subtle reference to the Union
forces of liberation, nothing in the text hinted that this was the case.
Southern viewers might just as easily have seen the image as a reference
to the revolutionary forces of the Confederacy fighting the oppressors of
the North.

Even when the *Almanac* did, on rare occasions near the end of the war,
deplore slavery as inherently repugnant, the view expressed was deeply
qualified. For instance, one item in 1864 related a visit to a Louisiana plan-
tation, "whose master was among the very best specimens of Southern
slaveholders, humane and liberal in this treatment of his slaves. They were

Fig. 29
Benjamin Childs,
engraver, French
soldiers inspecting
traveler, *Christian
Almanac.* New York:
American Tract Society,
1864, p. 31.

all plump and hearty, giving unmistakable signs of their good keeping."[35] In this master's cotton field the only act of barbarity the visitor witnessed was perpetrated by a fellow slave charged with overseeing a large work detail. The article proceeded to reject slavery as "a system of fear, where men must be driven by penalty, because they cannot be drawn by reward. . . . Such an instrument [the whip] is never seen under the system of free labor, because *pay-day* is coming."[35] Slavery was bad economics; labor was best controlled by a reward system of wages.

Although the Boston wing of the ATS issued anti-slavery material during the war, the New York wing waited until 1864 to produce literature for ex-slaves and even then did not circulate the material until 1865.[36] It was not until after the war that the rhetoric grew inflamed in the *Almanac*. In 1866 an article illustrated by a large rippling Union flag referred to the attack on Fort Sumter as "treason's first blow at the national flag." The flag now belonged to the "four millions" of slaves liberated by the war. Now we read that South Carolina (where Fort Sumter was located) entered the war for "no other purpose than to maintain an aristocracy through the institution of slavery."[37] Yet one is left wondering whether South Carolina was a synecdoche for the Confederacy or was being singled out to take the brunt of the blame for its original act of aggression. Not until after the war did the *Almanac* dare to run an image that took the side of abolition (fig. 30). In a nearly full-page image, "[p]oor hunted, heart-broken Milly" sits in a shack and looks heavenward as rays of light descend on her and her sleeping infant. The caption theologized her liberation in an often-repeated manner, figuring the Union as christological: "The sacrificial blood of thousands has flowed to purchase the redemption of thy people."[38]

Indians and the National Mission

The controversy over slavery in the ATS was tied to the Society's push to the West and to the iconography of the American Indian displayed in ATS publications. Indians were a useful object of Christian postmillennial zeal because evangelicals, regardless of their views on slavery, generally agreed that Indians needed to be evangelized. Furthermore, Indians had become a popular symbol of American progress and manifest destiny, whereas slavery served only to tarnish the image of America's mission as the flagship of civilization. In effect, the Tract Society was at pains to secure a foil in order to reaffirm its original vision and to stave off or mitigate the controversy of slavery. The increasing number of images of Indians reproduced in the *Christian Almanac* and the *Child's Paper* in the 1850s and 1860s as symbols of the founding of the nation, the settlement of the frontier, and of evangelism in the West allowed the ATS to foreground its mission over against the threat of the disintegration of the evangelical alliance. The subjugation of Indians—their violent defeat and christianization—and their transformation into emblems of Anglo triumph and progress conformed well to the millennial purpose of the American republic by serving to underscore its uniqueness, its special task in the world, and the defeat of savagery. While Europe's nations continued to suffer despotism and failed democratic revolutions, Americans in the antebellum

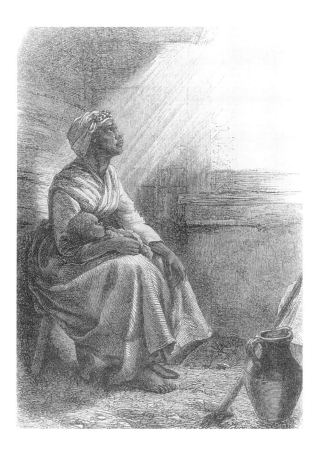

Fig. 30
Milly, *Christian Almanac*.
New York: American
Tract Society, 1866, p. 41.

period of national expansion and the assumption of hemispheric domination were fond of seeing themselves as having inherited the torch of western civilization.

By midcentury, Indian culture had come to signify the past, what Americans had overcome on their national mission, and was therefore visualized in the *Almanac* as belonging to an archaic, pioneer phase of American life that could now be looked back on as a historical curiosity, as part of the passing of bison from the Great Plains or the decline of beavers in forests or as incidents from the heroic life of Daniel Boone or the colonial period when armed force was necessary to protect whites on their way to worship (fig. 31).[39] The Indian was the uniquely American proof that the United States had come of age. Indian culture rooted the millennial mission of Christianity in American soil.[40] A professor of philosophy at Harvard countered Malthusian fears of overpopulation by stating confidently in 1856:

> I see only indications of a beneficent arrangement of Providence, by which it is ordained that the barbarous races which now tenant the earth should waste away and finally disappear, while civilized men are not only to multiply, but to spread, till the farthest corners of the earth shall be given to them for a habitation.[41]

The Visual Rhetoric of Northern Evangelicalism 87

Fig. 31
Elias J. Whitney,
engraver, Early settlers
of New England,
Christian Almanac. New
York: American Tract
Society, 1852, p. 23.

By midcentury writers on the Midwest praised the purging of Indians as a way of clearing the path for white progress on what had largely become the American continent. A guidebook for Minnesota lured immigrant settlers to a land in which all traces of savagery had been replaced by the evidence of advancing civilization: churches and schools "now stand where stood a few summers since the Indian's wigwam; the steam-cars, that fly across the land swifter than the light-footed Chippewa, the arrow from his bow, or the deer that he hunted—are not all these proofs enough that we are justified in boasting of what we have accomplished?"[42]

More explicitly evangelical statements of this view are not hard to find. A letter printed in 1860 in the *Well-Spring,* a children's newspaper published by the Massachussets Sabbath School Society, put the relations between Indians and whites in the typological terms employed since the Puritans. After describing Indian graves in eastern Iowa, the author commented:

> But God has allowed these savage people to be driven away, as he did the Philistines before the Israelites, because of their sins. He wanted a people to inhabit these beautiful prairies, who would consecrate them to him, and who would build churches and schoolhouses over them. He wanted the voice of love and praise to come up to his ears, instead of the songs of the war-dance, and the yell of the battle cry.[43]

Illustrated by a small cut of an Indian brave (fig. 32), an item in the 1862 *Almanac* declared not only the superiority of white culture but the obligation the United States had toward the foil of its cultural eminence:

> Time was when a savage, half-naked, grasping his weapon of death, and watching for his enemy or his victim, would have been a fair impersonation of man. That time has passed. The savage is now unknown in large sections of the globe, and the dark regions where he still is found are penetrated more and more every year by the light of Christian civilization. It was one object of our forefathers in coming to this country, to enlighten the heathen who then held it in his possession, and make them partakers of the blessings which Christ has furnished in the gospel. . . . The Indian tribes are a special hereditary charge of the United States; and they claim the gospel at our hands, in view not only of the pious designs of our ancestors, but of the cruelty and injustice to which they are often subject.[44]

The United States was not only the savior of the Indian peoples but also their benevolent protector. The engraving was a free adaptation of an oil painting by George Caleb Bingham (1811–1879), *Concealed Enemy* (fig. 33), which was painted in 1845 as a pendant to an image of a French trapper and his half-breed son traveling in a canoe, representing the advance of commerce in the face of primitive Indian savagery (*Fur Traders Descending the Missouri*).[45] Whereas Bingham valorized white progress against a still hostile enemy, the ATS image was meant to evoke the memory of a vanquished foe. Humanity had come of age in the United States, graduated to a level of civilization that was premised on the successfully defeated state of savagery represented by the Indian. The article in the *Almanac* referred to this progression as "the gradual elevation of fallen man, to be perfected only when the gospel has done its work in all the earth." Condescending to the "poor savage" by offering to continue efforts to civilize and convert him secured white hegemony and based it on the evangelical effort promoted, among others, by the ATS.

After the war, with the issue of slavery solved at least as a matter of legal status (and no longer such a threat to dividing Society membership), public attitudes toward the plight of Indians underwent important change. The shift is evident in the illustrations of the *Almanac* from the 1860s to the 1870s. Edward Bookhout engraved an image in the 1863 *Almanac* of the Moravian missionary Christian Henry Rausch teaching salvation by Christ's sacrifice to a docile Indian, Johannes, and an unnamed woman (fig. 34). The article, entitled "What Preaching Will Convert Men?" was narrated by Johannes, an appropriately Germanic name for the Indian converted by a German Pietist. The narrative portrayed Johannes and his fellows as pious and upstanding, while different missionaries came and failed to reach them with their messages: the first missionary argued for the existence of God, which the Indians already believed; the second admonished them not to drink, swear, lie, or lead a wicked life, to which Johannes responded: "Go and learn it first thyself."[46] Only Christian Henry Rausch succeeded by sharing the gospel of salvation by Christ's forgiveness of

Fig. 32 (*top*)
Edward Bookhout, engraver, Indian brave, *Christian Almanac.* New York: American
Tract Society, 1862, p. 31.

Fig. 33 (*bottom*)
George Caleb Bingham, *Concealed Enemy,* oil on canvas, 29 1/4 × 36 1/2 inches, 1845.
Courtesy of the Stark Museum of Art, Orange, Texas.

sins. The discourse stressed the inherent nobility of the Indians and portrayed the encounter with the Moravian missionary as a civil exchange between teacher and disciple. The illustration shows the missionary seated above the two listeners, who are both passively rapt, the woman echoing the gesture of reception in Johannes.

This portrayal of Indian-Anglo relations did not endure as the autonomy of American Indians dwindled to a final and violent end in the last third of the nineteenth century. A comparison of this image of 1863 with one from 1877 demonstrates how quickly the condescending posture toward the noble savage was replaced by a new urgency to eliminate once and for all the inferior, savage culture by conversion to Christianity. A full-page illustration (fig. 35), whose caption repeats the descriptive title of the article, "An Indian Village—Sioux," looks down from the perspective of a subtlely elevated point into an arrangement of what the article stressed were "buffalo skin 'teepees,'" with inhabitants in various states of dress—some wrapped in thick mantles, others in tunics, half-shirts, or apparently naked. The foreground is littered with cooking utensils lying on the ground beside an open hearth; pups are scattered about their mongrel mother. "Not an attractive village by any means," the article opened. "There is no architectural beauty to the dwellings without, and no convenience within." After a detailed description of the construction of teepees and household items within, the article concluded: "These 'teepees' are squalid dwellings, inhabited by squalid people. The 'nobility' of the red man is pretty much a figment of the imagination."

Continuing with this attempt to demythologize a romanticized image of Indian life, the article turned to what was no doubt expected to enrage gentle, no doubt largely female readers: the state of gender relations among Indians.

> The women and dogs are used as beasts of burden in addition to the ponies, for the "braves" must ride forsooth, and if there are not ponies enough left, there are the women to do the work! And work it is, indeed—carrying burdens almost equal to the horses, urging on the stubborn animals, caring for the children, and when the halting-place is reached, setting up the lodges, cooking the food, if there is any, eating what the men leave, and subject, not infrequently, to the most unfeeling abuse.
>
> The Indian needs civilizing beyond a doubt, and Christianizing above all.[47]

The same indignation over the exploitation of women in non-Christian societies animated Tract Society literature on Hindu as well as Islamic mission fields. By linking the primitive other with the mistreatment of women, evangelicals were able to fix the ideological configuration of the boundaries and the heartland. This organization of heartland and frontier is also evident in images of Christian and non-Christian women with children. Compare, for instance, the illustration of a Tract Society publication of 1863, in which a pagan mother unfeelingly commits infanticide (fig. 97), to several images of Christian women nurturing children, to be discussed later in this chapter (figs. 49, 50, and 54).[48] The message in this icono-

Fig. 34 (*top*)
Edward Bookhout, engraver, Indians and Moravian missionary, *Christian Almanac.*
New York: American Tract Society, 1863, p. 31.

Fig. 35 (*bottom*)
"An Indian Village—Sioux," *Christian Almanac.* New York: American Tract Society,
1877, p. 25.

graphical contrast seems to be that only in the bosom of the Christian American home were children and their mothers safe. When they existed outside of that privileged sphere, it was either in a state of barbarism or moral impropriety.

The ATS made no apologies for its zeal. In the annual report for 1872, an article on colportage proclaimed that "Christianity is intolerant of all other forms of belief or unbelief. Its adherents do no rest until the command to propagate their faith is obeyed and the promised victory assured."[49] This militant rhetoric, necessary to galvanize evangelical salespeople such as the army of colporteurs who hawked the Tract Society's products, served equally well in clarifying the mission among the Indians, which may have met resistance among the soft-minded who had been duped by the rhetoric of the noble savage. Anglo-Indian relations became increasingly violent as the gold rush in the Black Hills in the 1870s spread and the government ignored a treaty that placed the region under Lakota control. Sioux and Cheyenne Indians rebelled against the incursions. In the summer of 1876 the conflict grabbed widespread public attention when Custer was ignominiously defeated in the Dakota Territory, news of which broke on July 4, 1876, as Americans celebrated the nation's centennial. The Indian threat became a question of national honor as well as a threat to the millennial vision and manifest destiny of the republic. Matters were no doubt exacerbated for many by the saga, followed in daily papers in 1877, of Chief Joseph and his five bands of Nez Perce who successfully outmaneuvered the U.S. military for 105 days moving across the country.

The shift in the rhetoric of the *Almanac*'s visual and textual representation of Indians was certainly no accident. What is striking about the 1877 illustration of the Indian "village" is its sheer artlessness, its lack of emotion, its elimination of romantic landscape vistas (screened out by teepees and a stretched hide on the far right), and its entirely undramatic presentation of a foreign world—all of which may have been intended as a presumption to documentary description at a point when photographs were becoming the basis for most wood engravings in commercial publications. Within the rhetorical mode of the plain style the homily was exchanged for reportage. But the plain style was no less rhetorical than the embellished. The picture of the Sioux village was designed to strip away the romanticized connotation of the noble savage and to preach by "facts" alone, to forestall any sympathy for the oppression of the Indian by accentuating the need for further intervention, indeed, complete assimilation to "civilization." The facts as most white readers of the *Almanac* understood them were constructed to serve the Tract Society's vision of manifest destiny, to preserve its conception of America's millennial mission by securing a subaltern that would mark both progress over the past and the task remaining in the future before the age of universal peace could be attained.

The West and Roman Catholics

Indians were not alone as the object of the Tract Society's concern for the West. In fact, the much more urgent need stressed in annual reports and

documents on colportage was the newly arriving and vastly expanding population of European immigrants, many of whom were Irish and German Catholics. The extensive immigration beginning in the 1830s and the westward movement of the American populace stimulated the Tract Society's development of colportage, the door-to-door distribution of tracts and books that channeled resources and information back to the national office in New York. The spiritual wants of settlers and immigrants were stressed in the Society's first publication on colportage, *The American Colporteur System* (1836), as was the threat of "popery": "Swarms of Romanist priests will be provided from the Old World."[50] This echoed the rhetoric of *Plea for the West,* a book published in the previous year by Lyman Beecher, who applied to Catholic immigrants the same typological hermeneutic that was unleashed on American Indians: "Clouds like the locusts of Egypt are rising from the hills and plains of Europe, and on the wings of every wind are coming over to settle down upon our fair fields."[51] Beecher was so alarmed at the size of immigration in the 1830s because he noted that many of the immigrants settled in the Mississippi valley, what constituted the "West" in his day. For Beecher and the Tract Society this posed a grave geopolitical threat. "It is . . . plain that the religious and political destiny of our nation is to be decided in the West. There is the territory, and there soon will be the population, the wealth, and the political power."[52]

Having failed to secure the support of New England's Calvinist wealthy at his congregations in Litchfield, Hartford, and Boston, Beecher moved to Cincinnati in 1832 to take up the fight on the frontier for America's fallen moral order. He shifted from the anti-Unitarian front he had sought to establish in Boston to the old Puritan whipping-boy of Catholicism and took to heart the anti-Catholic and nativist ravings of Samuel F. B. Morse, whose accounts of international Catholic conspiracy against American democracy appeared in the press in 1834.[53] Both Beecher and Morse feared that sinister political machinations by demogogues aligned with Catholic clerics and European Catholic rulers might galvanize immigrant voters into a powerful bloc that could be blithely led to undermine the civil liberties and republican institutions of the United States. Morse and Beecher couched their fears in republican rhetoric. Morse, for instance, signed the newspaper installments of his revelations of Catholic conspiracy as "Brutus," the republican opponent of imperial Rome and assassin of Ceasar, the imperial predecessor of the papal regime. When he published his accounts in book form, he titled the volume *Foreign Conspiracies against the Liberties of the United States* (1835). Saving the West from this fate became synonymous with preserving the American experiment in democracy.

Beecher strongly advocated establishing strategic centers of learning throughout the West as crucial to the program of spreading civil and spiritual influence and assimilating immigrants. With such institutions in place, the millennial mission of the nation would be able to continue. "If this work be done, and well done, our country is safe, and the world's hope is secure. The government of force will cease, and that of intelligence and virtue will take its place; and nation after nation, cheered by our example, will follow our footsteps, till the whole earth is free."[54] To this end, Beecher took up a point made by Morse and called for "a governmental

supervision of the subject of immigration, which shall place before the nation, annually, the number and general character of immigrants" in order that the issue might receive thorough public review and that "the voice of the people aid in the application of the remedy."[55] In effect, what Beecher wanted was an annual national referendum on what kind and how many immigrants would be allowed into the country. And after their admittance, Beecher would have in place a regime of requirements that was sure to liberalize and assimiliate immigrants from the despotic domain of European Catholicism. In quick, successive paragraphs that sketched out an international conspiracy of Catholic Europe, which was "throwing swarm upon swarm upon our shores," Beecher bewailed the immigrants' insistence on sending their children to Catholic schools and submitting to the priesthood because such practices resisted the all-important assimiliation to an enlightened republican life.

> If they [Catholic immigrants] associated with republicans, the power of caste would wear away. If they mingled in our schools, the republican atmosphere would impregnate their minds. If they scattered, unassociated, the attrition of circumstances would wear off their predilections and aversions. If they could read the Bible, and might and did, their darkened intellect would brighten, and their bowed down mind would rise. If they dared to think for themselves, the contrast of protestant independence with their thraldom, would awaken the desire of equal privileges, and put an end to an arbitrary clerical dominion over trembling superstitious minds.[56]

Beecher did not shrink from using the language of social control and regulation, particularly in regard to immigration, naturalization, and assimilation. And he returned again and again to the issue of Catholic clerics and the need to "supplant the control of the priesthood" over Catholic laity. But Beecher was convinced that legislation, resolutions, and oratory alone could not achieve the assimilation of immigrants and the security of the West. Only by "well systematized voluntary associations" would the necessary efforts at educating be effectively undertaken.[57] This of course included the Tract Society, and Beecher's concern and rhetoric were enthusiastically shared by the ATS, which elected him an honorary vice-president in 1844. At the 1846 annual meeting a resolution was introduced and passed that "[c]olportage is an important, if not an indispensible instrumentality in gathering the great harvest of the West."[58]

In an address to the ATS in 1843, Beecher praised the introduction of the colporteur system in the West and happily pointed out that one of the most accomplished colporteurs was a German convert from Catholicism. Beecher framed his speech within the apocalyptic terms of "a last great conflict before the dominion under the whole heaven" and revealed a debt to Jonathan Edwards and the Puritan tradition. Edwards had taught that the millennium would begin with the overthrow of the "kingdom of Antichrist," which for Puritanism had always meant papal Rome. Announcing that the two parties in this conflict were now about to be "set over against the other," Beecher demanded that "the enemy must not have the power of the press all on his side."[59] The report on domestic colportage in the

1843 annual report opened with a sweeping preamble on the forces that threatened the salvation of America, chief among which were the "millions" that "swarm forth from the crowded states of the old world." Other threats to "our noble experiment of governing ourselves" were "royal jealousy" and "papal intrigue." The only hope of deliverance was God "and the speedy evangelization of the entire population." The leadership of the ATS expressed even less confidence in legislative measures than did Beecher, saying that any such initiatives were too late to be effective. The ATS looked ahead to an imminent engagement between Catholicism and Calvinism: "the conflict will be a dreadful one,—a war of extermination of principles. If the 'signs of the times' are not mistaken, this country will constitute the theatre of that struggle; and the great Valley of the West, already the scene of such animating interest, may be the Waterloo of truth and error."[60]

The first weapon in the evangelical armament, as the ATS liked to put it, was colportage, which the annual report of 1846 hailed as "an effectual barrier to the progress of Rome." Instructions to and reports from colporteurs in the 1830s through the 1850s included much commentary on the evangelizing of Catholics.[61] By the mid-1840s each annual report listed in a separate column the "number of families of Roman Catholics" visited by colporteurs. The story is clearly told in the steady growth of colporteurs in the field from the late 1830s through the 1850s. After the first year of the initiative (1841), the numbers increased dramatically in most sections of the country, but none greater than in the South and West (see table 1).

By 1858 the number of colporteurs around the country peaked at 613.[62] Whether the immigrants were Catholic, unbelievers, Universalists, or people of a faith other than Christianity, they represented a challenge to the Society that was no less political than religious.

But if Catholic immigrants and Catholics generally were such an object of concern, why don't we find them visually depicted in the publications of the Tract Society along with the many illustrations of drunkards, farmers, mechanics, family devotional scenes, Indians, pioneers, dutiful mothers, and country life? There is not one image of an ethnic Catholic immigrant, worker, settler, craftsman, or family that I have been able to locate. On the rare occasion that Catholics were represented, it was the "Romanist" hierarchy trying a heroic Jan Hus before he was burned at the stake for his proto-Protestant heresy of printing the Bible in the vernacular (fig. 36). The picture that editors of the *Almanac* selected posed Hus before a conciliar gathering of church authorities in a manner that recalls traditional portrayals of Christ as a boy before the learned priests and scribes of the Jewish Temple in Jerusalem. Yet, unlike the Jewish doctors captively listening to Jesus, the Catholic bishops and cardinals listening to Hus are unrepentent and unimpressed as they prepare to condemn to death this precursor of the Reformation, who professes his belief with the familiar visual rhetoric of depictions of Martin Luther, standing erect with a hand placed firmly on the Bible.

The uniqueness of this illustration in Tract Society publications and its strong Protestant bias against the priesthood and hierarchy of Roman Catholicism provides a clue to the absence of any other Catholic iconography. Colportage reports often cited the local Catholic priest as the source

Table 1 Numbers of Tract Society Colporteurs by Section*

	1841	1846	1851	1856	1861
New England	0	3	8	20	7
East**	0	68	96	145	103
West**	1	46	159	155	146
South**	1	59	162	219	175
Total	2	176	425	539	431

*Data are drawn from the following sources: *Twenty-First Annual Report of the American Tract Society* (New York: American Tract Society, 1846), 21, 101–5; *Twenty-Sixth Annual Report* (1851), 92; *Thirty-First Annual Report* (1856), 63; *Thirty-Sixth Annual Report* (1861), 64. Figures listed are for salaried part-time and full-time colporteurs. Not included are student volunteers.
**East: New York, New Jersey, Delaware, and Pennsylvania; West: Ohio, Michigan, Indiana, Wisconsin, Minnesota, Iowa, Illinois, and Missouri; South: Maryland, Virginia, North Carolina, South Carolina, Georgia, Florida, Alabama, Mississippi, Louisiana, Tennessee, Kentucky, Arkansas, and Texas.

of greatest resistance to evangelical inroads, particularly on the distribution and use of Tract Society printed materials.[63] Beecher directed his deepest scorn at the priesthood and papacy as the source of international conspiracy, regarding the laity as manipulated and naive. Furthermore, the evangelical aim was to assimilate European Catholics, that is, to make them like the white, Anglo-Saxon Protestant norm, unlike blacks and Indians, who, when depicted, were consistently contrasted with whites in class, status, and race.[64] The Tract Society may have chosen not to estab-

Fig. 36
"Trial of Jan Hus," *Christian Almanac.* New York: American Tract Society, 1852, p. 17.

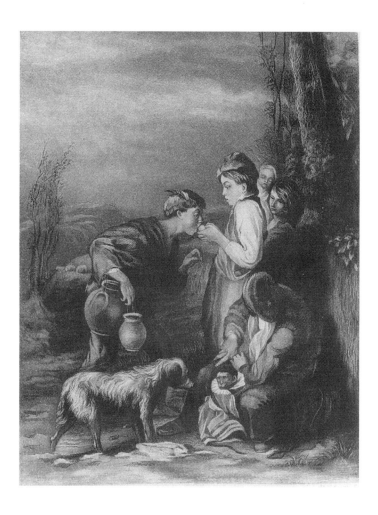

Fig. 37
H. W. Smith, engraver,
after William Mulready,
"Minstrel Emigrants,"
mezzotint, in *The Rose of
Sharon: A Religious
Souvenir,* ed. Mrs. C. M.
Sawyer (Boston: Abel
Tompkins and Sanborn,
Carter & Bazin, 1856),
facing p. 259.

lish a visual type for Catholics because it would have fixed the immigrant's difference in an iconographical taxonomy when the point was to absorb those who were, after all, of proximate or identical racial stock. Nor did the Tract Society want to visualize Catholics as part of the West, for this would have tended to naturalize their otherness as Catholics. Depictions of immigrants in other contemporary publications often did not hesitate to signal ethnic difference. For instance, the "minstrel emigrants" who appeared (fig. 37) in a Christian annual in 1856 represent a family of Italian minstrels whose ethnicity is registered by costume, ceramic water jugs, and the monkey. It might also signify a family of gypsies, but the poem accompanying the illustration stipulated Italian immigrants in search of a new home. By contrast, when ATS publications pictured settlers, there was no indication of race or ethnicity other than a generic Euro-American, Anglo-Saxon type.

Consider, for instance, two images from the *Christian Almanac* in the early 1850s (figs. 38 and 39). The first, by the popular illustrator Felix Octavius Darley (1822–1888), illustrates the current state of emigration to the West; the second the rustic homelife in the western country.[65] In each case the *Almanac* offers images of ideal family life: a mother tending children,

a protective father with the tools of his active life in hand, and the faithful family dog. It may be, therefore, that the Tract Society determined not to represent the Catholic laity in order to avoid making them either the object of contempt or special attention. Rather than singling them out for visual treatment and remembrance, the Tract Society let Catholic immigrants remain invisible in the hope that they would merge completely with the dominant culture of their new country, that they would be "seen" only as the object of systematic benevolence and evangelical labor as recorded in annual reports and narrated in the conversion stories of various tracts. Of the fifteen tracts devoted to or dealing with Roman Catholicism (such as narrating a conversion), only a few were illustrated, and only one or two of these included explicit visual references to Catholicism. Tract number 522, *Mary of Toulouse,* carried an illustration of a Catholic servant, Mary, joyfully listening to a Protestant lodger, to whom she had given her rosary after discovering its inefficacy and turned to Protestantism for conversion (fig. 40). The rosary is pictured on the table between them as a discarded symbol of difference, a marker of futile Catholic superstition. Without the rosary, in the Tract Society's ideological scheme of representation Mary is no longer identifiably Catholic.[66]

Fig. 38
Felix Octavius Darley, draughtsman, J. H. Hall, engraver, "Emigration in the United States," *Christian Almanac.* New York: American Tract Society, 1850, p. 37.

EMIGRATION IN THE UNITED STATES.—The great West is the field for emigration, both from foreign lands and from the eastern parts of our own. In 1848,

Fig. 39
John William Orr,
engraver, "Home in the
West," *Christian
Almanac.* New York:
American Tract Society,
1854, p. 31.

Anti-Catholic iconography was readily available had the ATS chosen to deploy it. Engravings, etchings, and lithographs of Catholic nuns killing infants or tending children begotten from illicit unions with priests, priests burning books, and the Pope flying on an Austrian imperial eagle with a long train of immigrants, clerics, and religious in tow were published in the hosts of anti-Catholic books and newspapers.[67] Two images from nativist author William Hogan's *Auricular Confession and Popish Nunneries* (1845) illustrate two of the most lurid preoccupations of anti-Catholic literature and visual culture (figs. 41 and 42). A young girl submits innocently to the wiles of a perverse confessor (fig. 41); an abbess murders an infant (born of a nun) who has been baptized by a priest (fig. 42). Hogan, who claimed to be a former Catholic priest, contended that he wrote with authority and knowledge based on countless confessions. According to Hogan, such infanticide was "common in nunneries throughout this country." Possibly inspired by similar episodes in the sensational *Awful Disclo-sures of the Hotel Dieu Nunnery of Montreal* (1836) by Maria Monk, each instance in Hogan's narrative tells of weak and innocent people who were exploited by the deceitful and heartless cleric and abbess, those who belonged to the caste that Hogan, Morse, and Beecher argued was

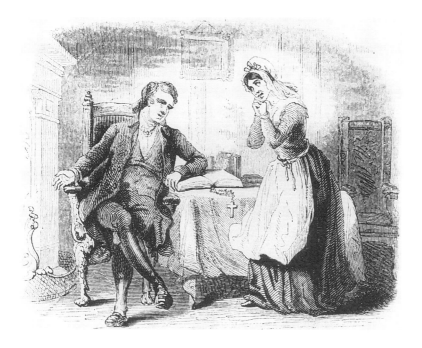

carrying out the masterplan of the papacy and despotic rulers of Catholic Europe.[68]

Yet as virulently anti-Catholic as he was, Beecher, unlike Morse and Hogan, was not a nativist politically. Neither did the ATS align itself politically with the Know-Nothing party during its brief career in the 1850s. The ATS stopped short of such political mobilization since it believed that legislation would be ineffective. More important, the "great conflict" was to be waged evangelically rather than politically. The best strategy was to convert the immigrants to Protestantism. And evangelical assimilation would have been severely compromised by racist or ethnocentric iconography or the alarmist, sensationalist imagery of Hogan's publications. Circulation of such images in Tract Society literature would have accomplished little more than to secure a split between Catholic and Protestant, a possibility the Society regarded as terribly dangerous. Whereas nativists such as Morse, Hogan, Samuel Smith, and William Morgan spewed their conspiratorial theories and ridiculous allegations in order to galvanize Protestants into political opposition and the formation of a nativist political party, the Tract Society wanted to bring Catholics into the evangelical fold, to Americanize them rather than contain or exclude them.[69]

But this should not suggest that images played no role in the Tract Society's endeavor to convert and assimilate Catholics. In fact, there is a distinctive iconography deployed in ATS publications that addressed Protestant-Catholic relations from an unabashedly Protestant perspective. Although in most instances the Society's substantial anti-Catholic literature was not illustrated, when it was, as in the case of *Spirit of Popery*, published by the Society in 1840 (see fig. 43), or the example in the *Almanac* (fig. 36), the images tended to portray Catholicism in the days of the Reforma-

Fig. 40
Robert Roberts, engraver (?), *Mary of Toulouse,* no. 522, *Tracts of the American Tract Society,* General Series (New York: American Tract Society, [1849]), 12:1.

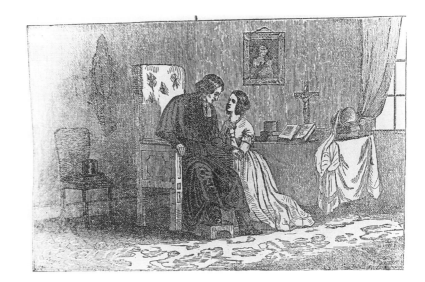

Fig. 41
"A Young Lady
Confessing to the
Priest," in William
Hogan, *Auricular
Confession and Popish
Nunneries* (Hartford:
Andrus & Son, 1845),
vol. 1, facing p. 254.

Fig. 42
"Mother Abbess
Strangling the Infant,"
in William Hogan,
*Auricular Confession and
Popish Nunneries*
(Hartford: Andrus &
Son, 1845), vol. 1, facing
p. 284.

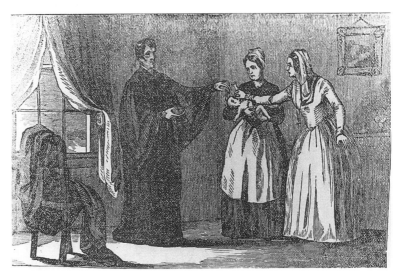

tion, seen through the filter of triumphant Protestant "history." Since colporteurs used the *Spirit of Popery* as a tool to convert Roman Catholics, the strategy was clearly not to offend or marginalize but to persuade by an interpretation of history that regarded the Reformation as a righteous correction of errors. The intent was consistently to stress the Catholic hierarchy's historical opposition to Protestant truth and the Roman priesthood's preoccupation with "idolatrous" display and "popish" ritual. Catholic laity rarely appear, and when they do, one knows they are Catholic only by textual reference, not by iconography.[70] The visual focus was almost exclusively on the hierarchy and the religious orders, which constituted the agents of Romanism in anti-Catholic literature, in contrast to the passive laity, who feared priestly authority and did what they were told.[71]

When illustrations did portray contemporary practice, such as confession (see fig. 44), the images were not designed to imply scandal or clerical perversion. Instead, illustrations such as the wood engravings by Benson J. Lossing (1813–1891) for *Spirit of Popery* aimed at evoking the strangeness of the rites.[72] It was left to the accompanying text to convince the reader of the theological error of the beliefs practiced by Catholics. The rites themselves were seen as empty and without efficacy, not because they were the tools of a devious priesthood but because they had no biblical foundation. Catholicism was regarded as a deviation from primitive Christianity and Protestantism as a return of the church to that source. The ATS did not undertake a smear campaign against Catholicism but sought to refute it on an evangelical Protestant understanding of biblical grounds. Thus the imagery deployed by the Society was selected for its ability to persuade viewers of Catholicism's old-world mentality, its extra-biblical authority, and its empty pomp and circumstance. The aim was to correct error and to disabuse Catholic laity of their illusions by bringing them to see the doctrinal rectitude and biblical fidelity of evangelical Protestantism. Lossing's cuts, therefore, were presented as visual documentation of Catholic practices that departed from evangelical truth. In addition to the historical events of the sale of indulgences and the submission of Philip IV to the Pope, *Spirit of Popery* included illustrations of

Fig. 43
"Sale of Indulgences,"
frontispiece of *Spirit of Popery* (New York: American Tract Society, 1840).

Fig. 44
"The Confessional," in
Spirit of Popery (New
York: American Tract
Society, 1840), facing
p. 156.

the following subjects: the feast day of St. Anthony, the confessional (fig. 44), the adoration of the sacramental host, homage to Mary, liturgical processions, the consecration of a bell, prayer for the dead, and mass for the dead. Each of these was discussed in the text as a point of error in Catholic belief and was intended not only for curious Protestants but for Catholic immigrants since the Tract Society used the book as a tool for conversion.[73]

Tract Society colporteur reports never tired of relating incidents of Catholic priests who denied the laity permission to read the Bible and the Tract Society's products. The evangelical response, of course, was to distribute such materials as deprived Catholics required to realize the truth that had been kept from them. The *Christian Almanac* published several images of pious people reading the Bible or tracts. An engraving of Luther, Melanchthon, and other northern European reformers (fig. 45) that appeared in the 1856 *Almanac* shows the company poring over texts and comparing notes as they translate the Bible into the vernacular. A caption that accompanies the image states: "When Christians began to read the Bible in their families, practical Christianity itself underwent a palpable change. The effect was seen in changed habits, improved morals, other conversations, in short, in a new life."[74] ATS publications such as the *Christian Almanac* frequently included images of a missionary reading or preaching

with a Bible in hand or a domestic scene in which a pious family is gathered about the hearth listening to the paterfamilias read from scripture. Tracts and colportage reports often focused on conversion accounts that pivoted on a Catholic person reading a Bible or tract. By 1859, the ATS had produced at least fifteen tracts dealing with Roman Catholicism, most of which were conversion narratives; these were preceded by over one hundred tracts in German produced by 1836 for immigrants, many of whom were Catholic.[75]

ATS annual reports in the early 1840s pitted Catholic image against Protestant text in the battle for literacy and assimilation. An account by a Baptist clergyman who distributed "5000 pages of Tracts" and "a supply of Bibles" among French, Swiss, and German Catholic immigrants related how a German man was seized by penitent fervor at an evangelical meeting, arose after weeping and praying, then "took from his pocket an image of the Virgin Mary, went to the stove, opened the door, held up the image to the congregation, saying 'This just good to make ashes for potash,' and thrust it into the fire. He then turned around and said, 'My Jesus is enough for me. Oh! poor Catholic!'"[76] A student at Lane Seminary, Beecher's institution, spent his summer vacation in 1843 visiting German families in Cincinnati as a colporteur for the ATS. He reported that he "met a Romanist who was engaged in selling the images of saints who was "somewhat alarmed when told that my stock consisted of Protestant books." But the two salesmen reached an agreement to exchange one of the Catholic's "'Saints' for a 'Saints' Rest'" by the seventeenth-century Puritan Richard Baxter. "And before the saint-pedlar left the ground he bought out the colporteur, taking twelve volumes, including two Testaments, side by side with his saints to the families of Romanists."[77] Even if the Catholic sales-

Fig. 45
"Luther, Melanchton, Pomeranus, and Cruciger Translating the Bible," *Christian Almanac*. New York: American Tract Society, 1856, p. 23.

man's motives had been strictly commercial—selling evangelical literature in a largely Protestant market could only have been good business, after all—the message of the anecdote to evangelical Protestants (and to Catholics) was that the printed word and literacy were displacing the idolatrous image and intrusive Romanism in the steady march of evangelical assimilation.

The Reformation's production of vernacular texts was interpreted by American evangelicals as holding important political implications. The text illustrated by the image of Luther and company (fig. 45) concluded with this observation on the publication of vernacular Bibles: "With the publication of the New Testament, so that all could read it, it seemed as if the Reformation passed from the seats of learning and took its proper place at the hearths and in the hearts of the people."[78] An image and its legend in the 1852 *Christian Almanac* (fig. 46) made the same point with even greater emphasis on egalitarianism:

Fig. 46
"Reading the Bible to the People," *Christian Almanac.* New York: American Tract Society, 1852, p. 21.

In the early part of the Reformation in England, the Bible was placed in churches, commonly chained to the desk, for the use of the common people; and many frequently assembled in the churches to hear it from those who could read. The cut represents a group of listeners gathered about one who is reading to them from the Book of God.[79]

The man reading the Bible is neither cleric nor intellectual but himself of "the people." Such an image struck at the privileged position of the Catholic priest and fed the Protestant belief that the priesthood, not the laity, was responsible for Catholic intransigence. Such images as these two (figs. 45 and 46), however, were also directed to American Catholics who received the *Almanac* and other illustrated publications from Tract Society colporteurs and agents, who understood themselves to be carrying out the mandate of the Reformation in distributing Bibles and tracts directly to "the people."

Discussion thus far reveals that the Tract Society pursued three complementary visual strategies in its treatment of principal American racial and ethnic "others." African-American slaves remained invisible or, when visualized, were seen as subordinate to whites and piously engaged in self-denial and the deferral of emancipation to the afterlife. Rather than address slavery, the ATS leadership sought to deflect attention to Catholic immigrants. In the heat of western expansion and before the revolts of Plains tribes beginning in the 1860s, Native Americans were relegated to the past as visual emblems of the nation's ascent—seen either as haunting the paths of colonial pioneers or as ghosts of a primitive, savage culture that once roamed the Plains before the West was settled by whites. By the 1870s, however, Indians were portrayed as living in squalor, husbands neglecting their wives, and children running about naked. By delineating the fringes of American society, the ATS hoped not only to conceal them beneath the wake of progress but to surround the heartland of the nation with expanding boundaries. It is to the visual representation of this heartland that I now turn.

The Domestic Scene and the Audience of the *Christian Almanac*

The house that antebellum Protestantism built rested in part on the removal of antecendents and rivals. But the house also stood on a foundation of affinities and affirmations. The means of representing (or not representing) what lay without the evangelical fold were interlocked with another set of frequently used images that turned inward to configure the domestic structure of evangelical life, that is, the world *within* the field of "civilization," the world as it ought and was providentially intended to be, the world of familar, affirming relations. Whereas the first set of images visualized what may be called the structure of difference—the difference between national white Protestant culture and the black slave, the Indian subaltern, and the Roman Catholic foreigner—the second set of images illustrated the structure of familarity inside the citadel of the dominant culture. The latter were largely images of the home, the family, and children. These images were charged with a special class consciousness and offer important evidence of the crusade to which the ATS was committed.

From the 1950s until the 1970s, interpretation of antebellum benevolent associations was dominated by the social control thesis, which argued that the real aim of benevolence was not to ameliorate the conditions of the destitute and illiterate or to save souls from eternal hellfire but to control

an unruly populace at a moment of chaos in the early republic. Clearly, there is an important element of truth in this account. But revisionist work by Donald Mathews and Lois Banner threw such a monolithic approach into doubt, resulting in a much more nuanced understanding of voluntary organizations and the Second Great Awakening.[80] The result suggested that the task the ATS and other benevolent organizations set for themselves was not simply to impose rigid control over the laboring classes and the destitute in creating a social order that would resist the threat of entropy and the dissolution of the moral restraint that was considered necessary for the success of republican government. As Lois Banner pointed out, many were no doubt moved by Christian compassion to assist the indigent and underprivileged.

Yet that compassion was not ahistorical or noninstitutional or separated from the social realities of class, status, race, and gender. It is quite clear that one consequence of the compassion, sympathy, proselytism, and mobilization of Christian volunteers around the country was the formation of the middle class. In identifying as other those for whom they expressed sympathy or disdain, Protestants organized themselves into a middling class that was characterized neither by the conspicuous display of wealth nor by the very behaviors they sought to correct: drunkenness, unbelief, illiteracy, or sloth. Walter Licht has seen the unrest among the laboring classes caused by industrialization as an important factor in moving the middle class "to mark themselves apart" by undertaking such efforts as benevolent associations.[81] He is surely correct. The threat was perceived as quite real. Benevolent associations did not merely use republican rhetoric about the American experiment at self-government as an ideological screen to render covert an ulterior motive of social control. In fact, they were quite open about the need for greater social order and the practice of the benevolent virtue of self-denial in an age of burgeoning individualism and materialism. With disestablishment, the extinction of the Federalist party, the rise of Jacksonian egalitarianism, the entreprenurial spirit, unprecedented immigration, migration to the West, and the spectacular emergence of non-Calvinist evangelical sects, on the one hand, and liberal Protestantism on the other, New England evangelicals sincerely (and rightly) believed that their world was in jeopardy. Accordingly, they sought to secure their world's foundations by means of revival, moral reform, proselytism, and the assimilation of non-Protestant populations.

Seen in this light, the mass-produced images of the benevolent associations put into practice the will to influence not only the "other" but one's own tribe. The object of the middle class's effort was as much itself as the immigrant, the urban worker, and the poor. As Licht puts it, "The organization of middle- and upper-class community members should be understood as an effort at self-definition as well as social control."[82] Indeed, the two are one in the same. Thus every effort at influence was directed inwardly as well as outwardly. Accordingly, the visual rhetoric of *Almanac* illustrations during the 1850s and 1860s evinces the deep concern to establish the family as the center of order necessary to endure the buffeting wrought by the new political and social conditions. The images assumed both the plain and the embellished styles. Illustrations increased in size in the late 1850s to half-page format and to full-page by the mid-1860s. They

were often set on end in order to fit the page instead of being produced at a smaller scale. A great number of images in these decades depicted children in the home—with family members, at play, or accompanied by pets or animals. Children had been portrayed in the *Almanac*'s programmatic style since the 1820s, but now the strong tendency was to see children less as the victims of errant, drunkard fathers and more as the source of paternal delight and the object of nurture. Certainly this was part of a new sensibility deposited in and disseminated by literature on domestic order and the family altar.[83] The principal concern of the Christian life was understood to consist of raising God-fearing children and striving to preserve their innocence, which, in its simplicity, served as the model for evangelical adult life and the quest for a childlike faith. Discussing the need to rear children in a loving manner, one author asked: "Can our Edens be guarded too religiously?"[84] Another writer praised the innocent love of two children pictured embracing on the steps of their home as they awaited the return of their parents (fig. 47): "Oh, that we could all become as little children!"[85]

The subject of nurture will occupy our attention in chapters 8 and 9 in regard to the role of images in the religious education of children. My purpose here is to understand domestic images in the *Almanac* within the larger ideological configuration of gender and class and to reconstruct how the images functioned in relation to the texts that accompanied them. Encoded in many images of children and family life in the *Almanac* were basic components of the social architecture that evangelicals prized as the heart of their world. These images were often linked to short narratives penned by the New Hampshire writer Helen Cross Knight (1814–1906), who contributed extensively to the *Child's Paper* in the 1850s, edited the *Almanac* during the Civil War, and was the author of many of the *Almanac*'s edifying and didactic narratives.[86] At least some of the images are signed and indicate that they may have been specially produced for the purpose of the story. It is also possible that writers such as Knight adapted stories to the imagery provided them by Tract Society engravers. This certainly occurs in the *Child's Paper* and other publications for children, as I will show in chapter 6.

Knight's prominent role in authoring and editing religious publications paralleled the heightened presence of women in the middle-class literary world, particularly in producing a great deal of poetry, nonfiction, tracts, and short stories aimed at a female audience. The rise of women editors, writers, reformers, educators, and organizers attended the continental shift in antebellum American society from a production-based economy to one premised on consumption. Advice literature, clergy, and bourgeois moralists, rather than promoting cottage industry or employment at the mill or factory, encouraged women of all stations to confine themselves to the business of homelife. For middle-class women in particular this was accompanied by new patterns of consumption: the purchase of goods made outside the home. Catherine Beecher and a host of other writers provided a literature to guide women in consumption-based homemaking.[87]

The religious ideology of domestic nurture among Protestants offered the new focus of homelife for women: childrearing. The literature that

Fig. 47
"Louis and Louise," *Christian
Almanac.* New York: American
Tract Society, 1874, p. 23.

Knight produced and the imagery that illustrated it delivered this message
of gender and class as part of a religious vocation for women. The rela-
tionship between imagery and text exploited the embellished style de-
veloped in Tract Society publications during the 1840s and merits close
attention as a subtle ideological device in middle-class efforts at self-
formation.

A close tie between illustration and fictional narrative signaled a novel
approach in the *Almanac* in the 1850s and 1860s in the use of the embel-
lished style. The relation between image and text was interactive. Whereas
programmatic imagery delivered its sermon in a one-to-one correspon-
dence with a text, where text and image exhausted one another's
significance, leaving nothing to imagine or fill in, the embellished style of
illustration invited a relationship with the text that was mutually con-
structive, one that relied on the viewer's imagination for completion.
According to one compelling thesis, this projective operation of the imag-
ination, which is fundamental for the success of modern consumerism, fu-
eled as it is by fantasy, was the contribution of romanticism. And roman-
ticism, the argument goes, was the cultural offspring of Protestantism's
affective strains.[88]

Of no less relevance for our focus on women writers and their illus-
trated publications is the fact that in the practices of the romantic imagi-
nation women played a special role as producers and consumers. By sub-
jectivizing faith, rooting it in the interior life of feeling, Pietism and
Arminianism, according to sociologist Colin Campbell, developed the
imagination as a vehicle of religious experience.[89] It was to this mode of

imagination that the embellished style appealed in generating a surplus of meaning in the gap left between text and image. In the case of short fiction in the *Christian Almanac* in the mid–nineteenth century, not only did the narrative fail to exhaust the meaning of the image, the image often amplified the significance of the story by visualizing aspects of it that were less prominent. It may be that this higher degree of allusion was directed to a female readership; twentieth-century advertisers have found that women consumers are much more interested in metaphor and allusion in advertising than are men.[90] In any case, a good example of an interactive relation between image and text involves a subject of domestic ideology.

A story by Knight called "A Call on the Bride," which appeared in the *Almanac* of 1862, was illustrated by an image of a young woman seated at the feet of an older woman, dressed as a formal visitor (fig. 48). The younger woman appears to display an article of clothing. One surmises a certain relation of social inequality, the greater prestige accruing to the older female, whose stern face we see gazing down at the item shown her. The younger woman's face is largely concealed, another mark of inferiority. Upon reading the story, we learn precisely what the relationship is between the two, but not without several re-starts. The story begins with comments that one might first wish to attribute to a conversation between the two pictured in the illustration: "Our young friend married. What sort of a wife has Harry? Ah. that's the question. His future depends on it. His Christian usefulness, his success in business, his true enjoyment of life, are all pending upon what sort of a wife he has."[91] But the potential dialogue

Fig. 48
"A Call on the Bride,"
Christian Almanac. New
York: American Tract
Society, 1862,
p. 27.

turns into a monologue on domestic happiness, a lengthy disquisition that would not have been the likely subject of conversation between the two pictured women. "A woman's temper and economies are the woof in that delicate fabric, domestic happiness, subject to such strains, liable to so many stains, so brittle and yet so tough, so pliant and yet so firm."

The young woman is accompanied by the "I" of the narrative, to an upstairs room to see some of her domestic work. When they arrive, the guest is invited to sit in the husband's chair, the "cosy rocking chair," which exceeds in stature the wife's own chair, undescribed in the story but shown in the illustration to be a trunk or mere cushion. Contrary to the presumptuous guest's expectations, the young woman presents not mere trifles of needlework but the industrious work of overhauling her husband's finest clothing. "A bride lining her husband's coat in *these* days! I was completely reassured Harry will get along."

The embellished style engaged the reader/viewer in an act of imaginative interpretation that involved negotiating meaning with the codes of conduct and social status, particularly as regards gender and class. Such interpretive acts may have been more instructive because the reader was constantly thrown back upon the image in the attempt to decipher its features, to rectify the coded relationship between image and text. Because the images that illustrated the moralizing fiction of Helen Knight and others in the *Almanac* consisted of family and domestic life in one form or another, the lessons were always an education in the geography of social relations as centered in the middle-class Protestant family.

In the case of Knight's illustrated story, we learn that the wife of an evangelical man is his foundation and that the measure of her worth is determined in the domestic duties she performs. Moreover, all this unfolds within the consciousness of an older woman who visits the young wife in order to ascertain her value for her new husband's welfare. Mothers and wives were carefully monitored and guided by Tract Society literature because of the power or influence they exerted over families and husbands. One tract, authored by Nathan Beman of Troy, New York, and entitled *Female Influence and Obligations* (1829), asserted that "the extent of Female influence in our world . . . is beyond computation immense."[92] Mothers shape the very character and soul of their infants, impressing "their own image upon their children." Indeed, their potential influence was considered so great that if all women were

> such Christians as they ought to be, a hope might be cherished that the world would soon be converted. The next generation might live in a new earth, and, as a part of their employment, celebrate the final victories of the cross. . . . If the whole female world were to revere the Sabbath, and were found in the house of God on this sacred day, what a happy revolution would soon be effected! The kingdom of God would come. The blessed reign of Christ would be established in earth.[93]

Situating women in the domestic sphere, in other words, was a central part of the ATS's millennial hope. This was addressed in the form of several illustrated tracts, books, and articles, where women were typically shown engaged in their chief domestic duty of teaching and caring for chil-

Fig. 49
Robert Roberts,
engraver (?), Mother and
child, in *Letters on
Christian Education. By a
Mother*, no. 197, *Tracts of
the American Tract Society*
(New York: American
Tract Society, [1849]), 6:1.

Fig. 50
Alexander Anderson,
engraver, Women and
children, in *Female
Influences and
Obligations*, no. 226,
*Publications of the
American Tract Society*
(New York: American
Tract Society, [1842],
7:389.

dren. The illustration of a tract entitled *Letters on Christian Education. By a Mother*, shows a mother clutching her infant so tightly that her own identity seems to merge with the child's (fig. 49). It is as if the mother is infusing character and religious knowledge directly into her child's mind as the two of them look at the Bible on the table. The influence of women was direct only in the context of the family or the Sunday school classroom. "Her dominion," Beman said of "woman," "is the fireside and family circle," and he went on to address women readers directly; "it is not your province to fill the chair of state, to plan in the cabinet, or to execute in the field."[94]

The public effect of female influence was only properly to work indirectly, that is, through the medium of the men in women's families: "with their husbands and sons, with their brothers and other family connections." This position was not in itself necessarily retarditaire in its day; it accorded with the deferential political role assigned to women by what Linda Kerber has called the ideology of the Republican Mother during the late eighteenth century. It was also the view taken by Catharine Beecher, who anxiously sought to balance "women's sphere" with an increasingly progressive yearning to empower women with a national mission in American life.[95] Yet conservative antebellum evangelicals like Beman stressed the importance of a woman's influence in a peculiarly negative way. Women, he said, were to assert social influence by withdrawing from public scenes that evangelicals considered morally objectionable, such as "the amusements of the theatre" and "the ball-room," which would surely vanish "if no female would appear on the stage" and "if every female were to set her face against them."[96] In other words, these vices were the fault of women, who apparently brought out the worst in men. The influence women exerted needed to be carefully restrained by a battery of obligations.

Women were inclined by constitution to perform two public roles: care for the sick, needy, and afflicted in the business of Christian benevolence and instructional work such as teaching the young the sacred truths of the Bible. "You are the very persons," Beman assured his female readers, "to collect the little female wanderers into Sabbath School," a passage that may have inspired Alexander Anderson to create the illustration for this tract (fig. 50), though the image includes both male and female children. Image and text in this case portray an anxious concern to gather up those who have strayed from the home into the unsafe and open domain of the streets and to usher them into the secure enclosure of the "Sabbath School." In their public role as healers and teacher / philanthropists, women could draw from their innate capacity for sympathy, for they "easily enter into the interests and sorrows of others." As Barbara Welter has pointed out, religion was highly acclaimed by the conservative arbiters of antebellum taste precisely because it did not take a woman away from her "proper sphere," the home. While this ignores the public roles of benevolent work, including the formation of women's auxiliaries in tract and temperance societies, the very idea of a "ladies' auxiliary" kept women separate from the administration and operation of such national organizations as the ATS, which remained overwhelmingly male domains.[97] For evangelicals like Beman, benevolent work such as Sunday school teaching duplicated the woman's role in the home and therefore did not threaten to undermine the ideology of antebellum evangelicals, which was premised on the containment of women within the sacred space of the home or the wider domestic sphere of benevolent work outside of the home.[98]

When addressing old themes such as intemperance, however, illustrations in the *Almanac* after midcentury often reverted to the hortatory style of earlier years. Yet illustrations still offered a map of the social world as the Christian middle class conceived it. The interior structure of American life as the ATS portrayed it was centered in the domestic stability and re-

spectability of the middle class. All social problems were understood as a willful deviation from the prevailing order of the bourgeois family. For instance, although alcoholism was a problem in all social strata, it was characterized in the *Almanac* as one of the distinctions between the lower and the middle classes. Two images engraved by Edward Bookhout for the 1854 *Almanac* were attended by captions that described the conditions of a drunkard's life and his life after he quit drinking (figs. 51 and 52). According to the images and their texts, the malady of alcoholism manifests itself principally in the home and is made recognizable by poverty and destitution. The drunkard "is his wife's woe, his children's sorrow, his neighbor's scoff, his own shame. His is a tub of swill, a spirit of sleep, a picture of a beast, and a monster of a man." The caption under the image of "Total Abstinence" revealed the secret to upward mobility:

> Whenever an artisan resident in one of the filthy places leaves off strong drink, the usual course of proceeding is this: He begins to pay his debts; he purchases decent clothing for himself and family; he makes his habitation clean, and provides good furniture; he buys a few books, takes his family to worship; and if not content with being clean and decent among surrounding dirt and wretchedness, he looks for a better residence in some airy and salubrious locality, leaving his unimprovable residence to be occupied by one like his former self, who prefers drinking, smoking, and gambling, to the comfort and decencies of domestic life.[99]

Following this caption were several brief items that rehearsed facts about the social impact of alcohol abuse. An item entitled "Intemperance" stated that only a tiny fraction of the forty-three thousand persons remanded to the prison of New York City could not trace the cause of their imprisonment to drink. "Well may the tax-payer and all the friends of humanity cry out for thorough temperance reform."[100] Ensconced within this rhetoric of factuality, the plain style of the *Almanac*'s homiletic cum reportorial manner, the illustrations combined with the captions to place the blame for poverty on the working classes who favored intemperance and to contrast them to the taxpayers who had to subsidize their error with the cost of prisons.

The "before" and "after" juxtaposition of the illustrations clearly attempted to distinguish between the classes on the basis of the will to drink, to ruin oneself. Poverty was brought on by willful behavior just as elevation to the bliss of bourgeois domestic comfort (the family in the second picture is hardly "artisan" any longer) was the result of a will to decency. The poor, in other words, had only themselves to blame for their poverty and degradation. The cause of misery was not part of an economic system or the social institutions that separated the haves from the have-nots but was the immodest and irresponsible indulgence of individuals. In other words, as one ASSU author succinctly put it, "[t]he evils of society have a moral origin: bred in the individual, they corrupt the mass."[101] For most moral reformers in the nineteenth century, at least those before the Civil War, the problem was seen not as systemic in nature, but as originating with the individual. This was clearly the purview of the Reformed

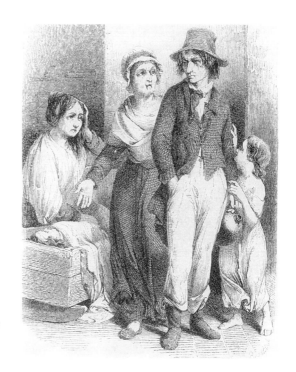

Fig. 51
Edward Bookhout,
engraver, "The
Drunkard's Home, or
Misery and its Cause,"
Christian Almanac. New
York: American Tract
Society, 1854, p. 24.

Fig. 52
Edward Bookhout,
engraver, "Total
Abstinence, and its
Blessed Result,"
Christian Almanac. New
York: American Tract
Society, 1854, p. 25.

tradition. In his address to the 1855 annual meeting of the Society, New York Presbyterian pastor Asa Smith attacked any deviation from the traditional Calvinist emphasis on individual responsibility for sin:

> That old Edwardsean individualism which puts every man alone before his conscience and his God, is in danger of being displaced by a theory or a feeling which weakens the sense of individual responsibility, and substitutes for it a reliance on general laws and forces, on organic vitalities, on corporate potencies.[102]

This was consistent with both the traditional Calvinist notion of sin as inherent human depravity and with the "New School" Calvinism of Lyman Beecher, Nathaniel Taylor, William Nevins, and others in the Yale orbit who taught that each person had the free will to choose redemption in Christ or to pursue the path of perdition. In either case, responsibility for one's alienation from God lay not with God but with the individual.[103]

The new role of personal agency was developed by theologians and ministers who were committed both to moral reform and benevolence. Such benevolent activities as tract distribution and revival of religion helped fuel the Second Great Awakening, where choice was promoted as an ingredient in conversion as well as personal commitment to the evangelical life. While this new dimension of free agency empowered human beings and fostered the "personal" relationship with Jesus that characterized evangelicalism, the freedom of choice came with dreadful consequences since the fallen could only attribute their misfortune to the bad choices they made. This point was soberly driven home in an illustrated article in the *Almanac* of 1864 in which a drunkard stands between his wife and child on one side and a fellow drunk on the other (fig. 53). "Why will you go with those vile men, who only want to ruin you?" his wife remonstrated, to which the husband replied, "I can't help it." The article then took up the issue of choice.

> "Is his fate sealed? Has he lost the inalienable right of free-agency? Has he lost the power of choosing? Alas, he has chosen. The choice between good and evil, between principle and appetite, between restraint and indulgence, took place perhaps years before. . . . By natural laws his fate is sealed. . . . This is the peril of every self-indulgence."[104]

If alcoholism was the salient feature of poverty, the distinguishing malady of the wealthy and professional classes, by contrast, was infidelism. No fewer than thirty tracts issued before 1859 addressed this topic and situated it most frequently in the life of a lawyer, physician, bank clerk, author, intellectual, military officer, or affluent person. Understood as disbelief rooted in philosphical skepticism and associated most often with such writers as Paine, Hume, and Voltaire, infidelism afflicted the learned and the wealthy who resisted evangelical conversion—until they faced death and the horrors of damnation, at which point they would often submit their wills to God in remorse.[105] The Tract Society's depiction of the classes at midcentury reflects a distinctly middle-class perspective and represents the attempt to structure human society around that class. This is evident from

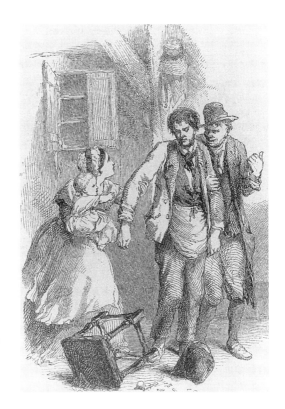

Fig. 53
J. G.; Elias J. Whitney (?),
engraver, "Influences
Good and Bad," *Christian
Almanac.* New York:
American Tract Society,
1864, p. 23.

the engraving by Benjamin Childs that was used on the cover of the
Almanac in 1851 and 1852 (fig. 54). A family sits in a domestic interior,
configuring the hierarchy of the ideal bourgeois family: father seated high-
est, reading the Tract Society's weekly paper, the *American Messenger;* the
father's mother or mother-in-law is seated in the next grandest fashion,
playing with her grandchildren, while their mother looks on. Behind the
family a manservant, who appears to be drawn as a primitive physical type,
enters with refreshments. The cover salutes not opulent wealth or promi-
nence in public life but bourgeois comfort and order in the neatly contained
structure of family life. The same point is made about class even more ob-
viously in the engraving by Alexander Anderson used for the cover of the
Society's *Address of the Executive Committee,* the first in its series of tracts (see
fig. 13). Similar images illustrated the *American Tract Magazine.*[106]

Of the 611 tracts published by 1859, more than two-thirds (411) may be
organized into three broad subject categories: invocation to conversion;
religious doctrines; and social and moral order. The first consists of mixed
genres comprising what the 1859 list and description of the tracts called
"invitation and entreaty" and "alarm and warning." In this class we find
narratives of repentance and conversion, sermons, visions of divine judg-
ment, deathbed scenes, and the accounts of the wages of sin. The second
category, religious doctrines, consists of tracts on the authority and status
of the Bible, the divinity of Christ, and such fundamental teachings as re-
demption and the trinity—all shaped by mainstream evangelical Protes-
tantism. The final category, social and moral order, includes tracts on the

"humble life"—primarily narratives of the faith of the indigent, slaves, servants, farmers, and laborers—and on infidelism, profanity, intemperance, sabbath worship, Roman Catholicism, parenting and the education of children, and unsuitable entertainment such as dance, theatre, gambling, and novels. The proportions of tracts in these categories break down as follows: "alarm and warning," 65; "invitation and entreaty," 63; "humble life," 52; "salvation by Christ alone," 48; infidelism, 30; biblical doctrine, 29; intemperance, 25; sabbath worship, 20; non-Anglo-Saxon conversion narratives or faith testaments, 17; "popery," 15; immoral entertainment, 13. The tracts addressing social order strongly tended to structure American society on three levels: the lower class, composed of indigents, slaves, servants, the intemperant, and laborers; the middle class, composed of evangelical businessmen, clergy, and those who practiced religious benevolence; and the professional classes, who were particularly afflicted by infidelism.[107]

Fig. 54
Benjamin Childs, engraver, *Christian Almanac*. New York: American Tract Society, 1851.

With the rise of leisure among the bourgeoisie came the opportunity to invest one's time in the cause of benevolence and to accelerate the advance of the republic in the national enterprise of progress and prosperity. The sign of Christianity became entrance into the middle class, with the economic status that bestowed. The rich were infidels, and the poor were drunkards. Only in the middle ground, where "everything was neat and tasteful; everything in keeping," as Helen Knight had described the proper household of a pious newlywed wife, only there did God reveal his highest pleasure and blessing.[108] The ATS promoted the interests of this class in its publications by developing a visual rhetoric that preached to viewers and coaxed them to imagine a new economy of divine favor manifest in national mission and the hierarchies of authority within the seat of American life, the family.

Adventism and Images of the End

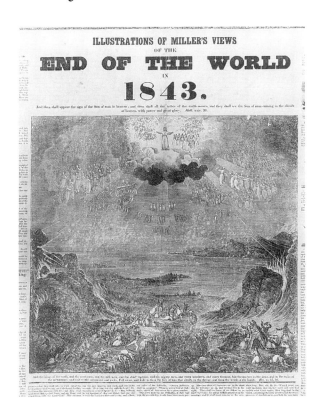

F O U R

Millerism and the Schematic Imagination

A ntebellum religious life in the United States was strongly colored by the early republic's radical evangelical egalitarians, who were steeped in revival and a fiery rhetoric attacking traditional church polity. By contrast, the ATS's accentuation of union and cooperation was a move to avoid evangelical factionalism and to focus energies on a clear, even single-minded agenda. The ATS, which rooted itself in the middle class and filled its executive committees with judges, lawyers, and divines, sought to forge an evangelical consensus from unity that was a safer bet than the radicalism of figures like Elias Smith or Lorenzo Dow. But the leaders of Millerism and Seventh-Day Adventism, impelled by a deep sense of urgency, threw caution to the wind and indulged in the heady experience of liberty and egalitarianism that celebrated the disestablishment of religion, fired the Second Great Awakening, and led to a flurry of upstart preachers and popular religious movements.[1] Millerite and Seventh-Day Adventism were premised on the revolutionary notion that the individual possessed the inherent right and capacity to decide for him or herself in what spiritual truth consisted. The evangelical belief in access to the Bible assumed that the Bible could be successfully interpreted by anyone who genuinely tried to understand it.[2]

This chapter and the next, on the visual culture of American Adventism, engage with the legacy of the egalitarian impulse of the early nineteenth century. Adventists learned from the effective technology of the camp meeting and the pioneering uses of mass media by egalitarian religious radicals like Elias Smith, who founded the Christian Connection, a church body in which Joshua Himes, an extraordinary publicist, served as

a clergyman for many years prior to becoming a Millerite. Yet we must not elide an Elias Smith with a William Miller, who did not share Smith's political rancor. Nor should we overlook the lessons learned by Adventists from the ATS on the use of the media, colportage, and the commerce of religious material culture. In fact, Adventism and the ATS were distinguished from one another most notably on the theological point of the millennium. Whereas the ATS was postmillennialist, believing that Americans could effect a reign of peace by universal evangelization after which Christ would appear, Millerism and Seventh-Day Adventism announced the imminent return of Jesus, to be followed by the immediate destruction of the world.[3] The implications of this theological distinction were much larger than one might expect. The ATS identified its efforts at universal proselytism as fundamentally patriotic in the service that the evangelistic enterprise rendered to the millennial role of the American republic. But James and Ellen White came to regard the government and mainstream Protestantism in the United States as a threat to liberty and as the apocalyptic beast.

This chapter and the next set out to assess the significance of premillennialism and the mass media for the production of images by American Adventists from 1840 to the early twentieth century. Millerism exhibited a unique visual culture with a popular theology and an aesthetic that were perfectly expressed in images. I begin with Miller himself in order to explore the aesthetic impulse of Millerite theology and then I turn to the imagery and its uses by this meteoric sect in the early 1840s.

William Miller and the Aesthetic of Biblical Interpretation

Born in the heyday of American deism, William Miller (1782–1849; fig. 55) grew up, as he put it in his *Apology and Defense* (1845), "perplexed with what I then deemed inconsistencies and contradictions in the Bible, which I was unable to harmonize."[4] After reading the work of Thomas Paine and Ethan Allen among others, Miller wrote, he rejected the Bible as a fabrication and professed the deist creed: "I . . . believed in a Supreme Being as brought to view by the works of Nature and Providence; and believed that there was to be an hereafter, in which our happiness would be proportioned to the virtue of our lives in the present state."[5] But even the need to harmonize scripture was a rationalist concern—something Miller and his associates never gave up as the necessary response to the challenges of Deist rationalism. Indeed, deism supplied Miller with a view of argumentation and proof that informed his biblical interpretation. While some historians of Millerism have downplayed the place of deism in his life as a matter of youthful fashion, the rationalist patterns of thought in deism continued to shape his reading of scripture and his assemblage of evidence against the deist critique.[6] As forms of popular culture, Millerite imagery and biblical interpretation set themselves up first in implicit competition with and then in explicit opposition to learned discourse at seminaries and universities, ultimately contending against both the theological establishment and the secularizing forces of the Enlightenment. In the end,

the Millerite chart amounted to a counterappropriation of the Enlightenment's visual pedagogy in the attempt to signal the end of the world rather than its culmination in a progressive utopia or millennial bliss.

Deism became untenable for Miller when it appeared to lead ineluctably to "a belief in annihiliation, which was always very abhorrent to my feelings." His deist credo in an afterlife was perhaps threatened by the more radical form of deism that dismissed any notion of survival after death. "I could . . . find no assurance of happiness beyond the grave; all was dim and uncertain there." Or perhaps he felt unworthy to inherit the reward that deism promised on the basis of his virtue "in the present state." Miller related that he sought an understanding of a God who could save him from his unworthy life and then hit upon the "character of a Savior" as a being so compassionate that he would "himself atone for our transgressions." From this introspection Miller turned to the Bible to find such an idea and could not conceive how an uninspired book might "develope principles so perfectly adapted to the wants of a fallen world. I was constrained to admit that the Scriptures must be a revelation from God; they became my delight, and in Jesus I found a friend."[7] When pressed by a deist friend in 1818 or 1819 to prove the truth of the Bible as an authoritative revelation of the savior by accounting for the "inconsistencies, the contradictions, and the mysticisms," Miller responded that, given time, he would "harmonize all these apparent contradictions, to my own satisfaction, or I would be a Deist still."[8]

Fig. 55
Portrait of William Miller, lithograph, Thayer & Company's Lithography, Boston, 1840s. Courtesy of the American Antiquarian Society.

The deist position is best stated in a book that Miller certainly read, Tom Paine's *Age of Reason* (1794–1795). Paine regarded Revelation as "a book of riddles that requires a revelation to explain it."[9] He complained that the poetic utterances in the Old Testament "have been erected into prophecies, and made to bend to explanations at the will and whimsical conceits of sectaries, expounders, and commentators." Such prophecies, he reasoned, ought to be "told in terms that could be understood, and not related in such a loose and obscure manner as to be out of the comprehension of those that heard it, and so equivocal as to fit almost any circumstance that may happen afterward." The "romantic interpretations and applications" that "comentators" have made of such books as Ezekiel and Daniel, "making them bend to times and circumstances as far remote even as the present day," demonstrate "the fraud or the extreme folly to which credulity or priestcraft can go."[10]

Paine opened the second part of *Age of Reason* with the assumption that "before anything can be admitted as proved by the Bible, the Bible itself must be proved to be true; for if the Bible be not true, or the truth of it be doubtful, it ceases to have authority, and cannot be admitted as proof of anything."[11] The rhetorical move, typical of Paine's strategy throughout *Age of Reason,* was all or nothing: either the Bible was completely true or it was useless as evidence. It is important to understand that Miller accepted the agenda set by this approach: he believed it necessary to demonstrate that the Bible was utterly without contradiction or inconsistency. In an early version of the autobiographical passage that shortly later appeared in his *Apology and Defense,* Miller wrote: "I could not believe that God had given a revelation that could not be understood."[12] In the fourteen rules of interpretation that he formed in his own practice of Bible-reading (which Joshua Himes made possible for Adventists by publishing in the journal *Signs of the Times*) Miller stated: "Nothing revealed in the scripture can or will be hid from those who ask in faith, not wavering." He also contended that all of scripture "may be understood by a diligent application and study."[13] In effect, Miller insisted that scripture was clear on all things for the faithful because deism assailed it on just this ground. Ten years before Paine's book appeared, another deist, Ethan Allen, had attacked the "loose, vague and indeterminate" meaning of prophetic writings, claiming that they were "equally applicable to a variety of events, which are still taking place in the world, and are liable to so many different interpretations, that they are incapable of being understood or explained."[14] He then singled out the ambiguous language of Daniel 7 and Revelation 12 (both of which were central to Miller's chronological scheme) as an instance of such obscurity and unlimited interpretation.

The criticism of unconstrained interpretation may well have concerned Miller more than any other and certainly accounts for the vitriolic tone of the disagreements among millennialists concerning prophetic symbols and their historical references. Miller's reading of the Bible moved toward eliminating polysemy, or multiple interpretations, due either to symbolic ambiguity or textual contradictions. Indeed, the method of scriptural interpretation that Miller practiced in the quest for harmonizing "apparent" biblical inconsistencies preempted the possibility of inconsistency by assuming that scripture was a self-contained, self-consistent "system of re-

vealed truths" that were only properly understood in light of one an-other.[15] Miller attempted to conform to his set of interpretive principles as strictly as a deist held to the scientific method that governed his con-templation of God's revelation in the order and design of nature.[16] Rule 4 of Miller's list of interpretive rules states that the Bible reader can proceed inerrantly if all of scripture is consulted; "bring all the scriptures together on the subject you wish to know; then let every word have its proper influence, and if you can form your theory without a contradiction, you cannot be in an error." Rule 2 claims: "All scripture is necessary" and rule 5: "Scripture must be its own expositor, since it is a rule of itself." Miller's conviction that a clear and unambiguous meaning resided in every passage as the communication of divine intention informed his first rule, which announced: "Every word must have its proper bearing on the subject pre-sented in the Bible." The task confronting the diligent Bible student was a patient process of intertextual comparison. "To learn the true meaning of figures, trace your figurative word through your Bible, and where you find it [the word] explained, put it on your figure, and if it makes good sense, you need look no further, if not, look again" (rule 12). Since all of scrip-ture was God's word, when God used a word in one place it could serve to explicate the use of the word in another. Scripture, strictly speaking, was its own lexicon.

In this practice, Miller's reading of scripture exhibited "system and reg-ularity."[17] Accordingly, he could conclude that he had "found the Bible, as a whole, one of the most simple, plain and literate books ever written." Miller railed against the impressing of the sectarian character of the deity on the innocence of young minds in schools as a procedure that ended only in "bigotry." In a statement reminiscent of the ideal of liberty that Paine and Allen understood as freedom from the oppressive systems of thought imposed by orthodoxy, Miller wrote: "A free mind will never be satisfied with the views of others." Those who impose their human constructions on young minds send them out as "slaves." Miller argued that the interpretation of scripture should be dependent on no one, on no sectarian creed, and on no rule but the Bible (see rule 5). If Ethan Allen proudly stated that "the Bible and a Dictionary have been the only books, which I have made use of" to write his Oracles of Reason, Miller could reply that he employed only the Bible and *Cruden's Concordance* to demonstrate contra deism that scripture was indeed a "system of revealed truths."[18]

Miller's preoccupation with biblical prophecy can be explained in part as his attempt to overturn the rationalistic claim that scripture was histor-ically false and that its prophecies were obscure or mystical. The prophe-cies also enabled Miller to develop a line of argument that opposed the deist conceptions of creation and human history. Prophetic texts in Daniel and Revelation as well as elsewhere in the Bible offered Miller what he con-sidered important links in and insights into the chronology of human his-tory. The evidential appeal of biblical chronology consisted of a tight se-quential pattern of historical events symbolized in prophecy that led from the past to the present. Miller vigorously sought to portray this sequence as historically corroborated. As such, it could vindicate the Christian claim for the clarity of the Bible against the rationalist critics who charged scrip-

ture with unintelligible mysticism in the prophetic imagery. Properly interpreted, the prophetic symbols of Daniel and Revelation could support the claims for the historicity and the lucidity of the Bible. Chronology was the Bible explained in utterly clear, systematically resolved, historically literal terms.

The concern to avoid mysticism in biblical interpretation may have been intensified in the 1830s by the rise of Mormonism, a contemporary premillennialist group that founded itself on secret texts and rites and on a cosmology that radically reinterpreted the Bible. The insistence on systematic interpretation among Millerites contrasted with the practice of the Mormons, who criticized Miller and his followers for making no appeal to extrabiblical or "latter-day" revelation. Miller insisted on working with the finite data of scripture interpreted by linking prophetic features with historical referents. Though history was unfolding, the Bible was closed and sacrosanct. For the Mormons, however, revelation was ongoing and invested in the prophet leading the church. Scripture was supplemented by the Book of Mormon, which added to ancient history and authorized the present pilgrimage of the latter-day saints in a world that had come to merit only divine wrath. Although the Mormons and Millerites shared a premillennial theology, Joseph Smith rejected Miller's biblical interpretations in 1843 because Miller proceeded without the assistance of revelation; because Smith himself did not foresee Christ's return for at least forty years; and because Smith and his followers adhered to the view, contra Miller, that the Jews would recover possession of Jerusalem before Christ's return.[19] These differences led the Mormons to fault Millerite arithmetic and interpretation. This may account for the absence of prophetic charts among the Mormons, who, nevertheless, made significant use of hermetic signs, hieroglyphics, and magical inscriptions and even invented a new alphabet, called Deseret, for use among the faithful.[20]

Because scripture was a complete and finished document, Miller believed that he had all the information necessary, concentrated in Daniel and Revelation, to carry out his deductions, resulting in the calculation of the second coming of Christ about 1843. This date was deduced from a chronology that defeated the accusation of biblical obscurantism: the darkness, contradictions, and rational objections to the contents of scripture vanished as a result of Miller's deductions. The Bible, he concluded,

> was indeed a feast of reason: all that was dark, mystical, or obscure to me in its teachings, had been dissipated from my mind, before the clear light that now dawned from its sacred pages; and O how bright and glorious the truth appeared. All the contradictions and inconsistencies I had before found in the Word were gone.[21]

Deism was also defeated on its account of creation and the nature of time. Not an eternal universe that was unviolated by divine intervention and respected by providence as self-governing, Miller's universe was rushing toward a violent end, to be brought about by the special intervention of God, which would be signaled by Christ's second appearance. Time was not without end, human history was not characterized by progress toward social perfection and the public good but was due to end imminently.

Providence and divine goodness were not merely evident in the design of the universe but made known in biblical prophecy: the foreknowledge of things to come revealed in figures that referred to historical events.

The appeal of chronology was indebted to what are best considered the *aesthetic* characteristics of the Adventist practice of biblical interpretation. Deism argued for a self-contained creation, a universe unviolated by the deus ex machina, a deity that created everything to be regulated by self-governing principles of eternal order. The Millerites shifted this formalist principle from creation (which they believed was doomed to eventual destruction) to holy scripture, which they regarded as an enclosed whole sufficient unto itself. In an article advocating the literal interpretation of scripture and the view that "the Bible is to be interpreted by itself," one Millerite writer said the Bible "comes to us as the revelation of God, and like the sun, shines and is alone visible by its own light."[22] This special status of autonomy applied only to the Bible because no other book exhibited "such a general connection as the Bible." In his argument with Miller, Adventist David Campbell invoked the use of images of seals, trumpets, and vials "and the harmony of their chronological numbers. I might add, also, their analogy, symetry [*sic*], and proportion."[23] In the introduction to his *Illustrations of Prophecy*, Campbell compared the successive discoveries from the careful study of biblical prophecies to "the views in the various scenery of a fine engraving."[24] There was an aesthetic justification of prophetic interpretation that millennialists used to argue against nonbelievers as well as one another.

Miller himself made explicit use of the aesthetics of prophetic interpretation. He opened a lecture published in the *Midnight Cry* with a telling proclamation of the aesthetic experience of interpreting revelation:

> There is such harmony, beauty, and knowledge in every part of the word of God, that the Bible student, whose heart is interested in the same, has often, while reading, been led to stop and admire the order, wisdom, and light which burst upon his enraptured vision, at the unfolding of the figures and truths which until that moment, perhaps, lay in darkness, doubt, and obscurity, and seemed to be wrapped up in a mysterious veil that almost makes the reader quail, and come to the conclusion that he is treading on forbidden ground; but, perhaps, in an unexpected moment, the inspired penman, seemingly having anticipated our ignorance or darkness, throws out a spark of that live coal which had touched his lips, and our darkness is dispelled, ignorance vanishes before the fulness of knowledge of the word of God, and we stand reproved and admonished for our stupidity and ignorance in the figures and truths before explained.[25]

In this single, long sentence, Miller leapt from the darkness of ignorance to the sublime summit of illumination to have all his fears dispelled and to be delivered from the doubts that assailed him concerning the Bible's obscurities. His primary concern was to overcome the ignorance and impotence he felt before the deist critique, or perhaps the fear and hopelessness of death to which the rationalist arguments against scripture exposed him.

The sublime and the beautiful comprised an aesthetic that was not strange to American evangelical Protestantism. In fact, a great native authority for many Protestants in nineteenth-century America was Jonathan Edwards (1703–1758), the Calvinist preacher and theologian of colonial New England, whose writings on divine sovereignty include a very important aesthetic component.[26] According to Edwards, spiritual understanding consisted in beholding "the supreme beauty and excellency of the nature of divine things, as they are in themselves." True saints, he insisted, "first rejoice in God as glorious and excellent in himself, and then secondarily rejoice in it, that so glorious a God is theirs." Edwards believed that the aesthetic experience of God's sovereignty resulted in a "sense of spiritual beauty" that served as the only source of "all true experimental knowledge of religion."[27] Reckoning "true religion," the object of his major work, *Religious Affections* (1746), relied on recognizing feelings that were "truly gracious and holy." These, Edwards argued, were the result of an "inward principle," the indwelling of the Holy Spirit "in union with the faculties of the soul, as an internal vital principle, exerting his own proper nature, in the exercise of those faculties." This indwelling Spirit moves the soul to genuine affections that "flow" into practices and holy exercises that appear "in all circumstances, and at all seasons, in a beautiful symmetry and proportion."[28] Symmetry and proportion signified a moderation and an orderliness that were universal and everlasting in contrast to passionate excess, which was temporary and changing.

In contrast to such aesthetic order or beauty is what might be called the evangelical sublime. In the midst of the Great Awakening in 1741, Edwards preached a vivid sermon of the sublime as the theological means of underscoring God's sovereignty and humanity's innate corruption:

> When God beholds the ineffable extremity of your case, and sees your torment to be so vastly disproportioned to your strength, and sees how your poor soul is crushed and sinks down, as it were into an infinite gloom, he will have no compassion upon you, he will not forebear the executions of his wrath, or in the least lighten his hand. . . . Now God stands ready to pity you; this is a day of mercy; you may cry now with some encouragement of obtaining mercy. But when once the day of mercy is past, your most lamentable and dolorous cries and shrieks will be in vain; you will be wholly lost and thrown away of God. . . . God will have no other use to put you to but only to suffer misery; you shall be continued in being to no other end; for you will be a vessel of wrath fitted to destruction; and there will be no other use of this vessel but only to be filled full of wrath.[29]

Nothing that humans might do could persuade God to grant them deliverance. Only God's work of redemption through Jesus effected salvation. The sublime was the sensation of being dwarfed by God's horrible demand for holiness, which meant, in the theological terms of Edwards's Calvinism, God's wrath and humanity's helpless damnation. Beauty, on the other hand, was the experience of God's inherent excellence and sovereignty, his self-contained perfection as God. This beauty was contemplated disinterestedly by the graciously affected soul, that is, without re-

gard for personal benefit. The heated rhetoric of his sermon "Sinners in the Hands of an Angry God," which rivals even James Joyce's account of Stephen Dedalus's vision of perdition in the hands of an angry Jesuit, might suggest that Edwards preferred the sublime to the beautiful. In fact, however, Edwards explicitly hailed God's beauty as the more important; it was God's "moral attribute, the basis of his holiness, his intrinsic goodness," while the sublime was an effect that followed from God's holiness, the expression of his power.[30]

Miller's experience of beauty and the sublime followed this pattern: the sublime condemned and assaulted him with powerlessness and death; and the beauty of scriptural prophecy and evangelical surrender to Jesus rescued him from despair.[31] One finds the same movement from tribulation and despair to deliverance and glory in eighteenth- and nineteenth-century hymns and revival sermons. It is an evangelical aesthetic that coupled the sublime and the beautiful and can be traced to Edwards. Yet whereas eighteenth-century aesthetics and theology had carefully distinguished beauty and the sublime, as in Edmond Burke's widely read *A Philosophical Enquiry into the Origin of Our Ideas of the Sublime and Beautiful* (1757),[32] many nineteenth-century writers intermingled the two categories. The aesthetics of the sublime and the beautiful were merged in order to characterize the beauty of divine harmony and the grandeur of divine conception. This is evident throughout Millerite writings, where scriptural prophecy was sublime inasmuch as it exhibited a grand historical scope and beautiful in the harmony and perfection of all its parts. In 1842 an anonymous article in the *Midnight Cry* entitled "Beauty of Prophecy" praised as "unutterable" the "grandeur and beauty in prophecy, and in prophetic symbols." The author applauded scripture's use of prophetic figures such as the sun, moon, and stars because they "speak the same sublime language to all nations, and suggest the same grand emotions to every heart." Nature joined with the Millerite publishing and mission efforts to evangelize universally. A lion, leopard, and bear (symbols in Daniel 7 and on the Millerite charts— fig. 56) were said to "produce the same sensations in every beholder." The prophecy of Daniel constituted "a grand diagrammatic illustration or representation of earth's eventful history" and was an "unerring diagram which God has given us in symbolic painting."[33] Scripture was sublime because it was universal. But its greatest wonder was its capacity to illumine human ignorance with a harmony.

The Adventist reading of scripture sought to transform it into a uniform field of correspondences, a homogenous fabric of similitudes. Interpreting scripture properly consisted of discerning similarities between prophetic symbols and historical periods. Miller proceeded by gathering diverse passages into a single unity. He always sought for a unified whole to which several parts of scripture might refer. This was what he meant by allowing scripture to interpret itself. The many visions and prophecies of Daniel and John "must be concentrated and brought together, which have reference to the point, or subject which we wish to investigate, and when we have them all combined, and let every word and sentence have its proper signification and force in the grand whole, . . . [then] the theory, or system, as I have said before, will be correct."[34] In effect, Miller embraced a coherence theory of truth. Prophecy consisted of

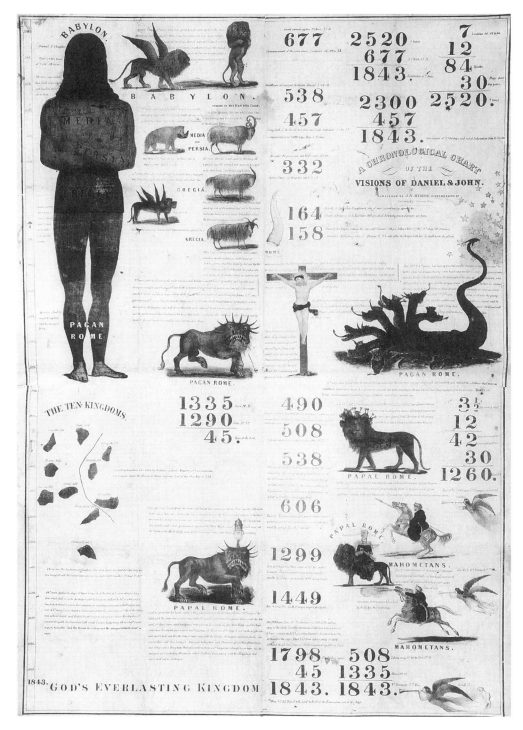

Fig. 56
After design by Charles Fitch and Apollos Hale, "A Chronological Chart of the Visions of Daniel & John," hand-tinted lithograph on cloth, 55 3/4 × 39 1/2 inches, J. V. Himes, Boston, 1842. Courtesy of James R. Nix.

the same event foretold by different prophets. But each of the components is a link in what amounts to "a perfect chain." The prophets "interweave their prophecies in such a manner that you take away one, and a link will be wanting. . . . Truth is one undeviating path, that grows brighter and brighter the farther we pursue it."[35] This truth of coherence is a fundamentally aesthetic configuration or harmony of parts that cohere as a whole according to such principles as symmetry, correspondence, and similitude. Highlighted in the Millerite charts, the symbols from Daniel 2, 7, and 8, for instance, correspond to one another. The truth of their interpretation consisted of the "one undeviating path" that the interpreter constructed by linking several portions of scripture into a single chain.

Visualizing this chain was the rhetorical function of the Adventist chart (see fig. 56).[36] As a visual form, a chart was able to demonstrate the simplicity and unity of (the Adventist reading of) the Bible. The Millerites anchored the meaning of very elusive, polyvalent prophetic symbols by investing them within a synchronic scheme of similitudes and a diachronic series of historical references. The resulting interplay of graphic, alphabetic, and numeric signs reduced the range of the symbols' meanings to "one undeviating path." The chart accomplished visually what the Millerite hermeneutic sought to achieve: the transformation of the connotative character of the symbol into a singular denotative operation.[37] The viewer was meant to see in the chart a systematic reading of prophecy across image and text as if the two merged seamlessly into a self-evident act of scripture reading itself. The Millerites sought to make their argument by visualizing the coherence of their interpretation as a system, in other words, by displaying the "beauty and harmony" of the Bible properly interpreted.

Moreover, the chart visualized the image of the Bible as a self-contained, complete, and inerrant document of God's will. Figurative speech was not suggestive or evocative or dark or obscure but required only the key of scripture interpreting itself to be properly understood. Fundamentally rationalist in spirit, biblical literalism presumed a single message plainly encoded in scripture. Meaning was thought to reside solely in the text where God placed it. One Millerite essay, published in *Signs of the Times,* insisted that true interpretation placed no private meaning in scripture but allowed only "the same Divine word, and not human opinion" to interpret scripture. True interpretation was "God, speaking upon, and expounding his own word." For this writer "figurative" interpretation could only mean private or personal and therefore unfounded interpretation of the Bible.[38] In his *Evidence from Scripture and History,* Miller assured his readers: "I have endeavored to divest myself of all prepossessed opinions" in studying the Bible.[39] Literalism, in other words, was a hermeneutic strategy that helped assure the apparent autonomy of scripture in order to assure the authenticity of what the Millerites found there. As such, literalism masked or naturalized the host of presuppositions that Miller, like any reader, brought to his reading of the Bible. Thus, the Millerites implied that their own interpretations of scriptural prophecies were not "private" or willful but methodical, systematic, and harmonious—that they replicated the structure of scripture. The chart effectively aestheticized biblical interpretation by appealing to an aesthetic sense of organization—what I call the coherence theory of truth.

As a "feast of reason" devoid of obscurity and mysticism, the Bible as the Millerites interpreted it was clear and without self-contradiction, illuminating the free mind with the light of its sacred pages. The secret was simply to learn to read the Bible properly. Along with a lexicon of prophetic symbols, the Millerites offered the chart as a way to visualize the lucid manner in which the scriptures presented themselves for reading.[40] The chart graphically displayed this clarity and systematic integrity as a visual fact to be illustrated like any fact in an encyclopedia for the sake of public edification such that, as Miller said of the Bible, "the 'wayfaring man, though a fool, need not err therein.'"[41] Once again, Miller, like much of the evangelical culture of his day, was deeply indebted to the legacy of the enlightenment. Millerism adopted from the Enlightenment both textual and visual rhetorics: the banishment of darkness and mysticism before the light of reason, assisted by such aids as lexicons, histories, and commentaries; and the use of visual illustrations to present information.[42]

The Origins of Millerite Iconography

The Protestant believers who filled the ranks of the Millerite movement between 1837 and 1844 were drawn from across the spectrum of American Protestantism but seem to have come largely from Baptist, Methodist, and other evangelical groups such as the Christian Connection (a fusion group of anticreedal Methodists, Baptists, and Presbyterians) and the evangelical Presbyterian and Congregationalist churches.[43] None of these traditions is known for an accomplished or "highbrow" practice of imagemaking. In fact, among these groups images were generally associated with the "Romanist error" and likened to idolatry. Thus it may seem surprising at first to find among the Millerites an important place given to images.

In a series of journal and newspaper articles, book illustrations, and painted and lithographed charts and images, Adventists from 1840 through the twentieth century have produced elaborate visual presentations of their central doctrine of time's course from the ancient days of prophetic announcement to imminent eschaton. Yet these images did not appear ex nihilo. In fact, Protestant premillennialists since the seventeenth century affixed various charts, diagrams, and depictions of apocalyptic creatures to commentaries on Revelation and Daniel.[44] Although the use of diagrams to illustrate apocalyptic subjects is much older than the Reformation, Protestant diagram-images are consistently nonpictorial in formats and deployed as mass-produced media.[45] Rather than devotional imagery painted in oil or tempera and depicting three-dimensional space with the Renaissance inventions of visual storytelling, Protestant images of prophecy were engraved or woodcut diagrams used as the frontispieces or the illustrations of pamphlets or thick volumes of prophetic commentary. The chart in Joseph Mede's *Key of the Revelation* (1643), is a good example (fig. 57).[46] This image, which claimed to diagram all the prophecies discussed in the book of Revelation, exhibits the highly schematic organization, geometrical arrangement of parts, and integration of image and text that characterize many premillennialist charts in the nineteenth century.[47] Most premillennialist charts are schematic rather than pictorial. A fellow

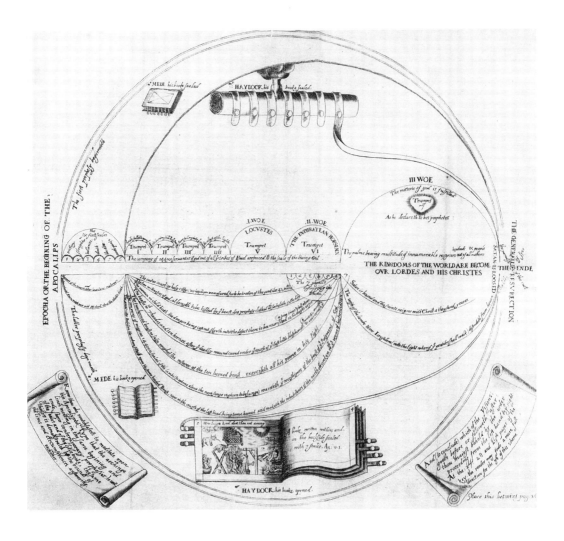

Fig. 57
"Apocalyptick Scheme,"
from Joseph Mede, *Key
of the Revelation,* tr.
Richard More (London:
R. B., 1643). Courtesy of
Department of Special
Collections, University
of Chicago Library.

at Christ College, Cambridge, Mede (1586–1638) originally published his
Key in Latin with a chart (*Clavis Apocalyptica,* 1627). The work appealed to
the Puritan government so much that a translation was ordered in 1643.[48]
Mede had included the chart in the Latin original because the figure, "to
be viewed at once," visualized "all the prophecies in the Revelation." In "A
Corollarie concerning the use of the Key" that Mede provided, the
"scheme" or chart is said to be "short, easie, and compendious" and to of-
fer "a ready way . . . whereby the line of Synchronisms and of order . . .
demonstrate the meaning of the other visions."[49] The chart completely
avoided Puritan iconoclasm and the injunction against images since
Parliament decreed on August 28, 1643 (the same year in which Mede's
book was ordered translated) that altars in British churches be destroyed
and paintings and statues therein be defaced. The stress Mede layed on
clarity and legibility circumvented the proscription by likening the image
to text.

The emphasis on immediate clarity and ease of understanding contin-
ued to justify the use of the chart in Protestant exegeses of Daniel and

Revelation. Most charts produced by the Adventist movements between the 1830s and the 1860s in the United States remained highly schematized, typically linear organizations of text and emblematic imagery.[50] Pictorial space was eliminated in favor of vertical and horizontal registrations of graphic information. It was not until the 1870s among Adventists that pictorial imagery began to rival the diagrammatic imagination of the chart among the Millerite legacy.

In the nineteenth century a curious iconography of beasts, trumpets, seals, and vials derived from the book of Revelation and inserted into tabular schemes and chronological timelines first appeared in illustrated Bibles and special treatises on biblical prophecy. Among the earliest is an unsigned metal engraving that appeared in a stereotype edition of the Collins Bible published in Boston in 1824 (fig. 58). The image attempts to correlate elements of Revelation 11, 12, 13, 15, 16, and 17 in a synoptic view of the final two thousand years of human history. Seven seals and trumpets release and herald the stages of the end along a timeline that runs from the birth of Christ to 2000 A.D. About 1824, the date of the engraving's publication, the first of seven vials is poured out, followed at regular intervals by five more until the the year 2000. A note indicates that the seventh vial of Revelation 16:17 "seems to refer to the last judgment; therefore only a part of it is faintly seen without the lines of this representation, as the time of its pouring out in that case is beyond the limits of this world's duration." Only half of the seventh vial appears in the lower right of the illustration, signifying the indeterminate date of the final device.[51]

The chart conforms to one view, prevalent at the time, that the world would last six thousand years (until 2000 A.D.) and be followed by the millennium. This interpretation was premised on the neat correspondence of

Fig. 58
Beast of Revelation 17:3,
from *The Holy Bible*
(Boston: C. Ewer and
T. Bedlington), 1824.

a seven-thousand-year history of earth to the first six days of creation and the seventh day of rest. The 1824 image appeared in the Boston Bible as a form of schematic commentary, the visual equivalent of notes and references in narrow columns of tiny print at the right of every page that referred the reader to other passages as a form of intertextual interpretation. The Bible itself was printed from plates stereotyped from the original edition by Isaac Collins. An advertisement dated 1819 stated: "Engravings of a superior quality, copied from the designs of eminent painters, will be supplied to those who may order them."[52] It is difficult to know the origin of the chart from Revelation and how widely it was included in the Boston edition. The prevalence of apocalyptic thought in the early republic probably explains the publishers' decision to make the image available. Certainly there was nothing unusual about the millennial interpretation that the chart offered contemporaries. But the appearance of the blasphemous beast of seven heads and ten horns described in Revelation 17:3 is striking, for it stands halfway between older European images of the beast and the image that brings us to the visual culture of Millerism: the image of blasphemy in a book of 1840 by David Campbell (fig. 59).

In 1833 William Miller published the results of many years of scriptural study and meditation: *Evidence from Scripture and History of the Second Coming of Christ about the Year 1843*. Subsequent versions appeared in pamphlet, lecture and book form in 1835, 1836, 1838, and 1840. None of these was illustrated. In 1839 a Grahamite health reformer in Boston named David Campbell completed a long response to Miller that must have seemed all the more urgent to its author since Miller's book and career were beginning to receive wider circulation in the late 1830s. Campbell offered his premillennial interpretation of Daniel and John "with a special intention to awaken in the youthful readers of the Bible an interest in the prophecies."[53] He pointed out in the preface to his book that he sought to avoid the obscurity of many treatments of prophetic interpretation by incorporating "pictural [*sic*] representations of the natural emblems used by the prophet in the passages under consideration."[54] His book was copiously illustrated with wood engravings of symbolic figures and creatures from Daniel and Revelation, which Campbell placed within his text and paired with corresponding biblical passages. His work is interesting primarily because it is the hitherto unacknowledged source of virtually all Millerite chart imagery.[55]

Campbell regretted in his introduction that those "unlearned in the prophecies may be drawn into the wild and unscriptural notion that the resurrection will take place in 1843."[56] Campbell and Miller disagreed sharply over the role of the Jewish people in the last days and the interpretation of the papacy and Islam in the prophetic calculus of symbols. Campbell contended that the Jews would have to be restored before Christ's return while Miller denied this. Much more recondite was their disagreement on the interpretation of Daniel 8, which stated that a "little horn" grew from one of four antecedent horns on the symbolic beasts of Daniel's apocalyptic vision. These four horns were thought by many premillennialists in the nineteenth century to refer to the four kingdoms (Macedonia, Thrace, Syria, and Egypt) fought over by Alexander's generals following the conqueror's death. Miller believed the little horn referred

Fig. 59
Beast of Revelation 17:3, from David Campbell, *Illustrations of Prophecy* (Boston: David Campbell, 1840), p. 55. Courtesy of the Adventist Heritage Center, Andrews University.

to pagan (and later papal) Rome; Campbell insisted that it symbolized Islam.

Miller reviewed Campbell's book in the first issue of the Millerite biweekly paper *Signs of the Times,* the issue of April 1, 1840. In the following issue Campbell replied and illustrated his text with a wood engraving of a sheep's head with four large horns labeled according to the usual interpretation and one small horn labeled "Mahomet" (fig. 60). The engraving was taken directly from page 71 of Campbell's *Illustrations of Prophecy.* The appearance of the image was faciliated by the fact that both Campbell's

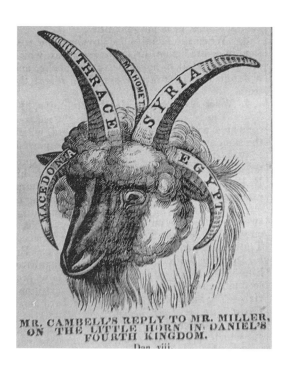

Fig. 60
Five-horned sheep of Daniel 8: little horn as Mahomet, *Signs of the Times* 1, no. 2 (April 15, 1840), 1; reproduced from David Campbell, *Illustrations of Prophecy* (Boston: David Campbell, 1840). Courtesy of the Adventist Heritage Center, Andrews University.

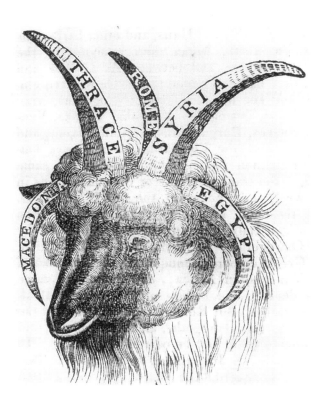

book and the *Signs of the Times* were printed by the same firm in Boston, Dow & Jackson, "Book, Card, and Fancy Job Printers," as they advertised themselves; they had the wood engravings on hand for easy reuse in the Millerite newspaper. The Millerite preacher and theologian Josiah Litch replied to Campbell in the next issue (May 1, 1840). An engraving of the same sheep's head appeared in Litch's response but with "Rome" inscribed in the small horn and the shading reversed, presumably because the block (or stereotype of it) had been patched and recut (fig. 61). Neither Campbell nor Litch offered any description or discussion of the images (nor had Campbell discussed individual images in his book). Like nearly all instances of images illustrating Adventist literature, no commentary accompanied the visual illustrations. The figures silently marked the site of disagreement, the contentious points of debate over biblical interpretation.

Campbell and those about Miller had much more to agree on than not. In fact, this may be why the Millerite contingent continued to use Campbell's images. The publication of the sheep's head in April of 1840 was only the beginning. In the same issue as Campbell's first reply to Miller (April 15, 1840), Joshua Himes, the editor of *Signs of the Times,* ran a notice of Campbell's book, approving of the author's "great care and industry" and, though parting company with him on the issue of the Jews' restoration and the mechanics of the millennium, Himes recommended the work and hoped it would enjoy wide circulation. "The pictorial illustrations," he added, "are generally correct, and are valuable."[57]

Fig. 61
Five-horned sheep of Daniel 8: little horn as Rome, *Signs of the Times* 1, no. 2 (April 15, 1840), 1. Courtesy of the Adventist Heritage Center, Andrews University.

Although it remains to be determined, Campbell may have assimilated from Miller's *Evidence* the general interpretation of the succession of prophetic figures in Daniel, differing from him on certain particulars and the final date of 1843. Campbell then sought to present his views to the public with the advantage of wood engravings to illustrate the arcane interpretations, with the reasonable expectation that illustrations would attract a broader audience. The images adhered so closely to Millerite teaching that they were eventually placed in the service of the Millerite cause, becoming a basic component of teaching and argumentation. In spite of the occasionally rather trenchant disagreement between Miller and Campbell over matters of interpretation, in the second and third numbers of volume 2 of *Signs of the Times* Campbell's images were used to illustrate excerpts from Miller's *Evidence* (fig. 62). Campbell was not mentioned, and discussion of the little horn focused exclusively on Rome. Campbell's visual repertory highlighted the considerable agreement between the two men on the principal components of Daniel's prophetic construction of historical periods spanning from Babylon to the legacy of Alexander. Miller and Campbell fastened on a series of symbolic images in Daniel 8 and 9 that they believed constituted a tight sequence that corresponded to historical chronology.

Miller focused on the dream of Nebuchadnezzar and Daniel's interpretation of it (Daniel 2:31–45). The dream of the Babylonian ruler is recorded as follows:

> Thou, O King, sawest, and behold a great image. This great image, whose brightness was excellent, stood before thee; and the form thereof was terrible. This image's head was of fine gold, his breast and his arms of silver, his belly and his thighs of brass. His legs of iron, his feet part of iron and part of clay. Thou sawest till that a stone was cut out without hands, which smote the image upon his feet that were of iron and clay, and brake them to pieces. Then was the iron, the clay, the brass, the silver, and the gold, broken to pieces together, and became like the chaff of the summer threshing floors; and the wind carried them away, that no place was found for them: and the stone that smote the image became a great mountain, and filled the whole earth (Daniel 2:31–5, King James Version).

Daniel proceeded to explain the meaning of the dream to the horrified Nebuchadnezzar: the five parts of the statue represented five successive kingdoms, beginning with the golden head, which was Babylon under the rule of Nebuchadnezzar. Each kingdom would replace the one before it in time or above it on the figure. In a tradition of prophetic interpretation that can be traced at least to the seventeenth century, Miller read the successive kingdoms as Babylon, Media and Persia, Greece, Rome, and the ten kingdoms / toes of the European tribes that came afterward. Campbell's figure representing the "Great Image" reappeared in the April 15, 1841 issue of *Signs of the Times* to illustrate the dream of Nebuchadnezzar. Looking rather like a Victorian gentleman in long underwear, the figure is divided into five portions indicated graphically by half-tone and black shading (fig. 63). Next, Miller turned to the seventh chapter of Daniel and

SIGNS OF THE TIMES
AND EXPOSITOR OF PROPHECY.

VOLUME II.--NO. 2.	BOSTON, APRIL 15, 1841.	WHOLE NO. 26.

THE SIGNS OF THE TIMES is published on the 1st and 15th of each month, at the Bookstore of MOSES A. DOW, 107 Hanover st. next door to Hancock School House.

JOSHUA V. HIMES, EDITOR.

TERMS.—One Dollar a year, payable in advance. 6 copies for five dollars, 13 copies for ten dollars. All communications should be directed to the Editor, post paid.

SECOND COMING OF CHRIST.

EVIDENCE FROM SCRIPTURE AND HISTORY OF THE SECOND COMING OF CHRIST ABOUT THE YEAR 1843, AND OF HIS PERSONAL REIGN OF 1000 YEARS, FIRST PUBLISHED IN 1833. BY WM. MILLER.

CHAPTER I.

THE DREAM OF NEBUCHADNEZZAR. Dan. ii. 31–45.

We have in this prophecy a description of four kingdoms which would arise in the world and continue until the end of all earthly kingdoms. This prophecy was revealed, first, to Nebuchadnezzar, afterward to Daniel, in a dream, together with the interpretation thereof. It was represented by an image, whose brightness was excellent, and the form thereof terrible. The head of the image "was of fine gold," representing, as Daniel has explained it in the 38th verse, the Chaldean kingdom under Nebuchadnezzar.——"The breast and arms of silver," denoted the Mede and Persian kingdom, which began with Darius after the destruction of the Babylonish kingdom, and was composed of two lines of kings, first the Medes, afterwards the Persians, very fitly represented by the breast and arms of the image. This kingdom began about 536 before Christ, and ended 336, lasting about 200 years. "Belly and thighs of brass," representing the Grecian monarchy, which began to fulfil this prophecy under Alexander the conqueror, 336 years before Christ, and lasted about 178 years, including the four kingdoms into which Alexander's was divided at his death, and finally subdued by the Romans, about 158 years before Christ, which last kingdom is properly and fitly represented by the "legs and feet" of the image, "part iron and part clay." "He saw until a stone was cut out of the mountain without hands, which smote the image upon his feet which were of iron and clay, and broke them in pieces. Then was the iron, the clay, the brass,

the silver, and the gold, broken to pieces together, and became like the chaff of the summer threshing floors; and the wind carried them away, that no place was found for them." Dan. ii. 34, 35. The reader will readily perceive that the kingdoms of this world must be totally and utterly destroyed when this prophecy is fulfilled. For all that is like the gold, the silver, the brass, the iron and the clay, must be swept away together, and that the kingdom of Christ, represented by the stone cut out of the mountain without hands, *will fill the whole earth.*

THE "FOUR GREAT BEASTS."—Dan. vii.

In the 7th chapter of Daniel, we have another prophecy of the same things, which Daniel calls a vision, in which he saw, under the figure of "four great beasts," coming up from the sea, diverse one from the other.——"The first was like a lion and had eagle's wings: I beheld till the wings thereof were plucked, and it was lifted up from the earth, and made to stand upon the feet as a man, and a man's heart was given to it." Dan. vii. 4. This verse describes clearly the Chaldean kingdom under Nebuchadnezzar; the *lion* denoting power and great authority, the *eagle's wings* the exaltation and glory *being plucked,* showed Nebuchadnezzar that his exaltation and glory would depart from him for a season, and he would be taught that he was no more than a man, for after suffering the want of his reason for a little time, he would have a man's heart restored to him, and learn that the Most High ruled—this is the head of gold.

The "second beast was like unto a bear, and it raised itself up on one side, and it had three ribs in the mouth of it, between the teeth, and they said thus unto it, arise and devour much flesh." This is a prophecy of the Mede and Persian kingdom, which conquered Babylon. By the figure of the *bear,* representing desire for conquest, and showing by the figure, that this government would have three separate kingdoms under its authority, by the "three ribs in the mouth of it," to wit: The Chaldean, Mede, and Persian, and that it would be governed by a line of kings from one of these nations only, when it began its conquests. "Raised up itself on one side." Cyrus, the conqueror of Babylon, being a Mede; and by the expression, "*arise, devour much flesh,*" we are taught that they would subdue many and populous kingdoms, which proved to be true; for in the days of Ahasuerus, he reigned from India even to Ethiopia, over an hundred and twenty-seven provinces. This kingdom agrees with the breast and arms of silver. Daniel vii. 5.

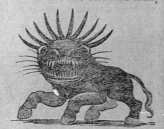

"And after this I beheld and, lo, another like a Leopard, which had upon the back of it four wings of a fowl; the beast had also four heads; and dominion was given to it." Dan. vii. 6. This beast represents the Grecian kingdom under Alexander the first king, which kingdom was divided into four parts at his death, shown in the vision, by the four wings of a fowl, and also established into four separate kingdoms, denoted by the four heads. Alexander, it is said, conquered the then known world, which is expressly noticed in the vision of the image. Dan. ii. 39, "which shall bear rule over all the earth," and also in the vision under consideration by these words, "and dominion was given to it." This Grecian kingdom, then, is the same as the belly and thighs of brass in the image vision.

And "after this I saw in the night visions, and behold a fourth beast, dreadful and terrible, and strong exceedingly; and it had great iron teeth; it devoured and break in pieces, and stamped the residue with the feet of it; and it was diverse from all the beasts that were before it, and it had ten horns." 7th verse. This is a very noted prophecy of the Roman kingdom, and much is contained in this vision of the fourth kingdom, represented by this dreadful and terrible beast—not like any other, or Daniel would have told us what one. But like them all, as represented by John, Rev. xiii. 2. "And the beast that I saw was like unto a Leopard, and his feet were as the feet of a Bear, and his mouth as the mouth of a Lion." This has been fulfilled in the Roman government, for Rome conquered with the celerity of an Alexander or Leopard. She stamped upon and governed as many provinces as the Medes and Persians, the Bear. She claimed, and exercised the same authority as Nebuchadnezzar; exalting and opposing herself above all that is called God. And like Nebuchadnezzar she destroyed Jerusalem, and has persecuted the people of the living God, like the lion. "And it had ten horns," answering to the ten toes of the image, and both together allude to the ten kingdoms, into which the Western or Roman empire was divided about A. D. 476 by the Goths, Huns, and Vandals. "I considered the horns, and behold there came up among them a little horn,"

Fig. 62

Figures of Daniel 7 and 8, cover, *Signs of the Times* 2, no. (April 15, 1841), 1. Courtesy of the Adventist Heritage Center, Andrews University.

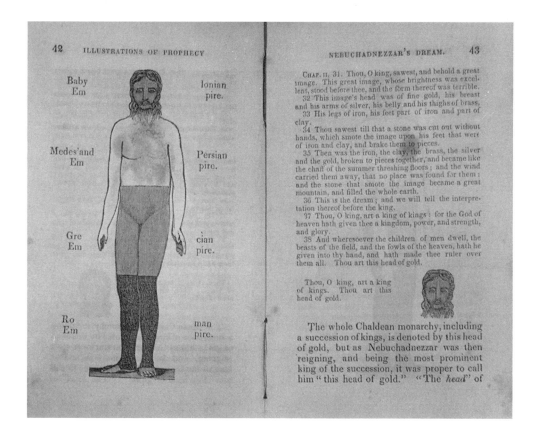

Fig. 63
The Great Image, from
David Campbell,
Illustrations of Prophecy
(Boston: David
Campbell, 1840) 42–43.
Courtesy of the
Adventist Heritage
Center, Andrews
University.

discerned in visions related there a second description of the series of kingdoms described in Daniel 2:

And four great beasts came up from the sea, diverse one from another. The first was like a lion and had eagle's wings: I beheld till the wings thereof were plucked, and it was lifted up from the earth, and made to stand upon the feet as a man, and a man's heart was given to it. And behold another beast, a second, like to a bear, and it raised up itself on one side, and it had three ribs in the mouth of it between the teeth of it: and they said thus unto it, Arise, devour much flesh. After this I beheld, and lo another, like a leopard, which had upon the back of it four wings of a fowl; the beast had also four heads; and dominion was given to it. After this I saw in the night visions, and behold a fourth beast, dreadful and terrible, and strong exceedingly; and it had great iron teeth: it devoured and brake in pieces, and stamped the residue with the feet of it: and it was diverse from all the beasts there were before it; and it had ten horns. I considered the horns, and behold, there came up among them another little horn, before whom there were three of the first horns plucked up by the roots: and, behold, in this horn were eyes like the eyes of man, and a mouth speaking great things (Daniel 7:3–8, King James Version).

According to Miller, these four beasts corresponded to Babylon, Medo-Persia, Greece, and Rome. The fourth beast constituted two stages of the

history of Rome: its first form represented pagan Rome; its second, with the little horn, papal Rome.

As in Campbell's book, the images accompanying Miller's *Evidence* were inserted into the columns of the article beside the discussion of the biblical text they illustrated. They appear therefore to summon to the mind's eye what the text describes. Although Miller's previous publications of *Evidence* only included a long fold-out "Chronological Chart of the World" that was composed of an elaborate timeline and biblical notations, a passage reproduced in the *Signs of the Times* reprint of the first chapter affirmed the visual sensibility of the prophecies and, by extension, the images included in the reprint:

> That God has seen fit to present important truths to the mind of man by plain figures and familiar objects, we do not wish to deny, for in this manner truth is more lastingly impressed, and the ideas are conveyed not only through the ear, but by the eye also. For instance—who ever read this vision in Daniel, with any anxiety to understand, and should afterwards see a lion, but would remember that in studying the prominent features, parts, or qualities of the animal, he was learning the same prominent characteristics of the Chaldean kingdom?[58]

The visual sense, according to Miller (and Campbell no doubt) was more durable than the aural because it was linked more firmly to memory.

In fact, imagery had been used in earlier periods of American visual culture to enhance memory. The illustrated primers and hieroglypic Bibles of the eighteenth and nineteenth centuries were popular instances in which a letter or a Bible verse was replaced by or set beside an image for the sake of teaching children to memorize the alphabet or scripture. Compare, for instance, the apocalyptic imagery illustrating a rebus of Revelation 13:2 in *A New Hieroglyphic Bible* of 1836 (fig. 64).[59] The animals served as substitutes for nouns in the biblical text given at the bottom of the page. Each image was a singularly defined equivalent of a proper noun (italicized in the text): it carried with it a shadow and fit within a rectangular perimeter that was inserted into the sentence of the rebus. The animals were seen in a characteristic angle, that is, one that offered their salient features. The *Hieroglyphic Bible* was intended "to promote an early love for the Sacred Writings in the minds of youth, by alluring attention towards them" and therefore shared the didactic purpose of imagery used by Campbell and the Millerites.[60] Both the images in the *Hieroglyphic Bible* and the animals in Campbell's book were derived from the wood engravings of Thomas Bewick, whose work so influenced Alexander Anderson, as discussed in chapter 2. Bewick and his students produced an enormous number of animals for his *General History of Quadrupeds* (1790). The leopard in Anderson's American edition of Bewick's *History* (fig. 65) was almost certainly the model for the *Hieroglypic Bible's* beast (fig. 64).

Images not only crystallized Miller's ideas in the imagination of the reader but provided a more concrete access to the mysteries of biblical prophecy. In fact, "mystery" is a word Miller despised in connection with biblical interpretation. He rejected the view that "prophecy is revealed to us in enigmas, on purpose to perplex or puzzle."[61] Millerism embraced

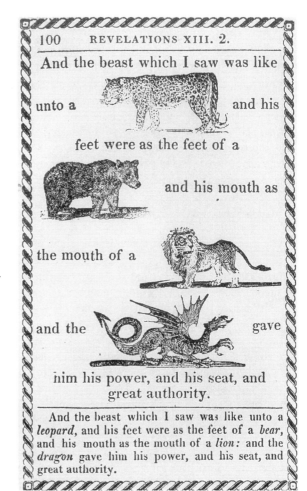

Fig. 64 (right)
"Revelation 13:2," *New Hieroglyphic Bible,* 11th ed.
(Chiswick: Printed by C. Whittingham for
William Jackson, New York, 1836), p. 100.

Fig. 65 (bottom)
Alexander Anderson, engraver, after Thomas
Bewick, leopard, from T[homas] Bewick, *A
History of Quadrupeds: Engravings chiefly copied
from the Original of T. Bewick by A. Anderson.*
Second American Edition from Eighth
London edition. New York: Jonas Booth,
Senior, 1841, p. 143. Courtesy of Department
of Special Collections, University of
Chicago Library.

100 REVELATIONS XIII. 2.

And the beast which I saw was like

unto a and his

feet were as the feet of a

and his mouth as

the mouth of a

and the gave

him his power, and his seat, and
great authority.

And the beast which I saw was like unto a
leopard, and his feet were as the feet of a *bear*,
and his mouth as the mouth of a *lion :* and the
dragon gave him his power, and his seat, and
great authority.

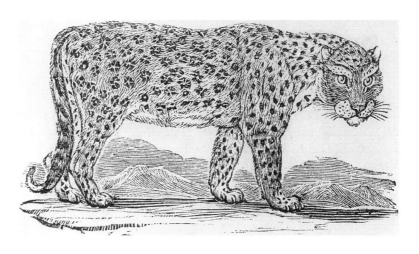

what its proponents called a literalist approach to interpretation of the prophecies, in opposition to allegorical or rationalist readings. Adventist hermeneutics will occupy our attention further, but it is sufficient for the moment to recognize that the early use of images in Millerite publications was especially appropriate for explaining and understanding the biblical prophecies. The use of the imagery did more than simply illustrate arcane religious ideas. The Millerite exegetes believed that God had elected to use graphically visual symbols to reveal the progressive scheme of history. Pictorial images were an appropriate mode of explication inasmuch as they preserved the original character of the revelation. The prophecies and their visual notation in the symbols were a special form of revelation as concretization, a unique language unveiled only in the Bible according to many nineteenth-century exegetes, millennialist and otherwise.[62]

The use of imagery to clarify Millerite doctrine as the movement gathered momentum from 1840 to 1842 led its preachers and lecturers to incorporate the imagery into a single, synchronic display. One year after the imagery was presented with the first chapter of Miller's *Evidence* in *Signs of the Times,* two Millerite converts, Charles Fitch, a Congregationalist clergyman, aided by Apollos Hale, a Methodist minister, designed a large, two-piece chart painted on canvas to present to the twelfth general conference of Adventists, held in Boston in May 1842. We learn about this event in Joseph Bates's *Second Advent Way Marks and High Heaps,* published in 1847. Bates described the years of 1841 and 1842 as contentious ones among Adventists, who gathered in a series of conferences in New England and New York to debate the interpretation of key chapters in Revelation and Daniel. Chief among these debates was disagreement over the historical reference of the "little horn." If, as Miller and his colleagues believed, the little horn signified Rome, Miller felt his broader chronological claims were further substantiated for a predicted end "about the year 1843." It is at this point in his narrative that Bates introduced the presentation and sanctioning of what was to become the standard "'43" chart (fig. 56).

Fitch presented his chart at the opening of the conference, where it "was unanimously voted to have three hundred of these charts lithographed forthwith."[63] In addition to Bates, who presided over this conference, several others were present who were emerging as Millerite leaders, including Joshua Himes, secretary of the conference, editor of *Signs of the Times,* and publisher of the chart; and Josiah Litch, who produced his own chart. Miller himself was also present. A core of preachers faithful to Miller's ideas were active in making this conference the most significant by passing a series of resolutions in support of their belief that, as they put it, "God has revealed the time of the end of the world and . . . that time is 1843."[64] This suggests that the chart emerged at a crucial point in Adventist history and was deployed by the circle around Miller to secure the views he held over those of other premillennialist writers and preachers such as Campbell.[65]

Whatever Fitch's original looked like—and given the repetitive use of Campbell's imagery heretofore, Fitch no doubt relied on existing iconography—Himes once again made use of the imagery in the possession of his printers Dow & Jackson. The calculations visualized on the '43 chart

were based on Miller's schematic table of dates called the "Chronological Chart of the World," which appeared in the 1842 version of *Evidence* and in the May 1, 1841 issue of *Signs of the Times*.[66] The '43 chart bears a similar title: "A Chronological Chart of the Visions of Daniel & John." Instead of wood engraving, which was too limited in size for the purpose of a large visual aid, Himes turned to another medium, lithography.[67] Only invented in 1796, lithography was newly arrived in American commerce. Color lithography in the United States was first practiced in Boston, where in 1840 an English immigrant produced the first chromolithograph, a multicolor print composed of separate layers of color added by successive printings from several stones. In the early 1840s lithography was beginning to become popular as an inexpensive means of producing business cards, sheet music, fine art prints, certificates, and posters. Himes went to the Boston lithography firm of Benjamin W. Thayer & Company, which was capitalized by Thayer and based on a partnership with his brother-in-law, John H. Bufford (1810–1870), who was among the earliest of Boston's lithographers. Bufford created his first chromolithograph in 1843, and twenty years later his shop produced a chart designed by Seventh-Day Adventist founder James White.[68]

But the Millerite chart published by Himes was not a chromolithograph but a black-and-white lithograph colored by hand after it was printed. The '43 chart consisted of figures and typography executed in black crayon on two stones. The top half ended just beneath the Great Image. The entire image measured forty by fifty-five inches.[69] The two halves were printed in monotone on two pieces of cloth. After the print was pulled it was hand-tinted in three colors and an additional mixture to create a fourth hue (green). Ochre was applied to the beasts of pagan and papal Rome and to the lions of Babylon. The same color was also used to indicate the patch of ground beneath each of the creatures on the chart. Over this was laid a blue wash to produce an earth green. The same blue colored the garments of the Mohammedan horsemen and Christ's wastecloth. Red was used for the dragon and the blasphemous beast on which the Whore of Babylon is seated. The Great Image displays bronze and silver pigments. The workmanship in color application throughout the chart is not high, appearing quite hasty.

The chart's colored versions of the lions, bear, leopard, ferocious beast, rams, and goats came more or less directly from the *Signs of the Times* articles and Campbell's book. The male figure of the Great Image, however, was new. Campbell's scantily dressed Victorian was replaced by a more ruggedly built figure whose long hair and beard appear less contemporary. The gesture of this Yankee Hercules, whose body is divided into colored zones that refer to the different materials described by Daniel, resembles Babylonian and Mesopotamian statuary, which were just beginning to be excavated in the 1840s and 1850s by French and British archeological expeditions in what is now Iraq.[70] The rigid, frontal aspect of the figure, the gesture of the arms, and the shape of the hair are quite similiar to the figure of Asurnasirpal, which, however, was excavated many years later (fig. 66). Whether or not it was possible that Himes, Fitch, or Hale derived the new version of the Great Image from reproductions of Assyrian, Babylonian, Sumerian, or Egyptian statuary remains to be determined. In

Fig. 66
Statue of Asurnasirpal, wood engraving, from
Ernest Babelon, *Manual of Oriental Antiquities*
(London: H. Grevel, 1906), p. 86.

any case, the arms of the figure in the lithograph are folded, flexing pow-
erful biceps and shoulders. This gesture modifies Campbell's version,
which identified the upper torso as Medes and the lowered arms as Persia.
In the lithographed version Greece is more distinct; the arms (Persia) do
not extend into the lower zone of the bronze belly (Greece). The exotic
appearance of the imagery struck one observer of the large painted chart
at a camp meeting the next month in New Hampshire (June 1842), the poet
John Greenleaf Whittier. He wrote that the chart was composed of "ori-
ental types and figures and mystic symbols translated into staring Yankee
realities, and exhibited like the beasts of a traveling menagerie."[71]

The lithographed chart was organized in a grid of several vertical
columns and horizontal registers.[72] On the left side a timeline runs from
700 B.C. to 1843 A.D., the length of time that encompassed the prophetic vi-
sions of Daniel and John, according to Miller. The Great Image occupies
the first vertical space on the left beside the timeline. Beneath the human
figure appear "The Ten Kingdoms," fragments of the clay and iron feet of
the Great Image. These pieces represent the tribes that followed the glory
of pagan Rome. These are an innovation in Millerite visual culture and
represent a development of thought concerning the interrelation of the
second and seventh chapters of Daniel. Daniel 2 indicates only that the clay
and iron feet of the Great Image will be "broken in pieces," whereas Daniel
7, which Miller insisted on reading as an elaboration of Daniel 2, specifies
that the fourth beast possessed ten horns, from which "ten kings shall
arise" (7:24).

Beside the Great Image descends the next column of images, these taken from the seventh and eighth chapters of Daniel. The lions, bear, leopard, and the ferocious fourth beast were positioned beside the Great Image in order to correspond with the successive regimes that compose the male figure. In this way the chart visually displays the Millerite interpretation of the biblical prophecies. Beside the animals from Daniel 7 appear a series of goats and rams from Daniel 8, which was read as yet another elaboration on Daniel 2, this one including explicit mention of the "Prince of the host" (8:11) interpreted by premillennialist Christians as Jesus Christ. The sequence ends in Daniel 8 with the cryptic statement that the entire process will require twenty-three hundred days until the "sanctuary shall be restored to its rightful state" (8:14). Following a very old tradition of interpreting a day in apocalyptic symbolism as a year, the Millerites read the twenty-three hundred days to equal twenty-three hundred years. Because the decree to restore and rebuild Jerusalem issued by Ezra occurred, it was determined, in 457 B.C., this date served as the commencement of the period of twenty-three hundred days, terminating in the advent of Christ to cleanse the sanctuary on earth in 1843 A.D. The Babylonian captivity of Israel was dated to 677 B.C. and therefore served as the beginning of the prophetic chronology, the commencement of Israel's sevenfold indignation as punishment for sins (Leviticus 26 served as the Millerites' source for this figure).

In the middle of the chart runs a column of dates with a crucifix in the center of the column and page. These dates were placed once again in reference to the Great Image in order to represent the historical beginning and ending of regimes, the death of Jesus at the point of transition from pagan to papal Rome, the countdown to the end of the papacy in 1798, and the extra forty-five day/years necessary to complete the twenty-three hundred day/years in 1843. This calculation was buttressed by additional figures derived from Daniel 12:11–12, which states that "from the time that the continual burnt offering is taken away . . . there shall be a thousand two hundred and ninety days. Blessed is he who waits and comes to the thousand three hundred and thirty-five days." The end of pagan Rome was given as 508 A.D., the date of what Miller interpreted to be the loss of the daily sacrifice mentioned in Daniel 12:11. The sum of 1,335 day/years and 508 is 1,843.

In the lower right quadrant of the chart appear apocalyptic images from Revelation, which were integrated into the total scheme of dates and configured chronology moving synchronically across the chart. These events were demarcated as the trumpets sounded in Revelation and constituted the countdown to the second coming of Christ, when the seventh trumpet and third woe would herald the end. The papacy, the ferocious beast with the little horn that grew from the midst of the others and is represented on Fitch's chart by the impaled head with papal tiara (shown much larger than the head in Campbell's beast, no doubt in order to stress the Roman rather than Moslem identity of the "little horn") was dated by Miller and his associates to have ended in 1798, when Napoleon's general Louis-Alexandre Berthier occupied Rome, whence the pope took flight only to die the following year in exile. A short forty-five year jump (the dif-

ference between the final 1,290 and 1,335 days mentioned in Daniel 12:12) from 1798 brings the chronological sequence of the chart to an end in 1843.

The Visual Rhetoric of Millerism

Bates's account of the authorization of the '43 chart is revealing. At the commencement of the meeting in the spring of 1842, Bates wrote, Fitch and Hale

> presented us the Visions of Daniel and John which they had painted on cloth, with the prophetic numbers and ending of the vision, which they called a chart. Br. F., in explaining the subject said in substance as follows: he had been turning it over in his mind, and felt that if something of this kind could be done, it would simplify the subject, and make it much easier for him to present it to the people. Here new light seemed to spring up. These brethren had fulfilled a prophecy given by Hab[akkuk] 2468 years before, where it says, "And the Lord answered me and said, *write the vision and make it plain upon the tables, that he may run that readeth it* [Habakkuk 2: 2]." This thing now became so plain to all, that it was unanimously voted to have three hundred of these charts lithographed forthwith, that those who felt the message may read and run with it.[73]

According to Bates, Fitch had sought a more effective manner of presenting Millerite views of prophecy. A basic motive for introducing the chart in Millerite homiletics was the practical need for enhancing the effectiveness of preaching the cryptic computation of the prophecies. The number of calculations, their correlation with diverse points in the Bible, the correspondence of different symbols and images, the use of arcane numerological multipliers such as seven and three and one-half, and reliance on symbolic transformations such as days to years must have strained any preacher's capacity to present the chronology to audiences. Visualizing the scheme in the form of a large chart to be displayed before an audience offered Millerite speakers a map to refer to throughout the course of their presentations. Indications, as I will show, are that the instructional value of the chart was high inasmuch as it provided a touchstone for each idea and interpretive move within Millerite theological discourse. The subtle doctrines displayed a sequential and synchronic logic in the visual order of the chart. To this visual rhetoric and its persuasive power I now turn.

At the opening of *Second Advent Way Marks and High Heaps*, Joseph Bates remarked that it was *"perfectly natural* for every person either travelling or sailing to have their minds excited respecting their starting place, their place of destination, and all the intermediate places on their way; among passengers on the land, but more particularly on the ocean, the continual enquiry is our whereabouts."[74] Bates, a career ship captain, knew whereof he spoke. If there is one trope that characterizes the discourse of Adventism, it is the map or chart. The familiarity of this nautical metaphor is not a surprise in an age when transatlantic and river navigation were a domi-

nant means of long-distance travel for Americans and when pioneers and explorers charted the unknown regions of an expanding nation. These existential conditions gave the metaphor currency. Implicit in the figure, also, is a view of time and history that appealed to Americans generally and to Adventists in particular. The chart metaphor configured time as linear and progressive, as moving uniformly toward an explicit destination. The chart served to plot one's progress and to prevent one from becoming lost on the journey.

This sense of plotting linear progress had also appealed to the ATS's ongoing arithmetic of production and proselytism. The quantitative approach certainly reflects the spread of numeracy in the early republican period but also testifies to the evangelical concern to conduct religious efforts on the basis of sound business practices.[75] But for the Millerites the impulse to plot a course signified something more. The chart visualized both the need for urgency and alarm and the assurance that order and divine authority would prevail. In a reply to objections to calculating historical periods, specifically to claims that biblical prophecies were too enigmatic to be used to delineate chronological sequences, Apollos Hale remarked on behalf of his fellows: "We have never been able to perceive the value of a chart that would not tell the sailor where to find his port, *until after he had arrived.*"[76] An anonymous article in *Signs of the Times* promoting the literal interpretation of the Bible stated that when believers ask *how* or *if* instead of accepting *what* scriptural prophecy proclaimed, "we shall soon be beyond our depth, and without chart or compass, sun or star."[77] One of the Advent Tracts (no. 4) published by Joshua Himes, written by "A Brother Sailor" and entitled *A Warning from the Faithful Pilot To Keep a Good Look-Out For Danger at the Close of the Voyage,* opened with a story about a shipwreck that occurred when the warning of an elderly sailor on board was not heeded. The old sailor was likened to the Bible, that "old neglected chart of the world's history." The tract continued with a brief interpretation of Daniel 7 and inserted several of the identical images from the 1841 *Signs of the Times* (fig. 61) and 1842 Himes chart (fig. 64). The tract concluded with the warning that "the great chart of the voyage, and all the landmarks, tell us we are near its end. Friend, if you are on the *wrong course, put the ship about while there is time to clear the rocks.*"[78]

The notion of the spiritual path in life would have also seemed quite "natural" to American evangelicals and Adventists because it sounded the basic theme of the most popular literary text of the eighteenth and nineteenth centuries, Bunyan's *Pilgrim's Progress.* The ATS reprinted the text and included several illustrations, one of which visualized the journey of Christian toward his heavenly destination. The allegorical conceit of *Pilgrim's Progress,* the Christian's path through life toward the City of God, was updated among nineteenth-century Adventists, who applied it to contemporary travel and technology and coded the "progress" as escape from the apocalyptic judgment drawing nigh. The millennial theme was something that the Puritan Bunyan and the readers of his day certainly embraced, but the difference between Bunyan and the Millerites involved the shift from a rhetoric of allegory to one of symbols. According to the Millerites, the prophetic creatures of Daniel and Revelation were not allegorical references to virtues and vices and the believer's trials but visual

symbols of historical chronology, a special key to the understanding of universal time rather than allegorical signs of the inner experience of temptation and tribulation on the pathway of the devout life. Thus, the familiar engraving of Bunyan by John Sturt (fig. 67) depicts the mental landscape of the dreaming author in the foreground whereas the '43 chart (fig. 56) claims to schematize the objective reality of human history.

The Adventist charts provided an orientation in time in the manner that a map offered position in space. In effect, the Adventist charts mapped time. Uriah Smith, an Adventist publisher and writer who had experienced the disappointment of the Millerite debacle as a boy, urged the student of Seventh-Day Adventist doctrine to "place the Chart before him, just as he would his atlas in learning a lesson in geography."[79] What Bates said about the travelers' excitement regarding the course of their journey may reveal why the mapping of time was so important to the Adventists. The excitement Bates observed must consist in the fact that the chart, as a map of space or an emplotment of time, enacted in symbolic form the progress of the traveler. Whether spatial or temporal, the chart was an analog code rather than a purely digital one, which meant that it offered the viewer a microcosmic vision of the macrocosm through which he or she traveled. The chart, in other words, brought the traveler into a secure relationship with the journey itself by providing an overarching sense of the journey and destination, by removing the feeling of impotence and ignorance that plagued those unfamiliar with or not in control of the course of travel. "Every anxious traveler knows," Bates continued, "what a relief it is to his mind to find a guide board, a mile stone, or a post." The very title of Bates's

Fig. 67
John Sturt, The author's dream, engraving from John Bunyan, *The Pilgrim's Progress* London: printed for J. Clarke and J. Brotherton, 1728. Courtesy of the Library of Congress.

history of Adventism, *Second Advent Way Marks and High Heaps,* was a reference to such markers along the way. The prophetic charts offered mileposts, which situated the contemporary traveler at the end of time. This realization intensified believers' sense of place: the charts showed them not only where they were but also what was about to happen. The Adventists occupied the final moment of human history.

As analog codes, the charts visualized an analogy of time's passage. They did so by combining the digitially recorded information of scriptural prophecy with the graphic codes of images. At the heart of Millerite visual culture was a semiotic interactivity, an interdependence of word and image, seeing and hearing, reading and looking. Bates referred to Daniel 7 and 8 as "pictorial prophecy."[80] In his discussion of the origin of Fitch's chart, he pointed out that the chart fulfilled an old prophecy that read: "[W]rite the vision and make it plain upon tables, that he may run that readeth it." In the King James translation of Habakkuk 2:1 the prophet stated that he would take his watch "to *see* what he [the Lord] will *say* to me" (emphasis added). The biblical text displays a play between ear and eye, hearing and seeing: from "see" to "say," from "vision" to "writing" and reading. Vision was inscribed for the purpose of transmitting what was seen.

In the case of the Adventist charts, this transposition of vision to text meant an interweaving of biblical texts and visual forms in the fabrication of a systematic interpretation of prophecy. The charts combined alphabetic, numeric, and graphic signs in a single visual field. The disparate forms of representation were integrated such that one could *read* images and *view* the spoken word. For Bates and his fellow Adventists in the 1840s, writing the vision meant transcribing it first to text (accomplished in Habakkuk), then visualizing it once again in the imagery of Fitch's chart. The contents of the original revelation passed unadulterated from the biblical inscription to the chart. Just as Habakkuk had written what he saw, the '43 chart visualized what the Millerites read. In effect, their charts provided the means of reading scripture.

In the center of the '43 chart (fig. 56) is the crucifix, which served as the radial point of prophecy and history. The crucifix was placed beside the end of pagan Rome and in the midst of a block of biblical text that runs in a column from Daniel 8:21 to 8:25. Verses 8:21–24 are interspersed among images of two rams and a he-goat. The text moves across the chart to the right to envelop the crucifix. Fitch borrowed from the 1841 articles in *Signs of the Times* (fig. 62) the practice of breaking up text with the imagery described therein. But in the crucifix he achieved an even closer integration of word and image by placing the crucified Jesus within a portion of text, Daniel 8:25, which the Millerites considered a prophecy of Christ. The text reads that an earthly power (pagan Rome, according to the Millerites) would arise and "stand up against the Prince of Princes, but he shall be broken without hand." On the chart the crucifix appears in the text such that "Prince of Princes" is inscribed on the horizontal member of the cross above Christ's head. As a result, biblical text and pictorial image intermingle in the manner of a rebus. Since the relationship of Christ to pagan Rome was considered by the Millerites important proof in the contested interpretation of the "little horn" as Rome, Fitch included additional notes

on the chart around the crucifix to bring image and text to support the Millerite position: "Of all the powers named in these visions, none but Pagan Rome could stand up against the Prince of Princes, as this only prevailed during the life of Christ." This text stretches from the body of Jesus on the cross to the grotesque image of the red, seven-headed dragon representing pagan Rome in Revelation 12:3–4.

The chart therefore brings together in a single visual field diverse moments in scriptural prophecy, visualizing the conservative Christian view that all of scripture is a unified, homogenous text revealed by God. This interweaving of texts and images effectively visualized the manner in which many Christians read the Bible. The design of the chart, the way it was decoded, constituted a visual practice of reading that was poised between two semiotic orders and sought to benefit from the authority of each. On the one hand, the images *are* the visions. We see what the prophets Daniel and John saw. These are the transcribed visions returned to their original visual form. On the other hand, these images are sandwiched between the biblical passages that evoke them. The scriptural texts are assembled into a pastiche that moves with its own logic in a pattern of synchronic parallels from left to right and top to bottom, assisted by the running chronology of the timeline on the left and the prophetic arithmetic descending on the right. The bottom line in the pictorial ledger of time is "God's Everlasting Kingdom" in 1843.[81]

The chart, in other words, marshaled together the veracity of images and the sacrosanct authority of the biblical word. The biblical text became concrete and immediate; the images were authorized as scriptural. This imaging of word and textualizing of the image served to portray the Millerite interpretation of history as biblical prophecy fulfilled. In effect, Adventist biblicism used images to map apocalyptic scripture over historical events. By "biblicism" I mean a practice of reading the Bible as a self-contained, homogenous text that is without error and entirely the revealed word of God. The Bible, it was often claimed by the Adventists, was exclusively its own interpreter and sole authority in matters of faith.[82] By this the Adventists meant more than the standard philological technique of comprising a lexicon of meanings for purposes of cross-reference from one historical document to another. The Millerites, like many conservative Protestants, considered the Bible self-contained and without any passage that would not disclose its proper meaning for the devout Christian given to prayerful reflection. Millerite writers and preachers were fond of dismissing commentaries and critical analyses of the text in favor of scripture alone (though in practice Millerite exegetes made extensive use of biblical commentaries and chronologies that supported their interpretation of prophecy, and they appealed to a wide array of historical studies—Fitch even included references to these in the '43 chart). William Miller related that his study of scripture was assisted only by a trusty *Cruden's Concordance,* an aid that encouraged the reading of scripture as sacrosanct and autonomous.[83] Readers of the *Midnight Cry* were urged to acquire *Cruden's* for this reason. "It enables a person to make the Scripture its own expositor. . . . It was by the use of this Concordance that Brother Miller was first led to embrace his present views on the coming of Christ."[84] Discussion of the hermeneutic practices of Miller's circle will complete a picture of

Adventist scriptural interpretation and provide an indication of the importance of the charts among the Millerites.

The Use of Charts among Millerites

Describing the form of the chart and its imagery and accounting for its theological significance among the Millerites does not exhaust our historical curiosity about why it came into use when it did and what changes the form and reception of the Adventist chart underwent in ensuing years. We must examine the use of the chart among the Millerites and successive generations of Adventism.

As Bates related, the '43 chart was used "to explain from."[85] In presenting his chart to the General Conference in May, 1842, Fitch said that he had created the chart in order to "simplify the subject, and make it much easier for him to present it to the people."[86] The chart quickly became a part of Millerite camp meetings. By October of 1842 at a meeting in Salem, Massachusetts, the mass-produced chart counted among the gear of many preachers. Bates recorded the following:

> The ministers present who preached were Elders Himes, Litch, Fitch, Hale, Plumer, Cole, and many others. So anxious were the people to hear on this great subject [the Second Advent], that those who could not be accommodated in the big tent, could be seen in the distance congregated under trees and clumps of trees, listening to selected ministers, explaining from the '43 chart, fastened to the trees.[87]

In his career as a Millerite preacher, Bates carried the '43 chart about with him when he took the message to the road in 1843–1844 during a circuit of several towns in the East. Upon entering a crowded schoolhouse one evening in Maryland he immediately set about finding a place to set up the chart. Then a companion "began to sing one of the favorite advent hymns, which stilled them into silence, and the meeting continued with deep interest to the close."[88] When he was invited to the home of a man in the audience, Bates was explicitly charged to bring the chart. While taking passage aboard a Long Island steamship, Bates took advantage of a captive audience. "In the evening, after passing Hurl Gate, we hung up the chart in the center of the passengers' cabin; by the time we had sung an advent hymn, a large company had collected, who began to inquire about the pictures on the chart. We replied, if they would be quietly seated, we would endeavor to explain."[89] Coupled with Advent hymnody, the chart served the purpose of calling attention to the proclamation of the Adventist gospel. For itinerant preachers who lacked the architectural milieu of a church interior and the formal structure of a liturgy, the chart and hymn established a focal point, a momentary site for presenting the good news of Christ's imminent Second Coming. Toting, hanging, and taking down the chart became something of a ritual in and sign of the ministry of the Millerite preacher and lecturer. A letter from a Millerite preacher in England proclaimed: "I preach about the streets with my chart hoisted up on a pole."[90] Apollos Hale reported in a letter published in *Signs of the Times*

that on the return trip from a second advent conference in Bangor, Maine, Joshua Himes "took his chart into the saloon [of the Boston-bound steamboat on which they were passengers] where he spent an hour or two in explaining it to all who wished to listen."[91] Hale also wrote that while in Bangor, Himes made a present of "one of our prophetic charts" to a theological school he visited. Advertisements in flyers and Millerite newspapers announced that preachers would include diagrams or charts in their lectures and publications.[92] The chart became one of the accoutrements of the Adventist preacher's oratory. The clergy possessed and conspicuously displayed the charts in the home and on the road as articles of their calling. The daughter of a Millerite preacher recalled that the walls of her home in 1844 "were covered with charts illustrating apocalyptic and prophetical visions."[93] A visitor to Miller's home in 1843 wrote that the preacher displayed in one room of the house "a large diagram of the visions of Daniel and John, painted on canvas."[94]

The chart also became part of the autobiographical memories of Millerism. James White, future leader of the Seventh-Day Adventists, had been one of the Millerite lecturers to use the chart. In the fall of 1842, White "had purchased the chart illustrating the prophecies of Daniel and John, used by lecturers at that time, and had a good assortment of publications upon the manner, object, and time of the second advent."[95] In a passage that parallels Miller's own autobiographical account of the origins of his ministry, the young schoolteacher applied himself to an intense study of these items: "with this chart hung before me, and these books and the Bible in my hands, I spent several weeks in close study, which gave me a clearer view of the subject." In the spring of 1843, the impoverished White, who had spent his winter's earnings attending meetings, buying clothing, and "in the purchase of books and the chart," set out "into the great harvest-field." He prepared three lectures on the millennium, the signs of the times, and the prophecy of Daniel, then "folded my chart, with a few pamphlets on the subject of the advent . . . and left my father's house on horseback." White bore indignities from riotous crowds but reported that many received his message. On one occasion, after speaking to an unruly group, he "closed with benediction, took my chart and Bible, and made my way out through the subdued crowd"—a terse allusion, perhaps, to a similar experience in the life of Christ recorded in Luke 4:28–30. The chart was part of the message for which the Adventist missionary suffered.[96]

The original edition of three hundred charts lithographed in the summer of 1842 was no doubt intended for Adventist preachers and lecturers since, according to an article in *Signs of the Times* of January 15, 1842, there were between three hundred and four hundred ministers at work on behalf of the Millerite cause.[97] In fact, the primary consumers of the chart seem to have been Millerite lecturers and preachers. The chart distinguished the Adventist speaker as someone with a message. The speaker was a teacher, a professor of special knowledge. The chart assumed that a passive audience was situated before a speaker who made use of a visual aid to convey his message more effectively. As a mass-produced item, Millerite lecturers understood the chart to address a mass audience. White proceeded like the Methodist circuit rider through his assigned district.

Lay speakers related presenting their charts to passengers in transit. The chart did not require the formal setting of organized religion but was designed for the task at hand: a peripatetic preaching of the end of the world shortly before it arrived.

But as advertisements in *Signs of the Times* and the *Midnight Cry* during the summer and fall of 1842 indicate, sale of the charts was not limited to Millerite clergy but made available to a much wider market. In June an ad in *Signs of the Times* offered the "now nearly finished" chronological chart of the visions of Daniel and John, presumably Fitch's design, for the price of $2.50 to subscribers;[98] and in a December ad of the same year in the *Midnight Cry* the same chart is said to "form a valuable auxiliary in the study of the Scriptures."[99] The editorial office also announced in this ad that stationery depicting Daniel's vision was available on a half sheet of letter paper priced at 6¢ (fig. 68). "This is convenient in correspondence on this subject, and the remainder of the sheet furnishes room for an accompanying letter." Arranged and published by Himes, this chart was designed to enhance communications among the faithful and in outreach. The three registers separated the parallel imagery of Daniel 2, 7, and 8 along three timelines that more or less corresponded to one another. The parallel organization presented the principal interpretations and calculations of Millerism and invited the viewer/reader to explicate the prophecies with

Fig. 68
A pictorial chart of Daniel's visions, stationery arranged and published by J. V. Himes, Boston, 1842. Courtesy of the Adventist Heritage Center, Andrews University.

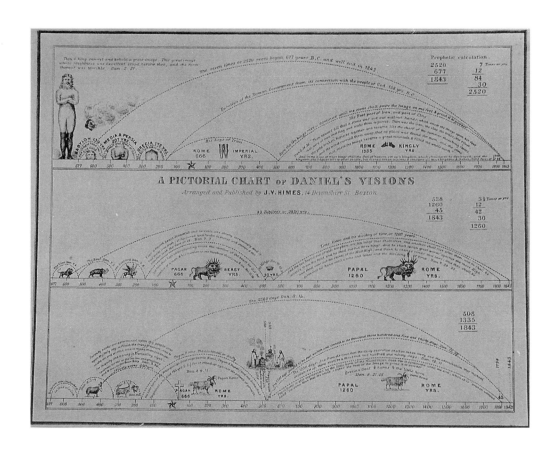

the aid of mass-produced ephemera that could be personalized by one's letter and shared with readers at any distance.

Himes also advertised two other forms of stationery or "letter sheets": one with Miller's "Chronological Chart" and another with his "Rules of Interpretation." Both products were repeatedly advertised in *Signs of the Times* and the *Midnight Cry*, where they were offered for 2¢ per sheet.[100] Himes wrote unabashed copy for the ads, in which he tied the stationery to other commodities that his firm sold:

> Those who believe in Christ's nearcoming, should write all their letters on [these] sheets. . . . All letters should be sealed with the monitory wafers, by which a letter may be sealed much more conveniently than with ordinary wafers. Each one of them carries an impressive sermon on the outside of it, in the shape of some text [eight New Testament texts were listed]. . . . In this way, our letters, as they go, PREACH, and the Lord may bless their testimony.
>
> Letter Sheets and Wafers for sale at this office.[101]

The point was to link the commodity to the occasion, indeed, to identify the two in such a way that God's work could only properly be accomplished by the use of Himes's product. Himes apparently did not fear this commodification of Millerism because of the dire circumstances of an imminent Second Advent. Certainly Himes was not becoming wealthy from his publishing efforts. He genuinely saw the commerce involved as a way of spreading the word, that is, of practicing his faith in its mandate to evangelize.

The flurry of Millerite paper put precipitously into global circulation convinced Bates that "no work of God had ever aroused the nations of the earth in such a powerful and sudden manner since the first advent of the Saviour and day of Pentecost."[102] It may have genuinely appeared this way to Bates and his colleagues because of the unprecedented immediacy of what amounted to a mass media feedback loop. Events were reported instantly in the Adventist press, a good portion of which was overseen by Joshua Himes. The Adventist public read about its own activities and those of others from around the globe within days of reported events. There was a carefully constructed sense of a wave or movement taking shape, fueled regularly by well-organized camp meetings, conferences, press coverage, and extensive correspondence published in the periodicals. True to their titles, nearly every issue of *Signs of the Times* and the *Midnight Cry* excerpted items from the world press reporting on natural disasters, meteorological phenomena, astronomical events, racial migrations, religious and political developments, and so on—all as harbingers of the end. The transmission of press reports of recent events promoted the notion that the entire world was witnessing the eschaton.[103]

In the Jacksonian age of populist politics, the mass media—newspapers, political caricature, and ephemeral handbills and broadsides—became especially powerful means of shaping public opinion. The modern age of mass media was under way. Newspaper and periodical publication burgeoned. The intimate linkages of commerce, belief, and the ideology of progress and populism provided a new context for mass-produced print

and imagery. But all the changes in technology that postmillennialists read as harbingers of the American republic's arrival and special mission were deciphered by the Millerites as indices of the end. Yet rather than repudiate the new communications networks, Himes, Miller, and their colleagues applied them to the final task of reform, what Barnum might have billed as the ultimate show on earth.

The Commerce of Images
and Adventist Piety

From its inception during the Millerite period to its reinstitution among Adventists after the failure of the Second Coming of Christ to occur as Miller had predicted, the prophetic chart became a proudly displayed mark of difference. This is not surprising when we remember that Millerism developed an oppositional consciousness as it was attacked by Protestant orthodoxy. Charles Fitch, who had designed the most popular chart in 1842, undertook in the summer of 1843 his "Out of Babylon" crusade, which drove a wedge between the Protestant mainstream and the Adventist movement (much to Miller's regret).[1] By 1844 the chart served to distinguish insider from outsider, as the daughter of Millerite preacher Joseph Marsh recalled when she wrote in 1886, about the charts covering the walls of her childhood home, that "those realistic conceptions of the supernatural bewilder[ed] one uninitiated in their mysteries."[2] Adventist imagery and charts often appeared at the intersection of conflict. A major assault on Millerite doctrine by the Baptist pastor John Dowling, which was reprinted on the front page of a *New York Tribune* extra, included a reproduction of a chart, "Daniel's Visions," first published in the *Midnight Cry* (fig. 69).[3] Opponents seized on the Millerite imagery as a means of public identification and ridicule of Millerite beliefs. One broadside lampooning Miller as the "high priest of Millerism" preaching at the East Kingston, New Hampshire, camp meeting in June and July of 1842 (where Fitch also presented the painted chart) included the ten-horned beast representing pagan Rome. The image was identical to the beast from Campbell's *Illustration of Prophecy,* which had also appeared in the April 15, 1841 issue of *Signs of the Times* (see fig. 58). An article in *Signs*

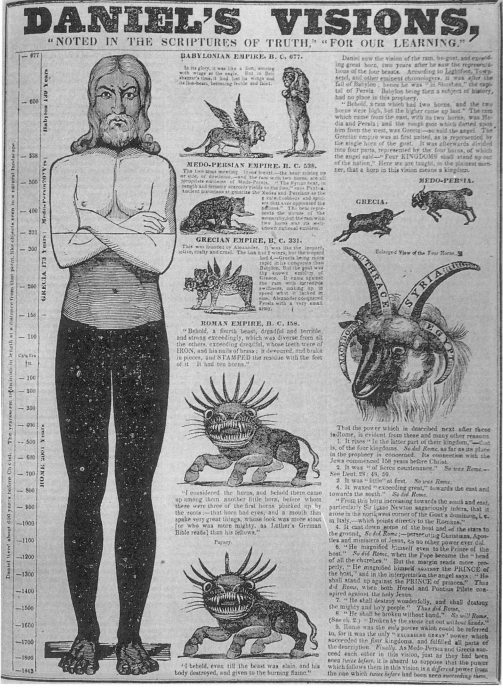

Fig. 69

"Daniel's Visions," from *Midnight Cry* 3, nos. 1 and 2 (February 24, 1843), 8–9; reprinted in the *New York Tribune* Extra, vol. 2, no. 277 (March 2, 1843), 1. Courtesy of the Adventist Heritage Center, Andrews University.

of the Times from March of 1843 complained of the circulation of several caricatures of the Millerites, one of which ridiculed the beasts seen by Daniel and taken from the Millerite chart.[4]

Charts after Millerism

The chart itself came in for special derision and resentment. Opponents of the Millerites blamed it for egregious and harmful effects. In the spring of 1843 a Massachusetts newspaper reported that a woman gave birth to "a nondescript child, with two heads and a double set of hands and feet, and nine toes on one foot. She had been excited at a Miller meeting, and looking at the disgusting animals on the Miller diagrams."[5] If it was not harmful to one's health, the chart could be regarded as the tool of deception and ignorance. This is evident in an acerbic parody of 1845, a five-act play called *"Asmodeus in America"* in which the use of the chart by the faithful underscored the playwright's idea of the absurdity of the Millerite movement:

> Brethren, you can perceive that the first Pope, according to this chart, wore horns, and that the present one has got none—which proves beyond doubt that we are correct. If you want any more proof, apply to our great Leader, and he will explain to you all about those prophecies, which he has long studied—some of which he has made himself![6]

Beyond being seen as a hazard or a means of deception, the chart was also associated with lunacy and deranged behavior that critics thought was characteristic of Millerites. An account in oral culture which survived into the twentieth century related the story of one Ben Whitcomb, an eccentric convert to Millerism in Massachusetts. Whitcomb was said to ride on horseback sporting a massive cloak, epaulettes made of a hornet's nest, bells and streamers sown to his clothing, bearing aloft, "as a flag, one of the Millerite charts made of linen on which was painted pictures of terrible beasts, and of the ram, the he-goat, and the exceeding great horn," as he shouted "the Day of Doom was at hand." Whitcomb eventually committed suicide.[7]

Among the Adventists the charts also served the purpose of distinguishing "us" from "them." This is perhaps no more clear than in the repeated use of the imagery in literature directed to Adventist youth.[8] The popularity of the imagery among children was made clear in the account published in 1886 by Jane Marsh Parker. Having lived through the great disappointment of October 22, 1844, Jane Marsh grew up to reflect on the experience of having been a Millerite child. The centrality of the chart and its imagery in the play of the movement's children is clear in the following passage:

> How well grounded we children were in the prophecies! The book of Daniel was our story book. We could play at "meeting" when the pranks of the scoffers were an outlet for our spirits; we could give for a sermon a fair version of Nebuchadnezzar's dream and the interpretation

thereof, piling up books and boxes to represent the great wooden image on the preacher's stand at the hall, taking away kingdom after kingdom until nothing was left but "these last days," awaiting the stone cut without hands. We liked to make pictures on our slates like those on the chart, and to work the mathematical problems of the 2300 days, the 70 weeks, the 1290 and 1335 days.[9]

The game of reproducing and gradually eliminating the "great image" may have been prompted by an illustrated article for children published in the *Midnight Cry* in 1844 by Nathaniel Southard.[10] Probably indebted to the device first put forward by David Campbell, Southard illustrated his discussion of the Great Image in incremental fashion, adding each section to the figure as he discussed its historical symbolism. Jane Marsh Parker indicated that these games were played during meetings of the adult Millerites, in the final days, when the children were no longer allowed to attend public school because sending children to school amounted to "counting upon a future" and "a denial of faith in the speedy coming." Instead, the children played together, imitating the meetings of their parents and suffering the abuse of "scoffers."[11]

As the Adventist movement developed from the Millerite phase (1839–1844) to the formation of the Seventh-Day Adventist church, the role of the chart evolved. The embattled culture of Adventism and the separatism of the Seventh-Day group led Adventists to regard the chart as a kind of banner charged with group identity, an exclusive sign of difference behind which to rally. Miller had first determined that the Second Coming would occur sometime in 1843. When this did not occur, a new calculation circulated among the faithful that set the time at October 22, 1844. Following the Great Disappointment of the second date, a small number of former Millerites, Joseph Bates among them, maintained their belief in the imminent Second Coming but refused to assign a date to it. They eventually gathered around two central themes: the view that what happened on October 22 had been a celestial rather than an earthly event; and the belief that the proper observance of the sabbath was Saturday, the seventh day of the week, not Sunday. Both ideas continued to separate the Adventists from mainstream Protestantism in the United States.

Already by 1850, Seventh-Day Adventist iconography registered the concern for difference as it developed its first chart to use among the faithful. For instance, one particular feature on a chart by Joseph Bates called the reader's attention to the shut door of the inner sanctuary or "holy of holies" within the celestial temple.[12] Originating in the final days of the Millerite period and surviving among certain Adventists in the late 1840s and early 1850s was the radical notion that this shut door foreclosed the possibility of redemption for those who had rejected the Millerite message of Christ's imminent return. This had the effect of distinguishing the small group of Adventists gathered around Bates and the Whites. To this belief the group added the directives of spiritual kissing and foot washing, two ritual acts that other Adventists, including Joshua Himes, strongly criticized.[13] Yet the result was a galvanized group consciousness in which the band of Adventists thrived. The charts they produced at the time enhanced this sense of uniqueness and mission.

The 1850 Rhodes Chart

On November 1, 1850, Ellen White, visionary and spouse of James White, wrote in a letter that she and her husband had just arrived in Dorchester, Massachusetts, where she received a vision in which she was shown "the necessity of getting out a chart. I saw it was needed and that the truth made plain upon tables would affect much and would cause souls to come to the knowledge of the truth."[14] Ellen White and her husband came to realize early on the efficacy of the publishing business in establishing their new church. A former Millerite preacher, James White no doubt learned this from the remarkable dissemination of information during the early 1840s. His wife, also a former Millerite, brought visionary legitimation to his enterprise and the founding of the Seventh-Day Adventist church, which was preceded by the establishment of a series of publications: *Present Truth* (1849) and the *Second Advent Review* and its replacement by the *Second Advent Review and Sabbath Herald* in 1850, all of which were edited by James White.

Ellen White's reference to the "tables" of Habakkuk 2 was of course drawn from Fitch's Millerite chart and from Joseph Bates's 1847 account of the '43 chart's origin. White referred in her letter to a vision of the apocalypse, millennium, and last judgment, of which she had written a description that was published in the November 1850 issue of *Present Truth*. In addition to the eschatological subjects of her vision, White said she also saw "that the shepherds should consult those in whom they have reason to have confidence, those who have been in all the messages, and are firm in all the present truth, before they advocate any new point of importance, which they think the Bible sustains."[15] White and her husband sought to consolidate church doctrine as well as the ranks of preachers already spread out across the East and penetrating into the Midwest. Her correspondence, her travels, her visions, her husband's publishing ventures, and the charts were the principal means of achieving doctrinal and ecclesiastical unity. Ellen White ended the account of her visions with one she dated to September 23, 1850. This vision affirmed the 1843 Millerite chart and explained the miscalculation it graphically represented: "The Lord showed me that the 1843 chart was directed by his hand, and that no part of it should be altered; that the figures were as he wanted them. That his hand was over and hid a mistake in some of the figures, so that none could see it, until his hand was removed."[16] White's vision in November occurred in the home of Otis Nichols, a former Millerite and a lithographer, who was engaged in the production of a new prophetic chart designed by Adventist preacher Samuel Rhodes. After Rhodes had shown his design to the Whites in August 1850, Ellen wrote: "[I]t is larger than any chart I ever saw; it is very clear. We like his chart very much."[17] Her vision of September 23 sanctioned the need for a chart, and the vision mentioned in the letter of November 1 christened the production of Rhodes's chart (fig. 70).

James White wasted no time in promoting the new chart. In fact, he followed his wife's affirmation of the '43 chart in November 1850 with an article the next month in the second number of his new *Review and Herald*. There he cited the chart published by Himes and claimed, like Bates in 1847, that the chart was a fulfillment of Habakkuk 2:2–3; he also

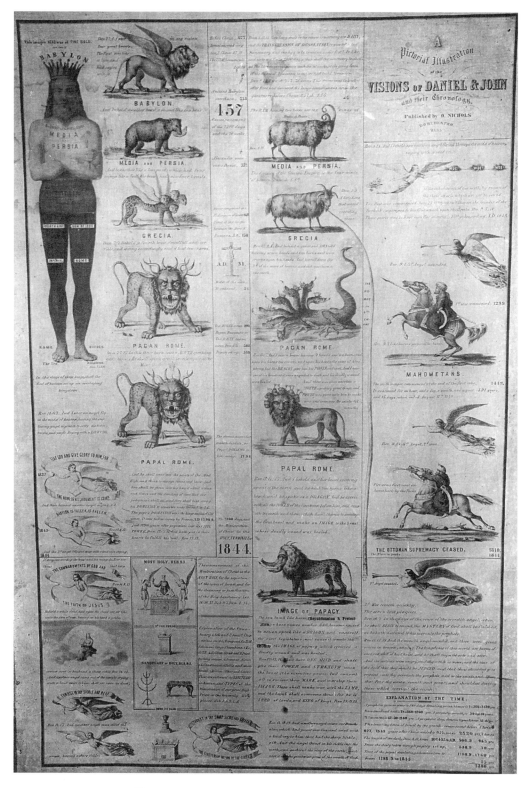

Fig. 70
Cecil Rhodes, *Pictorial Illustration of the Visions of Daniel & John,* lithograph,
published by O. Nichols, Dorchester, Massachusetts, 1850. Courtesy of the Adventist
Heritage Center, Andrews University.

announced that the chart had been a "subject of prophecy" and that "those who deny it leave the original faith."[18] One month later, in January 1851, White announced in the *Review and Herald* that the new chart was ready: "We think the brethren will be much pleased with it, and that it will be a great help in defining our present position. . . . Those whom God has called to give the message of the third angel can have it free."[19] The "present position" to be defined for audiences was the "message of the third angel" of Revelation 14:9–13.

As the focus of Seventh-Day Adventist preaching and evangelism, the "third angel" referred to the present age inaugurated in 1844 with the termination of the twenty-three hundred days of Daniel 8:14 when, according to the Seventh-Day Adventists, Christ entered the heavenly sanctuary, the holy of holies, to minister directly before God's throne on the mercyseat described in Exodus 25:8–40. Between 1845 and 1849 or so, the sabbath-keeping Adventists developed a theology that reinterpreted Miller's mission and the disappointment of October 22, 1844, and set the task of Adventists after that date, as the so-called closing work before the Second Coming of Jesus. Ellen White affirmed William Miller and the Millerite chart and did so in accord with Seventh-Day Adventist intepretation of the three angels of Revelation 14. The first angel (Revelation 14:6–7) announced that the hour of God's judgment had come. The Whites, Bates, and their colleagues determined that this angel signified the ministry of Miller and the end of the twenty-three hundred days on October 22, 1844. The second angel (Revelation 14:8), which proclaimed the fall of Babylon, the Seventh-Day Adventists took to refer to the fall of the "professed church, who rejected the truth," that is, the Second Advent message of the Millerites.[20] For the Adventists, besieged by Protestants and Catholics, "Babylon" came to represent all of Christian orthodoxy in the United States and elsewhere. James White remarked that this repudiation of "the sectarian churches" commenced during the Millerite period with the "Come Out of Her My People" initiative.[21] Estrangement was therefore institutionalized in Seventh-Day Adventism. The third angel (Revelation 14:9–12) was said to present a special message of warning to those who would confront the trials of the last days. White cited the angel's call for the saints' patience and considered that the "class of Christians mentioned by the third angel . . . are [those] keeping the Sabbath of the Lord our God" as they await the second coming."[22]

The 1850 chart by Rhodes features imagery derived from the '43 chart and from charts published first in *Signs of the Times* in May 1843 and shortly later in the *Midnight Cry*.[23] The beasts representing pagan and papal Rome came directly from the *Signs* chart (see fig. 61), as did the angel of Revelation 13:13, sounding the trumpet of woe three times in the upper right. The Great Image in the Rhodes chart borrowed its crown from the *Signs* version. The rest of the details common to the Rhodes and '43 charts (see figs. 56, 62, and 69) appear to have originated in the latter. New to Rhodes' chart were the three angels and the sanctuary in the lower left (fig. 71). Each of the first two angels bears a date, stressing their chronology: 1837 and 1843. White indicated that the "burden of the second angel's message" was delivered prior to the fall of 1843. The date of 1837 refers to Miller's work, as Bates indicated in his 1850 *Explanation of the Sanctuary*: "Just look back to

Fig. 71
Detail, Three angels, *Pictorial Illustration of the Visions of Daniel & John*, lithograph, 1850. Courtesy of the Adventist Heritage Center, Andrews University.

1837, when the glorious doctrine of the second Advent began its rise and move through this land of messengers, with their first and second messages."[24] A single line separates the first two angels from the third, which is followed by Christ enthroned in the clouds, depicting the long-awaited Second Advent. The third angel bears a banner reading "The Commandments of God and the Faith of Jesus," a reference to the Seventh-Day Adventist's keeping of Saturday sabbath as a recovery of the fourth commandment: "Remember the Sabbath to keep it holy." Beside Christ and the third angel is a schematic portrayal of the sanctuary. The outer court contains a candelabra, table, and censor; the inner sanctuary shows the ark and the cherubim with the high priest cleansing the holy of holies on the day of atonement. Beneath the sanctuary are the ritual laver and altar for burnt offerings.

Easy to miss in the 1850 chart is the New Testament antitype of the Jewish sacrifice: the crucifix. Located in the upper center, a tiny crucifixion took its place within the chronological sequence from the commencement of the 2,300 days in 437 B.C. to the cleansing of the sanctuary in 1844 A.D.

The crucifixion was not the pivot of the chart's diagrammatics but one calculation within the whole. This underscored the primary purpose of the chart among Seventh-Day Adventists: an overarching vision of the development of history in accord with divine prophecy from ancient Babylon to the present time when Christ was due to return. In the first phase, the Christ for whom Adventists looked was not the crucified savior but the triumphant judge and apocalyptic monarch returned to claim his own and pronounce judgment on those who had denied him and his remnant. Each of the visual elements of Rhodes's chart corresponded to the interpretation of biblical prophecies that led to the "present position" or "present truth," the time when the Bridegroom tarries just before his sudden arrival in the parable of the ten virgins (Matthew 25:5).[25]

The final innovation of the 1850 chart was the two-horned beast of Revelation 13:11, which appears at the bottom of the central column of figures. This new iconography further exemplified the tension between the Seventh-Day Adventists and the nation in which they lived. The zeal for social reform that had consumed many of those who went on to become Millerites in the 1830s and early 1840s was evidence of a deep discontent with national life. This discontent was transformed into the religious separation of the Millerites in 1843 and, as I have shown, was institutionalized from the beginning among the Seventh-Day Adventists. What bothered the sabbatarian Adventists more than anything, for obvious reasons, was the move among many state legislatures to enact Sunday laws that bestowed government sanction on the Sunday sabbath practice of Catholics and nearly all Protestants.[26] Rhodes indicated in text beneath the two-horned beast on the chart that the horns stood for "Republicanism and Protestantism."

> [The horns], whose names number 666, become unified in action, speak like a dragon, and controll the civil legislature, and cause it to make the Church the image of papacy which received a deadly wound and was healed. Rev. 17:13–14. These have one mind and shall give their power and strength unto the beast (the executive power). And causeth all to receive their mark, and worship their image.

In 1851, John Nevins Andrews, Joseph Bates, and James White—three of the most important figures in the movement—published essays that spelled out the identity of the beast figure.[27] Andrews ventured to put into print for the first time what he and his colleagues had no doubt been discussing privately for some time. He argued that the beast's lamblike character cited in Revelation 13:11 and the fact that it arose in the West and from the earth (as opposed to the sea) meant the following: the nation this beast represented exercised a mild form of power—a republic; unlike other beast-nations, this beast arose from the land rather than water, a symbol of peaceful origin. And it emerged in the West, that is, to the west of the Roman domain, which, Andrews reasoned, extended to the Atlantic coast of Europe. Therefore, the two-horned creature must mean the land west of Europe: America. The two horns "denote the civil and religious power of this nation—its Republican civil power, and its Protestant ecclesiastical power."[28]

Early in their formation as a church body, therefore, Seventh-Day Adventists nurtured autonomy from state control and difference from Protestant orthodoxy. Identifying this beast as the republicanism and Protestantism that made up the United States must have seemed compelling to a group of believers who considered themselves the faithful and persecuted remnant of the great disappointment of 1844. Now was the tarrying time, the moment of waiting before the Second Advent. The Seventh-Day Adventists placed themselves center stage and portrayed the government and religious establishment in the United States as the instruments of the antichrist. The prospect that the United States was the two-horned beast only underscored the message of the third angel: Persevere in upholding the law (i.e., keeping the sabbath) until the return of Christ (which was imminent, though incapable of being precisely determined).

The chart was intended to assist in the final phase of the history of the church: the gathering of the scattered flock. Ellen White spoke of this last period as the "gathering time," when God would bless attempts to "recover the remnant of his people" and when "efforts to spread the truth will have their designed effect."[29] James White aggressively promoted the chart and stated in the *Review and Herald* that "we are satisfied that [the chart] will be a great help to those who teach the present truth, and prove a blessing to the scattered flock."[30] White did not hesitate to convey his approval of the chart: "We esteem it a TREASURE. It is valuable, because it beautifully illustrates the most sublime and important truths of Revelation, which are particularly applicable to the present time."[31] Accordingly, White offered the chart free of charge to those who preached the message of the "third angel." The chart was marketed as a teaching aid for instructing the faithful before the end. White asked for donations to support the cost of the chart, which came to $400 for an edition of three hundred. The price for a single chart was advertised at $2.00, which included wooden rollers, a varnished finish, and cloth backing to which the paper chart was glued in order to endure travel and successive use. Without any of this, the price per item was $1.25.[32] White posted $140 in donations, including $75 from Otis Nichols, the lithographer who produced it.[33] Orders were directed to Nichols, postage paid, at Dorchester, Massachusetts.

In addition to the "main object" of providing the chart to Seventh-Day Adventist preachers and teachers to share the message in their itinerant ministries, James White felt that "each band of brethren might have one in their places of meeting." White intended for the chart to be provided not to every believer but, like the Millerite chart, only to the traveling ministers and isolated cells of believers around the country. "Those, therefore, who do not travel, and who are situated where they can meet with those who have a Chart, must not expect to have one without paying for it."[34] White continued to solicit donations through the remainder of 1851. Otis Nichols may have handled the business of the charts in 1851–1852; customers were directed to him in 1851 ads, and the *Review and Herald* carried no ads for the charts in 1852. By 1853, however, the *Review* office seems to have taken a larger role in the commerce of the charts. Orders were now directed to the *Review and Herald* as well as to Nichols, who was listed as an agent for the paper in the state of Massachusetts.[35] Charts were also sold at conferences and on regional mission tours. Joseph Bates com-

mented in his report about a tour in New England that orders for the *Review and Herald,* books, and charts resulted from four lectures he presented in Rhode Island. In the late summer of 1859, J. N. Loughborough and Andrews conducted a tent meeting in Michigan, where they delivered thirty-eight lectures, sold "$52.00 worth of books and charts," and "obtained sixteen new subscribers for the *Review.*"[36]

The charts were directly tied to Seventh-Day Adventist preaching and the formulation and dissemination of church doctrine. Letters from important preachers such as J. N. Loughborough, Joseph Bates, and Elon Everts document the use of the chart in mission efforts and preaching.[37] Some of these letters (and many other letters from these and other writers) also testify to the resistance that sabbatarian preachers met from Protestant clergy. "We found so much opposition to contend with here," Bates wrote in one letter, "that we began to question whether it was duty to stay."[38] Yet the Adventist preachers persisted, and the chart seems to have gone with them into the midst of their difficulties. When the preachers met with the faithful or those eager to learn, the charts were cited as a mark of distinction. A Vermont man wrote to the *Review* of his family's struggle to "keep all the commandments of God and the faith of Jesus" (quoting the banner carried by the third angel on the 1850 chart). He and his family were "surrounded with opposition to the seventh-day sabbath" and lived "twenty miles from any one of like precious faith." But he happily related locating Elon Everts and his group through seeing Everts listed as an agent of the *Review* in Vermont: "I met with them on the Sabbath, and what a soul-reviving time it was to me, Bro. Everts exhibited his chart, and made a short explanation on the Sanctuary. A flood of light burst into my mind, and filled my soul to overflowing."[39] Everts experienced this response on more than one occasion. He wrote in February of 1853 of visiting a lonely, Sabbath-keeping couple in New York: "I hung up the chart, and discoursed some hours, while the glad believing heart forced the trickling tears down their cheeks."[40]

Since the chart was closely associated with the Adventist's difference from the surrounding world of church, state, and secular society, and because it served to bind the Adventists together both as a visual symbol and as a homiletic and exegetical tool, James and Ellen White sought to control the chart's design. This may be reflected in the *Review's* more active involvement in sales of the chart in 1853, but this may also have been the result of James White's constant search for funds to support the *Review* and the church's other publishing activities. In any event, Ellen White acted decisively in 1853 when Hiram S. Case, an Adventist preacher, joined Samuel Rhodes to create a larger, apparently more spectacular chart. Sometime in the summer of that year, Ellen White received a stern vision that condemned the activities of Rhodes, Case, and others in Jackson, Michigan, for their willful use of funds, excessive display of means, threat to the harmony of the church, and reticence to respond faithfully to the dictates of her visions.[41] Brother Case, she announced, "had followed the desire of his eyes of late" by joining with Rhodes to promote a new chart, one that threatened to displace the official chart of 1850.

White was offended by the new chart's "uncouth disgusting images" of angels, which she said looked more like "fiends than beings of heaven,"

and by the "light chaffy spirit of ridicule" which the new larger and painted chart of Case and Rhodes created among the congregation. To this effect she contrasted the 1850 chart's depiction of angels as "light, lovely, and heavenly." That chart, which was "ordered by God," led the mind "almost imperceptibly . . . to God and heaven. But the other charts that have been gotten up disgusted the mind, and cause[ed] the mind to dwell more on earth than heaven." White regretted that Case had spent so much time and energy on the new chart and proclaimed that "the chart-making business was all wrong," that it had "spread like the fever," and that the resources "wasted in getting out charts" should have been invested in publishing tracts and like efforts.[42] Ellen White's concern was no doubt heightened by the publication of a letter in the *Review* in April of 1853, in which a new-comer to Seventh-Day Adventism warmly related his visit to Hiram Case and others in Jackson, Michigan: "Brother Case exhibited his Chart and gave a brief exposition of the Sanctuary, which was very striking."[43] The letter-writer praised the Jackson group of Adventists and portrayed them as decisive in his discovery of sabbath-keeping Adventism. This endorsement notwithstanding, Ellen White's denunciation of Case was unsparing and produced the desired result. In the August 28, 1853 issue of the *Review* appeared a brief letter to James White in which Case recanted, confessed his "wrong views" and abuse of "means," and asked the "forgiveness of all my brethren and sisters."[44]

Sales of the 1850 chart were steady through 1853. A notice in October 1853 announced that the *Review* office was out of the chart with rollers but would soon have more.[45] By the following April the chart was no longer listed for sale, presumably because the stock had been sold out. The *Review* continued to advertise and produce literature in book, tract, and pamphlet form, but not charts, in the mid-1850s. Two consecutive notices in July 1857 stated that Otis Nichols had sent the *Review* a dozen charts that could be purchased for $2.00.[46] In May 1858, a business item informed a customer that the *Review* had no more charts and would hold the $2.00 until the customer indicated what to do with the amount.[47]

White's hesitation to produce more charts was no doubt economical, for the charts were expensive to manufacture: in 1853 the $400 it took to produce the 1850 chart amounted to nearly one-third of the annual expense of producing the *Review*. The clientele remained largely preachers and teachers. In June of 1858 White repeated that no charts were "on hand for sale, and [we] cannot publish a revised edition at present." He stated that on an upcoming tour of eastern states he would "collect those unsoiled charts which brethren can spare to supply the urgent calls from those who are beginning to investigate the prophecies."[48] But then he followed this notice in the same issue with one that announced the intention "to print immediately a chart on fine, glazed paper, 20 by 25 inches, which will contain the illustrations by wood cuts found on our lithographed chart, with chronological dates, and explanations of the symbols, much more extensive than on the large chart. Price, 25 cents." White experimented with a new promotional device of combining this new paper chart with Ellen White's new book, *The Great Controversy*,[49] which retailed for 50¢, and a new supplement of Adventist hymns priced at 25¢. The combined set of three items was offered for $1.00.

With the new, inexpensive chart of the visions of Daniel and John, the *Review* was back in the "chart-making business." The chart was listed once again among publications for sale at the *Review* office, and correspondence in the *Review* reflects an increase in commerce of the chart. Interest in the 1850 lithographed chart persisted and White offered to exchange the package of the paper chart, *The Great Controversy,* and the hymn supplement for unsoiled charts on his eastern tour in the fall of 1858.[50] He was successful at this once again and offered the collected large charts for sale, still $2.00 postage paid, in December 1858.[51] In April 1859 White advertised "the small charts pasted on cloth, mounted on rollers and varnished" for $1.00.[52] But the new chart did not hold its value the way the 1850 chart had, and White was left with a large inventory. By the end of 1859 he advertised the chart at the reduced price of 15¢ for the paper version, four for 50¢, and ten for $1.00. The paper chart on cloth with rollers was discounted to 75¢ with no further discount for quantity.[53] The price for singles of each version held into the mid 1860s.

The 1863 Charts

The popularity and the scarcity of the 1850 chart convinced James White that a larger, sturdier chart was a commodity that would benefit both church and business. Therefore in 1863 he undertook a new project: to replace the 1850 chart with a new one. This venture was shaped by the new use to which the smaller chart had been put: decorative display in the home of the Adventists. Whereas the Millerite and the 1850 Rhodes chart had been promoted among preachers and teachers rather than as an item for every believer, White pitched the inexpensive and more available chart of 1858 to every Adventist believer and household. Ad copy for the small chart stated White's new strategy baldly: "We have some of the small charts pasted on cloth, mounted on rollers and varnished, in very good style—just the thing for family use and fire-side lecturing."[54] The production of more highly finished objects "in very good style" was an attempt to create a decorative item for the home. "Style" was an unambiguous appeal to the new role that domestic adornment played in the shaping of character. White now sought to make the itinerant teaching devices that had been mounted and prepared for the road into stationary items for display in the home, where they would take on a new formative power.

The concern for "good style" in the judicious and affordable decoration of the Christian home was stated authoritatively for many American homemakers by Catharine Beecher and her sister Harriet Beecher Stowe in *The American Woman's Home* (1869). The well-known chapter "Home Decoration," which advocated the use of chromolithographs, made the case that tasteful interior decoration was well within the means of the thrifty. Artistic imagery played an important role in this scheme: "Besides the chromos, which, when well selected and of the best class, give the charm of color which belongs to expensive paintings, there are engravings which finely reproduce much of the real spirit and beauty of the celebrated pictures of the world."[55] The Beecher sisters assured their readers of the salutary effects of such images on children. They framed their en-

tire treatise with the assertion that it was a woman's task to create a tasteful Christian home for her husband and family. They aimed to "illustrate a style of living more conformed to the great design for which the family is instituted than that which ordinarily prevails among those classes which take the lead in forming the customs of society."[56]

If Millerism had expected the world to end immediately, Seventh-Day Adventists reinstituted a sensibility of reform and looked to the longer term of a testimonial presence on earth, fashioning themselves as a remnant. Adventist writers therefore exhibited a spirit of reform and domestic mission and became increasingly aware of "home religion," the "family altar," and the importance of nurture during the 1850s and 1860s. Articles in the *Review and Herald* set out to extoll the practice of Christianity in the home and to identify its salient features and benefits. "Does our religion make us act as politely at home as abroad?" asked one writer in the *Review*. "Do we try to be gentle, obliging and kind in the family? . . . If we would have a happy home, and one where the Spirit of God can dwell, we should do all in our power to make it such."[57] Others wrote that "the holiest sanctuary on earth is home" and that the "family altar is more venerable than any altar in a cathedral."[58] Many articles complained that the "family altar" was collapsing in modern American life and linked the destruction of family values to the decline in national character.[59] A frequent item of discussion in the *Review and Herald* pertaining to domestic life was the rearing of children. Adventist readers were reminded again and again of the vital importance of raising children within a Christian—and Adventist—home. Some writers sounded very much like Horace Bushnell, the contemporary Hartford Congregationalist minister who was the foremost Protestant proponent of a theology and domestic pedagogy of nurture.[60] By enclosing domestic life within the word of God, "your home will be made in some degree like Paradise."[61] "Home," another author proclaimed, "should be the dearest and most desirable place in the world to [children], and the father and mother the dearest earthly friends."[62] Philosophies varied from the stern to the gently nurturing, but sabbatarian writers consistently praised the importance of family prayer and Bible study.

Group reading was advocated, and parents were urged to attend carefully to the kinds of reading materials they provided to their children. James Aldrich, president of the *Review* publishing committee in 1867, promoted a list of books for young people. In one advertisement he offered three collections or libraries of books that, he said, "though they are not entirely free from some of the popular errors of the day, [are], in the main, good, and well calculated to lead the young mind heavenward." Like many of the short items on home religion and training the young that were reprinted from non-Adventist sources such as the ATS, these books came from the non-Adventist religious press but were offered for sale through the *Review* office. The 1867 ad listed the following collections: "Youth's Gems," thirty-two volumes; "The Children's Library," sseventy-two volumes; and "The Youth's Cabinet," seventy-six volumes. Each volume consisted of thirty-two pages ranging from 6 1/2¢ to 12 1/2¢ in price. The total price for each collection was $4.00, $6.00, and $9.00, respectively. All the libraries, the ad stated, were "beautifully illustrated."[63]

James White no doubt reasoned that placing a chart among the family would foster a Christian home. Planning for the new venture was ambitious. White prepared not only a new prophetic chart but a Law-of-God chart of the same size (figs. 72 and 73). In October 1863 he announced that both charts were in the artist's hands. The artist is unknown, but the firm belonged to John H. Bufford, a long-established lithographer in Boston, who had produced the '43 chart. During the 1850s Bufford hired several apprentices to produce work that would compete with the steadily rising standards of draughtsmanship. Bufford's reputation had been built on making "fine hand-colored lithographic reproductions of paintings," which may have been what attracted the young Winslow Homer to the firm as an apprentice in the mid-1850s.[64] By 1863, the production of twenty-five hundred charts had become much more economical than it had been twenty years earlier when Himes published three hundred lithographed charts. In fact, White was able to offer his chart at a price 50¢ lower than the price of Himes's.

White promoted the chart as the latest, best piece of Adventist merchandise. The prophetic chart, his ad announced, "will be much improved in arrangement from the one in use," by which he must have meant the 1850 Rhodes chart. "The sanctuary and angels will be larger and bolder, so that all the figures upon the chart can be seen equally plain."[65] The changes White introduced in the new version (fig. 72) responded to the practical need of visual presentation. More than a dozen years of experience in preaching had focused on the messages of the angels of Revelation 14 and on the sanctuary. Accordingly, these elements of the new chart were enlarged. The two-horned beast was now clearly tagged "Protestantism" and placed at the bottom of a separate column of beasts: Roman paganism, Roman papacy, and (American) Protestantism. The cross was enlarged, though it now appears without the body of the savior.

Most noteworthy is the absence of text in the 1863 chart. Ellen White had praised the 1850 chart for its autonomously visual power: it "struck the mind favorably, even without an explanation."[66] James White sought to enhance the value of the chart as a visual aid by eliminating the text, which had been useless in lectures due to its fine print. The result was graphically more striking and doubtless more useful in a large group setting such as a lecture or sermon. In lieu of the text, Uriah Smith, who served as the editor of the *Review* from 1855 until 1869 and 1870 to 1873, wrote a *Key to the Prophetic Chart,* which appeared in 1864 and sold for 10¢ if bought separately from the chart. Three thousand copies of the *Key* were printed in the spring of 1864. They were sent free of charge to everyone who had bought the new chart and were promoted among preachers for them "to offer to the people, especially when they are lecturing on the prophecies and refer to the Chart."[67]

If, as James Moorhead has asserted, the "lords of the Tract and Bible societies assumed that they could . . . impress a common religious culture upon America," Seventh-Day Adventism moved contrary to the mainstream and its aspiration for a national Protestantism.[68] Led by James White, John Nevins Andrews, and Joseph Bates, the sabbath-keeping Adventists used their print and image publications to challenge the hege-

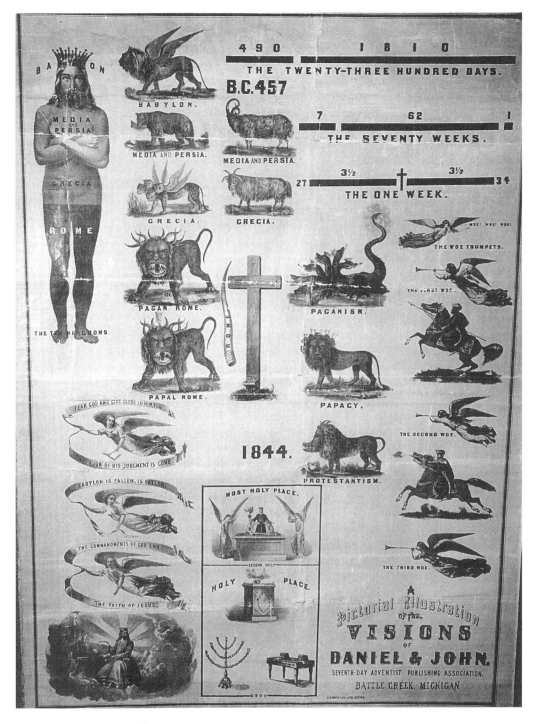

Fig. 72

James White, *A Pictorial Illustration of the Visions of Daniel & John*, Battle Creek, Michigan, 1863. Courtesy of the Adventist Heritage Center, Andrews University.

mony of Protestantism and to reach what they considered the true remnant among the apostasy of the Protestant mainstream. Not only did the image of the beast carry the term "Protestantism" in the 1863 chart, but the leadership issued numerous articles in the 1850s that reinforced the differences between Seventh-Day Adventism and mainstream Protestantism.[69] Writer, editor, and engraver Uriah Smith stressed the theme of separateness in his official discussion of the chart's subject matter as well as its status as a symbol of Seventh-Day Adventism. Moreover, the creation of the new chart coincided with the formation in May 1863 of the General Conference of sabbath-keeping Adventists. The chart may have been announced at the May conference in order to emulate the ratification exactly twenty-one years earlier of the '43 chart at the General Conference of the Millerites in Boston, in May 1842, where the painted prototype of the chart was first presented.[70] The theme of separateness was stressed in the Key's discussion of the chart's subject matter as well as its status as a symbol of

Fig. 73
James White, Law-of-God chart, 1863. Courtesy of the Adventist Heritage Center, Andrews University.

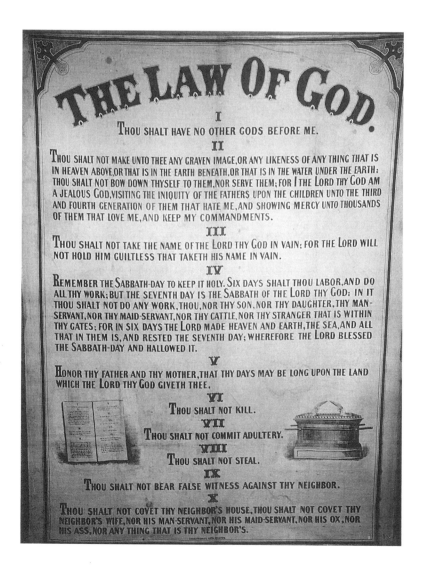

Seventh-Day Adventism. Smith acknowledged the embattled condition of the chart but regarded this as the basis of its privilege:

> Efforts are occasionally made to throw ridicule upon these illustrations of the symbols of Daniel and John's visions. We are described as going about the country with our "pictures," lecturing upon "heads and horns;" and some in their disgusting efforts to be witty on the subject, will even go so far as to apply to these symbols names of the lowest and most offensive animals. Such simple-minded individuals ought to know that they are thus in reality casting contumely and reproach upon the word of God; for all these things are therein plainly described. The illustrations upon the Chart are but the words of the prophet in another form.[71]

Disrespect for the charts (and by extension, for the Seventh-Day Adventists) was disrespect for the Bible. It is no surprise that Smith and his associates were more conscious of the charts as a sign of Adventism than the Millerites had been. The interpretation of the two-horned beast as the United States worked out among the Seventh-Day Adventist leadership by 1851 and treated in numerous publications in subsequent years was glossed in Smith's *Key,* which served moreover as a compendium of basic doctrine. In fact, the *Review* considered the *Key* "among our very best publications for general circulation" and continued to offer it on its publication sales list into the 1870s.[72]

As a sign of sabbatarian difference, White hoped the new chart would find a popular reception among not only preachers but all church members. "These [charts]," he proclaimed, would become "ornaments to the best room of any believing family, and will serve as a happy introduction to the subject of present truth to those who call on them."[73] Accordingly, White produced many more of these than he had of the 1850 chart. Whereas Otis Nichols published three hundred charts for $400 in 1850, White published $2,500 worth of prophetic and Law-of-God charts in 1863. The prophetic chart sold for $2.00 once again and the Law-of-God for $1.50.[74] White may have anticipated the greater popularity of the prophetic chart and made more of it than its companion, for, though he only advertised it for sale as a set with the Law-of-God chart, in the spring of 1864 he announced that the *Review* possessed "many more Law than Prophetic Charts" and offered to sell them singularly or as a set.[75]

White paid for and promoted the new charts in a variety of novel ways: by describing them as a decoration for the "best room in the house"; by offering a special discount on volume ("one-fourth discount and transportation paid by the hundred"); by appealing to ministers who wished to sell the charts "on time"; prompt filling of orders by expanding the number of agents across the country to handle them;[76] and by garnering a product endorsement from one of the most beloved and respected preachers among the Seventh-Day Adventists, the patriarch Joseph Bates, who had been a well-known user of charts since the Millerite days. In the spring of 1864 the *Review* quoted Bates's approval of the new chart: "The charts appear to be perfect, and are splended [sic] pictures for the house of God, and to ornament Sabbath keeper's dwelling places. They are a beautiful

finish. We're much pleased with them [in] every way. The explanation by diagram of the 2300 days is simple and very plain."[77] White also sought to cover initial outlays by accepting donations. From the fourth number (June 23, 1863) to the twenty-fourth number (November 10) of volume 22, $286.60 in donations were posted as received from a variety of individuals around the country, including such noteworthies as Hiram Edson and Merritt E. Cornell. Sales were so brisk that demand outstripped supply. On November 17, 1863, White announced that "up to this time the Eastern market has called for them faster than we could get them finished. We shall supply the West as soon as possible."[78]

Along with the controversial visions of Ellen White, the schematic design of the prophetic chart continued throughout the 1860s into the early 1870s to be the visual sign of Seventh-Day Adventism and the church's difference from both the secular world and from other Adventists. In their respective autobiographies, both published in 1868, James White and Joseph Bates each affirmed the prophetic authority of Fitch's schematic chart.[79] White discussed the relationship of the charts to the Seventh-Day Adventist theology of difference in connection with the message of the three apocalyptic angels. These three angels "illustrate the three great divisions of the genuine movement." White pointed out that Seventh-Day Adventists explain the messages "in their sermons, treat upon them in their books, and give them a place with the other prophetic symbols upon their charts." Those Adventists who stressed the importance of setting times for the Second Coming and those who did not acknowledge God's hand in the work of Miller repudiated the three messages, according to White, and "find no place for them among the other prophetic symbols upon their charts." Seventh-Day Adventists, he continued in a deliberately repetitive, catechetical manner, dwelled upon "the subject of the sanctuary in their sermons and books, and find a place for it among the symbols of prophecy upon their charts." But in the case of "nominal Adventists," one could not "find the sanctuary represented upon their prophetic charts."[80] Clearly, the chart had become a banner raised to identify opposed parties in doctrinal debates.[81] What had been an item designed to attract the masses and elucidate the end of time now was used to address the cleavages within the Adventist movement; the charts became political signs charged with the task of distinguishing orthodox from unorthodox and presenting the party line of a group.

From Schematism to Pictorialism

A new visual strategy occurred to White in 1873 when he saw an image by the sabbatarian evangelist and physician Merritt Gardner Kellogg, older brother of the inventor of cornflakes (John Harvey Kellogg) and son of John P. Kellogg, who had been one of the most generous of Michigan supporters of the Seventh-Day Adventist cause.[82] Two columns in the May 27, 1873 *Review and Herald* announced the appearance of an allegorical lithograph entitled *The Way of Life from Paradise Lost to Paradise Restored* (fig. 74). A lengthy explanation of the picture's symbolism by Kellogg was joined with endorsements of the picture by leading officials in the church such as

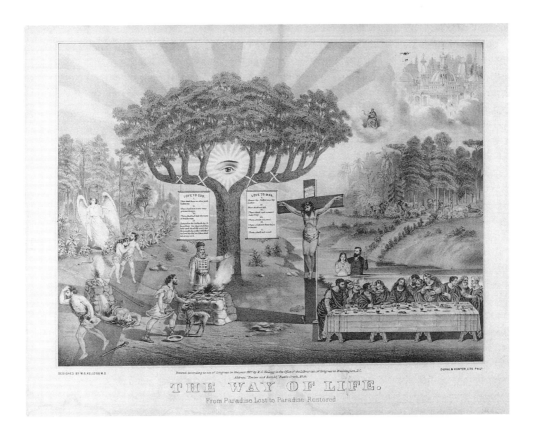

THE WAY OF LIFE.
From Paradise Lost to Paradise Restored

Fig. 74

Merritt Gardener
Kellogg, *The Way of Life
from Paradise Lost to
Paradise Restored,* 1873,
lithogragh. Courtesy of
the Billy Graham Center
Museum.

Uriah Smith, John Nevins Andrews, and J. N. Loughborough. An addi-
tional endorsement came from J. H. Waggoner, evangelist, editor, and
writer, in a note in Kellogg's *A Key of Explanation of the Allegorical Picture
Entitled "The Way of Life,"* published in 1873 by the Seventh-Day Adventist
Publishing Association, the new name for the church press in Battle Creek,
Michigan.

Kellogg stated in the *Review and Herald* advertisement that the picture's
careful arrangement and design justified its service as an "ornament" as
well as biblical illustration. As an ornament, of course, it was meant to be
displayed. The testimonials first printed in the ad and then reprinted in the
Key of Explanation read as if they were prompted by White, who, as I have
discussed, was interested since the late 1850s in supplying decorative im-
agery for the Adventist home. S. N. Haskell, organizer of the church's
Tract and Missionary Society and later evangelist to New Zealand, com-
mented that "no Christian family should wish to be without one" of
Kellogg's lithographs. Loughborough agreed: "Every family should have
one."[83] D. M. Canright exclaimed that he had "never seen anything so ap-
propriate to adorn the parlors of Seventh-Day Adventists." Another writer,
Issac Doren Van Horn, camp-meeting evangelist and former treasurer to
the church's General Conference, observed that the "picture is well wor-
thy of a place in every Christian family";[84] and J. H. Waggoner hoped that
Kellogg's picture might "take the place of many useless pictures now

found in Christian households."[85] "As a parlor ornament," Waggoner assured devout consumers, "it has attractions far in advance of ninety-nine one-hundredths of the pictures generally seen in well-furnished rooms." One imagines the same point was made in person at tent meetings and conferences around the country.

The competing visual culture to which Waggoner referred was made up largely of the prints produced by contemporary lithography firms, the most familiar of which was Currier & Ives. In the early 1830s lithography caught on as an inexpensive means of creating large editions of images, as individual prints and book and sheet music illustration as well as illustrations for magazines and newspapers. Nathaniel Currier (1813–1888), a New York lithographer and businessman, was among the first to recognize the commercial potential of the new visual medium. Beginning in the 1830s, Currier and his competitors produced certificates of membership, stationery, signs, cards, portraits, and commemorative imagery for a burgeoning mail-order business. Lithography allowed artists to preserve the sketchlike quality of charcoal and chalk, and it was not long before brilliant coloration became possible, first by means of stencils, but by the early 1840s in serial printings that produced the first chromolithographs, which quickly became a popular, inexpensive form of home decoration. The commerical viability and the novelty of displaying the new colored images in the home and used as gifts and religious mementos made the prints a formidable rival to the imagery produced by the Adventists. Not only did Currier & Ives flood the market with images of clipper ships, sentimental domestic scenes, and famous American heroes, religious imagery was a sizable portion of their commercial line. This imagery varied from decorative allegories of floral motifs forming mottoes to portraits of saints to domestic scenes of piety and biblical subjects. All of the images, however, shaped public taste in the direction of the pictorial image, a decorative scene suitable for domestic display. The religious subjects of Currier & Ives therefore contributed to the growing popularity of placing photographs, cartes-de-visite, postcards, and prints on view in the home.

According to one historian, in 1849 Nathaniel Currier was approached by the ATS and asked to produce two folio-sized images (fourteen by eighteen inches), *The Crucifixion* (fig. 75) and *The Resurrection* (fig. 76), presumably as premiums for ATS members or donors.[86] The print is signed by Currier's artist, John Cameron (c. 1828–1862). Both images assemble a host of features described in the four New Testament accounts, allowing viewers to read details that appear to add up to a single, comprehensive portrayal of the event. The assumption is quite the opposite of contemporary critical scholarship, such as that by David Friedrich Strauss or Ernest Renan, who produced highly controversial and influential studies of the life of Christ that stripped away much of the detail provided by New Testament writers, particularly wherever the Gospel writers departed from one another.[87] Cameron, by contrast, no doubt like most of his devout viewers, assumed that a single, uniform event lay behind the biblical accounts and that this event was accessible by merging features of each into a conflated version. Thus, in *The Crucifixion* (fig. 75), we see the two thieves mentioned in Luke (23:39–43), John the Evanglist attending Mary and the soldiers who gambled over Christ's garments cited in John (19:26–

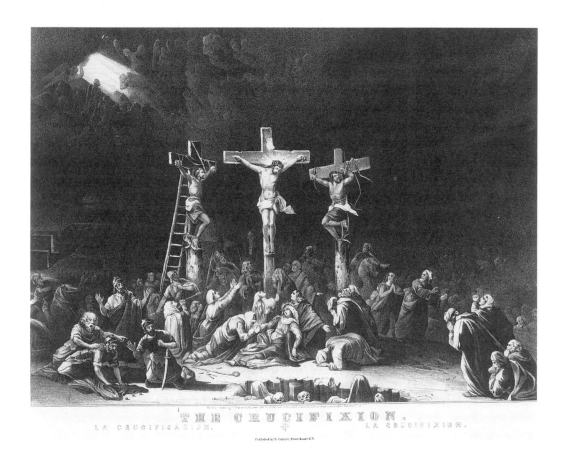

THE CRUCIFIXION.

LA CRUCIFICAZION. LA CRUCIFIXION.

Published by N. Currier, Tract House N.Y.

Fig. 75
John Cameron, *The Crucifixion*, 1849, lithograph, 14.2 × 18.1 inches, published by Nathaniel Currier. Courtesy of the Library of Congress.

7; 19:24), and the appearance of Elijah in the foreground as testament to Christ's authenticity, mentioned in Matthew (27:49). The dense narrative cues distributed through dramatically illuminated scenes allowed English, French, and Spanish-speaking Christians (note the titles in three languages) to use the image in both devotional and didactic settings.

Although the connection of the ATS and Currier cannot be definitively documented, the possibility that the two organizations cooperated in producing these two lithographs is historically significant because it represents yet another resourceful application of the mass production of imagery by American evangelicals. The Tract Society was no doubt impressed by the high volume at low cost that Currier and other lithographers had attained in the mass production of religious subjects for commercial distribution. Currier had produced religious images perhaps as early as 1835, when he entered the business of commercial lithography. The earliest dated images with his imprimatur are *Ascension*, 1844; *The Saviour of the World*, 1845; *Garden of Gethsemane*, 1846; *Adam Naming the Creatures in Paradise*, 1847; and *Reading the Bible*, 1848.[88] In addition to a total of 79 images dated in the 1840s, 164 undated images were produced between 1835 and 1856, such as the ever-popular *Last Supper* after Leonardo (fig. 77). It was no doubt this body of religious images in commercial cir-

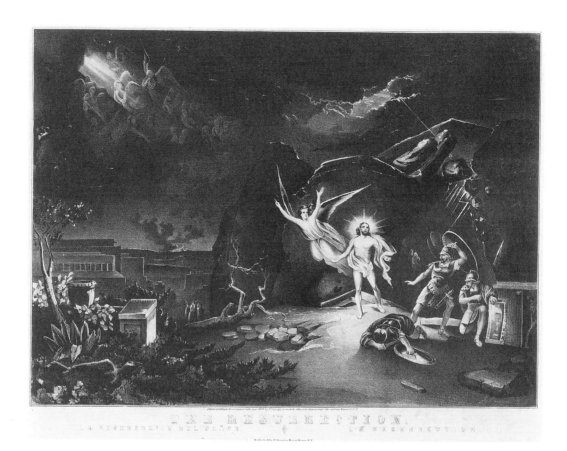

The Resurrection

Fig. 76
John Cameron, *The Resurrection*, 1849, lithograph, 14.3 × 18.3 inches, published by Nathaniel Currier. Courtesy of the Library of Congress.

culation that led the ATS to Currier. Moreover, Currier produced a number of subjects that Protestants would have welcomed: certificates of membership in a Methodist mission society from the 1830s; an image of Bible-reading and an image called *Family Devotion: Reading the Scriptures,* exemplifying a characteristically Protestant motif, as I discussed in chapter 3; an image of *The Death of Calvin* (1846); an 1873 illustration of a favorite Protestant hymn, *Rock of Ages,* which coincided with the team evangelism of Moody and Sankey at the time (Currier & Ives also produced undated portraits of the Chicago evangelist and his accompanist: *Dwight L. Moody: American Evangelist,* and *Ira D. Sankey: The Evangelist of Song*); and—a cause sacred to evangelicals from the ATS to the Adventists—the *Tree of Intemperance* and *The Tree of Temperance* of 1849, which were both reissued in 1872.[89]

Although it is rarely pointed out, from 1835 to 1907 Currier and (from 1852 to 1907) his partner James Merritt Ives (1824–1895) produced no fewer than 540 religious images. Between 1835 and 1856, Currier published no less than 247 religious subjects as black-and-white and hand-colored lithographs. From 1857 (when the title of the firm was changed) to 1907, Currier & Ives marketed at least 293 religious subjects. No fewer than 229 of these may be identified as Roman Catholic by virtue of title, language (Spanish, French, Italian), or subject matter. A handbill from the 1870s listed sepa-

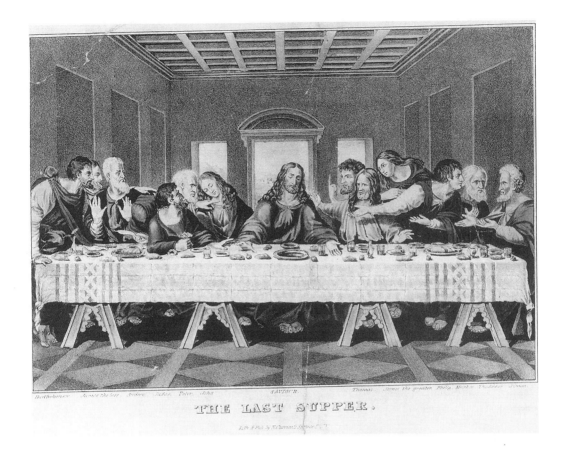

THE LAST SUPPER.

Fig. 77
Nathaniel Currier, *The
Last Supper,* after
Leonardo Da Vinci,
lithograph, c. 1838–1856.
Courtesy of the Billy
Graham Center
Museum.

rate categories of "Catholic" images and "Religious." The first consisted of seventy-two items, the second of forty-six. Mottoes of a religious character were listed separately.[90] Of 247 subjects listed between 1835 and 1856, 108 are clearly Roman Catholic: titles are frequently in Spanish and French, and familiar Catholic iconography is abundant, including the sacred heart, the fourteen stations of the cross, images of the intercessionary Virgin, commemorative portraits of contemporary popes and archbishops, and a wealth of saints important to Spanish, French, Irish, German, and Italian immigrants. Among the seventy-nine dated prints in the 1840s, forty-nine were of Roman Catholic subjects. Clearly, Currier was attuned to the marketplace of Catholic immigrants. Traditional in iconography and titled in two and three languages, the images were able to invoke the European traditions of Catholicism and served to bind immigrant communities along ethnic lines in the new world. Yet, as in the case of the Tract Society's images of the crucifixion and resurrection (figs. 75 and 76), the lithographs could also to reach over ethnic lines and invite the newcomer into American Protestantism.

As the popular market for lithographed images expanded in the second half of the nineteenth century, James White needed a powerful means for attracting devout customers to his product. In a new church body led by the very individuals who endorsed the picture, whose names appeared

each week in the *Review and Herald* and in other church publications, James White's latest visual enterprise moved ambitiously into the domestic space of the sabbatarian consumer to find a new market. Competition came from the advocacy of chromos in the Beecher sisters' influential book. Adventist leaders needed to respond in kind with a new style of image. Thus, White and Kellogg determined to produce an image that exhibited pictorial characteristics as current and as popular as any offered by Currier & Ives and other lithography firms. The new interest in pictorialism was a response to the cultural marketplace, but, as I will show, it also came to signal important theological changes.

According to Kellogg's announcement, the cost to produce the new image, which, rivaling Currier & Ives production, measured nineteen by twenty-four inches, was $200. It sold at prices comparable to the previous charts: "post-paid, by mail, on plate paper, $1.00; on rollers, backed [with cloth] and varnished, $2.00." The images were sold, as before, at the *Review* office and carried the firm's name and address in the lower left. The image was lithographed by Duval & Hunter, a short-lived Philadelphia firm (1869–1874) that produced popular chromolithographs of modern life.[91] It is not known who drew the image, though the inscription "Designed by M. G. Kellogg, M.D." appears with the address of the *Review and Herald* in the lower left corner. The price Kellogg asked was not high in comparison to the probable cost of production. An 1877 price list of bulk rates charged by Strobridge & Co., a Cincinnati firm, for chromos of *Christ Blessing Little Children* (ten by twelve inches) was $50 per hundred, or 50¢ per image.[92] A chromo portrait of Alexander Campbell, millennialist founder of the Disciples of Christ, was retailed in 1872 for $6.00 by a New York form.[93] Both these images were produced on a vastly larger scale than Kellogg's and were listed in sales catalogs and advertising bills sent to a much larger public than the Seventh-Day Adventists who read White's or Kellogg's ads.

Pricing of the earlier charts after the appearance of Kellogg's image suggests that White wished to keep the familiar Adventist charts within the market. In the summer of 1873 prices for the 1863 prophetic and Law-of-God charts dropped to $1.50 each for those mounted on cloth or varnished; with rollers as a set, $2.50. This was a significant reduction of the original prices of $2.00 each and $4.00 as a set.[94] He did not want to see the charts replaced by Kellogg's print. The prophetic interpretation encoded within the charts, after all, remained at the center of the church's mission. In January 1876 Uriah Smith encapsulated his *Key to the Prophetic Chart* in an article in the *Review and Herald* that was illustrated (presumably by Smith himself) with a wood engraving (fig. 78): a "miniature representation of our chart," White's 1863 version.[95] And the charts continued to sell. The quarterly report from the Wisconsin Tract and Mission Society of the Seventh-Day Adventist church, published in October 1876, recorded that ninety-five charts had been sold and fifty "given away." The report indicated that forty families had been visited in this district, which may suggest that the chart was being used in proselytizing.[96]

In the summer of 1876 White reprinted the charts and in the fall stated that the prophetic and the "Ten Commandments" charts "are greatly improved in size and workmanship from the old ones. The prophetic chart is much improved in arrangement."[97] The changes introduced were once

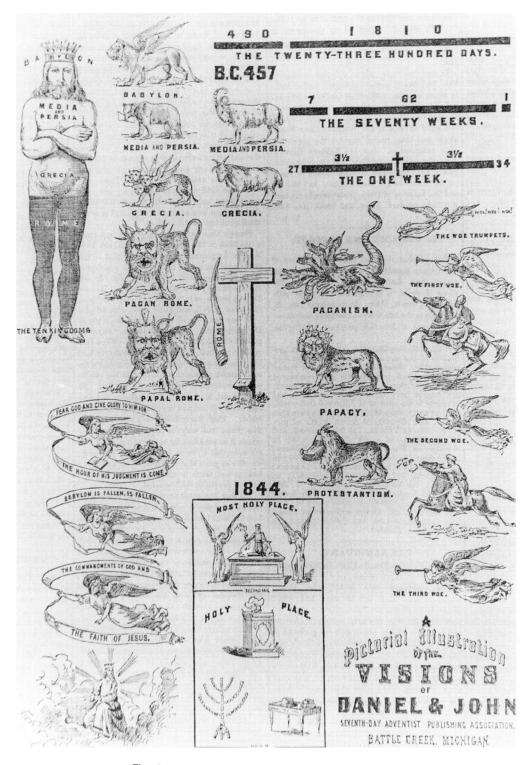

Fig. 78
Uriah Smith (?), "A Pictorial Illustration of the Visions of Daniel & John," wood engraving, from *Review and Herald* 47, no. 1 (January 6, 1876), 5. Courtesy of Adventist Heritage Center, Andrews University.

again prompted by oratorical and pedagogical needs; the new versions of the charts were larger, and the titles and headings were eliminated in order to increase the size of lettering on the Ten Commandments chart and the figures of the prophetic chart. Uriah Smith announced that the three angels, the sanctuary, the twenty-three hundred days, and the "Son of man on the white cloud" were also improved on the chart, allowing "the splendor [to] . . . show more clearly how all lines of prophecy center in this latter event [the Second Advent of Christ], which is made so prominent that it can be distinctly seen, as far as the voice of the speaker can ordinarily be distinctly heard."[98] The price was first announced at $4.00 for the set of two (October 5, 1876), but by the end of October the price was listed at $3.00. The decrease may have resulted from what a subsequent notice indicated was a delay due to "some misunderstanding of the artist."[99] (I have been unable, however, to locate any chart that evinces the stated changes.)

Although Smith continued to promote the prophetic chart, James White recognized in Kellogg's image a new possibility—something he had not considered within the context of the schematism of the prophetic charts. Kellogg's highly allegorical picture demonstrated to White that pictorialism, the use of illusionistic space in the tradition of fine art, was a visual prospect for Adventism. It was a momentous discovery, for it signaled a fundamental shift in the visual production of the church. Accounting for this change requires a close look at Kellogg's image and two subsequent images that White based on it and rigorously promoted in the *Review and Herald*.

In his *Key of Explanation*, Kellogg wrote that the picture presented "at a single glance" the relations of the religious systems of sacrifice from the Patriarchs through Jewish custom in the temple to Christ's career. "It also illustrates the fact that the Law of God and the Gospel of Christ run parallel, from the fall of man to the end of probation."[100] This had been the major theological contention behind the church's observation of the sabbath on Saturday in exception to the prevailing practice among Protestants and Catholics. Christ did not replace Jewish law but took his place as its fulfillment within an overarching system of types and antitypes. The sacrifice of Abel, the sacrifice of the scapegoat on the Day of Atonement, the burnt offerings in the sanctuary of the ancient Jews—all of these prefigured Christ's own paschal sacrifice on the cross. Accordingly, Kellogg showed the shadow of the cross cast "all the way back to Eden" in his print. Kellogg's picture did not privilege Christ's image by isolating it in the center or above other objects but placed it to the right of center, related sequentially to what came before it. The tree displaying the Law occupies the center of the image and frames the all-seeing eye of God, which looks at the world through the ten branches, which, Kellogg explained, represent the Ten Commandments. Gazing through the tree branches, "God looks at man through his law."[101] Seventh-Day Adventist theology stressed the centrality of the Law as the enduring statement of the relationship between God and humanity.

Neither Kellogg's theological point nor his visual device for making the point were novel. In 1852 Uriah Smith collaborated with Newell Mead to illustrate an article by Mead on the "Law of God."[102] Smith produced three woodcuts, the first illustrations to appear in the *Review and Herald*,

to which Mead made repeated references in his explanation of the Ten Commandments. One of these (fig. 79) identified each branch of the tree as a commandment and hung scrolls from either side of the tree displaying the text of the commandments, which, as Kellogg would do, organized the first four on the left as love of God and the second group of six as love of neighbor on the right. Kellogg could rely on over twenty years of theological discourse and pictorial illustration in designing his image. As novel as its pictorial space was, its doctrinal and its visual contents were rooted in Adventist tradition.

Kellogg's aim was to provide a visual compendium of sabbatarian doctrine on the salvation story. His visual rhetoric was both allegorical and narrative. The image is composed of several episodal units drawn from scripture and linked together by interpretation contained in Hebrews, a text of major importance for Adventist doctrine. There the concept of the type-antitype was set down to correlate the life of Christ with the history of law and prophecy in the Jewish Bible. Kellogg visualized the sabbatarian reading of Hebrews and Jewish scripture by joining each event within the single space of a landscape. Kellogg's artist gathered together a series of episodes within a single framework for the purpose of instruction and conceptual illustration. These images are allegorical because they do not signify historical individuals or a sequence of events so much as a system of ideas, a theology of correspondences. Adam and Eve on the left indicate the need for salvation; Kellogg pointed out in his *Key,* reveling in the semantic minutiae of the print's details, that as "the angel drives them out, he points toward the cross, as if telling them of a coming savior." The sub-

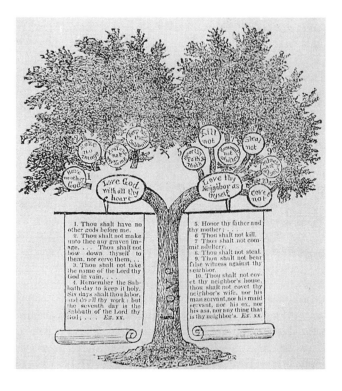

Fig. 79
Uriah Smith, Law Tree, in Newell Mead, "The Law of God Illustrated," *Review and Herald* 2, no. 14 (March 23, 1852), 109. Courtesy of the Adventist Heritage Center, Andrews University.

sequent references to sacrifice do not depict actual events as much as precursors of Christ's sacrifice. Even the crucifixion is not the culmination. Christ shares the stage with the Tree of Law whose Ten Commandments, Kellogg wrote, "are perpetual in their obligations through all dispensations."[103]

One scholar of American Protestantism and mass media has recently suggested that the gospel was a message readily put into mass distribution during the early-nineteenth-century Second Great Awakening by virtue of an "easily communicated narrative."[104] This story, spanning from the account of creation, fall, and redemption to the Second Coming, was also converted into a single visual narrative in Kellogg's print and placed into mass circulation via mail order. The sequence of symbols and the configuration of corresponding parts fall into a narrative organization in Kellogg's picture and address viewers as a corporate identity and as individuals. From the expulsion of Adam and Eve at the gateway of Eden on the left to the crowded steps of the temple in the heavenly Jerusalem on the far right is plotted a single path of progress that constitutes the history of the church and the way of personal salvation. A pathway is visible from Eden, down the shadow of the cross, through the baptism scene, along a shrubbery-lined trail from the river Jordan uphill into the forest, and onward into the celestial city where a faint crowd of the elect gather on the steps of a temple. This "Way of Life," a narrative sequence that recalls the structure of Bunyan's popular masterpiece, led through certain clearly defined stations or allegorical nodes that marked the path and represented progress toward the eventual destination (see fig. 66). The device is familiar enough in light of romantic landscape practice in the United States—one thinks of Thomas Cole's many similar conceits. But what distinguished Kellogg's print was the unapologetic confluence of diverse visual forms: Leonardo's *Last Supper* (see fig. 77), illustrations from *Pilgrim's Progress,* Uriah Smith's Law Tree, the tiny rendition of the millennium as a Peaceable Kingdom in the forest (compare figs. 10 and 11), and a contemporary baptism by immersion in the river.[105] A diversity of images were brought together and charged with meaning. Their semantic value was weighted heavily in favor of emblems within a narrative pastiche rather than merging seamlessly into a unified, naturalistic landscape. The viewer was meant to read this image, to decode it consciously as a text. The allegorical nature of the components anchored the image to an antecedent body of ideas—Seventh-Day Adventist doctrine.

The dense gathering of allegorical devices replaced the schematic display of the earlier charts in the attempt to create an "ornament" for the home, something closer to pictorial art but still riveted to the biblical text and to Adventist hermeneutics. Perhaps as an image that simultaneously addressed the destiny of the church and the individual, *The Way of Life* appealed to a place in the home where the religious formation in the family, particularly among children, stressed on the individual's identity within the ecclesial whole. Certainly the conventional practices of storytelling would have found easier application to Kellogg's image than to the prophetic charts with all their complex symbolic interpretations and calculations. Both genres of imagery were highly textual and deployed symbolisms that were opaque without knowledge of the textually based codes

that informed them. The advantage of Kellogg's more pictorial image was the immediate clarity of its meaning to those schooled in the sabbatarian community. As nearly all the testimonials that Kellogg and White reprinted indicate, it could be understood "at a glance," a phrase that was a commonplace in millennial charts and diagrams in books.[106] Moreover, Kellogg proved that the pictorial image could be as discursive as the chart, as illustrational, instructive or informational.

Adventists since the Millerites had been uneasy or quite opposed to pictorial illusion as inappropriate for images of divine truth, but Kellogg's picture was perhaps sufficiently illustrational to avoid the suspicion of idolatry. The semantic density of symbolic objects helped insure this. Andrews affirmed the discursivity and propriety of the image in his endorsement yet testified to the tenacity of the old fear: "Certainly, it is lawful to set forth divine truth in any manner by which it can be brought to bear in its purity upon the hearts of men."[107] An image that was so textual adequately deferred to the Bible and effectively converted the gospel into a dispersible medium for communication. "Even without the Key," Andrews wrote, "the picture tells the story with such distinctness that few persons could fail to take in the most essential of the truths which it illustrates."

The Way of Life, 1876 and 1883

James White probably saw a visual commodity with great appeal for domestic consumption. But his efforts to publish variations on Kellogg's prototype from 1874 until his death in 1881 suggest even more that White regarded the new imagery as an effective means of broadcasting a theological shift in Adventist belief. In the summer of 1876 he wrote to his son, William Clarence White (recently elected president of the board and business manager of the new Pacific Publishing Association, the Californian counterpart of the press in Battle Creek), that he was on his way to New York and Philadelphia to have a new version of Kellogg's print lithographed. He went to the lithographer Thomas Hunter, former partner of Stephen C. Duval, in Philadelphia, whose firm had produced Kellogg's lithograph. A letter of the following day indicates that he was "prepared to publish 10,000 Way of Life, and the Charts, if I can get the money."[108] White drew all the money he could from the *Review* office in Michigan and asked his son to send whatever he could from sales of the *Review and Herald* from his press in order to pay for the venture.[109] In August 1876 a notice in the *Review* stated that White was in Philadelphia "improving the present possibility to publish second editions of the engraving, entitled Way of Life, and of the Lecturer's Charts" and that he hoped to have these in hand for the Michigan camp meeting and the General Conference in September.[110]

The notice referred to the image as an engraving, though it was actually a lithograph (fig. 80). If it was a "second edition," it was a substantially revised one. Countless details were modified, presumably at White's request, though also possibly at the artist's discretion. The changes ranged from the most incidental to what could only have been deliberate and very

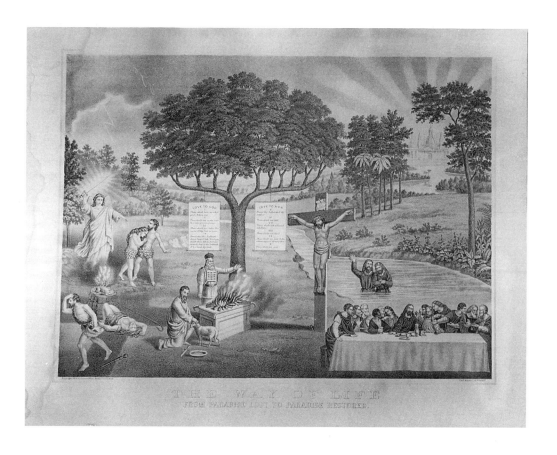

THE WAY OF LIFE
FROM PARADISE LOST TO PARADISE RESTORED.

meaningful. Noteworthy is the angel at the Gate of Paradise in the 1876 version: the Guardian stands with its sword raised instead of lowered, propelling Adam and Even more forcefully into the salvation history that awaits them. Also significant is the deletion of the eye of God in the second version—possibly because it was a symbol used on U.S. currency and therefore associated with the government.[111] Other changes in the new White print include the transformation of the ram about to be slaughtered beside the burning altar into a lamb, on whose head rests a benevolent hand. The baptism scene is no longer a nineteenth-century frontier or camp-meeting event but the baptism of Christ by John. And the Second Advent of Christ is nowhere to be seen in White's version. In Kellogg's design, a small, cloud-enthroned Jesus descended, sickle in hand, for an apocalyptic Last Judgment. All action in White's design occurs in the foreground and appears to be strictly historical. The heavenly Jerusalem shines in the distance, but no pathway leads to it, and no markers guide the viewer through the print in the same narrative fashion that Kellogg employed. There is not so much a story to be told in White's print as a set of symbols to be decoded—a tableau vivant of God's covenants and dispensations. White replaced Kellogg's strategy of engaging the viewer in a walk through time, from the distant past, through the present, and into the future of the awaiting city of God. Instead, White assembled the emblems of Adventist belief and biblical interpretation as a static display of

Fig. 80
James White, *The Way of Life from Paradise Lost to Paradise Restored,* lithograph, 1876. Courtesy of the Adventist Heritage Center, Andrews University.

information, a diadem of jewels to adorn the home, suitable for decoration and instruction.

Announcements in the *Review* proclaimed that the 1876 version was "greatly improved in plan, as well as in artistic beauty." The price remained $1.00. White offered a number of discounts to parties who would sell large quantities. Book agents for the *Review* received a 40 percent discount. To "canvassers," that is, those who solicited orders door to door, a discount of 50 percent was extended. To tract and mission societies "who assure us that [the picture] will not be smuggled through them to other parties, we give special discounts to club with the *Signs of the Times* and the *Health Reformer*."[112] White used this picture to promote the Seventh-Day Adventist Publishing Association's other publications. Emulating Currier & Ives's multilingual images, White announced in 1880 that *The Way of Life* was available with commandments and title in French, German, Danish, and Swedish. Following the popular practice of many magazines, White provided the picture as a premium to new subscribers of the *Review and Herald* and *Youth's Instructor*.[113] The translations not only appealed to immigrants in North America but represented the thrust of contemporary Seventh-Day Adventist mission efforts in Europe.

But White did not remain satisfied with his 1876 version of *The Way of Life*. Correspondence from the spring of 1880 until his death in the summer of the following year demonstrates that White was actively overseeing yet a third edition, this one even more different from its model than the second. He wrote to his wife in the spring of 1880 that he had a sketch entitled *Behold the Lamb of God,* which differed from *The Way of Life* in two crucial respects: the "Law tree" had been removed and the crucified Christ had been "made large, and placed in the center." The baptism and the celestial city had also been changed. The new title preserved the Seventh-Day Adventist concept of sacrifice by presenting Christ as the paschal lamb of substitutionary atonement but signaled a new theological emphasis.

Unsatisfied with the artistic quality of the 1880 sketch (presumably lost), White continued to work with a printer in New York or Philadelphia to arrive at something that pleased him.[114] He continued to plan the second revision of *The Way of Life* until he died. In January 1881 he determined to engage the notable landscape painter and illustrator Thomas Moran, who had enjoyed a distinguished career as an artist-printmaker in Philadelphia since the 1860s. It was no doubt on the basis of his reputation in Philadelphia that White reported that Moran was "said to be the best artist in the world."[115] According to White, Moran agreed to provide a drawing for $300. An engraver would render the drawing on a steel plate for an additional $800, totaling $1,100—more than White had first expected to spend but worth paying to secure a product whose artistic quality he was confident would be "very fine." He assured Ellen, "I shall have a picture that will readily sell for $2 a copy," a 100 percent increase over the price of the first two versions of *The Way of Life*.[116] Only a few weeks earlier he had suggested that the image sell for $1.25.[117]

As the sketch took shape, White increased his expectations for its commercial success and moved to cover his outlay. In a letter of 1880 to William Clarence White, he claimed that the new version would "kill the old one" and instructed that "those on hand should be disposed of."[118] White con-

sidered a variety of methods for enhancing the appeal of the image and using it to promote sales. In the fall of 1880 he wrote his son again to tell him that the new edition would exist in two versions: "one plate with baptism scene [showing two figures immersed in the Jordan River], one without it [*sic*] to sell to sprinklers, and one to be mortgaged. These will be wonderfully improved. Shall use them as premiums with *Review, Signs, Good Health* and all the other papers."[119] White entertained great expectations for the new print. When contemplating how to finance the considerable debt of the *Review* offices in the fall of 1880 ($100,000), he proposed "inducing the brethren to take stock" to cover half the debt and to provide the remaining half "by preparing four books for the canvassing field": Ellen's letters to her children; *Christian Temperance*; a *Life of Christ*; and the print *Christ the Way of Life from Paradise Lost to Paradise Restored.*[120]

On August 6, 1881, James White died. The image, which he was unable to see through production, was published in 1883 with the title *Christ, The Way of Life* (fig. 81). Whether Moran was engaged to complete the image under Ellen's patronage or whether it was largely complete at the time of White's death cannot be documented. The style of the landscape, however, appears to be Moran's work.[121] Possibly the figures in the middle ground were added by another artist. In any event, there is no reason to doubt that Moran was the artist. The 1883 print seems to be the one that White discussed in 1880 and 1881, and there is no documentation that indicates that Ellen White introduced any changes into the image. In fact,

Fig. 81

Thomas Moran, *Christ, The Way of Life,* engraving, 1883. Courtesy of the Adventist Heritage Center, Andrews University.

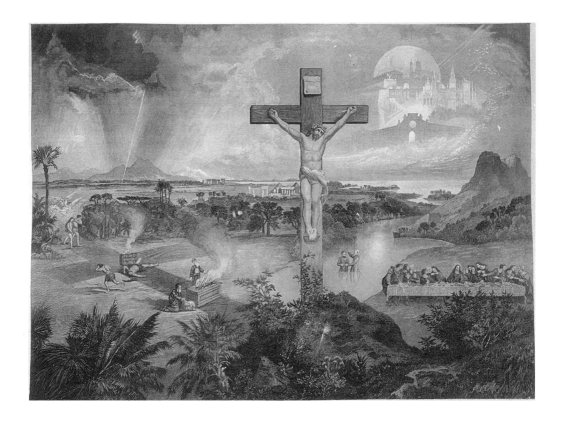

the *Key to the Allegorical Engraving Entitled The Way of Life from Paradise Lost to Paradise Restored,* published in 1884 to accompany the latest version of the print, referred to the artist, without naming him, as "one of the best artists in the country," which recalls what James White had written of Moran.[122]

In this final version of the print, Christ is indeed in the center, having displaced the Law Tree. The patriarchal and Jewish scenes of sacrifice are relegated to the middle distance. Compared to the 1876 version, the heavenly Jerusalem is much more dramatically conceived, and the landscape is executed in a manner much more in keeping with the tradition of nineteenth-century romantic painting. The naive, untrained quality of the 1876 lithograph has given way to a fine art quality. Space is depicted in a much more subtle and dramatic fashion. Christ rises on a promontory in the foreground, directly in front of the viewer and at eye level. A vast landscape extends into the distance as the stormy heavens of wrath and the epiphany of the new Jerusalem unfurl above the horizon on either side of the crucifixion. The historical precedents of his sacrifice have been moved to the middle distance, where they stretch across the image in a sequence that moves from left to right. Behind this register, architectural ruins of Egyptian and Greek design reach into the distance. The *Key* indicates that these are "the ruins of Pagan temples and the relics of heathenism, showing the decline of false religions before the true, which is yet to triumph over every form of error, and bear sway over all the universe."[123]

White further de-emphasized the sequential character of the 1873 print because he sought to create a *devotional* image separate from the chronological schematics of the prophetic chart, where Christ had not been exclusively important but part of the total equation. Christ was now front and center for empathic contemplation, his suffering made available to evoke pity. The "lamb of God," the first title White considered, was presented less as part of the biblical calculus of type and antitype than as a personal sacrifice for the benefit of the individual viewer standing before the image, facing the crucified Christ. In this sense, the image is strikingly more devotional than any before it in the Adventist tradition. Christ is visualized for the sake of prayerful meditation and thanks, an act of God's mercy offered to the devout viewer. The unprecedented centrality of Jesus is a significant indication of a debate that would emerge among Adventists in the years following James White's death: the preponderance of the Law versus the role of grace procured through Christ's sacrifice. James and Ellen White took the cause of the latter, which was eventually to prevail. White's redesign of the 1876 print visually documents the shift in Seventh-Day Adventist theology.

The Impact of Ellen White

By placing her copyright on the 1883 image and encouraging its sale and circulation, Ellen White exerted her considerable influence on contemporary theological debate among Seventh-Day Adentists. The image seems much closer to an evangelical concept of redemption: Christ's sacrifice is

presented as the singular focus of the salvation story. All other aspects of biblical history and tradition are shown as if to bear witness to rather than to interpret the significance of the crucifixion. Never had the crucified body of Jesus played such a role in the visual piety of Adventism. The *Key* stated that the "central purpose" of the picture was "the exaltation of the cross." "The Death of the Son of God is given prominence as the *great event in the plan of human redemption*. In the light of this grand scene, all other events in the history of the race pale into insignificance." Viewers were said to take their positions "at the foot of the cross" and to "look backward into the history of man, and trace the steps which have led upward to the scenes of Calvary."[124] The *Key* provided a chronological commentary on events portrayed in the image, from the expulsion of Adam and Eve to the entrance of the elect into the city of paradise. Yet the image itself was not a visual narrative but even more an ornament of display than the 1876 print. Components were arranged for their symmetry rather than any linear practice of narration. Clearly the symmetry was part of the meaning encoded in the image and decoded in the *Key,* but the symmetry served to underscore the centrality and focus on Jesus before whom the viewer was situated.

This new image of Jesus corresponded to a theological shift in favor of righteousness by faith and away from emphasis on the equal necessity of the Law in the preparation of the soul for and sustenance within grace. This shift became very controversial in the SDA church in the mid-1880s and in 1888, when Ellen White publically supported the new view in contrast to, among others, Uriah Smith.[125] At the time of the controversy, White announced that she had sought to communicate the notion of righteousness by faith throughout her ministry. At the General Conference meeting of 1888 she proclaimed that the Third Angel's message, so long the symbol of Seventh-Day Adventism, was in fact justification by faith.[126] Indeed, as early as 1883 she had stated that the Adventists "long desired and tried to obtain these blessings, but have not received them because we have cherished the idea that we would do something to make ourselves worthy of them. We have not looked away from ourselves, believing that Jesus is a living Saviour."[127] She also stressed the centrality of Christ's sacrifice in an essay entitled "The Sufferings of Christ," which was bound with the *Key to . . . the Way of Life* in 1884. In this essay she emphasized the suffering of Christ as the basis of redemption, underscoring the notion of Christ's substitutionary atonement for humanity, which was portrayed as quite unable to redeem itself. In what amounts to a Protestant version of the fourteen stations of the cross, White described in detail the agonies of Jesus' last days, from Gethsemane to the cross to the resurrection, when, the price fully paid for humanity's salvation, Jesus rose to proclaim his triumph and the end of the conflict with evil.

We should not underestimate the nature of the change from schematic chart to pictorial image. It was not merely a question of stylistic transformation. The move from chart to picture manifests a fundamental change in Seventh-Day Adventism and reflects even broader changes in Christian culture generally, as I shall explore hereafter. The prophetic charts addressed themselves to rational individuals who could follow the argument

via the visual schematics of the charts. As I have suggested, Enlightenment rationalism supplied Miller with protocols of argumentation and proof that informed his biblical interpretation. The problem for both William Miller and Thomas Paine was ignorance, and the solution was Enlightenment provided by sound knowledge based (in the case of Miller) on a correct reading of scripture. The Law orientation of Uriah Smith and others appealed more to this Enlightenment paradigm of knowledge versus ignorance. The prophetic charts visually organized knowledge as a way of conquering ignorance. But the emergence of the 1883 *Way of Life* as a sabbatarian devotional image manifested a new view of the problem as one of a state of being, not ignorance. The proper solution was regeneration through Christ. The result was a devotional and affective visual piety rather than a cognitive one.[128]

The shift did not come without a price. One risk of the new emphasis was a return of the old Protestant iconophobia. The enhanced spatiality of the image, Moran's very successful depiction of distance and atmosphere, the dramatic treatment of the sky, and the effective contrast between foreground and receding distance provided a new visual means for Adventist image making. The contrast to the earlier two versions of the subject signaled an even greater commitment to pictorialism as a visual device. The expensive employment of an artist of Moran's stature and reputation along with the considerable expense of manufacturing the steel engraving produced an artistically sophisticated piece of work that required a certain justification to sabbatarian consumers. They needed to know that the new visual form was still a language they could understand. The *Key* opened with the assertion that pictures were so ancient that in all likelihood "the universal language of the race is that product of the painter's brush or the artist's pencil." The author (probably James and / or Ellen White) conceded that art "has too often been made the medium through which sensual thoughts and associations have exerted their corrupting influence on the mind" but that "when Art is employed in the fulfillment of her Heaven-born mission," art, this "gift . . . of heavenly origin," was truly "a benefactor of mankind."[129] Although the *Key* stated that the image was "brought out in steel by one of the best artists in the country," it refrained from naming him lest, perhaps, the emphasis be moved from the product to the producer.

The concern to avoid the charge of vanity and to present the image as an unadulterated conduit of truth, a language that everyone could understand, may also have been intended to preempt an iconophobic reaction to the lavish new pictorialism. In January 1881 an article in the *Review and Herald* defended the use of pictures against the charge of idolatry. The author of the article, John Gottlieb Matteson, who founded the first Seventh-Day Adventist conference outside of North America in Denmark in 1880 and established an Adventist publishing house in Oslo, responded to a letter from an Adventist who, with other brethren, thought it "sinful to have anything to do with pictures" and invoked the second commandment, "Thou shalt not make unto thee any graven image." Matteson took the approach that Martin Luther had taken in his exegesis of the second commandment directed against early Reformation iconoclasts: the injunction forbade the *worship* of images, not images per se. Otherwise,

Matteson wrote, "the Lord has no objection to our making and owning likenesses."[130]

Defending the use and possession of images may have been important to Matteson because the *Way of Life* imagery was being used in Adventist mission work in Europe, as already indicated. Previous articles in the *Review and Herald* since the 1850s had occasionally dealt with idolatry but had never spoken to the point of image worship—in part, no doubt, because the highly textual nature of the charts and their exegetical, illustrational use among the sabbatarians never raised the charge of idolatry. Before the appearance of *Way of Life,* idolatry was more frequently used as a metaphor for placing anything before the importance of God—such as addiction to tobacco or the indulgence of undisciplined children.[131] One writer on "idolatry" remarked in 1872:

> You will not see Europeans or Americans (except papists) bow to idols, the work of the artificer, but in a multitude of ways, you may discover the principle of idolatry, eking out from a garb less objectionable than that of paganism, in some respects, but more dangerous in some of its developments.[132]

For this Adventist and no doubt many American Protestants in general, image worship was a pagan or heathen practice that distinguished Euro-American Protestants from Roman Catholics and all other nonwestern religions. The charts reinforced this idea by virtue of their schematism and textuality, but the new pictorialism of the *Way of Life* images may have renewed the old Protestant suspicions about images—at least for some Adventists.

For most, however, and certainly for the church leadership centered in the *Review and Herald,* visual likeness was not a problem. As early as 1860 the first edition of *Cassell's Illustrated Family Bible* had been endorsed on the pages of the *Reveiw,* which, the adveriesement read, "abounds with copious and impressive illustrations."[133] In 1861 and 1862 Uriah Smith provided two very pictorial wood engraving illustrations for the front page of two issues of *Youth's Instructor,* the denomination's publication for children and teachers. But the appearance of such images was rare among official publications. It was not until the 1870s that dense pictorial illustration began to appear in *Youth's Instructor,* although such images never became common in the *Review and Herald.*

The extensive use of engraved and lithographed landscapes and historical figure compositions, eventually even photographs, occurred first and foremost in books published by the *Review* press in the 1880s. This represents a tidal change in Adventist visual culture. For instance, the first edition of Uriah Smith's *Thoughts on Daniel and the Revelation* (1882; combined from two previous books of 1867 and 1873) included many illustrations of biblical and historical subjects. Smith's *Marvel of Nations* (1885), a compendious summary of Seventh-Day Adventist interpretation, contained extensive pictorial illustrations. The 1901 edition of the popular *Daniel and the Revelation* (1897) included many pictorial illustrations by William Robinson, a member of the Review and Herald Press art department. One painting rendered "The Great World-Kingdom Image" as a sculpture in ancient

Babylon. In 1907 the Pacific Press issued an edition of the same book illustrated by another art department staffer, Peter Rennings, who also produced a color rendition of the Great World-Kingdom Image.[134] The proliferation and continued commercial success of illustrated Bibles such as *Cassell's Illustrated Family Bible* in 1859, the Bible illustrations of Gustave Doré first published in the 1860s, and volumes dedicated to showcasing religious art no doubt encouraged the *Review* office to keep pace. New publications and changes in format and title in the 1880s, according to George Butler, president of the General Conference and of the Publishing Association during the decade (and one of those who had publically endorsed Kellogg's picture), were designed to appeal to an audience "that we could not reach by our distinctive religious periodicals."[135] The new pictorialism was part of such a strategy. These changes were the visual component of a new public rhetoric.

These changes, driven by the marketplace, in which illustrated books exerted a strong appeal, alarmed Ellen White. Around the turn of the century she repeatedly addressed the need for visual decorum. The proliferation of illustrations in Adventist publications included the use of images of poor quality, a practice she abhorred:

> A proper illustration of Bible scenes requires talent of a superior quality. With these cheap, common productions, the sacred lessons of the Bible disdain comparison. . . . God forbid that we should please the devil by lowering the standard of eternal truth by using illustrations that men, women, and children will make sport of.[136]

James White's concern for images that displayed "good style," his expensive investment in the fine art style of Thomas Moran, and Ellen White's fear of ridicule provoked by poor and excessive imagery collectively suggest that the Whites were increasingly concerned about attaining respectability for their faith in the American marketplace of religion. Ellen White's alarm intensified over the next few years as the cost and time of producing illustrations drove up publication expenses and delayed production. In a series of letters to the Pacific Press in 1899, she called for greater discrimination and constraint in the illustrations of Adventist books and newspapers. The increased expense caused her to repudiate "expensive covers" for books and "abundant illustrations." The money saved from these features, she argued, could be reinvested in greater production of less expensive publications. Enthusiasm for excessive display helped lead "away from the simplicity of the faith, which should characterize Seventh-Day Adventists as a chosen generation, a peculiar people zealous of good works. Canvassers and artists have had much influence in deciding this subject of illustrations."[137]

White attempted to suppress the effect of the marketplace, which dictated that illustrated materials sold better—as the popularity of illustrated almanacs, encyclopedias, dictionaries, newspapers, magazines, and Bibles had long shown. Mindful of the imprudent impressions that she believed were made by the new visual culture, White registered a candid concern: "I hope our publications will not come to resemble comic almanacs."[138]

The editorial departments of the church's press apparently did not respond in a way that pleased White, for she continued to write them admonishing letters. She regarded the "infatuation for so abundant illustrations" as a concession to the secular world and urged that all "unnecessary expenditure" be avoided.[139] She denied that the "manifestation of outward display" was an effective means of reaching unbelievers;[140] and she considered many pictures to be inaccurate and untruthful depictions of "heavenly things."[141]

Ellen White's displeasure peaked in 1902, when the Pacific Press published a picture of the birthplace of William Shakespeare on the cover of *Signs of the Times*. In a long letter to the press, White complained woefully of this secular incursion. She questioned the spiritual discernment of the "men who edit our papers" and proclaimed that they "needed the unction of the Holy Spirit" to rectify their judgment. "Let them see the sinfulness of exalting such men as Shakespeare, calling the attention of people to those who did not in their lives honor God or represent Christ."[142] The extensive use of inferior and secular illustration that she lamented may have represented to her a visual culture that had strayed from the original purity of Adventist imagery, an imagery, we recall, that had been authorized by her own visions and had been thoroughly committed to the pedagogy of mission efforts. The new illustrations, by contrast, may have struck her as merely decorative and entertaining, a concession to artists and salespersons. White went on in her letter to relate a vision she had received in response to the situation. Standing before "those in responsible positions in the Pacific Press" in her vision, she exclaimed: "Nothing is to appear in our literature that does not represent truth and righteousness." "The paper," she contended, "would do as much and more good if less room were given to illustration."[143]

What may have further irritated Ellen White was the fact that the most expensive illustrated books on the ad pages were her own, the most impressive being the Pacific Press's two-volume edition of *The Desire of Ages* (1898). Bound in "full Morocco" leather with "gilt edges," this was by far the most expensive volume advertised in the *Review and Herald* in 1899, retailing at $7.00. White's *The Great Controversy* and Uriah Smith's *Daniel and the Revelation* both ranged in price from clothbound, plain-edged at $1.00 to full morocco with gilt edges at $4.50.[144] Several other works by Ellen White had also been illustrated: *Steps to Christ* (1892), *Thoughts from the Mount of Blessing* (1896), and *Christ's Object Lessons* (1900).[145] Despite her objections, however, Seventh-Day Adventist presses continued to issue illustrated editions of her own and others' books. Art departments at the church's three presses grew steadily in size from the turn of the century.[146]

Whatever Ellen White may have thought appropriate or inappropriate, the fact was that decorated and densely illustrated volumes sold well, and Americans had become very accustomed to a visually rich print culture. The days of austerity were past. The visual culture of Seventh-Day Adventism was quickly adjusting to the larger marketplace of American Protestantism, indeed, even leading the way. The vocabulary and rhetoric of pictorialism transformed the visual piety of Adventism in order to appeal to the theatrical illusionism so much a part of twentieth-century popular

culture—from magazine advertisements to Hollywood movies and secular book and poster illustration. Not unlike James White's early ventures in chart making and sales, however, the new visual sensibility of belief united with commerce to create a product whose power and efficacy owed not a little to its status as a commodity.

Visual Pedagogy

ON EARLY

RELIGIOUS EDUCATION.

Pictures and Children

The evolution of the visual culture of Seventh-Day Adventism evinces two distinct concepts of the image: the didactic and the devotional. The first was the much older and characteristically Protestant visual practice; the latter represents a visual piety that emerged in the second half of the nineteenth century among American Protestants. It is not a distinction that is especially meaningful for Catholic visual culture, where the two, didactic and devotional, were not generally separated. Among many Protestants, however, the didactic sensibility riveted imagery to words and abstract ideas, which the images served to illustrate. The devotional image, by contrast, offered itself up to prayerful contemplation in which feeling was more important than abstraction.

This chapter and the next focus on the didactic function of imagery in the religious instruction of Protestant children from the antebellum period to the early twentieth century. Chapters 8 and 9 concentrate on the emergence of the Protestant devotional image between the Civil War and the 1930s. In both instances I will show that the millennial spirit was transmuted into a concern for securing believers, particularly children, for the longer haul. In other words, expectations of an imminent end were displaced among many Protestants by greater concern for forming the young and the use of images in devotional practices that were committed to nurturing lifelong faith. Indeed, postmillennialism declined after the Civil War, though it experienced a second life in the social progressivism of liberal Protestant advocates of the Social Gospel beginning late in the century. With the closing of the frontier in the last decade of the nineteenth century, the ideology of progress and manifest destiny, which made such

important use of millennialist thought, was refocused on national transformation. The assimilation of immigrants, the cult of masculinity, and the fabrication of a progressive society became the concerns of many Protestants, liberal and evangelical. National cohesion remained a constant goal, and technology and commerce were still the tools for achieving national consensus.

Memory, Literacy, and Assimilation

The single greatest application of mass-produced imagery in religious texts was directed toward children. The lists of children's literature published by the ATS and the ASSU included illustrated items far more often than did the lists for adults. In 1828–1829, the ATS invested in the time and talent of Alexander Anderson to improve engravings and add new ones to its series of children's tracts.[1] These series were comprised of "toy books" that combined image and text and were used as gifts to induce children to attend Sunday school or to reward them for having done so.[2] In 1824 the ATS of Boston listed only twelve volumes of illustrated children's books; by 1848 there were forty-eight titles, most of them illustrated; by 1863 over 190 different volumes appeared on the list.[3] The ATS's weekly illustrated periodical for children, the *Child's Paper,* begun in 1852, had reached a circulation of 305,000 by 1856. "As its title indicates," the Society's *Instructions to Colporteurs and Agents* (1868) explained, the *Child's Paper* "is intended for children, and to make it attractive to them, it is illustrated with cuts."[4] The *Instructions* urged colporteurs to be sure "to call attention to the publications for children and youth, which are so beautifully printed and illustrated by engravings as to tempt every eye."[5] By the time of the Civil War, annual reports of the ATS advertised several pages of illustrated children's items: four series of illustrated tracts, totalling 324 individual tracts; many sets of scripture cards used to memorize Bible verses; 108 picture cards used as Sunday school gifts; ABC Picture Cards, which continued the task of eighteenth-century pictorial primers; and illustrated cards of the Ten Commandments.[6]

The ASSU was even more ambitious at the outset than the ATS. Formed in 1824 from a previous affiliation of Philadelphia businessmen and Sunday schools around the country, the ASSU set out to nationalize the efforts of many denominations. Because it grew out of the Philadelphia Sunday and Adult School Union (founded in 1817), the ASSU was able to leap immediately into an impressive program of production and distribution. In the first year of its existence the organization printed 42,000 reward books, 51,000 tracts, 4,000 catechisms, 10,000 spelling books, 11,000 alphabetical cards, and 726,000 tickets (used as rewards for biblical recitation) among a total of one million printed items. The annual report for 1826 boasted a membership of 2,131 sabbath schools, 19,298 teachers, and 135,074 students. By 1828 production numbers had climbed to two and a half million items, including 1,007,500 Picture Reward Tickets (see fig. 84).[7]

The ever-burgeoning quantities of visual material published by benevolent associations married word and image in the form of evangelical mass

media. This connection allowed images to promote the cause of conservative Protestantism. Indeed, if Protestants still reviled idolatry and associated it with "heathenism" and "Romanism," they had no compunctions about producing reams and reams of wood engravings and lithographs in their tracts and books, and particularly in their publications intended for children. The task, of course, was to spread the "word" as far and wide as possible. "[T]he secret of that amazing moral reformation," the ATS proclaimed in 1836, "was not that Luther and his compeers wrote so much and so ably; but that *a suitable instrumentality was employed for giving ubiquity* to their stirring appeals and overwhelming arguments."[8] But this ubiquity presumed two even more important beliefs. First, for antebellum evangelicals committed to the campaign of benevolence, texts were authoritative and accurate in their power to present the spoken Word of God. Indeed, not only did mass-produced texts lose nothing of the authority and accuracy to convey the truth, they even allowed its packaging and mass distribution. Second, the ubiquity and authority of texts presupposed the ability of the populace to read. European and British Protestants had founded their trust in texts on the political and legal power of literacy to secure freedom of conscience. American Protestants in the nineteenth century linked their civil liberties to a literate populace committed to evangelical Christianity. Teaching children to read had been a high priority among Puritans and later colonists, and the production of primers and educational texts was an important component of the publications of the ATS and ASSU.

Ubiquity, authority, accuracy, and literacy were four of the essential features of the ideology of Protestant mass mediation. Each of these conditioned the role that images were assigned in evangelical America from the colonial period to the twentieth century. First of all, these conditions meant that images were understood as illustrations of evangelical texts, which is to say that the image was understood to operate not autonomously but in tandem with the text that anchored its meaning. Moreover, in the case of illustrated primers (fig. 82), the workhorse of colonial American education, image and text were integrated in a way that insisted on a rational and seamless relationship between them. Produced by Congregationalist, Presbyterian, Baptist, and Reformed believers, for whom the word of God was preeminent and images other than portraits and textual illustrations would probably have been suspect, the illustrated primers were studies in mapping word and image over one another.

Learning the alphabet was an exercise of the memory and was understood in visual terms. The primer was organized in columns that matched alphabet, image, and text (fig. 82). On the left was the capitalized letter; beside it was a pictograph featuring a subject, often religious, whose name began with the letter to the left. In the right column appeared a sentence describing the picture and including the italicized or capitalized name beginning with the letter to be memorized. Thus, the student's memory was constructed as an interaction between the graphic form of the letter, a picture, and a sentence that integrated the picture and the letter. The image was read, and the text was imaged, that is, both were seen as homologous forms of representation. Religion was folded into this system of references

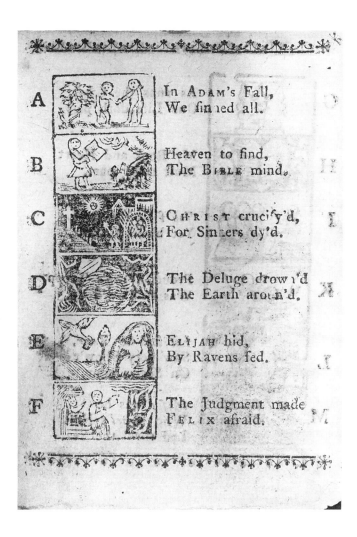

In ADAM's Fall,
We finned all.

Heaven to find,
The BIBLE mind.

CHRIST cruci'fy'd,
For Sinners dy'd.

The Deluge drown'd
The Earth around.

ELIJAH hid,
By Ravens fed.

The Judgment made
FELIX afraid.

as the subject matter of visual and scripted language. In fact, in a study of eighteenth-century primers, historian Patricia Bonomi has pointed out that primers produced during the Great Awakening of the 1740s eliminated all nonbiblical pictographs and put in their place subjects drawn from scripture.[9]

A similar interactive approach to memory was practiced in another eighteenth- and nineteenth-century genre of illustrated literature. Among the earliest illuminated Bibles printed on American soil was a collection of Bible verse rebuses specifically geared to appeal to children.[10] The so-called hieroglyphic Bible remained a popular and frequently reprinted publication well into the nineteenth century.[11] The image (figs. 83 and 63) served to trigger memories of the biblical text and supported a practice of precise memorization of scripture. Here the fun consisted of recalling texts already memorized. The hieroglyphic Bibles never reproduced every verse but selected those that were well known and that lent themselves to this kind of visualization. The correct version of the text was provided in

the bottom margin of the page (like the primer, the words visualized were placed in italics). The very notion of "hieroglyphic" is fascinating, since it implied a pictographic language that concealed wonderful secrets from all but those who knew how to decipher the mysterious visual script. The verses illustrated in the Bible could be used either as an exercise in recalling familiar verses (and the more it was perused, the more familiar its contents would have become) or as a mnemonic device to support the memorizing of selected Bible verses. Certainly this seems to be the use suggested on the title page of a hieroglyphic Bible published in 1855 by Silas Andrus & Son in Hartford, which states that its selected passages of the Old and New Testaments are "represented with emblematical figures for the amusement of youth: designed chiefly to familiarize tender age, in a pleasing and diverting manner, with early ideas of the Holy Scriptures."[12] Amusing but instructive.

One effect that illustrated Bibles, gift books, periodicals, primers, and tracts may have had among evangelicals was to corroborate the idea that texts were reliable representations. As an illustration, the image confirmed the accuracy of the text. The primers founded literacy itself on the correspondence of word and image, text and illustration, and the visual culture of antebellum evangelicalism was built on this foundation. Hieroglyphic Bibles, primers, and picture books continued the close correspondence of word and image, expanding the relation to the literary narrative and pictorial imagery. For all devout viewers, but particularly for children, images not only envisioned biblical events but enhanced their immediate claim on the believer. For instance, in 1860 an item in the *Well-Spring,* a weekly il-

Fig. 83
Ecclesiastes 12:1–2, wood engraving, from *The Hieroglyphic Bible* (Hartford: Silas Andrus & Son, 1855), p. 53.

lustrated newspaper for children published by the Massachusetts Sabbath School Society, related an author's childhood memory of a religious illustration.

> It was a picture of Jesus on the cross, with the people about him, smiting him, spitting upon him, and treating him so shamefully. It was in a little geography which I used to study, which told me when the event took place.
>
> One day when at school, looking at the picture with my little seatmate, and feeling much troubled that they should nail his hands and feet to the cross, I said to her, "How could they treat the Saviour so cruelly?"[13]

It is significant that this visual culture was prepared largely for children, to be used in religious instruction or as gifts for Sunday school attendance and membership or participation in benevolent enterprises. In fact, the rise of the Sunday school in the United States, as well as initiatives like tract distribution, was in part a result of the widespread discovery that the church could begin the formal socialization process into religion much earlier than adolescence or adulthood. In her superb study of the American Sunday school in the nineteenth century, Anne Boylan has argued that one of the reasons behind the phenomenal growth of Sunday school attendance and the robust national and local organizations that sponsored religious instruction was the new idea that children were susceptible to religious conversion.[14] In the first volume of the *American Sunday School Teacher's Magazine* (1824) a report from the New-York Union Society noted the success of a gift card (fig. 84), urging its use by other Society members. On the reverse side of the card was a note to parents, inviting them to send their children to Sunday school. According to the article, the card served several purposes:

> The purpose of these cards are to notify the parents of the teacher's appointment, and to obtain the privilege for the child to attend; and as they are passports to the meetings (being given at the door,) they tend to en-

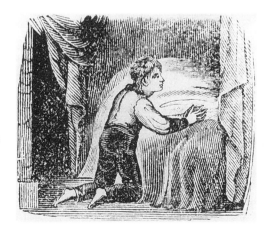

Fig. 84
Sunday school meeting card, wood engraving, 4 × 3 1/2 inches, reproduced in *The American Sunday School Teacher's Magazine and Journal of Education* 1, no. 8 (July 1824), 257.

hance the importance of the meetings in the minds of the children, and in some measure, tend also to heighten the influence of the instruction given.[15]

The illustrated cards formally announced the meeting, secured parental permission, acted as tokens of admission, and enhanced instruction. Because the cards were collected at the door, children felt privileged to enter and participate. The cards were thus embedded in the social practices of Sunday school attendance, membership, and learning. Given the importance of the Sunday school as the first step toward the formation of adult congregations, the cards were also subtle contributions to evangelical mission work. Asa Bullard (1804–1888), one of the pioneers in Massachusetts and Maine in the Sunday school cause, looked back in 1876 to recall that images were effective among both children and their parents because images exerted a coercive force over parents by virtue of their appeal to children:

> A very successful device in securing new scholars has been the giving of an illustrated certificate to both the new scholars and those who bring them in.
>
> In some cases the members of the infant classes are all invited to get new scholars, and are promised a little book or pretty card for every new scholar they bring into the school. These little ones will go directly home to their parents,—if they are not already connected with the school,—and with earnest looks and words, say, "Mother, or father, the superintendent says he will give me a beautiful book if I will get a new scholar into the school. Now, mother, or now, father, won't *you* go?" Of course they will go. How can they help it? Many and many a parent has thus been brought in, whom no one else could persuade to attend.[16]

Children, evangelicals came to learn, were a most effective avenue toward reaching adults and establishing the traditional form of institutional religion, the congregation. This is not surprising when we consider that in 1820 more than half of the white population in the United States was sixteen years old or younger. By 1840 the number of white persons twenty years old or older was nearly equal (99 percent) to the number of white children under sixteen.[17] There were proportionately more young people to convert and, because they were still susceptible to authority and control, they were easier to convert than adults. This activation of youth through the mass media—evident in children's literature and religious magazines in the nineteenth century—helped usher in mass culture as we know it today. Indeed, sociologist Edward Shils once remarked that the production of popular culture for youth in the modern period and its massive consumption is unprecedented and lies at the heart of the "revolution of mass culture."[18]

An iconography of the sabbath school and the instruction of children quickly emerged. Women were charged to gather up stray children and conduct them to school (fig. 49). Inside, when both sexes were taught together—which was by no means often the case—they were segregated and organized in neat groupings (fig. 85). The teacher, either male or fe-

male (increasingly female as the century passed, though the position of superintendent was reserved for men), conducted the class by lecture. Students responded by reading aloud, by recitation, and by singing hymns. A less literal illustration of the teaching setting appears in fig. 86, an engraving from *A New Picture Book* from the series of *Children's Tracts* produced by the ATS and illustrated with engravings by Anderson in 1829. A gentleman extends a gift book such as *A New Picture Book* to a poor child, who is brought for instruction by another child who, judging from his appearance, enjoys a higher station than the lad whom he introduces to religious study. According to Heman Humphrey, president of Amherst College and featured speaker before the ASSU in 1831, what this poor child stood to gain was not only the salvation of his soul but exposure to the higher culture of the middle classes. Humphrey praised the ASSU (and he might have included the ATS in his accolade) for seeking out "the poor and the ignorant, and . . . bringing them together every week within the Sabbath-school, with children of better circumstances, [and] introduc[ing] them into a new world of thought and feeling, and moral influence."[19] Seated like Christ receiving the children and doling out his blessing, the teacher in the illustration offers the product of systematic benevolence that is carefully encoded with the social structures of class and gender that acted as the conduits of grace in the socialization of antebellum children.

The success of illustrated materials was evident to teachers, organizers, and colporteurs. Colporteur reports from the 1850s—in the midst of Irish and European immigration—provide ample evidence of the use of illustrated materials in the field by the ATS in order to appeal to children, slaves, the illiterate, immigrants, and those proselytized at sea and in foreign missions. Foremost among the publications in this outreach were the *Illustrated Tract Primer* (also called the *Pictorial Primer*) by Frances Manwaring Caulkins (1795–1869), the *Christian Almanac,* and the *Child's Paper.* The *Tract Primer* and picture cards were gifts that one colporteur from Missouri reported giving to grateful slaves.[20] Near the end of the Civil War the ATS prepared its *United States Primer* for former slaves and promoted it as "the first round in the ladder of freedom." The *Tract Primer* was translated into several languages and used successfully in missionary work from the Hawaiian Islands to the Turkish empire. A missionary in the Pacific in 1850 wrote:

> [T]he Tract Primer and other beautiful books . . . made the little ones hop and sing finely, and I can't refrain from telling you how my own heart bounded with delight on beholding "The Christian Almanac," and the children's books in the same beautiful style. . . . "These books *will* go, and the devil cannot stop them—the pope cannot hinder them," was my first glad thought on seeing them.[21]

The *Pictorial Narratives,* a series of twenty-four illustrated tracts, was sold among Roman Catholic Irish immigrants, according to a colporteur in Illinois. Colporteurs in Illinois and elsewhere noted the success of the *Child's Paper* among Catholic as well as Protestant children. A colporteur in Virginia reported strides made in that state among Irish and German Catholics by means of what had become a standard technique: "By giving

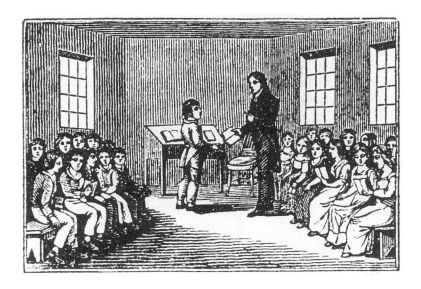

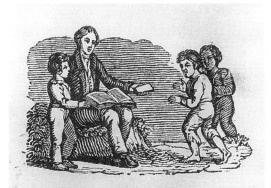

Give us an humble, active mind,
 From sloth and folly free;
Give us a cheerful heart, inclin'd
 To useful industry:

A faithful memory bestow,
 With solid learning store;
And still, O Lord, as more we know,
 Let us obey thee more.

Fig. 85 (top)
Alexander Anderson, engraver, Sabbath school session, wood engraving, in *Active Benevolence or Some Account of Lucy Careful* (New York: American Tract Society, n.d.), p. 102.

Fig. 86 (left)
Alexander Anderson, engraver, Benevolent gift, wood engraving, in *A New Picture Book* (New York: American Tract Society, c. 1829), p. 13.

books and tracts to their children and by treating them kindly they insensibly lose their prejudices against us and our faith." This colporteur indicated that he gave more materials away than he sold among Catholics. In fact, for every three volumes he sold in the Society's fiscal year 1853–1854, he gave away one volume. He recounted a visit to one cabin in which the family's entire library consisted of "a Bible, a few leaves of an old spelling-book, and a torn almanac."[22] A colporteur working among Germans in Kentucky in 1844 had reported the same situation in two-thirds of the families he visited.[23] Clearly the ATS was in the business of producing the essential materials.

In 1850 the ATS published 80,000 copies of the *Tract Primer* and 320,000 copies of the *Almanac*. In subsequent years these numbers declined markedly as the Society brought the *Child's Paper* into circulation. By 1853, for instance, the year following the appearance of the *Child's Paper*, only 20,000 *Tract Primers* were published and the *Almanac* fell to 250,000 copies.[24] By May 1853, after only seventeen months of production, the *Child's Paper* enjoyed a monthly circulation of 250,000. These numbers were comparable to and even exceeded contemporary nonreligious circulations. One historian of periodical publications estimated that between 1850 and the end of the Civil War, only thirteen magazines in the nation surpassed a circulation of one hundred thousand. These included the Tract Society's *American Messenger* at 190,000 in 1850 and *Godey's Ladies Book*, which peaked at 150,000 in 1860. *Harper's Weekly* attained a circulation of 120,000 by the beginning of the war, and *Harper's New Monthly* magazine averaged 110,000 from 1850 to 1865. By 1891 *Harper's Monthly* had climbed to only two hundred thousand.[25]

Nonreligious spellers and primers of the time were profusely illustrated with wood engravings; among the most impressive of these were two volumes published by George Coolege in New York: a pictorial edition of Noah Webster's *Elementary Spelling Book* and the *American Pictorial Primer*, both of which included illustrations engraved by Alexander Anderson. When spellers were used in common schools and published in several cities by various publishers, profit margins warranted elaborate illustration.[26] The frontispiece to Webster's *Pictorial Elementary Spelling Book* (fig. 87) amounts to a secular version of a tract illustration engraved by Anderson and used to promote Sabbath school attendance (see fig. 49). A female personification gathers up and conducts children in the landscape toward Fame's temple in the distance in a manner quite analogous to the benevolent work of women in the earlier picture (fig. 49). Given the parallel missions of promoting literacy as the basis for national prosperity, the iconographical similarity is not surprising.

From the perspective of the ASSU and the ATS, among other evangelical organizations committed to literacy and the education of the growing American public, the similiarity between religious and secular pedagogical initiatives was certainly not accidental. While antebellum state legislatures and boards of education established the nonsectarian use of the Bible in the public school, benevolence societies pushed for the continued importance of the Sunday school. The ASSU's *Sunday-School Journal* insisted that "secular and sectarian systems of education are not injured but promoted by the Sunday-school." Indeed, the ASSU believed that domestic

piety was insufficient for the religious training of youth and the formation of children and that the church dare not entrust the nation's children to "parental precept" and domestic example.

> With the ever present spectacle before us of that mass of juvenile depravity which runs riot in the streets of every city, unrestrained in its licentiousness, and uninstructed save in crime, have we yet to learn that, beyond the legitimate provisions of common schools, and the utmost efforts of mere parochial care, there is a wide and widening territory of ignorance, of vice and crime?[27]

Sunday schools and the use of the Bible in public schools were necessary to counter the unruly and expansive forces of urban youth as well as the immigrant population filling the heartland. Indeed, evangelicals followed the example of pedagogues from Noah Webster to Horace Mann in stak-

Fig. 87
Alexander Anderson, engraver, Allegorical figure directing children to Fame's temple, wood engraving, frontispiece in Noah Webster, *The Pictorial Elementary Spelling Book,* Coolege's Pictorial Edition (New York: Geo. F. Coolege & Bro., 1848). Courtesy of the American Antiquarian Society.

ing the success of the republic on a literate citizenry. In fact, for the ASSU and the ATS, civil liberty, republicanism, and Protestantism were inextricably bound up with one another. "It is notorious," remarked George Bethune to the annual gathering of the ASSU leadership in 1847, "that civil liberty sprang from Protestantism; it is equally certain that civil liberty will uphold Protestantism." By what means? By means of the Sunday school, of course, which was "admirably adapted" to secure "the sanctification of our country."[28] Thus, patterning religious spellers and primers after secular models (which themselves included a great deal of religious content) extended what Carl Kaestle has called the ideology of the antebellum common school, which coupled Anglo-American Protestantism to republican ideals.[29] Moreover, keeping tract and sabbath society instructional materials close in format and design to secularly published products for public schools helped insure the use of materials published by evangelicals in the common school setting.

In order to capture as wide a market as possible, the Tract Society published several primers during the middle decades of the century. The most frequently cited, Caulkins's *Illustrated Tract Primer,* which was 108 pages long, was first published in 1848 and was reissued with new images over the next several decades. Clothbound with gilt edges, it sold through the 1850s and 1860s for 25¢ and in soft-cover for 10¢. Profusely illustrated (on 29 of its 108 pages), the book included a frontispiece of Christ blessing children, the New Testament image used to authorize religious education as well as to symbolize the proper attitude of humble piety among Protestants. This image was invented during the Reformation, and Protestants have cherished it ever since.[30] The *Tract Primer* featured a modern-day counterpart to the biblical scene on its title page, engraved by Elias Whitney, in which a mother teaches her children the alphabet with the *Primer* (fig. 88). Each letter of the alphabet in the *Primer* was illustrated by an image of a biblical figure or subject: Adam, Bible, Christ, Dove, Elijah, and so on (fig. 89). The remaining contents of the primer were summarized in the notice for the book in the 1848 annual report: "spelling lessons, simple reading in prose and poetry, portions of Scripture history, and every variety of matter appropriate to a primer, with an admirable Catechism, the answers to which are in the language of the Bible." The list of 148 catechetical questions was a feature that enabled the *Tract Primer* to compete with the ASSU's catechisms and the widely used *Union Questions,* first produced in 1828. To make the book even more marketable, the ATS explicitly designed the *Primer* not only for children "but with a special reference to the benefit of families reached by colporteurs, in which parents or children are unable to read."[31]

The Tract Society continued to produce materials suited to the spread of literacy and evangelical Christianity by issuing in 1857 a sixty-one page version of the *New England Primer* (see fig. 82) called *A Child's Primer.*[32] In the following year *The Picture Alphabet* appeared. A thirty-two-page booklet produced in the small format of the "toy book" (four and a half by three inches) and selling for 5¢, this publication linked each letter of the alphabet to a contemporary scene and biblical admonitions on such predictable subjects as filial duty, scriptural study, and sabbath observance. And in 1861 a package of twenty-eight *ABC Picture Cards* was listed in the annual report

Fig. 88
Elias Whitney, engraver, Mother teaching children with primer, wood engraving, title page, *Tract Primer* (New York: American Tract Society, c. 1863). Courtesy of the Billy Graham Center Museum.

Fig. 89
Alphabet page, wood engraving, in *Tract Primer* (New York: American Tract Society, c. 1863), p. 5.

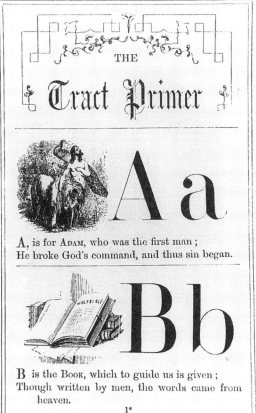

THE

Tract Primer

A a

A, is for ADAM, who was the first man;
He broke God's command, and thus sin began.

B b

B is the BOOK, which to guide us is given;
Though written by men, the words came from
heaven.

1*

for the first time.[33] These multiple versions of the same product allowed colporteurs to fit them to various contexts such as the public school classroom, the sabbath school, or the home, serving as everything from a textbook to a drill book to flash cards, as well as gifts.[34]

Each of the publications profiled here raised the image to the status of a visual text that did not suffer inferiority to the biblical scriptures as a conduit for evangelical truth. "Look at the instrumentalities," one Congregationalist pastor from Boston announced at the annual meeting of the ATS in 1853. "We have the pen, the press, and the graving tool; and as one man has well said, the *Child's Paper* and the present kinds of tracts are forming a nation of artists."[35] Artistic taste and the visual literacy of evangelicalism were deemed suitable partners in the task of converting and improving the nation. Artistic enjoyment and moral uplift were increasingly presented as desirable in the instruction of children. An advertisement for a new ATS book in 1853, *Songs for the Little Ones at Home,* "ornamented with sixty-two highly finished engravings," praised it as meeting "the wants of all ages" and "happily commingling amusement and the best moral and religious instruction."[36] A pamphlet published by the ASSU in 1829 praised the publications of the ASSU not merely for their ability to amuse children but for the power of their images to "give a notion of visible existences, such as is not attainable in any other way." Amusement and instruction belonged together.[37]

A practice among colporteurs was to canvas public and sabbath schools, offering donations of copies of the *Child's Paper,* the *Tract Primer,* and other illustrated materials, particularly tracts and gift books to teachers and students. Many colporteurs were active in organizing schools. In 1861, W. J. W. Crowder reported that he had "aided in organizing thirty-seven, and visited three-hundred and fourteen" Sunday schools during his work as a colporteur in Virginia.[38] The use of visual materials among children and the illiterate was most frequently mentioned in colportage reports from the South, particularly Virginia and North Carolina, where the ATS was particularly active and well organized.[39] Abner Perkins, a full-time colporteur in 1853, whose area was Rockingham County, Virginia, sold a total of 1,683 volumes and gave away 736 in that year. During the same twelve months he held or addressed sixty public meetings or prayer meetings, visited 1,106 families, and "conversed or prayed with" 697 of them. The Tract Society employed nine colporteurs in Virginia who worked eleven or twelve months of the year and an additional fifty-two who worked from less than one month to no more than ten months of the year. Among the full-time colporteurs, the average number of volumes sold in 1853 was 1,373. The average number of volumes donated to those who could not afford them was 656. Full-time colporteurs held or addressed an average of 62 public or prayer meetings and visited 913 families during 1853. Perkins, therefore, ranged near the middle of the full-time salesmen, performing slightly better than average in each category.[40] Like most colporteurs, he did not remain long on the job—from 1852 to 1854, working only for five months in the final year of service.[41]

Perkins reported in 1853 that the contents of the books he distributed were making a lasting impression on "youthful minds." "I saw a little girl of six years, last week, who six months ago was learning the alphabet. She

now can read books for children. Her father says her rapid progress is owing to a picture-book I gave her on a former visit. The plan of leaving something at every house has proved a good one."[42] As another colporteur from Virginia, Jonathan Cross, put it: "A pretty book given creates a desire that some one should be able to read it."[43] Colporteurs found that children were the key to effective evangelism. Children erected few of the resistances to appeals that adults did and offered important inroads to entire families and communities for subsequent evangelical activities such as the formation of Sunday schools and congregations. For instance, Perkins noted that "Dunkards," members of the Church of the Brethren, opposed the circulation of any book but the Bible. Yet this opposition had declined, according to Perkins, largely because of "the circulation of books for the young." In fact, Perkins continued,

> [i]t is no uncommon occurence for little boys and girls of eight and ten years to instruct their ignorant parents, who listen with all the earnestness of children. I have seen a father, mother, and five sons and daughters that could not read, listening to the story of Samuel [read from a child's book]. . . . Some little boy or girl gets interested in reading our books, the interest extends throughout the family, thence to the entire neighborhood; a school-house is soon erected; a prayer-meeting is organized, followed by the sabbath-school; some missionary spirit hears all this, and follows it by holding forth the word of life to them. A church is formed.[44]

Jonathan Cross reported in 1851 that whole families in Virginia that were illiterate required a heavy use of illustrated materials. Once again, the appeal to children was fundamental: "The colporteur would open some book, read a passage, and exhibit some of the pictures. The eyes of the children would sparkle; 'Mother, get me that book—I want to learn to read it.' What mother can resist such an appeal? The book is bought, or received as a gift. In a little time the child is in school."[45] A pastor and colporteur from North Carolina wrote of teaching the illiterate with the *Tract Primer* and reported attending a Sunday school where fifty of the *Primers* were in use, drawing from the superintendent of the school a succint and enthusiastic endorsement: "This book is just the right thing for interesting and instructing children. All are delighted with it."[46]

The use of ATS publications to stimulate revivals or channel their energies into sustaining an institutional organization is also documented in colportage reports.[47] But the principal concern was evangelism. Colporteurs spent most of their time speaking to families and individuals and found illustrated books a reliable means for establishing an interest in their wares. This was especially true among the unchurched. John Andrews, a full-time colporteur whose territory was three counties in North Carolina (Granville, Warren, and Nash), reported that progress was very slow in one district. Among the 104 families of this district, Andrews reported, only three held any kind of domestic observance of the sabbath.

> Here we get on very slowly. We have to go into these dark places and kindle up a little brush-light with the pictures in The Child's Paper and

Almanacs; and when the interest is sufficiently raised, read a little, talk some, and show "Tales about the Heathen"; read what it says about the pictures, and ask, "Why are we not all heathen? Can't you read? Do you love God? If you don't, you are a sinner, and when you die, you will have to go into a bad place, among those heathen. Now, God sent his Son Jesus Christ into the world to die for sinners, and if we love God, and ask him to make us good, he will give us a good heart; and then we shall try to read, and love to pray and go to church; and not hunt and fish, and visit, and burn plant-beds on the Sabbath-day; for that's the way the heathen do."[48]

Images of the "heathen" were used to depict a cultural and spiritual other against which the unchurched American citizen was urged to define him or herself. The book mentioned here, *Dr. Scudder's Tales for Little Readers, About the Heathen* by John Scudder, was first advertised in the ATS annual report of 1853 for 25¢. It included eighteen engravings of Hindu life—domestic, social, and religious. Scudder (1798–1855) was a physician and missionary in the Dutch Reformed church who spent thirty-five years in Ceylon and Madras and had preached widely in India. He authored four tracts and three books for the ATS.[49] In his *Tales for Little Readers,* concerned with distinguishing Protestantism from everything else, Scudder collapsed Greek Orthodoxy and Roman Catholicism into a single religion "which is nothing more nor less than paganism, with a few Christian doctrines added to it."[50] Dwelling in detail on acts of ritual violence and the frenzied worship of statuary among Hindus, Scudder included illustrations of scenes such as the sacrifice of a child (fig. 90), who is lashed to a tree like traditional depictions of Christ bound to a column, to visualize for his young readers the barbarous cruelty and spiritual darkness of hea-

Fig. 90
Khond tribesmen sacrificing a child, in Rev. John Scudder, *Dr. Scudder's Tales for Little Readers, About the Heathen* (New York: American Tract Society, 1853), p. 138.

thenism. According to Scudder, it was only with the intervention of British and American missionaries that the heathen were compelled to forsake their idols and debauchery and attend evangelical schools.

Religious Instruction
and the Didactic Image

The purpose of the didactic image was to attract children to evangelical learning, to install them in Sunday schools and other benevolent activities, to appeal to their parents, and to facilitate the memorization of information. Then and now, images complement ritual practices and assist memory formation because, neurologists tell us, an unusually large portion (40 percent) of the fibers linking the central nervous system to the physical world are dedicated to transmitting visual stimuli. The destination of these stimuli, the visual cortex, is one of the larger cortical structures of the human brain. Images appeal to the preliterate child because the brain is predisposed by virtue of its circuitry to pay attention to things seen. Moreover, the visual cortex is interlaced with parts of the limbic system, a set of structures responsible for emotion and homeostasis. Neurotransmitters in the limbic system modulate synaptic connections that enhance memory. Certain hormones such as adrenaline produced in response to pleasure and pain facilitate memory formation by closely associating feeling, imagery, and related information in the physical environment. Thus, as the brain processes and recalls images, it encodes and manipulates visual information in tandem with feelings.[51] This accounts not only for why images help us remember things, but also for why we recall events couched in fear, humor, and intense feeling so vividly.

Whatever the neurological explanation, children are fond of pictures. And so were nineteenth-century Protestants, especially pictures that acted like texts, presumably because it made the image a more reliable vessel of scriptural truth, or at least one that drew less attention to itself than a work of art does to its making. When left unanchored by words, doctrines, or authoritative texts, images are capable of an autonomy and a polyvalence that alarmed Protestants. Without text to frame or fix the image, the image can float away and be made to signify whatever a viewer wants or needs it to mean.[52] For nineteenth-century American Protestants this could mean idolatry, the confusion of the image with its divine referent, which Protestants believed characterized "heathenism" and Roman Catholicism. An image that appeared in *A Pretty Picture Book* (1829) shows two boys hawking small statuary (fig. 91). "Come, buy my images," the smaller boy cries. The reply evoked from an editorial voice is followed by a lesson on Hindu idolatry and the second commandment: "'Yes, they are very pretty, and some of them would look well on our mantelpiece; but only as an ornament.' In India and other parts of the heathen world the people buy images and set them up in their houses, and worship them. Can you repeat the Second Commandment?"[53]

An even earlier publication that proscribed Hindu idolatry was the tract entitled *Little Henry and His Bearer* (see fig. 92), which was deployed as early

Fig. 91 (top)
Alexander Anderson, engraver, Boys selling statuary, in *A Pretty Picture Book* (New York: American Tract Society, c. 1829), p. 12.

Fig. 92 (bottom)
Alexander Anderson, title page, *Little Henry and His Bearer,* tract no. 107, *Publications of the American Tract Society* (New York: American Tract Society, 1842), 4:169.

as 1817 by the American and Adult Sunday School Union, predecessor of the ASSU in Philadelphia.[54] The story of an orphaned white infant, Henry, who was raised by an Indian servant, this tract combined two favorite motifs in tract literature: conversion and the early death of a pious child. When he was five years old, Henry was visited by an English lady who became concerned when she saw him amidst native servants, "for, indeed, it is a dreadful thing for little children to be left among people who know not God."[55] So the lady spread out on the floor of her room "some of the prettiest coloured pictures she had" in order to tempt the boy to come in. The lure worked. When she discovered that Henry could not speak English, she taught him "by showing him things represented in the coloured pictures, telling him their English names."

Henry's instruction in literacy was coupled with evangelization. "While this young lady was taking pains, from day to day, to teach little Henry to read, she endeavoured by word of mouth to make him acquainted with such parts of the Christian religion as even the youngest ought to know." But in attempting to inculcate the view that there was only one true god, the lady encountered incredulity for, Henry pointed out, there were many gods. After insisting on this point, Henry ran from the lady and returned to his Indian comrade. But the following day, when Henry ambled into her room, having forgotten his anger, the lady launched an aggressive iconoclastic attack on the young polytheist's idolatrous beliefs.

> She had . . . provided herself with one of the Hindoo gods made of baked earth; and she bade him look at it, and examine it well: she then threw it down upon the floor, and it was broken into an hundred pieces. Then she said, "Henry, what can this god do for you? it cannot help itself. Call to it and ask it go get up. You see it cannot move." And that day the little boy was convinced by her arguments.[56]

Iconoclasm, literacy, and proselytism bolstered one another in this scenario of forceful colonialism in which a demonstration of violence was intended to underscore the rightness of the colonizer. Redemption began with the destruction of an idol, the breaking of an image that symbolized resistence to monotheism. The violence was for Henry's own good, and, by extension, for the infantilized culture of Hinduism, which he both represented and then, after his own conversion, turned to converting before his early demise. Pictures were an effective means of converting children and heathen, but as symbols of racial and creedal otherness, as "idols," images were turned to powerful evangelical use when shattered.[57]

An epilogue entitled "Little Children in America" sought to make explicit the meaning of Henry's story for American children: "[Henry] was born among ignorant heathen, those who worshipped the rivers, the stones, and the images they had made. You live in a christian land, where the true God, He who dwells in the heavens, and who knows every thing you say and do, is adored."[58] American children were urged to emulate Henry (who had gone on to convert his Indian servant) by supporting foreign missions. Redemption and idolatry were very much about race and nationhood; this story was told by white evangelicals to white evangelicals. The epilogue proclaimed that America was a country blessed by prov-

idence. Its children could feel fortunate that they were born in a land spared of ignorance and spiritual darkness.

In fact, however, this Protestant strategy of purging "idolatry" was practiced on domestic soil. Although many Protestants lamented it, iconoclastic violence in U.S. cities had become a part of anti-Catholic and anti-immigrant biggotry in the nineteenth century. Ray Billington noted that a dozen Catholic churches were burned by angry Protestant mobs in the mid-1850s, while others were attacked and robbed of liturgical items that served among nativists as symbols of Catholicism and the immigrant presence.[59] Whether domestic or abroad, the violent destruction of images constructed and enforced the category of idolatry as *the* mark of difference as well as the line of offense against or defense of Christian civilization. Moreover, the violence underscored the identity of Catholic and "heathen" in the minds of many Protestants.

It was not uncommon for anti-Catholic literature in the United States— including literature produced by tract, sabbath, and mission societies—to compare Catholicism with heathenism or paganism, particularly on the use of images. William Nevins, in an ATS publication, declared that there were "no people, unless it be some Pagans, who are so inclined to worship" images as were Roman Catholics.[60] "Popery, indeed," stated the Tract Society's *Spirit of Popery,* "meets the view as a slightly modified paganism."[61] The author corrected those American readers who wrongly assumed that "there is no idolatry nearer than India" by pointing to a Catholic chapel in Annapolis dedicated to the honor of the Virgin.[62] Two chapters were given to enumerating what the author understood to be the similarities of Catholicism and paganism, including their common worship of images.[63] Evangelical polemicists made a point of identifying idolatry as superstitious and a sign of moral depravity or as the illusions conjured up by priestly magic to decieve the laity. One Protestant writer— probably along with many others—was convinced that the priest's utterance at Mass, "hoc est corpus," was the source of the term "hocus pocus."[64] Worship directed to images was stringently condemned and identified not only with Hindu, African, and Oceanic cultures, which were being evangelized by American and European missionaries, but with the Roman Catholic immigrants arriving in the United States. An evangelical newspaper stated that before missionaries had destroyed their idols, indigenous inhabitants of the Hawaiian Islands were bound by fear to a "debased, ignorant worship and regard" for their carved deities.[65] "The history of idol worship is a history of the moral descent and degradation of the race," wrote a pastor and religious educator in Marshalltown, Iowa. When led astray from God, humankind "seems to gravitate with resistless force downward."[66]

Images, in the evangelical view, were associated either with the devolution of humanity to a primitive state, as in the case of idols, or with the evolution of children, natives, immigrants, and the illiterate and unchurched to a higher spiritual state, as in the case of illustrated primers and items of religious instruction. Thus, images that were bound to the text were able to install literacy and instill piety, in contrast to idols, which reduced humanity to a condition of ignorance and superstition. Children, Catholics, and heathen were situated on the threshold of civilization and

spiritual development and could be rescued only by evangelical intervention, which often demanded rituals of iconoclastic violence to wrench them free of the grip of idolatrous illusion. Each of these groups was illiterate—both in reading English and in American cultural literacy—and required the use of illustrated primers and similar materials to enable them to enter the fold of American Christianity.

The threat as well as the portrayal of violence aroused an affective response in readers and viewers that was not lost on pedagogues. Teachers and parents recognized the value of keying images to certain emotional sensations. First, this association both conveyed the gravity of the evangelical message and prompted the hearer to take the message to heart. The "message" in evangelical culture consisted of a transformation that was registered in the sighs and tears and inward anxieties of a protracted conversion process. "Experimental religion," as it had been called from the days of Jonathan Edwards and before, meant religion that was felt and experienced in the texture of one's emotional life. The affections, according to Edwards, were the proper measure of genuine religion. Second, coupling image and emotion assisted dramatically in memory retention.

But an image's capacity to stimulate feeling also presented a problem for American evangelical Christians because feeling could carry one away and subvert the precepts of reason and moral restraint. We might say that images existed on a continuum. One end was occupied by the illustrational or didactic picture, subordinate to text, whose meaning it self-effacingly signified. At the other of the spectrum was the idol, as evangelicals conceived it, an image that drained its user of moral and intellectual strength and reduced the divine to the material form of the image. The idol evoked extreme emotional states in its adherents, fostering such passions as lust, fear, and murderous rage.

Idolatry had a role in the evangelicals' economics of bodily energy in eighteenth- and nineteenth-century America. The idol represented the excessive production and wasteful dissipation of energy, whereas the didactic image and the pleasures of proper reading and entertainment were the means of conserving and replenishing the body's reservoir of resources. Appropriate amusement was something that the purveyors of evangelical morality spent a good deal of time thinking about. The problem was to provide a form of entertainment that avoided the excitation of the passions for no other reason than their own pleasure. Evangelical moralists, teachers, clergy, and parents were especially concerned about the harmful influence of gratuitious amusement on youth, what one writer called the "pursuit of pleasure for pleasure's sake."[67] A tract directed against "theatrical exhibitions" argued that "whatever draws off the heart from that which is sober, useful, and pious, and inspires it with a prevailing taste for the gay, the romantic, the extravagant, the sensual and the impure, cannot help but be deeply pernicious."[68] Another tract declared that proper amusements were those that united "the most valuable improvement with innocent pleasure." This tract was illustrated with an engraving by Anderson (fig. 93) that showed the dire consequences of what it called "fashionable amusements." Misled by the consuming character of wine, woman, cards, and dice—the instruments of the fatal serpent coiled beneath the table—a well-dressed young gentleman dances his way over the edge of

FASHIONABLE AMUSEMENTS.

Fig. 93
Alexander Anderson,
engraver, title page of
Fashionable Amusements,
tract no. 73, *Publications
of the American Tract
Society* (New York:
American Tract Society,
1842), 3:105.

the cliff toward the rolling waves below. "Fashionable amusements unfit the mind for religious duties, by diverting its attention from them," the tract warned. Indeed, such amusements not only "banish religious thought and conversation, but they fill the mind with an inordinate love of those things which reason and Scripture pronounce 'vanity and vexation of spirit.'"[69]

The romantic cult of sentiment, as I pointed out in chapter 3, has been linked by Colin Campbell to Protestant traditions of affect, which should not be overlooked by Max Weber's preoccupation with Calvinist asceticism. Among the latter-day proponents of Calvinism—many of the Presbyterians and Congregationalists of the ATS—sentiment came in for pointed criticism as a mistaken substitute for genuine religion. Echoing Jonathan Edwards's authoritative treatise on genuine and feigned religious affections, one nineteenth-century divine, writing in the ATS's *American Messenger,* attacked the notion of religious sentiment:

> A great many mistake religious sentiment for a religious life. Because they are touched by religious truth, they fancy they are religious. . . . Weeping over a book of martyrs, they almost think is as heroic as though they died at the stake themselves. . . . So to a great many, religion is only a reverie of devotion; a touching of the spiritual chords; an awakening of religious sentiment.[70]

Another writer in the *Messenger* marginalized feeling and emotion as superficial, variable, and transient and therefore unambiguously subordinate to character and principle. Yet this author betrayed his real fear of the dominance of affect when he asserted that feeling was "the steam of the engine, a motive power" that required "the guiding hand of principle, like that of the skilful engineer."[71] What Edwards had called the affections were dangerous not only because they could be feigned but because they

could carry the young person away to a life of moral dissipation. This engine of human behavior required the restraints of reason, character, and moral principle to channel feelings into appropriate actions and to serve as a brake to resist the push and pull of improper emotion.

Images provided evangelicals with just this moral technology. The image aroused interest and attention but fitted it to suitable amusement, harnessing affect to didactic ends. Images allowed evangelicals to compete effectively for the attention of the young, the immigrant, and the illiterate. A hieroglyphic Bible published in 1821 stated: "To imprint on the memory of youth by lively and sensible images, the sacred and important truths of Holy Writ, and to engage the attention, by striking the eye, and to make the lesson delightful as well as profitable to the juvenile mind, is the object of the following pages."[72] Images were useful because they were lively, sensible, and striking, which is to say that they curbed certain behaviors by actively grasping the young person's attention and profitably installing lessons that would preempt errant behavior. Images, in other words, when properly designed and deployed, negotiated an effective relationship between learning and the emotions of the young (as well as those other kinds of children—the illiterate, the immigrant, and the "savage").

Religious Affections and the Moral Technology of Images

The history of images in religious education in the nineteenth century indicates the importance of several affective associations. Fear, revulsion, pity, shame, comfort, humor, and surprise were used to tag memories in a way that made them indelible, forceful, easily retrieved, and formative. Each of these feelings accompanied the use of certain images in the religious training of American children. Jonathan Edwards had written his influential treatise on "religious affections" or feelings in the eighteenth century (1746), but not until the nineteenth century and the explosion of reproductive technologies did images became a crucial part of shaping behavior by the evocation and manipulation of feelings. Each of the affections just listed served as fundamental categories in evangelical visual piety, I will take them up in turn.[73]

Although it was explicitly rejected by such a nonevangelical writer of children's literature as Samuel Goodrich, author of the *Peter Parley* series, among the conservative Christians of the ATS and the ASSU, fear was understood to be an especially powerful emotional sheath in which to place images.[74] The use of fear took many forms. A comparatively subdued evocation of fear was keyed to the directed turmoil of the conversion process: the consideration of one's mortality and the need for personal salvation. This was a basic part of the affective life of Calvinist evangelicalism, and images were used to assist in the articulation of feelings conducive to conversion. The tract on "fashionable amusements" complained that indulgence in cards, theatre, and dancing dulled an individual's concern for such "momentous topics [as] death, judgment, and eternity."[75] This constituted serious competition for control over a person's emotional life, since these themes were the primary means of arousing a desire for conversion.

Believing that the socialization process could not start too early, the ATS issued *The Picture Alphabet,* which included an illustration (fig. 94) in which the letter *N* was committed to memory by linking it to the urgency of contemplating one's mortality "now." The ASSU included a reading lesson in its 1838 *Union Spelling Book* illustrated by a similar illustration of children at play in a church graveyard (fig. 95). The book posed questions about death and the afterlife and composed a spelling exercise from words used in the reading lesson.

Antebellum evangelical publishers could also rely on a less buccolic tone of fear. Evangelical fervor had reached a rhetorical high point in Jonathan Edwards's homiletics, which should have been enough to shatter the defenses of even the most intransigent backslider. The same divine anger and violence informed the portrayal of a recent catastrophe in the ASSU's *Infant's Magazine* in 1832. The cover image (fig. 96) depicted an earthquake in Syria in 1822 that had killed twenty thousand people. The wood engraving shows a mother and several children consumed by clouds of dust amid tumbling ruins. The accompanying text stated that an earthquake was "one of the most terrible judgments of God" and proceeded to draw from this event a lesson on divine sovereignty and judgment that was applied immediately to the lives of the article's young readers:

Fig. 94
R. M. Bogart, engraver, "N," wood engraving, in *The Picture Alphabet* (New York: American Tract Society, 1858), p. 16.

Now, my dear children, do not say, "What is all this to me?" Do you suppose that there were no little boys and girls killed? And were they worse sinners than you? (Read Luke xiii. 1 to 5). Might not God justly visit our land with an earthquake, as he did Syria; and may not you be among the number of those who shall perish suddenly? And should you not fear any longer to offend that great God, who can so easily throw down the strongest buildings, and not only take away your lives, but destroy your

SPELLING EXERCISE
ON
READING LESSON VI.

All	law	who	will	truth
trust	harm	serve	things	child
love	must	men	hate	pray
ought	Lord	hearts	keeps	safe

READING LESSON VII.

(1.) Do you ask if you are to die?

(2.) Yes. You, and I, and all in the world, must die; nor do we know how soon we shall die.

(3.) Do you know any man who has lived in this world one hun-dred years?

(4.) Where are all the men who were in the world one hun-dred years a-go?

(5.) Al-most all are dead, and gone to some oth-er world.

(6.) Are they happy or not?

(7.) I will tell you, if you will first tell me this one thing: Did they love and serve God when they were in this world?

(8.) If they did, they are hap-py. If they did not, they are not hap-py.

SPELLING EXERCISE
ON
READING LESSON VII.

Die	ask	a-go	now	how
man	one	first	tell	thing
years	soon	dead	since	gone
would	hun-dred	oth-er	hap-py	serve

bodies and souls in hell? O! Children, dread the thought of having God for your enemy.[76]

Although Edwards's vision of hell and this invocation of natural disaster as divine judgment may seem sadistic to modern readers, neither Edwards nor the ASSU derived perverse pleasure from horrifying their public. Fear was thought to be a tool for provoking spiritual awakening and was, in the truly evangelical setting, always attended by the gospel's message of comfort and deliverance. The point was not merely to terrorize but to shock the listener / viewer out of complaisance and to instill the inward perception of a need for salvation. In the case of the earthquake picture (fig. 96), the image helped overcome the child's indifference or apathy by graphically representing a violent event as a divine reckoning that could very well befall the reader. The image helped bring the impact of the event home, making its implications more immediate for the young American reader, who was no doubt inclined to pay more attention to pleasurable diversions than to impending divine judgment.

In addition to the obvious terror of God's wrath, images could also de-

Fig. 95

"Reading Lesson VII," in *The Union Spelling Book* (Philadelphia: American Sunday School Union, 1838), pp. 26–27.

THE
INFANTS' MAGAZINE.

SEPTEMBER, 1832.

THE EARTHQUAKE IN SYRIA.

Fig. 96
"The Earthquake in Syria," wood engraving, cover, *Infant's Magazine* 2, no. 9 (September 1832), 129.

ploy the more subtle but no less shocking fear that adults sometimes used to lodge in the minds of children certain cultural and racial distinctions between Christian and non-Christian, Protestant and Catholic. Consider an illustration (fig. 97) that appeared in *My Picture-Book,* published in 1863 by the ATS. The text, which contrasts the tenderness of American mothers to the cruel indifference of the "heathen mother," is illustrated by an image of a dark-skinned woman who watches casually as a crocodile moves to devour the infant she has thrown into a river. Although the child is white, because of the tonal limitations of the wood engraving (the water is portrayed as gray, and a darkly colored infant would not have been legible in the small print), the whiteness of the infant may have further aroused a white American child's revulsion (and its parent's indignation and pity) by suggesting that a Caucasian child had been abandoned by a black mother. (One thinks of the story of Little Henry, the white child "lost" in the grip of Indian heathens and rescued by a British missionary.) The image reverses the story of Moses being retrieved from the Nile by a servant girl and plays on any child's fear of maternal indifference. Whatever else the image suggested, it certainly reinforced the belief that American domesticity, rooted in Christianity, was superior to non-Christian family practices.[77]

Fear and revulsion played a primary role in *Rev. Scudder's Tales for Little Readers,* which seems almost preoccupied with brutal acts of human

sacrifice, enslavement, and infanticide (see fig. 90). Scudder repeatedly described all manner of "horrid cruelties." Addressing himself to children, Scudder wrote that he "should be glad to tell you nothing about [the horrors], as they are so cruel. But I must tell you; for if I do not, you can never know how to pity these poor creatures, and pray and labor for them as you should." Scudder asked his young readers to imagine themselves in the place of butchered Hindu children and then urged them to thank God, "who has made you to differ from these besotted and cruel heathen." He interwove this tactic of horrifying his readers with direct appeals for their own contrition about rejecting Christ, then pressed the need for their conversion.[78] The images illustrating the book were also intended to move children toward taking up the vocation of the missionary. Scudder recounted how one girl's path toward the decision to become an evangelist in Africa began with becoming "deeply impressed with the sight" of a "picture of a heathen mother throwing her child into the mouth of a crocodile."[79]

Closer to home were uses of imagery that monitored relations between Protestant and Catholic. Fear operated powerfully in instructional imagery among nineteenth-century Adventists, who, for a period of time following the demise of Millerism in the 1840s, were concerned with inculcating a distinct sense of group identity among their young. In a dialogue between a father and son, published in 1846 in the *Children's Advent Herald,* a father brings home a "Bible chart" (no doubt similar to the famous '43

Fig. 97
"The Heathen Mother,"
wood engraving, in
My Picture-Book (New
York: American Tract
Society, 1863), p. 46.
Courtesy of the Billy
Graham Center
Museum.

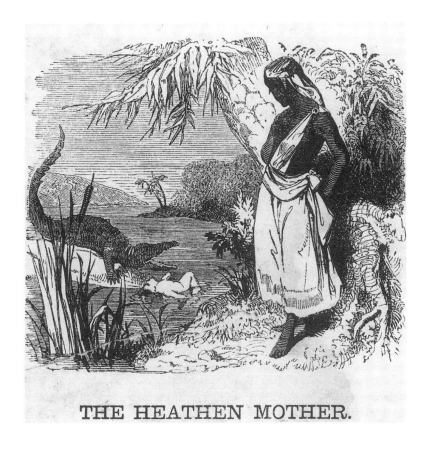

THE HEATHEN MOTHER.

chart produced by William Miller's followers; see fig. 56), which, when displayed upon a wall of the home, provoked in the boy "the highest expression of interest and delight."[80] The father who narrated the account carefully described paradise, the fall into sin, and the entry into the heavenly Jerusalem, then turned to the prophetic symbols of Daniel 7 that were illustrated with the article.[81] When the child asked where such horrible monsters as the "Roman beast" were kept, the father replied: "There are some of them in Boston, some in Charlestown, and some of them almost all over the world. Wherever there is a Roman Catholic priest, there that great ugly monster is."[82]

Although the tradition of linking the papacy to the antichrist is of course as old as the Reformation, the comment reflects contemporary anxiety over Catholic immigration.[83] In 1790 there were twenty-five thousand Catholics in the entire country. By 1850 more than thirty-five thousand natives of Ireland lived in Boston alone, making up 26 percent of the total population of the city and one-third of its laboring classes. Ten years later German- and Irish-born accounted for 41 percent of all immigrants in the United States.[84] Antagonism toward priests and Catholic religious was intensified by their demonic portrayal in anti-Catholic literature, such as the infamous *Awful Disclosures* of Maria Monk (1836), and its illustrations (see figs. 40 and 41). But the fictional dialogue between the Adventist father and his son stopped just shy of characterizing Roman Catholic priests as the keepers of ferocious monsters that devour Protestant children. To the son's inquiry whether "the priests have such monsters to kill people with," the father replied no. "Every man who partakes of their wicked spirit, and approves of their pride and cruelty, is like these beasts, in the sight of God."

Closely associated with fear was the expression of revulsion and shame that images were occasionally used to incite in young viewers. One image (fig. 98) depicts the pathetic state of a prisoner convicted of a capital offense. The heavy chains, beseeching gesture, and hushed stare of those in the background convey the grim despair of a man about to be executed. The text relies completely on the image, pointing to it in short, demonstrative sentences:

> Here is a murderer in prison. See how wretched he looks. Would you like to exchange places with that young man? You shudder at the mention of it. His name was Nathan Crist, and he was executed a few months ago at Mobile for his crime, which he fully acknowledged. I have brought him before you now, because I want you to think seriously upon the last words of his confession.[85]

By mentioning the man's name and the recent date and location of his execution, the text infuses the image with a factuality and contemporareity that make more real the guilt, horror, and condemnation into which viewers were suddenly invited to project themselves. No less powerful was the social dynamic of shame conveyed by the jailer and two gentlemen who look quietly at the desperate prisoner. The man on the left, with his gesture of disdain, seems to scrutinize the veracity of the prisoner's contrition; while the gentleman beside him clasps his hands and purses his lips

in an act of distant pity. Children who placed themselves in the prisoner's lowly state would become, vicariously, the social object of disgust. The consequent revulsion was calculated to strengthen a child's resolution to resist temptation. "Who can describe the danger of harboring sinful thoughts in the heart?" the text asked, building on Nathan Crist's confession of his crimes—all of which originated in a first temptation, a "first thought of crime." The image, then, projected the ultimate consequences of sin for an audience of children and enhanced the didactic device of internalizing a lesson.

Pity and sympathy were other, powerful emotional experiences provoked by images and texts directed to children. These two emotions were frequently conjured up because they instilled in young people the values of benevolence promoted by tract and sabbath societies. In his memoir of work among Sunday schools, Asa Bullard candidly observed how delightful it was "to witness the eagerness with which children will enter into any plan for the alleviation of human woe. Nothing so easily excites their sympathies as the story of pagan ignorance and wretchedness."[86] A visually enhanced regimen of pity for those less fortunate and sympathy for their hardships was thought conducive to conversion, temperance, proselytism, and contributions of time and money to benevolent enterprises. The influence on personal character fostered the evangelical virtues of charity and self-denial, the cornerstones of benevolence. An engraving of a destitute family by Benjamin Childs in the *Child's Paper* (fig. 99) carried a short passage that described the pathetic scene and named its dreadful cause in a gush of Victorian melodrama that became familar after the Civil War:

> Poor boy! No shoes or stockings on. That is not so bad, however, for many a boy in summer goes without them. His jacket is ripped, his trousers torn, and both too small to cover him. Mother has nothing on her feet; and I am sure I cannot tell what her gown is. She is crying, and poor old grandma is in sorrow. They live in a cellar. There are the rough beams overhead. No chairs are to be seen, no closets, no table, no bed. I am afraid they sleep on straw. There is a broken pitcher and an old tin pan. Perhaps it is all they have. What has brought this family so low? What makes them so poor? What makes them so wretched? I will tell you.
>
> The father is a *drunkard*. Bad company said to him, "Come with us;" and he went.[87]

Pity of this kind was experienced as a visceral welling-up of emotion at the sight of the utterly destitute. The publishers of benevolent literature were not above the most mawkish of tactics, such as the picture (fig. 100) in which a ragged little girl—Shirley Temple's poor cousin—knocks one cold day at little Bertie's door to ask for food.[88] Another item in the *Child's Paper* recounted Carrie's visit to a poor family whose tattered clothing, stark poverty, and drunkard father filled her eyes with tears. "Mother, she said, give them my clothes to wear. Oh, let me do something for them, mother." Carrie's self-denying resolution was offered as a model for young readers: "One day in the week she gave to [benevolence], what time she did not play with her dollies or help her mother about the house." Carrie

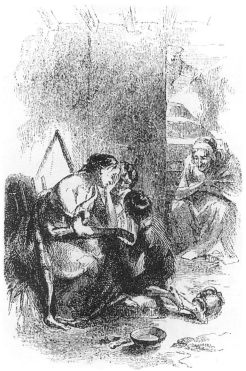

was pictured in an ornamented tondo (fig. 101), pausing from her reading (of scripture) to gaze solemnly into the viewer's eyes, quietly gathered in a circle of earnest self-containment, her head tilted to an angle of sincerity, her tranquil features delineating the round-eyed physiognomny of charity.[89]

The quiet child, soberly contemplating the serious things in life, is very much the Victorian iconography of benevolence. Consider a small vignette (fig. 102) in *Self-Denial; or, Alice Wood and Her Missionary Society*, published by the ASSU. The image was a tailpiece for the story, filling the white remainder of the last page as well as the mind of the reader upon finishing the story. The narrative recounted the determination of little Alice Wood to found a missionary society with her school friends after hearing a missionary recently returned from India tell of "the millions of poor degraded and ignorant people there who . . . worship idol gods of wood and stone, and sacrifice their children and themselves to these dumb idols."[90] Alice presented a slate of names for officers in the youthful society and then set about urging her peers to deny themselves certain gratifications such as sweets in order to save money for donation to foreign missions and to create sewing goods for sale. Alice galvanized her comrades to resist spending their pennies at Mother Grimes's confectionary shop in order "to send a great many Bibles to the destitute." When Mother Grimes accosted a few members of the missionary society concerning the decline in candy sales among them, one little girl told the vendor to abandon sweets and take

up selling "slates, and pencils, and pens, and sponges, and all such useful things."[91]

Transparently encoded in the story of Alice Wood were the central values of systematic benevolence: conversion of heart in the face of the world's need for Christ; the establishment of a benevolent organization; the collective action of boycotting the production and sale of vice; and the practice of self-denial to attain one's ends. But this was not all. The children of the story were shown to have learned that the spiritual economy of saving one's soul corresponded to the capitalist enterprise of saving one's money and investing it wisely. The story ends with the thought of the future and the dividends of benevolent investment. The double-entendre of "interest" and "saved" is striking in the following passage:

> Depend upon it, your interest in benevolent objects will increase from the very moment that you deny yourself for the sake of giving to others. Think what it would be to have even *one soul* saved from among the poor benighted heathen, to rise up in the last great day, and call you, yes *you,* my little reader, blessed.[92]

The benevolent virtue of self-denial was here disclosed to be a deferral of self-interest to the day of final reckoning, when the benevolent child would reap compounded returns: the salvation of her soul. Appearing at this point in the text, the illustration condensed the lesson of the booklet by picturing a sober discovery of death in the days of childhood ignorance and the self-indulgence of play (note the child's toys), thus marking the

Fig. 100
Poor girl at door, wood engraving, in *Child's Paper* 15, no. 11 (November 1866), 43. Courtesy of the Billy Graham Center Museum.

HAT do you think Aunt Mary
calls our Carrie? Her little

Fig. 101 (top)
Carrie, wood engraving,
in *Child's Paper* 17, no. 11
(November 1868), 42.
Courtesy of the Billy
Graham Center Museum.

Fig. 102 (right)
Child before grave, wood
engraving, tailpiece to *Self-
Denial; or, Alice Wood and
Her Missionary Society.* The
Child's Cabinet Library,
vol. 50 (Philadelphia:
American Sunday School
Union, n.d. [1847]), p. 29.
Courtesy of the Billy
Graham Center Museum.

moment of childhood's end. The image of the young boy gazing on a
grave quietly urged a chastened sense of mortality and the need to make
a choice between self-pleasure and the dutiful preparation of one's soul.
The child must choose between benevolent self-denial with its postpone-
ment of reward and the immediate playthings of this world, such as the
transient pleasures of toys and candy. The illustration, therefore, summa-
rizes and visually encapsulates the lessons of the tract with the somber
tones of a postlude.

Comfort was an emotional value that became increasingly popular among evangelicals as the cult of domesticity developed during the nineteenth century. The iconography of comfort was promoted in advice books and literature directed to parents, particularly young mothers. Not infrequently, identical images were shared among evangelical publications. The *Well-Spring* and the *Christian Almanac* each used the same illustration (fig. 103) to portray a cozy, comforting maternal ideal, marking a clear contrast to the "Heathen Mother" (fig. 97). The accompanying text in the *Well-Spring* noted that the editor was "always delighted to meet those [children] who are gentle and kind to each other, and obedient and affectionate to their parents."[93] Recut for use in the *Christian Almanac* of 1869, the image carried there the following text:

> Consider what picture-books are to a child; not only culture, nutriment, play, but medicine, comfort, rest; nothing enters so completely and entirely into child-life. They are repeated, quoted, dramatized, remembered. What sense and sensibility, spice and shortness are required to write one! I had rather be the author of a lively and wholesome picture-book, than to be Hume or Smollet. Let not picture-book makers undervalue their mission.[94]

The text pitted the highbrow culture of the philosopher and novelist against the culture of child-rearing, echoing the widespread belief that the

Fig. 103
Mother reading to children, wood engraving, in *The Family Christian Almanac*. New York: American Tract Society, 1869, p. 41.

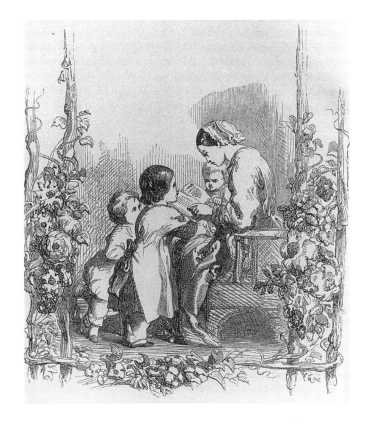

Fig. 104
Leading sketch, in Rev.
Robert F. Y. Pierce,
*Pictured Truth. A
Handbook of Black-
board and Object Lessons*
(New York: Fleming
H. Revell Company,
1895), p. 20.

influence exerted over children lasted a lifetime and exceeded in impor-
tance the impact that adults could extend over one another even with their
learned or artistic authority.

Finally, amusement in the form of humor and surprise was a very ef-
fective device used to aid instruction. For instance, surprise was an im-
portant factor in deciphering the rebus puzzles in the illustrated primer
and the hieroglyphic Bible. Finding hidden or coded meanings aroused
young persons' curiosity and served to direct and fix their attention on bib-
lical themes and passages.[95] No less amusing was a genre of performative
evangelical imagemaking, the blackboard illustration or the chalk talk, an-
other didactic application of the image to learning biblical truths and
church doctrines. The chalk talk's appeal was an element of curiosity and
surprise achieved in the quick evolution of a drawing before an audience.
Most chalk talk manuals included examples of metamorphosis as a fa-
vorite device for amusing an audience and keeping its attention. The artist
literally illustrated the transformation of one thing into another in a series
of drawings. An image in an 1895 manual on biblical chalk talks (fig. 104)
illustrated the transformation of a lima bean into a pig, which in turn be-
came a rose—a series of metamorphoses that visually demonstrated the
capacity of the young person to turn something objectionable in his be-
havior—the pig—into something commendable, the rose.[96] The devel-
opment and social function of this genre of instructional imagemaking is
the subject of the next chapter.

Talking Pictures

In his instructive social history of print and visual propaganda during the German Reformation, R. W. Scribner contended that the Reformation was "part of a movement from an image to a print culture."[1] But print culture did not mean aniconic or anti-iconic culture. The Reformation ignited an explosion of printed imagery in chapbooks, tracts, broadsides, and illustrated Bibles. What Scribner had in mind was a tectonic shift from the cult image as the site of authority to the printed text and image as the circulating, mechanically reproduced source of authority. The change eventuated new relationships between visual and textual signs that responded to new literacies and the cultural politics of representation. Printed words and images were conjoined in scientific and scholarly literatures but also and on a much larger scale in popular genres such as broadsides, maps, histories, primers, and almanacs.

The printed image has remained a fundamental part of popular and elite cultures ever since the Reformation but has generally operated among Protestants as part of textual literacy in the Christian enterprises of education and evangelization. Indeed, one of the most characteristic features of mass-produced Protestant imagery in the eighteenth and nineteenth centuries is the integration of word and image. Of course, the two have been closely associated since the Middle Ages in manuscripts and altarpieces.[2] But later medieval visual culture was much less inclined to exclude pictorial imagery that was independent of text (what Scribner meant by "image culture") in the way that Protestants have often avoided large wall paintings, altarpieces, and sculpture. Thus, other than portraits, emblems, and allegorical images, each of which possessed a clear and terres-

trial referent—an individual person in portraiture and an abstract idea in emblems and allegories—Protestants have generally avoided free-standing imagery.

But images anchored to text have rarely presented a problem to Protestants. Illustrated Bibles, almanacs, and primers were widely prized in colonial America and the nineteenth century. Judging from eighteenth-century illustrations of religious subjects, particularly from the time of the Revolution onward, printed religious imagery was increasingly popular.[3] Reasons for this are economic, theological, and pedagogical. America did not have a history of spending large sums on the visual arts, in part because many kinds of religious art were often considered inappropriate. But beyond these negative cultural restraints, illustrated books were an affordable commodity that made a good gift and heirloom and also served as the basic tool of American education and the display of learning in the study and home. Books could be more readily transported and exchanged than paintings and used from generation to generation in order to secure the stability of knowledge. And illustrated items such as almanacs and primers enhanced learning, which was heavily dependent upon memorization and the repeated reading of a small number of books.

Illustrated instructional items put the image to work within the domain of the printed text. In the age of mass mediation, the printed image enjoyed a magnified importance because it was an inexpensive means of appealing to hundreds of thousands of distant customers. When image and text were joined, evangelical educators expanded the repertoire for teaching their beliefs and attracting the attention of readers. The interrelation of word and image in mass-produced items of religious instruction during the nineteenth century tended to take the form of at least four schemes. First, the image could be "literally" substituted for text. Second, image and text were made to correspond to one another point by point. Third, image and text were used to generate one another. And fourth, image and text could be made to transform one another as graphic signs in two fluid orders of representation.

In the first instance, it is difficult to imagine a more literal commingling of word and image than the popular hieroglyphic Bible, where an image stood in the place of a word (see fig. 83). As pointed out in the previous chapter, the amusement generated by the hieroglyphic Bible's emblematic use of imagery consisted of the viewer's reconstruction of an elided text from the clue of an image. The displacement of a word and the insertion of an image into the syntax of a Bible passage required a deduction or guess that contrasted and compared verbal, written, and iconic sign systems. A disjuncture was caused by mapping the three varieties of signs over one another as a clue to the meaning of the absent text. Filling the gap was fun.

In the second case, certainly the most familiar connection of word and image in illustrated books and tracts, the image served as a visual counterpart to a text. For young children this was especially important since, as Asa Bullard, editor of the *Well-Spring,* pointed out, "Even the 'little ones', before they know a letter, can *read* the pictures."[4] Images drew children into the discourse of texts. Not only did images clarify and amplify the meaning of a text, they were a propaedeutic to reading, bearing a legibility that led

to textual literacy. This assumed a common-sense view of both images and texts: that they were designed and able to signify meaning about the world and that they corroborated one another in this enterprise. One advocate of "picture teaching" in the home and Sunday school urged "parents and the elder members of the household . . . to take the necessary pains to master entire details of engravings [in picture books, and to] . . . have the patience to unfold the stories with all the minutiae of the narrative interwoven with the details of the picture."[5] Another account in the *Well-Spring* shows that the significance of the ubiquitous picture book for young children resided in just this corroborative relationship of word and image.

> A short time ago, a little boy five years old was playing with his toys, but seeing his aunt take up the Bible, he immediately left his play, and ran to her saying, "Please aunty, do read to me about Daniel in the Lions' Den, and I will be very attentive, and please do let me have uncle's Picture Book, that I may see Daniel."
>
> Of course the request was granted, and it was pleasing to watch the little child examining the picture, to see that it corresponded with the account that his aunt was reading from the Bible. He asked many curious questions about the angel and the lions, which, if he had not had the picture before him, he might not have thought of.[6]

In the mind of this child, image and text corresponded directly and in narrative step with one another. In fact, the image expanded the meaning of the text for the boy by visualizing what was implicit or only marginally signified in the Bible. Image and text worked in tandem, though visual literacy was ultimately premised on the biblical text.

Third, images were read as generating narrative meaning encoded within their features in a way that was comparable to a text's ability to evoke an image. In other words, text and image could produce one another because each was a fundamentally legible code. "All pictures," an item in the *Well-Spring* stated, "are at first made to illustrate a book or story, but often such pictures can be used over and over again by different publishers, and so it happens that sometimes we write for pictures."[7] The reuse of cuts was a widespread practice, and many images, especially those created in the vignette format, were suited to multiple uses. In fact, publishers of prints issued "specimen books" of engravings from which book and magazine editors and other publishers could select images for use, purchasing either a block or an electrotype cast. Specimen books consisted of hundreds of vignette prints gathered in column after column, organized by theme and listing order number and cost beneath each image (fig. 106). The diffuse boundaries of a vignette allowed printers and publishers greater latitude in fitting the image into the text as well as the opportunity to use the image in new settings. With fewer restrictions in format and the avoidance of subject matter that entailed explicit attachment to a single narrative, the vignette could float from one context to the next, affording an obvious economic advantage—to the publisher or printer if not to the artist and engraver.

The practice of reading stories into such relatively unanchored pictures was common. Another writer for the *Well-Spring* introduced an illustrated

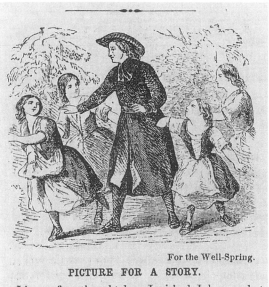

For the Well-Spring.

PICTURE FOR A STORY.

I have often thought how I wished I knew what
the little Well-Spring readers would write about, if
some one should send them a picture, with not a
word attached to it, and ask them what they should
think it might represent; or if they knew of any

Fig. 105
Priest and children,
wood engraving, in
"Picture for a Story,"
Well-Spring 18, no. 38
(September 20, 1861),
148. Courtesy of the
Billy Graham Center
Museum.

story in this way: "Do you ever look at pictures, and *think* stories about
them? Well, I do very often. I was looking at this picture just now, and
thought all this about it . . . "[8] The conditions of production were con-
ducive to the circulation of indeterminate images that could be fitted to a
variety of narrative contexts, indeed, could be used to generate their own
narrative settings. Meaning, in other words, was not fixed but constructed
by individual viewers and by the textual framework constructed about the
image. The author who spoke of an image being used by many publishers
conducted an experiment in a picture's narrativity by reproducing an en-
graving (fig. 105) without a caption or attendant story. In fact, the image
comes from a *Specimen Book of Engravings* published in New York in the
late 1850s. There the image was the first in a series of three illustrations
that appeared on a page dedicated to the subject of bad girls making good
(fig. 106). Viewed in this context, we see that this engraving (fig. 105) is part
of a series that narrates the conversion of a young girl who steals a book
from a clergyman's pocket, reads it, then repents and pleads for his for-
giveness.[9] Each image in the sequence was priced individually, the second
one notably less than the first and third, possibly because transgression
(the first image) and repentence (third image) stood alone easier than the
more subtle process of contritely imbibing the message of the purloined
devotional text (second scene). Yet even the *Specimen Book* does not pro-
vide the "original"; item number 5135 is missing from what appears to be
an even earlier and now incomplete sequence. For that matter, we have no
assurance that the series either begins or ends with the eight episodes pic-
tured (see fig. 106). In the endless pastiche of appropriations and rede-

Fig. 106
Priest and children series, in *Specimen Book of Engravings* (New York: Carlton & Porter, c. 1857–1860), p. 36. Courtesy of the American Antiquarian Society.

ployments that constitute mass visual culture, meaning is never final nor rooted in an original moment.

"Now, suppose six Well-Spring lovers and readers were to have the above picture [fig. 105] sent to them, with the request that they should write something about it. I think we should have six very different kinds of stories, don't you?" The author then ventured a story of her own to fit the picture. Two months later a reader replied with a different narration of the picture, though both accounts stressed the innocence of the children, in spite of the cleric's pained look and the ornery expression of the girl whose hand is buried in his pocket.[10]

This intriguing experiment in popular reception is significant for at least two reasons. First, it underscored the inherent narrativity of word and image, for the article ended with an admonition regarding the moral legibility of each person's life: "We are living lives which tell a story—a true story—upon our futures, of our inward and outward conditions and feelings." Each life bears a spiritual physiognomy just as every picture tells a story and every story calls forth a picture. Even though people will interpret texts and images differently, the article would argue, they are both inherently interpretable just as one's life is inherently meaningful since it tells the story and draws the picture of its spiritual state and development. Second, the publication of the exercise in the *Well-Spring* reminds us that reception was a crucial aspect of the determination of the meaning of mass-produced images. The religious press did not generate fixed, monolithic, and universal meanings, though it certainly went far to shape the semantic context for interpreting images. But finally viewers assigned meanings under diverse conditions and with widely varying needs. We learn from the *Well-Spring* that this was an acceptable state of affairs and one that mass-produced images were especially able to exploit. The commentator felt free to lift an illustration (fig. 105) from the narrative sequence of the specimen book and redeploy it for the purpose of engaging his readers in generating their own stories.

Finally, image and text were often transmogrified into one another in the visual magic of the blackboard illustration or chalk talk. Literature on "blackboarding" in the Sunday school appeared in the 1860s and 1870s in books and manuals and in such mainstream periodicals as the *American Sunday School Worker,* the *Sunday School Times,* and the *Sunday School Teacher*. In the first year of the publication of the *Sunday School Teacher* (1866), a monthly edited by John H. Vincent (1832–1920) and published by the Chicago Sunday-School Union, there appeared an article entitled "Blackboard Exercises," with two illustrations. In the following year, when Edward Eggleston (1837–1902) became managing editor, "Blackboard Outlines" became a regular feature produced by Eggleston himself. From 1869 to 1874 Samuel Wellman Clark edited and published a periodical devoted to such illustration, the *Sunday School Blackboard,* which provided blackboard lessons illustrating prominent national instructional series.[11] Somewhat later the Fleming H. Revell Company published the *Sunday School Lesson Illustrator*. Such images proved durable and helpful. The *American Sunday School Worker* published blackboard lessons such as "The Christian's Ladder to Glory" (fig. 107) as early as the 1870s, and the *Sunday School Times* continued to publish simple sketches for use by teachers with

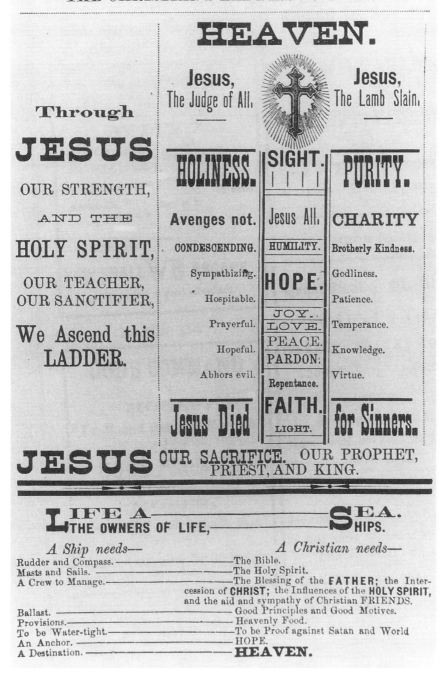

Fig. 107

"The Christian's Ladder to Glory," in *American Sunday School Worker* 3, no. 1 (January 1872), 32.

little skill at drawing (fig. 108) as late as the 1940s. In the case of the former (fig. 107), text played the fundamental role in graphically presenting the salient features of the Sunday lesson. Such illustrations were closely keyed to the scriptural text and were conceived as an "object lesson," that is, as a concrete exercise meant to assist teachers in making points and students in remembering them. Key words were printed in a variety of fonts and sizes and arranged in compositions that pictured an idea such as "the Christian's ladder to glory." Each of the virtues leading to heavenly glory

Fig. 108
Wade C. Smith, "Jesus Comforts His Disciples," in *Sunday School Times* 77 (February 27, 1932), 119.

is arranged as a rung on the ladder. In another example (fig. 109) the principal biblical figures from Adam to Jesus, identified in a lesson entitled "The Descent of Christ, and the Promises of His Coming," which consisted of nineteen questions and answers, were visualized in "the inner view of a temple of time" to help students commit to memory the linear descent from "the first Adam" to the "Second Adam," which students recited in concert. Arranged in an architecture of diminishing perspective, each arch and column is marked by a name moving from front to back.

Shaped by the needs of religious instruction such as teaching literacy and enhancing memorization, the four interrelations of word and image in illustrated publications were also invested with such tasks as nurture, enforcing conceptions of the moral order of the universe, gender, and authority, and applying techniques of secular pedagogy to the sabbath school. The connection of word and image consisted of a visual practice, as in the case of the picture card (fig. 84), where the card was part of ritualized membership in the school and joined image to scriptural text and social practice. In the case of blackboard illustration and particularly its itinerant version, the chalk talk, word and image were joined in perfor-

Fig. 109
Temple of time, illustration to "The Descent of Christ," in *American Sunday School Worker* 3, no. 7 (July 1872), 205.

mance. Both blackboard and chalk-talk imagery are overlooked genres of visual pedagogy that deserve historical attention because of their popularity and wide use, their unique contribution to the history of religious visual communication, and the fascinating intersection of instruction, advertising, and popular psychology, each of which became persuasive among Protestants during the Progressive Era.

Performing the Word: Blackboard Illustration and the Chalk Talk

Use of the blackboard in the Sunday school appeared at least as early as midcentury and no doubt even earlier. An editorial of 1871—objecting to the *Sunday School Time*'s presumptuous claim to have "originated" the "idea of using the Blackboard in the Sunday-school"—pointed out that that blackboard had been applied to Sunday school work in Maine "as early as 1854."[12] In fact, although blackboard illustration had developed its champions by the late 1860s, it had been criticized as early as the 1840s as "hardly reconcilable with our conceptions of a Sabbath School."[13] One advocate of religious illustration observed in 1872 that the blackboard had long been a symbol of secular education since chalk and slate were the staple of the public schoolhouse, where Sunday school classes were held in rural communities. But by the 1870s, the author contended, things had changed, and the blackboard "smacks of a time-honored agency."[14]

Attitudes had changed. Among the new generation of religious educators that gained prominence following the Civil War, the desire was not to distance Sunday school teaching from the techniques of the common school but to pattern religious instruction after the work and methods of public educators. In 1868 Edward Eggleston made his position very clear in the recently founded journal the *Sunday School Teacher*:

> The watchword of progress in the common school is the blackboard. . . . The great discovery which teachers have made is that the eye is better than the ear. A pupil receives quicker, understands better, and remembers longer that which is presented to the eye, than he does that which is taught orally. The motto of all good teachers is—to the blackboard with everything.[15]

This emphasis on the eye and the appeal of visual stimulation, which underscores the importance of youth in the formation of a mass visual culture, found staunch endorsement from leading lights in educational theory. Horace Mann (1796–1859), champion of the common school and secretary of the Massachusetts Board of Education, claimed in his *Lectures on Education* (1855) that "the use of some simple apparatus, so as to employ the eye, more than the ear, in the acquisition of knowledge" would "increase tenfold the efficiency of our Common Schools."[16]

Mann was among the many American educators in the antebellum period who welcomed the ideas of Johann Pestalozzi (1746–1827), a Swiss writer and pioneer in elementary education. Pestalozzi had organized in-

struction along developmental lines, moving from simple to complex, concrete to abstract, making great use of object lessons in order to help children grasp and retain the implication of principles and ideas. In an early work of enormous influence, *Leonard and Gertrude* (1781), which G. Stanley Hall considered a tractlike allegory of evangelical character, the sensible mother and wife, Gertrude, teaches her children, above all, "an accurate and intelligent observation of common objects and the forces of nature." Rather than insist they memorize the abstract principles of arithmetic, she taught them to count their steps and to figure fractions from the grid of window panes.[17] Pestalozzi also stressed the moral and religious function of education in shaping the child toward a fitness of life, to help students "become what they are meant to be," as Gertrude told one schoolmaster.[18] *Leonard and Gertrude* and other works by Pestalozzi were translated into English and found enthusiastic reception among several important and progressive educators in the United States by midcentury, including George Bancroft, Henry Barnard, Mann, and Edward Sheldon. Sheldon, the superintendent of schools in Oswego, New York, put into effect a pedagogy inspired by Pestalozzi's emphasis on the senses and progressive learning. Object teaching played an important role among teachers in the Oswego school system from the 1860s until well into the twentieth century.[19] Aesthetic education meant in the Pestalozzian tradition the cultivation of the senses as the basis for moral and intellectual understanding. The widespread use of chalk talks and object lessons in religious instruction in the second half of the nineteenth century reflects a Pestalozzian influence, which would have generally appealed to American Protestants, since it came attached to a theological commitment in its Swiss inventor to the idea that nature bears the evidence of divine authorship and that beauty is the signature of nature's maker.[20]

While Pestalozzi was deeply committed to education as the formation of the individual, American religious and secular educators persisted in a Puritan model that stressed the acquisition of knowledge. In this concept of instruction as the delivery and installation of information, attention was the gateway to the student's mind. This gateway possessed two handles—to use Bunyan's popular terminology, ear-gate and eye-gate. The attention of children was something for which one had to compete; but once it was secured, the teacher had sure access to thought and memory as the means of lasting influence. But Pestalozzi's recognition of the power of objects and actions to enhance learning was not lost on ambitious American educators. Blackboard illustrations were able to claim and hold attention by rooting discourse in concrete objects and compelling sensations. These talking pictures—images that integrated text, image, and verbal explanation—combined content with an effective bearer of information.

But charged with moral formation, Protestant instruction did not limit itself to channeling the information of a knowledge-based or subject-centered curriculum. The blackboard was an instrument of information delivery that was prized by secular and religious educators for its ability to command attention, to control the classroom by submitting it to the singular will of the instructor. An article in the *Sunday-School Times* in 1870 offered over a dozen answers to the simple question, Why use the

blackboard in Sunday school? The first seven leave no doubt about the importance of control in religious instruction given its accent on content:

1. Because by it the attention of the whole school may be called at any time to one subject.
2. The school is thereby easily brought under the control of one mind.
3. It may be so used as to preoccupy the mind of every scholar with the central thought of the lesson for the day.
4. The eye being employed as well as the ear, the transmission and impression of the truth are made doubly sure.
5. The attention secured by the blackboard is more intense, and may be held for a longer time, than without it.
6. Thus it aids the memory.
7. Thus, too, it renders the instructions of the teacher more lasting. It makes his influence felt beyond the school session.[21]

With all the students facing the front of the room, their eyes fixed on the blackboard, teachers could quickly survey the class and register understanding or confusion, obedience or misbehavior.

Blackboard illustration was encouraged by most of the prominent leaders in the Sunday school movement in the final decades of the nineteenth century. Edward Eggleston and the prominent lay Baptist leader Benjamin Jacobs shared the board at one meeting of the Brooklyn Sunday-School Union, where Eggleston emphatically endorsed the practice by announcing: "We cannot get the truth into a child by reading the catechism [only]."[22] Another apologist for blackboard illustration was Henry C. McCook (1837–1911), a Presbyterian pastor, writer, and Sunday school advocate from Philadelphia, who published a long "guidebook" for Sunday school teachers in 1871. As did many other Sunday school enthusiasts of the blackboard, McCook perfunctorily acknowledged the dissatisfaction of many clergy and teachers with the blackboard, but ascribed this to the abuse rather than the fault of "visible illustration."[23] McCook distinguished the appropriate use of images from abusive practices. In essence, any image that visualized excessive passion, deformity, pain, or gory detail was objectionable. As a common example of abusive imagery and its consequences, he cited the negative and enduring impression left on a pastor who, as a child, had seen a bloody illustration of the crucifixion in his home Bible. Moreover, there were certain subjects that were simply unacceptable: "A cross is well enough; but a crucifixion scene I have always shrunk from. The face of saints is a worthy subject of art; but the 'Veronica' is not for mortal hand to trace or mortal eyes to scan."[24]

The use of images in instruction concerned many Protestants because of the association with Catholic devotionalism. When Eggleston hoped aloud that "the day would soon come when the walls, panels and windows of our Sunday-schools would be adorned and painted with scriptural pictures," he felt compelled to add this disclaimer: "You will say that there is danger of drifting into Catholicism, but there is no fear of that."[25] If in fact there was no fear of idolatrous misuse of images and symbolic objects, it was because, among Protestants, these supplementary items were neither self-standing nor ritualistically essential in worship but anchored to text

and the protocols of instruction. Yet the anxiety persisted. Negative impressions and images of Jesus, McCook asserted, were psychologically and theologically unsuitable. No less dangerous were images that might lead "to such a relish for a sensational style of religious service as shall pave the way in [the minds of children] for Ritualism or Romanism." In order to avoid this, McCook stressed that the teacher was "to make truth plain," to use only those methods of illustration that helped make scriptural points. Any practice that sought "chiefly to invent and utter a beautiful or impressive exercise" strayed into "ritualism" and away from "plain" biblical truth. McCook insisted that "our system applies simply to the strictly Didactic, not to the Devotional, part of the children's service." The distinction between the didactic and the devotional use of imagery for this Presbyterian and many Protestants was crucial: "The use of visible objects or images in the direct worship, in the adoration, of the Invisible God is contrary to the whole spirit and letter of the Scritpures." But to justify the use of objects and images in instruction, McCook enumerated several pages worth of visible illustrations used in the Bible.[26]

Henry Clay Trumbull (1830–1903), Congregationalist minister, secretary of the ASSU from 1871 to 1875 and then editor of the *Sunday School Times* until his death, was also a supporter of the blackboard. Arguing that hearing and seeing were "the two senses given of God to enable the children of men to become familiar with His law," Trumbull claimed that teachers who ignored the importance of "eye teaching" treated students as if they were blind. Trumbull saw no end to the visual opportunities of learning in the modern visual culture of mass-mediated print:

> Every letter of the alphabet is an agency of Eye Teaching. Every picture of any sort is a specimen of visible illustration. Every written sentence is an equivalent of a Blackboard lesson. Books, cards, papers, scrolls, illuminated texts, banners, and models—all are but varieties in the plan God marked out to his people on Sinai, and which has been followed more or less closely in all teaching from that day to this.[27]

Striking here is the consonance of visual media with the original, biblical channel of divine revelation. The visual communication of truth was as untrammeled and reliable as its first and subsequent inscriptions. The modern schoolhouse blackboard, Trumbull insisted, was not different in principle from the doorposts, gateways, and wax tablets of ancient Egypt.

Yet it was necessary to monitor the use of the blackboard in order to preserve its purity and usefulness as a visual medium of evangelical truth. Accordingly, Trumbull warned the superintendent of the Sunday school not "to attempt any teaching with a blackboard that he would not attempt without it." Truth could not be simply visual. Its source remained scripture, inscribed truth. The blackboard was an additional channel of communication that enhanced the delivery of truth. Because this medium was not autonomous, it was not to be allowed to draw attention to itself. "Elaborate pictures on the blackboard are rarely of benefit to a Sunday school. . . . [I]f [the superintendent] brings a carefully-drawn chalk picture, he fails to carry his hand and his tongue in harmony." Word and image were to remain in tandem, therefore the illustration was best a cursory

sketch executed in step with the verbal presentation of the lesson. When the sketch turned into a picture, it lost its power to signify the lesson and became an end in itself, a display of skill that eclipsed the illumination of scripture. In effect, a carefully worked up picture lost its transparency to the text behind it and became opaque, something that captured the attention of the viewer and kept it focused on the features of the image. The superintendent, according to Trumbull, was always to bear in mind that "Bible truth, and not blackboard beauties or blackboard oddities, must be relied on, to make the Sunday School exercises profitable or even permanently attractive."[28]

Trumbull emphasized that the blackboard illustration was normally the domain of the superintendent and not his (largely female) teaching staff. Other proponents of the blackboard in the Sunday school agreed: "Usually the superintendent is the proper person to use the board."[29] It was Trumbull's recommendation that the blackboard was best used at the end of a session when the superintendent might ask each of his teachers to state for the entire class what was learned that day while the superintendent wrote what they said on the board. Finally, he himself should add "one thought more important, or more inclusive, than the others, and press that home on all." As the proper domain of the male leader, the use of the blackboard was a pedagogical practice that underscored the hierarchy and gender of authority while encapsulating the day's lesson.

From the mid-1890s through the 1930s and beyond, a steady stream of publications on blackboard and chalk talk imagery poured forth from a variety of church and trade presses.[30] Book-length presentations developed a more elaborate theological apparatus for the task and scope of illustration. A close look at a few works will exemplify the theological and pedagogical issues at stake as well as the conceptions of imagery and performed illustration that merged word and image in this evangelical visual piety.

Robert F. Y. Pierce (born 1852) was a Baptist pastor from Rock Island, Illinois, who specialized in ministries and publications that advocated blackboard techniques and explained their use in the classroom. Pierce contributed blackboard lessons to the *National Baptist,* the *Baptist Union,* the *Sunday-School Lesson Illustrator,* and the *Church Evangel,* and he published a large collection of his drawings and their explanations with the house of Fleming H. Revell in New York and Chicago, which published more books on blackboard illustration and chalk talk than any other press. Pierce opened his book, *Pictured Truth* (1895) with a chapter called "Eye Preaching," a fascinating attempt—recalling McCook and Trumbull—to justify the use of blackboard images on the basis of the Bible's frequent use of the visual sense to reveal God. Thus, Adam and Eve *saw* the tree of the knowledge of good and evil in Eden; they *beheld* the "manifest presence of Jehovah in glory flashes" when they were expelled from the garden; Abram *beheld* the "outward and visible sign" of God's covenant (Genesis 15); Moses "was permitted to *see* much of the Lord, as well as to hear his voice." And so on.[31] Faith, it would seem, came not only by what was heard, to alter the Pauline maxim (Romans 10:17), but also by what was seen. In effect, Pierce sought to continue the campaign put in place by

the Bible and Tract societies earlier in the century: to transmit religious truth along the visual avenue of modern mass media.

> Pictured truth is powerful, and if God has so wisely used the eye as the channel through which his truth might be imparted, surely we may use this means of reaching the hearts of those to whom we preach. In these days of pictorial literature and of kindergarten and object lessons, we have multiplied illustrations of the force of that teaching which appeals to the eye.[32]

Pierce invoked familiar arguments concerning the special power of images: "Pictures speak more quickly than books, and the teachings of the pictures are often more impressive and more abiding. Old and young, of every tribe and nation, find here a universal language." Images were a special linguistic phenomenon, a means of revelation chosen by God as well as a universal channel of communication. They were thought to convey information more rapidly and to do so without regard to the cultural boundaries separating peoples and ages. Because God sanctioned the visual sense by using the eye as a means of revelation, the gospel could justifiably be converted into visual information and disseminated more effectively. But the usefulness of images did not end there: "Crayon illustrations *arrest* and *rivet* the attention, and in the presentation of truth to youthful minds they are of incalulable value; for children think in pictures, and by pictorial and object-lessons, we can stimulate their thought."[33] As a means to "arrest and rivet the attention" of children, images offered a mechanism of control, a powerful technology for molding thought. By using pictures to educate children, the evangelical instructor was shaping the child's mind by working in the very medium of youthful cognition.

But a look at Pierce's diagrams and drawings demonstrates very clearly that he conceived of the image not as an independent means but as deeply dependent on text. Pierce's pictographic imagery moved beyond strictly textual material (figs. 108 and 109) by drawing from the tradition of the hieroglyphic Bible where an image was inserted in the place of a scriptural text. One of Pierce's diagrams (fig. 110) substituted three images for their corresponding terms in Psalm 119:105: "Thy word is a lamp unto my feet." But Pierce's illustration also integrated word and image by rhyming the two or conforming one to the other, as in another image (fig. 111) where the text "The Home Circle" is arranged in a circular format with a cord around the radiant logo, "mother." This picture illustrated Proverbs 31:28 and converted into a motto a very popular subject of countless nineteenth-century wood engravings and lithographs.

Most of Pierce's images do not make an artistically conscious use of the visual format but allow symbols and texts to float unanchored in the black space of the board (see fig. 110); large portions of black remain unengaged. This suggests that the images were keyed to oratorical presentation and were not meant as finished compositions. Instead of carefully designed graphic display in which the eye responds to inventive arrangements of visual elements, the blackboard pictographs merged spoken discourse with written text. The process of watching and listening to the image consti-

Fig. 110
Rev. Robert F. Y. Pierce,
"Thy Word is a Lamp
to My Feet," in Pierce,
*Pictured Truth. A
Handbook of Blackboard
and Object Lessons* (New
York: Fleming H. Revell
Company, 1895), p. 200.
Courtesy of Jesuit-
Krauss-McCormick
Library.

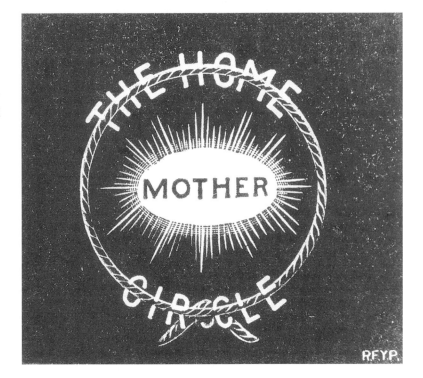

Fig. 111
Rev. Robert F. Y. Pierce,
"The Home Circle," in
Pierce, *Pictured Truth. A
Handbook of Blackboard
and Object Lessons* (New
York: Fleming H. Revell
Company, 1895), p. 201.
Courtesy of Jesuit-
Krauss-McCormick
Library.

tuted the occasion and aim of the picture, not artistic concerns of style or composition.

This instrumental and oratorical use of the image was widely advocated among religious educators. The *Pilgrim Training Course for Teachers,* written within the guidelines of the Sunday School Council and the International Sunday School Association, also stressed the importance of the proper use of the blackboard: "Its true use is free, living, and personal. A rapid descriptive sketch, an outline map or diagram, an important word or principle written as well as spoken—such is true blackboard illustration, done as the teacher talks, reinforcing the impression of ear with that of eye."[34] Rather than calling attention to itself, the blackboard image worked with words and the discourse of the speaker to convey and punctuate a message with greater clarity. The view expressed by Trumbull—that the hand and tongue should operate in harmony—remained a constant concern among evangelical advocates of the blackboard illustration. Pierce considered a "finished picture" of less value than a "crude" sketch because the audience was attracted to the "action in drawing." "Many finished pictures are like many printed sermons,—beautiful but lifeless. Most sermons to be effective must be accompanied with the voice."

This view was echoed among several clergymen quoted by Pierce. Although some Sunday school advocates, such as John Vincent, recommended that blackboard work be conducted by artists, others were unconcerned about artistic appearance or aesthetic quality, indeed, even suspicious of it.[35] Many veterans of the blackboard in religious instruction stressed the purely instrumental character of the sketch as a device that referred not to itself but to the ideas it signified. One writer urged the instructor to let the blackboard "stand one day without a line, rather than use it so as to divert attention from the TRUTH." Another asserted: "Elaborate pictures on the blackboard are rarely of benefit to a Sunday-school, while rude sketches in illustration of passing remarks are many times useful." Yet another author stressed the importance of simplicity, "lest the means by which we teach shall draw the attention from the truth to be taught."[36] Each of these writers shared the apprehension of the image becoming self-referential. The image was to be nothing more than a transparent or self-effacing sign whose sole purpose was to enhance the point the speaker made. For writers such as McCook, the blackboard was theologically unfit to depict certain subjects, such as Christ, but for most the issue was one of preserving the illustrative purpose of the image as opposed to the status of an autonomous work of art.[37] When the image drew attention to itself as a beautiful object, when the viewer became conscious of the picture as an end in itself, the image was no longer a conduit of evangelical truth. As one author put it, blackboard exercises were not "to be commended . . . for the skill of the artist, and lead us to say, 'How fine!' instead of 'How true'!" Another practitioner of the art stated: "Put nothing on the board simply to *amuse*—nothing to distract the mind, and divert from the great lesson sought to be impressed upon the school. Let the board, as well as the lesson *teach Christ*."[38]

Many chalk talkers and blackboard illustrators explicitly preferred the roughly drawn sketch executed in the course of talking to completed or mass-produced pictures. Drawing the sketch while talking enhanced the

"power of attraction." One writer stated: "In the production of a lesson before the school there is a continued interest awakened, not possible with a picture already prepared." And a sketch on a blackboard allowed greater "variety and amount of illustrative matter presented, than twenty times its cost in pictures or object." Speakers were aware that the simpler the mark, the greater freedom viewers were allowed in animating it and having their imaginations engaged. "The slightest mark appeals to the imagination of the little one, and he immediately proceeds to invest it with life. The simpler the marks, the more likely are they to attract and hold his attention." This augmented interest in techniques of engaging the viewer's imagination in the execution of the blackboard image married persuasion and oratory to salesmanship and performance. "By skillfully arranging what we write upon the board we will stimulate curiosity, which is the parent of attention, and attention is the parent of retention, and therefore of profit."[39] A later practitioner echoed the idea: "The development of a picture stimulates the creative imagination in the child's mind. As the different marks are made, the child is eagerly awaiting every movement to see if the picture will develop into what he thought it would be when finished."[40]

Evident here are the elements of an entreprenurial approach, a strategy of salesmanship: selling children on religious truth by convincing them with the psychological techniques of attraction and entertainment. Rather than submit students to disciplined, enforced memorization of information, the new visual strategy sought to win them with its persuasive power and the enchantment of the illustrated talk.

To this end, chalk talking became part of the commerce of religion around the turn of the century. As a more portable version of the blackboard illustration, the chalk talk could go on the road since it required only an easel and paper. Taking its place beside colportage as a form of traveling salesmanship and finding use at revivals, temperance meetings, youth camps, and establishing a circuit of church performances, the chalk talk soon became a profession.[41] Soon chalk talk literature had joined the genre of self-help, self-education manuals that promised a rich, new life to practitioners. In 1932 professional chalk talker William Allen Bixler (born 1876) published his manual *Chalk Talk Made Easy,* in which he repeatedly assured the reader that special artistic talent was not necessary to become a successful chalk talker (fig. 112). The manual was intended as the instrument for a new future: "The book in your hand will not only help you get started, but it may be the first foundation stone in a successful chalk talk career."[42] The author promised that chalk talking would provide "a great deal of satisfaction and pleasure to yourself" and exhorted the reader in a manner that recalls the tactics of advertising that promoted self-realization through consumption. "This book will help you find yourself," Bixler wrote. Finding yourself meant not only determining one's own style and repertoire of images but fixing on a vocation. The result was success, and the book was the means of achieving it, as expressed here in tract-like prose:

Before you close this book make up your mind to start at once. Get your materials as soon as possible and begin—not next week, but at once—at least plan now and prepare at the earliest possible moment. The book in your hand is full of gold nuggets, and is worth a great deal to you.

CHALK TALK
MADE EASY

The Artist-Author at His Easel

He tells you herein how Sunday-
school teachers, preachers, or any-
one else can make a success in
using chalk to illustrate lessons or
entertain.

By WILLIAM ALLEN BIXLER

Whether you are a blacksmith, farmer, factory worker, clerk, stenogra-
pher, day laborer, teacher, preacher—man or woman—boy or girl—in
whatever pursuit, *Chalk Talk Made Easy* is the open door of opportunity
for your future.[43]

Each of the occupations mentioned here represented hundreds of thou-
sands of people in the midst of the depression who were inclined to re-
ceive with enthusiasm the good news Bixler offered them. In fact, the pref-
ace to the second edition pointed to the "severe times of the depression"
as the context for the first edition's rapid success; and Bixler hailed a "re-
vival of the use of crayon and chalk in many phases of church work."[44]

Performance became the distinctive feature of the chalk talk. In 1871,
McCook had indicated that the teacher was to prepare blackboard illus-

Fig. 112
Cover, William Allen
Bixler, *Chalk Talk Made
Easy* (Anderson, Ind.:
Warner Press, 1932).

trations *before* class rather than execute them in front of students.[45] But the conception of the chalk talk among its practitioners changed markedly from the 1870s to the 1920s. By the turn of the century, one Sunday school advocate of the blackboard advised teachers to work on cloth that could be rolled up and taken home, where the teacher could prepare faint outlines of the lesson's images to be traced over during class: "As a rule, it is much better to do *all* the work in the presence of the class," no doubt because, as the author succinctly put it, "The first point in visible illustrations is . . . attracting attention and causing the child to use the imagination."[46] In 1903, another chalk talk expert urged teachers to execute their images in front of the children; "if a child can watch the picture grow and develop and feel that he is helping with his suggestions he will become intensely interested and the picture will leave a lasting impression."[47] Making the image appear before the class engaged both the children's attention and imagination by empowering the teacher with a magical ability to call forth images at will. Both lecturing and the use of finished pictures were best avoided.

While McCook, a learned clergyman, pedagogue, and naturalist (he wrote at least four books on insects), wished to work toward the "complete scientific arrangement" of the elements of visible illustration in 1871, by 1928 Harlan Tarbell described himself as a "professional chalk talk entertainer" and urged anyone else who wished to be one to "study high-grade vaudeville acts and their clean-cut manner of representation." The sense of "showmanship" to be acquired thereby was essential for the successful chalk talker, "for it gives an entertainer the much-prized power to play upon the emotions of his hearers."[48] Blackboard illustration was also part of nineteenth-century America's subculture of the performing peddler. Jackson Lears has narrated the career of one Indiana magic oil salesman who started out by illustrating the lectures or "performed advertisements" of his professorial employer, a Dr. Townsend. As the apprentice was to learn, "there were no sharp boundaries between salesmanship and other forms of performance."[49] The same lesson guided the development of the religious chalk talk as it developed from pedagogical aid into religious entertainment. Magic, as Lears has shown, played an important role in the appeal of popular performance. The efficacy of the illustrated talk consisted of a kind of performance in which the act of drawing exercised a special enchantment on the viewer. Some writers made a point of this magic or bemusement that transfixed the audience.[50] A newspaper article admired Bixler's ability at metamorphosis: "In a few moments he transforms a blank canvas into a charming landscape."[51] In fact, most chalk talk manuals included examples of metamorphosis (see fig. 104) as a favorite device for amusing an audience and keeping its attention.

Professional chalk talkers enacted the transformation of word and image into one another as part of their repertoire. Bixler provided an illustration of the steps that went into metamorphosing letters into the objects they spelled (fig. 113). This metamorphosis played on the fact that both drawing and writing are graphic signs. As a result, seeing and reading were transformed into one another, and linked directly to speaking in the "chalk talk" performance. Images were shown to be a linguistic medium, a bearer of meanings normally inscribed in spoken and written words. Spoken,

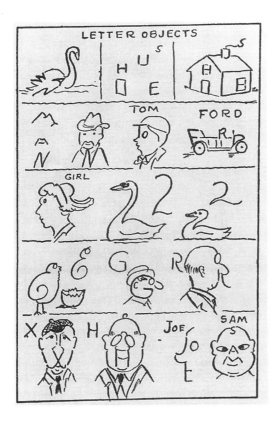

Fig. 113
William Allen Bixler,
"Letter Objects," in
Bixler, *Chalk Talk Made
Easy* (Anderson, Ind.:
Warner Press, 1932),
p. 67.

written, and drawn signs corroborated one another and enhanced learning by impressing the memory in three mutually confirming media. The chalk talker enacted an anchoring of image to text and text to image such that the image, text, and voice were seen as embedded in one another.

The chalk talk amplified the spoken word by translating it into the iconic sign of its referent in a performance that was both enthralling and considered to be universally understandable. Bixler made this point in a way that recalls the theme of religious illustration from the antebellum period to the early twentieth century: the power of engraved belief or pictured truth to cancel difference and promote the American, Protestant ideal of homogeneity.

> People may seem to forget everything else while watching a speaker draw a picture; but they will never completely forget the point if well made. The young as well as the old can read pictures; in fact, pictures are a universal language. . . . The modern moving picture has demonstrated this fact in getting information and facts to immigrant populations [*sic*] when attempts through unknown languages were futile.[52]

A kind of visual Pentecost, the image was believed to offer a powerful technology for communicating religious truth, translating spoken English into a visual esperanto that preserved both the evangelical and the national ideals of Protestant America.

The evolution of blackboard illustration and chalk talking is significant because it manifests a development of the Protestant concern to "influence." From enhancing memory by channeling information in visually stimulating ways to engaging the imagination in rehearsed acts of performance, the chalk illustration moved along a path parallel to the development of commercial advertising, whose origins lie in no small way in the evangelical use of mass-produced, ephemeral imagery.

Psychology, Advertising, and Visual Pedagogy

In 1895 a writer on advertising stated that "when we are a little more enlightened, the advertisement writer, like the teacher, will study psychology."[53] In fact, the confluence of psychology, advertising, and pedagogy was under way in practical terms much earlier in the century. In 1866 Asa Bullard noted "the powerful influence of illustrated story-books upon the young," and the ATS and the ASSU had long applied images to the rhetorical task of attracting and engaging readers of all ages.[54] The concept of "influence" that was developed to serve antebellum systematic benevolence was adapted by businessmen and advertisers after the Civil War to the secular art of persuasion—as is evident in the title of one advertising theorist's book of 1911, *Influencing Men in Business*.[55] The transition from religious imagery to commercial advertising is plain in the close resemblance of blackboard illustrations produced in the early 1870s (see fig. 107) to advertising of that time (fig. 114).[56] Both items arranged text in varying sizes and typefaces to attract the viewer's attention and to fix a central idea in the memory. Advertising in religious periodicals was another point of contact between commerce and religious media. Such advertising was so large and successful that media historian Frank Presbrey called it "the harbinger of national magazine advertising." Along similar lines, Protestants in Chicago produced cards with religious messages for distribution to the public by the YMCA. One writer on blackboard illustration found these cards (fig. 115) "akin" to the use and appearance of blackboard illustration in the Sunday school classroom.[57]

By the 1890s and the first decade of the twentieth century, all the reasons marshaled for using the chalk illustration—as well as the illustrated tract, picture book, or hieroglyphic Bible—were applied to advertising with illustrations. Advertising theorists observed that images allowed brands to be recognized "at a glance," the same language used by millennial chart designers who wished to condense ideas into quickly accessible visual form.[58] Just as chalk talkers claimed that pictures were a "universal language," proponents of advertising believed that pictures were "a common language." One textbook taught that "[t]he world over, where words from one language mean nothing to persons speaking another, pictures convey to all persons, in a quite similar way, detailed facts of thoughts, action, and effect."[59] Manuals on advertising stressed that pictures "suggest what hundreds of words of text would be required to describe"; that the illustration's purpose is "to aid in drawing the attention of the reader"; and that the memory or association of ideas was best accessed and manipu-

Fig. 114

Page of advertising, *Sunday School Times* 13, no. 25 (June 24, 1871), 399. Courtesy of the American Antiquarian Society.

Is your Soul Insured in the

Everlasting Life Ins. Co.?

HOME OFFICE—HEAVEN.

over

TO HEAVEN.

over

On the back, are :

Advantages Offered.	JESUS CHRIST
Dividends Strictly Equitable.	The Way.
Policies Nonforfeitable,	The Bible
Happiness Perpetual.	The guide.
PREMIUM,	The Holy Spirit
LOVE FOR JESUS.	The Conductor.
Whom Accepted?	The Fare
All who Repent and Believe.	Jesus paid.
INSURE TO-DAY.	WILL YOU GO?
over.	over

Fig. 115
Cards for distribution by the YMCA, in Charles B. Stout, "The Blackboard in Sunday-School," *Sunday School Times* 13, no. 10 (March 11, 1871), 155. Courtesy of the American Antiquarian Society.

lated by imagery.[60] The mind was a network of pathways in which one idea led to another. "This is important to the advertiser, for much depends on his being able to anticipate the turn the reader's thought will take or on his ability to guide that reader's thought." What the advertiser must do is lead the consumer by suggestion, "the act of imparting some idea that arouses or suggests some other idea or thought directly connected with the original."[61] The image attracted the viewer's attention, then provoked a particular association such as thirst, hunger, or desire for success. When the association of the product with the instinct or desire was repeated by mass advertising, the product was remembered and recognized by the consumer as the appropriate response to the sensation of thirst or hunger, or was anticipated as the proper product to purchase in order to avoid an unpleasant state of being. Writers on the theory and practice of advertising

correlated the instincts and desires to the illustrations that could be used "as a stimulus" and products with which the stimulus could be visually associated as a way to "appeal to this desire or tendency."[62]

By the turn of the century advertisers had indeed undertaken the study of psychology. Perhaps the most influential theorist on advertising and the psychology of persuasion was Walter Dill Scott (1869–1955), who had earned his Ph.D. at the University of Leipzig working under the pioneer of empirical psychology, Wilhelm Wundt, and later became director of the Psychological Laboratory of Northwestern University. In 1903 Scott published his *Theory of Advertising,* which set out "to present the principles and the methods which the modern psychologists have worked out and formulated." Scott applied contemporary experimental psychology with its host of processes—habit, attention, suggestion, memory, association, mental imagery, perception, and apperception—to the effectiveness of advertisements.[63] Two features of the psyche that received close attention in Scott's analysis were the influence of suggestion and direct command in advertising and in human behavior generally. Suggestion consisted of the power of repetition and of the association of ideas to link thought with action. A thought, Scott surmised, always suggested its corresponding action. "If I think of the right, I do the right. If I think of evil, I do evil," Scott explained. A direct command, he further reasoned, was a direct suggestion, since a command "calls for immediate action." Thus, people tend to do what they are told. "The function of the direct command in advertisements in twofold—to attract attention and to beget immediate action." One could not state the rhetorical posture of evangelical tracts more succinctly.[64]

Scott's work shaped the field of study over the next several decades as he continued to publish his research and as his books went through many successive editions. Another writer, researcher, and teacher was Daniel Starch (born 1883), who taught at Harvard and the University of Wisconsin before becoming the director of research at the American Association of Advertising Agencies and published his *Principles of Advertising* in 1923 and an abridged form in 1927. On the basis of quantitative consumer research and the content analysis of thousands of advertisements, Starch theorized the effect of advertisements along lines that are remarkably consistent with the nature of nineteenth-century mass-produced religious illustrations.

Starch delineated five functions that a successful ad must fulfill: 1) attract attention; 2) arouse interest; 3) bring about conviction; 4) impress the memory; and 5) produce action.[65] This is a concise summary of the stated aims of editors and publishing committees in the ATS and numerous religious periodicals and books. Starch went on to distinguish two kinds of advertising methods, the argumentative and the suggestive, which confirmed and developed Scott's findings on suggestion and command, and which correspond significantly to the plain and embellished styles of imagery in ATS publications. The argumentative approach, which made greater use of text in the ad, sought to persuade the reader by arguing the reasons why a product was superior. The second manner of advertising, the suggestive, relied more on imagery to imply or visually evoke the product's desirability. The argumentative technique was explicit; the suggestive

approach much less so. Where the argumentative ad stipulated a product's superior features and enumerated its competitor's faults, the suggestive ad clothed a product with insinuation, implying rather than declaring the glamour, ease, or peace of mind that attended its use.

If, like the plain style of ATS illustrations, the argumentative approach preached, the suggestive approach emulated the embellished style's engagement of the viewer by means of evocation. The same applies to the two philosophies of blackboard illustration versus the chalk talk. Whereas the former never drew attention to itself but was subordinate to the idea it signified, the chalk talk became a performance that stimulated the viewer's imagination through the power of suggestion.

A close correlation is especially evident between the argumentative manner of advertising outlined by Starch and the style and format of the religious tract. A tract was ephemeral, quickly digested, mass-produced, and not dependent on personal contact for distribution. Moreover, the tract, like the ad, was thought to possess the power to convince anonymous parties and, when illustrated, was believed especially able to attract and retain the attention of "customers" and lodge its "product" in their memories. The tract and the ad, particularly Starch's category of the argumentative ad, were both mediums of communication that attempted to persuade the reader/viewer by providing information about a commodity. Evangelical Christianity of the sort practiced by the benevolent associations in the nineteenth century made no excuses for an ambitious disposition to inform and convert. Tract visitation and distribution was seen by the ATS as an "earnest entreaty and personal solicitation." "True religion is aggressive," one annual report put it. "It assumes the fact of man's depravity."[66]

Likewise, advertisers assumed the public's need for their products and adopted a proactive missionary mentality in fulfilling that need by moving customers toward "conviction" through the agency of the advertisement. Advertising was theorized by its academic proponents in explicitly religious language. A textbook of 1921 listed one of the functions of mail-order advertising: "[t]o introduce the product, follow up the salesman, and act as missionary." For goods sold through an intermediary such as a dealer, one of advertising's functions was "[t]o act as a missionary in preparing the ground for the general selling campaign."[67] The success of the Tract and Bible societies through mail-order and colportage bequeathed to commercial advertising the prevailing example of how to sell effectively. Indeed, if we listen carefully to the ATS when it proclaims that the Bible was the first tract and the evangelists the first colporteurs, it becomes evident that evangelical Christianity and commerce have shared a great deal in method and aim.

The suggestive approach advocated by Scott and defined by Starch approximated the evocative use of imagery characteristic of the embellished style as well as the open-ended, generative application of pictures to storytelling. Pictures were more than didactic tags, for they could conjure a host of associations and narratives that were of great value in the religious formation of the young. This suggestive power accommodated a new, devotional sensibility in Protestant visual piety during the second half of the nineteenth century, as I will show in the remaining chapters.

Can the history of the chalk talk teach us anything about the dynamics of modern visual culture? Perhaps that the move from instruction to entertainment, from rituals of inculcation to rehearsed performance, from controlled argument to open-ended suggestion, from catechism to magic is a basic feature in the semiotics of persuasion. The technique of the chalk talk evolved from the highly abstract, schematic templates used by the classroom teacher to enhance memory to the pictorial tableaux, arresting tricks, and clever narrative cues performed by the professional chalk talker. The evolution is a familiar one: from the rustic devices of the teacher to the slick performance of the entertainer. It is precisely the development one would expect during the Progressive Era's march of optimistic social reforms and triumphant professionalization of white collar workers (including teachers). There is also the lesson that the suggestive power of images in advertising has to teach us. Benjamin's fascinating essay on the work of art in the age of mechanical reproduction notwithstanding, anyone who has studied the rise of advertising, and especially the role that images came to play in advertising by the turn of the century, will be hard pressed to deny the auratic character of the image in the commerce of mass culture. Charged with the task of packaging products with desirability, of creating both the perception of need and the promise of satisfaction, advertisers developed the strategy of selling products wrapped in perceptions. As Colin Campbell put it, the modern imagination has contributed inestimably to the sensibility of consumption in which "wanting rather than having is the main focus of pleasure-seeking." Images of things rather than the things themselves are the mechanism by which longing expands its inner life and places the consumer in a state of insatiable pleasure-seeking.[68]

The emergence of a vast, mass-produced visual culture in nineteenth-century Protestantism was part of a progressive technological collapsing of time to pivotal moments of persuasion. This development was fueled by the affinity of evangelical Christianity's millennial urgency and its need to proselytize; the widespread commerce of consumption; and the rise of periodicals and newspapers, which both provided information on the novel and momentary and became the primary means of advertising. In order to teach the large populations of children and illiterate, often immigrant adults, benevolent associations such as the ATS and the ASSU made great use of images as a primary language, just as advertising came to rely on images as a channel of communication. Saving souls was analogous in striking ways to convincing customers to buy products because both evangelist and advertiser assumed the power of imagery to influence thought and behavior. This understanding of mass mediation assumed that in the momentary transactions of everyday life viewers were subject to a visual rhetoric of persuasion delivered in mass-mediated images.

Throughout these developments, the image grew in use, surpassing even the printed text and the spoken word in the burgeoning competition for the neophyte/customer's attention. McCook was not the only evangelist who was certain of the ascendancy of the visual in the expansive ambitions of Sunday school educators: "[I]t is a fact, which I suppose will not

be disputed by any of my readers, that the impressions which come to us through the medium of the eyes are ordinarily much more distinct and reliable than those which come through hearing." He believed that teachers in Sunday school who "have largely resorted to visible illustration have gradually dropped the use of 'stories.'"[69] For McCook and many others, the task was to compete successfully with all distractions for the child's mind in the enterprise of shaping the child's Christian character. The earlier evangelical battle for influence over the child's socialization lost nothing in the mounting intensity of the late-nineteenth-century American ethos of militant competitiveness: "[T]he endeavor to fill the mind with images of beauty and purity is a wise line of action, both to guard the mind and deliver the mind from the power and presence of . . . evil."[70]

The visual culture of nineteenth-century America was increasingly characterized by a shrinkage of time in which attention was sharpened to the span of moments in a milieu of pitched sensory competition. The need to socialize children provided the first impetus for this development. Ironically, this meant contradicting the republican suspicion of images as generators of desire and longing, of the passions that dissipated attention and exchanged self-indulgence for the rustic self-denial of New England's Calvinist heritage. But the transition, evident in the history of the chalk talk, was paved by the recognition of the power of images in the new psychology of consumption. If attention was what Protestant educators wanted, images could deliver an effective means of focusing the imagination of the young on the performer's moral teachings. Images had demonstrated the ability to sell books since the earliest decades of the century, to attract children to Sunday school, and to assist in the acquisition of literacy. In fact, rather than simply conforming to a secular commercial culture, American Protestantism actively participated in the creation of consumption, powerfully anticipating the commercial use of the mass media. Where religion went, commerce quickly followed.

The Rise of the
Devotional Image in
American Protestantism

The Devotional Likeness
of Christ

While explicit millennialist theology ebbed and even all but vanished among many Protestants in the second half of the nineteenth century, the rhetoric, national expectations, and cultural politics of postmillennialism remained very much in place. Many American Protestants still thought of their faith as world-redeeming; as constitutive of a nation that enjoyed a manifest and now global destiny; as capable of unifying and mobilizing Christendom into a single force that would champion religious and political liberty; and as the mainstay of a church that should recognize no bounds in disseminating its evangelical message, adapting every technological means at its disposal.

Yet for some Christians in the late nineteenth and early twentieth centuries—Dispensationalists, Mormons, Jehovah's Witnesses, Adventists, and Church of God—premillennialism remained a commanding vision of history. A number of these groups still made use of a visual culture derived from Millerism. The intricate Dispensationalist charts in books published by the Baptist lay preacher Clarence Larkin (fig. 116) and the vast painted charts of itinerant Church of God preachers (fig. 117) both integrated the iconography of the Millerite chart with fundamentalist concepts of the earth's ages or dispensations.[1] These images, like their Millerite and Seventh-Day Adventist precursors, were dedicated to instruction and deployed imagery in tandem with sermons, detailed exegesis, and biblical interpretation.

The persistence of these images in the twentieth century clearly demonstrates that the didactic aspect of Protestant visual piety has not subsided. The emergence of devotional imagery and visual practice among

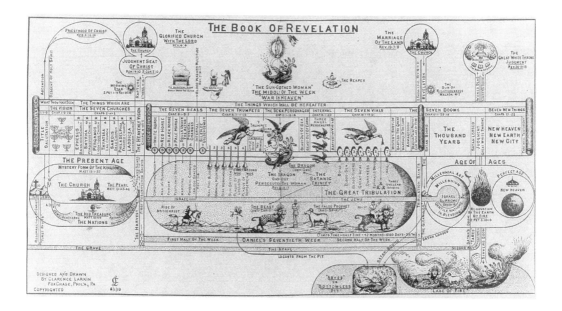

Fig. 116
Clarence Larkin, "The
Book of Revelation," in
Larkin, *The Book of
Revelation* (Philadelphia:
Rev. Clarence Larkin
Estate, 1919), n.p.

Protestants did not replace the need for tracts, charts, or catechetical illustrations. Children and converts needed to be taught. Yet a new visual piety became very important among many Protestant groups, including Methodists, Baptists, Lutherans, and many others, encompassing some of the premillennialist groups such as Seventh-Day Adventists and the Church of God. Interestingly, this new visual piety narrowed the differences historically interposed between Catholic and Protestant uses of imagery. Protestants in the twentieth century frequently speak of the use of images in "devotional centers" or home shrines, places set aside in the domestic setting where images are displayed for the purpose of meditation and prayer.[2] A similiar space was designed and built in the structure of many twentieth-century Protestant churches—from such prominent buildings as Rockefeller's Riverside Church in New York City to countless Lutheran and Methodist churches around the country. Baptist churches throughout the South frequently include murals of the River Jordan or the Baptism of Christ on walls adjacent to baptismal fonts (fig. 118). In many cases small prayer chapels or main chancels designed to accommodate prayer (fig. 119) surround large paintings or reproductions of Christ at prayer in Gethsemane with elaborate enclosures or frames and special lighting in order to provide a sequestered space for quiet, private meditation.

This devotional apparatus in Protestant life has its roots in attitudes formed during the nineteenth century. Jackson Lears has examined the late Victorian fascination with Catholic devotionalism among largely Episcopalian Americans who were deeply suspicious of modernism. Jenny Franchot has noted its development in antebellum American literature. And, most important for the purposes of this study, Neil Harris has studied the significant contributions made by liberal Congregationalists, Episcopalians, and Unitarians from the 1830s to the 1860s to the elevation of art and the artist to a virtually ministerial status.[3] But why would Prot-

estants, particularly more conservatively inclined Protestants who had long used images as a didactic device, become interested in the devotional aspects of imagery? This chapter and the next will chart a major development from the didactic to the devotional conception of images in late-nineteenth- and early-twentieth-century American Protestant visual culture.

As different as tract illustrations were from millennial charts or chalk talks, they were all didactic images designed to accompany texts, attract the viewer's attention, and visually supplement a text's communication of particular doctrines. This use of imagery lent itself to the purposes of evangelicals and Adventists whose principal concerns were admonition, education, and conversion. The image was not an end in itself but part of a larger program of persuasion. Accordingly, the didactic image was illustrative and designed to direct the viewer's mind beyond itself and toward a spiritual, nonaesthetic purpose. Such images were often schematic in design so that they could be quickly scanned, as with a millennial chart or a chalk diagram; or they were made compositionally compact in order to encapsulate in concise visual terms the theme and tone of a tract. Indeed, before the late nineteenth century, highly articulated and pictorialized images were often avoided in religious instruction and proselytism (they were much more common in book illustration and domestic adornment such as chromolithographs) because of their tendency to draw attention to themselves and the skill required to execute them. The success of didactic images was measured by the efficiency with which they attracted

Fig. 117
F. G. Smith (?),
Prophetic chart used
among the Church of
God, paint on canvas,
72 × 96 inches, c. 1930.
Courtesy of Anderson
University Archives.

Fig. 118
Artist unknown. River
Jordan, baptismal mural,
paint on panel, 96 × 72
inches, in First Baptist
Church, Frankston,
Texas, c. 1933. Courtesy
of Mrs. Frankie
Westbrook.

attention to their message and then conveyed that message as so much visual information.

This didactic sensibility reigned among nineteenth-century evangelicals and Adventists who were fired by an urgency to communicate a timely message and who used mass-produced images to achieve their ends. There was not a comparable use of visual mass media among liberal Protestants for whom conversion was not an issue. After the Civil War, however, another visual sensibility operated among liberal Baptists, Congregationalists, Episcopalians, and Unitarians, all of whom embraced millennialism not as an article of literal belief but as a theological metaphor for social progress. For liberal clergy and intellectuals, from Henry Ward Beecher to William Barton, G. Stanley Hall, and Albert Bailey, images exerted an influence that was measured in terms of "inspiration," "feeling," and the power of beauty to elevate public morals and to refine the American soul. All these aims belonged to the aesthetic education of humanity and constituted a visual piety among religious progressives. All these belonged, furthermore, to religious education in the church and home as an essential component in forming character.

Rather than filling the memory with information, the trope among liberal Protestants was shaping a malleable soul with the impress of fine imagery. Character formation was conceived as an aesthetic process, the artistic molding of souls. For this, it was felt, truly artistic images were required, none other than the products of aesthetic genius, which would reliably transmit the refinement of feeling and perception necessary for the aesthetic formation of character. Protestant visual piety availed itself of the new technology of the lithograph and photographic halftone in order to provide inexpensive reproductions of "great art" to the parlor and classroom. The task at hand was no longer to teach students to decipher the visual texts of chart or chalk illustration but to create in the aesthetic space of contemplation a devotional mood of reverence and pure ideals. In the midst of this aestheticized piety emerged a mass-produced Protestant devotional art that entered religious education and the private home in the later nineteenth century and that continued to serve, despite obvious dif-

Fig. 119
Chancel with copy after
Heinrich Hofmann,
Christ in Gethsemane,
image size 89 × 68
inches, Swede Valley
Lutheran Church, Iowa,
before 1922. Photo:
Phillip Morgan.

ferences, the quest for millennial progress undertaken by the didactic imagery of the antebellum period.

If liberal Protestants led the way in the appreciation and use of fine art in religious character formation, more conservative church bodies quickly followed as the influence of progressive pedagogy and psychology moved across the American cultural landscape. The focus of this and the next chapter, however, is more on the progressive groups and figures who embraced mass-reproduced fine art as part of the Progressive Era's recasting of American millennialism in the form of national advancement and social optimism.

From Conversion to Character Formation

The shift begins with a new set of practices and attitudes in family life regarding the rearing of children. Character emerged as the subject of religious formation in the late colonial era when the idea of national character became explicit. Concern for an ethnically homogenous and distinct character was intensified during the early republic, when non-Protestant and non-Anglo immigration began to change the relative uniformity of the young nation's populace. Assimilation of Catholic immigrants by conversion to Protestantism was no longer preferable for those Anglo Christians for whom preservation of Protestant white identity or character was preeminent. The anxiety over character was stimulated by the desire not only for racial distinction but also for the preservation of differences in gender and republican government. Character, in other words, was a matter not only of the moral integrity of the individual but of the distinctive identity of race, nation, and gender. The formation of character in all its aspects came to be seen as being centered in domestic life and as beginning in the cradle, and therefore child-rearing and the home became a fundamental theme in theology, religious education, advice books, and religious visual culture.[4]

The idea of character formation commanded attention in theological discourse most notably in Horace Bushnell's widely read book *Christian Nurture*, first published in 1847, followed by a revised edition in 1861. Bushnell (1802–1876) urged American Protestants to give close attention to how they raised their children from the earliest days, locating in childhood the most effective opportunity for formation. "Infancy and childhood," as he put it, "are the ages most pliant to good." He attacked the conversion theory of traditional American Calvinism, which associated spiritual identity with the conviction and conscious choice to submit to God. In its place he set a Romantic theory of the family as an organic matrix that infused character into the child from the first moment of nurture. According to Bushnell, spirituality was formed in the child's relationship with its parents, and most important, with its mother. The child was part of a nurturing, organically interwoven whole and was formed by a sympathy that ran through and characterized the domestic whole. "A pure, separate, individual man, living wholly within, and from himself, is a mere fiction," Bushnell insisted. Human beings were as much social beings as

they were individuals, dependent for their existence on "the three great forms of organic existence," nation, church, and family.[5]

The formation of "character" was the focus of Bushnell's study. He defined character as a spiritual sense of self that was slowly shaped in the womb of the family and something that he continually contrasted to the inorganic confession of faith during adolescent conversion experiences. Among the three forms of social life he delineated, Bushnell regarded the family as most powerful because it was most responsible for molding the child's character long before memory or will were able to exert any influence. Family relations were also the model for Bushnell's "in-birth" or propagation theory of religious conversion: rather than bothering to convert the masses of non-Christians, the better strategy, according to Bushnell, was to outlast them by out-producing them. American Christianity was to be identified by a single genetic, racially shared character.[6]

With this in mind, it is clear why Bushnell repeatedly subordinated "choice and memory" to the effects of the nurturing environment. Character formation was a "natural" action, the result of "the air the children breathe," rather than the product of forced learning or conscious teaching such as rote memorization. "The children fall into their places naturally, as it were, and unconsciously, to do and to suffer exactly what the general scheme of the house requires."[7] It is also clear why women, in Bushnell's mind, had to forego suffrage: by asserting their right to vote, they would abandon their traditional sphere and invade that of men, the public life of politics, law, and leadership, leaving empty the womb of character formation and threatening the purity and destiny of the American stock. Woman's suffrage, he said, was a "radical revolt against nature" and a "challenge of the rights of masculinity." In an essay against women's suffrage published in 1869, Bushnell reflected the postwar tendency to define masculinity in terms of ostentatious display when he asserted that women's claim for the right to vote was nothing less than the claim for a beard.[8] The character of a man is evident in his physical strength and in "the base of his voice and the shag of his face, and the swing and sway of his shoulders," all of which "represent a personality in him that has some attributes of thunder." But "woman," according to Bushnell, has "no look of thunder." She avoids the display of force and authority that is characteristic of man, her husband, whose name she takes on "herself and puts it on her children, passing out of sight legally, to be a covert nature included henceforth in her husband."[9] Character, therefore, was also determined by sexual difference, which was to be preserved by a political order that kept women in the domestic sphere nurturing children.

Bushnell's major contribution to American religious thought was the emphasis he laid on unconscious nurture. Instruction was replaced by formation; character was inherited genetically and grown organically in the hothouse of the family, safely cut off from the public world of distraction and moral confusion. In a sermon of 1846 devoted to the concept of "unconscious influence," Bushnell explored the webs of social influence that were submerged beneath the surface of awareness but were perceptible nonetheless in human behavior. He premised this form of influence on the collective character of human existence: "We overrun the boundaries of our personality—we flow together. . . . [O]ur life and conduct are ever

propogating themselves by a law of social contagion throughout the circles and times in which we live." According to Bushnell, however, this "contagion" largely conducted itself as an unconscious influence, flowing from human conduct and character "more uniformly than our active influence."[10] Bushnell was careful to acknowledge the importance of "voluntary influence" in his day, making a clear reference to such initiatives in voluntary benevolence as the ATS and the ASSU, but he believed that unconscious or involuntary influence was the more authentic revelation of "our real character." Differentiating two kinds of human language, the voluntary (speech) and the involuntary (nonverbal expression), Bushnell stressed the truth-content of the latter as disclosing "to others constantly and often very closely the tempers, tastes, and motives of our hearts." He referred to the "expression of the eye, the face, the look, the gait, the motion, [and] the tone or cadence" as the "natural language of the sentiments" and so reflected the older discourse of physiognomy, which had for centuries sought to identify a typology of facial expressions as the indices of character.[11]

At the heart of Bushnell's notion of unconscious influence was a theory of affinity or sympathy that served as the link that united human beings. It is striking that this sympathy was largely visual in Bushnell's discussion of unconscious influence: "Beholding as in a glass the feelings of our neighbor, we are changed into the same image by the assimilatory power of sensibility and fellow-feeling." At work in his thought was a psychology of mental imagery that understood communication as a replication of what was seen in the soul. Such a mental image was thought to generate the same effect as the original object. Thus, images of foul things retain the capacity to inspire foul behavior once they reside in the soul. Although he did not believe that the will was bound to conform to evil images, Bushnell did not wish his readers and listeners to underestimate the power of "bad images in the soul giving out their expressions there and diffusing their influence among the thoughts as long as we live." Bushnell cited those who believed that the look or expression of nurses often reproduced itself on the features of children, and he warned that "simply to look on bad and malignant faces or those whose expressions have become infected with vice, to be with them and become familiarized to them, is enough permanently to affect the character of persons of mature age." No one could stop the emanation of his or her character, nor could any one else help receiving this propagation, for all members of society "adhere together as parts of a larger nature in which there is a common circulation of want, impulse, and law." To exist in human society was to participate in a state of communication and a single "social body" or "social mass" characterized by a "national or family spirit."[12]

The role of the body in Bushnell's understanding of influence applied centrally to his view of Christ, which departed from the orthodox emphasis on Christ's words and miracles as the primary communication of his stature and power. Instead, the conduct, character, and feeling conveyed by Jesus were the basis of his authority:

> It is the grandeur of his character which constitutes the chief power of his ministry, not his miracles or teachings apart from his character.

Miracles were useful at the time to arrest attention, and his doctrine is useful at all times as the highest revelation of truth possible in speech; but the greatest truth of the gospel, notwithstanding is Christ himself— a human body become the organ of the divine nature and revealing under the condition of an earthly life the glory of God! The Scripture writers have much to say in this connection of the image of God.[13]

The embodiment of truth in the incarnation influenced believers, according to Bushnell, as the bodily image of God. People believed Jesus and responded to him because he expressed his divine character in his manner and presence. At the heart of Bushnell's theology, therefore, was a Christian doctrine of imaging the divine. Character formation and influence were conveyed by conduct and expression more than by spoken language.

While many Sunday school organizations focused on conversion and the classroom, the move toward the domestic nurture of children stressed the organic evolution of character and the preeminence of the home in this gradual development. Bushnell considered the home the true seat of the church and envisioned the congregation seated before the hearth as the ideal emblem of home religion. In a passage that evokes any one of numerous illustrations of family scenes beside the hearth used in Protestant and Catholic publications to promote the importance of the domestic altar, Bushnell wrote:

> We look in upon the Christian family, where every thing is on a footing of religion, and we see them around their own quiet hearth and table, away from the great public world and its strifes, with a priest of their own to lead them. They are knit together in ties of love that make them one; even as they are fed and clothed out of the same fund, interested in the same possessions, partakers in the same successes and losses, suffering together in the same sorrows, animated each by hopes that respect the future benefit of all.[14]

Bushnell described a utopian retrieval of the ancient Christian fellowship, now realized in the family, a refuge from the outer world, a self-contained community with a priest of its own. The task, according to Bushnell, was no longer to fill the memory with religious information but to plant seeds, to nurture the growth of the individual's character, to shape the whole person in the organic body of the family long before intellectual development even began.[15]

The priest of the family was nominally the father, but in practice, particularly for younger children, religious instruction was dominated in the home by the mother, or by other women in Sunday school instruction. One of the most basic tools in Christian formation was the illustrated book. As we saw in chapter 6, the engraving in the *Christian Almanac* of the mother reading to her children (fig. 103) urged the importance of illustrated literature for children, portraying what the experience of picture-books meant to youth: three children listen transfixed as their mother reads to them. The small company is snugly framed in a trellis of vines and festoons, a secure nest of visual storytelling that removes the children, the caption tells us, from the ordinary world of "toothache, earache, finger-

ache . . . fretfulness, moping, pouts."[16] It was thought that this domestic world in which the children were absorbed suspended pain and misbehavior and was freighted with moral purpose. It opened an affective avenue to the child's heart and constituted an aesthetic committed to the formation of character. The "picture story" the children requested of their mother became the occasion for domestic bonding and intimacy, which imprinted deeply on the child's memory and became a powerful vehicle of the evangelical message of Jesus.

The image, in other words, was about more than memorizing information. It became the site of the child's relationship to its siblings and parents and its experience of domestic life. Furthermore, with the commercial production of lithographs intended for domestic display and the rise of portrait photography as a popular visual culture, the portrait format began to service the domestic piety of the nineteenth-century Christian home. Such images of Jesus Christ as those in *The Sacred Heart of Jesus* (fig. 120) and *The Letter of Publius Lentulus* (fig. 130) were displayed in Catholic and Protestant homes because of their ability to shape character in tandem with such practices as prayer, catechism, and family devotion. The gaze of Jesus or Mary that followed family members about the domestic

Fig. 120
The Sacred Heart of Jesus, lithograph, 14 3/8 × 11 1/2 inches, Thomas B. Noonan & Co., Boston, Courtesy of the Library of Congress.

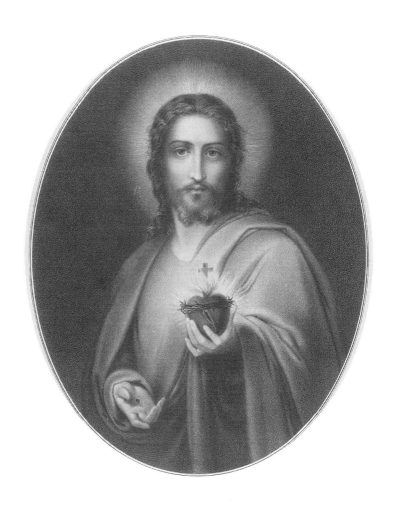

interior provided a constant sense of presence and made the heavenly person portrayed accessible to petition and prayer. The devotional sensibility allowed Protestants to practice a visual piety that Roman Catholics had long enjoyed: one that visualized a personal relationship with the sacred other.

Visualizing Character

American Protestants did not wake up one morning with the urge to pray to pictures. Rather, they learned to regard them as an influential presence in the formation of character in accord with the new estimate of influence developed by Bushnell and others. Furthermore, the notion of facial expression as the index of character was formulated in physiognomy and phrenology and disseminated in popular essays and journals; photographic, engraved, and painted portraiture; fiction; and public addresses, from the pulpit to the public lecture. The visibility of character, however, was most popularly and pervasively practiced in phrenology and photography, both of which contributed to the visual culture of nineteenth-century America in fundamental ways. Most important for the purpose of this study is the way in which phrenological and photographic portraits were constructed as the essential register of individual and national character.[17]

Phrenology became popular in the United States during the 1830s and 1840s. Its principal American popularizers, the Fowler family, published several books and a journal that continued until late in the century. Hailed in 1835 as the "phrenological emporium this side of the Atlantic," Boston had been the center of activities of Johann Gaspar Spurzheim, the European savant who brought the doctrine to the United States.[18] A much more materialist practice of facial and cranial interpretation than the older, premodern tradition of physiognomy, phrenology consisted of the doctrine that human behavior was both determined by and able to modify the physical structure of the brain.[19] Popular phrenology stressed that personality traits were localized in particular zones or "organs" of the brain. Phrenologists contended that these brain organs developed in size according to heredity, parenting, diet, clothing, exercise, and conduct. The result was a cranium whose shape reflected the development of the organs within. According to popular phrenological theory, the head could be measured and mapped in order to read the "moral and intellectual character."[20] The resulting information was tabulated on a register that was accompanied by a phrenological chart (fig. 121) that located the characteristic, such as amativeness, vivativeness, or secretiveness, on the cranium. Used as a book cover and advertisement for the Fowler enterprise's many phrenological products, the "Symbolical Head" (fig. 122) pictorialized each organ's function, translating abstractions into the popular visual culture of the day. Said to be responsible for the property of benevolence, kindness, or goodness, for instance, organ number 19 (located at the top of the forehead) was shown as a well-dressed gentleman distributing aid to a destitute mother and child and referring to a building in the background, which may represent a school or philanthropic establishment.

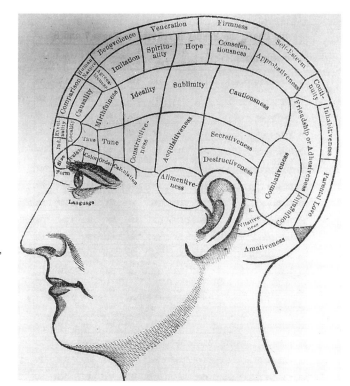

Fig. 121 (right)
Phrenological head, in *New Illustrated Self-Instructor in Phrenology and Physiology* (New York: Fowler & Wells, 1859), p. vi. Courtesy of the American Antiquarian Society.

Fig. 122 (bottom)
"Symbolical Head," wood engraving, *American Phrenological Journal* 23, no. 1 (January 1856), 14. Courtesy of the American Antiquarian Society.

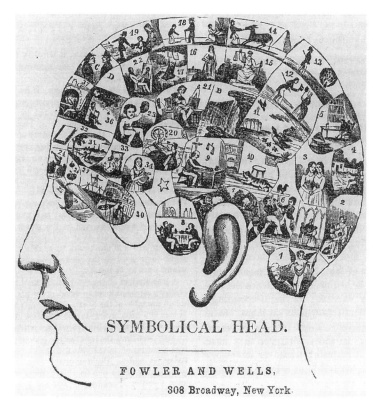

SYMBOLICAL HEAD.

FOWLER AND WELLS,
308 Broadway, New York.

The practice of phrenology taught a wide American public to regard the head as the measure or visual trace of character, in other words, the visible register of the invisible traits of personal identity. But phrenology was also believed capable of reading national and racial characteristics from the shape of the head. Many essays in phrenological journals and books were dedicated to typologizing national and racial characters and linking them, with a demeanor of scientific certainty, to moral character, national features, and corresponding systems of government.[21]

More common, perhaps, was the use of phrenology in the visual culture of celebrity. Ever attuned to the fashionable currents of his day, Henry Ward Beecher wrote the following phrenological analysis of ancient Roman statues of Trajan while visiting the Louvre in 1850: "Every statue of Trajan is alike in representing his head *low* in the moral region, very large in perceptives and very small reflectives, full in the sides, back and top." Beecher provided the same kind of analysis for statuary of Demosthenes and Caesar Augustus.[22] Thousands of engraved busts such as the one of his father reproduced here (fig. 123) appeared in newspapers and periodicals as well as in popular phrenological journals and manuals, collectively helping to create a mass visual culture premised on the notion that visual appearance was the highly legible deposit of personal identity. Often these engravings were made from commercial daguerreotype portraits, which provided a highly detailed source of visual information from which to conduct a phrenological analysis of a person's character. The *American Phrenological Journal* and many other Fowler publications were especially fond of publishing wood engravings of celebrated persons such as this one (fig. 123) and analyzing their character on the basis of their appearance.[23]

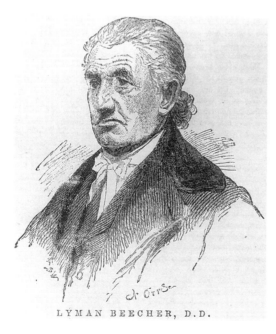

LYMAN BEECHER, D.D.

Fig. 123
Nathaniel Orr, engraver, "Lyman Beecher, D.D.," *American Phrenological Journal* 17, no. 3 (March 1853), 60. Courtesy of the American Antiquarian Society.

Fig. 124
"Another Turn in Our
Picture Gallery," wood
engraving, *Youth's Penny
Gazette* 14, no. 2
(January 16, 1856), 7.
Courtesy of the
American Antiquarian
Society.

But the practice of divining character was not limited to phrenologists. The advantages afforded by encoding appearance with moral character and regarding the face, gesture, and dress as correlates of proper diet and behavior were irresistible to Protestant moralists. We have seen the before-and-after of temperance and its consequences for family life in Tract Society imagery (figs. 50 and 51). The ASSU's *Youth's Penny Gazette* was also fond of using such visual comparisons. One illustration (fig. 124) contrasts "the intelligent citizen, fulfilling the duties of life, beloved by his family, respected by the community, and a pattern of domestic, social, and public virtue," on the left, to a man "whose infancy was neglected, whose child-

ANOTHER TURN IN OUR PICTURE GALLERY.

If the readers of the *Youth's Penny Gazette* will look over a few back numbers, they will find a picture of two children in very different conditions. One was cared for; the other was neglected.

In the next succeeding number to that, they will see one of them diligent in learning, virtuous in conduct, and beloved by all who knew him. Soon after, he appears on the busy stage of life as a useful and respectable man. And here we see him as the intelligent citizen, fulfilling the duties of life, beloved by his family, respected by the community, and a pattern of domestic, social, and public virtue.

It is no more than what we had a right to expect from such an infancy, childhood, and youth.

Would you have a good name, or a useful standing in society, a well-furnished mind, or a peaceful conscience at fifty, be careful how you spend the first fifteen years of your life.

And here, too, we see another step in the progress of one whose infancy was neglected, whose childhood and youth were spent in idleness and sin, and whose early manhood was given to the circus and the theatre, the race-course and the drinking saloon.

Without any love for books, or any desire to inform his mind, with no companions but gamblers and topers, what wonder is it that his mature years find him destitute of any means of enjoyment? He could not expect to reap where he has not sown, nor could he expect to gather grapes from thorns, or figs from thistles.

Look upon his forlorn and miserable state, and remember that the outline was seen, dimly in the child in the gutter; more clearly in the idle, hungry, "loafing" youth; distinctly in the circus and saloon, and in nearly full life in the picture before us.

hood and youth were spent in idleness and sin, and whose early manhood was given to the circus and the theatre, the race-course and the drinking saloon."[24] Since only the figures themselves are shown, this visual exegesis was deducible from the mere appearance of each individual—principally dress, facial features, and the activity of reading versus idle sitting. The pictures contrast markedly in the low and covered brow of the man in a "forlorn and miserable state" and the high, uncovered forehead of the man with "a good name . . . useful standing in society, a well-furnished mind . . . [and] peaceful conscience." According to phrenological doctrine, prominent foreheads were caused by large development of organs responsible for the moral sentiments of kindness and urbanity and by all intellectual and literary faculties, located behind the brow and forehead (see figs. 121 and 122).

Commercial photographers, particularly daguerreotypists, nearly all of whom specialized in portraiture, applied the traditional codes of expression, physiognomy, and portraiture to the new technology of image making, which met with a wildly popular reception. Albert Southworth, one of the most commercially successful and influential daguerreotypists in the United States, wrote that "The whole character of the sitter is to be read at first sight; the whole likeness is, as it shall appear when finished, to be seen at first, in each and all its details, and in their unity and combinations."[25] Marcus Root, the Philadelphia photographer, included a chapter on physiognomy and phrenology in his encyclopedic defense of and guide to photography, *The Camera and the Pencil* (1864), in which he stated that the human face was "the most perfect of all mediums of expression" and "the most important subject for representation by the portraitist whether with the camera or the pencil—since *its* true expression, when transcribed, is the revelation of the real man."[26] In an article entitled "Expressing Character in Photographic Pictures," an author counseled the practicing portrait photographer to engage his sitters in conversation in order to form "an opinion of their predominant peculiarities; those points of character by which they are best known, and for which they are most admired, that he [the photographer] shall in no way conflict with their expression." The author continued by pointing out the correspondences between gesture and attitude, on the one hand, and personality or character, on the other. Invoking the terminology of phrenology, the writer urged that the portraitist "must remember that every organ and every faculty has a special language." There followed a list of several such characteristic expressions:

> A proud man carries his head erect, a little thrown back, and with a stately air. This is the language of self-esteem; and to arbitrarily place him with his head bent ever so little in an humble way, would detract from the likeness. Love of approbation, when excited, draws the head a little back and to one side, and every operator [photographer] has noticed that women would nearly all sit with their heads thus bent if not prevented; and also, the arch curl of the neck on receiving a compliment.
>
> A deeply thoughtful and imaginative person sits with the head bent forward and to one side, and the eyes look away with a sort of dreamy

abstraction, and to give such a bolt-upright, staring position, would be stupidity.[27]

To assist the photographer with attaining this expression of character, the use of a series of engravings in the studio were highly recommended. Placed in view of the sitter, these images would evoke the appropriate physiognomic response, which the photographer might capture in his portrait. "Thus, a benevolent nature might be stirred by a scene of unjust suffering—not one to incite horror, but a tender commiseration." Images, then, produced the expression, which was in turn recorded in a new image. The photograph helped codify the expression of character in a mass-produced visual culture that fed on images in order to produce even more.

As photography became a mass commodity, it expanded the visual practices of many Americans by investing the photographic image, and other kinds of images, such as the engraved illustration (which were increasingly made from daguerreotypes and paper-based photographs), with a moral power derived from the visualization of the subject's character. The character image proliferated. An 1860 edition of *Pilgrim's Progress* published in London by Longmans, and later in Philadelphia by Lippincott, substituted linear portrait busts by Charles Bennett for the traditional tableaux illustrating the allegory.[28] Encoded in the faces of the text's many character-types were their moral features: in Christian (fig. 125), the determination of a young man who persists in his search; in Pride (fig. 126), the gesture delineated in the article just cited: "A proud man carries his head erect, a little thrown back, and with a stately air."

The fascination with character and portraiture is evident in religious publication and instructional materials in the second half of the nineteenth century. An edition of the Bible published in 1885 by B. F. Johnson & Company in Richmond, Virginia, included biographical essays on Jesus and the disciples that were illustrated with engravings of portrait busts (fig. 127) consistent with phrenological portraits and the Bennett illustrations of *Pilgrim's Progress*. The portraits of Jesus and Peter were drawn from the work of another delineator of character and an influential student of physiognomy, Leonardo da Vinci, whose *Last Supper* (1495–1498) was widely reproduced, including in lithographic versions by Currier & Ives that labeled all the figures with their names (fig. 77).[29] This allowed for subsequent versions such as that of a Sunday school lesson card produced by the ASSU in 1900 to illustrate the Uniform Lessons (fig. 128), which divided the painting into individual named portraits.

Systems of interpreting expression such as physiognomy and phrenology encoded the face with indices of character. But this encoding is both inscription and infusion. The face was read, but also venerated. To inscribe meaning was to code marks as script in a text with a prescribed set of meanings and a syntax or configuration that determined meaning. In the case of reading the face with the exegetical aid of physiognomy or phrenology, character was understood as a residue or trace on the visible surface of the face. In the instance of infusing the face with the presence of the soul, the visible emitted a glory or halo (see figs. 130, 131 and 135). Here was manifestation of the aura, a sacramental presence or a material expression of authenticity that Walter Benjamin argued mechanical reproduction was

Fig. 125 (top)
Charles H. Bennett, "Christian," from John Bunyan, *The Pilgrim's Progress* (Philadelphia: Lippincott, 1902), p. 10. Courtesy of Jesuit-Krauss-McCormick Library.

Fig. 126 (bottom)
Charles H. Bennett, "Pride," from John Bunyan, *The Pilgrim's Progress* (Philadelphia: Lippincott, 1902), p. 113. Courtesy of Jesuit-Krauss-McCormick Library.

Fig. 127 (top)
"Our Lord and Saviour Jesus Christ," wood engraving,
from Rev. Arthur P. Hayes, "Scenes and Incidents in the
Life of Our Lord and Saviour Jesus Christ," in *The Holy
Bible* (Richmond: B. F. Johnson & Co., 1885), n.p.
Courtesy of the Billy Graham Center Museum.

Fig. 128 (bottom)
"The Twelve Sent Forth," lithograph on cardboard, 4
× 2 7/8 inches, Little People's Lesson Picture, for
Sunday, June 3, 1900. Philadephia: American Sunday
School Union, 1900. Courtesy of the Billy Graham
Center Museum.

supposed to have eliminated. This is not to claim that the halo in each image is not a sign, for it surely is one drawn from the repository of Christian iconography. But for believers, the halo was an effulgence of the sacred person, a luminous emanation of holy substance. The didactic image was inscribed; its meaning depended on its connection to a text. The devotional image, by contrast, was preponderantly iconic. The person was the face; the auratic emission of authenticity was the glow that linked the face of the sacred person with one's own eyes as materially as the sun portrayed itself without the help of human hands on the photographic plate. But for Protestants to espouse the devotional image, some authentication of the leap from inscription to infusion was necessary. What better to do this than a text whose meaning could be completely transformed into an image? This presented itself in the form of the much-discussed letter of Publius Lentulus.

The task of portraying Jesus for a Protestant market, which was increasingly shaped by the visual rhetoric of photography, found textual support in a medieval manuscript that purported to be (and was long respected as) a description of Jesus by a contemporary. Supposedly written by Publius Lentulus, a Roman official said to be a contemporary of Pontius Pilate and working in Palestine, the letter was addressed to the Roman Senate. The letter was often cited and reproduced in translation during the nineteenth century. Few if any accepted it as authentic. But many saw in it the shadow of truth. A critic writing in *Sartain's Magazine* in 1849 about a contemporary image of Christ by the German sculptor Carl Johann Steinhäuser (1813–1877; fig. 129) quoted the Lentulus letter, which the critic believed was "not *altogether* unfounded" as an account of Christ's personal appearance, even though he dated the letter to the end of the third century after Christ. In her widely read *History of Our Lord as Exemplified in Works of Art* (1864), Anna Jameson was also prepared to accept that the let-

Fig. 129
Carl Johann Steinhäuser,
The Head of Christ, in
Sartain's Magazine 4, no. 2
(February 1849), 134.

ter may have originated in the third century.[30] Following Mrs. Jameson, whom he cited as an authority on the history of Christian art, Henry Ward Beecher also believed the letter to have originated in the early Christian period. The document, in his view, offered "a clear view of the countenance which [early Christian] art had already adopted, and which afterward served virtually as the type of all the heads of Christ by the great Italian masters, and by almost all modern artists."[31] The face described in the letter certainly resembles not only the illustration (fig. 129) but a great many depictions in the western tradition. The text of the letter that describes Christ's appearance reads as follows:

> His hair is the colour of wine, and golden at the root—straight, and without lustre—but from the level of the ears curling and glossy, and divided down the centre after the fashion of the Nazarenes. His forehead is even and smooth, His face without blemish, and enhanced by a tempered bloom; His countenance ingenuous and kind. Nose and mouth are in no way faulty. His beard is full, of the same colour as His hair, and forked in form; His eyes blue, and extremely brilliant.[32]

The letter had acquired sufficient interest to warrant visualization by ambitiously entrepreneurial lithographers such as William Pendleton and Currier & Ives. Perhaps the first lithographer in Boston, Pendleton produced his large, hand-tinted *Letter from Publius Lentulus* (fig. 130) in 1834. The image materializes in red, brown, and yellow above the cursive script of the letter, as if it were an icon made without human hands, visualizing the face carefully described in the historical document.[33] Pendleton issued his portrait before the invention of the daguerreotype but in the midst of the popularization of phrenology in the United States. A few years later, a phrenologist published a lecture in Boston (which had quickly became the center for phrenology in the 1830s) in which, arguing for the Christian nature of the new science, he stated that according to "the concurrent testimony of painters, divines, and ecclesiastic historians, it appears the configuration of the head of the Messiah was perfect, and his features regular and handsome."[34]

Pendleton's early effort was followed several years later by another attempt at visual authenticity when Currier & Ives published *The True Portrait of Our Blessed Savior, Sent by Publius Lentullus to the Roman Senate* (fig. 131) sometime between 1857 and 1872 (based on the address of the firm recorded at the foot of the print). Currier & Ives may have released the print in the hope of capitalizing on the growing popularity of such illustrated lives of Jesus as Beecher's.[35] While many Currier & Ives images were intended for a Roman Catholic market (or, as in the case of figs. 75 and 76, for Protestant evangelism among Catholic immigrants) and therefore included Spanish, French, or German text, the caption of this lithograph (fig. 131) is limited to English, suggesting perhaps that this was a commodity aimed at both Protestant and Catholic customers. Other than the trinimbus, the image is shorn of iconography. If Pendleton produced a pictorial rendering of the medieval description, Currier & Ives created a portrait of the face itself, dispensing with the text of the letter, as if having access to the very face it described. The result was what Bushnell cel-

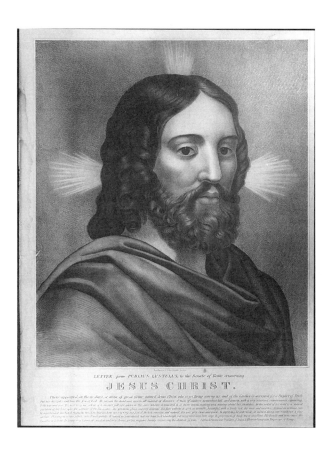

JESUS CHRIST.

Fig. 130 (*top*)
William S. Pendleton, *Letter from Publius Lentulus, to the Senate of Rome concerning Jesus Christ,* hand-tinted lithograph, 1834. Courtesy of the American Antiquarian Society.

Fig. 131 (*bottom*)
The True Portrait of Our Blessed Savior, Sent by Publius Lentullus to the Roman Senate, lithograph, 16 × 10 6/8 inches, Currier & Ives, c. 1857–1872. Courtesy of the Billy Graham Center Museum.

ebrated as "the greatest truth of the gospel"—not his words or deeds, but "Christ himself." Image overshadows text, indeed, seems to want to function without it by virtue of the direct gaze. Christ looks straight into the viewer's eyes and bears the features described by Lentulus: a short, forked beard, shoulder-length brown hair parted in the center, a smooth, large forehead, and bright, clear eyes.[36] The physiognomy of Christ's appearance, the nonverbal language of what Bushnell enumerated as "the eye, the face, the look" of Jesus, the man, was all that was deemed necessary for an authentic portrait. The large size of Pendleton's print may suggest an intended use in a church or school, whereas the much smaller Currier & Ives image suggests a market for domestic display, which was just where Bushnell expected the religious image would exert its greatest influence.

The idea of the "true portrait" was indebted to the Latin tradition of Veronica, the legendary woman who acquired the "true icon" of Christ when the savior's features were mysteriously transferred to the cloth she handed him as he paused on the way to Calvary.[37] But the Currier & Ives print translates the icon into a portrait with a claim to firsthand authority. The simplicity and directness of the image exhibits aspects of contemporary photographic portraiture. Christ turns from a three-quarters view to face the viewer. Background detail is eliminated in favor of a plain backdrop. The close focus on head and shoulders is reminiscent both of ancient icons and modern portraiture.

How viewers were meant to encounter the person in this picture was paramount. There is no text other than the brief caption assuring viewers of the image's authenticity. This autonomy from a narrative or textual reference is what made the image new for American Protestants. Christ is seen here as nothing but a visual description of himself. His features are encoded with his character as a benevolent, solemn, tranquil savior. He does not appear in a particular narrative moment but is abstracted from the events of his life and placed against the plain screen of a commercial studio. The image presents itself as a journalistic, eye-witness rendition of Christ's appearance as a human being, a God in the flesh (as the halo reminds viewers). By focusing on what Jesus looked like rather than what he did, the image was meant to visualize his character and to address it to the devout viewer with the directness of Christ's gaze.

The Place of Art in American Protestant Life

Among liberal Protestants such as Beecher, portraits of Jesus were popular as renditions of "the great Personage," as Beecher liked to call him. For liberals like Beecher the task was to discern the personality of the great teacher, the moral hero, the man of virtue, the humble servant, the chosen one of God. Rejecting the theological severity of his Calvinist forefathers, Beecher considered the depiction of Christ in Michelangelo's *Last Judgment* "repulsive" but lauded Leonardo's portrayal of Christ in the *Last Supper* as unforgettable and had this detail of the image engraved as the

Fig. 132
W. E. Marshall, after
Leonardo da Vinci,
The Last Supper, metal
engraving,
frontispiece in Henry
Ward Beecher, *The
Life of Jesus, The Christ*
(New York: J. B. Ford
and Company, 1871).

frontispiece for his *Life of Jesus* (fig. 132). For the liberal imagination, a Christ who judged and condemned could never be the moral equivalent of one who submitted to betrayal and laid "down his life for his friends" (John 15:13).[38]

Yet something of the Calvinist proscription of images of God lingered with Beecher; he remained christologically orthodox, parting company with Unitarians on this point despite his enthusiasm for art and religious subjects. If depictions of Christ could become iconic for him, it was only in brief moments of aesthetic revelation. Visiting galleries at Oxford in 1850, Beecher related how the age of architecture and artifacts there affected him, causing everything to open before him and disclose its immortality. Paintings, he said, "cease to be pictures. They are realities. The canvas is glass, and you look through it upon the scene represented as if you stood at a window. Nay, you enter into the action." This experience was especially potent as Beecher viewed two religious paintings: an image of the Apostles by Guido Reni and an unnamed image of Christ.

> At last you are with them! No longer do you look through the eighteen hundred years at misty shadows. The living men have moved down toward you, and here you are face to face! I was much affected by a head of Christ; not that it met my ideal of that sacred front, but because it took me in a mood that clothed it with life and reality. For one blessed moment I was with the Lord. I knew him. I loved Him. My eyes I could

not close for tears. My poor tongue kept silence, but my heart spoke, and I loved and adored.[39]

But this iconic disclosure, this cancellation of history and time before the face of revelation and divine presence, did not endure long for Beecher, for as his four-week tour of European art galleries and monuments waned, he concluded that "in almost all the heads of Christ which I have seen, there is much to admire but nothing to satisfy." The problem for Beecher was the inherent limitation of picturing Jesus, the God-man. The pictures he saw "are more than human, but not divine. They carry you up a certain distance, but then leave you unsatisfied."[40]

Beecher expressed the same disappointment twenty years later in *The Life of Jesus*. Indeed, not only were there no reliable descriptions or likenesses surviving from Christ's day, it was impossible, Beecher asserted in the face of his iconic experience at Oxford, to see Christ as his contemporaries saw him, to whom he was "simply a citizen." Modern-day believers, like every generation since Christ's lifetime, viewed the Savior "through a blaze of light." "The utmost care will not wholly prevent our beholding Jesus through the medium of subsequent history. It is not the Jesus who suffered in Palestine that we behold, but the Christ that has since filled the world with his name."[41] Beecher observed that depictions of Christ through the ages possess "a certain universality" since Christ "spiritually united in himself all nationalities. All races find in it something of their race features."[42] A plate reproduced in the book showed five engravings from historical portraits of Jesus (fig. 133), ranging from an early Christian catacomb fresco to a painting by Paul Delaroche, one of Beecher's favorite contemporary painters. The engraved faces bear a striking resemblance to one another and help make Beecher's point that the letter of Publius Lentulus served as the basis for subsequent portraits of Jesus.

But the larger point that Beecher wished to establish was that no single view of "the head of Jesus can satisfy the desires of a devout spectator." Indeed, he even entertained the idea that no images whatsoever of Christ might be appropriate: "Taking all time together, it may well be doubted whether religion has not lost more than it has gained by the pictorial representations of Jesus. The old Hebrew example was far grander. The Hebrew taught men spirituality, when he forbade art to paint or to carve an image of the formless deity."[43] Having raised the specter of anti-iconicism, Beecher did not press the point, perhaps because the sensation of looking at an image of Christ at Oxford persisted; or perhaps because the interposition of history between Christ and the believer no more invalidated the use of images than it undermined the historicity of Christ. History, finally, was not such a problem. Beecher fell short of proscribing images because what he really lamented was the artistic difficulty of portraying the mystery of divinity and humanity conjoined in the personhood of the biblical Jesus.

Other tourist-clergy were less concerned about this limitation than Beecher—either because they were Unitarians such as Cyrus Bartol or evangelical Christians such as George W. Bethune, a Dutch Reformed clergyman and a vice-president of the ATS, who called on artists to create an image of him "who lingered so long among us, shedding his soft religion

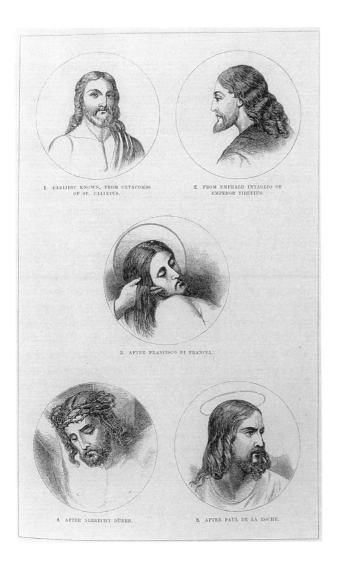

1. EARLIEST KNOWN, FROM CATACOMBS OF ST. CALIXTUS.

2. FROM EMERALD INTAGLIO OF EMPEROR TIBERIUS.

3. AFTER FRANCISCO DI FRANCIA.

4. AFTER ALBRECHT DÜRER.

5. AFTER PAUL DE LA ROCHE.

around like the mild rays of a summer's sunset" and wrote of the "birth of a passion for Art, lasting as life" in travelers standing before Raphael's *Transfiguration*.[44] Bartol, who considered "Art" a "preacher" and "a fifth evangelist," stood enrapt before another image by Raphael, the Dresden *Madonna and Child,* whose depiction of the Christ-child he experienced as an ideal combination of "simplicity and innocence" and "a majesty peculiar and unrivalled." The image was "the supernatural put into color and form" and affirmed all things spiritual and immortal.[45]

Bartol and Bethune were not alone in their appreciation of artistic depictions of Christ. Other clergy believed the portrayal of Christ's two natures to be well within the abilities of the artistic genius. Horace Bushnell, for instance, who had made a tour of London, Geneva, Florence, and Rome in 1845–1846, commented while visiting the Vatican that the upper portion of Raphael's *Transfiguration,* which portrayed Christ in glory, was "executed with a spirit and power almost superhuman. The supernatural

Fig. 133
"Heads of Christ," in Henry Ward Beecher, *The Life of Jesus, the Christ* (New York: J. B. Ford and Company, 1871), facing p. 134.

is here clothed in the natural, the spiritual in the terms of physics." While Bushnell faulted the painting's composition, he believed that the artist had accomplished "the thing most difficult" by visualizing the miracle of Christ's two natures.[46]

Neil Harris has rightly stressed how Protestant clergy in antebellum America were instrumental in helping to change attitudes toward the fine arts. Traveling to Europe and viewing art there, they returned to publish their letters, memoirs, diaries, and travel notes for an American middle class that avidly sought guidance in travel, appreciation, and the refinement of taste. Moreover, clergy experienced art and described their experiences in religious terms that not only made sense to Americans but elevated the status of art and artist in a culture that had, as Harris shows, formerly associated the fine arts with luxury and vanity.[47]

Although not a clergyman, author and art enthusiast Augustine Duganne (1823–1884) preached the spiritual mission of art for American life, imbuing art with a patriotic fervor and power of moral refinement that contributed to the rising estimation of art in American public life. In an 1853 pamphlet entitled *Art's True Mission in America*, Duganne applied to art the doctrine of moral influence developed earlier by the benevolent societies and even earlier by republican ideologues. Calling for the foundation of a "national conservatory of the Fine Arts" that would foster "the humanizing influence of a love or appreciation" of art, Duganne saw the mission of art in terms of social benevolence:

> There is no more blessed influence superacting on the world than the love of art nourished by the education of our higher feelings. It is never individual in its operation, never selfishly confined to the object upon which it was first directed; but it effuses like the atmosphere, radiates like light, enveloping, pervading, and ameliorating all surrounding things, and transforming the rudest antagonisms into the tenderest sympathies.[48]

Duganne couched his moral interpretation of art in religious rhetoric, which he applied to the improvement of American society and its elevation in world standing. Because of its democratic nature, the United States could use art like no nation before it to elevate the "great mass." The beautiful offered a political vision that put "national and sectional prejudices aside," offering a single national shrine to exalt and purify "the souls of men."[49] The practice of influence acquired a new means of diffusion.

The purification or refinement offered by art was not an obscure process of ethereal radiation but was conducted in the concrete medium of moral encounter and the ethical effects of art on the viewer. Duganne believed that art ought to be placed in schools, homes, public halls, and churches in order to be "a teacher of the people." The power of art to monitor behavior or soothe the mind was undoubted: "A picture of a quiet landscape may be a silent monitor to the vexed mind—a sweet face gazing from the wall, may make us ashamed of the frown which darkens our brows." Duganne related the story of a young child's reverent hush before Hiram Powers's marble *Slave* and could not imagine "a man so brutal, so impious, as to strike a blow in anger, or even to vent an imprecator, in the

mute presence" of the statue. American life at all levels would improve by "communion" with the beautiful. "Even the humblest engraving, in a poor man's chamber—if it possess but the symmetric proportions of beauty—may minister to the beholder's taste, enlarge his heart, embellish, so to speak, his views of life." George Bethune also praised the engraved and lithographic reproductions of works of art for their benefit on "the walls of many a humble dwelling," in educational materials such as spellers, and in penny magazines.[50] For Duganne, Bethune, and many other patriotic Americans caught between the domestic tensions over slavery and immigration and the international rivalry with European cultural prestige, the mission of art was to proliferate in American life and elevate public taste by virtue of moral edification.

As dated as such moralizing views of art seem today, it was not until the third and fourth decades of the nineteenth century that American artists, critics, and clergy came to regard the arts as fundamental to promoting national identity and assisting religion in fostering public manners and morals. For many clergy, art became a humanizing, reforming social force in the national task of shaping character. One can sense Bushnell's anxiety about America's coming of age and what role art should play in this maturation in a letter he wrote from Florence in 1845. Having spent the morning in the Pitti Gallery, he wrote that he left the place

> all in a glow; I seem to have breathed a finer atmosphere; and all my good feelings, if I have any, are invigorated. I feel conscious that my eye is forming or perfecting, and I know that it must be a benefit to me, as regards writing and the conduct of life, to have dwelt in such an atmosphere and received such an influence.

The moral significance of aesthetic refinement was quite clear to Bushnell. He concluded after leaving the gallery: "I seem to have been in the best society in the world, and feel that I can better act my part in any society in which I may be cast." Bushnell noted, in the tradition of theorists from Vasari to Joshua Reynolds, that the fine arts originated in mechanical trades, each having been gradually cultivated from the status of trade to the refined status of art. "This," Bushnell optimistically remarked, "I apprehend, is the law of all healthful growth in the fine arts, and it augurs well for America. It is no ill that we are a busy people. That is the only way to become a most truly cultivated people."[51] The nurture of culture conformed entirely to Bushnell's emerging views on child nurture as a process of gradual formation. His insistence on nurture rather than conversion stressed breeding and appealed to a genteel, liberal, nonproselytizing Christianity for which civility, manners, and taste were the marks of refinement.[52] His own and other liberal Protestants' belief in the importance of art was deeply implicated by theology and social theory.

If Bushnell looked forward to the day when America would attain parity between its cultural and commercial lives, Henry Ward Beecher dedicated his ministry at Plymouth Church, Brooklyn, to celebrating the achievement of culture and wealth among his affluent parishioners. William McLoughlin has pointed out in his none-too-sympathetic study of Beecher's career that neither Beecher nor his congregation were inter-

ested, as his father had been, in the redemptive mission of benevolent societies. Instead, Beecher and his congregation pursued a new form of philanthropy that understood benevolence in terms of artistic patronage and the display of the fine arts as expressions of the belief in the refining power of the arts.[53] Refinement replaced reform, and the development of reproductive technologies offered an affordable means of disseminating culture that substituted for the millions of tracts and books distributed by the Bible, tract, and Sunday school societies. As with Duganne and Bethune, in Beecher's mind the influence of mass-reproduced art paralleled the influence of the evangelical press. The mass refinement of American taste was displacing the mass reform of morals. As Beecher put it in an essay of 1859:

> The finest forms in glass, china, wedgewood, or clay, put classic models within the reach of every table. The cheapness of lithographs, mezzotints, etchings, and photographs, is bringing to every cottage-door portfolios in which the great pictures, statues, buildings and memorials of the past and triumphs of modern Art are represented. That which, twenty years ago, could be found only among the rich, today may be had by the day-laborer. This is the true leveling. . . . Let knowledge, beauty, goodness, shine down upon the path, and make the way plain along which the people are to tread.[54]

This democratic accolade, McLoughlin argues, was not in fact so democratic since Beecher conceived of cultural refinement as a trickle-down affair, a vertical arrangement whereby the elite pulled the lower classes into gradual enlightenment by virtue of their noble example and munificent patronage.[55] Thus, much of the class structure of the older form of benevolence remained in place in the new philanthropy. But whatever Beecher's motives may have been, his reticence to endorse any particular image of Christ as authentic notwithstanding, he sanctioned mass-reproduced religious images as did other clergy who saw in such visual culture an opportunity to refine feeling and influence public morality, to supplement the social function of religion, and to mediate commerce and moral progress in the Gilded Age.[56]

In Search of the Face of Jesus:
Illustrated Lives of Christ, 1860 to 1900

Among many Protestants the use of mass-produced artists' images thrived from the 1860s to the 1920s in a religious visual culture that generally took two forms: first, pictorial volumes that served as sourcebooks in the classroom and home, and second, individually produced images, such as picture cards, used in conjunction with uniform or graduated Sunday school lessons or as frameable images that were widely used as gifts to students for classroom performance and as a means of celebrating such achievements as perfect attendance or Sunday school graduation. This was hardly a new idea—the ATS and ASSU had sold picture cards since the 1820s and 1830s, and a number of firms such as Currier & Ives had offered lithographs

of religious subjects for domestic display since the 1830s. What was new, beginning in the 1860s, were lives of Christ copiously illustrated by works of fine art.

In the last third of the nineteenth century, American clergy and publishers found that the value of religious fine art for refinement, instruction, and moral uplift could be translated, as Beecher had suggested of the new reproductive technologies, into the mass culture of illustrated lives of Christ. Illustrated lives of Christ early in the century, such as John Fleetwood's 608-page *The Life of Our Lord and Saviour Jesus Christ,* published in 1830 by Nathan Whiting in New Haven, included as a frontispiece a metal plate engraving of Christ after Correggio and twenty-five wood engravings, several of which are signed "J. W. B." (probably John Warner Barber). The wood engravings were each printed on separate pages and keyed to a particular page number but were not commented upon in the text.[57] Fleetwood's text was reissued in thirty-eight parts in the early 1860s as *The Life of Christ* by Virtue and Yorston in New York, each part carrying two or three full-page steel engravings as frontispieces, totaling fifty-eight.[58] Works by both American and European artists (see figs. 11 and 134) were reproduced but not discussed. Stitched into the binding at the very front of each installment, the engravings, printed on heavy stock, could be easily detached and displayed as independent works. Advertised on the cover as "Presentation Plate Gratis," the engravings served as premiums no less than illustrations, and were examples of the sort of affordable, mass-produced imagery cited by Duganne, Bethune, and Beecher.

Fleetwood's enormously popular and widely reprinted *Life of Christ* helped initiate several new practices in illustrating the genre. Although not unprecedented, the use of a head-and-shoulders portrait of Jesus was certainly brought into the mainstream of illustrated lives of Christ by an 1855 edition of Fleetwood's book, published in Boston. Engraved by D. L. Glover after a contemporary Belgian history painter named Henri Decaisne, this portrait (fig. 135) addresses the viewer with a direct gaze in the manner already noted of the images illustrating the letter of Publius Lentulus. The delicately stippled engraving serves as an author portrait and the book's frontispiece, carrying as text the words spoken by Christ himself, "I am the Vine, Ye are the branches." An 1859 edition carries a frontispiece engraved after Paul Delaroche's frequently reproduced portrait-image of Christ (see fig. 133). This sort of image no doubt seemed more and more appropriate as popular audiences became accustomed to the daguerreotype, engraving, and photoengraving as media for portraiture.[59]

Composed largely, often exclusively, of reproductions of European religious fine art, executed first in wood and steel engraving, then in halftones by the 1890s, lives of Christ from the 1860s to the end of the century were increasingly dominated by imagery. At first, however, illustrations were strictly ancillary to the text. Scholarly versions were typically unillustrated, for example, Augustus Neander's *Life of Jesus Christ,* the third English-language edition of which was published by Harper Brothers in 1850. In 1869, however, the same firm published Lyman Abbott's *Jesus of Nazareth* and illustrated it with thirty-four full-page images or vignettes, eight of which were engraved after works by Gustave Doré, Paul Dela-

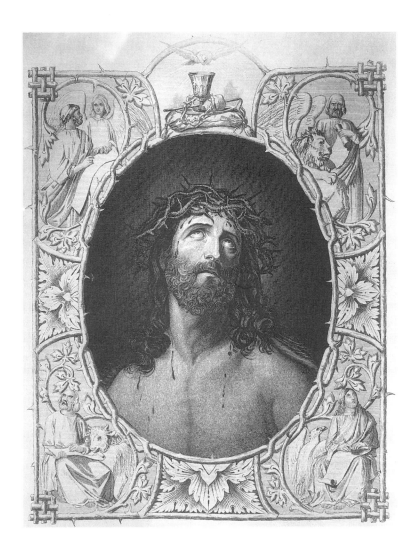

roche, and Ary Scheffer. Abbott (who eventually succeeded Beecher as
pastor of Plymouth Church, Brooklyn) made no reference to the illustra-
tions, which suggests that Harper Brothers sought out and introduced
them, knowing as they did from the stunning success of their *Illuminated
Bible* of the 1840s and the *New Monthly* magazine of the 1850s that illus-
trated popular publications sold well.[60]

It was not long, however, before authors and publishers began paying
tribute to illustrations. Already by 1851, Appleton in New York published
Our Saviour with Prophets and Apostles, edited by Jonathan Mayhew Wain-
right, bishop of the Protestant Episcopal church, who invited the
draughtsman John Wood to create eighteen "men of the Bible" of his own
choosing.[61] The drawings were then reproduced as steel engravings for
the book, and several prominent divines, including Presbyterian Asa Smith
and Unitarian clergymen Cyrus Bartol and Henry Bellows, were invited
to prepare brief essays about the figures selected by Wood. Although the
images were "prepared expressly for this work" and "the pencil of the artist

was not placed under any degree of restraint," the images were not provided to the writers and were not mentioned by any of them.[62] Yet the sumptuous bindings of the book, the license allowed to the artist, and the prominence given the imagery suggests a new willingness to intermingle the fine arts, religion, and the published book.

The interrelation of image and text had been an important feature since the second quarter of the nineteenth century in the noteworthy genre called the gift book. Images, just as verse and song, suited the purpose of the gift book: casual, leisurely browsing that required no sustained effort. The books could be the sort of inexpensive Sunday school text examined throughout this study—volumes given as gifts by teachers to students; or they could be higher priced commodities ranging in size from the pocket book to the folio, typically bound in embossed, gilt, and illuminated leather bindings, intended for display in the home, particularly the parlor. In either case, their themes, often religious, tended to memorialize occasions and domestic rites such as the celebration of holidays, frequently sentimentalizing memory in the form of the keepsake or token given at Christmas or New Year's.[63] The gift book was defined functionally both by the social occasion of presenting the collection of thoughtful verse and imagery and by the commemorative service the book fulfilled thereafter as an item of display and entertainment. Since they were often annuals, gift books were collected serially and could be displayed as such, documenting each year in the life of an individual or family, each volume bearing a personalized dedication page with the name of the recipient and the signature of the gift-giver.

Fig. 135
D. L. Glover after Henri Decaisne, *Christ,* steel engraving, frontispiece in Rev. John Fleetwood, *The Life of Our Blessed Lord and Savior Jesus Christ* (Boston: Phillips, Sampson & Co., 1855). Courtesy of the American Antiquarian Society.

The significance of this genre of book production for the mass-produced visual culture of American Protestantism is manifold. It helped make imagery part of the economy of the gift; acted as a bearer of sentiment in the form of family memories and the keepsake; and provided an important source of income for artists who found commissions for paintings lacking. Gift books also offered employment to engravers and illustrators in the major centers of book production—Philadelphia, Boston, and New York.[64] Most important for this study, the nineteenth-century gift book provided an upscale format for the display of religious fine art in the homes of middle-class Protestants. The images were not didactic illustrations but full-page pictures, often independent of text, intended to be appreciated for their workmanship, religious sentiment, historical significance, or their interpretation of poetry. Gift books, in other words, made religious imagery a matter of artistic appreciation as well as an occasion for religious feeling and contemplation, no longer just the instrument of instruction. Religious images and the memory acquired a new function: recalling divine providence and blessing in the family life over the past year. This expanded the more traditional American Protestant practice of using images as illustrations to encapsulate biblical or catechetical information for commital to memory.[65]

During the second half of the nineteenth century, publishers and authors were not slow to recognize the interest that images attracted to books such as the gift book aimed at broad audiences. The production of gift book annuals declined after the Civil War, but new genres of illustrated religious books quickly took their place. In 1875, when Methodist Sunday school advocate and author of Sunday school lessons Edward Eggleston published his *Christ in Art,* a harmonized narrative of Christ's life, he acknowledged in the preface that "the principal attraction of the book is not the part which fell to my share, but the illustrations [one hundred full-page engravings] after Alexandre Bida's magnificent designs."[66] Bida (1813–1895) was a French illustrator, watercolorist, and lithographer, student of Delacroix, and well-known Orientalist, who had made three trips to Palestine in the 1840s and 1850s. Second only to Doré, Delaroche, and James Tissot, Bida was a widely reproduced French artist of religious subjects from the 1860s to the early twentieth century. His *Jesus by the Sea* (fig. 136) served as Eggleston's frontispiece and was used by others as well. Bida's work was less fantastic and less steeped in dramatic mood than Doré's and always remained close to the biblical narrative by focusing on particular moments and passages. For this reason, Bida's images found wide acceptance as literal illustrations of scripture and readily inspired those who produced such religious instructional materials as International Lesson picture cards. This "plain style" also appealed to writers and editors who wished to use illustrations to bolster the historical claims made for the life of Christ.

The illustrated lives of Christ repeatedly cited the need for comprehensive historical and scientific research into the history of Christ's life, stimulated by the ongoing debates among scholars and ecclesiasts over the critical studies originating in such controversial lives of Christ as those written by David Friedrich Strauss and Ernest Renan.[67] Illustrations tended

to take two forms: ethnographic, archeological, and botanical illustrations of details and customs of biblical life; and reproductions of fine art depicting Christ and various scenes from the New Testament. The concern in the first instance was one of illustrating historical facts and in the second of interpreting biblical narrative in the inspirational form of works of fine art. Aesthetic experience in the latter case meant moral edification and inspiration. Subject matter and its imaginative interpretation of scriptural texts remained of paramount importance. The dearth of images by American painters suggests a persistent assumption, reflected in the pilgrimages to Eurpean art galleries undertaken throughout the century by American clergy, businessmen, and collectors, that the source of cultural refinement remained abroad.

The quest for the historical Jesus among biblical scholars on both sides of the Atlantic had a counterpart in the popular print culture of illustrated

Fig. 136
After Alexandre Bida, *Jesus by the Sea,* steel engraving, frontispiece in Edward Eggleston, *Christ in Art* (New York: J. B. Ford), 1875.

lives of Christ: the quest for the authentic image of Jesus. One instance of this occurs in what was perhaps the most densely illustrated life of Christ before the turn of the century, DeWitt Talmage's *From Manger to Throne* (1890), which included over four hundred engravings of ethnographic details, nearly two hundred reproductions of well-known paintings, and a twelve-color panorama of the crucifixion that folded out to ten feet in length. In the manner of Beecher in his *Life of Christ,* Talmage reproduced two plates of ten engravings after paintings of Christ. Like Beecher, Talmage was unsatisfied with all of them and acknowledged the challenge of determining a satisfactory image of the savior. Any picture, he said, "is apt to represent Christ either as effeminate or severe, weak or awful." The problem was as Beecher had defined it: What portrayal could do equal justice to Christ's humanity and divinity? "To commingle in one picture strength and humility, suffering and triumph, the lion-like and the lamb-like . . . that tasks the greatest genius to the utmost."[68] Yet unlike Beecher, Talmage believed that he had found a picture "which I think will satisfy as far as any human delineation can." After having wandered "up and down the chief art galleries of Europe," Talmage chose a painting by Ary Scheffer (1795–1858), a Dutch-born painter who spent his career in France. Scheffer produced many religious subjects including portraits of Christ, for example, a lithographed portrait of Christ weeping over Jerusalem (fig. 137) copied from a larger painting owned by the Walters Art Gallery in Baltimore—the image that Talmage selected and reproduced in his book.[69] Proud that he could choose the work of an artist from his own century, Talmage claimed that "the best paintings are yet to be presented to the world." Scheffer's Christ, he announced, was neither German, French, Italian nor Spanish, but, "as far as possible, presents 'THE WORLD'S CHRIST.'"[70]

Many clergy in late-nineteenth-century America shared the disappointment of Talmage and Beecher in artistic depictions of Christ. This was made abundantly clear by a collection of letters published in 1899 in the *Outlook,* a Protestant weekly edited by Lyman Abbott. After visiting an exhibition of James Tissot's depictions of the life of Christ, Kate Hampton decided to poll several clergymen in New York City to determine whether "the face of Christ, as depicted in ancient and modern art, realize[s their] idea of a strong face?" The responses were largely negative, and largely received from Episcopalian clergy (of the seventeen letters published, nine came from members of the Protestant Episcopal church; three from Presbyterian, two from Unitarian, one from Methodist Episcopal, and one from Roman Catholic clergy, and one from a Jewish rabbi).[71] With the exception of one Roman Catholic and a Presbyterian, none of the clergy expressed enthusiastic satisfaction with images of Christ, though several named particular pictures that conveyed very well the human aspects of Jesus. Works by Hiram Powers, Albrecht Dürer, and Ary Scheffer were praised for their portrayal of Christ's humanity and suffering. But a rabbi, a Unitarian clergyman, and an Episcopalian faulted artists for not envisioning Christ's Jewishness.

Yet the prevailing criticism among the letters was the sheer impossibility, as Beecher had seemed to indicate, of expressing Christ's divine characteristics. Indeed, one Presbyterian pastor was invariably revolted by the

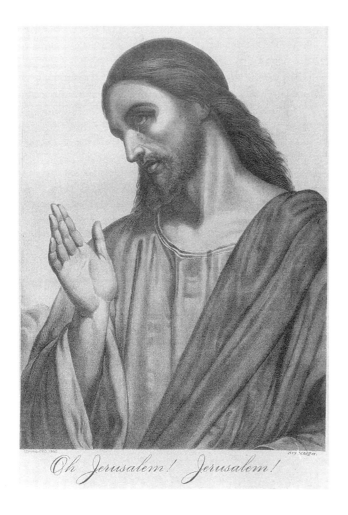

Oh Jerusalem! Jerusalem!

results of artistic futility: "I do not hesitate to say that, in my estimation, the artistic reproductions of the Christ face are weak—not only disappointing, but repulsive. I never see a pictured face of Christ that does not contradict my sense of the divine; such faces make me ache in sympathy with the futile strain made by the artist to do the impossible." Whereas a Unitarian contended that a better artistic representation of Christ would come only with "a new sense of the unqualified humanity of Jesus," another writer inveighed against this attitude as precisely the cause of repulsive images of Christ:

> The worst, the most hopeless, error is that of dragging Christ down to the level of a mere man like one of us; and this loss of the idea of his Deity, together with the modern exaggerated cult of philanthropy, sweetness, good nature, etc., has produced those feeble, mawkish, sickly portraits of Christ from which I, for one, turn in impatience and disgust. Whenever and wherever, in ancient or modern art, I find a strong face of our Lord, I recognize it as strong because God, perfect

Fig. 137
After Ary Scheffer, *Oh Jerusalem! Jerusalem!*, lithograph?, in Rev. T. De Witt Talmage, *From Manger to Throne* (Philadelphia: Historical Publishing Company, 1890), facing p. 652. Courtesy of Jesuit-Krauss-McCormick Library.

God, omnipotent, omniscient, omnipresent, is looking at me through the veil of flesh.[72]

To this high Protestant christology was contrasted the incarnational theology of Roman Catholic Cardinal Gibbons, who insisted that believers must "see," "witness," and "behold" Christ rather than only hear or read what he said.

Still others in Hampton's article sought to balance Christ's male and female, strong and weak aspects as the necessary ingredients in the proper portrayal of his divine and human natures. "We must find in [the face of Jesus]," the assistant rector of the Church of the Holy Communion stated, "strength for our weakness, [and] womanliness, tenderness, gentleness, and sweetness to temper our robustness." Jesus, as another writer put it, "included not only the two natures, God's and man's, but our two natures, man's and woman's."[73] Percy Grant, pastor of the Protestant Episcopal Church of the Ascension in New York City, agreed that the "traditional face of Christ in art" was not a strong one but countered that this was appropriate. "It has not the power of blood and iron—of a Bismarck." Nor should it. Grant found such jingoism, as popularized by Teddy Roosevelt, inappropriate for the character of Jesus.

> The kind of strength of character that we are most familiar with is that which is developed by the force of a competitive civilization. Among college athletes, among soldiers, young business men, and even city roughs we find this typical modern strong face. It is resolute, determined, firm . . .
>
> But Jesus took no part in the competitive life of his time, and he lived when competition was not as strenuous as to-day. . . . Jesus's life was not spent in resisting evil, but in realizing the good. His character developed, therefore, more as a woman's character develops—in innocence, sweetness, and love. We are not, therefore, to expect the Christ face to exhibit moral struggle.[74]

One expects that it was just this view that fired Bruce Barton's contempt for the feminization of the church a few years later. But Muscular Christianity was already at work among American Protestants in the late nineteenth century, and the opinion of several clergy cited in the article was unmistakable, as expressed by the Unitarian pastor of the Church of the Messiah who wasted no words in stating that most of the images of Christ he'd seen impressed him as being "weak and unmanly."

If many clergy doubted whether there might be a satisfactory image of Christ while Talmage and others sought a universally valid one, a third approach to the problem of imaging the historical Jesus was pursued by Chicago publisher Abraham Elder, who in 1896 issued *The Light of the World or Our Saviour in Art,* a parlor book that featured 145 halftone reproductions of paintings and engravings by European artists. Elder prefaced the book by celebrating the many "different ideals of The Christ by the great masters."[75] He assured his readers that his book was unprecedented as a collection of "so many rare and valuable pictures of our Saviour," and he presented the book as an unparalleled "opportunity for

comparison and study of the different masters' ideas." The volume was unique among American publications because it dispensed with a literary narrative of Christ's life and dedicated an entire page to each image, with short, accompanying texts printed on cover sheets. Designed for display in the parlor, the book's folio-sized bindings were elaborately embossed and gilt, recalling the same treatment given to expensive oversize family Bibles. Elder gestured or perhaps feigned an unwillingness to create a commodity of purely aesthetic value by stating that the motive behind the publication was the desire "to popularize study and research of the New Testament and the scenes and acts in the life of Christ." Yet the images were only intermittently organized according to the biblical narrative. It was in effect an early coffee-table art publication, a gift book that shrewdly relied on the appeal of religious subjects as works of art to find a large audience.

Elder's use of halftones was a recent innovation in American visual culture. If the wood engraving had offered the key technological advantage of allowing imagery to be printed as part of the typographic process, the halftone screen, invented and rapidly developed in the 1880s in the United States, dispensed with the slow and expensive process of multiblock wood engravings in use among illustrators of newspapers, magazines, and books, and merged the production of imagery with metal letterpress. Once it was perfected, by 1888, the halftone consisted of a grid of fine lines placed as a screen between the lens of the copy camera and a photosensitized copper plate. The resulting image was broken into a mesh of very fine dots of varying size registered on the surface of the plate, which was in turn bathed in acid. The light-sensitive gelatin film coating the surface of the plate acted as a resist where it had been exposed to light and allowed the acid to etch the plate wherever and to whatever degree the plate had not received light. The result was a negative relief of the original image that could be inked to produce a positive impression. The plate was then integrated with letterpress and printed in a single process. The end product was a planographic technique comparable in concept to wood engraving but much faster and cheaper in practice because it eliminated the toilsome intermediate stage of engravers tooling the original image into the surface of the wooden block. The camera did all that and did it with an accuracy and reliability that the photographer could control. The technical and conceptual consequences were enormous: anything that could be photographed could be reproduced cheaply and immediately in any publication, from a newspaper to a dime magazine to a one-penny religious image. In effect, the visual coding of tones as the linear patterns of the wood engraving was exchanged for the continuous tonalities of the photograph, a form of representation that approximated human vision much more closely than the gauze of engraved lines in a wood engraving. The individual tonal dots of the halftone screen were not visible to the naked eye and therefore fell below the threshold of normal consciousness where the optical coding of human vision was located. The consequence, as Eustelle Jussim has argued, was imagery that seemed inseparable from what one saw with one's own eyes, since the halftone imitated "the textural gradients" of nature.[76] While wood engravers were driven out of business, mass culture entered a new phase.

By the late 1890s, halftone technology had made the reproduction of works of art less expensive and more photographic in appearance. Those interested in the genre of the illustrated life of Christ or the history of Christ in the fine arts took advantage of the new opportunity and shifted quickly from engraved to halftone reproductions. Sometimes photographs themselves were used, as in the case of stereographs. By 1891 the firm of Underwood and Underwood, which specialized in photography and stereographic imagery, issued the Life of Christ in twenty-four cards for the stereograph. The only text consisted of titles of each scene in English, French, German, Spanish, Swedish, and Russian. The largest group of the imagery, cards 8 through 22, depicted the Passion of Christ, perhaps (along with the elaborately costumed and doll-like figures of the scenes) suggesting a dominantly Catholic clientele.[77]

For book publication, however, the halftone was much more economical once the screen technique was perfected. Whereas Frederic Farrar, canon of Westminster and chaplain to the Queen of England, relied on wood engravings for the few illustrations in the early editions of his *Life of Christ* (1874), editions beginning in 1900 incorporated halftone reproductions of drawings by Heinrich Hofmann on heavy, glossy stock. E. P. Tenney's *Our Elder Brother* (1898) used twenty-four halftones of paintings; Joseph Lewis French's *Christ in Art* (1900) was illustrated with thirty-three halftones of famous religious paintings. Such books at this time, such as Farrar's *Life of Christ,* still used both halftones and engravings, printed on separate pages. But by the publication of James Burns's *The Christ Face in Art* in 1907 the industry had changed irrevocably: all sixty-two illustrations in Burns's book were halftone photographs from the original paintings.[78]

Halftone technology also allowed authors of lives of Christ to illustrate their books not only with more images but with reproductions of higher quality, which promoted the concern to provide Americans with religious fine art. The Chicago Congregationalist pastor William Barton (1861–1930) profusely illustrated his 1903 *Jesus of Nazareth* with 350 halftone illustrations. His book also included a chapter dedicated to "The Christ in Art." This new feature focused on artistic interpretations of Jesus, thus departing from the hitherto prevailing tendency to subordinate the illustration to text in the genre of the illustrated life. With the arrival of the halftone, which was regarded as a flawless replication of the original, the space and honor given to images increased. In fact, Barton proclaimed the advantages of art over written discourse and lamented those ages in the history of the church when art was absent or lacking. Art excelled over text by virtue of its freedom from dogmatic statements and its avoidance of abstractions in favor of visible, concrete bodies. "If art uses symbols, it must be as symbols, and not as syllogisms."[79] With this renewal of the ancient rivalry between word and image, Barton sought to empower the latter among American Christians.

Barton enthusiastically pursued this empowerment by promoting the inexpensive visual culture of the reproduction. He was enamored of the new technologies because they popularized art. "Art," he said, "which was once for the few, has become the possession of the many. The average home of to-day has not merely more pictures than the home of forty years ago, but pictures of vastly better quality." He discerned the origin of this

development in the chromolithograph (which Catharine Beecher had hailed as an appropriate decoration for the Christian home), but he celebrated its full arrival in the invention of the halftone, which he considered to be as momentous as the invention of printing.[80] The wealth of reproductions of paintings of Christ now available allowed Barton and others to consider as never before the issue of Christ's likeness. In fact, a number of publications around the turn of the century reflect this intensified interest. Barton himself provided the clue to its stimulus when he wrote that the image of Christ in "popular thought is a composite photograph" of all the reproductions hanging in homes "all over the world."[81] This was the point made by Talmage and others. Though he stressed that no image could ever fully convey Christ's reality, lest it transgress the Second Commandment by claiming to become Christ himself, Barton nevertheless believed that artists and public had secured a "fixed ideal" of Christ's appearance and character. Rather than focus on a single instance of this fixed ideal, Barton regarded all art to collectively constitute it. This ideal could be relied upon to inform the appreciation of past religious art and the creation of new images of Christ's likeness, which Barton confidently announced "ennobles our daily tasks and exalts our ideal of the good and true and beautiful in human life."[82]

The anthologies of imagery and illustrated lives of Christ served rather like catalogues for teachers, who were able to purchase directly from religious publishing houses inexpensive collections of individual images to give as gifts. A number of publishers supplied the market. In *Jesus of Nazareth* Barton gathered scores of pictures that were commercially available, and in 1910 he published an essay on the use of the "Library as a Minister in the Field of Religious Art," which included a long list of art and art history books for the religious library.[83] Along similar lines, Walter Athearn, a professor of religious education at Drake in Des Moines, compiled a list of "religious art for intermediate grades" in his study *The Church School* (1914), and he included a list of nine companies from which the reproductions could be obtained.[84] In 1917 Albert Bailey (1871–1951), who was one of the most prolific of religious educators committed to the use of art, published a list of 1,227 pictures of the life of Christ in which he provided the sizes of reproductions available, their cost, and the name and address of publishers and firms from which the images could be purchased.[85] Bailey listed eleven sources, all of which were located in what had been the centers of mass-produced commercial imagery since the first days of chromolithography. Four of the businesses were in New York City, and the rest were in Massachusetts: Boston, Springfield, Malden, Newton, and Beverly. Taber-Prang's prices (Springfield, Massachusetts) ranged from 18¢ for a cabinet-sized carbon print (an early photographic method of printing), presumably the four-by-six-inch dimension of cartes de visite, to $3.50 for a photograph measuring twenty-by-twenty-six inches. In 1938 Bailey published an updated version of the list, now expanded to 1,689 images, which listed fifteen domestic and twenty-six European vendors.[86]

The quest for the face of the historical Jesus had produced dozens of versions available to American Protestants in countless illustrated lives of Christ as well as individual images. The plurality of depictions bothered some Protestants, particularly those in search of a suitably masculine

Jesus. On the other hand, the New Testament offered a savior of many moods and moments. The catechism called for a Christ of many doctrines. And the history of art offered the work of countless geniuses in wildly varying historical epochs. Seeing Christ's character was something the artist could provide, however partial or imperfect that vision might be. To behold his character was also to submit oneself to its influence. Images exerted a suggestive power, as advertisers were discovering and teachers were happy to know. Looking at Jesus was not an intellectual operation like analyzing a chart or reading a tract but an aesthetic perception, a sensuous intuition of his person that construed the viewer's relationship to Jesus. The purpose of the image was not epistemological but relational or interpersonal.

Protestant pedagogues generally welcomed the variety of artistic conceptions of Jesus and quickly learned to link different versions to the various needs of children passing through manifold stages of development. What the host of artistic images of Jesus and other biblical subjects could provide as visual influence on the child's growth, which is the subject of the final chapter of this study, constitutes the historical development that clinched the devotional significance of images for generations of Protestants.

Religious Art and the Formation of Character

The task confronting Protestant educators was how to incorporate mass-produced images of fine art into the pedagogy of nurture. Efforts at solving this resulted in innovations in religious education and lesson plan publication as well as a devotionalizing of artistic imagery. In order to understand the new context for the deployment of images it is necessary to examine important changes in Sunday school teaching in the first decade of the twentieth century.

Since the national rise of the Sunday school in the 1820s, images of one sort or another have been included in religious instruction. Production accommodated these needs—first in the form of the benevolent societies themselves and denominational publishing houses, later in the form of the independent firms such as Currier & Ives and the publishers that came to specialize in religious titles, such as Fleming H. Revell in Chicago and New York, David C. Cook in Illinois, and the Providence Lithograph Company in Rhode Island. Because there was no centralized production of lesson helps to accompany Sunday school lessons, as one historian of Sunday school curriculum has pointed out, "each denomination provided its editor and lesson writers" to do so. Publishers of images supplied products to a host of lesson helps. For instance, Samuel Wellman Clark's *Sunday School Blackboard* published visual lessons to accompany John H. Vincent's *Berean Series,* Edward Eggleston's *National Series,* and for a brief time to the international uniform lessons in the early 1870s; and the Providence Lithograph Company produced work for the ASSU.[1]

In the midst of the national migration westward and the wide concern of American Protestant churches to evangelize immigrants and un-

churched homesteaders, a new national consortium of Protestants emerged in a series of six National Sunday School Conventions, between 1832 and 1875.[2] Initiated by the ASSU, meetings halted after the second convention in 1833. The third convention did not occur until 1859, brought about by the national flurry of evangelical revivals in 1857. Gathering for a fourth time in the wake of the Civil War, the Convention assembled diverse denominational leaders in Sunday school formation and instruction, largely Methodist, Episcopalian, Congregationalist, Presbyterian, and Baptist teachers and clergy. A national leadership formed that included several prominent figures of the same generation, all born in the 1830s: Congregationalist Henry Clay Trumbull, Methodists John Vincent and Edward Eggleston, Presbyterian Henry C. McCook, and Baptist Benjamin F. Jacobs. An abiding topic of debate among these men was the value and contents of an international uniform lesson system. Vincent, Eggleston, and Jacobs succeeded at directing collective planning of the uniform lessons at the fifth National Convention of 1872, where a committee was organized to prepare the plan.[3]

Lesson helps, it became clear before the Civil War, were necessary to assist Sunday school teachers as that institution became the partner of the common school in educating American children. Sunday school instruction was compared more and more to common school as the nineteenth century passed and was found wanting in technique and quality of instruction. Lesson helps were intended to address this problem; uniform lessons, it was hoped, would augment the efficiency of teaching.[4]

The international uniform lessons operated on a seven-year schedule, during which time students from pre-school to adulthood around the world studied the same scripture lesson each Sunday as they made their way uniformly through the Bible. The advantages of this approach were many, according to its principal advocate and champion, Benjamin Jacobs. In a report to the National Sunday School Convention in 1872, Jacobs contended that the uniform plan would "promote a more thorough study" of the Bible; it would integrate what parents and children were learning, and therefore enhance family worship; and it would allow the increasingly mobile American population to continue biblical study uninterrupted as it moved from one state to another. Teachers would be better prepared since a school's faculty could study each lesson together. And those who produced the lessons—writers and publishers—would be able to work with greater systematic order. In all, the aim was greater efficiency, effect, and pedagogical thoroughness. Moreover, religious publishing houses came to recognize the commercial benefits of providing a single product in an enormous marketplace.[5]

Advocates of the uniform lesson promptly celebrated its universal distribution in tones that recall the national and ecumenical aims of antebellum benevolent associations. The secretary of the first International Sunday School Convention (1875), the sixth and final National Convention, held in Baltimore, hailed the new plan:

> These lessons are largely in use throughout our own land by Methodists, Presbyterians, Baptists, Episcopalians, Congregationalists, Lutherans, Moravians, Friends, members of the Reformed Churches, Adventists,

and many others,—a mighty host, to be enumerated only by millions. . . . [T]hus our Lessons have found their way to the Sunday-schools along the shores of the Atlantic, down the slopes of the Pacific, and through all the region which lies between. East and West and North and South have come to love and use them. Who would have thought, ten years ago, that Divine Providence was preparing for our land such a bond of Union![6]

The reference to a decade ago was of course the end of the Civil War, when the integrity of the Union had been breached and the providential security of the nation's mission was in doubt. For many American Protestants the uniform lesson was a symbol of national reunification in the wake of the war, a religious reconstruction of national purpose, and a welcome symbol of providential blessing. And like the antebellum vision of the ATS, this purpose was not content to rest within the national boundaries. America's destiny, realized in Protestant cooperation, spelled the destiny of the world.

> Our work will help to unify the nations. The tidal wave is already rolling along the shores of Continental Europe. The ground swell is felt in Asia, and even in the regions beyond that. . . . Australia, New Zealand, and the Sandwich Islands have clasped hands with us across the intervening waters, and it is literally true, that one set of Sabbath Studies is going with the sun around the globe.[7]

Not only was Jacobs instrumental in bringing the uniform lesson into effect, he remained its most prominent advocate and became the symbol of its success as well as the militant emblem of the national and international triumphalism that accompanied and proclaimed the uniform system. Edward Eggleston called Jacobs "the originator and generalissimo of the United States Sunday-school army." Another admirer, reflecting on Jacobs's long and active tenure, wrote that he "has been the right man to command the world's Sunday-school forces, and the splendid victories of the past twenty-five years evince his matchless generalship." The military rhetoric was not as jingoistic as the postwar masculinity so widely associated with Teddy Roosevelt and Muscular Christianity in the United States, but the insistence on the charismatic male leadership of a vast and highly organized force loyal to the heroic leader pervades convention speeches, reminiscences, and histories written by members of the Sunday school convention movement.[8]

A hero cult was perhaps the symbolic mechanism necessary in the postwar era of war heroes and president-generals to bring together the competing interests of many groups. Certainly the ostentatious redefinition of masculinity pressured by anxieties over its traditional understanding preferred the ideal of the generalissimo who, like the emergent captains of industry, would champion the vigor and discipline of systematized production. But the military rhetoric appealed not only for its ability to shape a new perception of masculinity but also as a way for American Protestants to keep alive their millennial hopes in view of their historical anxieties about democracy. An army, after all, is not a democratic organization, and

fidelity to imperium and king was a political relation that fit biblical precedents better than it did American democracy. A minister speaking at the Eleventh International Sunday School Convention in Toronto in 1905 gave clear expression to a millennial longing for divine rule:

> This great convention is a council of war. Under the great Commander are met the cohorts of the King. From every city and hamlet, every state and province, have gathered the picked legionaries of the Imperial army. Before them stretches, in imagination, the great world field. The battle is on. What the outcome will be no loyal soldier of the King can question. The day is coming when every one shall bow and when the knowledge of Jehovah shall fill the earth as the waters cover the sea.
>
> This vast world-army of more than 25,000,000 in the Sunday-schools of Christendom is moving steadily forward.[9]

The speaker urged his audience to train the army of the Sunday schools in patriotic resistence to commercialism, self-interest, greed, and alcohol. Temperance Sunday was proclaimed a day for "a declaration of independence"; and "instruction in the method and meaning of civil government" was judged to fall "quite within the province of the teacher whose eyes are open to the political manipulation by the forces of evil of all our cherished ideals of life, liberty and happiness."[10] The conspiracy theory and the need for national mobilization that energized Lyman Beecher's antebellum campaigns remained important components of the Protestant strategy for bolstering democracy's fragility.

The uniform lesson plan was attended by a form of visual culture that made effective use of color lithography: the lesson picture card. While this format of imagery could reflect the late-nineteenth-century ethos of masculinity, as I have discussed elsewhere, much of the iconography, if not all of it, was derived from previous paintings and from prints in circulation among American religious publishers and educators.[11] For example, Leonardo's *Last Supper* was the source for the card illustrating the twelve disciples sent forth by Christ (see fig. 127). Distributed by the ASSU, the card excerpted each disciple's image and added his name. A card based on a painting by the German artist Bernhard Plockhorst (fig. 138) was used to illustrate several verses from Paul's first epistle to the Thessalonians concerning the believer's reliance on a pastoral savior.

Keyed to the particular lesson for each Sunday, the picture cards, published by such firms as the Providence Lithograph Company and the David C. Cook Publishing Company in Elgin and Chicago, Illinois, encapsulated the lesson in visual form on one side and in the textual form of questions and statements on the other. They were handed out each week to students so that, according to one of the most prominent producers of weekly aids to the uniform lessons, F. N. Peloubet, "the children can carry [them] home in their pockets."[12] Illustrated cards had been used early on by the ASSU and the ATS, but the brilliant coloration and pictorial detail of the lithographic cards in the final decades of the nineteenth century enhanced the religious image's capacity to compete with the rival visual culture in advertisements and nonreligious books for children that made effective use of color printing and halftone technology.[13]

Aug. 8.—1 Thess. 4: 9 to 5: 2.

GOLDEN TEXT—If I go and prepare a place for you, I will come again, and receive you unto myself; that where I am, there ye may be also.—John 14: 3.

TRUTH.—Jesus has ready a place for those who love him.

Fig. 138
The pastoral Christ, color lithograph on cardboard, 4 × 2 7/8 inches, Lesson Picture Card, for Sunday, August 8, 1897, David C. Cook Publishing Co., Elgin, Illinois, 1897. Courtesy of the Billy Graham Center Museum.

But the dream of the uniform lessons did not last. Resistance to the use of a uniform system had preceded its formation and continued throughout its application from 1872 to the first decade of the twentieth century.[14] Many teachers felt the need to tailor lesson material to distinct age groups. This view eventually won out among both liberals and conservatives. Both found that lessons designed for incremental age groups engaged students and enabled teachers more than the uniform lessons. Among liberal Protestants the change was promoted with the support of principles of developmental psychology and evolutionary science as they were applied to religious education. Liberal Congregationalists, Methodists, and Baptists made a special point of studying the latest work in pedagogy, psychology, and biblical studies.

Liberal Protestantism, in the form of the Social Gospel, led the way to transforming religious education. Enthroning progress, calling for immediate reform, proclaiming the impact of environment on behavior, stressing the importance of science for understanding social change, and advocating the interests of the urban poor, adherents of the Social Gospel opened the Progressive Era with a passionate commitment to Christianity as social salvation. As Congregationalist minister and author Washington Gladden (1836–1918) put it, amelioration did not concern "the new social interest" but "social transformation and reconstruction." Whereas previous Christian reform had focused on the effects of social ills, according to Gladden, the new approach fixed on causes.[15] Gladden, Josiah Strong (1847–1916), and many others committed to the Social Gospel, characterized society as an organism, a living body that was the object of "social sal-

vation." Gladden objected to orthodox Protestantism's emphasis on the individual and shifted the preponderance of reform to "the 'organic filaments' by which a man is vitally bound to the community." He directly challenged the evangelical ideal of the conversion of individuals with its corrolary that religion is "an individual matter between themselves and God." No one, Gladden insisted, could be a Christian by himself. In fact, Gladden turned the modus operandi of antebellum reform on its ear by contending that "the view of the Christian life which puts the whole emphasis upon individual experience is seen to result in defective conduct and in morbid social conditions." True Christianity engaged in the welfare of the society in which one lived. The minister must therefore work toward social progress and he must "understand the laws of social structure."[16] To save society was to save the soul.

For Gladden this meant special dedication to the needs of the poor and working classes and the denunciation of any cultural activity that committed the error of individualism. Thus, he made a point of attacking aestheticism as an unchristian indulgence of private pleasure, whose standards were "purely selfish" and productive only of a weak and effeminate dilettantism.[17] For others, such as Josiah Strong, the collective thrust of reform aimed at realizing a millennial age on earth, a manifest kingdom of God wrought by the efforts of America's Anglo-Saxon race. Although Strong echoed the themes of antebellum reform by pointing out the "perils" of immigration, "Romanism," intemperance, and Mormonism and stressed the importance of religion in the public schools, he did not advocate Bushnell's view of Anglo-Saxon supremacy and the racial attrition of non-Anglo-Saxons. America was to be a model, not an imperialist tyrannt. Strong stopped short of jingoism and did not hesitate to criticize opportunistic American foreign policy or to acknowledge the shortcomings of American society. Yet the dream of America's missionary role as agent of the millennium infused Strong's vision of his nation.[18]

Many members of the generation of liberal Protestant clergy following Gladden and Strong's generation adopted the idea of a social Christianity and directed their efforts to education and scientific inquiry. The aim of religious education shifted accordingly. No longer a matter of saving souls from damnation, the purpose of the Sunday school, according to Henry Frederick Cope (1870–1923), among the most prolific spokesmen of the new agenda, was the "self-realization" of human society: "Hence the aim of every religious institution should be the development of character to fulness and efficiency under the best social conditions."[19] For progressives like Cope and Strong, human society was capable of higher evolution through education. Christianity was not otherworldly, but committed to "a larger, better life here." Christianity "bids man become a nobler being; it awakens in him the sense of his godlike possibilities, and it lays on every man the duty of leading his fellows to self-realization." The postmillennial hopes of the antebellum era were revived in a spirit of optimism and social progress that heralded "the grand social conceptions of a right world where peace reigns, where good-will rules, where one great family lives with the divine Father over all."[20]

Cope and other progressive religious educators were encouraged by developments in common school pedagogy, for instance, the work of Francis

W. Parker (1837–1902), principal of Chicago's Cook County Normal School and leading educational theorist, who promulgated his progressive philosophy during the 1880s and 1890s. Parker premised his pedagogy not on what the child needed to know but on the question "What is the child?" considering this the "central problem of the universe" since the child was the "climax and culmination of all God's creations." In this child-centered pedagogy, "The being to be developed determines what subjects and what methods shall be used."[21] The graded curriculum was therefore a matter of course since it fitted learning to the student's mental and physical patterns of development. Parker saw the individual, nature, human society, and the United States evolving progressively. The American republic was an experiment whose success depended on the cultivation of character that all other forms of government could only oppress. "Character," he assured his many audiences and readers, "whose essence is love for God and man, alone can save us, and lead us to the time when obedience to divine law shall be the one rule of action." The postmillennial hope for universal justice and happiness looked to education, in particular to the common school, for realization. It was, in Parker's words, the "essential means of gaining freedom." The common school alone could "dissolve the prejudices that have been inculcated under the methods of oppression" among the immigrants arriving on American shores.[22] Art, he believed, contributed fundamentally to the purpose of education by integrating and refining the mental, physical, and spiritual aspects of the soul in a way that binds souls together in moving forms of communication. The educative value of art consisted of "the expression of the most exalted states of the soul in the most defined way, appealing directly to all that is in other souls."[23]

Progressive Protestant educators were inclined to believe that the graded curriculum was the appropriate way of practicing a child-centered pedagogy, which promised to form the whole child toward the proper end of refining personal, communal, and national character. Henry Frederick Cope considered it "a sign of great encouragement, both for the future of the Sunday-school and for the speedy union of the whole family of God" that the Sunday school boards of the many denominations had been able to collaborate in the National Sunday School Convention and its production of the uniform lesson system.[24] But he did not conceal his strong preference for a graded system. In his history of the Sunday school, the vision of Edward Eggleston, who had opposed the adoption of the uniform plan, began to balance the previous acclaim for the proponents of uniform lessons, John Vincent and Benjamin Jacobs: "Only infatuation for business uniformity blinded the leaders to the wisdom of the simple plans of adaptation suggested by the teacher Eggleston." Cope narrated the formation of the organization to which he belonged, the Religious Education Association (REA), as a decisive turn away from such uniformity in favor of a graded lesson scheme authorized by scientific study and pedagogical professionalism.[25]

The uniform lesson system tended to assume an undifferentiated readership—from children to adults—whose primary concern was to read scripture for the sake of acquiring objective knowledge of it. The graded plan, by contrast, adapted curricula to individual levels of readers, incor-

porating psychological theories of development and formation into the study of the Bible. The result was a shift from a Bible-centered, evangelical curriculum to a student-centered, liberal Protestant approach. The task, according to Cope, was "not to teach the Bible but to educate children as religious persons." The Bible was not the end but the means of shaping character, or what was increasingly described as facilitating the formation of the personality. This approach placed the child at the center of the educational process and welcomed the contributions that scientific study made to understanding the development of personality and identity. Cope hailed the "new psychology" of George Albert Coe, Edwin Starbuck, and G. Stanley Hall (all early supporters of the REA) for its "scientific study of the laws of consciousness" and what this study offered the religious educator. The scientific approach, he wrote, "attempts to discover in terms of a unified, harmonious life the laws under which personality develops. The advent of the inductive study of the higher life has given a true, reliable, and scientific basis for all the work of the Sunday-school."[26] In contrast to those infatuated with "business uniformity" (he may have had in mind the prominent Chicago businessman Benjamin Jacobs), Cope proclaimed that a few among "the foremost men in education, those who have studied the laws of life, who are trained in psychology, and acquainted with world philosophy" were endowing the Sunday school with "the influence of modern progress, both scientific and philosophical."[27]

The principal mission of the REA, formed in Chicago in 1903, was to professionalize religious education by grounding its curriculum and initiatives in the academic study of religion and education. Chicago had become a national center for innovative initiatives in primary and advanced education that passionately pursued progressive educational reforms. At the first convention of the REA, Baptist William Rainey Harper (1856–1906), motive force behind the formation of the organization and founding president of the University of Chicago, outlined the purpose of the new organization in an address that characterized the REA's function as a "clearing-house" that would unify diverse efforts at religious education, serve as a "bureau of information," and create new agencies of investigation and coordination.[28] Harper envisioned a concentration of progressive Protestant energies that would affirm the democratic ideals of American life as the proper expression of Protestant Christianity. As one historian of the REA, Stephen Schmidt, has put it, "While interested in public religious education, [the membership of the REA] sought to keep faith with modernity while maintaining continuity with the ancient vision of a Judeo-Christian hope of a kingdom of Yahweh, a reign of love and justice in the midst of North Americans."[29] George Albert Coe, another founding member and influential participant in the REA, spoke of a "democracy of God" as the American religious ideal. Cope gathered together much of this discourse in his book, *Education for Democracy* (1920), in which he asserted that democracy was itself a religious ideal and that religion offered something essential to democratic education.[30] Democracy, he wrote, held as its central interest the value of people as persons, their formation and happiness as individuals—what was also the ideal of religious education. In effect, Cope, Coe, Harper, and those who joined them in the work of the REA refashioned the older evangelical arguments for the centrality

of religion in public life and education for the sake of the republic's well-being.

According to many liberal Protestants at the turn of the twentieth century, religious education was to promote a progressive democratic vision in which science and modernity were not seen as opposed to religious belief but were vigorously embraced as the optimistic means of empowering all citizens toward their fullest self-realization in the collective enterprise of a democracy. Cope wrote in his catechetical *Education for Democracy*: "Democracy seeks the salvation of the souls of men in the widest, highest, fullest sense, for democracy ultimately seeks the salvation of society." No doubt for this reason, John Dewey participated in the first convention by presenting a paper on the importance of modern psychology for religious education.[31] The millennial tropes of earlier American evangelicalism became figures of speech in the Protestant reformer's definition of religion in a democratic society:

> A religious person is one whose life is devoted . . . to realizing a society of the spirit, a social order, a 'kingdom of God' in which love, righteousness, peace and goodness are the ruling powers, in which men become more and more like their divine ideal and the world more and more like the splendid vision for which men so long have prayed.[32]

As nonsectarian as this lauding of democracy may appear, in the context of the REA, the republic remained dominantly and unambiguously Protestant: Catholics were not originally invited to join the REA, and Jews enjoyed only a nominal presence.

For liberals and conservatives alike, the United States remained a beacon on a hill and a moral exemplar par excellence. In a volume of talks to students, Harper divided human history into four periods dominated by four successive nations, "what Babylonia was in the first period, what Syria was in the second, what England was in the third, all this and more America will be in the fourth." According to Harper, world history consisted of a progressive, westward movement that charted "the development of a pure and true conception of God, and of his relation to man."[33] Christianity championed the idea of individual rights, though the battle was not yet won. America would play the decisive role. Harper issued a call for the Christianization of America as a way of evangelizing the world, recalling not only Strong's nationalistic vision but that of the ATS and the postmillennial role that Protestants since Jonathan Edwards had discerned for the New World. American exceptionalism in the early twentieth century did not abandon postmillennialism but stretched it to embrace modernity just at the moment when American fundamentalism was defining itself in explicit opposition to the critical-historical methodologies that Harper, Shailer Mathews, and other theologians and biblical scholars were incorporating into seminary studies and Bible study curricula.

Among the most prominent aspects of Harper's inaugural address was his emphasis on the scientific character of the REA: its efforts would be marked by "real, definite, scientific investigation." By this he meant rigorous procedure: "all work of this organization shall be done with the truly scientific spirit."[34] A scholarly journal, *Religious Education,* appeared in

1906 and specialized in the psychology and pedagogy of religious instruction and carried articles by prominent educators, scholars, and psychologists such as George Albert Coe, Walter Athearn, Luther Weigle, George Herbert Betts, and Edwin Starbuck, as well as such noted authors on religion and education as Francis Parker, G. Stanley Hall, and Jane Addams. Officers of the organization were prominent academics, representing such institutions as Union Theological Seminary, the University of Chicago, Vanderbilt University, Smith College, Oberlin College, Brown University, and several others.[35] If it was intellectual rigor and respectibility that the REA wanted for religious education, the organization was not short of academic and scholarly credentials in making a bid for it.

Foremost among the features of the scientific approach to religious education were the developmental or evolutionary nature of personal formation (which Cope explicitly linked to Darwin and "the doctrine of evolution") and the corrolary methodological focus on discrete stages in the process of formation. Harvard-trained psychologist Edwin Starbuck first published his *Psychology of Religion* in 1899 and stressed the significance of his field of research for religious education. Indeed, he used the term "conversion" to refer to the period of adolescence, "the whole series of manifestations just preceding, accompanying, and immediately following the apparently sudden changes of character."[36] Starbuck proceeded inductively by compiling questionnaires that were given to children and designed to elicit the features of their experience and perception of religion. Characterizing it as the "great formative period," Starbuck delineated adolescence ("extending from 10 or 11 years to the age of 24 or 25") as the period of personal formation marked as a series of stages that were synonymous among many of his informants with changes in religious consciousness. Differentiating by gender, Starbuck identified the following general stages: clarification (10–12); spontaneous awakenings (12–18); storm and stress (13–16); doubt (14–18); alienation (15–21); and the final stage (18–25). The final phase was what Starbuck believed to be the aim of adolescent development, "the birth of a new and larger spiritual consciousness."[37]

Adolescence and religious conversion was examined by G. Stanley Hall (1844–1924), another product of Harvard and the tutelage of William James, in his landmark study *Adolescence* (1904).[38] Hall, a Sunday school teacher himself and professor of psychology at Clark University, believed that the religious educator could profit directly from his study since he viewed religion not as a neurosis or delusion but as originating in the "basal needs of the human soul."[39] Work by Hall and Starbuck was enthusiastically applied to religious education by George Coe, Hall's former student, a professor of moral and intellectual philosophy at Northwestern University, an REA executive, and a frequent contributor to *Religious Education*. In an impressively synthesizing study of 1903, Coe proposed the cultivation of an "art of religious culture" that would integrate "scientific insight into the general organization of the mind" and its development with the "care of souls." The psychology of religion offered clues to the occurrence of spiritual unrest in believers, particularly among youth. Because Coe, like Cope and others, supported the liberal Protestant redefinition of the object of religious instruction as the young person's

development as a person rather than acquisition of knowledge of the Bible, the educator was obliged to make room for the contributions of psychology and to attend to the discrete stages of mental development in devising pedagogy.[40]

Hall, Starbuck, and Coe each stressed the developmental structure of character formation and the emergence of personal identity. Their work fueled the belief of many, and those active in the REA in particular, that graded Sunday school lessons were an essential reformation in order to maximize the efficiency of religious instruction. University of Chicago theologian Shailer Matthews, for instance, faulted the uniform lesson system for, among other things, "its disregard for the period of spiritual crises."[41] This evolutionary view clearly drew from contemporary biology and psychology but also from the organicism of Bushnell's conception of character formation. In fact, Bushnell's idea of nurture was honored and explicated in an article in *Religious Education* by Luther Weigle, the Horace Bushnell Professor of Christian Nurture at Yale, who claimed that the "modern movement for the better religious education of children owes more to Horace Bushnell, doubtless, than to any other one man."[42] Descendants of Bushnell's organicism, developmental psychologies stressed the slow, incremental emergence of the personality through more or less clearly marked stages. To fit pedagogical initiatives to these stages was among the principal aims of research reported to and disseminated by the REA.

The REA was formed in large part to reverse what liberal intellectuals in American Protestantism considered the devolution of religious education in the Sunday school system. Located at the epicenter of this change was the move from uniform to graded lessons. This move was motivated by the shift in liberal Protestantism from teaching the Bible to forming "religious persons." The change encouraged a more ambitious use of imagery, the purpose of which among proponents of the new pedagogy was no longer strictly illustrational. The pictorial images were not intended to enhance memorization of scriptural passages and doctrines, but to nurture the individual personality. It is not surprising, therefore, to note a corresponding shift from illustrational imagery to fine art. Romanticism in Europe and transcendentalism in America had long taught that the purpose of art was the spiritual realization of the individual and that art was best experienced in terms of a communion, a private contemplation that refined the individual's sense of self.[43]

When religious pedagogues looked around for treatments of religious art that would serve this purpose, they found the literature woefully lacking. William Rainey Harper mentioned among the REA's initiatives the need for "educational work . . . in church art and architecture and in church music—a field that is almost wholly neglected." At the first convention, seventeen departments were formed, including a Department of Religious Art.[44] The following year, Charles Cuthbert Hall, president of Union Theological Seminary, in an "annual survey of progress," described religious art and music as an educational field "where reconstructive work requires to be done from the foundations." In Hall's estimation, as well as that of the membership of the Department of Religious Art, the task was to cultivate the aesthetic aspects of worship for the devotional value they

offered. The arts were not merely a didactic affair or a technical or formal concern but a matter of the aesthetic embodiment of worship and devotion. The desired reconstruction would address the following artistic media:

> church-building, viewed not in its mechanical or sumptuary aspects, but as a form for embodying religious sentiment and as a method of molding that religious sentiment; church music, not as a technical branch of composition or performance, but as an outlet for devotion, and as a constraining and uplifting influence upon both the devout and the undevout; hymnody, regarded as a channel for both expression and impression in religious services of every degree.[45]

The importance of the fine arts to supporters of the REA lay in their capacity as forms of worship. This was not a virtue that most American evangelicals would have ascribed to images before the end of the nineteenth century. But there was nothing very evangelical about some of the speakers invited to appear at REA conventions. In 1905 the Boston architect Ralph Adams Cram (1863–1942), a man committed to a high church Anglicanism that comported with the neo-Gothic buildings he designed, conceived of the "artistic treatment of a church interior" in terms of "the visible methods of worship."[46] Beauty, according to Cram, was "inseparable from the idea of an acceptable church." Cram redeployed in Protestant church architecture and aesthetics the medieval belief that the church building must be grandly constructed and made from precious materials because its purpose was to house the divine presence and to serve as a material form of worship. He stated to the REA convention: "We try to make our churches beautiful and intrinsically precious because beauty and intrinsic worth are a kind of sacrifice, an oblation poured out before God."[47]

While Cram's Anglo-Catholic passions about art marked an extreme among REA members, his embrace of the Gothic style was regarded by Harper and others not as antimodern (which it certainly was) but as the cultivation of a venerated style that elevated American culture and sacralized art, affording it a presence and power in American religious life that it had not formerly enjoyed. (It was no mistake that the Gothic idiom was employed to build Harper's university, beginning in 1892.) If religious imagery was to be influential, it must become so in the culturally respectable form of fine art. The lack of American refinement—not the danger of artistic luxury or excess—remained the problem, according to liberal Protestants.

Whether or not American Protestants agreed with Cram's preference for the Gothic as the appropriate mode for church architecture—and many did—agreement was widespread on the power of art to influence thought and behavior. Cram defined art as "concrete and absolute beauty acting as a system of subtle, spiritual, and psychological influence." The rarified aesthetics of "absolute beauty" aside, liberal Protestants hoped he was right.[48] Articles on religious art and education in *Religious Education* stressed the power of art to nurture young people. William Barton wrote about the importance of books on religious art in the library, claiming that a library with such books "will make a contribution to religion in the very

stimulating of a love of art." It was not art for art's sake he advocated but art "for the sake of character." Barton believed with many other liberal Protestant moralists in the humanizing power of art:

> [N]ext to the love of righteousness our American life needs to learn a discriminating love of the beautiful. If we do not learn this, our commercialism will swamp us. We need the love of art, not as a veneer on the surface of a swift-grown and possibly decaying prosperity, but as an evolution of life through industry toward the ideal.[49]

If Henry Ward Beecher had been confident that wealth, commerce, and the American middle class were made for each other, Barton was perhaps a bit less optimistic, worrying that America's economic good fortune threatened to undermine the public morality and spiritual well-being of the nation. The concern was not new. The old republican castigation of luxury as deleterious of sound character had resounded as recently as 1884 in the pages of the *Andover Review,* where Washington Gladden warned that the growth of wealth and luxury in America had modified "the notions of the wealthier classes about obligations" to those less fortunate than themselves.[50] The spirituality of art offered a countervailing force as the moral capital of American civilization ebbed in inverse proportion to its financial wealth. But like Beecher, Barton looked to art to assure spiritual growth. He warmly recalled a visit to a chapel in London decorated by painter Frederic Shields (fig. 139). The Chapel of the Ascension "stands with its open door and its invitation to step in and rest and meditate and pray. The appeal is not at all that of the voice, for there is no preacher; not that of song, for there is no choir or organ, but only that of the eye, and it is a direct avenue to the soul of man."[51] Enclosed in this artistic space, the aesthetic and the spiritual merged in a meditative state where the image alone spoke (in a Beecheresque phrase) "the heart-message of the artist." Independent of the spoken word and the authority of the preacher, the chapel of art constituted a devotional site for Barton, a place of quiet prayer and reflection that was able to raise American Protestant industrial and commercial character to the higher stage of the "ideal." In the same year another Congregationalist, a Sunday school superintendent from Minneapolis, described in the pages of *Religious Education* "a beautiful chapel with a children's gallery" built in Gothic style. In a room thirty by thirty-four feet in size were displayed "forty-four brown carbon prints of the life of Jesus," after original paintings by such artists as Fra Angelico, Botticelli, Raphael, Corregio, Murillo, Plockhorst, and Heinrich Hofmann. According to the author, "[t]he whole effect of the room is one of quiet, beautiful serenity, and, as one has said of it: 'It is a benediction to pass within its doors.'"[52]

The historical consciousness of the wealth of Christian art, of its national and theological variations, and of its diverse interpretations of Jesus the man and the figure of church dogma all arose in the illustrated lives of Christ in the late nineteenth century in tandem with the longing for the refinement of American taste and the formation of major collections of European art in Chicago, Philadelphia, Boston, and New York, among other cities infused with new wealth.[53] In fact, such industrialists and

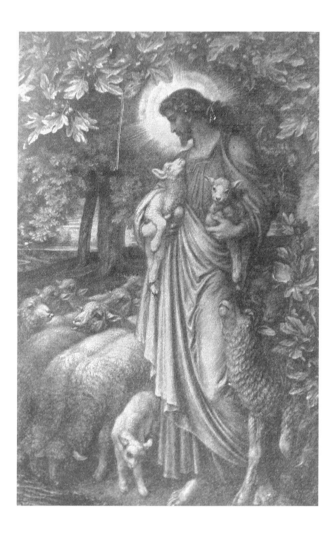

Fig. 139
Frederic Shields, *The Good Shepherd,* size, date, and location unknown, reproduced in William E. Barton, *Jesus of Nazareth* (Boston: Pilgrim Press, 1903), p. 24.

commercial leaders as John D. Rockefeller, Jr., and John Wanamaker patronized several of the artists who were most celebrated by religious educators. Rockefeller purchased several paintings of Christ by Heinrich Hofmann, while Wanamaker, W. H. Vanderbilt, William Astor, and W. T. Walters each owned works by Mihály Munkácsy.[54] Religious subjects by Alexandre Bida and Léon Lhermitte were collected in Boston. By promoting the appreciation of fine art and by investing artists with the power to interpret scripture rather than merely to illustrate it, liberal Protestant clergy, pedagogues, and the authors of illustrated lives of Christ joined with the new wealth of American commerce to imbue art with a devotional and liturgical purpose that overcame traditional Protestant anxieties about imagery.

Lawrence Levine has written insightfully about what he calls the "sacralization of art" in the decades following the Civil War, a process in which industrialists and financiers helped transform the production and reception of musical performance, dramaturgy, and the visual arts.[55] The formation of conspicuous museums and collections accompanied the endowment of orchestras and theatres in major U.S. cities as a means of

institutionalizing "highbrow" taste and establishing a professionally monitored canon. This process greatly depended on the wealth of people such as Wanamaker, Morgan, Rockefeller, and Frick, who received from the collection and endowment of fine art an aristocratic patina of culture. Wanamaker freely mixed commerce and culture by purchasing hundreds of paintings at the Paris Salon and displaying them in his Philadelphia department store, which included lavish classical galleries and wall spaces for the display, but not the sale, of works of art.[56] In 1889 the store publicly promoted the idea of "a great retailing house supplying amusement, inspiration, convenience and some degree of culture to the community." And as a motto, the store announced: "Art goes hand-in-hand with commerce."[57]

The enthusiastic reception of Mihály Munkácsy's *Christ Before Pilate* (fig. 140) is a case in point. Munkácsy (1844–1909), a Hungarian painter, painted his mammoth (nearly three hundred square feet) canvas in 1880–1881 and exhibited it triumphantly in the gallery of the dealer Charles Sedelmeyer when the Salon committee in Paris would not allow its late entry into the annual exhibition. The spectacular Parisian reception of the image led Sedelmeyer to take it on tour throughout Europe and England for several years. In 1886, Sedelmeyer shrewdly speculated on the picture by bringing it to the United States, where it was publicly exhibited from November until March at the Twenty-third Street Tabernacle in New York, a prominent space, which it was said to dominate from its display on the proscenium. One contemporary estimated that the picture was viewed during this time by more than one hundred and fifty thousand people (at 50¢ each).[58] Early in 1887, after months of widely noticed and warmly cel-

Fig. 140
Mihály Munkácsy, *Christ Before Pilate,* oil on canvas, 417 × 636 centimeters, 1881. Courtesy of the Library of Congress.

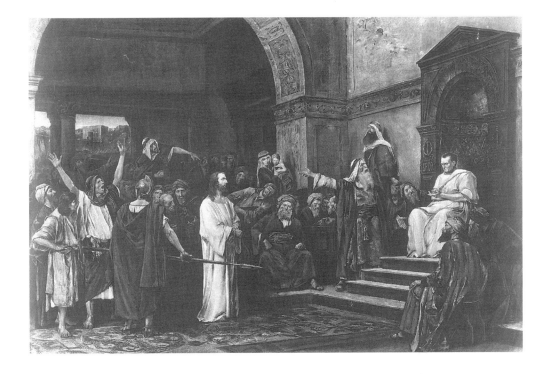

ebrated public reception, Wanamaker, who was an evangelical supporter of the Sunday school movement, purchased the picture. Munkácsy himself visited the United States at Wanamaker's invitation in December.

Key to overcoming Protestant discomfort with devotional images was the appeal of a "manly" depiction of Christ executed in a naturalistic and heroic manner. It was on the basis of an enthusiastic endorsement of the picture in the religious and secular press along these lines, in addition to the image's idealized naturalism, that Wanamaker purchased the painting, as well as Munkácsy's even larger *Christ on Calvary* (1884), which Sedelmeyer brought to New York in October 1887.[59] Commerce, masculinity, and the cultural hierarchy of taste made religious art not only safe but important for those who wished to see nothing contradictory in elevating American taste, promoting Protestantism, and conducting profitable business.

Many Protestant clergy praised Munkácsy's picture, including Charles Deems, De Witt Talmage, and Henry Ward Beecher, all of whom had written illustrated lives of Christ, applauding in particular the painting's portrayal of the historical Jesus.[60] A thick pamphlet was produced by Charles Kurtz to accompany the exhibition. Kurtz included several essays that introduced and praised Munkácsy's work and a long list of tributes from clergy, critics, and editors on both sides of the Atlantic. Numerous Protestant clergy—Methodist, Baptist, Congregationalist, Reformed, Presbyterian, and Episcopalian—incorporated discussion of the image into their sermons, which Kurtz excerpted in his booklet. While often noting the artist's Roman Catholic faith, clergy and journalists were quick to praise the historical accuracy of the image as well as the manly appearance of Jesus. Kurtz pointed out that the artist himself disliked the "effeminate" images of Jesus by "old Italian painters." A New York clergyman named Charles Robinson admired Munkácsy's picture as "the nearest to perfection as a representation of the New Testament story" he had seen and defended it against the charge that it visualized Ernest Renan's "conception of a 'soft, goodish enthusiast, a most sincere but impracticable idealist, intoxicated with his own success, and self-deceived in his estimate of himself and his mission.'" Indeed, Robinson found nothing in Munkácsy's painting similiar to Renan's notorious humanization of Christ, and he objected to claims that the composition had been derived from a photograph of the famous Oberammergau passion play.

The realism of *Christ Before Pilate* offended some as too literal and unheroic.[61] On the other hand, the verity of the image enhanced its power over many viewers, as an account by a Protestant clergyman from Boston, William Butler, suggests. Butler recorded how moved he was by the response of fellow spectators:

> I was at once impressed with the solemnity of manner which was upon the audience. Every hat had been removed as soon as the eye rested on that tall, white-robed figure in the centre [i.e., Christ]. . . .
>
> The reverence of the audience was easily accounted for. People as they entered paused awhile to realize the solemn scene before them. After resting and gazing upon it, they would advance down the aisle to the bar in front of the great canvas, to examine more closely, and would

again return to the background to sit and view the picture more quietly and at more leisure, so as to receive the entire impression which it was designed to make upon them. It was also affecting to see some of the mothers, as they led their children forward to explain to them what it all meant, and the little ones would look up and become awestruck. How real and how much the picture seemed to them, especially as they gazed so earnestly at the Redeemer, of whom they had so often heard! No doubt the evangelical narrative will henceforth mean far more to them, as to its reality and historical verity, than it ever could without this opportunity.[62]

Other writers defended the image against art critics who found it wanting in idealism and imagination. Butler praised Munkácsy for eliminating the nimbus and "any of the theatrical vanities in which artists have depicted Him, as seen in European and Mexican galleries and churches." Such devices were "false to the facts," according to Butler, for whom *Christ Before Pilate* was "a more worthy representation of the Saviour as He actually appeared on this occasion." Thus, the historicity of a masculine Jesus justified religious fine art and avoided fears of idolatry among American Protestants.

Monumental religious imagery continued to attract praise from Protestants in the United States during the remainder of the nineteenth century and the first years of the twentieth. One of the most accomplished and widely admired of American artists to produce liturgical murals and elaborate ecclesiastical decorations was John La Farge (1835–1910), who also contributed to the genre of the illustrated lives of Christ by publishing *The Gospel Story in Art* in 1913. La Farge made his reputation during the 1870s and 1880s with the decoration of the interior of Trinity Church in Boston as well as numerous other churches in the Northeast, such as the United Congregational Church in Newport, Rhode Island, and Saint Thomas Church, the Brick Presbyterian Church, the Church of the Incarnation, and the Church of the Ascension, all in New York City. Although Roman Catholic himself, La Farge was patronized by Protestant congregations and responsible for popularizing large mural paintings of biblical subjects (see, for example, fig. 141) among Protestants. Poised above altars and decorating chapel spaces, these images were linked to liturgy and sacramental ritual and went far to elevate the status of religious fine art in American Protestantism.[63]

No doubt encouraged by the precedent established by La Farge's popular ecclesiastical work, Rockefeller's ecumenical Riverside Church, which was completed in 1931, includes an elaborate iconographical program in stained glass, wood carving, and stone sculpture. Rockefeller also provided panel paintings of Christ. Serving as chair of the building committee, Rockefeller purchased Heinrich Hofmann's widely reproduced *Christ in Gethsemane* (fig. 142) in 1930 and offered it to the church to be placed in a small mortuary chapel in the narthex called Christ Chapel. As one clergyman at the church recalled, the devotional significance of the image was not lost on the Protestant clientele:

Soon after the chapel was opened to the public, it was noticed that frequently a visitor would spend an appreciable amount of time contem-

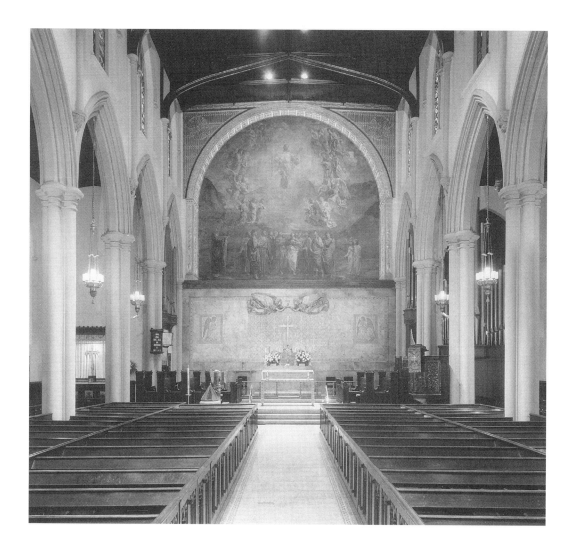

Fig. 141
John La Farge,
sanctuary, Church of
the Ascension, New
York City, 1886–1888.
Courtesy of
Whitney Cox.

plating the representation of the Saviour in His hour of decision, and before turning away, would kneel reverently on the floor before it in prayer and adoration.

Realizing that there had been provided a place and an atmosphere that stirred such an impulse of reverence, a Prie Dieu was designed and has found a permanent place there, thus emphasizing the invitation to stay and meditate which the painting itself had so naturally and effectively suggested.[64]

The writer was also happy to point out that Catholic visitors made use of the chapel and displayed "a highly intelligent and sympathetic understanding of what has been attempted at Riverside by way of iconography in all the media."

The early-twentieth-century liberal Protestant recognition of the importance of cultivating the "aesthetic sense" in religious education by the

use of fine art, particularly in the form of devotional settings for images, defused traditional Protestant suspicions of Roman Catholicism. This new detente was by no means always part of the late Victorian movement toward art and ritual. Protestant aestheticism for instance sought out the elaborate interiors of cathedrals, medieval galleries, and objects of exotic beauty as an escape from and gothicizing bulwark against the buzz and commerce of modern urban life.[65] But this anti-modern aestheticism was not shared by most Protestant teachers, pedagogues, and clergy. Indeed, the majority of American Protestants in the second half of the nineteenth century were becoming more accustomed to imagery in their increasingly visual mass culture, in which photographic imagery and artistic portrayals were increasingly used in advertisements and journalism as well as in book illustration. Morever, American Protestants came to accept the power of artistic imagery to influence thought and behavior as well as to elevate national taste and shape individual and national character. Finally, many Protestant viewers believed that images of the life of Jesus were able to visualize the manly, historical personality and career of the savior in a singularly persuasive way.

Fig. 142
Heinrich Hofmann, *Jesus in the Garden of Gethsemane,* oil on canvas, 66 × 55 inches, 1890. Courtesy of Riverside Church, New York.

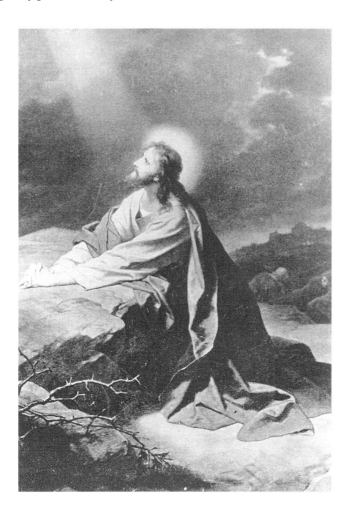

What I wish to argue was the decisive factor in the transformation of American Protestant visual piety between 1890 and the first decades of the twentieth century was a momentous innovation of the technology of visual reproduction: the halftone. William Barton did not urge his readers to collect fine art and immerse themselves in rarified contemplation and conspicuous consumption. To the contrary, the Minneapolis chapel and Barton's concept of the benefits of the library, cited earlier, were both outfitted with inexpensive, mass-produced images that were believed to forfeit no aesthetic quality or power to frugality. Echoing Beecher's endorsement of mass-produced imagery and the position he himself had taken in *Jesus of Nazareth,* Barton happily proclaimed: "American young people of the present day have opportunities in the sphere of art of which their parents never dreamed. This is the day of the penny halftone reproduction."[66]

Members of the REA placed great hope in the halftone because it offered a reliable means of reproducing works of fine art. One speaker at the second convention (1904), Waldo Pratt, discussing the role of biblical pictures in teaching children, lamented the iconoclasm of American and British Puritanism, denouncing in particular the visual culture of illustrated tracts and primers so important to Protestant pedagogy and evangelicalism during the eighteenth and nineteenth centuries:

> The crude woodcuts of the New England Primer and Fox's *Book of Martyrs,* the later pictures in lesson-helps and Sunday-school books and papers, the jig-sawed ornaments of "Wooden Gothic" churches, the monotonous patterns on their stenciled windows . . . cannot be called art, nor reckoned as influences for good.

By contrast, fine art was returning to Protestantism in the contemporary world, heralded by modern technological developments. After a two-hundred-year absence of art from Anglo-American Protestantism, according to this speaker,

> the camera has inaugurated the democracy of art, as the printing-press during the Reformation ushered in the democracy of learning. Pictures were in color and confined to the churches and the palaces of the wealthy in 1600; in 1900 they are to be found everywhere in the form of photo-engraved half-tone prints.

Photographic reproduction democratized art and advanced the Reformation's technology of religious literacy. The advantage of photographic imagery was that it suffered none of the technical impoverishments of the primer and Sunday school imagery but faithfully reproduced the artistic excellence of great art. The speaker outlined three kinds of pictorial art: the illustration; the picture to be carefully searched for ethnographic as well as symbolic truth and "suggestive detail"; and the image of beauty "to be received with thanksgiving." Examples of each were offered, ranging from works by Raphael, Titian, and Rubens to a host of nineteenth-century European and British painters such as Turner, Hofmann, Holman Hunt, Millet, Burne-Jones, and Watts. Interestingly, nearly all the examples

cited for the third type came from the nineteenth century. This preference for modern or recent art, much of it explicitly religious but some of it representing literary and mythological subjects, reflects the REA's progressive desire to situate religious education within the framework of the student's broader cultural education, indeed, to merge the two kinds of formation. Pratt, who was a Hartford Seminary professor and executive secretary of the REA's Department of Religious Art, concluded that "practically all artistic products . . . may be drafted into religious service in some way."[67]

For many Protestant educators, the halftone was guaranteed to deliver the aesthetic merit of the originals, which it offered free of the guilty association of wealth and privilege. Harriet Magee, another speaker at the 1904 REA convention, proposed the formation of clubs and classes for the study of religious art and bemoaned the fact that art had "been almost divorced from that which is religious or educational. Many think of it as merely a frill on the garments of the rich, the decoration of the palace, or the regalia of royalty." She urged religious educators "to return to the primitive simplicity and original motives of all genuinely artistic creations." American Protestants, according to Magee, could put aside any fear of image-worship, since the greater danger was that young Americans would worship nothing, "except possibly the almighty dollar or the man that makes it."[68]

Magee was convinced that the study of religious art and sacred music would advance the religious education of children and youth more than any other initiative. She recommended that congregations form clubs for the study of art and music. The club should have elected officers and be divided into several departments dedicated to the history of religious art, the illustration of Sunday school lessons, the decoration of Sunday school classrooms, and the study of religious music. The use of the inner-directed club format replaced the outer-directed, evangelical voluntary society of previous years and followed the successful model of such organizations as the YMCA, the Boy Scouts, and men's and women's clubs, though the plan did not indicate segregation according to gender. The only proviso Magee mentioned was not to entrust leadership of the club to anyone who embraced "aestheticism," which "does not make for righteousness." For Magee, as for so many of her colleagues in the REA, the task was to foster the aesthetic sensibilities of the young person as a vehicle of religious formation in a modern, visual culture:

> In the twentieth century Art must be used as a friend to religious education, not as a servant or a foe. It must be used to make eye-minded men and women. For the present-day psychologists teach us that the eye-minded are the most intellectual, that sense impressions received through sight are of a higher order than those received through any other sense. For this reason alone the delights of the eye should be afforded to the child.[69]

A writer in the REA's journal, *Religious Education,* noted that reproductions of "good" fine art could "cultivate the aesthetic sense." This idea was not aestheticist in origin but a development from Pestalozzian educational philosophy, which stressed "aesthetic" education as knowledge derived

from the senses and considered essential to the healthy development of the mind.[70] Another figure active in the REA, George Herbert Betts, professor of religious education at Northwestern, strongly urged Sunday school teachers to abandon the abstract imagery long used in the genre of blackboard illustrations and to employ in its stead "masterpieces executed by great artists."[71]

In the hands of William Barton and others, aesthetic cultivation came to mean that visual experience of works of fine art did not need to depend entirely on verbal discourse to shape character but could be relied upon to exert an immediate moralizing influence. In terms of the emergence of a Protestant devotional art, this is of great significance, because relinquishing the tight control of the text on the image meant that the image was empowered with a certain degree of unprecedented autonomy. Not complete autonomy by any means, but greater suggestive power—more opportunity to engage the devout viewer's imagination, to speak idiosyncratically, to come to symbolize what viewers might wish the imagery to address rather than what its producer intended by anchoring it to a prescribed text. And all of this was mediated by inexpensive halftone reproductions that teachers were urged to incorporate into a more "eye-minded" curriculum.

This new attitude toward images was also certainly indebted to advertising and the psychology of visual persuasion, suggestion, or influence. The psychology of advertising as Walter Scott Dill conceived it offered a different view of the human psyche than the rationalist model, which accented reason in human decision making. "Man has been called the reasoning animal," Dill wrote in 1903, "but he could with greater truthfulness be called the creature of suggestion. He is reasonable, but he is to a greater extent suggestible."[72] This reflects a modern, post-Enlightenment understanding of human knowledge and behavior, standing in contrast to the rationalistic tradition of the eighteenth-century. A great deal of evangelical and particularly Reformed Christianity in the United States during the nineteenth century bore the distinct influence of the Common Sense tradition of the Scottish Enlightenment, with its emphasis on reason and rational method. This helps account for the greater use of images as illustrations among evangelicals where the purpose of the image was to clarify or confirm discursive propositions. Theologically, salvation was understood in terms of what one knew and how that led one to conversion and dedication to the Christian life. Affect and the passions were suspect and often discounted in conversion and sanctification, while memorization and propositional statements of belief received great emphasis. But many American Protestants toward the end of the century came to reassess the importance of feeling, the power of suggestion over the nonrational, involuntary aspects of the human psyche, and the importance of the image as a powerful technology for shaping attitudes in light of the nonrational foundation of the personality. For many liberal Protestants the sort of imagery that was appropriate for this appeal to the affective side of humans was fine art.

Liberal Protestants contributed significantly to the loosening of the relationship between image and text by elevating the status of art in religious life and by diminishing the exclusive authority of the biblical text as the

aim and avenue for shaping belief. Influenced by the critical and historical analysis of scripture, liberals stressed the historicity of belief over the orthodox concept of original revelation. American liberals regarded the evolution of religious belief as progressive. Modern, scientifically informed Christianity was more spiritual, less superstitious, and less materially crass than any religion of previous ages, including the primitive apostolic period. Each age reinvented Christian belief to suit its own needs, liberals proclaimed, and moderns should do no less. Significantly for this study, liberals argued that art contributed to the liberal recasting of faith in a manner unprecedented in American Protestantism.

G. Stanley Hall and the Christ of Modern Psychology

Perhaps the most triumphant analysis of the purpose of art in liberal Protestant belief, though on the very edge of it, was G. Stanley Hall's 1917 study *Jesus, the Christ, in the Light of Psychology*. Hall began by accepting the results of the scholarly quest for the historical Jesus, in which the figure of the New Testament was, as Hall put it, "divested of his supernatural attributes and reduced to the dimensions of a great religious teacher and reformer and a purely human paragon of virtue."[73] To this Christ and the "mythophemes" of the Gospel narratives Hall applied the apparatus of modern psychology, in order "to reinterpret its Lord and Master to the [modern] Christian world." Although Hall affirmed his belief in the historical Jesus, he set out to demonstrate that the church could get along without him "and that this might possibly ultimately make for greater spirituality." Hall looked to art and literature in the opening chapters of his book to provide an essential aspect of the psychological Christ. The arts, he reasoned, dealt in feeling. Aesthetic experience was therefore indispensable in the psychological understanding of religion because, he said, "[f]eeling, emotion, sentiment, constitute by far the largest, deepest and oldest parts of Mansoul, and the roots of religion are always pectoral or thumic." Art assumed a new vitality and rank of importance in Hall's profession of faith; it was able to raise up the living Christ of imagination from the dead Christ of history, whom the higher criticism had laid to rest: "The creative imagination has made Jesus live again. The plea here is that both these departments ["plastic" art and "literature"], which have already done so much, have now a new responsibility and new incentives to reincarnate the risen Lord in the modern world."[74] Hall did not limit art to illustration because he expected from it a new inspiration, nothing less than the evocation of an imaginative ideal that would replace the Jesus of dogma.

Following the conclusions of several scholars, Hall did not consider any depictions of Jesus from late antiquity or the Middle Ages to be authentic. Indeed, he argued for the diversity rather than the similarity of surviving images, and he dismissed the letter of Lentulus as "[u]ndoubtedly a forgery . . . not earlier than the twelfth century."[75] It was important for Hall's analysis that no image be authentic, for he argued in historicist fashion that each period of history crafted a Jesus to fit its ideal. The history of

belief in Christ was a history of mental imagery created by a collective or "racial" soul that manifested itself in each believer's mind. By psychologizing Jesus, Hall focused attention on the importance of the Jesus ideal as a heroic, inspiring mental image in a manner parallel to Emile Durkheim's contemporary sociological treatment of religion, in which the deity was said to be society—a "collective representation" that organized and expressed the organization of social order. Hall's concern was to scrutinize the formation of what he called the "ideal self," which he insisted modern humanity need no longer project "upon the clouds" in a "neurotic flight from present now and here reality."[76]

Hall was raised in an orthodox Presbyterian home and spent two years as a ministerial student at New York's Union Theological Seminary in 1867–1868 before studying in Germany for a year and returning to take his divinity degree at Union in 1871. While in New York, he joined Henry Ward Beecher's congregation, worked as a tract distributor, and earned 50¢ an hour inviting prostitutes on Bleecker Street to attend midnight mission services. Although in his autobiography he stated that theological study made him less devout and that he was "profoundly influenced" as a student by the writings of Charles Darwin, Ernest Renan, David Friedrich Strauss, Ludwig Feuerbach, and Auguste Comte, Hall was deeply concerned as a mature thinker with salvaging Christianity in the face of what he considered its precipitous decline in cultural authority and intellectual respectibility.[77] Having abandoned all belief in the literal truth of orthodox Christianity, Hall sought to reinfuse his boyhood faith with a spiritual or psychologized belief. He was convinced that the essence of religion was not literalistic adherence to dogma but lay in the formation of the personal self toward an internalized ideal of Jesus. Psychology as an academic discipline and profession was vital to the success of this religion, in which Hall placed an intensely millennial hope:

> Would that psychology, by re-revealing Jesus in a new light, and re-laying the foundations of belief in him, might contribute to bring in a real third dispensation, so long predicted yet so long delayed, and thus help to a true epoch by installing in the world the type of religion that can do something to make such holocausts henceforth impossible![78]

The holocaust to which Hall referred was the present world war, which, in spite of its conflagration, or perhaps because of it, would bring "the world a great revival of the true religion of deeds." The connection of a violent struggle and a purified age is typical of millennialist views and did nothing to compromise Hall's triumphalist expectations of a progressive Christianity born from the ruins of a defunct orthodoxy and a world thrown into armed conflict.

Hall was determined that a spiritualized Christianity should survive the wreck of his childhood faith. His psychologizing of belief, focusing on the mental image of an ideal self, was constructed around the heroic figure of Christ. But liberating the psychological Christ from "a crass, literal, material sense" came with a risk. Hall celebrated the freedom of the artist working in the imagination to fashion new, compelling images of Jesus. Yet the distance artists placed between themselves and the biblical account, as well

as the constraints of dogma as the intellectual expression of belief, threat-ened to feminize the artistic imagination, according to Hall's persistently Calvinist view, by giving the imagination wholly over to feeling. Coding feeling as feminine and intellect as masculine, Hall was wary of a great deal of religious art. The purely imaginative Jesus, created entirely from and for feeling, was a ghostly and "bisexual" figure. Although he praised Hof-mann's and Scheffer's pictures of Jesus, Hall saw no shortage of effeminate Christs: "Most pictures of Jesus during the last century give him a distinctly feminine look. The brow, cheek, and nose, if all below were covered, would generally be taken for those of a refined and superior woman." Some pictures almost suggested "a bearded lady."[79]

Hall worried about the effect of these images on adolescent boys, ask-ing "whoever heard of a normal adolescent today who was really im-pressed by artistic representations of Christ?" He based his rhetorical ques-tion on fifteen years of showing more than eighty reproductions of Christ to boys, who commonly responded that Jesus looked "sick, unwashed, sissy, ugly, feeble, [or] posing [or as if he] needs a square meal." The un-derfed, sickly, unhygienic, affected, and effeminate Christ contrasted sharply with the manly ideal that Hall and other reformers in the Pro-gressive Era hailed as the solution to western civilization's illness.[80] Hall concluded that "the personality of Jesus is in some danger of paling into ineffectiveness." He called for a remasculinizing of Jesus and urged artists to create more compelling images: "Until the spell of his portraiture in-trinsically fascinates and thrills beholders with beauty, power, and sublim-ity, the divine is not yet incarnate, while so far as this is achieved, Jesus lives in the world today."[81] This ideal, a radical departure from American Protestantism, rooted theology in art by identifying the aesthetic experi-ence as revelatory and fully constitutive of the incarnation as a spiritual event in the psyche of each believer. Christ's life in religious belief con-sisted of his evocation in works of art. This radical psychologizing of be-lief also relativized Christ to the believer's time and place. Hall encouraged artists to indulge their "racial and national tastes"—an attitude that did not second the call for artistic depictions of a Jewish Jesus that other liberal Protestants had sounded.

Hall also stressed a vitalistic, Nietzschean exaltation of Christ, whom he considered the *Ubermensch* par excellence—the collective ideal who would lead the race to a new, higher level of existence. Recalling Nietz-sche's Dionysian ideal, Hall advised artists not to dwell on pain and grief nor to confine themselves to "the old ideas of classical repose" whenever "wrath, ecstasy, or effort in the climaxes" were appropriate for the por-trayal of Christ. Artists were not to limit themselves to representing Jesus in his own life time, but to introduce him "into every department and ac-tivity of modern life."[82] In another passage, Hall anticipated the treatment of Jesus as the supreme businessman undertaken a few years later by William Barton's son Bruce: "Could we not have Jesus as an athletic cham-pion, illustrating perhaps the ideal of doing the prodigies that athletes so admire? Could Jesus be knight, priest, banker, sailor, landed proprietor, so-ciety man, manufacturer, actor, professor, editor, etc? and if so, why not?"[83] Whatever he might be, Hall beseeched his readers, "cannot art or literature create a Christ image that shall be at least manly and have in it

some vital appeal to the ideals and inspirations of the rising generation?" Committed to an affirmative answer, Hall concluded his chapter on Christ's physical appearance by enumerating four inferences regarding the "personal impressiveness" of Jesus. Reasoning from a psychological analysis of heroes and gods, Hall contended that Jesus must have been taller than average, strong, beautiful, and possessed of "personal magnetism" in his bearing and presence. Each of these characteristics accounted for the impression Jesus made on his contemporaries and, if properly exhibited in works of art, would ensure his impact on the modern world, particularly on boys and young men.

The Graded Visual Curriculum

While Hall's call for the application of art to the psychological development of young people extended beyond the limits of Protestant orthodoxy, the application of developmental psychology to religious education and to the use of art in the religious classroom also received systematic treatment by a contemporary educator who directed herself to a more conventionally Protestant audience. Frederica Beard, a specialist in religious pedagogy from Oak Park, Illinois, and author of numerous educational texts and guides for use in the church, published several essays in *Religious Education* and produced two especially noteworthy publications in 1915 and 1920. The first, an article on the use of pictures in religious education, appeared in the *Encyclopedia of Sunday Schools and Religious Education* in 1915. Here Beard claimed that "the world's history of art has been the greatest means of religious teaching" and cited a variety of authorities, including John Ruskin, to make the case for the importance of religious fine art. She regarded Fra Angelico as unsurpassed and preferred his work to any other's as paradigmatic of Christian "devotional pictures." Beard pointed out that although religious educators had made use of pictures "for purposes of illustration . . . there is yet to be a full appreciation of a beautiful ideal in art in relation to Christian training."[84] Beard proceeded to do so in encapsulated form. Beauty, she maintained (by quoting other authorities), stimulated the sense of life and the desire for living and led people from beautiful things "to beautiful thoughts and deeds." Ideal beauty informs humans, particularly those who have been deprived: "The street waif gains an ideal of mother love as he looks at Gabriel Max's Madonna." Beard was convinced that pictures could be categorized according to their appeal to and effect on children of different ages and gender. She provided a long list of individual pictures and their artists for students of varying age groups as well as for boys and girls. Then she listed several firms and their addresses from whom pictures could be acquired by teachers.

Beard's article evinced the enduring influence of Bushnell's view of nurture as a largely unconscious process—a concept that was taken up and endorsed in the early twentieth century by psychologists of religion. Beard felt that children were "molded unconsciously by their surroundings as consciously by their discipline," and she reasoned, therefore, that a "good picture" should be "made part of the child's environment by being placed

where eyes can see it well." The teacher could engender "real feeling and love for a picture" by using it effectively.[85] This interest in environment was typical of reform thought in the Progressive Era. The new psychology and its preoccupation with influence through unconscious suggestion encouraged educators to accent environmental factors in learning. For instance, one contemporary writer on the benefits of psychology for religious instructors stated that the "value of psychology in creating autosuggestion is great, if wisely used." The writer also pointed out the capacity of architectural settings and Sunday school classroom decor to "provide at least the antecedents for a sense of the presence of God."[86]

The article that Beard contributed to the *Encyclopedia of Sunday Schools* must have met with success because five years later she published *Pictures in Religious Education* (1920), in which she expanded on many of the ideas discussed in the article, gathered together scores of images, and examined their role in Sunday school instruction.[87] Judging by the fact that she cited them most frequently, she considered Heinrich Hofmann and Bernhard Plockhorst the most useful artists. Beard believed that art was a powerful and direct form of communication, which proceeded from a devout artist's imagination and which religious teachers could not afford to do without. She taught that art was a legitimate interpretation of the life of Christ and even asserted that "no greater valuation of that life and character is manifest through any other medium."

Since images of Christ and other sacred subjects exerted a special character-forming influence on children, pictures belonged, therefore, to the religious instruction of the child. Beard related a story of children behaving as if on "holy ground" before a copy of Raphael's *Sistine Madonna* in the Chicago Art Institute, and another story in which a picture of a devout couple making prayerful sacrifice hanging on the wall of a classroom influenced "the children's 'thanks you's' and the manner of their offerings." Beauty had the special advantage of calming children, particularly the rowdy immigrant children of the early twentieth century, and assimilating them to the dominant culture.[88] Beard cited the harmonious effect of a tastefully decorated public schoolroom on an otherwise unmanageable group of "sixth grade Poles and Bohemians" and pointed out that pictures on the wall of a Sunday school classroom helped create a "pleasant homelike room" that attracted people such as "foreigners, especially Italians, [who] are interested in pictures." Conversely, certain images should not be shown to children, such as "images of wrong-doing," which "lead to imaginations of evil."[89] Because the image's appeal to the eye fixed it in the memory longer than the spoken word, Beard reasoned that any "picture that is coarse, inharmonious, and untrue in its physical aspects or its spiritual suggestion, is in its influence as bad as, or worse, than a story of the same type."[90]

Other Protestant educators associated with the REA agreed. One Baptist clergyman, Frank Erb from Hyde Park, Illinois, characterized progressive religious educators as those who "are seeking to control environment with a view to the development of the whole personality." Erb quoted a friend, who said of Hofmann's *Christ among the Doctors*: "It is a picture that seems to me to impel morality, purity and holiness. I could not have a wicked thought or commit a sin in the presence of that picture."

Beauty generated an emotional response in the devout viewer that served as "a minister of the higher life."[91] Art was able to do this in a way that integrated beauty into the "whole personality." Liberal Protestants, authors, and clergy publishing in *Religious Education* over the next two decades continued to develop this perspective on the "influence" of religious art, claiming that the aesthetic dimension of religious life would make fundamental contributions to the formation of character and personality in religious education.[92]

Yet the concern, for Beard and her colleagues, was not simply social control but the power of artistic beauty to generate or "influence" the moral growth of the student. Beard was an educator who understood images in terms of pedagogical theory. For instance, she cited and quoted extensively from an article by the pedagogue Horace Brown entitled "Efficiency in Teaching by Pictures," which stressed the importance of images for memory recall and the power of suggestion.[93] Beard agreed with Brown's assessment of the image's capacity to engage the viewer in an intimate and emotional relation with itself. Rather than "solely an intellectual value," Beard argued, the picture offers "an ideal element and a possible spiritual influence" by virtue of the absorption it inspires in its viewers. Beard enriched Brown's account by investing it within the framework of developmental psychology, her deepest interest being the impact that pictures had on children of different age groupings and gender. Brown and Beard both pursued the ideal of the Progressive Era in educating youth: operate the Sunday school and public school classroom, like society and all institutions, on the sound bureaucratic principles of efficiency, centralized organization, managerial control, and clear division of labor. The classroom was to be strictly age-graded because the human psyche evinced discrete stages of development, each of which was especially susceptible to certain pedagogical techniques.

Beard focused on how pictures of biblical subjects could shape children's character and piety as well as their understanding of the content of faith. She took the effects of images on children with the greatest seriousness: "Discrimination is as much needed in the selection of pictures as in the selection of Bible lessons for different ages."[94] She counseled the Sunday school teacher to coordinate pictures to "the progressive stages of childhood," and listed images by age group and gender for teachers to use as a guide. Differentiating the impact of images along the dual axes of age and gender, Beard was convinced that pictures were an important technology for visually fitting biblical truths to the child's personality as it developed over time.

Boys and girls would respond better to images that were keyed to and designed to nurture their gender consciousness. Whereas the boy's list included subjects dominated by male protagonists—the Arrival of the Shepherds, Journey of the Wise Men, Adoration of the Magi, St. Joseph and the Child, The Boy Christ (fig. 143), Christ and the Fishermen, Christ Stilling the Tempest, and Jesus Bearing the Cross—the girl's list put in place of these subjects biblical themes from the life of Christ that were intended to heighten their self-awareness as females: The Annunciation, Mary and Elisabeth, the Madonna, the Madonna and Child, Christ

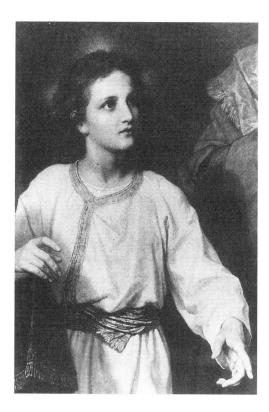

Fig. 143
Heinrich Hofmann, *The Boy Christ,* detail from *Christ in the Temple,* medium and size unknown, 1882. Courtesy of Riverside Church, New York.

Blessing the Children,[95] Jesus and the Woman of Samaria, In the Home of Mary and Martha, and Christ Taking Leave of His Mother (see fig. 144).[96] Instead of the boy's subject Peter and John Running to the Tomb, Beard listed Holy Women at the Tomb for the girls; instead of The Boy Christ, the girl's list prescribed two versions of The Child Jesus; and instead of Jesus Healing the Ten Lepers on the boy's list, girls were offered Christ Feeding the Five Thousand. Encoded in these were the persistent Victorian gender roles for boys and girls. Girls were urged to identify with pregnant women, and the infant Christ, who leaves his mother in adulthood; boys with St. Joseph, the earthly father, and the adolescent Jesus. Boys were given an active Christ, seen active and out-of-doors in most of the images, practicing miraculous medicine, stilling storms, and receiving the approbation of other men. Girls, on the other hand, saw a Christ situated in the domestic sphere, feeding multitudes, caring for children, and preaching to women. Beard encouraged the same use of gender-suitable images in the home and urged parents to consider the impact of the images hung there on children:

> Parents and teachers who watch carefully and observe unnoticed, and who also realize the effect of a picture on themselves, will feel the truth of Newell Dwight Hillis' words, "Having lingered long before the portrait of Antigone or Cordelia, the young girl finds herself pledged to

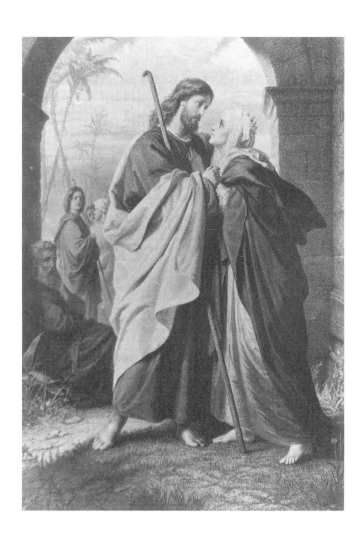

Fig. 144
Bernhard Plockhorst,
*Christ Taking Leave of His
Mother,* size, date, and
location unknown.
From Cynthia Pearl
Maus, *Christ and the Fine
Arts,* rev. ed. (New York:
Harper and Row, 1959),
p. 354.

turn that ideal into life and character. The copy of the Sistine Madonna hanging upon the wall asks the woman who placed it there to realize in herself this glorious type of motherhood."[97]

Plotted beside gender was the additional differential of age and corresponding stages of development.

The little child naturally responds to the picture of action, to the simple unit without many details and to the one that tells a story. The child a little older seeks the story also, and the pictures that is full of life, but the descriptive type and what may be termed the picture of facts has greater interest for him than one that is beautiful as an artistic production.[98]

Beard followed contemporary Sunday school age divisions: beginner, 2–6; primary, 6–8; junior, 9–12; intermediate, 13–16; and senior, 16–20. Her lists of pictures appropriate for each group can be summarized by stating that

with few exceptions, the older, the group the fewer Old Master images and the increasing frequency of works of mid- to late-nineteenth-century academic naturalism. Thus, whereas the sweet imagery of the Spanish baroque painter Murillo and the Madonnas of Raphael appear on the lists of pictures for beginner and primary ages, works by Hofmann, Plockhorst, Hunt, and Munkácsy dominate the lists of images for junior, intermediate, and senior age groups.

Of the sixty-two images listed in all the categories, eighteen, or nearly one-third, were by two artists, Plockhorst and Hofmann. In fact, Plockhorst was the single artist whose work appears on every list of age and gender; Hofmann's appears on all but the beginner's level. Each of these artists are familiar to anyone who has paged through the catalogues of religious publishers, books of the life of Christ, illustrated Bibles, and Sunday school illustrations. For the generations of American Protestants enrolled in Sunday school from the 1890s to the 1930s, Hofmann and Plockhorst were readily familiar. Hofmann's works were cited more frequently than any other in the informal study conducted in 1912 by Frank Erb referred to earlier, which consisted of asking young adults between the age of twenty-five and thirty-five (who were Protestant and "largely graduate university students preparing for religious work") what images they thought of when considering various aspects of religious life. Erb stipulated these for his informants: God's presence and power, the believer's relationship to God, the sense of human brotherhood, and consciousness of life after death. Hofmann's *Christ in Gethsemane* (fig. 142), *Christ among the Doctors, Jesus Blessing Little Children* (Erb probably had Plockhorst's painting of this subject in mind), and *Christ and the Rich Young Ruler* were cited in every category by the respondents. Erb concluded that Hofmann's *Christ among the Doctors* or the detail of the head of Christ from that picture (fig. 143) should be placed in every Sunday school classroom. The persistent prevalence of these images in religious catalogues and periodicals indicates that Erb's suggestion was heeded.

Reasons for the popularity of work by Hofmann and Plockhorst certainly include the commercial availability of reproductions of their major paintings. Each artist produced paintings (in Hofmann's case, paintings and drawings) that illustrated the key moments of the life of Christ and that were gathered into series for publication.[99] Furthermore, reproductions of works by Plockhorst and Hofmann were readily available from a number of commercial publishers in the east. In his 1917 catalogue of pictures available for purchase, Albert Bailey listed thirty-one images by Hofmann, most of which could be purchased from George O. Brown & Company in Beverly, Massachusetts, or Cosmos Pictures Company in New York. Eleven pictures by Plockhorst were listed, all of which were available from New York firms.[100] Works by Plockhorst and Hofmann were also available from other companies such as Perry Pictures and from a great variety of denominational presses.

Not only were images by Plockhorst and Hofmann available, they were executed with a legible and popular naturalism that consisted of clear contours, unambiguous tonal patterns of light and dark, and figure compositions that focused on a single action narrated in scripture. Each artist carefully selected a key moment, typically an exchange between Jesus and

another figure. This greatly appealed to Frederica Beard, who insisted that a religious picture "should speak . . . of the most important part of the story, the heart of it, and not just of the physical environment or incidental facts."

Finally, Plockhorst and Hofmann restricted themselves to highly illustrational and narrative subjects. Although she claimed that pictures possessed a suggestive power that allowed them to "tell more than words," Beard understood the religious picture to operate best in tandem with scripture and the teacher's lesson. The instructor was intended to narratize the image by asking students: "What story does it tell you?" The paintings of Old Masters were certainly narrative and informed everything Hofmann and Plockhorst ever painted, but Beard noted that for children between the ages of ten and twelve, to whom "physical realism appealed most strongly," the stylistic distortions of anatomy in Murillo and Rubens were ridiculous, resulting in "an irreverence for subjects that in reality were sacred and uplifting." For this age the concrete realism of Tissot and Munkácsy, informed by photography, was deemed highly appropriate. Thus, "if the crucifixion is pictured at all to boys and girls under twelve or fourteen years, Munkácsy's 'Christ on Calvary' is better than Rubens' 'Elevation of the Cross' or his 'Descent from the Cross.'"[101]

The realism that Beard found effective among young teenagers was the same as that praised by Protestant clergy and journalists in the 1880s as well as that purchased by Protestant patrons such as Rockefeller and Wanamaker, who considered it the appropriate style for artistic depictions of Christ. The historian is lead to surmise that key images in Protestant visual culture in the United States were fixed at an early age by their use in religious education at a moment in the 1880s when religious fine art acquired an unprecedented status among American Protestants. These images—Hofmann's *Christ in the Temple* and *Christ and the Rich Young Man*, Plockhorst's *Christ Blessing the Children* and *The Good Shepherd*, and Munkácsy's *Christ Before Pilate*—maintained currency and significance into adult life, being reinforced by American patrons such as Wanamaker and Rockefeller who installed these paintings or copies of them in churches and museums. This authorization of several images, artists, and their style—what may best be called an idealistic naturalism—certainly accounts for the nostalgic character of much Protestant visual piety, inasmuch as the preference for such images as Hofmann's *Christ in the Temple* seemed dedicated to commemorating the emotional significance of the image in the believer's childhood or youth. It also helps explain the success of later painters such as Harry Anderson, Warner Sallman, and Louis Jambor, who based several of their most widely reproduced religious works in the mid–twentieth century on several paintings by Hofmann and Plockhorst.

The devotional quality of reproductions of religious fine art arose from the effect such images were believed able to exert over viewers. Whether influencing them unconsciously or shaping them according to the propensities of a viewer's particular stage of psychological development, fine art did more than teach doctrine. By stimulating feeling and guiding emotional expression, fine art shaped the personality and spiritual disposition. It was best viewed reverently and contemplatively in the church, chapel,

classroom, or home. Religious educators urged American Protestants to refine artistic taste and to reintroduce fine art into the church interior in order to enhance the experience of worship. No longer content with the didactic visual piety of an earlier day, liberal Protestants (in particular) came to see mass-produced examples of fine art as the basis for recovering a devotional visual piety lost to the austerity of Puritanism. Instead of dissipating aura, mechanical reproduction was poised to rechristen it in the icons of modern mass culture.

Conclusion

The Return of Aura

Aura, that mysterious sense of presence that an image often possesses when it is wrapped in the mantle of rite, reputation, or cultural prestige, vanished with the rise of mechanically reproduced images, according to Walter Benjamin.[1] The cult status of Benjamin's essay has only encouraged the ease with which his thesis has been accepted by students of art, film, and modern visual culture. Yet the evidence of Protestant devotional art in the late nineteenth century shows that Benjamin's notion of the loss of aura is not borne out. Mass-produced reproductions of religious works of fine art from Fra Angelico and Raphael to Heinrich Hofmann and Mihály Munkácsy were invested with a special power, the ability to form character and energize the personality of young people, and reproductions were installed in devotional settings in churches, schools, and homes for the purpose of practicing reverence and prayer. No longer merely learning devices, mass-produced images became part of a piety that valued the image as a means of empathy and meditation, a way of evoking or making present the sacred reality that fine art was believed able to achieve. Images became icons of a sort, and Protestant educators sought to provide students and worshippers with new protocols of devotion for experiencing them. This concluding section considers how the mass-produced image reinstituted aura among American Protestants in the shift from a didactic to a devotional visual culture. The return of aura is evident in the literature in the early twentieth century produced by religious educators who advocated the use of fine art in the classroom as a way of stimulating the development of the personality.

From Character to Personality

Intellectual historian Warren Sussman once suggested, in a perceptive article, that a shift in the modern consciousness of the self occurred in the late nineteenth and early twentieth centuries—from character as the dominant construct of personal identity to personality.[2] In his study of advice literature, self-help manuals, and popular psychology, Sussman found that "personality" was configured as a dynamic, assertive, masculine, energetic, and evanescent mode of selfhood, while "character" was regarded as organic, sculpted, grounded, and permanent. Sussman argued that the shift from a "culture of character" to one of personality was motivated by the need to address new problems of personal identity in a society that was undergoing fundamental changes. If character was a conception and practice of the self ideally rooted in what I defined as "local culture" in my introduction, personality represented a mode of personal consciousness that thrived on commodification, packaging, advertising, and the semiotics of display. In other words, an advice author whom Sussman quoted stated in 1915: "Personality is the quality of being Somebody."[3]

The ideal of personality lionized abundance—abundant energy, courage, masculinity, power among and over peers. The culture of character endorsed moderation, self-restraint, even self-denial. The abundant personality was shaped by competition and struggle. It therefore embraced patterns of consumption that helped delineate its path to and arrival at dominance. Consumption defined the personality in the way that production had shaped character. Hard work still mattered, but now it was dedicated to the acquisition of surplus for the sake of consumption. Whereas the culture of character had stigmatized leisure and striven to occupy all spare moments with virtuous, character-forming activities, the culture of personality sought release from busyness in fantasies of leisure, justified as well-earned moments of ease that produced nothing but the therapeutic pleasure of being or becoming oneself. Self-fulfillment, self-expression, self-gratification, as Sussman argues, replaced self-control and self-denial.[4]

G. Stanley Hall's vitalist assessment of Christ's presence and power accommodated the idea of personality, which was becoming the focus of psychologists in Europe and the United States. Bruce Barton embraced this concept of Christ as a hero, possessed of influence and personal magnetism, a man's man who modeled masculinity, resolve, and enviable appeal. The image of Christ that Barton used as frontispiece in his 1914 book *A Young Man's Jesus* willfully substituted such machismo for the suffering, emaciated, and, to Barton, effeminate Christ of previous religious art. The culture of character had informed depictions of Christ suffering, the believer's character was thought to be improved by the experience of guilt and shame produced by the humiliating portrayal of Christ. Barton sought to deal a death blow to this lingering concept of piety by criticizing the portrayal of suffering, as a sign of weakness, and replacing it with the evidence of a Personality who exuded confidence and self-possession.[5]

Sussman pointed out that advice manuals from the turn of the century defined personality as standing out in a crowd. This is largely how Barton depicted Jesus in his interpretation of the Gospels in *The Man Nobody*

Knows: standing out against the teeming, gray masses by virtue of his magnetism, the power of presence that drew people into his orbit or drove them away, impressed in either case by his evident authority.[6] Personality thus conceived is an aura, a cloud of influence that emanates from the visage of the celebrity-hero like the effulgent glory shining in the face of Moses after his return from Sinai. The aura is captured and transmitted in mass-produced images, which lend the personality ubiquity by circulating it afar, insinuating it into popular discourse in patterns of reception that are characterized by awe, envy, and reverence. Mechanically reproduced images—at least the images promoted by liberal Protestants at the turn of the century—were not, therefore, deprived of aura, as Benjamin would have it, but served to evoke it in a new cult of desire devoted to the celebrity, and to transmit personality as deposited in the iconography of the face. The shift from character to personality brought with it a corresponding change in the function of printed pictures: if illustrations or didactic images had formed character, devotional images rehearsed or performed personality. With this, as I will show, pedagogy premised on the aesthetic of expression replaced the role of illustrations in the culture of character. Fine art—that is, *reproductions* of fine art—became the privileged means of inspiring the growth of a child's personality because such pictures expressed artistic feeling and genius.

Jackson Lears has summarized the shift in definitions of selfhood in an insightful analysis of the emergence of a therapeutic culture committed to self-realization rather than the orthodox salvation of earlier generations.[7] Although he acknowledges the ambivalence of many practitioners of the therapeutic sensibility, noting their frequent nostalgic regression to the rhetoric of character and its rural, producer-oriented culture, Lears sets up a distinction that applies best to liberal, urban Protestants who openly embraced modernization. Such Christians were of course inclined to accommodate modernity, but certainly many among them believed that this was the best way to keep their religious faith alive. Whether they were unwittingly advancing the cause of secularization by doing so, as Lears believes, is not so clear. In fact, Protestants who focused on the stages of development in a child's personality and advocated the use of inexpensive mass-produced images as an effective method for guiding young people through the crises of adolescence were not necessarily indulging in strategies of therapeutic self-realization. Liberals, moderates, and even conservatives were not being disingenuous when they justified stepping out of the tradition to make use of what modern science could offer. Secularization did not spell the end of religion, as Max Weber believed, though to court it surely risked marrying outside of the family.

Aura and the Aesthetic of Expressivism

If G. Stanley Hall and Bruce Barton, situated on the margins of American Protestant belief, asserted the great importance of art in inspiring the formation of religious ideals in the young, educators closer to the liberal Protestant mainstream developed an elaborate pedagogy that foregrounded art in the growth of the personality.[8] Influenced by the

pedagogical assumptions about graduated psychological development promoted by Coe, Starbuck, and Hall, as well as the REA, progressive Protestant educators such as Albert Bailey, Frederica Beard, and Cynthia Pearl Maus came to specialize in advocating the power of religious imagery in nurturing personal development and religious understanding.[9]

Albert Bailey was director of religious education at the Worcester Academy and lecturer in religious education at Newton Theological Institution when he published his *Art Studies in the Life of Christ* in 1917. Shortly afterward he became professor of religious art and archaeology at Boston University. He published several popular books on religious art, including *The Gospel in Art* (1915), *Art Studies in the Life of Christ* (1917), and *The Uses of Art in Religious Education* (1922). *Art and Character* (1938) was his summary statement on art, religion, and education.[10] Bailey was among the first who committed his advocacy of fine art, particularly the history of painting and architecture, to pedagogical programs for the education of church laity. By publishing a catalogue of images with price lists, supplier's information, and instructions on how to apply the images to religious instruction, Bailey helped create an infrastructure for the dissemination of reproductions among American Christians, particularly mainstream Protestants.

Like many Protestant believers who sought to benefit from modern thought, Bailey integrated the discourses of character and personality in his treatment of art and religion. Thus, though he titled his final work *Art and Character*, Bailey placed at the heart of his analysis the twentieth-century concept of personality, dedicating two chapters early in the book to its discussion. The older discourse of character persisted, but it clearly gave way to the new psychology. Like many writers born in the nineteenth century, Bailey's treatment of the personality proceeded from a vitalist understanding of energy, which he found congenial to an expressivist theory of art. This strongly predisposed him to prefer a nineteenth-century concept of modernism rather than an early-twentieth-century one. Even as late as 1938, when he published *Art and Character*, Bailey excluded twentieth-century modernists, leaving a gaping hole between late-nineteenth-century artists such as Franz Stuck, Gustave Moreau, and John Singer Sargent and twentieth-century painters such as Grant Wood, Reginald Marsh, and José Orozco. Georges Rouault, Edvard Munch, Emil Nolde, Wassily Kandinsky, and Paul Klee are no where to be found. The distortions of expressionism, the abstractionism of cubism, and or the spiritualizing extremes of Mondrian were never included in Bailey's canon of great religious art because these artistic developments did not accommodate themselves to his belief that art is an infectious communication of emotion. Like Leo Tolstoy, who published a polemical treatise on this subject in 1896, Bailey had a strong preference for naturalistic styles because these facilitated the transmission of feeling in accord with the theory of expression that both men held was the basis of all true religious art. It was not that art was a direct transcription of nature; it was an interpretation. "The artist does not copy nature merely. He invents, assembles, arranges, emphasizes, in order to speak clearly some message from his soul to ours. It is our business to discover what that message is."[11] Bailey quoted Tolstoy in calling art the "language of emotions" and in contending that the artist's

work seeks to "arouse in others emotions that are like his own." Emotion, passion, feeling—all of these represented a powerful channel of communication, a language all their own.

Rooted as his aesthetic was in the academic theory of the passions and human expression, Bailey argued for a close link between feeling and facial form. His approach betrays an affinity with Bushnell's romantic view of unconscious influence rather than the modernist sensibility of shock, alienation, and primitivizing violence to the human form so important to cubist and expressionist art. Like Bushnell, Bailey relied on the trope of contagion or infection to describe the communication of feeling that shaped the person—in homelife as well as in the appreciation of works of art. In light of the sharp opposition to the arousal of the passions in nineteenth-century evangelical denunications of fiction, dance, and theatre, Bailey's position represents a significant turn in its committment to the visualization and evocation of feeling as fundamental to the healthy development of the personality.[12] Art was an interpreter and communicator of emotion, according to Bailey. Because this was so, and because young people were engaged in sorting out their feelings, great works of art should be made available to them "in the hope that some day as the youth ripens to his full capacities the masterpiece may catch him and reveal to him his own deeper self."[13] This is why, Bailey added, such care must be put into the selection of pictures for the home, church, and religious classroom.

As I have shown, materials for Sunday schools had been illustrated for many years. The strategy Bailey employed, however, was not simply informational but was calculated to move the student to establish a relationship with the artist by sharing in the artist's emotional response to the subject. Bailey built on the use of the high art tradition as it was used in illustrated lives of Jesus in the 1870s and 1880s. This literature had set out to visualize the heroic yet concrete humanity of Jesus and turned to the art of the "Old Masters" to do so. Thus, in *The Use of Art in Religious Education* Bailey affirmed this use of the artistic image, claiming that "a serious study of pictures of Christ is a most valuable religious exercise" for children as a "preliminary to worship" or as a "method of soul culture." In fact, since the purpose of art was to channel feeling into the growth of the personality, the church did best in Bailey's view to prefer "works of permanent beauty that have proved their power to enrich and refine life for many generations. That is why modern artists in general should give place to the old masters."[14]

Although he subordinated some nineteenth-century artists and completely ignored a host of twentieth-century painters, Bailey did not hesitate to elevate the artist generally. Characterizing the artist as a "genius," an "intellectual interpreter," an "emotionalizer," a "revealer of spiritual values," and an "ideal builder," Bailey made it clear that the artist was everything a teacher of young people could want—and just what a liberal Protestant could hope for. The great masters of art have left "revelations of life" in which are invested countless "spiritual values." Viewing these (mechanically reproduced) masterpieces of religious art invigorated the affective life—of feeling, loving, and aspiring—to "higher living." If "we are still spiritually sensitive to higher living," Bailey argued, then "the artist becomes to us both prophet and priest and his work becomes a sacra-

ment."[15] Regretting the loss of images enjoyed in Roman Catholic and Orthodox ritual, Bailey argued that art should be reintroduced into Protestant churches in America because of its power "to elevate and purify and discipline the emotions." This consciously reversed the evangelical view of the passions as unnecessarily aroused by the arts. Bailey dismissed the Puritan legacy (as he and nearly all liberal Protestants were fond of portraying it) as a supression of feeling on behalf of plainness and simplicity: "We must abandon our whitewashed walls, our stenciled frescos, our plain meetinghouse windows, the simplicity that passed with our ancestors for godliness." It is difficult to imagine antebellum Calvinists acceding to this. But one imagines that this was the point. In contrast to evangelicals, who only praised the characters of those committed to preaching the gospel, Bailey regarded artists as uniquely bestowed with the capacity to impart spiritual messages. "All great artists are primarily great men; they have intellectual and spiritual powers above the average, powers of observation, insight, feeling. They see more things, more deeply into the meaning of things, and they feel more strongly about things than we do."[16] Essential to the devotionalizing of art in early twentieth-century liberal Protestantism was devotion to the cult of the artist. Belonging to something of a priesthood, artists were an elect body of spiritual heroes set apart by their extraordinary abundance of feeling. A wealth of power allowed the artist to infuse his or her work with a special richness: "[The artist's] pictures will be perpetual reservoirs of life, surcharges of high potential whose fields of force induce mighty currents in all who come within their range." The artist was a dynamo and the work of art a relay station for distributing energy. Therefore both art and artist were of crucial importance to youth, whose vitality and personality were understood to depend directly on the appropriate use of their artistically excited psychic energy.

Bailey started with the nonevangelical assumption that great works of art possessed "spiritual values" that the trained eye could discern. Images, in other words, were not illustrations, not avenues for transmitting information, not bound to texts but were the product of genius and therefore, although informed by texts like the Bible, were independent works of creative imagination. Images possessed the power to concentrate feeling within them—"the emotion of [the] creative personality" that created them—and to store this in the memory of the young person under the seal of the image. When called up later in life, the images "liberate within the consciousness sometimes just the dynamic that is necessary to move the will to action, to determine the choice, to give the energizing emotion, to open a vista, to start a trend, and so in some degree to shape character."[17] Religious images were installed in the child's memory in instruction and taken up into the total economy of the person. Bailey distinguished the power of images in terms of their "after-effects." Stored in the memory, the images act as guides and relays of feeling that are called into action by suggestion or association. Infiltrating the psyche, they give shape to the emotional life of the individual, inclining him or her in a particular manner.

Art could augment and inspire feeling, in the experience of sympathy, "the act of sharing with another any emotion." Sympathy, Bailey wrote,

"is worth our while to cultivate because it is the key of social understanding. It leads to all the virtues that are necessary for our highest usefulness in a world made up of people."[18] Bailey urged the student and teacher to indulge in an openly empathetic experience of art in which feeling was the means and the end. The viewer was to reach the artist's "message" by feeling after it.

> This you may accomplish by assuming either by bodily posture or in imagination the actual position and facial expression of the chief characters in the picture. Then by a sure reflex the proper emotion and sometimes the proper idea will come to you. You feel your way into the picture. You absorb it. You become it and it becomes you. Then you know what the artist meant.[19]

This exercise certainly sheds light on the popularity of tableaux vivants, or "living pictures," in which church members arranged themselves in the poses of figures from religious paintings such as Leonardo's *Last Supper*. But the use of sympathy exceeded the literal mimicking of gesture and facial expression. Bailey pointed to the effectiveness of "hero-worship" in religious education and advised that teachers use art since the viewer "absorbs the picture hero." Referring to Albert von Keller's painting *Raising the Daughter of Jairus* (1885), Bailey instructed the reader to become each of the principal figures in the image, including Christ: "Be Jesus, and realize with him the serene confidence of one who is doing the Father's will, and the joy of loving and helping people."[20]

This sympathetic identification or empathizing with pictured figures helped foster a new way of looking at images among American Protestants. It promoted a visual piety in which the image no longer merely formed the viewer's character by instruction but offered a dramaturgical means of performing the self, of stepping outside of oneself and acting as another. (The insertion of a famous painting's composition into a church performance of the passion of Christ was standard fare during the celebration of Easter in many Protestant churches.)[21] This was not so much a form of empathy, in which the self was lost, but a sympathetic playing of roles, a performance of the self as another in the attempt to discover one's "own deeper self," as Bailey had put it. He intimated this near the end of *The Use of Art in Religious Education* when he discussed what he called the "personal religious values in art." In order for devout viewers "to get the message" of a work of art, they must recognize that the artist "is trying to express it to [them] personally." The (mechanically reproduced) picture came to stand between artist and viewer as the bearer of the message. It behooved the viewer to "discover some spiritual relationship between the picture and his own soul. He must find in the picture some hint of his own half conscious longing, his own dimly discerned ideal."[22] Pictures presented ideal occasions for exercising and improving sympathy because they constituted singular acts of emotional communication, not only between the artist and the viewer but between the viewer and his own soul masked in the persona of the image.

But religious art and the aesthetic of sympathy were not privatist self-communion for Bailey. A Methodist committed to the Social Gospel,

Bailey hailed sympathy as an interpersonal relation that went to the heart of Christianity as an essentially social experience. This consciousness of the power and importance of sympathy was growing, according to Bailey, so much so, in fact, that in surveying the Christian art of the nineteenth and twentieth centuries and in admiring academic compositions narrating Christ's ministry, Bailey remarked that the "social gospel does not exist in art until the nineteenth century." In the modern world, art was a celebration no longer of theology but of social praxis, which Bailey linked to the formative experience of his generation, stating that

> the art of the twentieth century is recognizing that the sacrifices demanded by one's community, by the church and the state are sacrifices for a social ideal and are therefore fruits of the Christian spirit. . . .
>
> The public certainly recognized the truth of this ideal in the days of the Great War. Then it was preached from the pulpit and on the posters, that when one poured out time and treasure or sacrificed life for the ideals that our flag represents one was serving both humanity and God. There was a constant interchange and interfusion of the religious, the social and the patriotic ideal.

The vision of the Social Gospel merged these ideals within an ultimately postmillennial framework: "Religion undertakes to make better homes, better nations, better industrial and commerical institutions, better schools. To hasten the universal reign of God is man's religious task."[23] The purpose of art was to guide spiritual formation by fostering sympathy as the capacity to be with and for others. Mass-produced religious images were iconic for Bailey, inasmuch as they helped viewers recognize what the artist was telling them about their relations to God and to one another. They glimpsed in the religious image a visualization of ideal social relations, genuine sympathy, and true heroism. The image offered a way of improving oneself by becoming like someone else. By performing the spiritual hero, one was moved to encounter one's "own deeper self."

American Protestants did not need to stand in front of actual works of art in museums to undergo this transformative experience but could have it with the halftone reproductions that Bailey listed for purchase in most of his books. To be sure, Bailey insisted on what he regarded as the best of fine art. The portrait of a beloved pastor must give way to "works of permanent beauty," and the "story picture" or illustration "should yield to the picture that interprets a mood or reveals a soul in action at some supreme moment." As far as fashionable aesthetic theories go, this was an extremely outmoded one for the 1920s. But Bailey did not care how anachronistic his visual habits were. True to the Protestant heritage, communication was what mattered.

Yet Bailey was breaking away from or at least seriously emending that tradition by reconceiving how communication took place. The pictures that Protestants were now encouraged to place on their walls were those able to "stimulate the imagination" and move young people "to build with-

in their own souls that supreme work of the imagination, the Christian ideal." What could be more auratic than this interiorized vision of God's postmillennial reign? Evoking mood and rooting itself in the constructive power of the modern imagination, the aura shimmered in mechanically reproduced works of art, inviting the souls (or psyches) of children to bask in its glow and build worlds that only icons could reveal.

In the culture of character, where images had informed, instructed, and reproved, the self was not alone but part of a common life. Character was not simply one's own but what one inherited from and shared with one's family, class, race, and nation. As such a common property, character was something that could be judged good or bad. By contrast, a personality was one's own, a psyche that belonged to no other. If conforming to the collective ideal was the goal of character formation, in the competitive ethos of modern life, personality meant being Somebody in order to overcome the isolation of being a nobody. Triumphing over others or participating in team sports offered one a social presence, a standing among or above one's fellows.

This was the excess to which the emphasis on personality was suceptible. One's character was not just one's own but that which the individual shared with the larger group. In a volume entitled *Education and National Character,* published by the REA in 1908 and authored by such central figures of the Social Gospel movement as Lyman Abbott and Washington Gladden, the national dimensions of character were foremost. Reinforcing the republican belief that "our national need is a religious need," the authors underscored the collective nature of character and redemption. "That is democracy," proclaimed Abbott: "Feeling, thinking, willing together; with one thought, one emotion, one purpose. . . . There must be a corporate judgment, a corporate feeling, a corporate purpose, a corporate conscience." Gladden agreed: "No man liveth to himself. No man builds his own manhood out of materials furnished by himself."[24]

Later writers, publishing their estimations of the religious power of art in *Religious Education,* described the transcendence of the personal self or personality in Neoplatonic terms of mystical experience. The director of education at the Metropolitan Museum of Art, for example, insisted that art, unlike morality, was not actively engaged in public behavior and the observance of the dictates of conscience. Art is passive, "it does not preach." "Art calls to the spirit to soar into pure realms where self is forgotten: where, through the contemplation of beauty, the spirit may for an instance lose itself in the Infinite."[25] Only there, in the empyrean realm of the Infinite, did beauty reveal itself as aesthetic enjoyment arising through the surrender of the self. "When the creative moment comes, [the artist] must be unaware of his own personality." The same was to hold true for any viewer of a work of art.

Sympathy represented another solution for Bailey. Experienced within the apparatus of sympathy that he proposed, images offered Protestants a bridge, a way of joining other selves, a means of escaping the dark prison of a lonely psyche. Not a collective experience, it was dialogical, unfolding between the individual soul of the viewer and the artist behind the work of art. If Protestants accepted Max Weber's grim analysis of a disenchanted modernity, many no doubt found solace in a liberal Protestantism

that, as Bailey put it, conceived of "actual personal contacts [as] the essence of religion." For Bailey and many like him, reproductions of fine art were a portal to such encounters, a recovery of the sacred other. The aura that radiated from prints and halftones of religious masterpieces promised to reanimate a world bereft of spiritual presence.

Notes

Introduction

1. *Life and Observations of Rev. E. F. Newell* (Worcester: C. W. Ainsworth, 1847), 16. My thanks to Leigh Schmidt for bringing Newell's memoirs and the passage on the image to my attention.

2. Ibid., 28.

3. Jonathan Edwards, "Sinners in the Hands of an Angry God," 1741, in *A Jonathan Edwards Reader,* ed. John E. Smith, Harry S. Stout, and Kenneth P. Minkema (New Haven: Yale University Press, 1995), 95.

4. See, for instance, a diagram (Fig. 57) explaining the interpretation of Revelation that illustrated a seventeenth-century Latin text whose English translation was authorized by the Puritan parliament in 1642—the same year that iconophobic body passed legislation prohibiting images in churches.

5. Walter Benjamin, "The Work of Art in the Age of Mechanical Reproduction," in *Illuminations,* tr. Harry Zohn, ed. Hannah Arendt (New York: Schocken Books, 1968), 217–51.

6. Ibid., 221.

7. For a discussion of the history of the term, see William Pietz, "Fetish," in Robert S. Nelson and Richard Shiff, eds., *Critical Terms for Art History* (Chicago: University of Chicago Press, 1996), 197–207.

8. William Wroth, *Images of Penance, Images of Mercy: Southwestern Santos in the Late Nineteenth Century* (Norman, Okla.: Published for the Taylor Museum for Southwestern Studies by the University of Oklahoma Press, 1991), 65, 98–9.

9. For a detailed study of one instance, see David Morgan, ed., *Icons of American Protestantism: The Art of Warner Sallman* (New Haven: Yale University Press, 1996) and David Morgan, *Visual Piety: A History and Theory of Popular Religious Images* (Berkeley: University of California Press, 1998); see also Yvonne J. Milspaw, "Protestant Home Shrines: Icon and Image," *New York Folklore* 12, nos. 3–4 (1986), 119–36.

10. Benjamin, "The Work of Art in the Age of Mechanical Reproduction," 224–25.

11. William M. Ivins, Jr., *Prints and Visual Communication* (Cambridge: MIT Press, 1953), 143, 122.

12. Ibid., 176–77.

13. Eustelle Jussim, *Visual Communication and the Graphic Arts: Photographic Technologies in the Nineteenth Century* (New York: R. R. Bowker, 1974), 9–17.

14. I have found helpful a number of important studies of mass media and communication in American religious history. An excellent collection of essays is Leonard I. Sweet, ed., *Communication and Change in American Religious History* (Grand Rapids: Eerdmans, 1993), especially Elmer J. O'Brien's extensive annotated bibliography, "American Christianity and the History of Communication," 355–479; see also Nathan O. Hatch, *The Democratization of American Christianity* (New Haven: Yale University Press, 1989), 141–46; David Paul Nord, "The Evangelical Origins of Mass Media in America, 1815–1835," *Journalism Monographs* (1984), 1–30; Quentin J. Schultze, ed., *American Evangelicals and the Mass Media* (Grand Rapids: Academie Books, 1990); and R. Laurence

Moore, *Selling God: American Religion in the Marketplace of Culture* (New York: Oxford University Press, 1994), 204–37.

15. William E. Barton, *Jesus of Nazareth: The Story of His Life and the Seasons of His Ministry* (Boston: Pilgrim Press, 1903), 504.

16. For a discussion of Sallman, see Morgan, *Icons of American Protestantism;* for Anderson, see Raymond H. Woolsey and Ruth Anderson, *Harry Anderson: The Man Behind the Paintings* (Washington, D.C.: Review and Herald, 1976).

One: Media, Millenium, Nationhood

1. This has been insightfully discussed by Richard D. Birdsall, "The Second Great Awakening and the New England Social Order," *Church History* 39, no. 3 (September 1970), 355, 358.

2. Robert Baird, *The Christian Retrospect and Register; A Summary of the Scientific, Moral and Religious Progress of the First Half of the XIXth Century* (New York: Dodd, 1851), 188; quoted in Arthur Alphonse Ekirch, *The Idea of Progress in America, 1815–1860* (New York: Peter Smith, 1951), 121.

3. Anonymous, *Design, Character, and Uses of the Books of the American S. S. Union* (Philadelphia: American Sunday School Union, n.d. [1829]), 3–4. I follow Ralph Ruggles Smith's dating of the pamphlet; see "'In Every Destitute Place': The Mission Program of the American Sunday School Union, 1817–1834," Ph.D. diss., University of Southern California, 1973. Although the author of the pamphlet remains unknown, a list of reasonable guesses would be topped by Frederick Packard, who became editor of the ASSU's *American Sunday School Magazine* in 1828 and general editor of all the ASSU's publications in 1829. Packard succeeded Frederick Porter as the magazine's editor. Another possibility is Robert Baird, who was the general agent for the ASSU from 1829 to 1834.

4. "Characteristics of the Age," *Christian Almanac* (New York: American Tract Society, 1834), 36. *The Christian Almanack* was published first by the New England Tract Society in Boston in 1821 by Lincoln and Edmands. This organization changed its name to the American Tract Society in 1823. In that year and the following year the *Almanac* was published in other cities such as Philadelphia and New York by branches of the Boston-based ATS. In 1825, a new, national organization called the American Tract Society was formed in New York from a merger of the New York Religious Tract Society, begun in 1812, and the Boston ATS. The title of the *Almanac* thereafter varied. Later versions include *The Family Christian Almanac* beginning in 1841 and *The Illustrated Family Christian Almanac* from 1849 to 1852, after which the title reverted to *The Family Christian Almanac,* until 1871, when the title became once again *The Illustrated Family Christian Almanac.* Hereafter the publication will be referred to as *Christian Almanac.* The best collection is to be found in the American Antiquarian Society, Worcester, Massachusetts.

5. Studies that have been important for my thought on this subject are Grant McCracken, *Culture and Consumption: New Approaches to the Symbolic Character of Consumer Goods and Activities* (Bloomington: Indiana University Press, 1990); Daniel Miller, *Material Culture and Mass Consumption* (Oxford: Blackwell, 1987); Mary Kupiec Cayton, "Print and Publishing," in *Encyclopedia of American Social History,* 3 vols., ed. Mary Kupiec Cayton, Elliott J. Gorn, and Peter W. Williams (New York: Scribner's, 1993), 1:2427–45; and William J. Gilmore, "Literacy, The Rise of an Age of Reading, and the Cultural Grammar of Print Communications in America, 1735–1850," *Communication* 11, no. 1 (1988), 23–46.

6. Colin Campbell, *The Romantic Ethic and the Spirit of Modern Consumerism* (Oxford: Basil Blackwell, 1987).

7. For a nuanced discussion of the relationship of longing and consumerism in the celebration of religious holidays among American Christians in the nineteenth century that echoes Campbell's analysis, see Leigh Eric Schmidt, *Consumer Rites: The Buying and Selling of American Holidays* (Princeton: Princeton University Press, 1995), esp. 23–37.

8. See Charles Sellers, *The Market Revolution: Jacksonian America, 1815–1846* (New York: Oxford University Press, 1991). Sellers's book is critically discussed by several historians in "A Symposium on Charles Sellers, *The Market Revolution: Jacksonian America, 1815–1846,*" *Journal of the Early Republic* 12, no. 4 (Winter 1992), 445–76; see also Paul E. Johnson, "The Market Revolution," in *Encyclopedia of American Social History,* 1:545–60; and Mark S. Schantz, "Religious Tracts, Evangelical Reform, and the Market Revolution in Antebellum America," *Journal of the Early Republic* 17, no. 3 (Fall 1997), 425–66.

9. Nord, "Evangelical Origins of Mass Media"; see also by Nord, "Systematic Benevolence: Religious Publishing and the Marketplace in Early Nineteenth-Century America," in Sweet, *Communication and Change in American Religious History,* 239–69.

10. I have relied on Judith A. McGaw's fine study, *Most Wonderful Machine: Mechanization and Social Change in Berkshire Paper Making, 1801–1885* (Princeton: Princeton University Press, 1887), which includes a chapter that studies the innovations of the 1820s (59–89).

11. Richard Ohmann, *Selling Culture: Magazines, Markets, and Class at the Turn of the Century* (London: Verso, 1996), 11–38. Ohmann does not regard production before the 1890s as genuinely "mass culture" and he insists on basing his definition of "mass" on national rather than regional markets since the former are much larger. I prefer to take a systemic view that privileges over the actual numbers of production (such as a magazine's circulation among one million subscribers or more) the cultural economy of production and consumption, with its new set of social relations first at a regional and then a national level. What trans-

forms human experience from local to mass culture is not the quantitites of production but the socioeconomic apparatus of circulation, which occurs at the regional level no less than at the national.

Other useful studies of consumerism and the formation of mass culture in the United States and Britain are: Susan Strasser, *Satisfaction Guaranteed: The Making of the American Mass Market* (New York: Pantheon Books, 1989); W. Hamish Fraser, *The Coming of the Mass Market, 1850–1914* (Hamden, Conn.: Archon Books, 1981); Thomas Richards, *The Commodity Culture of Victorian England: Advertising and Spectacle, 1851–1914* (Palo Alto: Stanford University Press, 1990); Christopher P. Wilson, "The Rhetoric of Consumption: Mass-Market Magazines and the Demise of the Gentle Reader, 1880–1920," in Richard Wightman Fox and T. J. Jackson Lears, eds., *The Culture of Consumption: Critical Essays in American History, 1880–1980* (New York: Pantheon Books, 1983), 39–64; and Patricia Anderson, *The Printed Image and the Transformation of Popular Culture 1790–1860* (Oxford: Clarendon, 1991).

12. See for instance Ivins, *Prints and Visual Communication* (Cambridge: MIT Press, 1969), 177; Ivins claims that the halftone process was "prerequisite to the existence of all our popular magazines and of our illustrated newspapers." See also David Clayton Phillips, "Art for Industry's Sake: Halftone Technology, Mass Photography and the Social Transformation of American Print Culture, 1880–1920," Ph.D. diss., Yale University, 1996.

13. Among the most influential books advocating the social control thesis in connection with religious benevolence are John R. Bodo, *The Protestant Clergy and Public Issues, 1812–1848* (Princeton: Princeton University Press, 1954), Clifford S. Griffin, *Their Brothers' Keepers: Moral Stewardship in the United States, 1800–1865* (New Brunswick: Rutgers University Press, 1960), and Charles I. Foster, *An Errand of Mercy: The Evangelical United Front, 1790–1837* (Chapel Hill: University of North Carolina Press, 1960). For more recent examples of this approach, see Stephen E. Berk, *Calvinism versus Democracy: Timothy Dwight and the Origins of American Evangelical Orthodoxy* (Hamden, Conn.: Archon Books, 1974) and Paul Boyer, *Urban Masses and Moral Order in America, 1820–1920* (Cambridge: Harvard University Press, 1978). For a critique of the historiography of the social control thesis, see Lois W. Banner, "Religious Benevolence as Social Control: A Critique of an Interpretation," *Journal of American History* 60, no. 1 (June 1973), 23–41. For further bibliography and discussion, see chapter 3, note 79.

14. For studies of contemporary religious belief in the United States, see George Gallup, Jr., "Religion in America," *Annals of the American Academy of Political and Social Science* 480 (July 1985), 167–74; and Wade Clark Roof and William McKinney, *American Mainline Religion: Its Changing Shape and Future* (New Brunswick: Rutgers University Press, 1987), 8–9; for a history of church growth and decline, see Roger Finke and Rodney Stark, *The Churching of America, 1776–1990: Winners and Losers in Our Religious Economy* (New Brunswick, N.J.: Rutgers University Press, 1992). On academic debates over the suitability of the secularization thesis, see Steve Bruce, ed., *Religion and Modernization: Sociologists and Historians Debate the Secularization Thesis* (Oxford: Clarendon Press, 1992). It is important to temper the secularization thesis with the operative distinction between secularization—the abandonment of religious belief—and privatization, the confinement of explicit assertions and practices of belief to the private or communal domains of church and home. While American society has not largely become secularized, it has certainly privatized belief. This does not mean, however, that belief plays no role in the public sphere, as the political debate and "culture wars" in the late twentieth century have demonstrated. Nor does it mean that by embracing a disenchanted world, as Max Weber defined it, do Christians secularize themselves out of belief. As Colin Campbell has argued, the subjectivization that ensues from disenchantment, the turn inward and location of spirituality within one's self-development and the cultivation of feeling as the basis of religious experience, becomes part of religious practice; Campbell, *The Romantic Ethic*, 73–4, 133. As I will explore in my conclusion, and as Jackson Lears has pointed out in a probing essay, American Protestants intermingle the older culture of self-control and character formation with the very modern practice of self-realization and the development of the personality. But whereas Lears regards this as fatefully secularizing, I do not. T. J. Jackson Lears, "From Salvation to Self-Realization: Advertising and the Therapeutic Roots of the Consumer Culture, 1880–1930," in Wightman Fox and Lears, *The Culture of Consumption*, 1–38.

15. Beecher's address was printed in *Proceedings of the Public Meeting Held in Boston to aid the American Sunday School Union in their Efforts to establish Sunday Schools throughout the Valley of the Mississippi* (Philadelphia: American Sunday School Union, 1831), 19.

16. Heman Humphrey, *The Way to Bless and Save Our Country: A Sermon* (Philadelphia: American Sunday School Union, 1831), 10.

17. Beecher, in *Proceedings*, 22.

18. Humphrey, *Way to Bless and Save Our Country*, 16.

19. Ibid., 17.

20. Anonymous, *Design, Character, and Uses of the Books of the American S.S. Union*, 9.

21. Ibid., 23, 24.

22. Horace Bushnell, "Unconscious Influence," in *Sermons for the New Life* (New York: Scribner's, 1905), 202.

23. Ann Douglas, *The Feminization of American Culture* (New York: Doubleday, 1977). For Douglas's discussion of influence, see 9, 46–8, 66–76, and 353 n. 4. For other considerations of influence, see Jackson Lears, *Fables of Abundance: A Cultural History of Advertising in America* (New York: Basic Books, 1994), 60–3, and Karen Haltunen, *Confidence Men and Painted*

Women: A Study of Middle-Class Culture in America, 1830–1870 (New Haven: Yale University Press, 1982), 4–5. Both Lears and Haltunen are interested in how influence was practiced as a means of control over and deception of the unsuspecting.

24. Douglas, *Feminization of American Culture*, 68–9.

25. Gardiner Spring, *Influence. A Quarter-Century Sermon, Preached in Behalf of the American Tract Society* (New York: American Tract Society, 1850), 4–5.

26. For excellent discussions of deception in nineteenth-century American culture, see Neil Harris, *Humbug: The Art of P. T. Barnum* (Boston: Little, Brown, 1973) and Haltunen, *Confidence Men and Painted Women*.

27. See Daniel Starch, *Advertising Principles* (Chicago: A. W. Shaw, 1927), 206–25.

28. *The Address of the Executive Committee of the American Tract Society to the Christian Public* (New York: American Tract Society, 1825), 6; reprinted in *The American Tract Society Documents*, ed. Edwin S. Gaustad (New York: Arno Press, 1972). This volume will be henceforth referred to as ATSD.

29. "Great System of Benevolence for Evangelizing the World," *Christian Almanac* 1822), 19.

30. "The Unknown Christians of India," *Christian Almanac* (1858), 40.

31. *The American Colporteur System* (New York: American Tract Society, 1836), 4; reprinted in ATSD. Emphasis in original.

32. "Miscellaneous Tract Distribution," *Thirteenth Annual Report of the American Tract Society* (New York: American Tract Society, 1838), 25. Hereafter referred to as *Thirteenth Annual Report* (1838).

33. Quotation of "a devout author in a former century," in "Volume Circulation," *Thirteenth Annual Report* (1838), 50. Emphasis in original. For a fascinating discussion of the importance of oral communications in eighteenth-century America, see Harry S. Stout, "Religion, Communication, and the Ideological Origins of the American Revolution," *William and Mary Quarterly* 34, no. 4 (October 1977), 519–41.

34. Rev. Charles P. M'Ilvaine, *Importance of Consideration*, no. 202, *Tracts of the American Tract Society* (New York: American Tract Society c. 1842), 6:1; [Rev. Nathan Beman], *Female Influence and Obligations*, no. 226, *Tracts*, 7:6. The New England Tract Society (forerunner of the Boston American Tract Society) issued tracts individually and its first two bound volumes as early as 1814. I have made use of seven volumes entitled *Publications of the American Tract Society* published in Andover by Flagg & Gould in 1824, consisting of the first 172 tracts published by the Boston ATS, which was the new name of the New England Tract Society beginning in June 1823. Each tract in the 1824 *Publications* was titled and numbered individually. For a helpful discussion of the New England Tract Society, the Boston ATS, and the New York ATS, see the *Twenty-fifth Annual Report of the American Tract Society* (New York: American Tract Society, 1850), 20–21. In 1825, the New York ATS began issuing these and additional tracts individually and in bound format.

Dating the tracts is generally possible by tracing a title's first appearance in the ATS annual reports or, better, by consulting the *American Tract Magazine,* published by the New York ATS, which advertised and discussed each new tract in the year of its appearance. General dating of tracts is also indicated by the address of the New York ATS listed on the wrapper and title page of each tract. The address of the ATS from 1825 to 1827 was 87 Nassau Street. From 1827 to 1832 the Society was located at 144 Nassau Street. And after 1832 its headquarters were at 150 Nassau Street. Precise dating of the bound volumes, however, is often very difficult since the volumes were reprinted frequently and without indication of date. Even more confusing is the fact that illustrations were not consistently used. I have relied largely on a twelve-volume set of the tracts, also titled *Publications of the American Tract Society*. Since the last tract (No. 428) of the twelfth volume of this edition of the tracts appeared individually in 1842, the date of the edition is presumably 1842. This set of volumes includes about one hundred illustrations engraved by Alexander Anderson from 1825 until 1834, when tract no. 313 appeared, which was the last tract illustrated in the 1842 edition.

I have also made use of an additional, undated twelve-volume set of tracts entitled *Tracts of the American Tract Society, General Series*. This set was produced in 1849 since it consists of five-hundred-twenty-two tracts and tract no. 522 appeared in 1849. The *Twenty-Fourth Annual Report* states that since the stereotype plates of the general series of tracts were worn out and the wood engravings inferior, most plates had been recast and "all the engravings inserted are neat and attractive." Moreover, this new version was gathered into twelve volumes instead of the previous fourteen. "Publishing Department," *Twenty-Fourth Annual Report* (1849), 15. This edition was illustrated in part if not entirely by Robert Roberts, who worked for the ATS as its first full-time engraver from 1847 until his death in 1850. Tract 474 in the final volume of this edition includes an illustration signed by Roberts.

Hereafter tracts are cited by title and number and by volume and page number with the year of publication referring to the two collections of the *Publications* consulted, 1824 and 1842; and to *Tracts,* 1849. In the event, however, that it is necessary and possible to indicate the date of an individual tract's publication, I have cited the tract as an independent publication. Complete collections of several series of the tracts are in the American Antiquarian Society. I am indebted to Jane Pomeroy for her extensive bibliographical knowledge of Anderson and the publications of the ATS. She has generously shared with me many of the findings that will appear in her study, "Engravings of Alexander Anderson," in progress.

35. Boyer, *Urban Masses and Moral Order in America,* 28–9.

36. "Rev. Smith's Address," *Thirtieth Annual Report* (1855), 6.

37. *Twenty-Fifth Annual Report* (1850), 16.

38. "Rev. Mr. Kirk's Address," *Twenty-Eighth Annual Report* (1853), 11.

39. "General Agents," *Twenty-Ninth Annual Report* (1854), 51.

40. For Schorr von Carolsfeld's image, see Julius Schnorr von Carolsfeld, *Die Bibel der Bildern* (Leipzig: Georg Wigland [1870?]), pl. 186; reproduced in Morgan, *Icons of American Protestantism*, 16.

41. *Twenty-First Annual Report* (1846), 76.

42. *American Colporteur System*, 31–2.

43. Hatch, *Democratization of American Christianity*, 14; see also by Hatch, "*Sola Scriptura* and *Novus Ordo Seclorum*," in *The Bible in America. Essays in Cultural History*, ed. Nathan O. Hatch and Mark A. Noll (New York: Oxford University Press, 1982), 59–78; and by the same author, "Elias Smith and the Rise of Religious Journalism in the Early Republic," in *Printing and Society in Early America*, ed. William L. Joyce, David D. Hall, Richard D. Brown, and John B. Hench (Worcester, Mass.: American Antiquarian Society, 1983), 250–77.

44. Moore, *Selling God*, 10.

45. Anonymous, *Design, Character, and Uses of the Books of the American S.S. Union*, 3.

46. Rev. J. D. Knowles, in *Proceedings*, 14.

47. Humphrey, *Way to Bless and Save Our Country*, 15.

48. "To the Patrons of the Christian Almanac," *Christian Almanac* (1829), 4.

49. "To the Patrons of the Christian Almanac," *Christian Almanac* (1832), 3. This issue of the *Almanac* included a section on religious revival, 18–24, as well as items on temperance and opposition to the use of tobacco. For a very instructive essay on antebellum millenialism and mass communications, see James H. Moorhead, "The Millennium and the Media," in Sweet, *Communication and Change*, 216–38.

50. On the identification of the clergymen's respective denominations, see Elisabeth McClellan, *History of American Costume 1607–1870* (New York: Tudor, (1937), 609–12; and Vergilius Ferm, *Pictorial History of Protestantism: A Panoramic View of Western Europe and the United States* (New York: Philosophical Library, 1957). My thanks to Gail Husch for providing this latter source. Professor Husch suggests on the basis of it that the figures may depict leading churchmen in eighteenth century who were influential in American Protestantism, including William Carey, John Wesley, George Whitefield, and Jonathan Edwards; personal correspondence.

51. See "John Gambold," *Dictionary of National Biography*, ed. Leslie Stephen (New York: Macmillan, 1889), 20:396–97.

52. Colin Brummit Goodykoontz, *Home Missions on the American Frontier* (Caxton, Idaho: Caxton Printers, 1939), 31. For an informative discussion of the Methodist outreach and publishing enterprise in the West, see Walter Sutton, *The Western Book Trade: Cincinnati as a Nineteenth-Century Publishing and Book-Trade Center* (Columbus: Ohio State University Press

for the Ohio Historical Society, 1961), chap. 12: "The Western Methodist Book Concern."

On Sartain and Fourierism, see Ann Katharine Martinez, "The Life and Career of John Sartain (1808–1897): A Nineteenth-Century Philadelphia Printmaker," Ph.D. diss., George Washington University, 1986, 84–101. Sartain and his family of engravers produced many religious prints both as individually framed images and as book illustrations. For a discussion of some of these, see the *Descriptive Catalogue of Sartain's Series of Sacred and National Engravings* (Rochester: R. H. Curran, 1866); and a series of gift books illustrated by Sartain and published in the 1840s in Philadelphia by Lindsay and Blakiston: *Scenes in the Life of the Savior* (1845); *Scenes in the Lives of the Apostles* (1846); and *Scenes in the Lives of the Patriarchs and Prophets* (1847). After undertaking the publication of *Sartain's Magazine*, formerly the *Union Magazine of Literature and Art*, Sartain published a list of 108 engravings used in the magazine that were available for individual purchase. More than ninety of these engravings were of religious subjects, nearly eighty of which were drawn from the life of Christ, see *Sartain's Magazine* 7, no. 5 (November 1850), 320.

53. On the AHMS and slavery, see Victor B. Howard, *Conscience and Slavery: The Evangelistic Calvinist Domestic Missions, 1837–1861* (Kent, Ohio: Kent State University Press, 1990), 40–72; and Goodykoontz, *Home Missions*, 289-305. Goodykoontz pointed out that in 1835 the AHMS sponsored fifty-three representatives in southern states; by 1860 this number had fallen to three (292).

54. Albert Barnes, *A Sermon in Behalf of the American Home Missionary Society* (New York: Printed for the American Home Missionary Society, 1849), 42, and Albert Barnes, *Inquiry into the Scriptural Views of Slavery* (Philadelphia: Perkins & Purves, 1846). An authoritative survey of the history of American Protestantism's millennialist longing for Christian hegemony and nationalism that has been of reliable use to this study is Robert T. Handy, *A Christian America: Protestant Hopes and Historical Realities*, 2nd ed. (New York: Oxford University Press, 1984).

55. Humphrey, *Way to Bless and Save Our Country*, 14.

56. *Speeches of Messrs. Webster, Frelinghuysen and Others at the Sunday School Meeting in the City of Washington, Feburary 16, 1831* (Philadelphia: American Sunday School Union, 1831), 17.

57. Beecher's address, in *Proceedings*, 21. For further discussion, see Smith, "'In Every Destitute Place.'"

58. Quoted in David B. Tyack, ed., *Turning Points in American Educational History* (Waltham, Mass.: Blaisdell, 1967), 189–90.

59. Some of the Millerite imagery is reproduced but not discussed in any detail in Ronald L. Numbers and Jonathan M. Butler, eds., *The Disappointed: Millerism and Millenarianism in the Nineteenth Century* (Bloomington: Indiana University Press, 1987); George Marsden reproduced three dispensationalist charts by

Clarence Larkin but did not discuss them (or even mention Larkin's name) in his *Fundamentalism and American Culture: The Shaping of Twentieth-Century Evangelicalism 1870–1925* (Oxford: Oxford University Press, 1980), 53, 58–9, 64–5. Edwin Le Roy Froom, Seventh-Day Adventist teacher and writer, included a chapter on Millerite charts in his monumental four-volume work *The Prophetic Faith of Our Fathers: The Historical Development of Prophetic Interpretation* (Washington, D.C.: Review and Herald, 1950–1954), 4:719–37, and a discussion of Seventh-Day Adventist charts, 4:1071–82, but his account transmits many errors and offers little more on the Millerites than could be gleaned from Francis D. Nichol's *The Midnight Cry* (Washington, D.C.: Review and Herald, 1944). More recent work by Adventist historians, though brief and written for popular consumption among the devout, has been helpful: Ron Graybill, "America: Magic Dragon," *Insight* 2 (November 30, 1971), 6–12, and "Picturing the Prophecies," *Adventist Review* 161, no. 27 (July 5, 1984), 11–14; and Vern Carter, "Horace Greeley and the Millerites," unidentified article, Ellen G. White Research Center, Andrews University, file DF 257, 33–34.

60. Uriah Smith, "A Bird's Eye View of the Great Field of Prophecy," *Review and Herald* 47, no. 1 (January 6, 1876), 5.

61. Ellen White, editorial in *Present Truth*, 1, no. 11 (November 1850), 86.

62. See Moorhead, "The Millennium and the Media," 216–38.

63. Joshua V. Himes, "Our Past Labors," *Midnight Cry* 4, no. 8 (April 13, 1843), 1.

64. Quoted in Joseph Bates, *The Autobiography of Elder Joseph Bates* (Battle Creek: Steam Press of the Seventh-Day Adventist Publishing Association, 1868), 269. That the Millerite images traveled far was demonstrated in a story in the *Midnight Cry*. A Millerite canal boat captain related a conversation with three newly arrived Norwegian immigrants. When he spoke to them concerning Miller's writings, they replied that they had heard of him. "I then showed them the Chart I have on board. The moment they saw it, they said that they had seen it in their own country," [Joshua V. Himes], notice, *Midnight Cry* 5, no. 5 (September 21, 1843), 37.

65. Ernest Sandeen, *The Roots of Fundamentalism: British and American Millenarianism, 1800–1930* (Chicago: University of Chicago Press, 1970), 185.

66. On the notion of biblical literalism and the fundamentalist notion of inerrancy, see Sandeen, *Roots of Fundamentalism*, 103–31; and Marsden, *Fundamentalism and American Culture*, 51, 107–23.

67. Paul Boyer, *When Time Shall Be No More: Prophecy Belief in Modern American Culture* (Cambridge: Harvard University Press, 1992).

68. See the essays, in Numbers and Butler, *The Disappointed*, by David T. Arthur, "Joshua V. Himes and the Cause of Adventism" 36–58, and Ronald D. Graybill, "The Abolitionist-Millerite Connection," 139–52; on Bates's promotion of temperance and aboli-

tion, see his *Autobiography*, 234–38; and Lewis Perry, *Radical Abolitionism: Anarchy and the Government of God in Anti-Slavery Thought* (Ithaca: Cornell University Press, 1973), 92–128.

69. Graybill, "The Abolitionist-Millerite Connection," 150.

70. Butler, "Making of a New Order," in Numbers and Butler, *Disappointed*, 193.

71. Graybill, "The Abolitionist-Millerite Connection," 141–42; Bates, *Autobiography*, 262.

72. D., "Improvements in the Arts," *Signs of the Times* 3, no. 12 (June 22, 1842), 95.

73. Modern science could also be derided by the Millerites as unequal to the task of marking the signs of the times—see, for instance, the critique of a lecture on the great comet of the spring of 1843, "The Comet," *Signs of the Times* 5, no. 4 (March 29, 1843), 28.

74. See Frank Presbrey, *The History and Development of Advertising* (Garden City, N.Y.: Doubleday, Doran, 1929), 227–351; Charles Goodrum and Helen Dalrymple, *Advertising in America, The First Two Hundred Years* (New York: Abrams, 1990), 13–34; and John Tebbel and Mary Ellen Zuckerman, *The Magazine in America 1741–1990* (New York: Oxford University Press, 1991), 140–6. Yet advertisement only began to flourish after the Civil War.

75. "Advertising," *Review and Herald* 7, no. 14 (January 3, 1856), 103.

76. The final issue of Marsh's paper appeared on June 10, 1854. Marsh turned to advertisement as a form of revenue for his publishing effort. He was forced to terminate his efforts at Adventist publication with the *Harbinger and Advocate* due to lack of finances—see David L. Rowe, *Thunder and Trumpets: Millerites and Dissenting Religion in Upstate New York, 1800–1850*, American Academy of Religion Studies in Religion (Chicago, Calif.: Scholars Press, 1985), 157.

77. Ronald L. Numbers and David R. Larson, "The Adventist Tradition," in *Caring and Curing: Health and Medicine in the Western Religious Traditions*, ed. Ronald L. Numbers and Darrel W. Amundsen (New York: Macmillan, 1986), 447–67; see also Ronald L. Numbers, *Prophetess of Health: A Study of Ellen G. White* (New York: Harper & Row, 1976).

78. Paul E. Johnson and Sean Wilentz, *The Kingdom of Matthias* (New York: Oxford University Press, 1994), 10.

Two: Evangelical Images and the American Tract Society

1. The ATS has not been the subject of a single published monograph but has been carefully studied in several dissertations and numerous essays and books. The dissertations of greatest use are Harvey Neufeldt, "The American Tract Society: An Examination of its Religious, Economic, Social, and Political Ideas," Ph.D. diss., University of Michigan, 1971; Stephen E. Slocum, Jr., "The American Tract Society: 1825–1975: An Evangelical Effort to Influence the

Religious and Moral Life of the United States," Ph.D. diss., New York University, 1975; and Karl Eric Valois, "To Revolutionize the World: The American Tract Society and the Regeneration of the Republic, 1825–1877," Ph.D. diss., University of Connecticut, 1994. Additional studies are cited throughout chapters 1 and 2 here.

For an overview of the many religious benevolent societies formed in the second and third decades of the nineteenth century and related initiatives among American Protestants to evangelize the rapidly growing population on the basis of the voluntary principle in the wake of disestablishment, see Robert Baird, *Religion in the United States of America* (Glasgow and Edinburgh: Blackie & Son; London: Duncan and Malcolm, 1844; reprint, New York: Arno Press, 1969), 310–411. Baird spoke at the ATS annual conference in 1838, *Thirteenth Annual Report* (1838), 3 (see chapter 1, note 32). For a list of American and British societies, see Charles I. Foster's fine study, *An Errand of Mercy: The Evangelical United Front, 1790–1837* (Chapel Hill: University of North Carolina Press, 1960), 275–80. For a history of the Society for the Propagation of the Gospel in Foreign Parts, the Anglican missionary society that formed the predecessor of all nineteenth-century benevolent societies, see John Calam, *Parsons and Pedagogues: The S.P.G. Adventure in American Education* (New York: Columbia University Press, 1971). The scholarly literature on antebellum benevolent societies and the voluntary principle is vast. A few of the most influential and useful studies are: Clifford S. Griffin, *Their Brothers' Keepers: Moral Stewardship in the United States, 1800–1865* (New Brunswick: Rutgers University Press, 1960); Foster, *An Errand of Mercy;* Elwyn A. Smith, "The Voluntary Establishment of Religion," in *The Religion of the Republic,* ed. Elwyn A. Smith (Philadelphia: Fortress Press, 1971), 154–82; Lois Banner, "Religious Benevolence as Social Control: A Critique of an Interpretation," *Journal of American History* 60 (June 1973), 23–41; Gregory H. Singleton, "Protestant Voluntary Organizations and the Shaping of Victorian America," *American Quarterly* 27, no. 5 (December 1975), 549–60; and Ralph Ruggles Smith, Jr., "'In Every Destitute Place': The Mission Program of the American Sunday School Union, 1817–1834," Ph.D. diss., University of Southern California, 1973.

2. *The American Colporteur System* (New York: American Tract Society, 1836), 22–23; reprinted in ATSD (see chapter 1, note 28). The same source indicates that in 1835 the thirty-one agents and colporteurs working for the ATS that year were members of the following churches: Congregational (six), Presbyterian (ten: five New School, five Old), Baptist (four), Episcopal (three), Methodist Episcopal (three), Dutch Reformed (one), Lutheran (two), and German Reformed (two).

3. "Constitution of the American Tract Society," article 1; in *The Address of the Executive Committee of the American Tract Society to the Christian Public* (New York: D. Fanshaw, 1825), 23; reprinted in ATSD.

4. Article 6 (ATSD), 24.

5. "Editor's Address," *Christian Almanac* 1822), iii (see chapter 1, note 4).

6. *Christian Almanac* (1822), iii–iv.

7. Ibid., iv.

8. Ibid., iii.

9. The characteristic visual aspect of the zodiac in almanacs was the man-of-signs, an emblem that visually related the parts of the body to astral signs according to the ancient system of astrological medicine. For the man-of-signs and illustrated almanacs in the eighteenth century, see Georgia B. Bumgardner, "American Almanac Illustration in the Eighteenth Century," in *Eighteenth-Century Prints in Colonial America: To Educate and Decorate,* ed. Joan D. Dolmetsch (Williamsburg, Va.: Colonial Williamsburg Foundation, 1979), 51–70. For a contemporary example, see "The Anatomy of Man's Body, as Governed by the Twelve Constellations" in John Bradford, *The Kentucky Almanac for the Year of Our Lord 1820* (Lexington: Thomas Smith, 1820), 3. For a fascinating discussion of the man-of-signs as part of colonial American magic, see Jon Butler, *Awash in a Sea of Faith: Christianizing the American People* (Cambridge: Harvard University Press, 1990), 80–3.

10. *Christian Almanac* (1822), 7.

11. Ibid., 6.

12. *Christian Almanac* (1823), 3.

13. The unrivaled revivalist in the 1830s, Charles Grandison Finney, for instance, claimed that if Christians "were united all over the world the Millennium might be brought about in three months," quoted in Paul E. Johnson, *A Shopkeeper's Millennium: Society and Revivals in Rochester, New York, 1815–1837* (New York: Hill and Wang, 1978), 109; for other examples of the imminent and inducible millennium, see Whitney R. Cross, *The Burned-Over District: The Social and Intellectual History of Enthusiastic Religion in Western New York, 1800-1850* (Ithaca: Cornell University Press, 1950), 168, 200–1.

The body of literature on revolutionary and antebellum millennialism is quite large and very accomplished. Two superb studies of millennialism and its political inflections in the American Revolution are Nathan O. Hatch, *The Sacred Cause of Liberty: Republican Thought and the Millennium in Revolutionary New England* (New Haven: Yale University Press, 1977) and Ruth Bloch, *Visionary Republic: Millennial Themes in American Thought, 1756–1800* (Cambridge: Cambridge University Press, 1985); see also C. C. Goen, "Jonathan Edwards: A New Departure in Eschatology," *Church History* 28, no. 1 (March 1959), 25–40. Helpful studies of antebellum millennialism include J. F. Maclear, "The Republic and the Millennium," in Smith, *Religion of the Republic,* 183–216; Nathan O. Hatch, "Millennialism and Popular Religion in the Early Republic," in *The Evangelical Tradition in America,* ed. Leonard I. Sweet (Macon, Ga.: Mercer University Press, 1984), 113–30; and James H. Moorhead, "Between Progress and Apocalypse: A Reassessment of Millennialism in American Religious Thought, 1800–1900," *Journal of*

American History 71, no. 3 (December 1984), 524–42; and by the same author, "The Millennium and the Media," in *Communication and Change in American Religious History,* ed. Leonard I. Sweet (Grand Rapids: William B. Eerdmans, 1993), 216–38. A very fine study of the millennial mission of the ATS is Valois, "To Revolutionize the World," 210–53, especially 231–33.

14. Original drawing by Westall, engraved by Charles Heath in *The Holy Bible,* 3 vols. (London: White, Cochrane and Co., 1815).

15. See Eleanore Price Mather, *Edward Hicks. His Peaceable Kingdoms and Other Paintings* (Newark: University of Delaware Press, 1983), 19. Westall's image was recut by Oliver Pelton to illustrate Isaiah 11:6 in Daniel D. Smith's 1825 edition of the Bible and by John Chorley for Holbrook's 1828 Bible, *The Holy Bible* (New York: Daniel D. Smith, 1825); *The Holy Bible* (Brattleborough, Vt.: Holbrook and Fessenden, 1828). As late as 1843 it appeared as the frontispiece in *The English Version of the Polyglott Bible* (Franklin, N.H.: Peabody & Daniel and D. Kimball, 1843).

16. Josiah Priest, *A View of the Expected Christian Millennium,* 5th ed. (Albany: Lomis' Press, 1828). A prolific author, Priest wrote historical works on American Indians, captivity narratives, the Revolutionary War, the western frontier, pre-Columbian American antiquities, a defense of slavery, and a refutation of William Miller's premillennialism. According to Winthrop Hillyer Duncan, "Josiah Priest: Historian of the American Frontier. A Study and Bibliography," *Proceedings of the American Antiquarian Society* 44 (1934), 45–102, Priest published seven editions of his book between 1827 and 1839 (57–60), though Duncan was unable to find the second, third, fourth, and fifth editions.

17. Priest, *A View of the Expected Millennium,* 84, 86, xii.

18. Ibid., 84.

19. By 1845, the Tract Society had printed twenty-one thousand copies of Beecher's *Sermons,* see *Twentieth Annual Report* (1845), 126. Beecher participated in several national and branch meetings of the ATS, see for instance *Thirteenth Annual Report* (1838), 4; "Report on a Western Tour," *Fifteenth Annual Report* (1840), 3; (1843), 3, 116; and (1848), 97.

20. Lyman Beecher, *A Plea for the West* (Cincinnati: Truman and Smith, 1835), 10; on Edwards's millennial beliefs, see Goen, "Jonathan Edwards."

21. Beecher, *Plea for the West,* 8.

22. Ibid., 10.

23. Quoted in Rev. Asa Bullard, *Fifty Years with the Sabbath Schools* (Boston: Lockwood, Brooks & Co., 1876), 162.

24. "Great System of Benevolence for Evangelizing the World," *Christian Almanac* (1822), 20.

25. Ibid., 25.

26. "General View of the Movements of the Church for the Last Thirty Years," *Christian Almanac* (1822), 41, 38, 40–41.

27. David Paul Nord, "Systematic Benevolence: Religious Publishing and the Marketplace in Early Nineteenth-Century America," in Sweet, *Commun-*

ication and Change, (Grand Rapids: Eerdmans, 1993), 243: *Christian Almanac* (1823), 3.

28. *Christian Almanac* (1822), 19.

29. See, for instance, Patricia U. Bonomi, "Education and Religion in Early America: Gleanings from *The New England Primer,*" Thirteenth Annual Phi Alpha Theta Distinguished Lecture on History, 1993, Department of History, State University of New York, Albany, 1993; Paul Leicester Ford, ed., *The New-England Primer: A History of Its Origin and Development* (New York: Dodd, Mead, 1897; reprint, New York: Teachers College, Columbia University, 1962), 1–26; Clifton Johnson, *Old-Time Schools and School-Books* (New York: Dover, 1963), 69–99; the bibliographic checklist by Charles F. Heartman, *The New England Primer Issued Prior to 1830* (New York: Printed for the compiler, 1922); and Vincent Faraone, *Teaching the ABC's in America 1647–1934: An Overview of Beginning Reading Materials,* exhibition catalogue, David Filderman Gallery, Hofstra University, 1984. For further examples of printed religious imagery in the seventeenth and eighteenth centuries, see Elizabeth Carroll Reilly, *A Dictionary of Colonial American Printers' Ornaments and Illustrations* (Worcester: American Antiquarian Society, 1975).

30. Sinclair Hitchings has discussed the issue of print and paper quality among ATS illustrated publications, "Some American Wood Engravers 1820–1840," *Printing and Graphic Arts* 9 (1961), 125–26.

31. Ibid., 125.

32. "Tenth Report. May 26, 1824," *Proceedings of the First Ten Years of the American Tract Society,* 128; reprinted in ATSD.

33. "Brief View of the Principal Religious Tract Societies," *Proceedings of the First Ten Years,* 181–82. For a helpful introduction to the ATS's efforts in illustrating its products, see Lawrence Thompson, "The Printing and Publishing Activities of the American Tract Society from 1825 to 1850," *Papers of the Bibliographical Society of America* 35, no. 2 (1941), 97–102. See also Hitchings, "Some American Wood Engravers." Since 1805, the Religious Tract Society of London had illustrated its tracts, many of which were reproduced by the ATS or used as models for engravers in Boston and New York. Thompson, "Printing and Publishing Activities," 97, indicates that Abel Bowen and his student, William Croome, illustrated ATS tracts in the 1820s by copying imagery from British tracts. For a discussion of British tract and other benevolent societies, see Ford K. Brown, *Fathers of the Victorians: The Age of Wilberforce* (Cambridge: Cambridge University Press, 1961), 317–60.

34. *Address of the Executive Committee of the American Tract Society to the Christian Public* (New York: American Tract Society, 1825), 6; ATSD, 6.

35. For a number of excerpts from nineteenth-century technical manuals on the craft of wood engraving, see *History of Graphic Design and Communication. A Source Book,* ed. Clive Ashwin (London: Pembridge Press, 1983), 124–62. For a discussion of new technologies for printing imagery in the eighteenth and nine-

teenth centuries, see Michael Twyman, *Printing 1770–1970: An Illustrated History of Its Development and Uses in England* (London: Eyre and Spottiswoode, 1970), 18–35. An excellent account on the technology of wood engraving is John Jackson and W. A. Chatto, *A Treatise on Wood Engraving* (London: Henry Bohn, 1861).

36. Anderson had used blocks on which type-metal plate cast from a combination of tin, lead, and antimony was attached to a layer of wood to make it the thickness of letterpress. But by 1797 Anderson had come to prefer boxwood. Although more expensive and difficult to acquire than type metal, boxwood did not require the troublesome process of melting and combining metals. Furthermore, type-metal blocks did not last as long as boxwood nor did they produce the clean gravure that lines in boxwood offered. I have relied on the excellent discussion of type metal and boxwood in Anderson's early practice in Jane Pomeroy, "Alexander Anderson's Life and Engravings before 1800, with a Checklist of Publications Drawn from His Diary," *Proceedings of the American Antiquarian Society* 100, pt. 1 (1990), 154–56, 172.

37. Twyman, *Printing 1770–1970*, 22, cites one nineteenth-century estimate of a single edition of 425,000 copies from a single wood-engraved block. In an article published in 1861, one author pointed out that copperplate engravings produced at maximum from one to three thousand copies, while engravings on steel produced a maximum of fifty thousand copies of good quality and one hundred thousand copies of coarser quality. Wood engravings produced one hundred thousand to one hundred fifty thousand copies of good quality. Lithographs provided a much smaller quantity, from five to ten thousand copies, John Collins, "Engraving on Metal, Wood, and Stone," *American Phrenological Journal* 28, no. 2 (August 1861), 21, and no. 5 (November 1861), 75.

38. See, for instance, the images reproduced by Bonomi, "Education and Religion in Early America," 2–8.

39. Benson J. Lossing, "Memorial," on Alexander Anderson, New York Historical Society, 1872; cited in W. J. Linton, *The History of Wood-Engraving in America* (London: George Bell and Sons, 1882), 2–3.

40. Charles Rosen and Henri Zerner, "The Romantic Vignette and Thomas Bewick," in Charles Rosen and Henri Zerner, *Romanticism and Realism. The Mythology of Nineteenth-Century Art* (New York: W. W. Norton, 1984), 86. Patricia Anderson has said the same of British illustrated newspapers from the 1830s to the 1860s: "The new inexpensive printed image thus became the first medium of regular, ongoing, mass communication," *The Printed Image and the Transformation of Popular Culture 1790–1860* (Oxford: Clarendon Press, 1991), 3. For a study that situates Bewick in eighteenth-century British culture, see John Brewer, *The Pleasures of the Imagination: English Culture in the Eighteenth Century* (New York: Farrar Straus Giroux, 1997), 499–530.

41. For biographical information on Bowen and his work, see Sinclair Hamilton, *Early American Book Illustrators and Wood Engravers 1670–1870.* 2 vols. (Princeton: Princeton University Press, 1958), 1:78–83; see also William H. Whitmore, *Abel Bowen, Engraver. A Sketch Prepared for The Bostonian Society* (Boston: Press of Rockwell and Churchhill, 1884), 3–16. Other sources on Bowen are Linton, *History of Wood-Engraving*, 11; and a brief note in William Dunlap, *History of the Rise and Progress of the Arts of Design in the United States,* ed. Alexander Wyckoff, 3 vols. (New York: Benjamin Blom, 1965), 3:19.

42. "Editor's Address," *Christian Almanac* (1821), v.

43. See, for instance, *Publications of the American Tract Society,* vol. 1 (New York: American Tract Society, 182–?), which includes the first thirty-three tracts issued by the Society, most of which were illustrated by Anderson. Jane Pomeroy has pointed out to me in personal correspondence that Anderson's first palm tree image appeared in the *Christian Almanack for the Western District. For the Year . . . 1828* (Utica: For the American Tract Society, by the Western Sunday School Union, [1827]). Anderson contributed several wood engravings to a Bible published in 1813 by Evert Duyckinck, John Tiebout, and G. & R. Waite in New York; for fourteen images by Anderson, see *The Holy Bible* (Philadelphia: H. C. Carey & I. Lea, 1825) and for an additional sixteen images, *The Holy Bible* (New York: Daniel D. Smith, 1825); three images by Anderson also appeared in an 1832 publication of the Bible by the Brattleboro Bible Company of Brattleboro, Vermont; for a good bibliographical study of Bible illustration in the early republic, which includes many Anderson illustrations, see Jacquelynn Slee, "A Summary of the English Editions of Illustrated Bibles Published in America between 1790 and 1825, with Indices of Subjects Illustrated and Engraved," M.A. thesis, University of Michigan, 1973. The best collection of Anderson's original work is gathered into twelve volumes entitled *Anderson Scrapbooks* and four volumes of *American Engravings,* neither dated, in the Duyckinck Collection in the Prints and Photographs Room in the New York Public Library. See also the Sinclair Hamilton Collection in the Princeton University Library and a bound volume of over eight hundred proofs of wood engravings entitled *Anderson's Wood Engravings* in the Boston Athenaeum. For further indications of which Bibles Anderson's work appeared in, see Margaret T. Hills, ed., *The English Bible in America: A Bibliography of Editions of the Bible and the New Testament Published in America 1777–1957* (New York: American Bible Society and New York Public Library, 1962). See also Pomeroy, "Alexander Anderson's Life and Engravings," 177–230, and 146–47 on the effects of the epidemic on Anderson's life; and Hamilton, *Early American Book Illustrators,* 1:48–67 and 2:28–40. For a very helpful summary of works in which Anderson's work appeared, see *A Brief Catalogue of Books illustrated with engravings by Dr. Alexander Anderson* (New York: Thompson & Moreau, Printers, 1885). On Anderson and his work, see Benson J. Lossing, "Dr. Alexander Anderson," *Child's Paper* 16, no. 11 (November 1867), 41;

Benson J. Lossing, *A Memorial of Alexander Anderson, M.D., the First Engraver on Wood in American. Read before the New York Historical Society, October 1870* (New York: Printed for the Subscribers, 1872); Frederic M. Burr, *Life and Works of Alexander Anderson, M.D., The First American Wood Engraver* (New York: Burr Brothers, 1893); John Wright, *Early Bibles in America,* 3rd rev. ed. (New York: Thomas Whittaker, 1894); and Helen M. Knubel, "Alexander Anderson and Early American Book Illustration," *Princeton University Library Chronicle* 1, no. 3 (April 1940), 8–18.

44. Abraham John Mason, quoted by William Dunlap in 1834 in *History of the Rise and Progress of the Arts of Design,* 2:135. Linton considered Anderson the first wood engraver in the United States and discussed his work for the ATS, *History of Wood-Engraving in America,* 2–9. Anderson's first edition of Bewick's book, *A General History of Quadrupeds,* was published in New York by G. & R. Waite in 1804. A second edition and several reprintings followed.

45. For Anderson's work, see the title page covers in the 1833 and 1834 *Christian Almanacs* by Anderson and illustrations on pages 18 and 17 of each year, signed "A." On the signature practice, see Pomeroy, "Alexander Anderson's Life and Engravings," 209; and Hitchings, "Some American Wood Engravers," 123.

46. My thanks to Jane Pomeroy for this information. Personal correspondence.

47. Bewick also produced two other images of the same motif, though varied in composition; both exhibit a more formally uniformed soldier with cane or gun (?) over the shoulder, carrying a bag, arriving home at a humble cottage, and greeted by a waiting woman—see *1800 Woodcuts by Thomas Bewick and His School,* with an introduction by Robert Hutchinson (New York: Dover, 1962), pl. 134, fig. 6; and *1,000 Quaint Cuts from Books of Other Days* (New York: Irving Zucker, 1950), 48.

48. Walter Licht, *Industrializing America: The Nineteenth Century* (Baltimore: Johns Hopkins University Press, 1995), 46–48.

49. On the Whiggish approbation of business and manufacture in the ASSU's children's literature, see Bernard Wishy, *The Child and the Republic: The Dawn of Modern American Child Nurture* (Philadelphia: University of Pennsylvania Press, 1968), 61–62; on the portrayal of labor in the literature of ATS tracts, see Mark S. Schantz, "Religious Tracts, Evangelical Reform, and the Market Revolution in Antebellum America," *Journal of the Early Republic* 17, no. 3 (Fall 1997), 425–66.

50. Leo Marx, *The Machine in the Garden: Technology and the Pastoral Ideal in America* (New York: Oxford University Press, 1964), 209–26.

51. *Christian Almanac* (1848), 15. The line was from "The Task" (1785), the best known work of Cowper (1731–1800), an evangelical whose work remained popular among British and American evangelicals in the nineteenth century. At least one of Bewick's students illustrated "The Task" with wood engravings, includ-

ing vignettes of idyllic rural scenes, see Twyman, *Printing 1770–1970,* 22; on the depiction of the rural or country setting in tract literature, see Schantz, "Religious Tracts, Evangelical Reform, and the Market Revolution."

52. Paul Boyer, *Urban Masses and Moral Order in America, 1820–1920* (Cambridge: Harvard University Press, 1978), 31, 33.

53. *Address of the Executive Committee,* 4, 5.

54. For a fascinating treatise on the power of influence, see the sermon preached by one of the founding members of the ATS and a cosigner of the *Address of the Executive Committee,* Gardiner Spring, *Influence* (New York: American Tract Society, 1850).

55. For a concise description of the historiography, see Gordon S. Wood, "The Significance of the Early Republic," *Journal of the Early Republic* 8 (Spring 1988), 11–12, where Wood cites a host of very instructive studies, including Cathy Matson and Peter Onuf, "Toward a Republican Empire: Interest and Ideology in Revolutionary America," *American Quarterly* 37, no. 4 (Fall 1985), 496–531, and Linda K. Kerber, "The Republican Ideology of the Revolutionary Generation," *American Quarterly* 37, no. 4 (Fall 1985), 474–95. Wood has taken up the entire issue in his very readable book *The Radicalism of the American Revolution* (New York, Knopf, 1992).

56. Wood, *Radicalism,* 221.

57. See, for instance, Arthur Schlesinger, Jr., *The Age of Jackson* (Boston: Little, Brown, 1946), 267–68.

58. For further discussion of antebellum evangelical sympathy and its visual expression, see David Morgan, *Visual Piety: A History and Theory of Popular Religious Images* (Berkeley: University of California Press, 1998), chap. 2. On coercion and persuasion in the voluntary principle of evangelical benevolence, see Smith, "The Voluntary Establishment of Religion," 154–82.

59. I have found helpful here Neil Harris's fine discussion of art, luxury, and republicanism in *The Artist in American Society: The Formative Years 1790–1860* (Chicago: University of Chicago Press, 1982), 28–53.

60. Information from *Christian Almanac* (1831, 1832) and Annual Reports (1833–1851):

1821—14,000 copies	1837—64,500
1822—40,000	1838—66,000
1823—50,000	1839—63,000
1824—50,000	1840—66,500
1825—50,000	1841—69,000
1826—50,000	1843—77,000
1827—71,500	1844—80,000
1828—123,000	1845—105,000
1829—127,500	1846—120,000
1830—116,050	1847—100,738
1831—147,000	1848—128,000
1833—75,500	1849—192,000
1834—86,738	1850—320,000
1836—71,000	1851—310,000

Note: between 1827 and 1830, the branch offices of the ATS in Boston and Rochester together produced one hundred thousand additional copies of the *Almanac*.

61. *Christian Almanac* (1828), 25–26.

62. Thompson, "Printing and Publishing Activities," 86.

63. For a discussion of stereotyping in the ATS, see David Paul Nord, "The Evangelical Origins of Mass Media in America, 1815–1835," *Journalism Monographs* (1984), 7–8; for an anthology of historical essays on the stereotyping process as it developed in the eighteenth and nineteenth centuries, see George A. Kubler, *Historical Treatises, Abstracts, and Papers on Stereotyping* (New York: Brooklyn Eagle Press, 1936. See also Valois, "To Revolutionize the World," 111–15. For an instructive study of the effect of stereotyping on wood engravings, see Jane R. Pomeroy, "On the Changes Made in Wood Engravings in the Stereotyping Process," *Printing History* 17, no. 2 (1995), 35–40.

64. Judith A. McGaw, *Most Wonderful Machine: Mechanization and Social Change in Berkshire Paper Making, 1801–1885* (Princeton: Princeton University Press, 1987), 64, 77. For a more general discussion of paper and print production as it affected the ATS, see Valois, "To Revolutionize the World," 101–11.

65. Elizabeth Twaddell, "The American Tract Society, 1814–1860," *Church History* 15 (1946), 123.

66. *Ninth Annual Report* (1823), 15.

67. *Christian Almanac* (1825), 3.

68. *Third Annual Report* (1828), 10. As sales of the *Almanac* fell, however, so did the number of local editions of the publication. Only 66,500 copies in 14 editions were produced in 1840. The *Fifteenth Annual Report* (1840) lamented the "considerable pecuniary loss" caused by the numerous editions and announced that the members of the central committee, "with the approbation of one of the most experienced Almanac makers, have determined to issue but one edition for 1841, entitled the Family Christian Almanac, and adapted to the United States generally" (p. 16). Sales must not have been strongly encouraging, however, for the *Sixteenth Annual Report* listed the production of only 69,000 copies of the *Almanac* (p. 16).

69. *Eighth Annual Report* (1833), 13.

70. *Christian Almanac* (1838), back cover.

71. *Fifteenth Annual Report* (1840), 16.

72. Howland's design appeared on the cover of the 1846, 1847, and 1848 *Almanacs* and was followed with several variations by Robert Roberts (1849, 1850), Benjamin Childs (1851, 1852), and Augustus Kinnersley (1853–1855, 1857–1858, and 1862–1864).

73. On Chapman (1808–1889), see Dunlap, *History of the Rise and Progress of the Arts of Design*, 3:244–45, and Hamilton, *Early American Book Illustrators*, 1:90–91; on Adams, see Linton, *History of the Wood-Engraving*, 12–16, and Hamilton, *Early American Book Illustrators*, 1:45–46. I have found very instructive on the history of Bible production a paper by Paul Gutjahr, "Revisiting Babel: A People of the Book Become a People of the Books," presented at the Pew Fellows Conference on Religion and American History at Yale University, April 7, 1995.

74. Linton, *History of the Wood-Engraving*, 22. For the scant biographic information available for any of these men, see Hamilton, *Early American Book Illustrators*, vols. 1–3; and George C. Groce and David H. Wallace, *The New-York Historical Society's Dictionary of Artists in America, 1564–1860* (New Haven: Yale University Press, 1957).

75. Thompson, "Printing and Publishing Activities," 100.

76. Eugene Exman, *The House of Harper: One Hundred and Fifty Years of Publishing* (New York: Harper and Row, 1967), 34–35.

77. *Twenty-Second Annual Report* (1847), 34.

78. Ibid., 30.

79. Groce and Wallace, *New-York Historical Society's Dictionary*, 330.

80. Although in 1841 Howland had engraved a cover for Babcock's Toy Books entitled *Animal Biography, or Book of Natural History* (New Haven: S. Babcock, 1841), which was similar to the Harper design, he had probably already seen Chapman's drawings for the Bible since he was working on that project in the early 1840s. My thanks to Jane Pomeroy for bringing the Babcock book to my attention.

81. Misquoted and inaccurately cited in Frank Luther Mott, *A History of American Magazines*, 4 vols. (New York: D. Appleton, 1930–1938), 2:192; "Illustrated Works," *Cosmopolitan Art Journal* 1, no. 4 (June 1857), 111. The principal engraver employed by the *Journal* was Nathaniel Orr. Works by Nathaniel Jocelyn, Elias Whitney, John William Orr, William Howland, and Phineas Annin also frequently appeared in the early volumes.

82. "Wood Engraving," *Cosmopolitan Art Journal*, 1, no. 2 (November 1856), 53–54.

83. *Eighteenth Annual Report* (1850), 39.

84. The Harper figure is cited in P. Marion Simms, *The Bible in America* (New York: Wilson-Erickson, 1936), 266; the Tract Society figures appear in the *Twenty-Fifth Annual Report* (1850), 31, 152. The "Treasurer's Report" in the *Twenty-Fifth Annual Report* (1850) listed payments of $463.18 for "printing steel engravings" and $5,959.35 for "engraving and designs" (152). Moses Allen, the treasurer for many years, did not itemize engravings and designs or their printing cost until 1850, when the sudden increase in production justified a separate line in the report. Expenditure on engravings varied over the next decade from a minimum of $4,938.31 in 1853 (*Twenty-Eighth Annual Report* [1853], 138) paid out on engravings (wood and steel) to as much as $8,944.95 in 1857 (*Thirty-Second Annual Report* [1857], 210) when the additional annual expense of "cards" was added to the "steel engravings" line. These were presumably the "Picture Cards for Children" advertised in each annual report. In 1857 the number of cards advertised in each package for purchase increased from 54 to 108, possibly corresponding to the increased expense registered in the treasurer's report that year.

85. *Twenty-Third Annual Report* (1848), 20.

86. The *Thirty-Second Annual Report* (1857) states that an engraver was first salaried in 1847 (236).

87. *Twenty-Fifth Annual Report* (1850), 39. According to Groce and Wallace, *New-York Historical Society's Dictionary of Artists in America,* Childs published the *Child's Paper* in which several of his images appeared, in New York from 1858 to 1863 (124–25).

88. *Twenty-Sixth Annual Report* (1851), 21.

89. *Twenty-Fifth Annual Report* (1850), 39.

90. This calculation does not include the thirty-three additional maps, star charts, and astronomical illustrations included in the first pages of many issues in the 1860s, a new feature that augmented the total number of images offered to readers of the *Almanac.* Factored into the decade, these additional images bring the average to fifteen illustrations per issue.

91. *Instructions of the Executive Committee of the American Tract Society, to Colporteurs and Agents* (New York: American Tract Society, 1868), 115; ATSD.

92. Exman, *House of Harper,* 69–70.

93. For instances of these engravers' work in the *Christian Almanac,* see the 1851 issue, p. 33, for an image by Richardson and p. 25 for one by Andrew; and the 1853 issue, p. 35, for an illustration by Bobbett. For a discussion of *Harper's New Monthly Magazine* and a number of other contemporary ventures in illustrated periodicals, see Linton, *History of the Wood-Engraving,* 27–33.

94. For illustrations in the *Christian Almanac* by Whitney and Jocelyn, see the 1856 issue, 23; for J. W. Orr, the 1854 issue, 31, and 33; for Annin, the 1853 issue, 29. On Whitney, see Hamilton, *Early American Book Illustrators,* 1:221.

95. Samuel P. Newman, *A Practical System of Rhetoric: or the Principles and Rules of Style,* 2nd ed. (Portland, Maine: Shirley & Hyde; Andover: Mark Newman, 1829), 188, 191. Cicero defined the simple style of speaking (*genus orationis adtenuatum*) as a manner of diction modeled on "the most ordinary speech of every day," Cicero, *Rhetorica ad Herennium,* tr. Harry Caplan (Cambridge: Harvard University Press, 1954), 260–61. Of the three styles differentiated by Cicero, the middle style was more relaxed than the grand style of discourse, in which "to each idea are applied the most ornate words that can be found for it" (255). The distinction held through much of the classical tradition. In the eighteenth century rhetorical treatises still distinguished between simplicity and sublimity in styles eloquence, see Thomas M. Conley, *Rhetoric in the European Tradition* (Chicago: University of Chicago Press, 1990), 231, for an example in a French text of 1751. An excellent discussion of the plain style as a pervasive category of rhetoric in British and American eighteenth-century culture, particularly as it related to the heroic portraits of republican patriarchs by Charles Willson Peale, is Brandon Brame Fortune, "Charles Willson Peale's Portrait Gallery: Persuasion and the Plain Style," *Word and Image* 6, no. 4 (October–December 1990), 308–24.

96. A statement of "those great doctrines" in which members of the ATS "all harmonise" appears in the *Address of the Executive Committee,* 1825: "Man's native sinfulness—the purity and obligation of the law of God—the true and proper Divinity of our Lord Jesus Christ—the necessity and reality of his atonement and sacrifice—the efficiency of the Holy Spirit in the work of renovation—the free and full offers of the Gospel, and the duty of men to accept it—the necessity of personal holiness—as well as an everlasting state of rewards and punishments beyond the grave—these are the doctrines dear to our hearts, and constitute the basis of our union." *Address of the Executive Committee,* 9.

97. The characterization of the language of tracts is found in the *Address of the Executive Committee,* 4.

98. *Christian Almanac* (1871), 30. The same image appeared three years earlier in *Child's Paper* 17, no. 3 (March 1868), 11, where the accompanying text, after describing a northern village's feast on "awks," pointed out: "This picture, however, is not that of the little awk which God sends in such vast numbers to feed the hungry Esquimaux. This is the *Great Awk,* the king and queen of awks." Apparently, the *Christian Almanac* article was an inaccurate gloss of the longer item in *Child's Paper.*

99. *Christian Almanac* (1860), 6.

100. I avoid the term "denotation" here for the reason that no meanings are fixed since a sign's meaning is constituted by its use in a given situation. On the issue of denotation and connotation and Roland Barthes's useful rhetoric of the image, which has been influential here, see Steve Baker, "The Hell of Connotation," *Word and Image* 1, no. 2 (April–June 1985), 164–75.

Three: The Visual Rhetoric of Northern Evangelicalism

1. David Chidester and Edward T. Linenthal, eds., *American Sacred Space* (Bloomington: Indiana University Press, 1995), 25.

2. Ocean steamers: *Christian Almanac* (1852), 25 (see chapter 1, note 4); suspension bridge over the Niagara River; *Christian Almanac* (1851), 25; telegraph: *Christian Almanac* (1863), 37, and in *Fireside Pictures* (New York: American Tract Society, 1863), 27; the construction of the Capitol: *Christian Almanac* (1853), 33.

3. *Christian Almanac* (1854), 17.

4. On the politics of this era, see Edward Pessen, *Jacksonian America: Society, Personality, and Politics,* rev. ed. (Homewood, Ill.: Dorsey Press, 1978) and Daniel Feller, *The Jacksonian Promise: America, 1815–1840* (Baltimore: Johns Hopkins University Press, 1995).

5. *Proceedings of the First Ten Years of the American Tract Society,* in ATSD, 65, 129 (see chapter 1, note 28). On the origin and development of the ATS in the South, see John W. Kuykendall, *Southern Enterprise: The Work of National Evangelical Societies in the Antebellum South* (Westport: Greenwood Press, 1982), 67–68, 113–15; and John W. Quist, "Slaveholding Operatives of the Benevolent Empire: Bible, Tract, and Sunday School

Societies in Antebellum Tuscaloosa County, Alabama," *Journal of the Early Republic* 62, no. 3 (August 1996), 481–526.

6. *Responsibilities of the Publishing Committee Under the Constitution* (New York: American Tract Society, 1858), 7.

7. For discussion of the slavery issue among benevolent societies, see John R. McKivigan, *The War against Proslavery Religion: Abolitionism and the Northern Churches, 1830–1865* (Ithaca: Cornell University Press, 1984), 111–27; Clifford S. Griffin, *Their Brothers' Keepers: Moral Stewardship in the United States, 1800–1865* (New Brunswick: Rutgers University Press, 1960), 177–97; and Karl Eric Valois, "To Revolutionize the World: The American Tract Society and the Regeneration of the Republic, 1825–1877," Ph.D. diss., University of Connecticut, 1994, 321–48.

8. Arthur M. Schlesinger, Jr., *The Age of Jackson* (Boston: Little, Brown, 1946), 451–52; for an overview of the Jacksonian proslavery position, see Pessen, *Jacksonian America*, 301–3.

9. See *Letters Respecting a Book "Dropped From the Catalogue" of the American Sunday School Union, in Compliance with the Dictation of the Slave Power* (New York: American and Foreign Anti-Slavery Society, 1848), a thirty-six-page pamphlet; on *Independent,* see Louis Fuller, *The Crusade against Slavery 1830 to 1860* (New York: Harper, 1960), 195–97; and Bertram Wyatt-Brown, *Lewis Tappan and the Evangelical War Against Slavery* (Cleveland: Press of Case Western Reserve University, 1969), 318–21.

10. *Letters Respecting a Book,* 9. The offending passage was reproduced in the American and Foreign Anti-Slavery Society pamphlet and demonstrates how dramatically the climate had changed from 1832 to 1848. "What is a slave, mother? asked Mary; is it a servant? Yes, replied her mother, slaves are servants, for they work for their masters and wait on them; but they are not hired servants, but are bought and sold like beasts, and have nothing, but what their master chooses to give them. They are obliged to work very hard, and sometimes their masters use them cruelly, beat them, and starve them, and kill them: for they have nobody to help them. Sometimes they are chained together and driven about like beasts" (6). The American and Foreign Anti-Slavery Society was founded in 1840 by Lewis Tappan and occupied a middle ground between the ASSU's accommodationism and the radicalsim of Garrison's American Anti-Slavery Society. On Tappan and the group of activists he gathered about him, see Lawrence J. Friedman, "Confidence and Pertinacity in Evangelical Abolitionism: Lewis Tappan's Circle," *American Quarterly* 31, no. 1 (Spring 1979), 81–106.

11. *Letters Respecting a Book,* 27. For a discussion of the ASSU and slavery, see Ralph Ruggles Smith, Jr., "'In Every Destitute Place': The Mission Program of the American Sunday School Union, 1817–1834," Ph.D. diss., University of Southern California, 1973, 202–7. Smith points out that the ASSU eventually abandoned

its mission to blacks in order to avoid controversy with proslavery members, 189.

12. *The Unanimous Remonstrance of the Fourth Congregational Church, Hartford, Conn., Against the Policy of the American Tract Society on the Subject of Slavery* (Hartford: Silas Andrus & Son, 1855).

13. "Rev. Mr. Cuyler's Address," *Thirtieth Annual Report* (1855), 9 (see chapter 1, note 32).

14. Ibid.

15. "Colportage," *Thirtieth Annual Report* (1855), 40.

16. "American Tract Society Circular," *Thirty-First Annual Report* (1856), 193–200. The document was republished in the 1856 annual report.

17. Ibid., 193, 197.

18. *A Review of the Official Apologies of the American Tract Society for its Silence on the Subject of Slavery* (New York: American Abolition Society, 1856), 6–8.

19. *Thirty-First Annual Report* (1856), 4.

20. "Publishing Department," *Thirty-First Annual Report* (1856), 23.

21. "Address of Dr. Johns," 206; "Rev. Mr. Denison of Charleston," 207; "Bishop Meade of Virginia," 210, *Thirty-Third Annual Report* (1858).

22. The special report of the executive committee that year noted that colporteurs had actually been withdrawn in some instances or were excluded, funds withheld from the national body, and "measures initiated for the entire separation of our southern auxiliaries, "Special Report of the Executive Committee of the American Tract Society," 196. For a consideration of the situation from the southern point of view in the wake of the 1858 annual meeting, see *Report and Resolutions, Adopted June 1, 1858, by the South-Carolina Branch of the American Tract Society in Reference to the Action Taken on Slavery by the Parent Society at its Last Annual Meeting, May 1858* (Charleston: South-Carolina Branch of the American Tract Society, 1858).

23. "Bishop McIlvaine's Address," *Thirty-Third Annual Report* (1858), 200–201.

24. "Rev. Dr. Stevenson's Address," *Thirty-First Annual Report* (1856), 179.

25. For a detailed overview of the controversy from the perspective of a longtime ATS officer, Seth Bliss, see his *Letters to the Members, Patrons, and Friends of the Branch American Tract Society in Boston,* 3rd ed. (Boston: Crocker & Brewster; New York: Carter & Bros., 1858). Bliss, secretary of the Boston ATS, was voted out of office in 1858 by the new anti-slavery majority. The New York ATS responded to the loss of its Boston branch by opening a "New England Branch of the American Tract Society," see the *Thirty-Fourth Annual Report* (1860), 351–55.

26. See a West Indies black woman shown in a subordinate role in an illustration, *Christian Almanac* (1862), 37; an African servant at the table at which Christ eats, *Christian Almanac* (1864), 25; a small cut of a white boy offering a tract to a black girl from "far over the seas" appeared in *Child's Paper* 2, no. 4 (April 1853), 16. The girl, who is seated beneath the boy who sits on an elevated platform, submits herself to the

boy's tutelage. Young black servants appear in an illustration by Alexander Anderson for tract no. 112, *History of Peter and John Hay* reproduced on the cover of *American Tract Magazine* 5, no. 7 (July 1830).

27. Fifth Annual Report in *Proceedings of the First Ten Years of the American Tract Society* (New York: American Tract Society (1824), 60–61. See also other tracts published by the ATS: *The African Servant*, no. 53; *The Happy Negro*, no. 7; *The Forgiving African*, no. 92; *The Blind Slave in the Mines*, no. 126; "Narrative of Phebe Ann Jacobs," no. 536; and "Old Moses," no. 571, *Tracts*, 1849, see chapter 1, note 34.

28. *The Praying Negro*, tract no. 92, in *Publications* (1824), 5:78; *The Forgiving African*, tract no. 92, in *Tracts*, 3:381.

29. *The Praying Negro*, 79. A tract entitled *The African Servant* by the very successful British tract writer Legh Richmond was resigned to the fact "for a season" many "are devoted to earthly slavery." The white narrator once again admonished the slave to be submissive, to which the slave happily replied: "Me know that if me sin against mine own massa, me sin against God, and God be very angry with me," tract no. 53, *Tracts*, (1849) 2:9.

30. Ambrose Serle, *The Happy Negro*, tract no. 7 (New York: American Tract Society, n.d. [ca. 1825]), 2. The same tract was first published by the Boston American Tract Society (*The Happy Negro*, tract no. 7, *Publications* (1824), 1:89–94 and was illustrated by a different cut from the one that appears in fig. 28 of which appears by virtue of its style to date to the late 1840s or 1850s.

31. "Passages from Dr. Bethune's Address," *Thirty-Third Annual Report* (1858), 203.

32. *Address of Rev. Stephen H. Tyng, D.D. At a Public Meeting held in the church of the Puritans, New York, in Behalf of the American Tract Society, (Boston)* (No publisher: May 12, 1860), 12. Copy at the American Antiquarian Society.

33. *Christian Almanac* (1863), 45, 49.

34. *Christian Almanac* (1864), 31.

35. "The Difference," *Christian Almanac* (1864), 34.

36. *United States Primer* (New York: American Tract Society, 1864) carries advertisements for items not published until 1865, suggesting that release was later or that the publication date was back-dated.

37. "Fort Sumter," *Christian Almanac* (1866), 19; 20.

38. *Christian Almanac* (1866), 42. *Child's Paper* followed suit. For an image of a former slave reading the Tract Society's *United States Primer*, prepared specifically for freedmen, see *Child's Paper* 14, no. 3 (March 1865), 10. The break-away Boston branch of the Society, however, produced images of blacks in its evangelical publications during the war that challenged slavery—see, for instance, *Pictures and Lessons for Little Readers* (Boston: American Tract Society, n.d.), 16, 28, 68, and 76.

39. See, for instance, *Christian Almanac* (1851), 29, 35; (1862), 35; (1856), 21. For a wide-ranging but fascinating discussion of contemporary depictions of Daniel

Boone among American painters, see David M. Lubin, *Picturing a Nation: Art and Social Change in Nineteenth-Century America* (New Haven: Yale University Press, 1994), 55–105.

40. See n. 43. Nonwestern cultures also provided the foil for other Christian nations such as England. A brief item entitled "The Gospel as an Element of Progress" in the 1852 *Almanac* made this clear: "The sons of Chinese peasants could read and write when the princes of England were ignorant of both. China has since made no advance; while England has reached a height of civilization that no one at that time could have formed any idea of. England has had the gospel, China has been without it. This accounts for their relative change of position." *Christian Almanac* (1852), 27.

41. Francis Bowen, *The Principles of Political Economy* (Boston: Little, Brown, 1856); quoted in Arthur Alphonse Ekirch, Jr., *The Idea of Progress in America, 1815–1860* (New York: Peter Smith, 1951), 86–87. For a comparable statement by a member of the United States House of Representatives speaking at a meeting of the ASSU, see *Speeches of Messrs. Webster, Frelinghuysen and Others at the Sunday School Meeting in the City of Washington* (Philadelphia: American Sunday School Union, 1831), 10–11.

42. N. H. Parker, *The Minnesota Handbook for 1856–57* (Boston, 1857), 103; quoted in Ekirch, *Idea of Progress*, 90.

43. H.K.E., "Indians in Iowa," *Well-Spring* 17, no. 29 (July 20, 1860), 14. For a pertinent discussion of typology, see Sacvan Bercovitch, "The Typology of America's Mission," *American Quarterly* 30, no. 2 (Summer 1978), 135–55.

44. *Christian Almanac* (1862), 31.

45. George Caleb Bingham, *Fur Traders Descending the Missouri*, 1845, oil on canvas, Metropolitan Museum of Art, New York.

46. "What Preaching Will Convert Men?" *Christian Almanac* (1863), 31.

47. "An Indian Village—Sioux," *Christian Almanac* (1877), 24.

48. For discussion of the abuse of women in Hindu and Islamic societies according to the views of evangelical missionaries and contributors to Tract Society publications, see Rev. John Scudder, *Dr. Scudder's Tales for Little Readers, About the Heathen* (New York: American Tract Society, 1853), and Rev. Henry Lyman, *Condition of Females in Pagan and Mohammedan Countries*, tract no. 13, *Publications* (1842), vol. 1. Scudder was a missionary in Ceylon and Madras; Lyman was a missionary in Sumatra. The low state of women in "savage" cultures was reported by authors before Scudder and Lyman and by some who were as non-evangelical as Thomas Jefferson, who wrote in his *Notes on Virginia* (1785) that "the stronger sex" among "barbarous" peoples imposes its will on "the weaker" and that only in civilized cultures did it occur that women were accorded their "natural equality," cited and discussed in Leo Marx, *The Machine in the Garden:*

Technology and the Pastoral Ideal in America (New York: Oxford University Press, 1964), 121–22.

49. "Colportage. Responsibility in the Choice of Means for Evangelization," *Forty-Seventh Annual Report* (1872), 34.

50. *The American Colporteur System* (New York: American Tract Society, 1836), 15, 15–19; reprinted in ATSD. For a discussion of the ASSU's Mississippi Valley campaign, in which Beecher and anti-Catholicism had also played a role, see Smith, "'In Every Destitute Place,'" 110–15. On ATS colportage, see David Paul Nord, "Religious Reading and Readers in Antebellum America," *Journal of the Early Republic* 15 (Summer 1995), 241–72.

51. Lyman Beecher, *A Plea for the West* (Cincinnati: Truman and Smith, 1835), 69.

52. Ibid., 11.

53. For a biographical discussion of Lyman Beecher's successive campaigns, (and their impact on his daughter Catharine), see Kathryn Kish Sklar, *Catharine Beecher: A Study in American Domesticity* (New York: W. W. Norton, 1976), 67–121.

54. Beecher, *Plea for the West*, 36–37.

55. Ibid., 161.

56. Ibid., 117–18.

57. On social control and regulation: *ibid.*, 158, 161, 169–70; on priesthood, 117; on voluntary associations, 41.

58. *Twenty-First Annual Report* (1846), 3.

59. "Address of Dr. Beecher, of Cincinnati," *Eighteenth Annual Report* (1843), 116. On Edwards's millennialism, see C. C. Goen, "Jonathan Edwards: A New Departure in Eschatology," *Church History* 28, no. 1 (March 1959), 25–40, especially 27–28; for other nineteenth-century postmillennialist notions of final conflict, see James H. Moorhead, "Between Progress and Apocalypse: A Reassessment of Millennialism in American Religious Thought, 1800–1880," *Journal of American History* 71, no. 3 (December 1984), 534–35, and Berkovitch, "Typology of America's Mission," 138–41.

60. "Our Own Country," *Eighteenth Annual Report* (1843), 24, 25–26; see also *Twenty-First Annual Report* (1846), 77. The rhetoric of the "great conflict" or "battle" was used by benevolent societies that shared an anti-Catholic view: see, for instance, the AHMS's concern for the West, where "the great battle is to be fought between truth and error," quoted in Ray Allen Billington, *The Protestant Crusade 1800–1860: A Study of the Origins of American Nativism* (New York: Rinehart, 1938), 129.

61. *Twenty-First Annual Report* (1846), 95; on Catholics and colportage: *American Colporteur System*, 17–19; *Eighteenth Annual Report* (1843), 63–67; *Nineteenth Annual Report* (1844), 65, 82–87; *Twenty-First Annual Report* (1846), 95–98; *Thirty-Third Annual Report* (1858), 126–28.

62. *Thirty-Third Annual Report* (1858), 39.

63. See, for instance, *Twelfth Annual Report* (1837), 127; and *Twenty-First Annual Report* (1846), 96.

64. Valois has discussed the fact that several among the ATS elite were noteworthy supporters of the recolonization of American blacks in Africa, "To Revolutionize the World," 322–23.

65. On Darley and his work, see Sue W. Reed, "F. O. C. Darley's Outline Illustrations," in *The American Illustrated Book in the Nineteenth Century,* ed. Gerald W. R. Ward (Winterthur, Del.: Winterthur Museum, 1987), 113–36; Christian Anne Hahler, ". . . illustrated by Darley", exhibition catalogue (Wilmington: Delaware Art Museum, 1978); and Ethel King, *Darley: The Most Popular Illustrator of His Time* (Brooklyn: Gaus, 1964).

66. Although there were several series of tracts published by the ATS and each series illustrated different tracts, the bound tracts published after Roberts and Childs became employees of the Society, that is, around or after 1850, are those from which I have drawn my information regarding Catholic imagery. These tracts are numbers 62, 251, 248, 255, 319, 432, 438, 498, 522, 528, 556, 557, 568, and 577. *Mary of Toulouse,* no. 522, discusses Mary's abandonment of the rosary on page 16. For brief descriptions of each tract, see *Sketch of the Origin and Character of the Principal Series of Tracts* (New York: American Tract Society, 1854); reprinted in ATSD.

67. For examples of this iconography, see those reproduced in Billington, *Protestant Crusade.*

68. William Hogan, *Auricular Confession and Popish Nunneries* (Hartford: S. Andrus & Son, 1845), 283. For accounts of priestly abuse of the confessional and infanticide at the hands of the abbess and priest, see Maria Monk, *Awful Disclosures of the Hotel Dieu Nunnery of Montreal* (New York: Published by Maria Monk, 1836; reprint, New York: Arno Press, 1977), 19–21, 154–57, and 195–96.

69. The following studies have been helpful in understanding the history of American nativism, anti-Catholicism, and evangelicalism: Billington, *Protestant Crusade;* John R. Bodo, *The Protestant Clergy and Public Issues 1812–1848* (Princeton: Princeton University Press, 1954; reprint, Philadelphia: Porcupine Press, 1980), 61–84; David Brion Davis, "Some Themes of Counter-Subversion: An Analysis of Anti-Masonic, Anti-Catholic, and Anti-Mormon Literature," *Mississippi Valley Historical Review* 47, no. 2 (September 1960), 205–24; Eric Foner, *Free Soil, Free Labor, Free Men: The Ideology of the Republican Party before the Civil War* (Oxford: Oxford University Press, 1995), 226–60; John Higham, *Strangers in the Land: Patterns of American Nativism, 1860–1925,* 2nd ed. (New Brunswick: Rutgers University Press, 1988); Roger Daniels, *Coming to America: A History of Immigration and Ethnicity in American Life* (New York: HarperPerennial, 1990), 265–84; and Jenny Franchot, *Roads to Rome: The Antebellum Protestant Encounter with Catholicism* (Berkeley: University of California Press, 1994).

70. For instance, the frontispiece to the pamphlet *The Colporteur and Roman Catholic. A Dialogue* (New York: American Tract Society, 1847) portrayed a colpor-

teur entering a doorway and meeting a seated man, the Roman Catholic, whom we know to be Catholic only because of the title of the tract.

71. For an instance of the use of *Spirit of Popery* in ATS missions, see *Twenty-First Annual Report* (1846), 97. The "Sale of Indulgences" engraving (fig. 2.18) also appeared in the ASSU's *Youth's Penny Gazette* 1, no. 17 (August 23, 1843), 65.

72. Lossing also illustrated John Dowling's *History of Romanism* (New York: Walker, 1845), a polemical text that had gone through sixteen editions by 1848.

73. *Twenty-First Annual Report* (1846); *Thirtieth Annual Report* (1855), 143.

74. *Christian Almanac,* 1856, 23–24. A subtle and very rich analysis of Protestant perceptions of Roman Catholics during the antebellum period, one that includes a discussion of the Protestant discourse on word versus image, is Franchot, *Roads to Rome,* 6–7.

75. See the *Sketch of the Origin and Character of the Principal Series of Tracts of the American Tract Society* (New York: American Tract Society, 1859), in ATSD; for German tracts, see *American Colporteur System,* 16–17. A book reprinted by the ATS in the attempt to argue on historical grounds for the corruption of Catholicism and the importance of the Reformation was J. H. Merle D'Aubigne's three-volume *History of the Great Reformation in the Sixteenth Century.* By 1844 the Society had printed two thousand copies of this work (*Nineteenth Annual Report* [1844], 138); only two years later, however, the number jumped to twenty-six thousand as the Society prepared to deploy this text as an important tool in colportage among Catholic immigrants (*Twenty-First Annual Report* [1846], 79). For the ATS's sales pitch for D'Aubigne's book, which promised to disclose the true likeness of "popery," see the *Nineteenth Annual Report* (1844), 12–13. A colporteur reported in 1846 that Roman Catholics in the Northeast had circulated a critical review of D'Aubigne's book, *Twentieth Annual Report* (1846), 95; for further discussion of D'Aubigne's text, see Billington, *Protestant Crusade,* 350.

76. "Something Can Be Done For Romanists," *Eighteenth Annual Report* (1843), 65.

77. "Home Operations," *Nineteenth Annual Report* (1844), 87. Baxter's *Saints' Rest,* his *Dying Thoughts,* and his *Call to the Unconverted* were among the titles most heralded by the Society, see *Twentieth Annual Report* (1845), 138. By 1837, the Society had printed 111,000 copies of the three titles, *Twelfth Annual Report* (1837), 18. By 1840 the total had increased to over 187,000, *Fifteenth Annual Report* (1840), 17.

78. *Christian Almanac* (1856), 24.

79. "Reading the Bible to the People," *Christian Almanac* (1852), 21.

80. David G. Mathews, "The Second Great Awakening as an Organizing Process, 1780–1830," *American Quarterly* 21, no. 1 (Spring 1969), 23–43; Lois W. Banner, "Religious Benevolence as Social Control: A Critique of an Interpretation," *Journal of American History* 60, no. 1 (June 1973), 23–41; three important

studies of nineteenth-century religious benevolence that helped establish the social control thesis are Clifford S. Griffin, "Religious Benevolence as Social Control, 1815–1860," *Mississippi Valley Historical Review* 44 (December 1957), 423–44; Griffin, *Their Brothers' Keepers;* and Charles I. Foster, *An Errand of Mercy: The Evangelical United Front, 1790–1837* (Chapel Hill: University of North Carolina Press, 1960). For an assessment and bibliography of the social control thesis in the context of the benevolent associations, see Valois, "To Revolutionize the World," 74–78, and 94 n. 26. See also chapter 1 here and note 13.

81. Walter Licht, *Industrializing America: The Nineteenth Century* (Baltimore: Johns Hopkins University Press, 1995), 74. I have explored the social implications of the sympathy practiced in the visual culture of benevolence in *Visual Piety: A History and Theory of Popular Religious Images* (Berkeley: University of California Press, 1998), chapter 2.

82. Licht, *Industrializing America,* 76.

83. For discussion of this literature, see Sklar, *Catharine Beecher;* Maxine Van de Wetering, "The Popular Concept of 'Home' in Nineteenth-Century America," *Journal of American Studies* 18, no. 1 (April 1984), 5–28; Joanna Bowen Gillespie, "'The Clear Leadings of Providence': Pious Memoirs and the Problems of Self-Realization for Women in the Early Nineteenth Century," *Journal of the Early Republic* 5 (Summer 1985), 197–221; and Colleen McDannell, *The Christian Home in Victorian America, 1840–1900* (Bloomington: Indiana University Press, 1986).

84. Anonymous, "A Nursery Lesson," *Christian Almanac* (1865), 45.

85. C.E.R.P., "Louis and Louise," *Christian Almanac* (1874), 23.

86. Knight published numerous biographies, including a *Life of Bunyan*; she also produced an account of eighteenth-century revivalism in Great Britain called *Lady Huntington and Her Friends,* which was published by the ATS in 1853, as well as several children's books (such as a *Pictorial Alphabet,* 1845), many of which were published by the ATS and advertised on the pages of the *Almanac.* Her work was also published by the ASSU and the Massachusetts Sabbath School Society. In 1851 she published a history of Liberia, colonized by free blacks as the American Colonization Society's answer to the plight of black slavery, *Africa Redeemed: or, The Means of Her Relief Illustrated by the Growth and Prospects of Liberia* (London: James Nisbet & Co., 1851). The *National Union Catalog* lists twenty-eight different titles by Knight ranging from the 1840s to the 1880s. For a compilation of much of her work published in *Child's Paper* during the 1850s, see Helen Cross Knight et al., *Flowers of Spring-Time* (New York: American Tract Society, 1861).

87. A study fundamental to scholarship on antebellum women writers and Protestantism is Ann Douglas, *The Feminization of American Culture* (New York: Doubleday, 1977). Two other studies of basic importance to the issue of class and women in the same pe-

riod are Mary P. Ryan, *Cradle of the Middle Class: The Family in Oneida County, New York, 1790–1865* (New York: Cambridge University Press, 1981) and Nancy Cott, *Bonds of Womanhood: "Women's Sphere" in New England, 1780–1835* (New Haven: Yale University Press, 1977).

88. Colin Campbell, *The Romantic Ethic and the Spirit of Modern Consumerism* (Oxford: Basil Blackwell, 1987), 171–201.

89. Ibid., 99–137.

90. See, for instance, Malcolm Gladwell, "Listening to Khakis," *New Yorker*, July 28, 1997, 54–65.

91. H[elen] C. K[night]., "A Call on the Bride," *Christian Almanac* (1862), 27.

92. [Nathan Beman], *Female Influence and Obligations*, no. 225 (New York: American Tract Society, [1829]), 1.

93. Ibid., 3–4.

94. *Female Influence*, 4; *Letters on Christian Education*, no. 197, *Tracts*, (1849), vol. 6.

95. Linda Kerber, "The Republican Mother: Women and the Enlightenment—An American Perspective," *American Quarterly* 28, no. 2 (Summer 1976), 187–205; Sklar, *Catharine Beecher*, 134–37.

96. *Female Influence*, 4.

97. Barbara Welter, "The Cult of True Womanhood: 1820–1860," *American Quarterly* 18, no. 2 (Summer 1966), 153; on women's benevolence, see Keith Melder, "Ladies Bountiful: Organized Women's Benevolence in Early Nineteenth-Century America," *New York History* 68, no. 3 (July 1967), 231–54; Anne M. Boylan, "Women in Groups: An Analysis of Women's Benevolent Organizations in New York and Boston, 1797–1840," *Journal of American History* 71, no. 3 (December 1984), 497–515; and Lori D. Ginzberg, *Women and the Work of Benevolence: Morality, Politics, and Class in the Nineteenth-Century United States* (New Haven: Yale University Press, 1990); for more on "women's sphere," see Cott, *Bonds of Womanhood*, and Anne M. Boylan, "Evangelical Womanhood in the Nineteenth Century: The Role of Women in Sunday Schools," *Feminist Studies* 4 (October 1978), 62–80.

98. In spite of the restrictive boundaries of the "woman's sphere," some evangelical women were successful in expanding or reshaping its limits or working within its bounds to discover news definitions of the self—see Gillespie, "'The Clear Leadings of Providence,'" Gillespie differs from Barbara Welter and Mary Ryan, who, in her words, "view evangelicalism in the nineteenth century as part of a conspiracy to keep women in the domestic sphere," 211 n. 41.

99. "Worth Knowing," *Christian Almanac* (1854), 25.

100. *Christian Almanac* (1854), 24.

101. James W. Alexander, *The American Sunday-School and Its Adjuncts* (Philadelphia: American Sunday School Union, 1856), 268. Alexander acknowledged the contribution that government made to poverty and class distinctions but saw the deeper cause of social ills in "the individual character of whole classes," 285. Poverty, finally, "as all the world knows, . . . arises from ignorance and vice," 280.

102. "Dr. Smith's Address," *Thirtieth Annual Report* (1855), 7.

103. On the role of the individual in social reform and the New School theory of free agency, see John L. Thomas, "Romantic Reform in America, 1815–1865," *American Quarterly* 17, no. 4 (Winter 1965), 656–81; Timothy L. Smith, "Righteousness and Hope: Christian Holiness and the Millennial Vision in America, 1800–1900," *American Quarterly* 31, no. 1 (Spring 1979), 21–45; Richard O. Curry and Karl E. Valois, "The Emergence of an Individualistic Ethos in American Society" and Robert M. Calhoon, "Religion and Individualism in Early America," in *American Chameleon: Individualism in Trans-national Context*, ed. Richard O. Curry and Lawrence B. Goodheart (Kent, Ohio: Kent State University Press, 1991), 20–43 and 44–65; and Valois, "To Revolutionize the World," 216–20.

104. "Influences of Good and Bad," *Christian Almanac* (1864), 23–24. Other Tract Society publications could stress hope for the alcoholic, see tract no. 422, *Reformation of Drunkards*, by John Marsh, secretary of the American Temperance Society. This tract was described as showing "that there is hope for the drunkard, with appeals to himself and friends," *Sketch of the Origin and Character of Tracts*, 20.

105. For further consideration of infidelism in ATS publications, see Valois, "To Revolutionize the World," 256–63.

106. See for instance the image of a woman in an elaborate bonnet handing a Bible to a farm worker, *American Tract Magazine* 9, no. 2 (February 1834), 13. This image is reproduced and discussed in Morgan, *Visual Piety*, 90–92.

107. Data drawn from tracts and *Sketch of the Origin and Character of Tracts*. For further discussion of the tracts, their themes, implications for class, and their categorization, see Paul Boyer, *Urban Masses and Moral Order in America, 1820–1920* (Cambridge: Harvard University Press, 1978), 27–33; and Valois, "To Revolutionize the World," 133–34; see also Mark S. Schantz, "Religious Tracts, Evangelical Reform, and the Market Revolution in Antebellum America," *Journal of the Early Republic* 17, no. 3 (Fall 1997), 425–66.

108. Helen Knight, *Christian Almanac* (1861), 42.

Four: Millerism and the Schematic Imagination

1. Nathan O. Hatch, *The Democratization of American Christianity* (New Haven: Yale University Press, 1989); and Nathan O. Hatch, "Elias Smith and the Rise of Religious Journalism in the Early Republic," in *Printing and Society in Early America*, ed. William L. Joyce, David D. Hall, Richard D. Brown, and John B. Hench (Worcester, Mass.: American Antiquarian Society, 1983), 274–76.

2. See Nathan O. Hatch, "*Sola Scriptura* and *Novus Ordo Seclorum*," in *The Bible in America: Essays in Cultural History*, ed. Nathan O. Hatch and Mark A. Noll (New York: Oxford University Press, 1982), 59–78.

3. It was important among the Adventists to distinguish carefully between their views and those of rival millennialists, which were subdivided by some into two categories: pre- and post-millennialists. Adventist preacher and theologian Josiah Litch, the first to publicly embrace the views of William Miller, put the differences this way: "The Adventists believe in a pre-millennial and personal advent of Christ from heaven, to glorify his saints and to take vengeance on his foes. While the Millenists believe in the universal spiritual reign of Christ a thousand years, before his second personal reign . . . [t]he Millennarians believe in the pre-millennial advent of Christ, and his personal reign for a thousand years before the consummation or end of the present world, and creation of the new heavens and earth, and the descent of the New Jerusalem. While the Adventists believe the end of the world . . . [etc.] will be at the beginning of the thousand years," "The Rise and Progress of Adventism," in *The Advent Shield and Review*, ed. J. V. Himes, S. Bliss, and A. Hale (Boston: Joshua V. Himes, 1844), 47. For a helpful distinction of terminology, see Ernest R. Sandeen, *The Roots of Fundamentalism: British and American Millenarianism 1800–1930* (Chicago: University of Chicago Press, 1970), 5, 37. There were additional doctrinal distinctions (see Litch, "Rise and Progress of Adventism," 48), but this statement by Litch suffices to set out the differences. Millennialism generally diverged from the orthodox Protestant and Catholic view that the thousands years mentioned in the book of Revelation was not a literal reference.

4. William Miller, *Apology and Defense* (Boston: J. V. Himes, 1845), 2.

5. Ibid., 3; Miller also mentioned Hume and Voltaire as authors whose works he read. The exemplary books by American deists, presumably the works with which Miller was familiar, were Thomas Paine, *Age of Reason, Being an Investigation of True and Fabulous Theology* (1794) and Ethan Allen, *Reason The Only Oracle of Man, Or Compenduous System of Natural Religion* (1784).

6. Whitney R. Cross, *The Burned-Over District: The Social and Intellectual History of Enthusiastic Religion in Western New York, 1800–1850* (Ithaca: Cornell University Press, 1950), 290, suggested that Miller's "early skepticism had been rather a fashionable, youthful adventure than a firm-rooted conviction." Ruth Alden Doan followed this view by suggesting that Miller merely "played the role of the skeptical deist for some years" when it was fashionable for young men to do so, *The Miller Heresy, Millennialism, and American Culture* (Philadelphia: Temple University Press, 1987), 17.

7. Ibid., 3, 4, 5.

8. Miller, *Apology and Defense*, 6; see also Josiah Litch, "Rise and Progress of Adventism," 50.

9. Thomas Paine, *Age of Reason*, part 1, 1794; pt. 2, 1795 (New York: Freethought Association, n.d.), 16.

10. Ibid., 66, 137.

11. Ibid., 75.

12. Quoted in Litch, "Rise and Progress of Adventism," 50.

13. "Mr. Miller's Letters, no. 5. The Bible its Own Interpreter," *Signs of the Times* 1, no. 4 (May 15, 1840), n.p.; reprinted in William Miller, *Views of the Prophecies and Prophetic Chronology*, ed. Joshua V. Himes (Boston: J. V. Himes, 1842), 20–24.

14. Ethan Allen, *Reason the Only Oracle of Man* Bennington, Vermont: Haswell and Russell (1784; reprint, New York: Scholars' Facsimiles and Reprints, 1940), 285.

15. Miller, *Apology and Defense*, 6.

16. Compare Paine, *Age of Reason:* "Every science has for its basis a system of principles as fixed and unalterable as those by which the universe is regulated and governed" (36).

17. William Miller, "Rules of Interpretation," in William Miller, *Views of the Prophecies and Prophetic Chronology, selected from Manuscripts of William Miller, with a Memoir of His Life*, ed. Joshua V. Himes (Boston: Joshua V. Himes, 1842), 23.

18. Allen, "Preface," *Reason the Only Oracle of Man,* n.p.; Miller quoted in Litch, "Rise and Progress of Adventism," 50. See also Thomas Paine: "The evidence that I shall produce [to demonstrate that the books of the Pentateuch were spurious and not written by Moses] in this case is from the books themselves, and I shall confine myself to this evidence only," *Age of Reason*, 80. Both Millerites and deists proceeded on the rationalist grounds of an internally consistent or inconsistent configuration to make their case for or against the veracity of the Bible.

19. For a fine discussion of Mormon millennialism and its relation to Millerism, see Grant Underwood, *The Millenarian World of Early Mormonism* (Urbana: University of Illinois Press, 1993), 24–41, 112–26.

20. A fascinating discussion of Mormon occultism is D. Michael Quinn, *Early Mormonism and the Magic World View* (Salt Lake City: Signature Books, 1987), which includes many illustrations of occult diagrams and inscriptions used by Joseph Smith; see also the exceptional study by John L. Brooke, *The Refiner's Fire: The Making of Mormon Cosmology, 1644–1844* (New York: Cambridge University Press, 1994). For material on the Mormon interpretation of Egyptian hieroglyphics, see T. B. H. Stenhouse, *The Rocky Mountain Saints* (New York: D. Appleton & Co., 1873), 507–22; for a study of Mormon religious architecture and its ritualism and symbolism, see Laurel B. Andrew, *The Early Temples of the Mormons: The Architecture of the Millennial Kingdom in the American West* (Albany: State University of New York Press, 1978). For a Deseret primer in the alphabet invented by the Mormons, see *Second Primer* (Salt Lake City, 1868), copy in the American Antiquarian Society. I do not wish to say categorically that Mormons did not use millennial charts, but I have not been able to uncover evidence that they did. A search of several Mormon journals dating from the 1830s and 1840s—*Millennial Star, Times and Seasons,* and *Messenger and Advocate*—produced no charts or tabular graphics such as those used by Adventists.

21. Miller, *Apology and Defense*, 12.

22. A Bible Reader, "Criticism on Rev. xi.8—True Principles of Bible Interpretation," *Signs of the Times* 1, no. 13 (October 1, 1840), 92. Hereafter abbreviated as *Signs*.

23. David Campbell, "Chronology of Revelation," *Signs*, 1, no. 3 (May 1, 1840), 19.

24. David Campbell, *Illustrations of Prophecy: particularly the Evening and the Morning Visions of Daniel, and the Apocalyptical Visions of John* (Boston: published by the author, 1840), 9. For further consideration of Campbell, see hereafter.

25. William Miller, "Lecture VIII. The New Song," *Midnight Cry* 1, no. 21 (December 12, 1842), 3.

26. For discussion of Edwards and aesthetics, see David Morgan, *Visual Piety: A History and Theory of Religious Images* (Berkeley: University of California Press, 1998), chaps. 1 and 2.

27. Jonathan Edwards, *Religious Affections* (1746), ed. John E. Smith, in *Works of Jonathan Edwards,* vol. 2 (New Haven: Yale University Press, 1959), 271; 250; 275.

28. Ibid., 392; 396; see also 369

29. Jonathan Edwards, "Sinners in the Hands of an Angry God," in *Jonathan Edwards: Representative Selections*, ed. Clarence H. Faust and Thomas H. Johnson, rev. ed. (New York: Hill and Wang, 1962), 166–67.

30. Edwards, *Religious Affections, 263.*

31. Stephen O'Leary has persuasively argued that in the final phase of the movement, Miller abandoned "rational demonstration in favor of charismatic proof," *Arguing the Apocalypse: A Theory of Millennial Rhetoric* (New York: Oxford University Press, 1994), 112. But before the first disappointment, the rhetorical strategy remained one of rational demonstration based on prophetic calculations. Not without reason, O'Leary distinguishes the rational and the charismatic into successive historical moments, yet I believe they should also be seen as either side of the same psychological coin.

32. Edmond Burke, *A Philosophical Enquiry into the Origin of Our Ideas of the Sublime and Beautiful,* ed. J. T. Boulton (Notre Dame: University of Notre Dame Press, 1968).

33. "Beauty of Prophecy," *Midnight Cry* 1, no. 15 (December 3, 1842), 2.

34. Miller, *Evidence from Scripture and History,* "Prefatory Remarks," *Signs* 2, no. 1 (April 1, 1841), 1.

35. Ibid.

36. One Adventist writer visualized the subtitle of his book in a graphic image of text listing the "Family Descent of Christ from David" in the shape of two links of chain, Elder Z. Campbell, *Who is the Messiah? Showing the Past and Future Events in the Prophetic Chain of His Messiahship* (Hartford: J. G. Arthur, 1854), 104. Such devices, in addition to demonstrating the orderliness of scriptural prophecy, clarified the organization of information and no doubt made it easier to commit the information to memory.

37. In accord with the practice of assigning one denotatum to each denotation, Miller compiled a lexicon of biblical symbols and their meanings, his "Expla-

nation of Prophetic Figures," in which he provided an alphabetized list of figures from scripture and their decoded meaning along with the scriptural passages which held the key to this interpretation. Himes included this lexicon in his edition of Miller's *Views,* 25–32, and placed the lexicon immediately after Miller's "Rules of Interpretation." The effect is one of stressing method. Once again Miller invoked the legacy of the enlightenment by using its prized tool, the lexicon, and its preoccupation with method.

38. A Bible Reader, "Criticism on Rev. xi.8," n.p.

39. William Miller, "Prefatory Remarks," *Signs* 2, 1.

40. See note 35.

41. *Miller, Apology and Defense,* 6.

42. Barbara Maria Stafford has assembled a fascinating study of eighteenth-century visual culture which demonstrates how prints and paintings participated in the public presentation of information in visual form. Stafford argues that such visual devices as "the picture book format slowed down, simplified, and socialized abstractions by representing them in more comprehensible visual terms," *Artful Science: Enlightenment Entertainment and the Eclipse of Visual Education* (Cambridge, Mass.: MIT Press, 1994), 63. For the influence of the common sense realism of the Scottish enlightenment on American evangelicals, see George M. Marsden, *Fundamentalism and American Culture: The Shaping of Twentieth-Century Evangelicalism, 1870–1925* (New York: Oxford University Press, 1980), 14–16; on rationalism in Archibald Alexander and Princeton theology in the early antebellum period, see Sandeen, *Roots of Fundamentalism,* 114–31.

43. See Francis D. Nichol, *The Midnight Cry* (Washington, D.C.: Review and Herald, 1944), 57–103; for more recent scrutiny of the membership, see David L. Rowe, "Millerism: A Shadow Portrait," and Ruth Alden Doan, "Millerism and Evangelical Culture," in *The Disappointed: Millerism and Millenarianism in the Nineteenth Century,* ed. Ronald L. Numbers and Jonathan M. Butler (Bloomington: Indiana University Press, 1987), 1–16, especially 9 and 118–38.

44. For examples of this imagery, see the first three volumes of Le Roy Edwin Froom, *The Prophetic Faith of our Fathers,* 4 vols. (Washington, D.C.: Review and Herald, 1950–1954).

45. See pre-Reformation diagrams mentioned in Paul Boyer, *When Time Shall Be No More: Prophecy Belief in Modern American Culture* (Cambridge: Harvard University Press, 1992), 52. For an extensive study of late medieval linear depictions of Joachim of Fiore's interpretations of the ages of history as derived in part from Revelation, see Marjorie Reeves and Beatrice Hirsch-Reich, *The Figurae of Joachim of Fiore* (Oxford: Clarendon Press, 1972).

46. Joseph Mede, *The Key of the Revelation,* tr. Richard More, preface by William Twisse (London: R. B., 1643). More translated Mede's Latin original, *Clavis Apocalyptica,* 1627.

47. Compare Mede's diagram with E. B. Elliott's *Horse Apocalypticae,* first printed in 1843, or Barthol-

omew Bussier's "Prophetic Chart," from "The Opening of the Three Books of Judgment," *American Quarterly Journal of Prophecy,* ed. Bartholomew Bussier, vol. 1, no. 2 (1859), 17–24, 29–32. For other radial charts, see Joshua Himes's "A Pictorial Chart of Daniel's Visions," produced in 1842, advertised in *Midnight Cry* 1, no. 16 (December 5, 1842), 2, reproduced in Numbers and Butler, *The Disappointed,* 44–45; see also the diagram on the first page of *World's Crisis,* no. 9 (March 15, 1854).

48. The chart of the 1643 translation differs from the 1627 Latin version because of an addition (authorized by More, the translator, which he justifies in his preface) of imagery referring to a Mr. Haydock, a friend of Mede's who corresponded with him on the design of the book and seals used by John. For further discussion of Mede and his diagram, see Katharine R. Firth, *The Apocalyptic Tradition in Reformation Britain 1530–1645* (Oxford: Oxford University Press, 1979), 213–24.

49. Mede, *Key of the Revelation,* 26, 28.

50. An exception is the long, slender series of images representing "A Chart of the River of Life, Or the Dispensations, From Abraham to the End of Time," in Joshiah Priest's *A View of the Expected Christian Millennium,* 5th ed. (Albany: Loomis' Press, 1828). See fig. 12 reproduced here. The foldout gathers together a series of emblematic images which increase in size, detail, and organic complexity as the "river of life" deepens about the human observer. The image delineates the course of biblical history from Abraham to the "conflagration of the Solar System," the final image of which resembles alchemical illustrations from sixteenth-century England. Compare the last scene of Priest's serial chart with Robert Fludd's plate of "The Creation of the Primum Mobile," in his *Philosophia sacra et vere Christiana Seu Meterologia Cosmica* (Frankfurt: Officina Bryana, 1626), 160; reprinted in Joscelyn Godwin, *Robert Fludd: Hermetic Philosopher and Surveyor of Two Worlds* (Boulder: Shambala, 1979), 27.

51. The Collins Bible diagram is generally similar to a scheme elaborated by Jonathan Edwards in his private *Notes on the Apocalypse* in Jonathan Edwards, *Apocalyptic Writings,* ed. Stephen J. Stein (New Haven: Yale University Press, 1977). But assigning particular dates to the trumpets and vials of Revelation (which culminated in the year 2000 A.D. for Edwards) was part of a lively tradition of interpreting the Apocalypse in the seventeenth and eighteenth centuries in England, Europe, and North America. For a discussion of Edwards and the literature that served as his sources, see Stephen J. Stein, introduction to Edwards, *Apocalyptic Writings,* 1–29.

52. "Advertisement to the Stereotype Edition," *Holy Bible* (Boston: C. Ewer & T. Bedlington, 1824).

53. Campbell, *Illustrations of Prophecy,* 5. A former Garrisonian abolitionist, manager of a Grahamite boarding house in Boston, and editor of a Grahamite journal that folded in 1839, Campbell (also spelled Cambell) was briefly and unsuccessfully employed by Charles Grandison Finney as "steward" or supervisor of student diet at Oberlin College in 1840–1841, where he imposed a Grahamite regimen on the student body; they rebelled, precipitating his discharge. After leaving Oberlin, Campbell became general manager of a water-cure at New Lebanon Springs, New York, where he remained for ten years. On Campbell, see James C. Whorton, *Crusaders for Fitness: The History of American Health Reformers* (Princeton: Princeton University Press, 1982), 126–27; William B. Walker, "The Health Reform Movement in the United States, 1830–1870," Ph.D. diss., Johns Hopkins University, 1955, 134–41; and Stephen Nissenbaum, *Sex, Diet, and Debility in Jacksonian America: Sylvestor Graham and Health Reform* (Westport: Greenwood Press, 1980), 143, 150; on Campbell and White, see Ronald L. Numbers, *Prophetess of Health: A Study of Ellen G. White* (New York: Harper and Row, 1976), 54–55, 57; on Sylvester Graham's Christian health reform, see Whorton, *Crusaders for Fitness,* 38–49, Nissenbaum, *Sex, Diet, and Debility,* 3–24. My thanks to Ron Numbers for assistance with material on Campbell.

54. Campbell, *Illustrations of Prophecy,* 6.

55. Neither Campbell nor his illustrations and their use by the Millerites is mentioned in the two most compendious discussions of Adventism and the charts, Nichol, *Midnight Cry,* or Froom, *Prophetic Faith.* Froom refers to a diagram of seals, trumpets, and vials in *Signs* (May 1, 1840), 24, as "anonymous" (4:723), even though it is the diagram accompanying Campbell's article in the same issue, which Campbell drew from his *Illustrations.* Neither is Campbell mentioned in more recent studies of Adventist imagery: Ron Graybill, "America: The Magic Dragon," *Insight* 2 (November 30, 1971), 6–12; Ron Graybill, "Picturing the Prophecies," *Adventist Review* 161, no. 27 (July 5, 1984), 11–14; J. Paul Stauffer, "Uriah Smith: Wood Engraver," *Adventist Heritage* 3, no. 1 (Summer 1976), 17–21; Jonathan Butler, "The Seven-day Adventist American Dream," *Adventist Heritage* 3, no. 1 (Summer 1976), 3–10; Vern Carner, "Horace Greeley and the Millerites," unidentified article in the Ellen G. White Research Center, Andrews University, file DF 257, 33–34.

The first self-contained chart to appear in *Signs* (*Signs* 1, no. 3 [May 1, 1840], 24) was designed by David Campbell and depicts the seven seals, trumpets, and vials of Revelation (see discussion hereafter). The terms "chart" and "diagram" were used interchangably by the Millerites. I will use the term "chart" to refer to formats integrating image and text and "diagram" or "table" to refer to schematic arrangements of text that make no use of imagery. Miller himself made such a table or diagram of his chronology, which appeared in *Signs* 2, no. 3 (May 1, 1841), 20–21 and in the 1842 edition of his *Evidence from Scripture and History of the Second Coming of Christ about the Year 1843* (Boston: Joshua V. Himes, 1842).

Numerous diagrams appeared in Millerite literature. Some of the most important for interpreting the prophetic symbols in terms of Millerite chronology of

history are: "Chronological Chart of the World," *Signs* 2, no. 3 (May 1, 1841), 20–21; C[alvin] French, "Diagram of Daniel's Visions," *Midnight Cry* 1, no. 2 (November 18, 1842); "Plan of Calculating the Prophetic Periods," *Signs* 5, no. 15 (June 14, 1843), 115; "Diagram Exhibiting the Events of Prophecy," *Midnight Cry* 6, no. 6 (February 29, 1844). Some diagrams, as in the case of the last example listed, arrange text into a graphic form.

56. Campbell, *Illustrations of Prophecy,* 10.

57. *Signs* 1, no. 2 (April 15, 1840), 13. Miller, for his part, remained antagonistic toward Campbell, see "The Path of the Just," 14. Campbell proposed to engage Miller in a congenial way, without "severity" in tone over what he considered incorrect in "Brother Miller's theory in the chronology of the Apocalyptic trumpets. To aid in this, I shall employ diagrams, showing the order of the seals, trumpets, and vials, and the harmony of their chronological numbers" (May 1, 1840), 19. On the last page of the issue (24), a full-page diagram appeared that Campbell had compiled from *Illustrations of Prophecy,* where the seals, vials, and trumpets appeared on pages 31–33. Miller, however, remained harsh in tone toward Campbell, see *Signs* 1, no. 5 (June 1, 1840), 34.

58. Miller, *Evidence from Scripture,* reprinted in *Signs* 2, no. 2 (April 15, 1841), 10.

59. *A New Hieroglyphic Bible,* 11th ed. (Chiswick, New York: C. Whittingham, 1836), 100; reprint, New York: American Heritage Press, 1970.

60. Ibid., iii.

61. Miller, *Evidence from Scripture,* chap. 1, reprinted in *Signs* 2, no. 2 (April 15, 1841), 10.

62. For the study of the semiotics of scriptural figures, symbols, types, and hieroglyphs as they related to the appropriate interpretation of scriptural language as revelation, see Edwin Ruthven McGregor, *The Figures and Symbols of Divine Inspiration and the Method of Learning Their Meaning* (New York: E. French, 1853) and John T. Demarest and William R. Gordon, *Christocracy; or, Essays on the Coming and Kingdom of Christ* (New York: A. Lloyd, 1867).

63. Joseph Bates, *Second Advent Way Marks and High Heaps, or A Connected View of the Fulfillment of Prophecy, By God's Peculiar People, From the Year 1840 to 1847* (New Bedford: Benjamin Lindsey, 1847), 11.

64. Quoted in Froom, *Prophetic Faith,* 4:617; Nichol, *Midnight Cry,* 101.

65. See Dexter Dickinson, *Key to the Prophecies, and Second Advent of Christ, with the Time of his First and Second Manifestations* (Boston: Published by the Author, 1843), which uses Campbell's imagery and follows many of his disagreements with Miller. Dickinson set the commencement of the millennium at 1850.

66. "Chronological Chart of the World," *Signs* 2, no. 3 (May 1, 1841), 20. A detailed exposition of the chronological chart followed on the next page, which included page citations of Miller's works. In short, Fitch and Hale had virtually all the information they needed in two issues of the *Signs* to create their chart. Froom describes a chart in Miller's own hand on which the *Signs* chart is probably based, *Prophetic Faith,* 4:722–23. For a discussion of the innovations and details of Fitch's chart, see Froom, *Prophetic Faith,* 4:735–37.

67. Multiple block wood engravings were produced in the 1850s in large editions of such commercial periodicals as *Harper's New Monthly.*

68. On Thayer, Bufford, and early American lithography, see Peter C. Marzio, *The Democratic Art: Chromolithography 1840–1900, Pictures for a Nineteenth-Century America* (Boston: Godine, 1979), 19–20; and Harry T. Peters, *American on Stone* (New York: Doubleday, 1931); the best discussion on Bufford and Thayer, however, is David Tatham, "John Henry Bufford, American Lithographer," *Proceedings of the American Antiquarian Society* 86 (1976), 47–73, especially 55–56.

69. "Historical Data on the '1843' Chart," unidentified article in the Ellen G. White Research Center, file DF 257.

70. The young British archeologist Austen Henry Layard visited Babylonian and Assyrian ruins in the winter and spring of 1840; French excavations at Nineveh, conducted by Paul Emile Botta, were not underway until 1842. Botta published letters on his discoveries in 1843–1844 in *Journal Asiatique,* see Paul Emile Botta, *M. Botta's Letters on the Discoveries at Nineveh,* tr. C. T. (London: Longman, Brown, Green and Longmans, 1850); see also Austen Henry Layard, *Nineveh and Its Remains,* 2 vols. (New York: George P. Putnam, 1849), 1:25–38; for further discussion of early excavations of Assyrian and Babylonian antiquities, see James Baikie, *The Glamour of Near East Excavation* (London: Seeley, Service, (1927), 191–268.

71. Quoted in Sylvester Bliss, *The Life of William Miller* (Boston: J. V. Himes, 1853), 166; also quoted in Nichol, *Midnight Cry,* 110; Froom, *Prophetic Faith,* 4:648–49.

72. Although Whittier's description of the original painted version (assuming the image used at the camp meeting during the final week of June was Fitch's) mentions only the Great Image and the beasts of the apocalypse in Revelation, it seems certain that the lithographed chart (see fig. 56) reproduced the contents of Fitch's image (if not, perhaps, in every detail). Whittier's description: "Suspended from the front of the rude pulpit were two broad sheets of canvass, upon one of which was the figure of a man,—the head of gold, the breast and arms of silver, the belly of brass, the legs of iron, and feet of clay,—the dream of Nebuchadnezzar! On the other were depicted the wonders of the Apocalyptic vision—the beasts—the dragons—the scarlet woman seen by the seer of Patmos." Quoted in Bliss, *Life of William Miller,* 166.

73. Joseph Bates, *Second Advent Way Marks,* 10–11; emphasis in original.

74. Ibid., 3; emphasis added.

75. On the development of numeracy, see Patricia Cline Cohen, *A Calculating People: The Spread of Numeracy in Early America* (Chicago: University of Chicago Press, 1982). The ATS insisted of its colportage system that "[t]he same minute accuracy in all

the business transactions of the Society is aimed at that [that] is to be found in systematic commercial establishments," *The American Colporteur System* (New York: American Tract Society, 1836), 22.

76. Apollos Hale, "Objections to Calculating the Prophetic Times Considered," *Midnight Cry* 4, nos. 12 and 13 (June 8, 1843), 90, emphasis in original.

77. A Bible Reader, "Criticism of Rev. xi:8."

78. A Brother Sailor, *A Warning from the Faithful Pilot To Keep a Good Look-Out For Danger at the Close of the Voyage,* Advent tracts, no. 4 (Boston: J. V. Himes, December 30, 1843), 3, 16; emphasis in original; reprinted from *Signs* 5, no. 11 (May 17, 1843), 82–83.

79. [Uriah Smith], *Key to the Prophetic Chart* (Battle Creek: Seventh-Day Adventist Publishing Association, 1864), 6. The essay carries as an epitaph Habakkuk 2:2: "Write the vision, and make it plain upon tables, that he may run that readeth it."

80. Bates, *The Autobiography of Elder Joseph Bates* (Battle Creek: Seventh-Day Adventist Publishing Association, 1868), 244.

81. Paul Boyer has pointed to the rise in numeracy, popular in almanacs, and Millerism's preoccupation with calculation, *When Time Shall Be No More,* 83–84.

82. Miller's preoccupation with the Bible is evident in a letter he wrote to Truman Hendryx, a clergyman who had begun corresponding with him in the summer of 1831. In a letter of March 26, 1832, Miller gave Hendryx the following advice on preaching: "I would therefore advise you to lead your hearers by slow and sure steps to Jesus Christ. I say *slow* because I expect they are not strong enough to run yet, *sure* because the Bible is a sure word. And where your hearers are not well doctrinated, you must preach *Bible.* You must prove all things by *Bible.* You must talk *Bible,* you must exhort *Bible,* you must pray *Bible,* and love *Bible,* and do all in your power to make others love *Bible* too," quoted in Nichol, *Midnight Cry,* 47. Emphasis in original.

83. Miller, *Apology and Defense,* 6.

84. "Cruden's Concordance," *Midnight Cry* 2, no. 2 (December 30, 1842), 3.

85. Bates, *Second Advent Way Marks,* 15.

86. Ibid., 11.

87. Bates, *Autobiography,* 266.

88. Ibid., 287.

89. Ibid., 289, 292.

90. *Midnight Cry* (May 18, 1843); see also January 4, 1844.

91. Apollos Hale, "Bangor Conference," *Signs* 3, no. 17 (July 27, 1842), 133.

92. For instance, Richard Shimeall, who conducted lectures on the "Unfulfilled Prophecies of Scripture" in New York University's "large chapel" every Sunday evening, advertised one lecture's topic on the Antichrist in the *Midnight Cry* 4, no. 9 (May 18, 1843), 65, with this special point: "N.B.—To be accompanied by large diagrams, etc." Shimeall had a rather troubled relationship with the Millerite inner circle but insisted he was a "Millerarian," see hereafter.

93. Jane Marsh Parker, "A Little Millerite," *Century Illustrated Monthly Magazine* 33 (December, 1886), 314; also quoted in Nichol, *Midnight Cry,* 195.

94. A. Spaulding, "William Miller at Home," *Midnight Cry* 4, no. 19 (July 6, 1843), 145.

95. James White, *Life Incidents* (Battle Creek: Seventh-day Adventist Publishing Association, 1868), 1:72.

96. Ibid., 72, 73, 79.

97. *Signs,* January 15, 1842.

98. *Signs* 3, no. 12 (June 22, 1842), 96.

99. *Midnight Cry* 1, no. 16 (December 5, 1842), 2.

100. *Midnight Cry* 1, no. 20 (December 10, 1842), 3.

101. *Midnight Cry* 2, no. 1 (December 23, 1842), 8.

102. Bates, *Autobiography,* 269.

103. Perhaps the most frequent of such items were celestial phenomena such as comets, meteors, and the northern lights. Heavenly signs were considered fulfillments of biblical prophecy regarding the last days—see Henry Jones, "Second Advent 'Wonders,' 'Fearful Sights,' 'Great Signs,' etc.," *Midnight Cry* 1, no. 23 (December 14, 1842), 1.

Five: The Commerce of Images and Adventist Piety

1. See William Miller, *Apology and Defense* (Boston: J. V. Himes, 1845), 24–25; Charles Fitch, *Come Out of Her My People* (Rochester, N.Y.: J. V. Himes, 1843). For a discussion of this phase of Millerism, see Ruth Alden Doan, *The Miller Heresy, Millennialism, and American Culture* (Philadelphia: Temple University Press, 1987), 119–40.

2. Jane Marsh Parker, "A Little Millerite," *Century Magazine* (December 1886), 314.

3. Dowling had published a 232-page refutation of Miller in 1840 (*An Exposition of the Prophecies Supposed by William Miller to Predict the Second Coming of Christ, in 1843*) in response to Miller's 1840 edition of *Evidence from Scripture and History of the Second Coming of Christ, about the Year 1843* (Boston: B. B. Mussey, 1840). Miller replied in *Signs of the Times* 1, no. 9 (August 1, 1840), 67–68, and no. 10 (August 15, 1840), 74–75, 80 (hereafter abbreviated as *Signs*). Horace Greeley, who founded the *New York Tribune* in 1841, reprinted a portion of Dowling's text on March 2, 1843, and with it two pages of a chart first published in *Midnight Cry* on February 24, 1843. For a discussion of Dowling, Greeley, and Miller, see Vern Carner, "Horace Greeley and the Millerites," unidentified article, Ellen G. White Research Center, Andrews University, file DF 257, 33–34.

4. "Scoffing," *Signs* 5, no. 4 (March 29, 1843), 29. For a reproduction of the broadside, see Francis D. Nichol, *The Midnight Cry* (Washington, D.C.: Review and Herald, 1944), facing page 305.

5. *Haverhill Gazette,* April 15, 1843; quoted in Nichol, *Midnight Cry,* 302.

6. Asmodeus in America, [pseudonym] *The Millerite Humbug; or the Raising of the Wind!! A Comedy*

in *Five Acts* (Boston: printed for the publisher, 1845), 16–17. Asmodeus was an evil spirit mentioned by Milton in *Paradise Lost* (bk. 4, l. 168), borrowed from the Book of Tobit, where the spirit was repelled by the angel Raphael with the use of a foul odor, hence the scatological reference in the subtitle of the play.

7. Clara Endicott Sears, *Days of Delusion. A Strange Bit of History* (Boston: Houghton Mifflin, 1924), 207–8. Sears collected scores of accounts remembered by children and grandchildren of persons living in the area of Miller's home during 1843–1844.

8. Nathaniel Southard, "To Children and Youth," *Midnight Cry* 7, no. 14 (October 10, 1844), 108–10; reprinted in *Children's Advent Herald* 1, no. 1 (May 1846), 3–4. Southard was editor of *Youth's Cabinet* (1837–1841) and *Midnight Cry* (1842–1844).

9. Parker, "A Little Millerite," 315.

10. Southard, "To Children and Youth."

11. Parker, "A Little Millerite," 314–15.

12. Joseph Bates, *An Explanation of the Typical and Anti-Typical Sanctuary by the Scriptures* (New Bedford: Benjamin Lindsey, 1850), provided detailed annotations to the chart—indeed, the entire essay is a point-by-point explication of the numbered features of the image, which, unfortunately, has been separated from all surviving versions of the manuscript that I have consulted.

13. On the history of the shut door among the Millerites, see Whitney R. Cross, *The Burned-Over District: The Social and Intellectual History of Enthusiastic Religion in Western New York, 1800–1850* (Ithaca: Cornell University Press, 1950), 313–16; on the shut door, spiritual kissing, and foot washing, see Malcolm Bull and Keith Lockhart, *Seeking a Sanctuary: Seventh-Day Adventism and the American Dream* (New York: Harper & Row, 1989), 33–37.

14. Letter to Brother and Sister Loveland, November 1, 1850, Ellen White Research Center, file L-26-1850.

15. Ellen White, letter to readership, *Present Truth* 1, no. 11 (November 1850), 86.

16. Ibid., 87; also in Ellen White, *Early Writings* (Washington, D.C.: Review and Herald, 1963), 74.

17. Ellen White, letter of August 15, 1850, Ellen White Research Center, DF 257, letter 12, 1850, manuscript release 1162; I have found Ron Graybill, "Picturing the Prophecies," *Adventist Review* 161, no. 27 (July 5, 1984), 11–14, helpful for its citation and discussion of sources.

18. James White, "Our Present Position," *Second Advent Review and Sabbath Herald* 1, no. 2 (December 1850), 13. The paper, whose title varied over the years, will hereafter be referred to as *Review and Herald*.

19. James White, announcement, *Review and Herald* 1, no. 4 (January 1851), 31.

20. See [James White], "The Sanctuary, 2300 Days, and the Shut Door," *Present Truth* 1, no. 10 (May 1850), 79.

21. James White, "Our Present Position," *Present Truth* vol. 1 (1849), 15.

22. Ibid.

23. *Signs* 5, no. 10 (May 10, 1843), 79; no. 11 (May 17, 1843), 82; *Midnight Cry* 4, nos. 12 and 13 (June 8, 1843), 94, 97.

24. Joseph Bates, *An Explanation*, 9; 1837 was also the year identified by Josiah Litch when Miller's published lectures first began to receive notice, Litch, "The Rise of Adventism," in *Advent Shield and Review*, ed. J. V. Himes, S. Bliss, and A. Hale (Boston: Joshua V. Himes, 1844), 53.

25. See White, "Our Present Position," 13.

26. For a discussion of the Adventist view of Protestantism and Sunday legislation, see Jonathan M. Butler, "Adventism and the American Experience," in *The Rise of Adventism: Religion and Society in Mid-Nineteenth-Century America*, ed. Edwin S. Gaustad (New York: Harper and Row, 1974), 180–83; on the general subject of sabbatarianism and legal controversies, see Bertram Wyatt-Brown, "Prelude to Abolitionism: Sabbatarian Politics and the Rise of the Second Party System," *Journal of American History* 58 (September 1971), 316–45; and James R. Rohrer, "Sunday Mails and the Church-State Theme in Jacksonian America," *Journal of the Early Republic* 7 (Spring 1987), 53–74; for an extensive discussion of Seventh-Day Adventist attitudes toward the state, see Douglas Morgan, "The Remnant and the Republic: Seventh-day Adventism and the American Public Order," Ph.D. diss., University of Chicago, 1992; and for a very helpful history of the Protestant imperial urge, see Robert T. Handy, *A Christian America: Protestant Hopes and Historical Realities*, 2nd rev. ed. (New York: Oxford University Press, 1984).

27. John Nevins Andrews, "Thoughts on Revelation XIII and XIV," *Review and Herald* 1, no. 11 (May 19, 1851), 81–86; Joseph Bates, "The Beast with Seven Heads," *Review and Herald* 2, no. 1 (August 5, 1851), 3–4; James White, "The Angels of Rev. xiv—No. 1," *Review and Herald* 2, no. 2 (August 19, 1851), 12. For subsequent discussions, see J. N. Loughborough, "The Image of the Beast," *Review and Herald* 4, no. 11 (September 20, 1853), 85, which includes a Wisconsin statute of 1852 against sales on Sunday; and a much longer article by the same author, "The Two-Horned Beast," *Review and Herald* 5, no. 9 (March 21, 1854), 65–67; no. 10 (March 25, 1854), 73–75, 79; and "Rise of the Two-Horned Beast," *Review and Herald* 7, no. 3 (August 7, 1855), 21; and M. E. Cornell, "They Will Make an Image to the Beast," *Review and Herald* 6, no. 6 (September 19, 1854), 42–43. For a discussion of the changing interpretations of the beast in Adventist history, see Ron Graybill, "America: Magic Dragon," *Insight* 2 (November 30, 1971), 6–12.

28. Andrews, "Thoughts on Revelation XIII and XIV," 83.

29. Ellen White, letter to readership, 86.

30. "The Chart," *Review and Herald* 1 no. 5 (January 1851), 38.

31. "The New Chart," *Review and Herald* 2, no. 8 (December 9, 1851), 64.

32. See advertisement in *Review and Herald* 1, no. 6 (February 1851), 46.

33. See "The Chart," *Review and Herald* 1, no. 4 January 1851), 31; *Review and Herald* no. 5 (January 1851), 38.

34. James White, "The Design of the Chart," *Review and Herald* 1, no. 6 (February 1851), 46.

35. Beginning in May 1853, the charts were placed on the list of the *Review*'s publications on the final page of every other issue; see *Review and Herald* 4, no. 1 (May 1853), 8. The ad appeared in fourteen of twenty-six numbers of volume 4 (May 26 to December 27, 1853). The price with or without rollers was listed as $2.00. In August of 1853 correspondence from the editor to a subscriber indicated that the chart could be purchased from two people in Michigan, one of whom was listed in the same issue as a Michigan agent for the *Review and Herald*, see *Review and Herald* 4, no. 6 (August 4, 1853), 48. Listing brief messages to customers, the "Business" and "Correspondence" columns of the back page of the *Review* offer some impression of sales of the charts in the 1850s. In 1853–1854, messages to fourteen different individuals appeared in the *Review* indicating chart orders that were mailed. At least one of these was an agent, who may have undertaken resale of the charts. A notice in the fall of 1853 named two men in Michigan from whom the chart could be purchased, *Review and Herald* 4, no. 13 (October 4, 1853), 104.

36. Joseph Bates, "Letters From Bro. Bates," *Review and Herald* 3, no. 23 (March 31, 1853), 183. On Loughborough and Andrews, see their letter, see "Tent Meeting at Parkville, Mich.," in *Review and Herald* 14, no. 17 (September 15, 1859), 136.

37. For Loughborough, see "Tent Meeting at Parkville, Mich.," *Review and Herald* 136; and "Business," no. 26 (January 10, 1854), 208; for Bates, "From Bro. Bates," *Review and Herald* 3, no. 19 (February 3, 1853), 151; "From Bro. Bates," no. 23 (March 31, 1853), 183; and "From Bro. Bates," vol. 5, no. 8 (March 14, 1854), 63; and for Everts, "From Bro. Everts," *Review and Herald* 3, no. 19 (February 3, 1853), 152; and "From Bro. Alexander," vol. 4, no. 8 (August 28, 1853), 63.

38. Joseph Bates, "Letters From Bro. Bates," *Review and Herald* 3, no. 23 (March 31, 1853), 183.

39. Letter, *Review and Herald* 4, no. 8 (August 28, 1853), 63.

40. Elon Everts, letter, *Review and Herald* 3, no. 19 (February 3, 1853), 152.

41. For Ellen White's vision, see ms. 1, 1853, Ellen White Research Center, 3–7.

42. Ellen White, manuscript release 1068, vol. 13, 1993, Ellen White Research Center, 359–60.

43. Letter, *Review and Herald* 3, no. 24 (April 14, 1853), 191.

44. Letter from Hiram Case, *Review and Herald* 4, no. 8, August 28, 1853), 64. I have found no further mention of Case's chart in the historical record.

45. *Review and Herald* 4, no. 13 (October 4, 1853), 104.

46. *Review and Herald* 10, no. 11 (July 16, 1857), and no. 12 (July 23, 1857).

47. *Review and Herald* 12, no. 1 (May 20, 1858), 8.

48. James White, "The Chart," *Review and Herald* 12, no. 6 (June 24, 1858), 48.

49. Volume 1 of *Spiritual Gifts,* published in September 1858, whose full title was *The Great Controversy Between Christ and His Angels and Satan and His Angels.* This title served Ellen White as a general theme and title in several subsequent publications.

50. Notice, *Review and Herald* 12, no. 18 (September 23, 1858), 144.

51. "Large Charts," *Review and Herald* 13, no. 6 (December 30, 1858), 48. White must have done the same in the next year, for a January 1860 notice states that "about twenty" of the large charts were available at $2.00 each, *Review and Herald* 15, no. 7 (January 5, 1860), 56. White found that taking his business on the road in conjunction with the tours became a means of generating lucrative sales of the *Review.* He reported that in May, June, and July of 1857 he traveled two thousand four hundred miles, participated in the "eastern tour" of New York and Pennsylvania, and "transacted business amounting to between three and four thousand dollars," "Eastern Tour," *Review and Herald* 10, no. 11 (July 16, 1857), 88.

52. *Review and Herald* 13, no. 20 (April 7, 1859), 160.

53. *Review and Herald* 15, no. 2 (December 1, 1859), 8.

54. "A New Feature," *Review and Herald* 13, no. 20 (April 7, 1859), 160.

55. Catharine E. Beecher and Harriet Beecher Stowe, *The American Woman's Home: or, Principles of Domestic Science* (New York: J. B. Ford and Co., 1869), 93.

56. Ibid., 24. On Catharine Beecher's writings and her ideology of domesticity, see Kathryn Kish Sklar, *Catharine Beecher: A Study in American Domesticity* (New York: W. W. Norton, 1976); for discussion of domestic Christianity in nineteenth-century America, see Maxine Van de Wetering, "The Popular Concept of 'Home' in Nineteenth-Century America," *Journal of American Studies* 18, no. 1 (April 1984), 5–28; and Colleen McDannell, *The Christian Home in Victorian America, 1840–1900* (Bloomington: Indiana University Press, 1986).

57. J. O. Corliss, "Home Religion," *Review and Herald* 47, no. 5 (February 3, 1876), 37.

58. "Religion at Home," *Review and Herald* 7, no. 17 (January 24, 1856), 131.

59. "No Family Altar," *Review and Herald* 11, no. 18 (March 18, 1858), 139; "The Family Altar is Broken Down," *Review and Herald* 12, no. 20 (October 7, 1858), 154; Joseph Clarke, "The Family Institution—Morals of Our Nation," *Review and Herald* 14, no. 13 (August 18, 1859), 98–99.

60. I discuss Bushnell's work extensively in chapters 8 and 9.

61. J[oseph] C[larke], "Teach Your Children," *Review and Herald* 11, no. 14 (February 11, 1858), 109.

62. R. C. Baker, "Parental Responsibility," *Review and Herald* 33, no. 21 (May 18, 1869), 163.

63. J. M. A., "Books for the Children," *Review and Herald* 30, no. 25 (December 3, 1867), 400.

64. White's prophetic chart of 1863 bore the imprimatur "J. H. Bufford's Litho." On Bufford and Thayer, see David Tatham, "John Henry Bufford, American Lithographer," *Proceedings of the American Antiquarian Society* 86 (April 1976), 62; and Peter C. Marzio, *The Democratic Art. Chromolithography 1840–1900: Pictures for a Nineteenth-Century America* (Boston: Godine, 1979), 19–20.

65. *Review and Herald* 22, no. 19 (October 6, 1863), 152.

66. Ellen White, manuscript release 1068, 1993, vol. 13, Ellen White Research Center, p. 359.

67. "Key to the Prophetic Chart," *Review and Herald* 23, no. 15 (March 3, 1864), 120.

68. James H. Moorhead, "The Millennium and the Media," in *Communication and Change in American Religious History*, ed. Leonard I. Sweet (Grand Rapids: Eerdmans, 1993), 236.

69. See, for instance, Andrews, "Thoughts on Revelation XIII and XIV," 81–86; Bates, "Beast with Seven Heads," 3–4; and White, "The Angels of Rev. xiv—No. 1," 12. A spate of related articles by the same and additional authors continued to appear into the mid-1850s and then later in official volumes of doctrine, such as Uriah Smith's compendious *The Marvel of the Nations. Our Country: Its Past, Present, and Future, and What the Scriptures Say of It* (Battle Creek: Review and Herald, 1885).

70. See Bates, *Second Advent Way Marks and High Heaps, or a Connected View of the Fulfillment of Prophecy, By God's Peculiar People, From the Year 1840 to 1847* (New Bedford: Benjamin Lindsey, 1847), 10–11.

71. [Uriah Smith], *Key to the Prophetic Chart* (Battle Creek: Seventh-Day Adventist Publishing Association, 1864), 5.

72. "Key to the Prophetic Chart," *Review and Herald* 120.

73. James White, "The Charts," *Review and Herald* 22, no. 19 (October 6, 1863), 152.

74. Calculating what the charts cost White and what his profit margin was must remain conjectural, but some estimation can be proposed. He stated on October 6, 1863, that the expense of producing the chart was more than double what it might have been two years before. If we work from the 1850 prices of $1.50 production cost for each chart (sold at $2.00 with a 33 percent mark up), and the 1863 prices were in fact at least double those figures as White said they were, then the 1863 prophetic chart cost $3.00 to produce and the Law-of-God chart $2.00. Presuming that White made five hundred sets of the prophetic and companion Law-of-God charts, we might calculate a cost of $1,500 for the first and $1,000 for the second to arrive at the total $2,500.

75. Announcement, *Review and Herald* 23, no. 15 (March 3, 1864), 120.

76. "The Charts," *Review and Herald* 23, no. 5 (December 29, 1863), 40; the same notice lists agents for the chart in Massachusetts, Ohio, and Iowa, and three in Michigan.

77. "The Charts. What Father Bates Says of Them," *Review and Herald* 23, no. 16 (March 15, 1864), 128.

78. "About the Charts," *Review and Herald* 22, no. 25 (November 17, 1863), 200.

79. James White, *Life Incidents* (Battle Creek: Seventh-Day Adventist Publishing Association, 1868), 108–9; Joseph Bates, *The Autobiography of Elder Joseph Bates* (Battle Creek: Steam Press of the Seventh-Day Adventist Publishing Association, 1868).

80. White, *Life Incidents*, 307, 308–9.

81. An example of an Adventist rival Smith may have had in mind was Joseph Marsh, the former Millerite preacher who became editor and owner of a weekly newspaper, the *Advent Harbinger and Bible Advocate*, from 1849 to 1854. In the second volume of the paper, Marsh printed a long series of articles on the interpretation of prophetic symbols in the Book of Daniel by E. R. Pinney (another New York Millerite preacher) which was illustrated by the same images used to illustrate two articles on the Great Image and the Four Kingdoms in Millerite papers—see "Daniel's Testimony. What Shall Be in the Latter Days," *Signs* 5, no. 10 (May 10, 1843), 79, and "Where Are We?" *Signs* 5, no. 11 (May 17, 1843), 82–83, reprinted in *Midnight Cry* 4, nos. 12 and 13 (June 8, 1843), 95–100. Pinney used the Millerite imagery but did not illustrate or discuss the three angels of Revelation 13 or the sanctuary, which were so important to Smith and the sabbatarian Adventists. For a discussion of Marsh and Adventism, see Godfrey T. Anderson, "Sectarianism and Organization 1846–1864," in *Adventism in America*, ed. Gary Land (Grand Rapids: Eerdmans, 1986), 37; on Marsh and Pinney, see David L. Rowe, *Thunder and Trumpets. Millerites and Dissenting Religion in Upstate New York, 1800–1850*, American Academy of Religion Studies in Religion (Chico, Calif.: Scholars Press, 1985), 153–57 (Marsh); 143, 149 (Pinney).

82. "Kellogg, Merritt Gardner," *Seventh-Day Adventist Encyclopedia*, rev. ed. (Washington, D.C.: Review and Herald, 1976), 724.

83. M[erritt] G[ardner] Kellogg, *A Key of Explanation of the Allegorical Picture Entitled "The Way of Life"* (Battle Creek: Steam Press of the Seventh-Day Adventist Publishing Association, 1873), 13.

84. Ibid., 14.

85. Ibid., 15.

86. Elizabeth Gilmore Holt, "Revivalist Themes in American Prints and Folksongs 1830–50," in *American Printmaking before 1876: Fact, Fiction, and Fantasy* (Washington, D.C.: Library of Congress, 1975), 34–46, mentioned the contract between the ATS and Currier. Unfortunately, Holt did not indicate the source of her information. Janet A. Flint, *The Way of Good and Evil: Popular Religious Lithographs of Nineteenth-Century America*, exhibition catalogue (Washington, D.C.: National Collection of Fine Arts, Smithsonian Institution, 1972), included *The Resurrection* in her 1972 exhibi-

tion and conjectured that the image "was no doubt intended as a visual aid to missionary work in other parts of the country," catalogue item no. 7. *The Resurrection* is listed in *Currier & Ives: Catalogue Raisonné*, 2 vols. (Detroit: Gale Research Company, 1984), as no. 5556; *The Crucifixion* as no. 1439. I have been unable to corroborate Holt's claim.

87. David Friedrich Strauss, *The Life of Jesus: Critically Examined*, translated from the 4th German edition (London: Chapman Brothers, 1846, originally published in 1835); Ernest Renan, *Vie de Jesus* (Paris: Michel Levy Freres, 1863).

88. See *Catalogue Raisonné*, nos. 302, 5799, 2405, 45, and 5501.

89. See *Catalogue Raisonné*, nos. 6481, 5501, 1995, 1600, 5631, 1783, 3366, 6614, and 6622. The final two entries, the Trees of Intemperance and Temperance, were both reissued in 1872, nos. 6615 and 6623; see also the narrative series entitled *The Bible and Temperance* by Currier, undated, nos. 579–82.

90. See the handbill reproduced in *Catalogue Raisonné*, 1:xli.

91. Marzio, *Democratic Art*, 39. Peter S. Duval (d. 1886) was among the most important lithographers in antebellum Philadelphia. He retired in 1869, when his son, Stephen, became partners with Thomas Hunter. On Duval, see Nicholas B. Wainwright, *Philadelphia in the Romantic Age of Lithography* (Philadelphia: Historical Society of Pennsylvania, 1958), 30–45, 61–74.

92. Marzio, *Democratic Art*, 137. Religious images produced by Currier & Ives were typically small (twelve-by-nine inches) among the firm's repertoire and inexpensive. The same Currier & Ives handbill from the mid-1870s cited in note 90 listed 903 individual images at 20¢ each at thirteen-by-seventeen inches; a catalogue from the late 1860s listed uncolored prints on sixteen-by-twenty–inch paper at the same price; thirteen-by-eighteen inches at 10¢; and a range of sizes from twenty-by-twenty-six (40¢ each) to twenty-five by thirty-three inches at $2.00 each, see *Catalogue Raisonné*, 1:xli–xlii.

93. Marzio, *Democratic Art*, 45.

94. "Books, Pamphlets, Tracts, etc.," *Review and Herald* 41, no. 25 (June 3, 1873), 200.

95. Uriah Smith, "A Bird's Eye View of the Great Field of Prophecy," *Review and Herald* 47, no. 1 (January 6, 1876), 5–6.

96. "Wisconsin Tract and Missionary Society," *Review and Herald* 48, no. 16 (October 19, 1876), 127.

97. "The New Charts," *Review and Herald* 48, no. 14 (October 5, 1876), 112.

98. Uriah Smith, "The New Charts," *Review and Herald* 48, no. 22 (November 30, 1876), 176.

99. *Review and Herald* 48, no. 17 (October 26, 1876), 136.

100. Kellogg, *Key of Explanation*, 3.

101. Ibid., 5, 4.

102. Newell Mead, "The Law of God Illustrated," *Review and Herald* 2, no. 14 (March 23, 1852), 109–10.

103. Kellogg, *Key of Explanation*, 5, 7.

104. Quentin J. Schultze, "Keeping the Faith: American Evangelicals and the Media," in *American Evangelicals and the Mass Media* (Grand Rapids: Academie Books, 1990), 36.

105. Kellogg may have derived his depiction of the Peaceable Kingdom from one of Edward Hicks's many versions of the subject or from an engraving after Richard Westall's painting, which was the source for Hicks (see fig. 11), for Josiah Priest's image (see fig. 12), and for a host of engravings that appeared in illustrated Bibles in the 1820s and 1830s.

106. A "Plan of Calculating the Prophetic Periods," *Signs* 5, no. 15 (June 14, 1843), 115, noted that the design of the chart was "to present at a glance the methods of computing the various prophetic periods." Francis Bodfield Hooper, a British premillennialist, stated that he included an elaborate chart as the frontispiece in his *The Revelation of Jesus Christ by John*, 2 vols. (London: J. & F. H. Rivington, 1861), "to exhibit the structure of the Revelation at a glance," 1:iii.

107. Quoted in Kellogg, *Key of Explanation*, 10.

108. James White, letters to W. C. White, July 18, 1876 and July 19, 1876, James White Letters, Ellen White Research Center, DF 718-a.

109. James White, letters to W. C. White, July 18, 1876.

110. *Review and Herald* 48, no. 7 (August 10, 1876), 56.

111. Association with free masonry may also have been a problem. In 1876 the Cincinnati-based lithography firm Strobridge & Co. issued an eighteen-by-twenty-three–inch chromo entitled *Distinguished Masons of the Revolution*, which included portraits of George Washington and Benjamin Franklin, among several others, all of whom were organized beneath the all-seeing eye of God. Reproduced in Marzio, *Democratic Art*, plate 93.

112. Notice, *Review and Herald* 48, no. 19 (November 9, 1876), 152.

113. James White, "The Way of Life," *Review and Herald* 56, no. 18 (October 28, 1880), 288; see also James White, letter to W. C. White, September 16, 1880, James White Letters, DF 718-a. On the use of chromos by commercial periodicals as premiums, see Marzio, *Democratic Art*, 127–28.]

114. Letter to Ellen White, May 1, 1880, James White Letters, DF 718-a.

115. James White, letter to Ellen White, January 19, 1881, James White Letters, DF 718-a.

116. Letter to Ellen White, February 7, 1881, James White Letters, DF 718-a.

117. Letter to W. C. White, January 19, 1881; quoted in pamphlet *Key to the Allegorical Engraving Entitled WAY OF LIFE From Paradise Lost to Paradise Restored*, 1980, Ellen White Research Center, n.p. [4].

118. Letter to W. C. White, undated 1880; quoted in pamphlet *Key to the Allegorical Engraving*, n.p. [4].

119. Letter to W. C. White, September 16, 1880.

120. Letter to W. C. White, October 15, 1880, James White Letters, DF 718-a. It is possible that White was referring to the 1876 version of the print since both

could be referred to by the same title. But given his occupation with and excitement about the third version in 1880, it seems more likely that he had it in mind as a key to the financial problem.

121. Thanks to Ann Morand, curator of art collections at the Gilcrease Museum, for her considered judgment that the 1883 print bears the features of Moran's work. The celestial city in *Christ, The Way of Life* is executed in a technique that is identical to that used by Moran in a depiction of heaven, *No Night in Heaven,* which carried his name and appeared in Daniel March, *Night Scenes in the Bible* (Philadelphia: Zeigler, McCurdy & Co., 1869).

122. *Key to the Allegorical Engraving Entitled The Way of Life from Paradise Lost to Paradise Restored* (Battle Creek: Review and Herald, 1884), 4.

123. *Key to the Allegorical Engraving,* 8. For a contemporary use of the picturesque depiction of ruins to describe the effects of prophetic judgment on prominent cities and nations that opposed ancient Israel, see Ezra Hall Gillett, *Ancient Cities and Empires: Their Prophetic Doom* (Philadelphia: Presbyterian Publication Committee, 1867). The text is illustrated with picturesque vignettes of each city and nation as it appears in ruins today. For a discussion of the same subject by a Seventh-Day Adventist writer, see Joseph Clarke, "In Ruins," *Review and Herald* 14, no. 16 (September 8, 1859), 126–27.

124. *Key to the Allegorical Engraving,* 5; emphasis in original.

125. For background and discussion of the controversy, see Richard W. Schwarz, "The Perils of Growth 1886–1905," in *Adventism in America,* ed. Gary Land (Grand Rapids: Eerdmans, 1986), 97–102; Roy E. Graham, *Ellen G. White, Co-Founder of the Seventh-day Adventist Church,* American University Studies, vol. 12 (New York: Peter Lang, 1985), 105–7; and Geoffrey J. Paxton, *The Shaking of Adventism* (Grand Rapids: Baker Book House, 1977), 53–69.

126. Ellen G. White, *Review and Herald* (April 1, 1890); quoted in Paxton, *Shaking of Adventism,* 67.

127. General Conference talk, Battle Creek, Michigan, November 1883; published in E. G. White, *Gospel Workers* (Washington, D.C.: Review and Herald, 1892), quoted in Paxton, *Shaking of Adventism,* 61.

128. In subsequent years the crucified Jesus was pictured in Adventist publications such as White's *Steps to Christ* and Carlyle Haynes's *Return to Jesus* as a devotional image that was linked explicitly to biblical passages that stressed substitutionary atonement, for example, the illustration entitled *The One Who Died For Me,* in which the crucified Christ hovers above a wounded soldier—see Ellen G. White, *Steps to Christ* (Washington, D.C.: Review and Herald, 1921), 18, and Carlyle B. Haynes, *The Return of Jesus* (Washington, D.C.: Review and Herald, 1926), 82.

129. *Key to the Allegorical Engraving,* 3, 4.

130. J. G. Matteson, "Pictures or Likenesses," *Review and Herald* 57, no. 3 (January 18, 1881), 41. For Luther's discussion of images and the second commandment, see Martin Luther, *Against the Heavenly Prophets in the Matter of Images and Sacraments* (1525), in *Luther's Works,* (Philadelphia: Muhlenberg Press, 1958). For information on Matteson, see "Matteson, John Gottlieb," *Seventh-day Adventist Encyclopedia,* rev. ed. 860–61.

131. J. M. McLellan, "Idolatry," *Review and Herald* 8, no. 7 (June 12, 1856), 49–50; J. H. Waggoner, "Idolatry," *Review and Herald* 15, no. 15 (March 1, 1860), 117; Mary M. Cook, "The Last Idol," *Review and Herald* 32, no. 10 (August 25, 1868), 158.

132. Joseph Clarke, "Idolatry," *Review and Herald* 40, no. 9 (August 13, 1872), 67. Ellen White also negatively associated idolatry with the papacy in her major work, *The Great Controversy,* 52, 65.

133. *Review and Herald* 15, no. 21 (April 12, 1860), 168.

134. William Robinson, "The Great World-Kingdom Image," from Uriah Smith, *Daniel and the Revelation* (Washington, D.C.: Review and Herald, 1901). Eventually even the beloved charts were transformed into the pictorial mode as in the painting *Daniel's Great Prophecy,* by Charles Menthe, a New York artist who provided illustrations to the Review and Herald Press in Washington, D.C., in the early twentieth century. (The image is unsigned, but the style is identical to signed works by Menthe—see, for instance, the illustration of angels harvesting in *Review and Herald* 76, no. 43, October 24, 1899, p. 686, and another image in Haynes's *Return of Jesus,* "The Lord of Peace," 314, which exhibits Menthe's initials, "C. M.") This image converted the schematic features of the old Adventist chart into a portrayal of Daniel showing the familiar looming figure to a gaping Nebuchadnezzar. The Babylonian king could see the many kingdoms conjured forth in the transparent figure. The toppling dynasties and succession of violence were glimpsed in a visionary haze through the body of the Great Image. The devout viewer could still recount the symbolic references to regimes as in the original charts: the melting ruins of a stepped ziggurat at the level of the head are Babylonian; those showing through the chest resemble the remains of Persepolis, capital of Persia at the end of Persian power; Greek temples appear through the belly; the Roman Coliseum is beside the knees of the figure; and late medieval towers collapse near the feet of the Great Image. But now the visual strategy was to create a dramatic moment, as if the viewer were present, standing behind the Babylonian ruler and his queen, watching the vision and listening to Daniel explain it. The device of drawing the viewer into the immediate foreground was the same as that used in Moran's version of the *Way of Life* (see fig. 81).

135. Quoted in Morgan, "The Remnant and the Republic," 88.

136. Ellen White, ms. 23, 1896, Ellen White Research Center, reprinted in Ellen G. White, *Counsels to Writers and Editors* (Nashville: Southern Publishing, 1946), 168.

137. Ellen White, Letter 133, 1899; *Counsels to Writers,* 169.

138. Ellen White, Letter 28a, 1897; *Counsels to Writers,* 172.

139. Ellen White, Letter 147, 1899; *Counsels to Writers,* 169.

140. Ellen White, Letter 133, 1899; *Counsels to Writers,* 170.

141. Ellen White, Letter 145, 1899; *Counsels to Writers,* 171.

142. Ellen White, Letter 106, 1902, Ellen White Research Center; *Counsels to Writers,* 173.

143. Ibid., 174, 176. Professor Ronald L. Numbers has pointed out to me that Ellen White "increasingly shifted . . . from trancelike 'visions' to less sensational 'dreams'" beginning in the 1870s as part of her search for greater respectability for the church. Thus, in Numbers's view, the vision of 1902 was actually a dream. Correspondence with the author.

144. Advertisement, *Review and Herald* 76, no. 45 (November 7, 1899), 627.

145. See "Art in the SDA Church," *Seventh-day Adventist Encyclopedia,* 84.

146. Ibid.

Six: Pictures and Children

1. "Labors of the Publishing Committee," *Fourth Annual Report* (1829), 9 (see chapter 1, note 32).

2. See Anne M. Boylan, *Sunday School: The Formation of an American Institution 1790–1880* (New Haven: Yale University Press, 1988), 48. For a discussion of illustrated children's materials produced by the ATS, see Lawrance Thompson, "The Printing and Publishing Activities of the American Tract Society from 1825 to 1850," *Papers of the Bibliographical Society of America* 35 (1941), 92–97.

3. *Proceedings of the First Ten Years of the American Tract Society* (Boston: American Tract Society, 1824), 177, reprinted in *ATSD* (see chapter 2, note 28); and "Index; and Prices of Volumes," in *Circulation and Character of the Volumes of the American Tract Society* (New York: American Tract Society, 1848), 139–40. *Thirty-Eighth Annual Report* (1863), 182–84.

4. *Instructions of the Executive Committee of the American Tract Society to Colporteurs and Agents* (New York: American Tract Society, 1868), 43.

5. Ibid., 39.

6. *Thirty-Eighth Annual Report* (1863), 182–84.

7. *The First Annual Report of the American Sunday-School Union* (Philadelphia: American Sunday School Union, 1825), 5; ASSU, *Second Annual Report* (1826), 13; ASSU, *Fourth Annual Report* (1828), 4. For instructive discussions of the history of the ASSU, see *American Sunday School Union Papers 1817–1915: A Guide to the Microfilm Edition,* ed. Barbara A. Sokolosky (Sanford, N.C.: Microfilming Corporation of America, 1980); Boylan, *Sunday School;* and Edwin W. Rice, *The Sunday-School Movement, 1780–1817, and the American Sunday-School Union, 1817–1917* (Philadelphia: American Sunday School Union, 1917). A very fine study of the first

phases of the ASSU's history is Ralph Ruggles Smith, Jr., "'In Every Destitute Place': The Mission Program of the American Sunday School Union, 1817–1834," Ph.D. diss., University of Southern California, 1973. For a general discussion of the illustrated children's books published by the ASSU, see Ellen Shaffer, "The Children's Books of the American Sunday-School Union," *American Book Collector* 17, no. 2 (October 1966), 20–28. On the use of the ticket in the system of rewards, see Asa Bullard, *Fifty Years with the Sabbath Schools* (Boston: Lockwood, Brooks, & Co., 1876), 51.

8. *American Colporteur System,* 1–2, reprinted in ATSD. Emphasis in original.

9. Patricia U. Bonomi, "Education and Religion in Early America: Gleanings from *The New England Primer,*" Thirteenth Annual Phi Alpha Theta Distinguished Lecture on History (Albany: State University of New York, 1993), 6–7. On the primer, see chapter 2, note 29 here.

10. *Curious Hieroglyphic Bible* (Worcester, Mass.: Isaiah Thomas, 1788).

11. Based essentially on two British prototypes— *A Curious Hieroglyphick Bible,* published about 1780, and *A New Hieroglyphic Bible,* published in 1794, both in London—a host of new editions, reprints, and derivations followed in England, Germany, Holland, and the United States throughout the nineteenth century. From 1780 to 1812 at least twenty editions and four reprints of *A Curious Hieroglyphic Bible* appeared, see W. A. Clouston, *Hieroglyphic Bibles: Their Origin and History* (Glasgow: David Bryce & Son, 1894), 8. Versions of both Bibles were published in the United States. Over the century following Isaiah Thomas's version of the *Curious Hieroglyphic Bible,* published in Worcester, Massachusetts, in 1788, and the *New Hieroglyphic Bible,* published in 1794 by W. Norman in Boston, the *National Union Catalogue* lists thirty-three editions and printings in American cities of a variety of hieroglyphic Bibles. Since several of these were fourth and fifth editions, the total number is much higher. The Phinneys in Cooperstown and Silas Andrus & Son in Hartford stereotyped their plates and produced many printings. By 1836 *A New Hieroglyphic Bible* had entered its eleventh edition, printed for William Jackson in New York (reprint, New York: American Heritage Press, 1970).

12. *The Hieroglyphic Bible* (Hartford: S. Andrus & Son, 1855). The rebus Bible remained popular in the United States during the twentieth century—see, for instance, M. Lücke, *Biblische Symbole oder Bibelblätter in Bildern,* rev. ed. (Chicago: John A. Hertel, 1911), which was also issued in English.

13. Cousin E., "Picture of Jesus," *Well-Spring* 17, no. 33 (August 17, 1860), 130.

14. Boylan, *Sunday School,* 15–16; Anne M. Boylan, "The Role of Conversion in Nineteenth-Century Sunday Schools," *American Studies* 20 (1979), 35–48; see also Joseph Kett, *Rites of Passage, Adolescence in America 1790 to the Present* (New York: Basic Books, 1977), 118–20. An informative study of this development is Ber-

nard Wishy, *The Child and the Republic: The Dawn of Modern American Child Nurture* (Philadelphia: University of Pennsylvania Press, 1968).

15. "Improvements in Sunday Schools: Extract from the Report of Sunday School No. 23," *American Sunday School Teacher's Magazine, and Journal of Education* 1, no. 8 (July 1824), 258. This image also appeared in a primer by Dorothy Kilner, published under her pseudonym, M. Pelham, *The Primer; or Mother's Spelling Book for Children* (New York. George C. Morgan, 1823), p. 36. Boylan, *Sunday School*, 48, has discussed how gift cards proved to be a very popular inducement among children to attend Sunday school.

16. Bullard, *Fifty Years with the Sabbath Schools*, 217–18.

17. United States Bureau of the Census, *A Century of Population Growth from the First Census of the United States to the Twelfth 1790–1900* (Washington, D.C.: Government Printing Office, 1909), 103.

18. Edward Shils, "Mass Society and Its Culture," in *Culture and Mass Culture*, ed. Peter Davison, Rolf Meyersohn, and Edward Shils, vol. 1, *Literary Taste, Culture and Mass Communication*, (Cambridge, England: Chadwyck-Healy, 1978), 214.

19. Heman Humphrey, *The Way to Bless and Save Our Country: A Sermon* (Philadelphia: American Sunday School Union, 1831), 15.

20. *Thirty-First Annual Report* (1856), 109. [Frances Manwaring Calkins], *Illustrated Tract Primer* (New York: American Tract Society, n.d. [1848]). For a study of slave literacy and religious efforts to teach and promote reading among southern blacks, see Janet Duitsman Cornelius, *"When I Can Read My Title Clear": Literacy, Slavery, and Religion in the Antebellum South* (Columbia: University of South Carolina Press, 1991); on ATS colportage among slaves, see 112–13, 126; for a discussion of publications by the New York and Boston ATS wings directed to ex-slaves during and after the Civil War, see Robert C. Morris, *Reading, 'Riting, and Reconstruction: The Education of Freedmen in the South, 1861–1870* (Chicago: University of Chicago Press, 1982), 188–202.

21. On the United States Primer, see *Child's Paper* 14, no. 3 (March 1865), 10; on the *Tract Primer* among the Turks, see *Thirty-Sixth Annual Report* (1861), 8; for the missionary's statement, see *Twenty-Fifth Annual Report* (1850), 151, emphasis in original.

22. On the *Pictorial Narratives*, see *Thirty-First Annual Report* (1856), 127; on colporteurs and Catholic children, see *Twenty-Ninth Annual Report* (1854), 121–22, and "Report of Mr. D. H. S[mith]," *Twenty-Ninth Annual Report* (1854), 104, 71.

23. *Nineteenth Annual Report* (1844), 59.

24. *Twenty-Sixth Annual Report* (1850), 42, 39; *Twenty-Eighth Annual Report* (1853), 22–23.

25. Frank Luther Mott, *A History of American Magazines 1850–1865* (Cambridge: Harvard University Press, 1938), 10–11; John Tebbel and Mary Ellen Zuckerman, *The Magazine in America 1741–1990* (New York: Oxford University Press, 1991), 142.

26. In 1848, Noah Webster's *Pictorial Elementary Spelling Book* was published by Coolege in New York, W. J. Reynolds & Co. in Boston, J. P. Lippincott in Philadelphia, and Morton & Griswold in Louisville. For a discussion of the Webster family publishing story, see Walter Sutton, *The Western Book Trade: Cincinnati as a Nineteenth-Century Publishing and Book-Trade Center* (Columbus: Ohio State University Press for the Ohio Historical Society, 1961), 167–78. McGuffey's Readers, first published in 1836, were also enormously popular and extensively illustrated. *McGuffey's Pictorial Eclectic Primer*, which appeared in 1849, contained 172 engravings. For discussion and reproductions of many of the images McGuffey used in this and subsequent editions, see Harvey C. Minnich, *William Homes McGuffey and His Readers* (New York: American Book Company, 1936), 113–41. These readers were thoroughly Protestant in content and represent the importance of Protestantism in American public education in the nineteenth century—see John H. Westerhoff III, *McGuffey and His Readers: Piety, Morality, and Education in Nineteenth-Century America* (Nashville: Abingdon, 1978); Richard D. Mosier, *Making the American Mind: Social and Moral Ideas in the McGuffey Readers* (New York: King's Crown Press, 1947), 57–123; and Sutton, *Western Book Trade*, 179–87.

27. "The Influence of the Sunday-school on Home, Secular, and Sectarian Teaching," *Sunday-School Journal* 22, no. 13 (July 2, 1851), 111. For a discussion of the relationship between the Sunday school and common school, see Boylan, *Sunday School*, 22–59; also Carl F. Kaestle, *Pillars of the Republic: Common Schools and American Society, 1780–1860* (New York: Hill and Wang, 1983), 30–61.

28. Geo. W. Bethune, *The Relations of the Sunday-school System to Our Christian Patriotism*. Annual sermon, in Behalf of the American Sunday-School Union (Phil-adelphia: American Sunday School Union, 1847), 18, 19.

29. Kaestle, *Pillars of the Republic*, 75–103.

30. On the origin of the iconographical motif of Christ blessing the children during the German Reformation, see Carl C. Christensen, *Art and the Reformation in Germany* (Athens: Ohio University Press, 1979), 207. Christensen found no instances of Christ blessing the children among a sample of 441 German religious paintings executed between 1495 and 1520, in contrast to the common occurrence of the theme during the 1520s and thereafter.

31. ATS, *Twenty-Thrid Annual Report* (1848), 19.

32. ATS, *Thirty-Second Annual Report* (1857), 15.

33. ATS, *Thirty-Sixth Annual Report* (1861), 17. This was a late version of what the ASSU had disseminated as early as 1825, when it produced eleven thousand "alphabetical cards," *The First Report of the American Sunday-School Union* (Philadelphia: American Sunday School Union, 1825), 5.

34. On the contribution of religious initiatives to literacy and public education during the antebellum

period, see Lawrence A. Cremin, *American Education: The National Experience, 1783–1876* (New York: Harper and Row, 1980), 19–100; see also David Tyack, "The Kingdom of God and the Common School: Protestant Ministers and the Educational Awakening in the West," *Harvard Educational Review* 36, no. 4 (1966), 447–69; and Timothy C. Smith, "Protestant Schooling and American Nation-ality, 1800–1850," *Journal of American History* 53, no. 4 (March 1967), 679–95; on the relationship of the Sunday school to public education, see William Bean Kennedy, *The Shaping of Protestant Education* (New York: Associa-tion Press, 1966), 21–38; William K. Dunn, *What Hap-pened to Religious Education? The Decline of Religious Teaching in the Public Elementary School 1776–1861* Balti-more: Johns Hopkins University Press, 1958); Francis X. Curran, *The Churches and the Schools: American Protestant-ism and Popular Elementary Education* (Chicago: Loyola University Press, 1954); and Boylan, *Sunday School*, 22–59.

35. "Rev. Mr. Kirk's Address," *Twenty-Eighth Annual Report* (1853), 11.

36. Ibid., 20.

37. Anonymous, *Design, Character, and Uses of the Books of the American S. S. Union* (Philadelphia: American Sunday School Union, n.d. [1829]), 7–8.

38. "Rev. Mr. Kirk's Address," 91; ATS, *Thirty-Sixth Annual Report* (1861), 112.

39. Of the 158 colporteurs at work in ten southern states in 1855, more than half (87) were in Virginia and North Carolina, *Thirteenth Annual Report* (1855), 62. Virginia was not separated to create West Virginia un-til 1862, so the region was quite large during the antebellum colporteur efforts of the ATS. According to Lee Soltow and Edward Stevens, in 1840 North Carolina had the highest illiteracy rate of any state in the Union, and Virginia had the fifth highest rate, *The Rise of Literacy and the Common School in the United States: A Socioeconomic Analysis to 1870* (Chicago: University of Chicago Press, 1981), 159.

40. All information on Perkins and Virginia col-portage during 1852–1853 was taken from the tabular "Statistics of Colportage for the Year Ending March 1, 1853," *Twenty-Eighth Annual Report* (1853), 57–8. The following are general statistics, comparing Virginia and national figures, were taken from the same tables (57–58 and 71):

Virginia
61 colporteurs
36,569 volumes sold
15,633 volumes donated
1,890 meeting conducted
28,581 families visited

The Nation
516 colporteurs
452,254 volumes sold
133,019 volumes donated
12,888 meetings conducted
492,760 families visited

41. Colporteurs for the ATS were overwhelmingly male. The average age of ATS colporteurs at a convention in Chicago in 1855 was 42, "Chicago Colporteur Convention," *Thirty-First Annual Report* (1855), 150.

42. Ibid., 92.

43. *Thirty-First Annual Report* (1856), 89.

44. *Twenty-Eighth Annual Report* (1853), 92.

45. *Twenty-Sixth Annual Report* (1851), 105.

46. *Thirtieth Annual Report* (1855), 98.

47. See, for instance, *Twelfth Annual Report* (1837), 125; "Divine Blessings on the Society's Volumes," *Fourteenth Annual Report* (1839), 126, 133; "Home Operations," *Nineteenth Annual Report* (1844), 24–25, 76; *Twenty-First Annual Report* (1846), 99–100; *Twenty-Third Annual Report* (1848), 85–6; *Thirty-First Annual Report* (1856), 192; *Thirty-Sixth Annual Report* (1861), 83.

48. *Twenty-Eighth Annual Report* (1853), 101.

49. For biographical information on Scudder, see *Thirtieth Annual Report* (1855), 15.

50. Rev. John Scudder, *Dr. Scudder's Tales for Little Readers, About the Heathen* (New York: American Tract Society, 1853), 195.

51. See Larry R. Squire et al., ed., *Encyclopedia of Learning and Memory* (New York: Macmillan, 1992), 2, 397, 451–52, 487. On the dedication of the nervous system to visual stimuli, see Paul Glees, *The Human Brain* (Cambridge: Cambridge University Press, 1988), 165.

52. The best study of this is in Roland Barthes's stimulating essays, "The Photographic Message" and "The Rhetoric of the Image," in *The Responsibility of Forms: Critical Essays on Music, Art, and Representation,* tr. Richard Howard (Berkeley: University of California Press, 1991), 3–20, 21–40.

53. *A Pretty Picture Book* (New York: American Tract Society, n.d. [1829]), 12. *A Pretty Picture Book* was first listed in the *Fourth Annual Report* (1829), 79, as the seventh item in volume one of the first series of Children's Tracts. Several of the illustrations, including the one reproduced here, appear to have been engraved by Anderson. Others in the edition cited here were produced in the late 1840s or 1850s.

54. Philip E. Howard, *The Life Story of Henry Clay Trumbull, Army Chaplain, Editor, and Author* (New York: International Committee of the Young Men's Christian Association, 1906), 150. According to Asa Bullard, this tract was also one of the earliest titles in-cluded in Sunday school libraries in the Northeast, *Fifty Years with the Sabbath Schools,* 161.

55. *Little Henry and His Bearer,* no. 107, *Tracts* (1849), 4:173.

56. Ibid., 174.

57. For another account of the ritualized destruction of images among nonwestern "idolators," see *Tahiti, Receiving the Gospel* (Philadelphia: American Sunday School Union, 1832), 115–19.

58. Ibid., 199.

59. Cited and discussed in Roger Daniels, *Coming to America: A History of Immigration and Ethnicity in American Life* (New York: HarperPerennial, 1990), 267.

60. William Nevins, *Thoughts on Popery* (New York: American Tract Society, 1836; reprint, New York: Arno Press, 1977), 89. For several articles in the ASSU's *Youth's Penny Gazette* that portray the worship of images among Hindu and Catholic faithful, see the following: "The Car of the Juggernaut," vol. 2, no. 11 (May 22, 1844), 29; "The Lesson on the Map," vol. 3, no. 18 (August 27, 1845), 70; "Offerings to Heathen Idols," vol. 3, no. 21 (September 24, 1845), 82; "The Adoration of the Crucifix," vol. 5, no. 6 (March 17, 1847), 21; woman praying before roadside shrine (untitled), vol. 5, no. 13 (June 23, 1847), 49; and "Pagan Superstition," vol. 6, no. 8 (April 12, 1848), 29.

61. *Spirit of Popery* (New York: American Tract Society n.d. [1845]), 129. The book carries no date but was first advertised in *Twentieth Annual Report* (1845), 15–16.

62. *Spirit of Popery*, 73–74.

63. Ibid., 127–51 and 221–49; see also Rev. James Shaw, *The Roman Conflict: or, Rise, Power, and Impending Conflict of Roman Catholicism* (Cincinnati: Hitchcock and Walden, 1878), 214–24.

64. Robert J. Breckinridge, *Paganism in the xix. century in the United States* (Baltimore: David Owen & Son, 1841), 60; on idolatry, superstition, and moral depravity, see *Spirit of Popery*, 224–26, and Rev. W. Windsor, "Idolatry," *The American Sunday School Worker* 6, no. 7 (July 1875), 193–95.

65. *Child's Paper* 16, no. 5 (May 1867), 20.

66. Windsor, "Idolatry," 195. For condemnations of Catholic image worship by the ATS, see the following tracts: *Twenty-Two Plain Reasons for Not Being a Roman Catholic*, no. 62, Tracts (1849) 2:333–34; and Rev. Thomas Hartwell Horne, *Romanism Contradictory to the Bible*, no. 255, Tracts (1849) 9:39.

67. *Christian Almanac* (1861), 36 (see chapter 1, note 4).

68. *Theatrical Exhibitions*, tract no. 130, Tracts (1849) 5:19.

69. *Fashionable Amusements*, tract no. 73, *Publications*, 3:7, 8.

70. Richard Cordley, "Sentiment and Life," *American Messenger* 36, no. 11 (November 1877), 82.

71. Rev. F. F. Williams, "Principle, and not Mere Emotion," *American Messenger* 36, no. 6 (June 1878), 43.

72. *A New Hieroglyphic Bible* (Hartford: Oliver D. Cooke, 1821), n.p.

73. Jonathan Edwards, *Religious Affections,* ed. John E. Smith, in *The Works of Jonathan Edwards,* vol. 2 (New Haven: Yale University Press, 1959). For further discussion of Protestant visual practices in regard to Edwards's treatment of affections, see Morgan, *Visual Piety: A History and Theory of Popular Religious Images* (Berkeley: University of California Press, 1998), chap. 2.

74. On Goodrich, see David D. Hall, "Introduction: The Uses of Literacy in New England, 1600–1850," *Printing and Society in Early America,* ed. William L. Joyce, David D. Hall, Richard D. Brown, and John B. Hench (Worcester, Mass.: American Antiquarian Society, 1983), 41–42. Goodrich expressed contempt for *New England Primer,* which both the ATS and the Massachusetts Sabbath-School Society reprinted and used in the three decades before the Civil War. Goodrich, Hall points out, became a Unitarian, "Uses of Literacy," 45.

75. *Fashionable Amusements,* 112.

76. "The Earthquake in Syria," *Infant's Magazine* 2, no. 9 (September 1832), 132–33. On the role of fear and death in children's religious literature, see Boylan, *Sunday School,* 139–40.

77. For some viewers there were limits to what was visually acceptable. Several readers of *Well-Spring* wrote to the editor in the spring of 1861 to object to the horror and vulgarity of graphic depictions of a dead horse in one issue and a crocodile devouring a black child in another, see vol. 18, no. 15 (April 12, 1861), 60, and vol. 18, no. 22 (May 31, 1861), 86. For another depiction of an Indian mother throwing her child to crocodiles, see Scudder, *Tales,* 87, which includes a discussion of the practice, 86–90.

78. Scudder, *Tales,* 137, 143, 152, 150–52.

79. Ibid., 201.

80. "Conversation between a Father and Son, On the 7th Chapter of Daniel," *Children's Advent Herald* 1, no. 4 (October 1846), 14.

81. Although probably fictional, the narrative may have been based on the experience of Joshua Himes, who published the paper, or Nathaniel Southard, who wrote other material for children using Millerite symbols. For additional discussion of the prophetic imagery for Adventist youth, see Nathaniel Southard, "To Children and Youth," *Midnight Cry* 7, no. 14 (October 10, 1844), 108–110; reprinted in *Children's Advent Herald* 1, no. 1 (May 1846), 3–4. Southard was the editor of *Youth's Cabinet* from 1837 to 1841 and *Midnight Cry* from 1842 to 1844.

82. "Conversion between a Father and Son," 15.

83. See Robert C. Fuller, *Naming the Antichrist: The History of an American Obsession* (New York: Oxford University Press, 1995), 36–37.

84. Daniels, *Coming to America,* 130–38, 146.

85. "The Prisoner," *Child's Paper* 1, no. 12 (December 1852), 46.

86. Bullard, *Fifty Years with the Sabbath Schools,* 236.

87. *Child's Paper* 16, no. 5 (May 1867), 18.

88. Untitled, *Child's Paper* 15, no. 11 (November 1866), 43.

89. Untitled, *Child's Paper* 17, no. 11 (November 1868), 42.

90. *Self-Denial: or, Alice Wood and Her Missionary Society,* Child's Cabinet Library, vol. 50 (Philadelphia: American Sunday School Union, n.d. [1847]), 4.

91. Ibid., 9, 23.

92. Ibid., 28. Emphasis in original.

93. "Mama's Story," *Well-Spring* 18, no. 25 (June 21, 1861), 96. In this instance a common link between *Well-Spring* and the *Christian Almanac* was Helen Cross Knight, who edited the *Almanac* in the 1860s and published religious books through the Massachusetts Sabbath School Society.

94. *Christian Almanac* (1869), 41–42.

95. Many viewers have claimed to find images hidden in a popular image of Jesus by Warner Sallman; see Morgan, *Visual Piety*, chap. 4.

96. Robert F. Y. Pierce, *Pictured Truth. A Hand-Book of Blackboard and Object Lessons* (New York: Fleming H. Revell, 1895), 20.

Seven: Talking Pictures

1. R. W. Scribner, *For the Sake of Simple Folk: Popular Propaganda for the German Reformation* (Oxford: Clarendon Press, 1994), 229.

2. See Meyer Schapiro, *Words, Script, and Pictures: Semiotics of Visual Language* (New York: George Braziller, 1996), for an important study of word and image in medieval art. For an overview of word and image relations in art since the Reformation, see the editor's introduction to David Morgan, ed., *Icons of American Protestantism: The Art of Warner Sallman* (New Haven: Yale University Press, 1996), 2–18.

3. See John D. Morse, ed., *Prints in and of America to 1850* (University Press of Virginia, 1970); Elizabeth Carroll Reilly, *A Dictionary of Colonial American Printers' Ornaments and Illustrations* (Worcester, Mass.: American Antiquarian Society, 1975); *American Printmaking before 1876: Fact, Fiction, and Fantasy* (Washington, D.C.: Library of Congress, 1975); and Robert F. Looney, ed., *Philadelphia Printmaking: American Prints before 1860* (Philadelphia: Tinicum Press, 1976).

4. *Well-Spring* 23, no. 49 (December 7, 1866), 196.

5. Rev. H[enry] C. McCook, *Object and Outline Teaching: A Guidebook for Sunday-School Workers* (St. Louis: J. W. McIntyre, 1871), 317.

6. "Value of Pictures," *Well-Spring* 17, no. 31 (August 3, 1860), 124.

7. "Picture for a Story," *Well-Spring* 18, no. 38 (September 20, 1861), 148.

8. Ella, "Almost Home," *Well-Spring* 17, no. 33 (August 17, 1860), 130. Emphasis in original.

9. *Specimen Book of Engravings. Electrotype Casts Furnished to Order* (New York: Carlton & Porter, published between 1857 and 1860), 36, catalogue nos. 5133–36.

10. "Picture for a Story, Again," *Well-Spring* 18, no. 47 (November 22, 1861), 186.

11. Joseph Clark, "Samuel Wellman Clark," *The Encyclopedia of Sunday Schools and Religious Education* ed. John T. McFarland and Benjamin S. Winchester, 3 vols. (New York: Thomas Nelson, 1915), 1:274.

12. "The Blackboard in Sunday-school," *Sunday School Times* 13, no. 15 (April 15, 1871), 232.

13. Rev. H. Clay Trumbull, "Eye Teaching," *American Sunday School Worker* 3, no. 6 (June 1872), 164. Trumbull quotes a British author, Mrs. Davids, in her treatise on the Sunday school published "a quarter of a century ago." Asa Bullard, *Fifty Years with the Sabbath Schools* (Boston: Lockwood, Brooks & Co., 1876), 65, indicated that the blackboard had been in use in Sunday schools in Dedham, Massachusetts, as early as the 1840s to teach scripture geography lessons and to provide maps of foreign missions.

14. Trumbull, "Eye Teaching," 164. Ibid.

15. E[dward] E[ggleston], "The Blackboard," *Sunday School Teacher* 3, no. 1 (January 1868), 11.

16. Horace Mann, "Means and Objects of Common School Education," in *Lectures on Education* (Boston: Ide & Dutton, 1855), 28.

17. Johann Heinrich Pestalozzi, *Leonard and Gertrude*, tr. and ed. Eva Channing, intro. G. Stanley Hall (Boston: D. C. Heath & Co., 1885), 130–31. For an instructive introduction to Pestalozzi, see Solomon Bluhm, "Johann Pestalozzi," *The Encyclopedia of Education*, 10 vols. (New York: Macmillan, 1971), 7:87–92.

18. Pestalozzi, *Leonard and Gertrude,* ibid., 152.

19. For a helpful study of the Oswego movement, see Dorothy Rogers, *Oswego: Fountainhead of Teacher Education. A Century in the Sheldon Tradition* (New York: Appleton Century Crofts, 1961).

20. For a discussion of Pestalozzi's notion of aesthetic education contemporary with Barton and Cope, see A[uguste] Pinloche, *Pestalozzi and the Foundation of the Modern Elementary School* (New York: Scribner's, 1901), 171–75. For Pestalozzi's influence on Horace Mann, see Mann's *Ninth Annual Report* to the Massachusetts Board of Education (1845), in Horace Mann, *The Republic and the School: The Education of Free Men*, ed. Lawrence A. Cremin (New York: Terachers College, Columbia University, 1957).

21. "The Blackboard," *Sunday-School Times* 12, no. 1 (January 1, 1870), 11.

22. Rev. Edward Eggleston, "The Brooklyn Sunday-School Union. Blackboarding," *Sunday-School Times* 13, no. 2 (March 25, 1871), 186.

23. McCook, *Object and Outline Teaching,* 12.

24. Ibid., 3, 4.

25. Eggleston, "Blackboarding," 186. A paper read before a meeting of the Philadelphia Sunday-School Teachers' Institute in 1870 carefully distinguished between the "Romanist" abuse of object-teaching and Protestant pedagogy in the hands of teachers who substituted such instructional devices as the Bible, cross, dove, and lamb for holy water, ashes, palm leaves, wafe, altar, robes, and vestments. Miss Harriet B. M'Keever, "Object Teaching," *Sunday-School Times* 12, no. 14 (April 2, 1870), 218.

26. McCook, *Object and Outline Teaching,* 4, 6, 30–35.

27. Trumbull, "Eye Teaching," 164.

28. Trumbull, "Eye Teaching," 164–65; 165.

29. "The Blackboard and its Uses," *American Sunday School Worker* 6, no. 10 (October 1875), 294. A Baptist author on the role of men and women in the Sunday school wrote in 1871 that "it would be better to have a man of *very* moderate ability as superintendent, than to have a very gifted woman," quoted in Anne M. Boylan, *Sunday School: The Formation of an American Institution 1790–1880* (New Haven: Yale University Press, 1988), 124; for a very instructive study of gender

and the Sunday school teacher, see Anne M. Boylan, "Evangelical Womanhood in the Nineteenth Century: The Role of Women in Sunday Schools," *Feminist Studies* 4 (October 1978), 62–80.

30. The following very small selection of publications indicates several of the authors, titles, and publishing firms that dominated the market for blackboard and chalk talk literature: McCook, *Object and Outline Teaching* [T. B. E.], *Curiosities of the Bible*, rev. ed. (New York: E. B. Treat, 1880); Eva C. Griffith, *Chalk Talk Hand Book* (Chicago: Woman's Temperance Publishing Association, 1887); Rev. Robert F. Y. Pierce, *Pictured Truth: A Hand-Book of Blackboard and Object Lessons* (New York: Fleming H. Revell, 1895); Ella N. Wood, *Chalk: or, We Can Do It* (Chicago: F. H. Revell, 1903); Rev. Robert F. Y. Pierce, *Pencil Points for Preacher and Teacher* (New York: Fleming H. Revell, 1905); Bert J. Griswold, *Crayon and Character: Truth Made Clear Through Eye and Ear or Ten-Minute Talks With Colored Chalks* (Indianapolis: Meigs, 1913); Rev. Robert F. Y. Pierce, *Blackboard Efficiency* (New York: Fleming H. Revell, 1922); Ella N. Wood, *Chalk Talks with Boys and Girls* (New York: Fleming H. Revell, 1923); George A. Crapullo, *Blackboard Outlines: Through Eye and Ear to Heart and Mind* (New York: Fleming H. Revell, 1924); Harlan Tarbell, *Chalk Talks for Sunday Schools* (Chicago: T. S. Denison, 1928); William Allen Bixler, *Chalk Talk Made Easy* (Anderson, Ind.: Warner Press, 1932); and Lourie Ottis Brown, *Crayon Talks* (New York: Fleming H. Revell, 1941).

31. Pierce, *Pictured Truth*, 13–16.

32. Ibid., 16.

33. Ibid. Emphasis in original.

34. Luther A. Weigle, "The Teacher," in *The Pilgrim Training Course for Teachers* (Boston: Pilgrim Press, 1917), 132.

35. John H. Vincent, *The Modern Sunday-School* (New York: Eaton and Mains; Cincinatti: Curts and Jennings, 1887), 293.

36. Pierce, *Pictured Truth*, 18, 23, 24, 25. See also "The Blackboard," *Sunday School Times* 12, no. 3 (January 15, 1870), 45; and C[harles] B. Stout, "Philosophy of the Blackboard," *Sunday School Times* 12, no. 16 (April 16, 1870), 250.

37. Wilbur F. Crafts, quoted by Pierce, took this position: "Some things are too sacred for chalk or pencil; an outline of Christ in the form of a man is one of these. Put away your chalk as you approach such 'holy ground,'" Pierce, *Pictured Truth*, 25.

38. Pierce, *Pictured Truth*, 25, 26; emphasis in original. Not infrequently, evangelical chalk talkers contended that their work was not artistic but strictly instrumental—see for instance, Paul E. Holdcraft, *Outline Chalk Talks* (Indianapolis: Meigs, 1921), n.p.: "The sketches are not designed for works of art, but to be so simple that others may be encouraged to take up these methods."

39. Quoted in Pierce, *Pictured Truth*, 26, 27.

40. Bixler, *Chalk Talk Made Easy*, 17.

41. Chalk talks were especially popular at temper-ance meetings, and texts on chalk talks often included temperance themes, see Pierce, *Pictured Truth*, 150–57; Wood, *Chalk*, 117–21, 126–31; Griswold, *Crayon and Character*, 103–5; and Crapullo, *Blackboard Outlines*, 56–58. For a list of eleven temperance chalk talk titles, see Israel P. Black, *Practical Primary Plans for Primary Teachers of the Sunday-School*, rev. ed. (New York: Fleming H. Revell, 1903), 252–53.

42. Bixler, *Chalk Talk Made Easy*, 14.

43. Ibid., 44, 46.

44. Ibid., 15.

45. McCook, *Object and Outline Teaching*, 310.

46. Black, *Practical Primary Plans*, 89, 88. Emphasis in original.

47. Wood, *Chalk*, 46.

48. Tarbell, *Chalk Talks for Sunday School*, 15.

49. Jackson Lears, *Fables of Abundance: A Cultural History of Advertising in America* (New York: Basic Books, 1994), 42.

50. Bixler, *Chalk Talk Made Easy*, 17: "I have found, while doing public illustrating, that the little child will sit almost breathlessly, and the eye will follow every move of the hand. At the same time the older person will display no less interest, and will sit perfectly still with eyes, ears, and mouth open—taking in the entire situation."

51. Quoted from the *Long Beach Telegram*, 1927, in Bixler, *Chalk Talk Made Easy*, 7.

52. Bixler, *Chalk Talk Made Easy*, 124.

53. Quoted in Walter Scott Dill, *The Theory and Practice of Advertising* (Boston: Small, Maynard, 1908), 3.

54. *Well-Spring* 23, no. 49 (December 7, 1866), 196.

55. Walter Dill Scott, *Influencing Men in Business: The Psychology of Argument and Suggestion* (New York: Ronald Press, 1911).

56. For further discussion of advertising's development at this time, see Frank Presbrey, *The History and Development of Advertising* (Garden City, N.Y.: Doubleday, Doran, 1929), 227–301.

57. Presbrey, *History and Development of Advertising*, 456; see also 281–88; Charles B. Stout, "The Blackboard in Sunday-School," *Sunday School Times* 13, no. 13 (March 11, 1871), 155.

58. Earnest Elmo Calkins and Ralph Holden, *Modern Advertising* (New York: Appleton, 1905, reprint, New York: Garland, 1985), 9; Daniel Starch, *Advertising Principles* (Chicago: A. W. Shaw, 1927), 300. Compare the same phrase used by a Millerite author writing of the millennial chart, "Plan of Calculating the Prophetic Periods," *Signs of the Times*, 5, no. 15 (June 14, 1843), 115.

59. Harry Tipper et al., *The Principles of Advertising. A Text-Book* (New York: Ronald Press, 1921), 253.

60. S. Roland Hall, *The Advertising Handbook* (New York: McGraw-Hill, 1921), 347; 77–85. See also John H. Cover, *Advertising: Its Problems and Methods* (New York: Appleton, 1926), 195: "Pictures are universally understood. The child will 'read' them without knowledge of the words in the text. They require no interpreta-

tion by caption. It is this universal appeal that makes the illustration so important a contribution to effective advertising."

61. Hall, *Advertising Handbook*, 80, 85.

62. See Arthur Judson Brewster and Herbert Hall Palmer, *Introduction to Advertising* (Chicago: A. W. Shaw, 1925), 78–82; see also Tipper et al., *Principles of Advertising*, 64–66.

63. Walter Dill Scott, *The Theory and Practice of Advertising* (Boston: Small, Maynard, 1908), 5. For biographical information, see Edmund C. Lynch, *Walter Dill Scott: Pioneer in Personnel Management* (Austin: Bureau of Business Research, University of Texas at Austin, 1968), 15. All the activities or brain functions listed were treated by William James, one of the most influential writers on psychology of his day, and one whose work spanned the growing gap between humanistic and experimental psychology, see his *Principles of Psychology*, 2 vols. (New York: Henry Holt and Company, 1890).

64. Dill, *Theory and Practice of Advertising*, 50, 74.

65. Starch, *Advertising Principles*, 197.

66. "Tract Visitation and Distribution," *Sixteenth Annual Report* (1841), 24, 25.

67. Tipper, *Principles of Advertising*, 12; T. J. Jackson Lears has written a very instructive article on the religious rhetoric of advertising, "From Salvation to Self-Realization: Advertising and the Therapeutic Roots of the Consumer Culture, 1880–1930," in *The Culture of Consumption: Critical Essays in American History, 1880–1980*, ed. Richard Wightman Fox and T. J. Jackson Lears (New York: Pantheon Books, 1983), 1–38. See also T. J. Jackson Lears, *Fables of Abundance: A Cultural History of Advertising in America* (New York: Basic Books, 1994), 261–98. Rolf Lundén, *Business and Religion in the American 1920s* (New York: Greenwood Press, 1988) is instructive on the advertising mentality adopted by many clergy and Christian educators during the 1920s.

68. Colin Campbell, *The Romantic Ethic and the Spirit of Modern Consumerism* (Oxford: Blackwell, 1987), 86. Jackson Lears has argued that modern advertising "reversed the process described by . . . Benjamin . . . restoring an aura of uniqueness to products," the "vitality" or "personality" of a commodity, *Fables of Abundance*, 289, 291.

69. McCook, *Object and Outline Teaching*, 24, 21.

70. Ibid., 306–7.

Eight: The Devotional Likeness of Christ

1. Clarence Larkin, *Dispensational Truth or God's Plan and Purpose in the Ages*, rev. ed. (Philadelphia: Rev. Clarence Larkin Estate, 1920) and *The Book of Revelation: A Study of the Last Prophetic Book of Holy Scripture* (Philadelphia: Rev. Clarence Larkin Estate, 1919). I have discussed Larkin's work and other Dispensationalist charts in *Visual Piety: A History and Theory of Popular Religious Images* (Berkeley: University of California Press, 1998), chap. 6. For Adventist imagery, see chapter 5 here; for Jehovah's Witness Dispensationalist imagery, see the fold-out frontispiece to Charles Taze Russell, *Studies in the Scriptures. Series 1, The Plan of the Ages* (Allegheny, Pa.: Watch Tower and Tract Society, 1908); and Paul Boyer, *When Time Shall Be No More: Prophecy Belief in Modern American Culture* (Cambridge: Harvard University Press, 1992).

2. I have examined such claims in response to the imagery of Warner Sallman—see Morgan, *Visual Piety*, chap. 5. See also Yvonne J. Milspaw, "Protestant Home Shrines: Icon and Image," *New York Folklore* 12, nos. 3–4 (1986), 119–36.

3. T. J. Jackson Lears, *No Place of Grace: Antimodernism and the Transformation of American Culture, 1880–1920* (Chicago: University of Chicago Press, 1981), see chap. 5; Jenny Franchot, *Roads to Rome: The Antebellum Protestant Encounter with Catholicism* (Berkeley: University of California Press, 1994); Neil Harris, *The Artist in American Society: The Formative Years 1790–1860* (Chicago: University of Chicago Press, 1982), 124–44, 170–86, 300–316.

4. A fine study of character-building efforts among American Protestants in the late nineteenth century is David I. Macleod, *Building Character in the American Boy: The Boy Scouts, YMCA, and Their Forerunners, 1870–1920* (Madison: University of Wisconsin Press, 1983).

5. Horace Bushnell, *Christian Nurture*, intro. John M. Mulder (Grand Rapids: Baker Book House, 1991), 13, 31, 91; for a study of the history of nurture in the nineteenth century, see Bernard Wishy, *The Child and the Republic: The Dawn of Modern American Child Nurture* (Philadelphia: University of Pennsylvania Press, 1968).

6. Bushnell, *Christian Nurture*, 195–223.

7. Ibid., 101, 110.

8. Horace Bushnell, *Women's Suffrage: The Reform Against Nature* (New York: Charles Scribner & Co., 1869), 56, reprint, Washington, D.C.: Zenger, 1978.

9. Ibid., 52.

10. Horace Bushnell, "Unconscious Influence" (1846), in *Sermons for the New Life* (New York: Scribner's, 1905), 186, 187–88. For a similar discussion of the same ideas, see Rev. T. S. King, "Indirect Influences," *The Rose of Sharon: A Religious Souvenir for MDCCCLII*, ed. Mrs. C. M. Sawyer (Boston: A. Tompkins and B. B. Mussey & Co., 1852), 230–43.

11. Bushnell, "Unconscious Influence," 188, 192. For a clear explanation of the basic ideas of Lavater's physiognomy, see John Graham, *Lavater's Essays on Physiognomy: A Study in the History of Ideas* (Bern: Peter Lang, 1979), 35–59.

12. Bushnell, "Unconscious Influence," 193, 194, 195.

13. Ibid., 200.

14. Bushnell, *Christian Nurture*, 405.

15. For consideration of Bushnell's idea of unconscious influence in regard to Sunday school, see H. Clay Trumbull, *Teaching & Teachers, or The Sunday-School Teacher's Teaching Work and the Other Work of the*

Sunday-School Teacher (Philadelphia: John D. Wattles, 1884), 265–66; see also Rev. Daniel Rice, "Unconscious Teaching," *Sunday School Teacher* 3, no. 8 (August 1868), 225–26.

16. *Christian Almanac* (1869), 41 (see chapter 1, note 4). For further discussion of the role of mother and father in the domestic altar, see Colleen McDannell, *The Christian Home in Victorian America, 1840–1900* (Bloomington: Indiana University Press, 1986), especially chaps. 5 and 6.

17. On nineteenth-century American art and phrenology, see Charles Colbert, "'Each Little Hillock Hath a Tongue': Phrenology and the Art of Hiram Powers," *Art Bulletin* 68, no. 2 (June 1986), 281–300; Charles Colbert, *A Measure of Perfection: Phrenology and the Fine Arts in America* (Chapel Hill: University of North Carolina, 1997); and Dolores Beck Yonkers, "The Face as an Element of Style: Physiognomical Theory in Eighteenth Century British Art," Ph.D. diss., University of California, Los Angeles, 1970; on literature, see Edward Hungerford, "Walt Whitman and His Chart of Bumps," *American Literature* 2 (May 1931), 750–84, as well as several other articles by Hungerford and others in the same volume of *American Literature*.

18. Quoted by John D. Davies, *Phrenology: Fad and Science. A Nineteenth-Century American Crusade* (New Haven: Yale University Press, 1955), 25, from *Phrenological Magazine and New York Literary Review* 1 (1835), 48.

19. For a helpful study of phrenology, see Davies, *Phrenology: Fad and Science.* For more recent examinations of its history, see Angus McLaren, "Phrenology: Medium and Message," *Journal of Modern History* 46, no. 1 (March 1974), 86–97; and Jason Y. Hall, "Gall's Phrenology: A Romantic Psychology," *Studies in Romanticism* 16 (Summer 1977), 305–17. On the originator of phrenology, see Erwin Ackerknecht, *Franz Joseph Gall, Inventor of Phrenology and His Collection*, tr. C. St. Léon (Madison: University of Wisconsin Medical School, 1956).

20. O. S. Fowler, *Practical Phrenology*, 22nd ed., rev. (New York: Published by the author, 1845), 4.

21. See, for instance, [George Lyon], "Essay on the Phrenological Causes of the Different Degrees of Liberty Enjoyed by Different Nations," *Annals of Phrenology* 1, no. 2 (September 1834), 168–88; "Republicanism: Its Destined Influence on Human Intellect and Action," *American Phrenological Journal* 18, no. 1 (July 1853), 1–3; D. H. Jacques, "American Faces," *American Phrenological Journal* 49, no. 1 (January 1869), 12–13; O. S. and L. N. Fowler, *New Illustrated Self-Instructor in Phrenology and Physiology* (New York: Fowler and Wells, 1859), 64.

22. Henry Ward Beecher, *Star Papers: or, Experiences of Art and Nature* (New York: J. C. Derby, 1855), 71. Emphasis in original. Beecher defended his understanding of phrenology as the "science of the mind" in a newspaper column, reprinted in his *Eyes and Ears* (Boston: Ticknor and Fields, 1862), 20–25. For an engraving of Beecher taken from a daguerreotype, see

"Written Descriptions, from Daguerreotypes," *American Phrenological Journal* 19, no. 1 (July 1856), 1.

23. For an example of a visual analysis that would have interested members of religious benevolent societies, see "The Phrenological Developments and Character of the Late Rev. Dr. [James] Milnor," *American Phrenological Journal* 8, no. 2 (February 1846), 39–44, which pointed out that Milnor, a member of the ATS Publishing Committee from 1826 to 1845, possessed a head that demonstrated his benevolence. Pictured in the article, Milnor's head was said to evince "a truly prodigious organ of Benevolence. I rarely remember to have seen as great a development of this organ in any one," 41.

24. "Another Turn in Our Picture Gallery," *Youth's Penny Gazette* 14, no. 2 (January 16, 1856), 7. For a discussion of the use of physiognomy to create visual types to represent the working class and ethnic groups in nineteenth-century illustrated newspapers, see Joshua Brown, "Reconstructing Representation: Social Types, Readers, and the Pictorial Press, 1865–1877," *Radical History* 66 (Fall 1996), 5–38.

25. Quoted in Richard Rudisill, *Mirror Image: The Influence of the Daguerreotype on American Society* (Albuquerque: University of New Mexico Press, 1971), 177.

26. M[arcus] A[urelius] Root, *The Camera and the Pencil; or the Heliographic Art* (Philadelphia: M. A. Root and J. B. Lippincott, 1864), 84, 89. Emphasis in original.

27. E. K. Hough, "Expressing Character in Photographic Pictures," *American Journal of Photography* n.s. 1, no. 14 (December 15, 1858), 214–15.

28. John Bunyan, *The Pilgrim's Progress* (Philadelphia: Lippincott, 1902).

29. *A Biography of The Saviour, and His Apostles, with a Portrait of Each* (New York: H. L. Barnum, and Wiley & Long, 1835), reproduced Leonardo's image and individual portraits from it, coupled with each figure's biography.

30. Charles G. Leland, "The Head of Christ, By Steinhauser," *Sartain's Magazine* 4, no. 2 (February 1849), 135, emphasis in original. Mrs. [Anna] Jameson and Lady Eastlake, *The History of Our Lord as Exemplified in Works of Art*, 3rd ed., 2 vols. (London: Longmans, Green, and Co. 1872), 1:35.

31. Henry Ward Beecher, *The Life of Jesus, the Christ* (New York: J. B. Ford and Company, 1871), 141.

32. Quoted in Jameson and Eastlake, *History of Our Lord*, 35. The letter was also quoted by Beecher, *Life of Jesus*, 140–41, and by Leland, "Head of Christ," 136.

33. On Pendleton, see Harry T. Peters, *America on Stone: The Other Printmakers to the American People* (Garden City, N.Y.: Doubleday, Doran, 1931), 312–33. A related image of Christ, engraved from a portrait said to have been originally carved during Christ's lifetime, appeared as the frontispiece to G. T. Bedell, ed., *The Religious Souvenir* (Philadelphia: Key & Biddle, 1834). A caption reads: "A true likeness of Our Saviour copied from the portrait carved on an emerald by order of Tiberius Caesar . . ."

34. William Ingalls, *A Lecture on the Subject of Phrenology not Opposed to the Principles of Religion; nor the Precepts of Christianity* (Boston: Dutton and Wentworth, 1839), 48.

35. *Currier & Ives. A Catalogue Raisonné*, 2 vols. (Detroit: Gale Research Company, 1984), 1:xvi. A black-and-white version of the print is listed with a slightly different title in volume 2 of the *Catalogue Raisonné*, cat. no. 5026.

36. For the text of the letter of Publius, see Beecher, *Life of Christ*, 140–41 n. 2.

37. A superb study of Veronica is Ewa Kuryluk, *Veronica and Her Cloth: History, Symbolism, and Structure of a "True" Image* (Cambridge, Mass.: Basil Blackwell, 1991).

38. Beecher, *Life of Jesus*, 143.

39. Beecher, *Star Papers*, 53.

40. Ibid., 81.

41. Beecher, *Life of Jesus*, 136, 135.

42. Ibid., 142.

43. Ibid., 143, 144.

44. George W. Bethune, "The Prospects of Art in the United States" (1840), in *Orations and Occasional Discourses* (New York: George P. Putnam, 1850), 188, 160–61.

45. Cyrus A. Bartol, *Pictures of Europe, Framed in Ideas* (Boston: Crosby, Nichols, and Company, 1855), 203, 204.

46. *Life and Letters of Horace Bushnell*, ed. Mary Bushnell Cheney (New York: Harper & Brothers, 1880), 156.

47. Harris, *Artist in American Society*, 136, 28–53; see also note 3 in this chapter. For further consideration of clergy's reactions to works of art, see John Dillenberger, *The Visual Arts and Christianity in America: From the Colonial Period to the Present*, expanded ed. (New York: Crossroad, 1989), 43–56; and Diane Apostolos-Cappadona, *The Spirit and the Vision: The Influence of Christian Romanticism on the Development of Nineteenth-Century American Art* (Atlanta: Scholars Press, 1995), 39–62.

48. Augustine Duganne, *Art's True Mission in America* (New York: Geo. S. Appleton, 1853), 3.

49. Ibid., 29, 31.

50. Duganne, *Art's True Mission*, 23–6; Bethune, "Prospects of Art," 167.

51. *Life and Letters of Horace Bushnell*, 150, 151.

52. See Richard L. Bushman's discussion of Bushnell in *The Refinement of America: Persons, Houses, Cities* (New York: Knopf, 1992), 326–31.

53. William G. McLoughlin, *The Meaning of Henry Ward Beecher: An Essay on the Shifting of Values of Mid-Victorian America, 1840–1870* (New York: Knopf, 1970), 101, 130.

54. Beecher, *Eyes and Ears*, 220.

55. McLoughlin, *Meaning of Henry Ward Beecher*, 127.

56. The belief in the stature of reproductions and their power to refine public sensibilities was evident in the proposal of 1869 to establish a museum of art in Boston. Charles Callahan Perkins wrote: "Original works of art being out of our reach on account of their rarity and excessive costliness, and satisfactory copies of paintings being nearly as rare and costly as originals, we are limited to the acquisition of reproductions in plaster and other analogous materials of architectural fragments, statues, coins, gems, metals, and inscriptions, and of photographs of drawings by the old masters, which are nearly as perfect as the originals from which they are taken, and quite as useful for our purposes." Quoted in Walter Muir Whitehill, *Museum of Fine Arts, Boston: A Centennial History*, 2 vols. (Cambridge: Harvard University Press, 1970), 1:10.

57. An even earlier edition, published in 1822 by S. Walker in Boston, was illustrated with several plates engraved (in metal) by J. B. Neagle and by J. Palmer after works by Benjamin West and Raphael, among others.

58. About this time, ca. 1861–1864, Johnson, Fry & Co., then Martin, Johnson & Co., in New York published Fleetwood's *Life of Christ* in the same format but with forty-seven different engravings, many from the Old Testament. The illustrations were engraved by several people such as J. C. Buttre, W. W. Rice, J. Bannister, H. C. Shotwell, Ezekiel Teel, and H. B. Hall after such contemporary painters of religious subjects as the German Phillip Veit and the Britan John Martin. Buttre, Rice, and Bannister were Philadelphia engravers who also contributed to the publication of their fellow Philadelphian engraver, *Sartain's Magazine*, published by John Sartain and his family from 1848 to 1852.

59. Rev. John Fleetwood, *The Life of Our Lord and Saviour Jesus Christ* (New York: D. W. Evans & Co., 1859). Other early illustrated lives of Christ include: *Biography of the Saviour, and His Apostles, with a Portrait of Each* (New York: H. C. Barnum and Wiley & Long, 1835); Rev. H. Hastings Weld, *The Life of Christ* (Philadelphia: Hogan & Thompson, 1850), with ten metal plate engravings; *Scenes of the Life of the Saviour*, The Good Child's Library, First Book (Philadelphia: Hogan & Thompson, 1850), with four color wood engravings; Rev. John Todd, "Scenes in the Life of the Saviour," *Sartain's Magazine* 8, no. 1 (January 1851), 5–12; no. 2 (February 1851), 81–88; no. 3 (March 1851), 152–58; no. 4 (April 1851), 230–37; no. 5 (May 1851), 295–301; no. 6 (June 1851), 359–65; vol. 9, no. 1 (July 1851), 9–15; no. 2 (August 1851), 90–95; no. 3 (September 1851), 169–75; no. 4 (October 1851), 249–56; no. 5 (November 1851), 331–37; no. 6 (December 1851), 412–19; and *The Child's Life of Our Saviour* (Philadelphia: Fisher & Brothers, 1860), with a frontispiece head-and-shoulders called "Portrait of Christ."

60. Augustus Neander, *The Life of Jesus Christ in Its Historical Connexion and Historical Development*, tr. John M'Clintock and Charles E. Blumenthal, 3rd ed. (New York: Harper & Brothers, 1850). Lyman Abbott, *Jesus of Nazareth: His Life and Teaachings* (New York: Harper & Brothers, 1869). For a discussion of the Harper's Illustrated Bible, see chapter 2 here. For a life of Christ

illustrated by twenty engravings after Doré and published by the American Tract Society, see Rev. William Hanna, *The Life of Christ* (New York: American Tract Society, n.d. [1863]).

61. This book followed Wainright's *Women of the Bible* (New York: D. Appleton, 1849), which used the same format and included essays by such clergy as Episcopal clergyman William Muhlenberg and Episcopal bishop and American Tract Society supporter Charles McIlvaine.

62. *Our Saviour with Prophets and Apostles,* ed. Rev. J. M. Wainright (New York: D. Appleton & Co., 1851), 9.

63. The following is a small, representative list of Christian gift book annuals: *The Christian's Annual* (Philadelphia: Henry F. Anners, 1846); *The Christian Keepsake and Missionary Annual,* ed. Rev. John A. Clark (Philadelphia: William Marshall & Co., 1840); *The Christian Souvenir: An Offering for Christmas and the New Year,* ed. Isaac F. Shepard (Boston: Henry B. Williams, 1843); *The Religious Keepsake; for Holiday Presents,* ed. Lydia H. Sigourney (Hartford: S. Andrus & Son, 1846); *The Religious Offering,* ed. Catharine H. Waterman (Philadelphia: W. Marshall & Co., 1840); *The Religious Souvenir, A Christmas, New Year's and Birthday Present,* ed. G. T. Bedell (Philadelphia: Key and Biddle, 1833); *The Rose of Sharon: A Religious Souvenir,* ed. S. C. Edgarton (Boston: A. Tompkins and B. B. Mussey, 1845); and *The Union Annual* (Philadelphia: American Sunday School Union, 1837), the first such annual for the ASSU.

64. David S. Lovejoy has determined that just more than half of the artists contributing to two prominent gift-book annuals from 1826 to 1843 were American. He does not indicate, unfortunately, how many of the engravings were produced by American engravers, but the number is at least as high, since paintings by Americans in America were probably engraved by American engravers and since the American books were generally produced in Boston, Philadelphia, and New York, which supported many firms and individuals who produced metal and wood engraving as well as lithography, "American Painting in Early Nineteenth-Century Gift Books," *American Quarterly* 7, no. 4 (Winter 1955), 346.

65. For a discussion of the history of the illustrated gift book, see "Annuals and Gift-Books," in *The Cambridge History of American Literature,* ed. William Peter Trent et al., 4 vols. (New York: Putnam, 1918), 2:170–74; Ralph Thompson, *American Literary Annuals and Gift Books 1825—1865* (New York: H. W. Wilson Co., 1936, reprint, New York: Archon Books, 1967); and E. Bruce Kirkham and John W. Fink, *Indices to American Literary Annuals and Gift Books 1825–1865* (New Haven: Research Publications, 1975). For the late Victorian artistic gift book, see Michael Felmingham, *The Illustrated Gift Book, 1880–1930, With a Checklist of 2500 Titles* (Aldershot, England: Scolar Press, 1988). On the imagery, art, and artists in gift books, see Martinez, "The Life and Career of John Sartain (1808–1897): A Nineteenth-Century Philadelphia Printmaker," Ph.D.

diss., George Washington University, 1986. 34–62; more recently, Ann Katharine Martinez, "'Messengers of Love, Tokens of Friendship': Gift-Book Illustrations by John Sartain," in *The American Illustrated Book in the Nineteenth Century,* ed. Gerald W. R. Ward (Winterthur, Del.: Henry Francis du Pont Winterthur Museum, 1987), 89–112; and Benjamin Rowland, Jr., "Popular Romanticism: Art and the Gift Books 1825–1865," *Art Quarterly* 20 (Winter 1957), 365–81.

66. Edward Eggleston, *Christ in Art: The Story of the Words and Acts of Jesus Christ, as Related in the Language of the Four Evangelists, Arranged in One Continuous Narrative* (New York: J. B. Ford and Company, 1875), iv.

67. For a highly polemical review of nineteenth-century debate over the historicity of Jesus, see John M. Robertson, *The Historical Jesus: A Survey of Positions* (London: Watts, 1916). For a more sympathetic review of the most influential nineteenth-century scholarly studies of the life of Christ, from Strauss and Renan to Schweitzer and Petrie, see G. Stanley Hall, *Jesus, the Christ, in the Light of Psychology,* 2 vols. (Garden City, N.Y.: Doubleday, Page, 1917), 1:126–56. Many lives of Christ were directed to a popular readership in the effort to defend the orthodox faith from the higher criticism. For instance, an advertisement for the first edition of Frederic Farrar's *Life of Christ* (1874) in *Nation* 19, no. 481 (September 17, 1874), 191, cited *Harper's Weekly* as praising the book for its tendency "to counteract the influence of authors like Renan and Strauss."

68. Rev. T. DeWitt Talmage, *From Manger to Throne, Embracing a New Life of Jesus the Christ, and A History of Palestine and Its People* (Philadelphia: Historical Publishing Company, 1890), 652.

69. For a discussion of the Walters painting (1851), which was apparently a copy of an even earlier painting of the subject (1848) by Scheffer, and of Scheffer's career, see Martin L. H. Reymert and Robert J. F. Kashey, eds., *Christian Imagery in French Nineteenth-Century Art 1789–1906,* exhibition catalogue (New York: Shepherd Gallery, 1980), 144–53. The Walters painting, *Christ Weeping Over Jerusalem,* 1851, is oil on canvas, 42 3/8 by 28 15/16 inches. A very helpful study of nineteenth-century French religious art is Michael Paul Driskel, *Representing Belief: Religion, Art, and Society in Nineteenth-Century France* (University Park: Pennsylvania State University Press, 1992).

70. Talmage, *From Manger to Throne,* 652.

71. Kate P. Hampton, "The Face of Christ in Art: Is the Portraiture of Jesus Strong or Weak?," *Outlook* 61, no. 13 (April 1, 1899), 735–48. My thanks to Kristin Schwain for bringing this article to my attention.

72. Ibid., 746–47; 738.

73. Ibid., 746; 748. A few years before this article, Lyman Abbott, the editor-in-chief of *Outlook,* commented on the International Sunday School Lesson for December 17, 1893, which described Christ's apocalyptic appearance to John in Revelation 1:9–20. Abbott contrasted the sublime "manliness" of the image in Revelation with "the pictures of Christ which conven-

tional art has furnished us—a feminine face, hair parted in the middle, long flowing locks, all gentleness, tenderness, femininity." Yet Abbott felt that both aspects belonged to the biblical Jesus since "in Jesus Christ the strength of manhood and the patience of womanhood were united," Abbott, "The Manliness of Christ," *Outlook* 48, no. 24 (December 9, 1893), 1084.

74. Hampton, "The Face of Christ in Art," 742.

75. Abraham P. Elder, *The Light of the World or Our Saviour in Art* (Chicago: The Elder Company, 1896), n.p.

76. Estelle Jussim, *Visual Communication and the Graphic Arts. Photographic Technologies in the Nineteenth Century* (New York: R. R. Bowker, 1974), 66. Jussim's discussion of the history of technological developments is extremely helpful, and her interpretations of its significance are very insightful; see also David Clayton Phillips, "Art for Industry's Sake: Halftone Technology, Mass Photography and the Social Transformation of American Print Culture, 1880–1920," Ph.D. diss., Yale University, 1996; and Reese V. Jenkins, *Images and Enterprise: Technology and the American Photographic Industry 1839–1925* (Baltimore: Johns Hopkins University Press, 1975). For an international perspective on these developments, see Jean-Claude Lemagny and André Rouillé, eds., *A History of Photography: Social and Cultural Perspectives,* tr. Janet Lloyd (Cambridge: Cambridge University Press, 1987), 76–79. A useful essay on the cultural history of the halftone is Neil Harris's "Iconography and Intellectual History: The Halftone Effect," in *Cultural Excursions: Marketing Appetites and Cultural Tastes in Modern America* (Chicago: University of Chicago Press, 1990), 304–17.

77. On stereoptical imagery, see Edward Earle, ed., *Points of View: The Stereograph in America: A Cultural History* (Rochester, N.Y.: Visual Studies Workshop, 1979); and Jonathan Crary, *Techniques of the Observer: On Vision and Modernity in the Nineteenth Century* (Cambridge: MIT Press, 1990), 116–36.

78. Frederic W. Farrar, *The Life of Christ* (New York: World, 1874; also published in two volumes by E. P. Dutton in the same year); Frederic W. Farrar, *The Story of a Beautiful Life. A New Twentieth Century Edition of the Life of Christ* (London: Henry Neil, 1900); Frederick W. Farrar, *The Life of Christ* (Boston: The United States History Company, n.d.). E. P. Tenney, *Our Elder Brother. His Biography* (Springfield, Mass.: King-Richardson Publishing Company, 1898); Joseph Lewis French, *Christ in Art* (Boston: L. C. Page, 1900); the series published by L. C. Page also included the following titles: *The Madonna in Art, Angels in Art,* and *Saints in Art.* The generally pious tone of the texts, full of awe for the spiritual genius of great artists to interpret the mysteries of art, avoided sectarianism altogether in order to appeal to the broadest conceivable Christian audience. For a more scholarly but still reverent study, see James Burns, *The Christ Face in Art* (New York: Dutton, 1907); for an early scholarly study, see Giovanni E. Meille, *Christ's Likeness in History and Art,* tr. Emmie M.

Kirkman (London: Burns, Oates and Washbourne, 1924).

79. William E. Barton, *Jesus of Nazareth: The Story of His Life and the Scenes of His Ministry* (Boston: Pilgrim Press, 1903), 499.

80. Ibid., 451–52, 453.

81. Ibid., 455. On the likeness of Christ and the composite photograph, see Morgan, *Visual Piety,* chap. 1.

82. Barton, *Jesus of Nazareth,* 558, 550, 554.

83. William E. Barton, "The Library as a Minister in the Field of Religious Art," *Religious Education* 4, no. 6 (February 1910), 596–603.

84. Walter S. Athearn, *The Church School* (Boston: Pilgrim Press, 1914), 242–43; for a pictorial life of Jesus for children, see Walter Athearn, Alberta Munkres, and Minetta Sammis Leonard, *My Best Book* (Cleveland: Foundation Press, 1927), 31–52.

85. Albert E. Bailey, *Art Studies in the Life of Christ* (Boston: Pilgrim Press, 1917), 22–3.

86. Albert Edward Bailey, *Art and Character* (New York: Abingdon Press, 1938), 311–12.

Nine: Religious Art and the Formation of Character

1. Frank Glenn Lankard, *A History of the American Sunday School Curriculum* (New York: Abingdon Press, 1927), 279; Joseph Clark, "Samuel Wellman Clark," *The Encyclopedia of Sunday Schools and Religious Education,* 3 vols. John T. McFarland and Benjamin S. Winchester, eds. (New York: Thomas Nelson, 1915), 1:144.

2. On the history of the conventions, see Edwin Wilbur Rice, *The Sunday School Movement 1780–1917 and the American Sunday School Union 1817–1917* (Philadelphia: American Sunday School Union, 1917), 351–87; Henry Frederick Cope, *The Evolution of the Sunday-School* (Boston: Pilgrim Press, 1911), 91–100; and E. M. Ferguson, "Sunday School Conventions," *Encyclopedia of Sunday Schools,* 1:296–310.

3. See Lankard, *History,* 201–71; John Richard Sampey, *The International Lesson System: The History of Its Origin and Development* (New York: Fleming H. Revell, 1911); Rice, *Sunday School Movement,* 294–317; and Anne M. Boylan, *Sunday School: The Formation of An American Institution* (New Haven: Yale University Press, 1988), 88–100.

4. See William Bean Kennedy, *The Shaping of Protestant Education* (New York: Young Men's Christian Association Press, 1966), 33.

5. Sampey, *International Lesson System,* 79–86. At a meeting in 1871, Eggleston, Vincent, and McCook met with twenty-nine publishers in the attempt to select a list of uniform lessons for 1872, Sampey, 75.

6. Quoted in Sampey, *International Lesson System,* 101–2.

7. Ibid., 102.

8. Ibid., 72, 90, 138. On Roosevelt, see Gail Bederman, *Manliness and Civilization: A Cultural History of*

Gender and Race in the United States, 1880–1917 (Chicago: University of Chicago Press, 1995), 170–215; and Caroll Smith-Rosenberg, *Disorderly Conduct: Visions of Gender in Victorian America* (New York: Knopf, 1985). Such rhetoric is also found in the Protestant ethos of the National Education Association, founded in 1857, which, as David Tyack has noted, urged "the occupation army of teachers in the belabored city ghettos" under the banner "Onward Christian Soldiers," see "Onward Christian Soldiers: Religion in the American Common School," in *History and Education: The Educational Uses of the Past,* ed. Paul Nash (New York: Random House, 1970), 220. For many more examples of gendered, especially militaristic Protestant discourse during the Progressive Era, see Robert T. Handy, *A Christian America: Protestant Hopes and Historical Realities,* 2nd ed. (New York: Oxford University Press, 1984), 101–33.

9. Rev. Ernest Bourner Allen, "The Army of the Future; or, After Enlistment, What?" in *The Development of the Sunday-School 1780–1905,* Official Report of the Eleventh International Sunday-School Convention (Boston: Executive Committee of the International Sunday-School Association, 1905), 212.

10. Ibid., 218.

11. For a discussion of the iconography of Jonathan and David on lesson cards and within the context of images of masculinity in the late nineteenth century, see David Morgan, *Visual Piety: A History and Theory of Popular Religious Images* (Berkeley: University of California Press, 1998), chap. 3.

12. Quoted in Sampey, *International Lesson System,* 126.

13. Asa Bullard quoted a report in the 1829 *Sabbath School Treasury* regarding the Infant Department: "After a hymn, ten minutes are occupied by reading, reciting, and explaining by the picture the lesson on one of the cards." *Fifty Years with the Sabbath Schools* (Boston: Lockwood, Brooks, & Co., 1876), 196.

14. See Lankard, *History,* 273–76; Cope, *Evolution,* 119–123; and Rice, *Sunday-School Movement,* 310–12.

15. Washington Gladden, *Social Salvation* (Boston: Houghton, Mifflin, 1902), 4. For an instructive study of the Social Gospel and its relation to Progressivism, see Dorothea R. Muller, "The Social Philosophy of Josiah Strong: Social Christianity and American Progressivism," *Church History* 28, no. 2 (June 1959), 183–201, especially 185. For an excellent study of moral reform in the urban setting, see Paul Boyer, *Urban Masses and Moral Order in America, 1820–1920* (Cambridge: Harvard University Press, 1978).

16. Gladden, *Social Salvation,* 6, 7, 11, 15.

17. Washington Gladden, "Christianity and Aestheticism," *Andover Review* 1 (January 1884), 19. Gladden identified Oscar Wilde as the purveyor of the philosophy of aestheticism and denounced it as incapable of creating either great art or a worthy civilization: "it can give birth to nothing but pretty, petty, puny dilettantism, weak in the sinews, light in the head, rotten at the heart," 23.

18. For Strong's manifesto, see Josiah Strong, *Our Country: Its Possible Future and Its Present Crisis,* rev. ed. (New York: Published by The Baker & Taylor Co. for The American Home Missionary Society, 1891). Two balanced studies of Strong's work are Dorothea R. Muller, "Josiah Strong and American Nationalism: A Reevaluation," *Journal of American History* 53, no. 3 (1966–1967), 487–503, and Muller, "Social Philosophy of Josiah Strong." For a helpful discussion of the Anglo-Saxon imperative and American Protestantism at the end of the nineteenth century, see Handy, *Christian America,* 101–58. Two good studies of postmillennialism and its relation to the broader American culture around the turn of the century are: Jean B. Quandt, "Religion and Social Thought: The Secularization of Postmillennialism," *American Quarterly* 25, no. 4 (October 1973), 390–409; and James H. Moorhead, "The Erosion of Postmillennialism in American Religious Thought, 1865–1925," *Church History* 53, no. 1 (March 1984), 61–77.

19. Cope, *Evolution,* 4.

20. Ibid., 13.

21. Francis W. Parker, *Talks on Pedagogics: An Outline of the Theory of Concentration* (New York: E. L. Kellogg & Co., 1894), 3, 376.

22. Ibid., 399, 420, 423.

23. Ibid., 244. On progressivism in education during this time, see Timothy L. Smith, "Progressivism in American Education, 1880–1900," *Harvard Educational Review* 31, no. 2 (Spring 1961), 168–93.

24. Cope, *Evolution,* 90.

25. Ibid., 108, 120–22. Stephen A. Schmidt has written a concise and instructive history of the REA, *A History of the Religious Education Association* (Birmingham, AL.: Religious Education Press, 1983).

26. Cope, *Evolution,* 138, 139. Bernard Wishy has shown that the awareness of the developmental formation of the personality and the appeal to "science" to describe it first appeared in advice books in the 1870s, though the science was not yet the quantitative, experimental psychology of the 1880s and 1890s—concerned as much (or more) with measuring "personality" as with forming "character"—but a kind of popularized vitalist discourse, *The Child and the Republic: The Dawn of Modern American Child Nurture* (Philadelphia: University of Pennsylvania Press, 1968), 94–104.

27. Cope, *Evolution,* 142.

28. William Rainey Harper, "The Scope and Purpose of the New Organization," in *The Religious Education Association, Proceedings of the First Annual Convention* (Chicago: Executive Office of the Association, 1903), 230–40. For a discussion of Harper's role in the origin of the REA, see Schmidt, *History of the Religious Education Association,* 23–30. For the call issued by Harper and his colleagues to form an organization to reform the Sunday school and religious education, see *A Call for a Convention to Effect a National Improvement of Religious and Moral Education through the Sunday School and Other Agencies* (Chicago: American Institute of Sacred Literature, 1902).

29. Schmidt, *History of the Religious Education Association*, 6.

30. Henry Frederick Cope, *Education for Democracy* (New York: Macmillan, 1920).

31. Cope, *Education for Democracy*, 30. John Dewey, "Religious Education as Conditioned by Modern Psychology and Pedagogy," in *The Religious Education Association, Proceedings of the First Annual Convention* (Chicago: Executive Office of the Association, 1903), 60–66. For a probing discussion of Protestantism and self-realization, see T. J. Jackson Lears, "From Salvation to Self-Realization: Advertising and the Therapeutic Roots of the Consumer Culture, 1880–1930," in *The Culture of Consumption: Critical Essays in American History, 1880–1980*, ed. Richard Wightman Fox and T. J. Jackson Lears (New York: Pantheon Books, 1983), 1–38. I discuss this essay in my conclusion.

32. Cope, *Education for Democracy*, 33–34.

33. William Rainey Harper, *Religion and the Higher Life* (Chicago: University of Chicago Press, 1904), 175. For an excellent study of the Protestant crusade for a Christian America, see Handy, *Christian America*, chaps. 5 and 6, for the period discussed here; see also Edward McNall Burns, *The American Idea of Mission: Concepts of National Purpose and Destiny* (New Brunswick: Rutgers University Press, 1957).

34. Harper, "Scope and Purpose," 239.

35. For a list of officers, see *Religious Education* 7, no. 3 (August 1912), 270.

36. Edwin Diller Starbuck, *The Psychology of Religion: An Empirical Study of the Growth of Religious Consciousness* (New York: Scribner's, 1915), 8–9, 21.

37. Ibid., 252.

38. G. Stanley Hall, *Adolescence: Its Psychology and its Relations to Physiology, Anthropology, Sociology, Sex, Crime, Religion, and Education*, 2 vols. (New York: Appleton, 1905), 2:281–362.

39. Ibid., 1:v.

40. George A. Coe, *The Spiritual Life: Studies in the Science of Religion* (Philadelphia: Westminster Press, 1903), 21–22.

41. Shailer Matthews, "The Curriculum of Study in the Sunday School," *Proceedings of the First Annual Convention*, 189.

42. Luther A. Weigle, "The Christian Ideal of Family Life as Expounded in Horace Bushnell's 'Christian Nurture,'" *Religious Education* 19, no. 1 (February 1924), 47.

43. On the significance of moral renewal through art for romanticism's ethic of feeling and its role in the formation of modern consumerism, see Colin Campbell, *The Romantic Ethic and the Spirit of Modern Consumerism* (Oxford: Basil Blackwell, 1987), 187–90.

44. See Waldo S. Pratt, "Work of the Department of Religious Art," *Religious Education* 1, no. 1 (1906), 70–74.

45. Charles Cuthbert Hall, "The Annual Survey of Progress in Religious and Moral Education," in *The Religious Education Association, Proceedings of the Second Annual Convention* (Chicago: Executive Office of the Association, 1904), 94.

46. Ralph Adams Cram, "The Treatment of Church Interiors," in *The Aims of Religious Education, Proceedings of the Third Annual Convention of the Religious Education Association* (Chicago: Executive Office of the Association, 1905), 403–6. Cram offered as the sole criterion for selecting church architects and decorators the Pre-Raphaelite commitment "to follow the pre-sixteenth-century laws" of architectural beauty, 405.

47. Cram, "Treatment of Church Interiors," 404; for an important discussion of Cram's significance in late Victorian American culture, see T. J. Jackson Lears, *No Place of Grace: Antimodernism and the Transformation of American Culture, 1880–1920* (Chicago: University of Chicago Press, 1981), 203–9.

48. Cram, "Treatment of Church Interiors," 404. See also Cram's *The Ministry of Art* (Boston: Houghton Mifflin, 1914).

49. William E. Barton, "The Library as a Minister in the Field of Religious Art," *Religious Education* 4, no. 6 (February 1910), 595.

50. Gladden, "Christianity and Aestheticism," 16.

51. Barton, "Library as a Minister," 595.

52. Harrington Beard, "Art in the Sunday School," *Religious Education* 5, no. 3 (August 1910), 272.

53. For useful studies of major collectors and the formation of important art collections in the nineteenth and twentieth centuries, see Nathaniel Burt, *Palaces for the People: A Social History of the American Art Museum* (Boston: Little, Brown, 1977); W. G. Constable, *Art Collecting in the United States of America: An Outline of a History* (London: Nelson, 1964); Daniel M. Fox, *Engines of Culture: Philanthropy and Art Museum* (New Brunswick, N.J.: Transaction 1995); Neil Harris, "Collective Possession: J. Pierpont Morgan and the American Imagination," in *Cultural Excursions: Marketing Appetites and Cultural Tastes in Modern America* (Chicago: University of Chicago Press, 1990), 250–75, which provides an excellent bibliography on the history of collecting in America; Aline B. Saarinen, *The Proud Possessors: The Lives, Times and Tastes of Some Adventurous American Art Collectors* (New York: Random House, 1958); Calvin Tomkins, *Merchants and Masterpieces: The Story of the Metropolitan Museum of Art*, rev. ed. (New York: Holt, 1989); and Walter M. Whitehill, *Museum of Fine Arts, Boston*, 2 vols. (Cambridge: Harvard University Press, 1970).

54. On the patronage of Munkácsy, see Charles M. Kurtz, *Christ Before Pilate: The Painting by Munkacsy* (New York: Published for the Exhibition, 1887), 8. On Rockefeller's purchase of Hofmann's work, see Religious Interests, Riverside Church, Hofmann Paintings, Rockefeller Archives, folder 637; center, Pocantico Hills, North Tarrytown, New York on J. D. Rockefeller, Jr., and his father and his children as art collectors, see Saarinen, *The Proud Possessors*, 344–95.

55. Lawrence W. Levine, *Highbrow Lowbrow: The Emergence of Cultural Hierarchy in America* (Cambridge: Harvard University Press, 1988). For further analysis of the formation of hierarchies of taste, see Harris,

Cultural Excursions; and Paul DiMaggio, "Cultural Boundaries and Structural Change: The Extension of the High Culture Model to Theatre, Opera, and the Dance, 1900–1940," in Cultivating Differences: Symbolic Boundaries and the Making of Inequality, ed. Michèle Lamont and Marcel Fournier (Chicago: University of Chicago Press, 1992), 21–57.

56. On Wanamaker's Parisan purchases, see Herbert Adams Gibbons, John Wanamaker, 2 vols. (New York: Harper, 1926), 2:77–80.

57. Cited in Golden Book of the Wanamaker Stores, Jubilee Year 1861–1911 (Philadelphia: John Wanamaker, 1911), 256, 245. On Wanamaker's view of religion and commerce, see William Leach, Land of Desire: Merchants, Power, and the Rise of a New American Culture (New York: Pantheon Books, 1993), 191–224.

58. Kurtz, Christ Before Pilate, 8.

59. I take my information from Kurtz's booklet; F. Walter Ilges, M. von Munkacsy, Künstler Monographien, vol. 40 (Bielefeld and Leipzig: Verlag von Velhagen & Klasing, 1899), 78, 92; and Charles Sedelmeyer, M. von Munkácsy: Sein Leben und seine künstlerische Entwicklung (Paris: Charles Sedelmeyer, 1914), 21–28, 78; see also Michael Paul Driskel, Representing Belief: Religion, Art, and Society in Nineteenth-Century France (University Park: Pennsylvania State University Press, 1992), 203–7, and "Le Christ devant Pilate par Michel de Munkacsy," Revue de l'art chrétien, 2nd series, vol. 15 (1881), 215, 237.

Wanamaker allowed his two pictures by Munkácsy to be exhibited at the Paris Exposition in 1889 and at the World Columbian Exposition at Chicago in 1893 but thereafter restricted their display to his residence and the department store, Gibbons, John Wanamaker, 2:76.

60. Charles F. Deems, The Light of the Nations (New York: Gay Brothers, 1884); for Talmage and Beecher, see chapter 8 here.

61. Quoted in Kurtz, Christ Before Pilate, 53; for images of the passion play, including a portrait of Christ as played by Anton Lang, see Louise Parks-Richards, Oberammergau, Its Passion Play and Players: A Twentieth-Century Pilgrimage to a Modern Jerusalem and a New Gethsemane (Munich: Piloty & Loehle, 1910).

62. Rev. William Butler, quoted in Kurtz, Christ Before Pilate, 42–43.

63. On La Farge's religious murals and church decoration, see H. Barbara Weinberg, "John La Farge: Pioneer of the American Mural Movement," in John La Farge, exhibition catalogue, Carnegie Museum of Art (New York: Abbeville Press, 1987), 161–93. For La Farge's contemplations of religious works of fine art, see his One Hundred Masterpieces of Painting (Garden City, N.Y.: Doubleday, Page, 1912), 231–328. This work was originally serialized in McClure's from 1903 to 1908. See also John La Farge, The Gospel Story in Art (New York: Macmillan, 1913).

64. Eugene C. Carder, "The Riverside Church As I Have Known It," typescript, pp. 53–54, Carder Box, Riverside Church Archives; a cover letter to Rev.

Robert James McCracken dated April 1, 1955 accompanies this draft, of which there are other, undated versions. For information on Rockefeller's acquisition of Hofmann's painting, see correspondence with the art dealer A. Livingston Gump, Rockefeller Archives, folder 637.

65. Lears, No Place of Grace, 184–97.

66. Barton, "Library as a Minister," 594.

67. Waldo S. Pratt, "The Field of Artistic Influences in Religious Education," in Proceedings of the Second Annual Convention, 510.

68. Harriet Cecil Magee, "Clubs and Classes for the Study of Religious Pictorial Art," Proceedings of the Second Annual Convention, 485. In order to bring the advantages offered by these and other images to the modern American Sunday school teacher, Henry Turner Bailey encouraged the REA to gather together several series of topographical views of the Holy Land, historical and archeological images, Bible illustrations, and artistic "pictures for contemplation." Bailey, "The Use of Biblical Pictures in Teaching Children," Proceedings of the Second Annual Convention, 472, 475.

69. Magee, "Study of Religious Pictorial Art," 489.

70. Helen E. H. Russell, "The Use of Pictures in the Church School," Religious Education 14, no. 1 (February 1919), 92.

71. George Herbert Betts, How to Teach Religion: Principles and Methods (New York: Abingdon Press, 1919), 126.

72. Walter Scott Dill, The Theory and Practice of Advertising (1903; Boston: Small, Maynard & Company, 1908), 59.

73. G. Stanley Hall, Jesus, the Christ, in the Light of Psychology, 2 vols. (Garden City, N.Y.: Doubleday, Page, 1917), 1:vii.

74. Ibid., viii.

75. Ibid., 5, note. Hall cited Frederic Farrar's Life of Christ.

76. Hall, Jesus, xiv. Emile Durkheim, The Elementary Forms of Religious Life, tr. Karen E. Fields (New York: Free Press, 1995).

77. G. Stanley Hall, Life and Confessions of a Psychologist (New York: Appleton, 1923), 179–84. See also Dorothy Ross, G. Stanley Hall: The Psychologist as Prophet (Chicago: University of Chicago Press, 1972), 31–49.

78. Hall, Jesus, xvii.

79. Ibid., 22, 23. According to Hall, Hofmann "has painted more than a score of perfectly consistent and elevated faces of Jesus," 22.

80. Ibid., 28; on Hall and the ideal of manliness, see Bederman, Manliness and Civilization, 77–120.

81. Hall, Jesus, 29.

82. Ibid., 29–30.

83. Ibid., 34–5; Bruce Barton's most well-known book, The Man Nobody Knows, was first published in 1924; his A Young Man's Jesus (Boston: Pilgrim Press) appeared in 1914. An excellent study of Barton and religion is Leo P. Ribuffo, "Jesus Christ as Business

Statesman: Bruce Barton and the Selling of Corporate Capitalism," *American Quarterly* 33, no. 2 (Summer 1981), 206–31; see also Lears, "From Salvation to Self-Realization," 30–38.

84. Frederica Beard, "The Use of Pictures in Religious Education," *Encyclopedia of Sunday Schools,* 3:794–95.

85. Ibid., 796.

86. Edward Aldridge Annett, *Psychology for Bible Teachers* (New York: Scribner's, 1925, reprint 1934), 85. Annett was a missionary and director of the teacher training program of the World's Sunday School Association.

87. Frederica Beard, *Pictures in Religious Education* (New York: George H. Doran, 1920), 155–57.

88. Ibid., 22, 26, 99.

89. Ibid., 32, 81, 100.

90. Ibid., 33, 31.

91. Frank O. Erb, "The Influence of Religious Art," *Religious Education* 7, no. 5 (December 1912), 502, 506.

92. See, for instance, Von Ogden Vogt, "Esthetics in Education," *Religious Education* 22, no. 10 (December 1927), 986–92; Ray B. Carlson, "Art Education and Character Integration," *Religious Education* 25, no. 1 (January 1930), 51–54; and John J. Becker, "Fine Arts and the Soul of America," *Religious Education* 25, no. 9 (November 1930), 803–7.

93. Beard, *Pictures in Religious Education,* 149–54; Horace G. Brown, "Efficiency in Teaching by Pictures," *Education* 34, no. 3 (November 1913), 171–78.

94. Beard, *Pictures in Religious Education,* 115. For another, contemporary study of the use of art keyed to graded instruction, written by two religion professors at Yale and an Episcopal seminary professor, see E. Hershey Sneath, George Hodges, and Henry Hallam Tweedy, *Religious Training in the School and Home: A Manual for Teachers and Parents* (New York: Macmillan, 1917), chap. 16, "The Aesthetic Life."

95. This theme became quite popular in the last quarter of the nineteenth century. In *Christian Nurture* Bushnell quoted or alluded several times to Christ's admonition: "Suffer the little children to come unto me." In 1876, Asa Bullard, an outspoken advocate of religious training for the very young, fondly told the story of a five-year-old girl who replied to a pastor who thought her too young for church membership: "Suffer the little children to come unto me and forbid them not," Bullard, *Fifty Years with the Sabbath Schools* 155.

96. Beard, *Pictures in Religious Education,* 110–12.

97. Ibid., 30–31.

98. Ibid., 115.

99. See, for instance, *The Hofmann Gallery of Original New Testament Illustrations* (Philadelphia: A. J. Holmes & Co., 1891); and H. Hofmann, *Sixteen Pictures from the Life of Christ* (Minneapolis: Augsburg Publishing House, n.d.).

100. Albert E. Bailey, *Art Studies in the Life of Christ* (Boston: Pilgrim Press, 1917), 23–35.

101. Beard, *Pictures in Religious Education,* 84, 90, 116, 122.

Conclusion: The Return of Aura

1. Walter Benjamin, "The Work of Art in the Age of Mechanical Reproduction," in *Illuminations,* tr. Harry Zohn, ed. Hannah Arendt (New York: Schocken Books, 1968), 217–51.

2. Warren I. Sussman, "'Personality' and the Making of Twentieth-Century Culture," in *New Directions in America Intellectual History,* eds. John Higham and Paul K. Conkin (Baltimore: Johns Hopkins University Press, 1979), 212–26.

3. Ibid., 218.

4. Ibid., 220. I rely also on a superb discussion by Jackson Lears, which will be discussed hereafter.

5. Bruce Barton, *A Young Man's Jesus* (Boston: Pilgrim Press, 1914). The image is reproduced and discussed in David Morgan, *Visual Piety: A History and Theory of Popular Religious Images* (Berkeley: University of California Press, 1998), chap. 3. For a penetrating discussion of Barton and Hall in this regard, see T. J. Jackson Lears, "From Salvation to Self-Realization: Advertising and the Therapeutic Roots of the Consumer Culture, 1800–1930," in *The Culture of Consumption: Critical Essays in American History, 1880–1980,* ed. Richard Wightman Fox and T. J. Jackson Lears (New York: Pantheon, 1983), 1–38.

6. Bruce Barton, *The Man Nobody Knows: A Discovery of the Real Jesus* (Indianapolis: Bobbs-Merrill, 1925).

7. Lears, "From Salvation to Self-Realization," 4.

8. In fairness, Hall would have objected to being marginalized. Consider the following polemic, aimed at orthodox objections to his own claim of Christian identity: "Whether we regard Jesus as myth or history, we all need him alike. If I hold him a better and purer psychological being than any other, although made warp and woof of human wishes, and needs, and ideals, I insist that on this basis I ought to be called an orthodox Christian, because thus to me he remains the highest, best, and most helpful of all who ever lived, whether that life be in Judea or in the soul of man," G. Stanley Hall, *Jesus, the Christ, in the Light of Psychology,* 2 vols. (Garden City, N.Y.: Doubleday, Page, 1917), 34. It is hard, however, to imagine many orthodox American Protestants who would have agreed with Hall. Methodists, Congregationalists, Presbyterians, Lutherans, and Baptists, not to mention Fundamentalists of all kinds insisted on the historicity of Jesus as God incarnate and on the literal truth of the Apostles' Creed, which Hall was able only to spiritualize (xviii).

9. Bailey and Beard are examined at some length here; for Maus's discussion of imagery and graded lessons, see Cynthia Pearl Maus, *Teaching the Youth of the Church: A Manual on Methods of Teaching Graded, Elective, and Uniform Lesson Courses to Intermediates, Seniors, and Young People in the Church's School* (New York: George H. Doran, 1925), 94–96; see also Cynthia Pearl Maus, *Christ and the Fine Arts,* rev. ed. (1938; New York: Harper, 1959), 5–9.

10. Albert E. Bailey, *The Gospel in Art* (Boston:

Pilgrim Press, 1916); *Art Studies in the Life of Christ* and an accompanying *Teacher's Manual* (Boston: Pilgrim Press, 1917); *The Use of Art in Religious Education* (New York: Abingdon Press, 1922); *Art and Character* (New York: Abingdon Press, 1938). Bailey published several other works on religious art including *Christ in Recent Art* (New York: Scribner's, 1935); *Pictures in the Upper Room: Interpretations by Albert Edward Bailey* (Nashville: Upper Room Press, 1940); and *Jesus and His Teachings: The Approach through Art* (Philadelphia: Christian Education Press, 1942). *The Gospel in Art* was reprinted by Pilgrim Press in 1927, 1931, 1936, and 1946.

11. Bailey, *Art Studies in the Life of Christ*, 16. Leo Tolstoy, *What is Art?* (Indianapolis: Bobbs-Merrill, 1960).

12. On nineteenth-century views of literature among evangelicals, see Cathy N. Davidson, *Revolution and the Word: The Rise of the Novel in America* (New York: Oxford University Press, 1986); Jane P. Tompkins, *Sensational Designs: The Cultural Work of American Fiction, 1790–1860* (New York: Oxford University Press, 1985); Ann Douglas, *The Feminization of American Culture* (New York: Doubleday, 1977).

13. Bailey, *Use of Art in Religious Education*, 96.

14. Ibid., 102, 96.

15. Ibid., 31.

16. Bailey, *Art Studies in the Life of Christ*, 11.

17. Bailey, *Use of Art in Religious Education*, 34, 49.

18. Ibid., 92–94, 96.

19. Ibid., 40.

20. Ibid., 69, 94.

21. See, for instance, Ryllis Clair Alexander, "Drama and the Church," *Church Monthly* 4, no. 6 (April 1930), 114–18. This journal was published by the Riverside Church in New York, whose benefactor was John D. Rockefeller, Jr., and whose pastor in the 1920s and 1930s was a leading liberal clergyman, Harry Emerson Fosdick.

22. Bailey, *Use of Art in Religious Education*, 101.

23. Ibid., 111, 115, 110.

24. Henry Churchill King, "Enlarging Ideals in Morals and Religion," 8; Lyman Abbott, "The Significance of the Present Moral Awakening in the Nation," 28; Washington Gladden, "Bringing All the Moral and Religious Forces into Effective Unity," 41, in Henry Churchill King, Francis Greenwood Peabody, Lyman Abbott, Washington Gladden, and others, *Education and National Character* (Chicago: Religious Education Association, 1908).

25. Huger Elliott, "A Note on Painting and Sculpture," *Religious Education* 22, no. 10 (December 1927), 997–99.

Bibliography

Ackerknecht, Erwin. *Franz Joseph Gall, Inventor of Phrenology and His Collection*. Tr. C. St. Léon. Madison: University of Wisconsin Medical School, 1956.

Alexander, James W. *The American Sunday-School and Its Adjuncts*. Philadelphia: American Sunday School Union, 1856.

Allen, Ethan. *Reason the Only Oracle of Man*. Bennington, Vermont: Haswell and Russell, 1784; reprint, New York: Scholars' Facsimiles and Reprints, 1940.

Anderson, Alexander. Scrapbooks. Duyckinck Collection, New York Public Library.

Anderson, Patricia. *The Printed Image and the Transformation of Popular Culture 1790–1860*. Oxford: Clarendon Press, 1991.

Andrew, Laurel B. *The Early Temples of the Mormons: The Architecture of the Millennial Kingdom in the American West*. Albany: State University of New York Press, 1978.

Annett, Edward Aldridge. *Psychology for Bible Teachers*. New York: Scribner's, 1925.

Anonymous. *Design, Character, and Uses of the Books of the American S. S. Union*. Philadelphia: American Sunday School Union, n.d. [1829].

Apostolos-Cappadona, Diane. *The Spirit and the Vision: The Influence of Christian Romanticism on the Development of Nineteenth-Century American Art*. Atlanta: Scholars Press, 1995.

Ashwin, Clive, ed. *History of Graphic Design and Communication. A Source Book*. London: Pembridge Press, 1983.

Asmodeus in America [pseudonym]. *The Millerite Humbug; or the Raising of the Wind! A Comedy in Five Acts*. Boston: printed for the publisher.

Athearn, Walter S. *The Church School*. Boston: Pilgrim Press, 1914.

Baikie, James. *The Glamour of Near East Excavation*. London: Seeley, Service, 1927.

Bailey, Albert E. *Art and Character*. New York: Abingdon Press, 1938.

———. *Art Studies in the Life of Christ*. Boston: Pilgrim Press, 1917.

———. *The Gospel in Art*. Boston: Pilgrim Press, 1916.

Bailey, Albert E. *The Use of Art in Religious Education.* New York: Abingdon Press, 1922.

Baird, Robert. *The Christian Retrospect and Register; A Summary of the Scientific, Moral and Religious Progress of the First Half of the XIXth Century.* New York: Dodd, 1851.

———. *Religion in the United States of America.* Glasgow and Edinburgh: Blackie & Son; London: Duncan and Malcolm, 1844; reprint, New York: Arno Pres, 1969.

Baker, Steve. "The Hell of Connotation." *Word and Image* 1, no. 2 (April–June 1985), 164–75.

Banner, Lois. "Religious Benevolence as Social Control: A Critique of an Interpretation." *Journal of American History* 60, no. 1 (June 1973), 23–41.

Barnes, Albert. *Inquiry into the Scriptural Views of Slavery.* Philadelphia: Perkins and Purves, 1846.

———. *A Sermon in Behalf of the American Home Missionary Society.* New York: Printed for the American Home Missionary Society, 1849.

Barthes, Roland. *The Responsibility of Forms: Critical Essays on Music, Art, and Representation.* Tr. Richard Howard. Berkeley: University of California Press, 1991.

Bartol, Cyrus A. *Pictures of Europe, Framed in Ideas.* Boston: Crosby, Nichols, and Company, 1855.

Barton, Bruce. *The Man Nobody Knows: A Discovery of the Real Jesus* Indianapolis: Bobbs-Merrill, 1925.

———. *A Young Man's Jesus.* Boston: Pilgrim Press, 1914.

Barton, William E. *Jesus of Nazareth: The Story of His Life and the Scenes of His Ministry.* Boston: Pilgrim Press, 1903.

———. "The Library as a Minister in the Field of Religious Art." *Religious Education* 4, no. 6 (February 1910), 596–603.

Bates, Joseph. *The Autobiography of Elder Joseph Bates.* Battle Creek: Steam Press of the Seventh-Day Adventist Publishing Association, 1868.

———. *An Explanation of the Typical and Anti-Typical Sanctuary by the Scriptures.* New Bedford: Benjamin Lindsey, 1850.

———. *Second Advent Way Marks and High Heaps, or A Connected View of the Fulfillment of Prophecy, By God's Peculiar People, From the Year 1840 to 1847.* New Bedford: Benjamin Lindsey, 1847.

Beard, Frederica. *Pictures in Religious Education.* New York: George H. Doran, 1920.

Becker, John J. "Fine Arts and the Soul of America." *Religious Education* 25, no. 9 (November 1930), 803–7.

Bederman, Gail. *Manliness and Civilization: A Cultural History of Gender and Race in the United States, 1880–1917.* Chicago: University of Chicago Press, 1995.

Beecher, Catharine E., and Harriet Beecher Stowe. *The American Woman's Home; or, Principles of Domestic Science.* New York: J. B. Ford and Co., 1869.

Beecher, Henry Ward. *Eyes and Ears.* Boston: Ticknor and Fields, 1862.

———. *The Life of Jesus, the Christ.* New York: J. B. Ford and Company, 1871.

———. *Star Papers; or, Experience of Art and Nature.* New York: J. C. Derby, 1855.

Beecher, Lyman. *A Plea for the West.* Cincinnati: Truman and Smith, 1835.

———. *Six Sermons on the Nature, Occasions, Signs, Evils, and Remedy of Intemperance.* New York: American Tract Society, 1827.

Benjamin, Walter. "The Work of Art in the Age of Mechanical Reproduction." In *Illuminations: Essays and Reflections.* Tr. Harry Zohn. Ed. Hannah Arendt. New York: Schocken Books, 1968.

Bercovitch, Sacvan. "The Typology of America's Mission." *Amerian Quarterly* 30, no. 2 (Summer 1978), 135–55.

Berk, Stephen E. *Calvinism versus Democracy: Timothy Dwight and the Origins of American Evangelical Orthodoxy.* Hamden, Conn.: Archon Books, 1974.

Bethune, George W. *Orations and Occasional Discourses.* New York: George P. Putnam, 1850.

———. *The Relations of the Sunday-School System to Our Christian Patriotism.* Philadelphia: American Sunday School Union, 1847.

Betts, George Herbert. *How to Teach Religion: Principles and Methods.* New York: Abingdon Press, 1919.

Bewick, T[homas]. *A History of Quadrupeds: 340 Engravings Chiefly copied from the Original of T. Bewick, by A[lexander] Anderson.* New York: Jonas Booth, Senior, 1841. Second American Edition from Eighth London Edition.

Billington, Ray Allen. *The Protestant Crusade 1800–1806: A Study in the Origins of American Nativism.* New York: Rinehart, 1938.

A Biography of The Saviour, and His Apostles, with a Portrait of Each. New York: H. L. Barnum, and Wiley and Long, 1835.

Birdsall, Richard D. "The Second Great Awakening and the New England Social Order." *Church History* 39, no. 3 (September 1970), 345–64.

Bixler, William Allen. *Chalk Talk Made Easy.* Anderson, Ind.: Warner Press, 1932.

Bliss, Seth. *Letters to the Members, Patrons, and Friends of the Branch American Tract Society in Boston.* 3rd ed. Boston: Crocker & Brewster; New York: Carter & Bros., 1858.

Bliss, Sylvester. *The Life of William Miller.* Boston: J. V. Himes, 1853.

Bloch, Ruth. *Visionary Republic: Millennial Themes in American Thought, 1756–1800.* Cambridge: Cambridge University Press, 1985.

Bodo, John R. *The Protestant Clergy and Public Issues, 1812–1848.* Princeton: Princeton University Press, 1954; reprint, Philadelphia: Porcupine Press, 1980.

Bonomi, Patricia U. "Education and Religion in Early America: Gleanings from *The New England Primer,*" Thirteenth Annual Phi Alpha Theta Distinguished Lecture on History, 1993, Department of History, State University of New York, Albany, 1993.

Botta, Paul Emile. *M. Botta's Letters on the Discoveries at Nineveh*, tr. C. T. London: Longman, Brown, Green and Longmans, 1850.

Boyer, Paul. *Urban Masses and Moral Order in America, 1820–1920*. Cambridge: Harvard University Press, 1978.

——. *When Time Shall Be No More: Prophecy Belief in Modern American Culture*. Cambridge: Harvard University Press, 1992.

Boylan, Anne M. "Evangelical Womanhood in the Nineteenth Century: The Role of Women in Sunday Schools." *Feminist Studies* 4 (October 1978), 62–80.

——. "The Role of Conversion in Nineteenth-Century Sunday Schools." *American Studies* 20 (1979), 35–48.

——. *Sunday School: The Formation of an American Institution 1790-1880*. New Haven: Yale University Press, 1988.

——. "Women in Groups: An Analysis of Women's Benevolent Organizations in New York and Boston, 1797–1840." *Journal of American History* 71, no. 3 (December 1984), 497–515.

Breckinridge, Robert J. *Paganism in the XIXth Century in the United States*. Baltimore: David Owen & Son, 1841.

Brewer, John. *The Pleasures of the Imagination: English Culture in the Eighteenth Century*. New York: Farrar, Straus, and Giroux, 1997

Brewster, Arthur Judson, and Herbert Hall Palmer. *Introduction to Advertising*. Chicago: A. W. Shaw, 1925.

A Brief Catalogue of Books Illustrated with Engravings by Dr. Anderson. New York: Thompson & Moreau, Printers, 1885.

Brooke, John L. *The Refiner's Fire: The Making of Mormon Cosmology, 1644–1844*. New York: Cambridge University Press, 1994.

Brown, Ford K. *Fathers of the Victorians: The Age of Wilberforce*. Cambridge: Cambridge University Press, 1961.

Brown, Horace G. "Efficiency in Teaching by Pictures." *Education* 34, no. 3 (November 1913), 171–78.

Brown, Joshua. "Reconstructing Representation: Social Types, Readers, and the Pictorial Press, 1865–1877." *Radical History* 66 (Fall 1996), 5–38.

Bruce, Steve, ed. *Religion and Modernization: Sociologists and Historians Debate the Secularization Thesis*. Oxford: Clarendon Press, 1992.

Bul, Malcolm, and Keith Lockhart. *Seeking a Sanctuary: Seventh-Day Adventism and the American Dream*. New York: Harper and Row, 1989.

Bullard, Asa. *Fifty Years with the Sabbath Schools*. Boston: Lockwood, Brooks & Co., 1876.

Bunyan, John. *The Pilgrim's Progress*. Philadelphia: Lippincott, 1902.

Burke, Edmond. *A Philosophical Enquiry into the Origin of Our Ideas of the Sublime and Beautiful*. Ed. J. T. Boulton. Notre Dame: University of Notre Dame Press, 1968.

Burns, Edward McNall. *The American Idea of Mission: Concepts of National Purpose and Destiny*. New Brunswick: Rutgers University Press, 1957.

Burns, James. *The Christ Face in Art*. New York: Dutton, 1907.

Burns, Sarah. *Pastoral Inventions: Rural Life in Nineteenth-Century American Art and Culture*. Philadelphia: Temple University Press, 1989.

Burr, Frederic M. *Life and Works of Alexander Anderson, M.D., The First American Wood Engraver*. New York: Burr Brothers, 1893.

Burt, Nathaniel. *Palaces for the People: A Social History of the American Art Museum*. Boston: Little, Brown, 1977.

Bushman, Richard L. *The Refinement of America: Persons, Houses, Cities*. New York: Knopf, 1992

Bushnell, Horace. *Christian Nurture*. Intro. John M. Mulder. Grand Rapids: Baker Book House, 1991.

——. *Life and Letters of Horace Bushnell*. Ed. Mary Bushnell Cheney. New York: Harper & Brothers, 1880.

——. *Sermons for the New Life*. New York: Charles Scribner's, 1905.

——. *Women's Suffrage; The Reform Against Nature*. New York: Charles Scribner & Co., 1869; reprint, Washington, D.C.: Zenger, 1978.

Butler, Jon. *Awash in a Sea of Faith: Christianizing the American People*. Cambridge: Harvard University Press, 1990.

Butler, Jonathan. "The Seventh-Day Adventist American Dream." *Adventist Heritage* 3, no. 1 (Summer 1976), 3–10.

Calam, John. *Parsons and Pedagogues: The S. P. G. Adventure in American Education*. New York: Columbia University Press, 1971.

Calkins, Earnest Elmo and Ralph Holden. *Modern Advertising*. New York: D. Appleton & Co., 1905; reprint, New York, Garland, 1985.

[Calkins, Frances Manwaring]. *Illustrated Tract Primer*. New York: American Tract Society, n.d. [1848].

Campbell, Colin. *The Romantic Ethic and the Spirit of Modern Consumerism*. Oxford: Basil Blackwell, 1987.

Campbell, David. *Illustrations of Prophecy: particularly the Evening and the Morning Visions of Daniel, and the Apocalyptical Visions of John*. Boston: published by the author, 1840.

Carlson, Ray B. "Art Education and Character Integration." *Religious Education* 25, no. 1 (January 1930), 51–54.

Chidester, David and Edward T. Linenthal, eds. *American Sacred Space*. Bloomington: Indiana University Press, 1995.

Christian Almanac. New York: American Tract Society, 1825–1877.

Christian Almanack. Boston: Lincoln & Edmands, 1821–1834.

Christensen, Carl C. *Art and the Reformation in Germany*. Athens: Ohio State University Press, 1979.

Cicero. *Rhetorica ad Herennium.* Tr. Harry Caplan. Cambridge: Harvard University Press, 1954.

Circulation and Character of the Volumes of the American Tract Society. New York: American Tract Society, 1848.

Clarke, Graham, ed. *The Portrait in Photography.* London: Reaktion Books, 1992.

Clouston, W. A. *Hieroglyphic Bibles: Their Origin and History.* Glasgow: David Bryce & Son, 1894.

Coe, George A. *The Spiritual Life: Studies in the Science of Religion.* Philadelphia: Westminster Press, 1903.

Cohen, Patricia Cline. *A Calculating People: The Spread of Numeracy in Early America.* Chicago: University of Chicago Press, 1982.

Colbert, Charles. "'Each Little Hillock Hath a Tongue': Phrenology and the Art of Hiram Powers." *Art Bulletin* 68, no. 2 (June 1986), 281–300.

———. *A Measure of Perfection: Phrenology and the Fine Arts in America.* Chapel Hill: University of North Carolina Press, 1997.

Conley, Thomas M. *Rhetoric in the European Tradition.* Chicago, University of Chicago Press, 1990.

Constable, W. G. *Art Collecting in the United States of America: An Outline of a History.* London: Nelson, 1964.

Cope, Henry Frederick. *Education for Democracy.* New York: Macmillan, 1920.

———. *The Evolution of the Sunday-School.* Boston: Pilgrim Press, 1911.

Cornelius, Janet Duitsman, *"When I Can Read My Title Clear": Literacy, Slavery, and Religion in the Antebellum South.* Columbia: University of South Carolina Press, 1991.

Cott, Nancy. *Bonds of Womanhood: "Women's Sphere" in New England, 1780–1835.* New Haven: Yale University Press, 1977.

Cover, John H. *Advertising: Its Problems and Methods.* New York: Appleton, 1926.

Cram, Ralph Adams. *Ministry of Art.* Boston: Houghton, Mifflin, 1914.

———. "The Treatment of Church Interiors." In *The Aims of Religious Education. Proceedings of the Third Annual Convention of the Religious Education Association.* Chicago: Executive Office of the Association, 1905.

Crary, Jonathan. *Techniques of the Observer: On Vision and Modernity in the Nineteenth Century.* Cambridge: MIT Press, 1992.

Cremin, Lawrence A. *American Education: The National Experience, 1783–1876.* New York: Harper and Row, 1980.

Cross, Whitney R. *The Burned-Over District: The Social and Intellectual History of Enthusiastic Religion in Western New York, 1800–1850.* Ithaca: Cornell University Press, 1950.

Curious Hieroglyphic Bible. Worcester, Mass.: Isaiah Thomas, 1788.

Curran, Francis X. *The Churches and the Schools: American Protestantism and Popular Elementary Education.* Chicago: Loyola University Press, 1954.

Currier & Ives: Catalogue Raisonné. 2 vols. Detroit: Gale Research Company, 1984.

Curry, Richard O., and Lawrence B. Goodheart, eds. *American Chameleon: Individualism in Trans-National Context.* Kent, Ohio: Kent State University Press, 1991.

Daniels, Roger. *Coming to America: A History of Immigration and Ethnicity in American Life.* New York: HarperPerennial, 1990.

Davidson, Cathy N. *Revolution and the Word: The Rise of the Novel in America.* New York: Oxford University Press, 1986.

Davies, John D. *Phrenology: Fad and Science. A Nineteenth-Century American Crusade.* New Haven: Yale University Press, 1955.

Davis, David Brion. "Some Themes of Counter-Subversion: An Analysis of Anti-Masonic, Anti-Catholic, and Anti-Mormon Literature." *Mississippi Valley Historical Review* 47, no. 2 (September 1960), 205–24.

Davison, Peter, Rolf Meyersohn, and Edward Shils, eds. *Culture and Mass Culture.* Vol. 1 of *Literary Taste, Culture and Mass Communication.* Cambridge, England: Chadwyck-Healy, 1978.

Deems, Charles F. *The Light of the Nations.* New York: Gay Brothers, 1884.

Descriptive Catalogue of Sartain's Series of Sacred and National Engravings. Rochester: R. H. Curran, 1866.

The Development of the Sunday-School 1780–1905. The Official Report of the Eleventh International Sunday-School Convention. Boston: The Executive Committee of the International Sunday-School Association, 1905.

Dewey, John. "Religious Education as Conditioned by Modern Psychology and Pedagogy." In *The Religious Education Association, Proceedings of the First Annual Convention.* Chicago: Executive Office of the Association, 1903.

Dill, Walter Scott. *The Theory and Practice of Advertising.* Boston: Small, Maynard, 1908.

———. *Influencing Men in Business: The Psychology of Argument and Suggestion.* New York: Ronald Press, 1911.

Dillenberger, John. *The Visual Arts and Christianity in America: From the Colonial Period to the Present.* Expanded ed. New York: Crossroad, 1989.

Doan, Ruth Alden. *The Miller Heresy, Millennialism, and American Culture.* Philadelphia: Temple University Press, 1987.

Dolmetsch, Joan D., ed. *Eighteenth-Century Prints in Colonial America: To Educate and Decorate.* Williamsburg: Colonial Williamsburg Foundation, 1979.

Douglas, Ann. *The Feminization of American Culture.* New York: Doubleday, 1977.

Dowling, John. *History of Romanism.* New York: Walker, 1845.

Driskel, Michael Paul. *Representing Belief: Religion, Art, and Society in Nineteenth-Century France.* University Park: Pennsylvania State University Press, 1992.

Duganne, Augustine. *Art's True Mission in America.* New York: Geo. S. Appleton, 1853.

Duncan, Withrop Hillyer. "Josiah Priest: Historian of the American Frontier. A Study and Bibliography." *Proceedings of the American Antiquarian Society* 44 (1934), 45–102.

Dunlap, William. *History of the Rise and Progress of the Arts of Design in the United States.* Ed. Alexander Wyckoff. 3 vols. New York: Benjamin Blom, 1965.

Dunn, William K. *What Happened to Religious Education? The Decline of Religious Teaching in the Public Elementary School 1776–1861.* Baltimore: Johns Hopkins University Press, 1958.

Durkheim, Emile. *The Elementary Forms of Religious Life.* Tr. Karen E. Fields. New York: Free Press, 1995.

Earle, Edward, ed. *Points of View: The Stereograph in America. A Cultural History.* Rochester: Visual Studies Workshop, 1979.

Edwards, Jonathan. *Apocalyptic Writings.* Ed. Stephen J. Stein. New Haven: Yale University Press, 1977.

———. *A Jonathan Edwards Reader.* Ed. John E. Smith, Harry S. Stout, and Kenneth P. Minkema. New Haven: Yale University Press, 1995.

———. *Jonathan Edwards: Representative Selections.* Ed. Clarence H. Faust and Thomas H. Johnson. Rev. ed. New York: Hill and Wang, 1962.

———. *Religious Affections.* Ed. John E. Smith. In *Works of Jonathan Edwards,* vol. 2. New Haven: Yale University Press, 1959.

Eggleston, Edward. *Christ in Art: The Story of the Words and Acts of Jesus Christ, as Related in the Language of the Four Evangelists, Arranged in One Continuous Narrative.* New York: J. B. Ford and Company, 1875.

1800 Woodcuts by Thomas Bewick and His School. Intro. Robert Hutchinson. New York: Dover, 1962.

Ekirch, Arthur Alphonse, Jr. *The Idea of Progress in America, 1815–1860.* New York: Peter Smith, 1951.

Elder, Abraham P. *The Light of the World or Our Saviour in Art.* Chicago: The Elder Company, 1896.

Elliot, Huger, "A Note on Painting and Sculpture." *Religious Education* 22, no. 10 (December 1927), 997–99.

Encyclopedia of American Social History. Ed. Mary Kupiec Cayton, Elliott J. Gorn, and Peter W. Williams. 3 vols. New York: Scribner's, 1993.

The Encyclopedia of Education. 10 vols. New York: Macmillan, 1971.

Erb, Frank O. "The Influence of Religious Art." *Religious Education* 7, no. 5 (December 1912), 502–9.

Exman, Eugene. *The House of Harper. One Hundred and Fifty Years of Publishing.* New York: Harper and Row, 1967.

Faraone, Vincent. *Teaching the ABC's in America 1647–1934: An Overview of Beginning Reading Materials.* Exhibition catalogue, David Filderman Gallery, Hofstra University, 1984.

Farrar, Frederic W. *The Life of Christ.* New York: World, 1874.

Feller, Daniel. *The Jacksonian Promise: America, 1815–1840.* Baltimore: Johns Hopkins University Press, 1995.

Felmingham, Michael. *The Illustrated Gift Book, 1880–1930, with a Checklist of 2500 Titles.* Aldershot, England: Scolar Press, 1988.

Ferm, Vergilius. *Pictorial History of Protestantism: A Panoramic View of Western Europe and the United States.* New York: Philosophical Library, 1957.

Finke, Roger, and Rodney Stark. *The Churching of America, 1776–1990: Winners and Losers in Our Religious Economy.* New Brunswick: Rutgers University Press, 1992.

Firth, Katharine R. *The Apocalyptic Tradition in Reformation Britain 1530–1645.* Oxford: Oxford University Press, 1979.

Fleetwood, John. *The Life of Our Lord and Saviour Jesus Christ.* New York: D. W. Evans & Co., 1859.

Flint, Janet A. *The Way of Good and Evil: Popular Religious Lithographs of Nineteenth-Century America.* Exhibition catalogue. Washington, D.C.: National Collection of Fine Arts, Smithsonian Institution, 1972.

Foner, Eric. *Free Soil, Free Labor, Free Men: The Ideology of the Republican Party Before the Civil War.* Oxford: Oxford University Press, 1995.

Ford, Paul Leicester, ed. *The New-England Primer: A History of Its Origin and Development.* New York: Dodd, Mead, 1897; reprint, New York: Teachers College, Columbia University, 1962.

Fortune, Brandon Brame. "Charles Willson Peale's Portrait Gallery: Persuasion and the Plain Style." *Word and Image* 6, no. 4 (October-December 1990), 308–24.

Foster, Charles I. *An Errand of Mercy: The Evangelical United Front, 1790–1837.* Chapel Hill: University of North Carolina Press, 1960.

Fowler, O. S. *Practical Phrenology.* 22nd ed., rev. New York: Published by the Author, 1845.

Fowler, O. S., and L. N. Fowler. *New Illustrated Self-Instructor in Phrenology and Physiology.* New York: Fowler and Wells, 1859.

Fox, Daniel M. *Engines of Culture: Philanthropy and Art Museum.* New Brunswick, N.J.: Transaction, 1995.

Foy, Jessica H., and Thomas J. Schlereth, eds. *American Home Life, 1880–1930: A Social History of Spaces and Services,* Knoxville: University of Tennessee Press, 1992.

Franchot, Jenny. *Roads to Rome: The Antebellum Protestant Encounter with Catholicism.* Berkeley: University of California Press, 1994.

Fraser, W. Hamish. *The Coming of the Mass Market, 1850–1914.* Hamden, Conn.: Archon Books, 1981.

French, Joseph Lewis. *Christ in Art.* Boston: L. C. Page, 1900.

Friedman, Lawrence J. "Confidence and Pertinacity in Evangelical Abolitionism: Lewis Tappan's Circle." *American Quarterly* 31, no. 1 (Spring 1979), 81–106.

Froom, Edwin Le Roy. *The Prophetic Faith of Our Fathers: The Historical Development of Prophetic Inter-*

pretation. 4 vols. Washington, D.C.: Review and Herald, 1950–1954.

Fuller, Louis. *The Crusade against Slavery 1830 to 1860.* New York: Harper, 1960.

Fuller, Robert C. *Naming the Antichrist: The History of an American Obsession.* New York: Oxford University Press, 1995.

Gallup, George, Jr. "Religion in America." *Annals of the American Academy of Political and Social Science* 480 (July 1985), 167–74.

Gaustad, Edwin S., ed. *American Tract Society Documents 1824–1925.* New York: Arno Press, 1972.

———. *The Rise of Adventism: Religion and Society in Mid-Nineteenth-Century America.* New York: Harper and Row, 1974.

Gibbons, Herbert Adams. *John Wanamaker.* 2 vols. New York: Harper, 1926.

Gillespie, Joanna Bowen. "'The Clear Leadings of Providence': Pious Memoirs and the Problems of Self-Realization for Women in the Early Nineteenth Century." *Journal of the Early Republic* 5, no. 2 (Summer 1985), 197–221.

Gillett, Ezra Hall. *Ancient Cities and Empires: Their Prophetic Doom.* Philadelphia: Presbyterian Publication Committee, 1867.

Gilmore, William J. "Literacy, The Rise of an Age of Reading, and the Cultural Grammar of Print Communications in America, 1735–1850." *Communication* 11, no. 1 (1988), 23–46.

———. *Reading Becomes a Necessity of Life: Material and Cultural Life in Rural New England, 1780–1835.* Knoxville: University of Tennessee Press, 1989.

Ginzberg, Lori D. *Women and the Work of Benevolence: Morality, Politics, and Class in the Nineteenth-Century United States.* New York: Yale University Press, 1990.

Gladden, Washington. *Social Salvation.* Boston: Houghton, Mifflin, 1902.

———. "Christianity and Aestheticism." *The Andover Review* 1, no. 1 (January 1884), 13–24.

Gladwell, Malcolm. "Listening to Khakis." *New Yorker,* July 28, 1997, 54–65.

Glees, Paul. *The Human Brain.* Cambridge: Cambridge University Press, 1988.

Godwin, Joscelyn. *Robert Fludd: Hermetic Philosopher and Surveyor of Two Worlds.* Boulder: Shambala, 1979.

Goen, C. C. "Jonathan Edwards: A New Departure in Eschatology." *Church History* 28, no. 1 (March 1959), 25–40.

Golden Book of the Wanamaker Stores, Jubilee Year 1861–1911. Philadelphia: John Wanamaker, 1911.

Goodrum, Charles, and Helen Dalrymple. *Advertising in America, The First Two Hundred Years.* New York: Abrams, 1990.

Goodykoontz, Colin Brummit. *Home Missions on the American Frontier.* Caxton, Idaho: Caxton Printers, 1939.

Graham, John. *Lavater's Essays on Physiognomy: A Study in the History of Ideas.* Bern: Peter Lang, 1979.

Graham, Roy E. *Ellen G. White, Co-Founder of the Seventh-day Adventist Church.* American University Studies, vol. 12. New York: Peter Lang, 1985.

Graybill, Ron. "America: Magic Dragon." *Insight* 2 (November 30, 1971), 6–12.

———. "Picturing the Prophecies." *Adventist Review* 161, no. 27 (July 5), 1984, 11–14.

Griffin, Clifford S. "Religious Benevolence as Social Control, 1815–1860." *The Mississippi Valley Historical Review* 44, no. 3 (December 1957), 423–44.

———. *Their Brothers' Keepers: Moral Stewardship in the United States, 1800–1865.* New Brunswick: Rutgers University Press, 1960.

Groce, George C., and David H. Wallace. *The New-York Historical Society's Dictionary of Artists in America, 1564–1860.* New Haven: Yale University Press, 1957.

Gutjahr, Paul. *An American Bible: A History of the Good Book in the United States, 1777–1880.* Stanford: Stanford University Press, 1998.

Hall, Jason W. "Gall's Phrenology: A Romantic Psychology." *Studies in Romanticism* 16 (Summer 1977), 305–17.

Hall, G. Stanley. *Adolescence: Its Psychology and its Relations to Physiology, Anthropology, Sociology, Sex, Crime, Religion, and Education.* 2 vols. New York: Appleton, 1905.

———. *Jesus, the Christ, in the Light of Psychology.* 2 vols. Garden City, N.Y.: Doubleday, 1917.

———. *Life and Confessions of a Psychologist.* New York: Appleton, 1923.

Hall, S. Roland. *The Advertising Handbook.* New York: McGraw-Hill, 1921.

Haltunen, Karen. *Confidence Men and Painted Women: A Study of Middle-Class Culture in America, 1830–1870.* New Haven: Yale University Press, 1982.

Hamilton, Sinclair. *Early American Book Illustrators and Wood Engravers 1670–1870.* 3 vols. Princeton: Princeton University Press, 1958.

Hampton, Kate P. "The Face of Christ in Art: Is the Portraiture of Jesus Strong or Weak?" *The Outlook* 61, no. 13 (April 1, 1899), 735–48.

Handy, Robert T. *A Christian America: Protestant Hopes and Historical Realities.* 2nd rev. ed. New York: Oxford University Press, 1984.

Harper, William Rainey. *Religion and the Higher Life.* Chicago: University of Chicago Press, 1904.

———. "The Scope and Purpose of the New Organization." In *The Religious Education Association, Proceedings of the First Annual Convention.* Chicago: Executive Office of the Association, 1903.

Harris, Neil. *The Artist in American Society: The Formative Years 1790–1860.* Chicago: University of Chicago Press, 1982.

———. *Cultural Excursions: Marketing Appetites and Cultural Tastes in Modern America.* Chicago: University of Chicago Press, 1990.

———. *Humbug: The Art of P. T. Barnum.* Boston: Little, Brown, 1973.

Hatch, Nathan. *The Democritization of American Christianity.* New Haven: Yale University Press, 1989.

———. *The Sacred Cause of Liberty: Republican Thought and the Millennium in Revolutionary New England.* New Haven: Yale University Press, 1977.

Hatch, Nathan, and Mark A. Noll, eds. *The Bible in America. Essays in Cultural History.* New York: Oxford University Press, 1982.

Haynes, Carlyle B. *The Return of Jesus.* Washington, D.C.: Review and Herald, 1926.

Heartman, Charles F. *The New England Primer Issued Prior to 1830.* New York: Printed for the compiler, 1922.

The Hieroglyphic Bible. Hartford: S. Andrus & Son, 1855.

Higham, John. *Strangers in the Land: Patterns of American Nativism, 1860–1925.* 2nd ed. New Brunswick: Rutgers University Press, 1988.

Higham, John, and Paul K. Conkin, eds. *New Directions in American Intellectual History.* Baltimore: Johns Hopkins University Press, 1979.

Hills, Margaret T. *The English Bible in America: A Bibliography of Editions of the Bible and the New Testament Published in America 1777–1957.* New York: American Bible Society and New York Public Library, 1961.

Himes, J. V., S. Bliss, and A. Hale, eds. *The Advent Shield and Review.* Boston: Joshua V. Himes, 1844.

Hitchings, Sinclair. "Some American Wood Engravers 1820–1840." *Printing and Graphic Arts* 9 (1961), 121–38.

The Hofmann Gallery of Original New Testament Illustrations. Philadelphia: A. J. Holmes and Co., 1891.

Hogan, William. *Auricular Confession and Popish Nunneries.* Hartford: S. Andrus & Son, 1845.

Holt, Elizabeth Gilmore. "Revivalist Themes in American Prints and Folksongs, 1830–1850." In *American Printmaking before 1876: Fact, Fiction and Fantasy.* Washington, D.C.: Library of Congress, 1975.

Howard, Philip E. *The Life Story of Henry Clay Trumbull, Army Chaplain, Editor, and Author.* New York: The International Committee of the Young Men's Christian Association, 1906.

Howard, Victor B. *Conscience and Slavery: The Evangelistic Calvinist Domestic Missions, 1837–1861.* Kent, Ohio: Kent State University Press, 1990.

Humphrey, Heman. *The Way to Bless and Save Our Country: A Sermon.* Philadelphia: American Sunday School Union, 1831.

Hungerford, Edward. "Walt Whitman and His Chart of Bumps." *American Literature* 2 (May 1931), 750–84.

Igles, F. Walter. *M. von Munkacsy.* Künstler Monographien, vol. 40. Bielefeld and Leipzig: Verlag von Velhagen and Klasing, 1899.

Ingalls, William. *A Lecture on the Subject of Phrenology not Opposed to the Principles of Religion; nor the Precepts of Christianity.* Boston: Dutton and Wentworth, 1839.

Instructions of the Executive Committee of the American Tract Society to Colporteurs and Agents. New York: American Tract Society, 1868.

Ivins, William M., Jr. *Prints and Visual Communication.* Cambridge: MIT Press, 1969.

Jackson, John, and W. A. Chatto. *A Treatise on Wood Engraving.* London: Henry Bohn, 1861.

James, William. *Principles of Psychology.* 2 vols. New York: Henry Holt and Company, 1890.

Jameson, Mrs. [Anna], and Lady Eastlake. *The History of Our Lord as Exemplified in Works of Art.* 3rd ed. 2 vols. London: Longmans, Green, and Co., 1872.

Jenkins, Reese V. *Images and Enterprise: Technology and the American Photographic Industry 1839–1925.* Baltimore: Johns Hopkins University Press, 1975.

Johnson, Clifton. *Old-Time Schools and School-Books.* New York: Dover, 1963.

Johnson, Paul E. *A Shopkeeper's Millennium: Society and Revivals in Rochester, New York, 1815–1837.* New York: Hill and Wang, 1978.

Johnson, Paul E., and Sean Wilentz. *The Kingdom of Matthias.* New York: Oxford University Press, 1994.

Jonsson, Hedvig Brander, et al. *Visual Paraphrases: Studies in Mass Media Imagery.* Special issue of *Figura,* vol. 21. Stockholm: Almqvist and Wiksell, 1984.

Joyce, William L., David D. Hall, Richard D. Brown, and John B. Hench, eds. *Printing and Society in Early America.* Worcester, Mass.: American Antiquarian Society, 1983.

Jussim, Estelle. *Visual Communication and the Graphic Arts: Photographic Technologies in the Nineteenth Century.* New York: R. R. Bowker, 1974.

Kaestle, Carl F. *Pillars of the Republic: Common Schools and American Society, 1780–1860.* New York: Hill and Wang, 1983.

Kellogg, M[erritt] G[ardner]. *A Key of Explanation of the Allegorical Picture Entitled "The Way of Life."* Battle Creek: Steam Press of the Seventh-Day Adventist Publishing Association, 1873.

Kennedy, William Bean. *The Shaping of Protestant Education.* New York: Young Men's Christian Association Press, 1966.

Kerber, Linda. "The Republican Ideology of the Revolutionary Generation." *American Quarterly* 37, no. 4 (Fall 1985), 474–95.

———. "The Republican Mother: Women and the Enlightenment—An American Perspective." *American Quarterly* 28, no. 2 (Summer 1976), 187-205.

Kett, Joseph. *Rites of Passage. Adolescence in America 1790 to the Present.* New York: Basic Books, 1977.

Key to the Allegorical Engraving Entitled The Way of Life from Paradise Lost to Paradise Restored. Battle Creek: Review and Herald, 1884.

King, Ethel. *Darley: The Most Popular Illustrator of His Time.* Brooklyn: Gaus, 1964.

King, Henry Churchill, Francis Greenwood Peabody, Lyman Abbott, Washington Gladden, et al. *Education and Character.* Chicago: Religious Education Association, 1908.

Kirkham, E. Bruce, and John W. Fink. *Indices to American Literary Annuals and Gift Books 1825–1865.* New Haven: Research Publications, 1975.

Knight, Helen Cross, et al. *Flowers of Spring-Time.* New York: American Tract Society, 1861.

Knubel, Helen M. "Alexander Anderson and Early American Book Illustration." *Princeton University Library Chronicle* 1, no. 3 (April 1940), 8–18.

Kubler, George A. *Historical Treatises, Abstracts, and Papers on Stereotyping.* New York: Brooklyn Eagle Press, 1936.

Kurtz, Charles M. *Christ Before Pilate: The Painting by Munkacsy.* New York: Published for the Exhibition, 1887.

Kuryluk, Ewa. *Veronica and Her Cloth: History, Symbolism, and Structure of a "True" Image.* Cambridge, Mass.: Basil Blackwell, 1991.

Kuykendall, John W. *Southern Enterprise: The Work of National Evangelical Societies in the Antebellum South.* Westport, Conn.: Greenwood Press, 1982.

La Farge, John. *The Gospel Story in Art.* New York: Macmillan, 1913.

Lamont, Michèle, and Marcel Fournier, eds. *Cultivating Differences: Symbolic Boundaries and the Making of Inequality.* Chicago: University of Chicago Press, 1992.

Land, Gary, ed. *Adventism in America.* Grand Rapids: Eerdmans, 1986.

Lankard, Frank Glenn. *A History of the American Sunday School Curriculum.* New York: Abingdon Press, 1927.

Larkin, Clarence. *Dispensational Truth or God's Plan and Purpose in the Ages.* Rev. ed. Philadelphia: Rev. Clarence Larkin Estate, 1920.

———. *The Book of Revelation: A Study of the Last Prophetic Book of Holy Scripture.* Philadelphia: Rev. Clarence Larkin Estate, 1919.

Layard, Austen Henry. *Ninevah and Its Remains.* 2 vols. New York: George P. Putnam, 1849.

Leach, William. *Land of Desire: Merchants, Power, and the Rise of a New American Culture.* New York: Pantheon Books, 1993.

Lears, T. J. Jackson. *Fables of Abundance: A Cultural History of Advertising in America.* New York: Basic Books, 1994.

———. *No Place of Grace: Antimodernism and the Transformation of American Culture, 1880–1920.* Chicago: University of Chicago Press, 1981.

Leland, Charles G. "The Head of Christ, By Steinhauser." *Sartain's Magazine* 4, no. 2 (February 1849), 134–37.

Lemagny, Jean-Claude, and André Rouillé, eds. *A History of Photography: Social and Cultural Perspectives.* Tr. Janet Lloyd. Cambridge: Cambridge University Press, 1987.

Letters Respecting a Book "Dropped From the Catalogue" of the American Sunday School Union, in Compliance with the Dictation of the Slave Power. New York: American and Foreign Anti-Slavery Society, 1848.

Levine, Lawrence. "The Folklore of Industrial Society: Popular Culture and Its Audiences." *The American Historical Review* 97, no. 5 (December 1992), 1369-99.

———. *Highbrow Lowbrow: The Emergence of Cultural Hierarchy in America.* Cambridge: Harvard University Press, 1988.

Licht, Walter. *Industrializing America: The Nineteenth Century.* Baltimore: Johns Hopkins University Press, 1995.

Linton, W. J. *The History of Wood-Engraving in America.* London: George Bell and Sons, 1882.

Looney, Robert F., ed. *Philadelphia Printmaking: American Prints before 1860.* Philadelphia: Tinicum Press, 1976.

Lossing, Benson J. "Dr. Alexander Anderson." *Child's Paper* 16, no. 11 (November 1867), 41.

———. *A Memorial of Alexander Anderson, M.D., the First Engraver on Wood in America. Read before the New York Historical Society, October 1870.* New York: Printed for the Subscribers, 1872.

Lovejoy, David S. "American Painting in Early Nineteenth-Century Gift Books." *American Quarterly* 7, no. 4 (Winter 1955), 345–361.

Lubin, David M. *Picturing a Nation: Art and Social Change in Nineteenth-Century America.* New Haven: Yale University Press, 1994.

Lücke, M. *Biblische Symbole oder Bibelblätter in Bildern,* rev. ed. Chicago: John A. Hertel, 1911.

Lundén, Rolf. *Business and Religion in the American 1920s.* New York: Greenwood Press, 1988.

Luther, Martin. *Luther's Works.* Philadelphia: Muttenberg Press, 1958.

Lynch, Edmund C. *Walter Dill Scott: Pioneer in Personnel Management.* Austin: Bureau of Business Research, University of Texas at Austin, 1968.

McClellan, Elisabeth. *History of American Costume 1607–1870.* New York: Tudor, 1937.

McCook, H. C. *Object and Outline Teaching. A Guidebook for Sunday-School Workers.* St. Louis: J. W. McIntyre, 1871.

McCracken, Grant. *Culture and Consumption: New Approaches to the Symbolic Character of Consumer Goods and Activities.* Bloomington: Indiana University Press, 1990.

McDannell, Colleen. *Material Christianity: Religion and Popular Culture in America.* Yale University Press, 1995.

———. *The Christian Home in Victorian America, 1840–1900.* Bloomington: Indiana University Press, 1986.

McFarland, John T., and Benjamin S. Winchester, eds. *The Encyclopedia of Sunday Schools and Religious Education.* 3 vols. New York: Thomas Nelson, 1915.

McGaw, Judith A. *Most Wonderful Machine: Mechanization and Social Change in Berkshire Paper Making, 1801–1885.* Princeton: Princeton University Press, 1987.

McKivigan, John R. *The War against Proslavery Religion: Abolitionism and the Northern Churches, 1830–1865.* Ithaca: Cornell University Press, 1984.

McLaren, Angus. "Phrenology: Medium and Message." *Journal of Modern History* 46, no. 1 (March 1974), 86–97.

Macleod, David I. *Building Character in the American Boy: The Boy Scouts, YMCA, and Their Forerunners, 1870–1920.* Madison: University of Wisconsin Press, 1983.

McLoughlin, William G. *The Meaning of Henry Ward Beecher: An Essay on the Shifting of Values of Mid-Victorian America, 1840–1870.* New York: Knopf, 1970.

Mann, Horace. *Lectures on Education.* Boston: Ide & Dutton, 1855.

Mann, Horace. *The Republic and the School: The Education of Free Men,* ed. Lawrence A. Cremin. New York: Teachers College, Columbia University, 1957.

Marsden, George M. *Fundamentalism and American Culture: The Shaping of Twentieth-Century Evangelicalism 1870–1925.* Oxford: Oxford University Press, 1980.

Martinez, Ann Katharine. "The Life and Career of John Sartain (1808–1897): A Nineteenth-Century Philadelphia Printmaker," Ph.D. diss., George Washington University, 1986.

Marx, Leo. *The Machine in the Garden: Technology and the Pastoral Ideal in America.* New York: Oxford University Press, 1964.

Marzio, Peter C. *The Democratic Art. Chromolithography 1840–1900: Pictures for a Nineteenth Century America.* Boston: Godine, 1979.

Mather, Eleanore Price. *Edward Hicks: His Peaceable Kingdoms and Other Paintings.* Newark: University of Delware Press, 1983.

Mathews, Donald G. "The Second Great Awakening as an Organizing Process, 1780–1830." *American Quarterly* 21, no. 1 (Spring 1969), 23–43.

Maus, Cynthia Pearl. *Christ and the Fine Arts.* Rev. ed. New York: Harper, 1959.

———. *Teaching the Youth of the Church.* New York: George H. Doran, 1925.

Mede, Joseph. *The Key of the Revelation.* Tr. Richard More. London: R. B., 1643.

Meille, Giovanni E. *Christ's Likeness in History and Art,* tr. Emmie M. Kirkman. London: Burns, Oates and Washbourne, 1924.

Melder, Keith. "Ladies Bountiful: Organized Women's Benevolence in Early Nineteenth Century America." *New York History* 68, no. 3 (July 1967), 231–54.

Miller, Angela L. *The Empire of the Eye: Landscape Representation and American Cultural Politics, 1825–1875.* Ithaca: Cornell University Press, 1993.

Miller, Daniel. *Material Culture and Mass Consumption.* Oxford: Blackwell, 1987

Miller, William. *Apology and Defense.* Boston: J. V. Himes, 1845.

Miller, William. *Evidence from Scripture and History of the Second Coming of Christ about the Year 1843.* Boston: Joshua V. Himes, 1842.

———. *Views of the Prophecies and Prophetic Chronology.* Ed. Joshua V. Himes. Boston: J. V. Himes, 1842.

Milnor, James, et al. *The Address of the Executive Committee of the American Tract Society to the Christian Public.* New York: American Tract Society, 1825.

Milspaw, Yvonne J. "Protestant Home Shrines: Icon and Image." *New York Folklore* 12, nos. 3–4 (1986), 119–36.

Minnich, Harvey C. *William Homes McGuffey and His Readers.* New York: American Book Company, 1936.

Monk, Maria. *Awful Disclosures of the Hotel Dieu Nunnery of Montreal.* New York: Published by Maria Monk, 1836; reprint, New York: Arno Press, 1977.

Moore, R. Laurence. *Selling God: American Religion in the Marketplace of Culture.* New York: Oxford University Press, 1994.

Moorhead, James H. "Between Progress and Apocalypse: A Reassessment of Millennialism in American Religious Thought, 1800–1880." *Journal of American History* 71, no. 3 (December 1984), 524–42.

———. "The Erosion of Postmillennialism in American Religious Thought, 1865–1925." *Church History* 53, no. 1 (March 1984), 61–77.

Morgan, David. *Visual Piety: A History and Theory of Popular Religious Images* Berkeley: University of California Press, 1998.

———, ed., *Icons of American Protestantism: The Art of Warner Sallman.* New Haven: Yale University Press, 1996.

Morgan, Douglas. "The Remnant and the Republic: Seventh-Day Adventism and the American Public Order." Ph.D. diss., University of Chicago, 1992.

Morris, Robert C. *Reading, 'Riting, and Reconstruction: The Education of Freedmen in the South, 1861–1870.* Chicago: University of Chicago Press, 1982.

Morse, John D., ed. *Prints in and of America to 1850.* University Press of Virginia, 1970.

Morse, Samuel F. B. *Foreign Conspiracies against the Liberties of the United States.* New York: Leavitt, Lord, 1835.

Mosier, Richard D. *Making the American Mind: Social and Moral Ideas in the McGuffey Readers.* New York: King's Crown Press, 1947.

Mott, Frank Luther. *A History of American Magazines.* 4 vols. New York: Appleton, 1930–1938.

Muller, Dorothy R. "Josiah Strong and American Nationalism: A Reevaluation." *Journal of American History* 53, no. 3 (1966–1967), 487–503.

———. "The Social Philosophy of Josiah Strong: Social Christianity and American Progressivism." *Church History* 28, no. 2 (June 1959), 183–201.

Nash, Paul, ed. *History and Education: The Educational Uses of the Past.* New York: Random House, 1970.

Nelson, Robert S. and Richard Shiff, eds. *Critical Terms for Art History.* Chicago: University of Chicago Press, 1996.

Neufeldt, Harvey. "The American Tract Society: An Examination of its Religious, Economic, Social, and Political Ideas." Ph.D. diss., University of Michigan, 1971.

Nevins, William. *Thoughts on Popery.* New York: American Tract Society, 1836; reprint, New York: Arno Press, 1977.

The New-England Primer Improved. Boston: W. M'Alpine, 1767.

A New Hieroglyphic Bible. Hartford: Oliver D. Cooke, 1821.

A New Hieroglyphic Bible. 11th ed. New York: Printed for William Jackson, 1836; reprint, New York: American Heritage Press, 1970.

A New Hieroglyphihc Bible, 11th ed. Chiswick, New York: C. Whittingham, 1836; reprint, New York: American Heritage Press, 1970.

New Hieroglyphic Bible. Boston: W. Norman, 1794.

Newell, Rev. E. F. *Life and Observations of Rev. E. F. Newell.* Worcester, Mass.: C. W. Ainsworth, 1847.

Newman, Samuel P. *A Practical System of Rhetoric: or the Principles and Rules of Style.* 2nd ed. Portland, Maine: Shirley & Hyde; Andover: Mark Newman, 1829.

Nichol, Francis D. *The Midnight Cry.* Washington, D.C.: Review and Herald, 1944.

Nissenbaum, Stephen. *Sex, Diet, and Debility in Jacksonian America: Sylvester Graham and Health Reform.* Westport, Conn.: Greenwood Press, 1980.

Nord, David Paul. "The Evangelical Origins of Mass Media in America, 1815–1835." *Journalism Monographs* (1984), 1–30.

———. "Religious Reading and Readers in Antebellum America." *Journal of the Early Republic* 15 (Summer 1995), 241–72.

———. "Systematic Benevolence: Religious Publishing and the Marketplace in Early Nineteenth-Century America." In *Communication and Change in American Religious History,* ed. Leonard I. Sweet. Grand Rapids: Eerdmans, 1993.

Numbers, Ronald L. *The Disappointed: Millerism and Millenariansim in the Nineteenth Century.* Bloomington: Indiana University Press, 1987.

Numbers, Ronald L., and Darrel W. Amundsen, eds. *Caring and Curing: Health and Medicine in the Western Religious Traditions.* New York: Macmillan, 1986.

Numbers, Ronald L., and Jonathan M. Butler, eds. *Prophetess of Health: A Study of Ellen G. White.* New York: Harper & Row, 1976.

Ohmann, Richard. *Selling Culture: Magazines, Markets, and Class at the Turn of the Century.* London: Verso, 1996.

O'Leary, Stephen. *Arguing the Apocalypse: A Theory of Millennial Rhetoric.* New York: Oxford University Press, 1994.

1,000 Quaint Cuts from Books of Other Days. New York: Irving Zucker, 1950.

Onuf, Peter. "Toward a Republican Empire: Interest and Ideology in Revolutionary America." *American Quarterly* 37, no. 4 (Fall 1985), 496–531.

Orvell, Miles. *The Real Thing: Imitation and Authenticity in American Culture, 1880–1940.* Chapel Hill: University of North Carolina Press, 1989.

Overton, Charles. *Cottage Lectures; or, The Pilgrim's Progress Practically Explained.* Philadelphia: American Sunday School Union, 1849.

Paine, Thomas. *The Age of Reason.* Reprint, New York: Freethought Association, n.d.

Parker, Francis W. *Talks on Pedagogics: An Outline of the Theory of Concentration.* New York: E. L. Kellogg, 1984.

Paxton, Geoffrey J. *The Shaking of Adventism.* Grand Rapids: Baker Book House, 1977.

Perry, Lewis. *Radical Abolitionism: Anarchy and the Government of God in Anti-Slavery Thought.* Ithaca: Cornell University Press, 1973.

Pessen, Edward. *Jacksonian America: Society, Personality, and Politics.* Rev. ed. Homewood, Ill.: Dorsey Press, 1978.

Pestalozzi, Johann Heinrich. *Leonard and Gertrude.* Tr. and ed. Eva Channing. Intro. G. Stanley Hall. Boston: D. C. Heath & Co., 1885.

Peters, Harry T. *America on Stone. The Other Printmakers to the American People.* Garden City, N.Y.: Doubleday, Doran, 1931.

Phillips, David Clayton. "Art for Industry's Sake: Halftone Technology, Mass Photography and the Social Transformation of American Print Culture, 1880–1920." Ph.D. diss., Yale University, 1996.

Pierce, Robert F. Y. *Pictured Truth. A Hand-Book of Blackboard and Object Lessons.* New York: Fleming H. Revell, 1895.

Pinloche, A. *Pestalozzi and the Foundation of the Modern Elementary School.* New York: Scribner's, 1901.

Pomeroy, Jane R. "Alexander Anderson's Life and Engravings before 1800, with a Checklist of Publications Drawn from His Diary." *Proceedings of the American Antiquarian Society* 100, pt. 1 (1900), 137–230.

———. "On the Changes Made in Wood Engravings in the Stereotyping Process." *Printing History* 17, no. 2 (1995), 35–40.

Pratt, Waldo S. "Work of the Department of Religious Art." *Religious Education* 1, no. 1 (1906), 70–74.

Presbrey, Frank. *The History and Development of Advertising.* Garden City, N.Y.: Doubleday, Doran, 1929.

A Pretty Picture Book. New York: American Tract Society, n.d. [1829].

Priest, Josiah. *A View of the Expected Millennium.* 5th ed. Albany: Lomis' Press, 1828.

Proceedings of the Public Meeting Held in Boston to aid the American Sunday School Union in their Efforts to establish Sunday Schools throughout the Valley of the Mississippi. Philadelphia: American Sunday School Union, 1831.

Promey, Sally M. "Sargent's Truncated *Triumph*: Art and Religion at the Boston Public Library, 1890–1925." *Art Bulletin* 79, no. 2 (June 1997), 217–50.

Publications of the American Tract Society. 12 vols. New York: American Tract Society, 1842.

Publications of the American Tract Society. 7 vols. Andover: Flagg & Gould, 1824.

Quandt, Jean B. "Religion and Social Thought: The Secularization of Postmillennialism." *American Quarterly* 25, no. 4 (October 1973), 390–409.

Quinn, D. Michael. *Early Mormonism and the Magic World View.* Salt Lake City: Signature Books, 1987.

Quist, John W. "Slaveholding Operatives of the Benevolent Empire: Bible, Tract, and Sunday School Societies in Antebellum Tuscaloosa County, Ala-

bama." *Journal of the Early Republic* 62, no. 3 (August 1996), 481–526.

Reeves, Marjorie, and Beatrice Hirsch-Reich. *The Figurae of Joachim of Fiore*. Oxford: Clarendon Press, 1972.

Reilly, Elizabeth Carroll. *A Dictionary of Colonial American Printers' Ornaments and Illustrations*. Worcester, Mass.: American Antiquarian Society, 1975.

Renan, Ernest. *Vie de Jesus*. Paris: Michel Levy Freres, 1863.

Report and Resolutions, Adopted June 1, 1858, by the South-Carolina Branch of the American Tract Society in Reference to the Action Taken on Slavery by the Parent Society at its Last Annual Meeting, May 1858. Charleston: South-Carolina Branch of the American Tract Society, 1858.

A Review of the Official Apologies of the American Tract Society for its Silence on the Subject of Slavery. New York: The American Abolition Society, 1856.

Reymert, Martin L. H., and Robert J. F. Kashey, eds. *Christian Imagery in French Nineteenth Century Art 1789–1906*. Exhibition catalogue. New York: Shepherd Gallery, 1980.

Ribuffo, Leo P. "Jesus Christ as Business Statesman: Bruce Barton and the Selling of Corporate Capitalism." *American Quarterly* 33, no. 2 (Summer 1981), 206–31.

Rice, Edwin W. *The Sunday-School Movement, 1780–1817, and the American Sunday-School Union, 1817–1917*. Philadelphia: American Sunday School Union, 1917.

Richards, Thomas. *The Commodity Culture of Victorian England: Advertising and Spectacle, 1851–1914*. Stanford: Stanford University Press, 1990.

Rogers, Dorothy. *Oswego: Fountainhead of Teacher Education: A Century in the Sheldon Tradition*. New York: Appleton Century Crofts, 1961.

Rohrer, James R. "Sunday Mails and the Church-State Theme in Jacksonian America." *Journal of the Early Republic* 7, no. 1 (Spring 1987), 53–74.

Roof, Wade Clark, and William McKinney. *American Mainline Religion: Its Changing Shape and Future*. New Brunswick: Rutgers University Press, 1987.

Root, Marcus Aurelius. *The Camera and the Pencil; or the Heliographic Art*. Philadelphia: M. A. Root and J. B. Lippincott, 1864.

Rosen, Charles, and Henri Zerner. *Romanticism and Realism. The Mythology of Nineteenth-Century Art*. New York: W. W. Norton, 1984.

Ross, Dorothy. *G. Stanley Hall: The Psychologist as Prophet*. Chicago: University of Chicago Press, 1972.

Rotskoff, Lori E. "Decorating the Dining Room: Still-Life Chromolithographs and Domestic Ideology in Nineteenth-Century America." *Journal of American Studies* 31, no. 1 (1997), 19–42.

Rowe, David L. *Thunder and Trumpets. Millerites and Dissenting Religion in Upstate New York, 1800–1850*. American Academy of Religion Studies in Religion. Chico, Calif.: Scholars Press, 1985.

Rowland, Benjamin, Jr. "Popular Romanticism: Art and the Gift Books 1825–1865." *Art Quarterly* 20, no. 4 (Winter 1957), 365–81.

Rudisill, Richard. *Mirror Image: The Influence of the Daguerreotype on American Society*. Albuquerque: University of New Mexico Press, 1971.

Russell, Charles Taze. *Studies in the Scriptures Series 1, The Plan of the Ages*. Allegheny, Penn.: Watch Tower and Tract Society, 1908.

Russell, Helen E. H. "The Use of Pictures in the Church School." *Religious Education* 14, no. 1 (February 1919), 89–94.

Ryan, Mary P. *Cradle of the Middle Class: The Family in Oneida County, New York, 1790–1865*. New York: Cambridge University Press, 1981.

Saarinen, Aline B. *The Proud Possessors: The Lives, Times, and Tastes of Some Adventurous American Art Collectors*. New York: Random House, 1958.

Sampey, John Richard. *The International Lesson System: The History of Its Origin and Development*. New York: Fleming H. Revell, 1911.

Sandeen, Ernest. *The Roots of Fundamentalism: British and American Millenarianism, 1800–1930*. Chicago: University of Chicago Press, 1970.

Sawyer, C. M. *The Rose of Sharon: A Religious Souvenir for MDCCCLII*. Boston: A. Tompkins and B. B. Mussey & Co., 1852.

Schantz, Mark S. "Religious Tracts, Evangelical Reform, and the Market Revolution in Antebellum America." *Journal of the Early Republic* 17, no. 3 (Fall 1997), 425–66.

Schapiro, Meyer. *Words, Script, and Pictures: Semiotics of Visual Language*. New York: George Braziller, 1996.

Schlesinger, Arthur, Jr. *The Age of Jackson*. Boston: Little, Brown, 1946.

Schmidt, Leigh Eric. *Consumer Rites: The Buying and Selling of American Holidays*. Princeton: Princeton University Press, 1995.

Schmidt, Stephen A. *A History of the Religious Education Association*. Birmingham: Religious Education Press, 1983.

Schnorr von Carolsfeld, Julius. *Die Bibel der Bilder*. Leipzig: Georg Wigland [1870?].

Schultze, Quentin J., ed. *American Evangelicals and the Mass Media*. Grand Rapids: Academie Books, Zondervan, 1990.

Scribner, R. W. *For the Sake of Simple Folk: Popular Propaganda for the German Reformation*. Oxford: Clarendon Press, 1994.

Scudder, John. *Dr. Scudder's Tales for Little Readers, About the Heathen*. New York: American Tract Society, 1853.

Sears, Clara Endicott. *Days of Delusion. A Strange Bit of History*. Boston: Houghton, Mifflin, 1924.

Sedelmeyer, Charles. *M. von Munkácsy: Sein Leben und seine künstlerische Entwicklung*. Paris: Charles Sedelmeyer, 1914.

Sellers, Charles. *The Market Revolution: Jacksonian America 1815–1846*. New York: Oxford University Press, 1991.

Seventh-Day Adventist Encyclopedia. Rev. ed. Washington, D.C.: Review and Herald, 1976.

Shaffer, Ellen. "The Children's Books of the American Sunday-School Union." *American Collector* 17, no. 2 (October 1966), 20–28.

Shaw, James. *The Roman Conflict: or, Rise, Power, and Impending Conflict of Roman Catholicism.* Cincinnati: Hitchcock and Walden, 1878.

Simms, P. Marion. *The Bible in America.* New York: Wilson-Erickson, 1936.

Singleton, Gregory H. "Protestant Voluntary Organizations and the Shaping of Victorian America." *American Quarterly* 27, no. 5 (December 1975), 549–60.

Sklar, Kathryn Kish. *Catharine Beecher: A Study in American Domesticity.* New York: W. W. Norton, 1976.

Slee, Jacquelynn. "A Summary of the English Editions of Illustrated Bibles Published in America between 1790 and 1825, with Indices of Subjects Illustrated and Engraved." M.A. thesis, University of Michigan, 1973.

Slocum, Stephen E. "The American Tract Society: 1825–1975. An Evangelical Effort to Influence the Religious and Moral Life of the United States." Ph.D. diss., New York University, 1975.

Smith, Elwyn A., ed. *The Religion of the Republic.* Philadelphia: Fortress Press, 1971.

Smith, Ralph Ruggles, Jr. "'In Every Destitute Place': The Mission Program of the American Sunday School Union, 1817–1834," Ph.D. diss., University of Southern California, 1973.

Smith, Timothy L. "Progressivism in American Education, 1880–1900." *Harvard Educational Review* 31, no. 2 (Spring 1961), 168–93.

———. "Protestant Schooling and American Nationality, 1800–1850." *Journal of American History* 53, no. 4 (March 1967), 679–95.

———. "Righteousness and Hope: Christian Holiness and the Millennial Vision in America, 1800–1900." *American Quarterly* 31, no. 1 (Spring 1979), 21–45.

[Smith, Uriah]. *Key to the Prophetic Chart.* Battle Creek: Seventh-Day Adventist Publishing Association, 1864.

Smith, Uriah. *The Marvel of the Nations. Our Country: Its Past, Present, and Future, and What the Scriptures Say of It.* Battle Creek: Review and Herald, 1885.

Smith, Daniel. *Thoughts, Critical and Practical, on the Book of Daniel and the Revelation.* Oakland, Cal.: Pacific Press Publishing House, 1882.

Smith-Rosenberg, Caroll. *Disorderly Conduct: Visions of Gender in Victorian America.* New York: Knopf, 1985.

Sneath, E. Hershey, George Hodges, and Henry Hallam Tweedy. *Religious Training in the School and Home: A Manual for Teachers and Parents.* New York: Macmillan, 1917.

Sokolosky, Barbara A., ed. *American Sunday School Union Papers 1817–1915: A Guide to the Microfilm Edition.* Sanford, N.C.: Microfilming Corporation of America, 1980.

Soltow, Lee, and Edward Stevens. *The Rise of Literacy and the Common School in the United States: A Socioeconomic Analysis to 1870.* Chicago: University of Chicago Press, 1981.

Speciman Book of Engravings. Electrotype Casts Furnished to Order. New York: Carlton and Porter, ca. 1857–1860.

Speeches of Messrs. Webster, Frelinghuysen and Others at the Sunday School Meeting in the City of Washington. Philadelphia: American Sunday School Union, 1831.

Spirit of Popery. New York: American Tract Society, n.d. [1845].

Spring, Gardiner. *Influence. A Quarter-Century Sermon, Preached in Behalf of the American Tract Society.* New York: American Tract Society, 1850.

Squire, Larry R., et al., eds. *Encyclopedia of Learning and Memory.* New York: Macmillan, 1992.

Stafford, Barbara. *Artful Science: Enlightenment Entertainment and the Eclipse of Visual Education.* Cambridge: MIT Press, 1994.

Starbuck, Edwin Diller. *The Psychology of Religion: An Empirical Study of the Growth of Religious Consciousness.* New York: Scribner's, 1915.

Starch, Daniel. *Advertising Principles.* Chicago: A. W. Shaw, 1927.

Stauffer, Paul. "Uriah Smith: Wood Engraver." *Adventist Heritage* 3, no. 1 (Summer 1976), 17–21.

Stout, Harry S. "Religion, Communication, and the Ideological Origins of the American Revolution." *William and Mary Quarterly* 34, no. 4 (October 1977), 519–41.

Strasser, Susan. *Satisfaction Guaranteed: The Making of the American Mass Market.* New York: Pantheon, 1989.

Strauss, David Friedrich. *The Life of Jesus: Critically Examined,* translated from the 4th German edition. London: Chapman Brothers, 1846.

Strong, Josiah. *Our Country: Its Possible Future and Its Present Crisis.* Rev. ed. New York: Published by The Baker & Taylor Co. for The American Home Missionary Society, 1891.

Sussman, Warren I. "'Personality' and the Making of Twentieth-Century Culture." In *New Directions in American Intellectual History,* ed. John Higham and Paul K. Conkin. Baltimore: Johns Hopkins University Press, 1979.

Sutton, Walter. *The Western Book Trade: Cincinnati as a Nineteenth-Century Publishing and Book Trade Center.* Columbus: Ohio State University Press for the Ohio Historical Society, 1961.

Sweet, Leonard I., ed. *Communication and Change in American Religious History.* Grand Rapids: Eerdmans, 1993.

———. *The Evangelical Tradition in America.* Macon, Ga.: Mercer University Press, 1984.

"A Symposium on Charles Sellers, *The Market Revolution: Jacksonian America, 1815–1846.*" *Journal of the Early Republic* 12, no. 4 (Winter 1992), 445–76.

Talmage, T. DeWitt. *From Manger to Throne, Embracing a New Life of Jesus the Christ, and A History of Palestine and Its People*. Philadelphia: Historical Publishing Company, 1890.

Tatham, David. "John Henry Bufford, American Lithographer." *Proceedings of the American Antiquarian Society* 86, pt. 1 (1976), 47–73.

Tebbel, John, and Mary Ellen Zuckerman. *The Magazine in America 1741–1990*. New York: Oxford University Press, 1991.

Tenney, E. P. *Our Elder Brother. His Biography*. Springfield, Ma.: King-Richardson Publishing Company, 1898.

Thomas, John L. "Romantic Reform in America, 1815–1865." *American Quarterly* 17, no. 4 (Winter 1965), 656–81.

Thompson, Lawrence. "The Printing and Publishing Activities of the American Tract Society from 1825 to 1850." *Papers of the Bibliographical Society of America* 35, no. 2 (1941), 81–114.

Thompson, Ralph. *American Literary Annuals and Gift Books 1825–1865*. New York: H. W. Wilson, 1936.

Tipper, Harry, et al. *The Principles of Advertising. A Text-Book*. New York: Ronald Press, 1921.

Tolstoy, Leo. *What is Art?* Indianapolis: Bobbs-Merrill, 1960.

Tomkins, Calvin. *Merchants and Masterpieces: The Story of the Metropolitan Museum of Art*. Rev. ed. New York: Holt, 1989.

Tompkins, Jane P. *Sensational Designs: The Cultural Work of American Fiction, 1790–1860*. New York: Oxford University Press, 1985.

Tracts of the American Tract Society, General Series. 12 vols. New York: American Tract Society, [1849].

Trent, William Peter, et al., eds. *The Cambridge History of American Literature*. 4 vols. New York: Putnam, 1918.

Trumbull, H. Clay. *Teaching & Teachers, or The Sunday-School Teacher's Teaching Work and the Other Work of the Sunday-School Teacher*. Philadelphia: John D. Wattles, 1884.

Twadell, Elizabeth. "The American Tract Society, 1814–1860." *Church History* 15, no. 2 (June 1946), 116–32.

Twyman, Michael. *Printing 1770–1970: An Illustrated History of Its Development and Uses in England*. London: Eyre and Spottiswoode, 1970.

———, *Turning Points in American Educational History*. Waltham, Mass. Blaisdell, 1967.

Tyack, David. "The Kingdom of God and the Common School: Protestant Ministers and the Educational Awakening in the West." *Harvard Educational Review* 36, no. 4 (1966), 447–69.

The Unanimous Remonstrance of the Fourth Congregational Church, Hartford, Conn., Against the Policy of the American Tract Society on the Subject of Slavery. Hartford: Silas Andrus & Son, 1855.

Underwood, Grant. *The Millenarian World of Early Mormonism*. Urbana: University of Illinois Press, 1993.

United States Bureau of the Census. *A Century of Population Growth from the First Census of the United States to the Twelfth 1790–1900*. Washington, D.C.: Government Printing Office, 1909.

United States Primer. New York: American Tract Society, 1864.

Valois, Karl Eric. "To Revolutionize the World: The American Tract Society and the Regeneration of the Republic, 1825–1877," Ph.D. diss., University of Connecticut, 1994.

Van de Wetering, Maxine. "The Popular Concept of 'Home' in Nineteenth-Century America." *Journal of American Studies* 18, no. 1 (April 1984), 5–28.

Vincent, John H. *The Modern Sunday-School*. New York: Eaton and Mains; Cincinnati: Curts and Jennings, 1887.

Vogt, Von Ogden. "Esthetics in Education." *Religious Education* 22, no. 10 (December 1927), 986–92.

Wainwright, J. M., ed. *Our Saviour with Prophets and Apostles*. New York: D. Appleton & Co., 1851.

Wainwright, Nicholas B. *Philadelphia in the Romantic Age of Lithography*. Philadelphia: Historical Society of Pennsylvania, 1958.

Walker, William B. "The Health Reform Movement in the United States, 1830-1870." Ph.D. diss., Johns Hopkins University, 1955.

Ward, Gerald W. R., ed. *The American Illustrated Book in the Nineteenth Century*. Winterthur, Del.: Winterthur Museum, 1987.

Webster, Noah. *Pictorial Elementary Spelling Book*. New York: George Coolege, 1848.

Weigle, Luther A. "The Christian Ideal of Family Life as Expounded in Horace Bushnell's 'Christian Nurture,'" *Religious Education* 19, no. 1 (February 1924), 47–57.

Weinberg, H. Barbara. "John La Farge: Pioneer of the American Mural Movement." *John La Farge*. Exhibition catalogue, Carnegie Museum of Art. New York: Abbeville Press, 1987.

Weiss, Harry B. *The Number of Persons and Firms connected with the Graphic Arts in New York City 1633–1820*. New York: New York Public Library, 1946.

Welter, Barbara. "The Cult of True Womanhood: 1820–1860." *American Quarterly* 18, no. 2 (Summer 1966), 151–174.

Westerhoff, John H. III. *McGuffey and His Readers: Piety, Morality, and Education in Nineteenth-Century America*. Nashville: Abingdon, 1978.

White, Ellen. *Counsels to Writers and Editors*. Nashville: Southern Publishing Association, 1946.

———. *Early Writings*. Washington, D.C.: Review and Herald, 1963.

———. *The Great Controversy Between Christ and His Angels and Satan and His Angels*. Battle Creek: Review and Herald, 1888.

White, Ellen G. *Steps to Christ*. Washington, D.C.: Review and Herald, 1921.

White, James. *Life Incidents*. Battle Creek: Seventh-Day Adventist Publishing Association, 1868.

Whitehill, Walter Muir. *Museum of Fine Arts, Boston: A Centennial History.* 2 vols. Cambridge: Harvard University Press, 1970.

Whitmore, William H. *Abel Bowen, Engraver. A Sketch Prepared for The Bostonian Society.* Boston: Press of Rockwell and Churchhill, 1884.

Whorton, James C. *Crusaders for Fitness: The History of American Health Reformers.* Princeton: Princeton University Press, 1982.

Wightman Fox, Richard, and T. J. Jackson Lears, eds. *The Culture of Consumption: Critical Essays in American History, 1880–1920.* New York: Pantheon Books, 1983.

Wishy, Bernard. *The Child and the Republic: The Dawn of Modern American Child Nurture.* Philadelphia: University of Pennsylvania Press, 1968.

Woolsey, Raymond H., and Ruth Anderson. *Harry Anderson: The Man behind the Paintings.* Washington, D.C.: Review and Herald, 1976.

Wood, Gordon S. "The Significance of the Early Republic." *Journal of the Early Republic* 8, no. 1 (Spring 1988), 1–20.

———. *The Radicalism of the American Revolution.* New York: Knopf, 1992.

Wright, John. *Early Bibles in America.* 3rd rev. ed. New York: Thomas Whittaker, 1894.

Wroth, William. *Images of Penance, Images of Mercy: Southwestern Santos in the Late Nineteenth Century.* Norman: Published for the Taylor Musuem for Southwestern Studies by the University of Oklahoma Press, 1991.

Wyatt-Brown, Bertram. *Lewis Tappan and the Evangelical War against Slavery.* Cleveland: Case Western Reserve, 1969.

———. "Prelude to Abolitionism: Sabbatarian Politics and the Rise of the Second Party System." *Journal of American History* 58, no. 2 (September 1971), 316–45.

Yonkers, Dolores Beck. "The Face as an Element of Style: Physiognomical Theory in Eighteenth-Century British Art." Ph.D. diss., University of California, Los Angeles, 1970.

Zalesch, Saul E. "What the Four Million Bought: Cheap Oil Paintings of the 1880s." *American Quarterly* 48, no. 1 (March 1996), 77–109.

Index